London Calling

A Countercultural History of London since 1945

Barry Miles

Atlantic Books

LONDON

First published in hardback in Great Britain in 2010 by Atlantic Books,
an imprint of Grove Atlantic Ltd.

This paperback edition published in Great Britain in 2011 by Atlantic Books.

1 2 3 4 5 6 7 8 9

A CIP catalogue record for this book is available from the British Library.

ISBN: 978 1 84354 614 6

Designed by Richard Marston
Printed in Great Britain

Atlantic Books
An imprint of Atlantic Books Ltd
Ormond House
26–27 Boswell Street
London
WC1N 3JZ

www.atlantic-books.co.uk

London Calling

Barry Miles is the author of many seminal books on popular culture including *Frank Zappa*; *Paul McCartney: Many Years from Now*; *Ginsberg: A Biography*; *William Burroughs: El Hombre Invisible*; *Jack Kerouac: King of the Beats* and *The Beat Hotel. Ginsberg* *aris,* 1957–1963.

Contents

PART THREE

Acknowledgements

Many thanks to Richard Adams, Kate Archard, Peter Asher, Don Atyeo, James Birch, Peter Blegvad, Julia Bigham, Christine and Jennifer Binnie of the Neo-Naturists, Victor Bockris, Joe Boyd, Sebastian Boyle of the Boyle Family, Valerie Boyd, Lloyd Bradley, Udo Breger, Alastair Brotchie and the Institutum Pataphysicum Londiniense, Peter Broxton, Aaron Budnick at Red Snapper Books, Stephen Calloway at the V&A, Simon Caulkin, Pierre Coinde and Gary O'Dwyer at The Centre of Attention, Harold Chapman, Rob Chapman, Chris Charlesworth, Tchaik Chassey, Caroline Coon, David Courts, David Critchley, Virginia Damtsa at Riflemaker Gallery, Andy Davis, David Dawson, Felix Dennis, Jeff Dexter, Michael Dillan at Gerry's, John Dunbar, Danny Eccleston at Mojo, Roger Ely, Michael English, Mike Evans, Marianne Faithfull, Colin Fallows at John Moores Liverpool University, College of Art, Nina Fowler, Neal Fox, Raymond Foye, Richard Garner, Hilary Gerrard, Adrian Glew at the Tate Archives, Anthony Haden Guest, Susan Hall, Jim Haynes, Michael Head, Michael Henshaw, John Hopkins (Hoppy), Michael Horovitz, Mick Jones of the Clash, Graham Keen, Gerald Laing, David Larcher, George Lawson, Mike Lesser, Liliane Lijn, Paul McCartney, Owen McFadden at BBC Radio Belfast, Michael McInnerney, Howard Marks, John May, James Maycock, James Mayor of the Mayor Gallery, Susan Miles, Theo Miles, Amanda Lady Neidpath, Thomas Neurath, Jon Newey at Jazzwise, Philip Norman, Melissa North, Lady Jaye and Genesis Breyer P-Orridge, Mal Peachy at Essential Works, John Pearce, Gary Peters, Dick Pountain, Susan Ready, Marsha Rowe, Greg Sams, Jon Savage, Andrew Sclanders at Beatbooks.com, Paul Smith, Peter Stansill, Susan Stenger, Martha Stevens, Tot Taylor at Riflemaker Gallery,

Paul Timberlake, Dave Tomlin, Dan Topolski, Charlotte Troy at the Hayward Gallery, Simon Vinkenoog, Anthony Wall at BBC Arena TV, Nigel Waymouth, Mark Webber, Carl Williams at Maggs Brothers Rare Books, John Williams, Mark Williams, Andrew Wilson at the Tate Gallery, Michael Wojas at the Colony Room, Peter Wollen.

To Michael Head for his recordings of my onstage interview with Michael Horovitz (Riflemaker Gallery, 30 January 2007); to Jon Savage for giving me access to his punk interviews, his London photographs and his CD compilations of London songs; to Rob Chapman and also Andy Davis for providing valuable DVDs of archive fifties and sixties TV documentaries; to James Maycock for some extremely rare DVDs; to Owen McFadden for hard-to-find DVDs and CDs of radio and TV programmes; to Anthony Wall for Arena documentaries; to Andrew Scanders for finding tricky sixties documentation.

Special thanks to the Society of Authors for an Author's Foundation award which enabled me to extend my research. To James Birch, Valerie Boyd, Caroline Coon and Genesis P-Orridge, who kindly allowed me to interview them. To Toby Mundy, Sarah Norman and Daniel Scott at Grove Atlantic, to Mark Handsley for his fine copy-edit – all remaining mistakes are still mine – and, most of all, to Rosemary Bailey for reading and re-reading the manuscript, correcting my numerous mistakes and, as usual, making extremely valuable editorial suggestions.

List of Illustrations

Introduction

Look at London, a city that existed for several centuries before anything approximating England had been thought of. It has a far stronger sense of itself and its identity than Britain as a whole or England. It has grown, layer on layer, for 2,000 years, sustaining generation after generation of newcomers.

DEYAN SUDJIC, 'Cities on the Edge of Chaos'[1]

My earliest memories are of London in the forties: watching the red tube trains running across the rooftops, which was how it looked to a three-year-old peering out of the grimy window on the second floor, seeing the Metropolitan line trains on their way to Hammersmith. I remember running with a gang of local kids to buy chips from the fish and chip shop on the corner: they had to hand the pennies up to the counter for me because I was too small to reach it myself. But these were memories of a visit. My parents had lived in London before the war when my father drove a London tram, but my mother returned to her family in the Cotswolds when my father joined the armed forces to fight against the Nazis. Consequently, though I'm told I was probably conceived in London, I was born in the Cotswolds. I always felt there had been some mistake. After demobilization, my father returned to London Transport and drove a bus so we often visited him in London. But the bombing had caused a tremendous housing shortage and there was no way we could join him there. Eventually he got a job in the Cotswolds, and we settled into country life. But I never forgot London and hankered after the city throughout my childhood.

On the bus between Cheltenham and Cirencester I would fantasize all the way that there was a row of houses on each side, blocking out the trees and fields. In 1959, shortly after turning sixteen, I hitch-hiked around the south coast with a friend, a copy of Jack Kerouac's *On the Road* in my pocket, spending the nights in barns, with London as our ultimate destination. I had a cousin whose family had been rehoused in a prefab in Wembley and the previous year he and I had explored Soho together, so we headed there, the only

part of London I knew. We went to the 2i's coffee bar and the Partisan coffee house on Carlisle Street, where a bearded man wearing sunglasses at night-time strummed a guitar and people sat around playing chess and drinking coffee from glass cups. We finished up just down the street, two doors from Soho Square, drinking wine with the waiters at La Roca Spanish restaurant, now the Toucan Irish bar. That night they let us unroll our sleeping bags in the basement among the wine racks and shelves of plates and napkins. To a teenage Cotswold lad, this was the height of bohemian life, just the sort of thing that Kerouac might have done. This was the life I wanted. I was determined to live in London and throughout my years at art college I hitch-hiked to town as often as I could, staying on couches and floors, sometimes even finding a welcoming bed. In 1963 I achieved my aim. I lived in Baker Street, Westbourne Terrace, Southampton Row and Lord North Street before settling in Fitzrovia almost forty years ago.

'London calling' were the first words heard on the crackling crystal sets across the nation when, on 14 November 1922, the 2LO transmitter of what would become the BBC first went on the air. Radio was the height of modernity and the phrase caught on immediately, so much so that Noel Coward launched a new show called *London Calling!* Since then the phrase has had a deep emotional association with the capital. BBC newsreaders always announced themselves with the words 'London calling', and throughout the war they brought a message of hope, and sometimes terrible news, to people huddled around clandestine radio sets in Nazi-occupied countries. The BBC made a point of detailing setbacks before the Nazi propaganda machine could use them because in that way people would believe the BBC when there was good news, or possibly the call to arms. Even when Broadcasting House itself received a direct hit, the news reader, Bruce Belfrage, continued his broadcast as if nothing had happened despite being covered in plaster and dust. All listeners heard was a distant 'crump' as the music library and two studios were destroyed, killing seven people. Even now, for millions overseas, it is the call signal of the BBC World Service, bringing uncensored news and, for many listeners, free English lessons.

Edward R. Murrow always opened his nightly CBS reports from the war-damaged capital with the words: 'Hello, America. This is London calling', drumming up support for Britain in the hope that the Americans would one day enter the war. These days in Britain, 'London calling' immediately brings to mind the name of the Clash's single and their best album, the title of which came from this collective memory. The phrase evokes a melange of

feelings: of nostalgia, of history and pride, memories and fantasies. To some in the provinces it provokes a simmering distrust of 'trendy Londoners' but to many more it evokes a destination to aspire to, the source of so much wealth, art and culture. Unlike the USA and numerous other countries, Britain combines its cultural, political and financial capital all in one place. To reach the top in any of these areas, you have to move to London. The Beatles PR Derek Taylor was not joking when he suggested that the 'fifth Beatle', of endless press speculation, was London; it was London where they did everything that mattered.[2]

This book is concerned with the creative life of London and, more particularly, with its bohemian, beatnik, hippie and counter-cultural life since World War Two. As this is not an encyclopedia, I have usually described the people I know, or whose work I am most familiar with, thus the B2 gallery on Wapping Wall, but not the equally significant 2B gallery on Butler's Wharf; I describe COUM Transmissions and Genesis P-Orridge but not Bow Gamelan and Paul Burwell, who were doing equally interesting work. The subject of underground rock 'n' roll is altogether too large for this book, and has been mulled over in hundreds of books already; only with punk bands do I deal with the subject directly. The jazz world and the lives of black musicians and visiting American jazzmen in London should, by rights, be included but it is largely outside my experience. Fortunately Val Wilmer has already written a magnificent history of this subject in her book *Mama Said There'd be Days Like These*. In fact, to attempt to cover all aspects of avant garde, or transgressive activity in London would have led me 'into fields of infinite enquiry', as Ruskin said. I have concentrated on people who make their art their life, who live in the counter-culture, not comment upon it, those who want to transform society, and not necessarily from within. I also wanted to make the book accessible and amusing as humour is an often overlooked side of the avant-garde, so many of the anecdotes are included purely for the sake of levity.

The underground life of any city, Paris, Berlin or New York, and also smaller places like San Francisco, Amsterdam or Copenhagen, is shaped not just by the prevailing social and political situation but also by its built environment: the availability of cheap accommodation, the provision of cafés, bars and meeting places, the existence of galleries or performance spaces, the physical sense of place created by its local architecture. There are always neighbourhoods where artists and students gather. So it is in London.

Chelsea was once just such an area but in the 1920s many of the streets of

working-class houses were demolished to make way for blocks of flats for the rich. The rise of the motorcar allowed developers to dismiss the grooms and coachmen and convert their mews cottages into bijou residences for artistic young people of the sort described in Dorothy L. Sayers' novels. In 1930 there was an insurrection by tenants armed with 'thick sticks, clappers, bells and whistles' resisting eviction to make way for luxury flats. They were overcome by a small army of mounted and foot police accompanied by massed bailiffs. Soon the wealthy newcomers were exclaiming over Chelsea's delightful 'village atmosphere'. After the war Chelsea was shabby and run-down but the bomb damage was quickly repaired, and, with a few exceptions such as Quentin Crisp, only the wealthier bohemians could afford to live there.

Soho, on the other hand, had always been the cosmopolitan centre of London, its character formed by successive waves of refugees. Greek refugees from Ottoman rule settled there in 1670, giving Greek Street its name. They were followed by French protestant Huguenots in the 1680s, and more French escaping the Revolutionary Terror of the 1790s. Belgians arrived fleeing the Germans in 1914 and Germans and Italians have been settling in Soho ever since the 1850s. Many Polish and Russian Jews moved there from the East End in the 1890s. But until World War Two, Soho took its character mainly from the French: they had their own school on Lisle Street, a French hospital and dispensary on Shaftesbury Avenue, four churches, including the French Protestant church on Soho Square, and a full supporting cast of restaurants, cafés, boucheries, boulangeries, pâtisseries, chocolateries and the like. When I first came to London in the early sixties, you could buy vegetables and home-made cheese at La Roche on Old Compton Street sent over three times a week by the owner's French relatives; all the signs were in French and that was the language of the store. The Vintage House down the street sold wine *en vrac* and the meat at La Bomba was butchered in French cuts. Until the Street Offences Act, most of the prostitutes on the streets of Soho were also French. The French still have a presence in the area now, but most of the community has now settled around the French lycée in South Kensington.

Superimposed on French Soho was Italian Soho, which by the 1940s was of equal importance to the French presence and introduced the British to spaghetti and pizza, olive oil and Chianti. Italian restaurants sprang up all over Soho and are still plentiful. With them came wonderful Italian food stores, some of which survive. Soho was also home to a large Cypriot community and also housed numerous Hungarians and Spanish, and from the seventies onwards came the Chinese, who have now developed their own Chinatown. Almost from the day it was first built Soho has been truly cosmopolitan and

remains so. At the end of the war, it was the only place in Britain that had a genuine continental flavour, as the bistros and cafés tried to scrape together meals for a war-weary population. Strange to think that a candle in a Chianti bottle and a fishing net across the ceiling was then considered unbelievably romantic and sophisticated.

Before the war the area north of Oxford Street was often included in the definition of Soho, when it was not referred to as Fitzrovia, and like Soho it had a large continental population, including so many Germans that Charlotte Street was known as Charlottenstrasse. I loved Schmidt's on Charlotte Street which used the German system of the kitchen selling the food to the waiters, who then sold it to the customers. Inevitably there was hot competition over where the guests sat and fights were commonplace. One of my earliest memories of living in London is of one of the waiters at Schmidt's shrieking: 'Hans! Again you haff stolen my spoons!' and lunging across the huge room wielding a carving knife. Hans escaped through the swing doors.

Regrettably, the re-zoning of Fitzrovia as light industrial to meet the demand for office space after the war let in the property 'developers', who lost no time in finishing off the destruction wrought by the Nazis: down came Howland Street and the artists' studios of Fitzroy Street to be replaced by tacky office blocks, most of which have since been replaced. Down came John Constable's beautiful eighteenth-century house and studio in Charlotte Street to be replaced by a glass box containing PR companies and advertising agencies, and next door looms the great bulk of Saatchi and Saatchi, replacing a whole block of eighteenth-century houses. The Bloomsbury Group lived in these streets, as did Nina Hamnett and the painters of the Euston Road School. It is entirely appropriate that in twenty-first-century Britain streets that were once filled with artists now contain Britain's highest concentration of advertising agencies; real artists displaced by the counterfeit, the second rate; creative individuals prostituting their talent.

Not surprisingly then, it was to Soho that people came to get away from Britain for a few hours. It was in Soho that British jazz and British rock 'n' roll found their beginnings in dozens of late-night clubs; it was in the Soho pubs, like the French, which even today does not possess a pint mug, where bohemia thrived and painters and boxers and students and prostitutes mingled; it was where the bookshops were, and the cheap Greek and Italian cafés, and the drinking clubs, and spielers and brothels, and where even a few art galleries tentatively opened their doors on to bomb-shattered streets.

When I first was first taken to the French pub in the early sixties, I felt

immediately at home. In the Cotswolds I had always felt a complete outsider in the pubs with their horse brasses and red-faced gentlemen farmers in cavalry twills and chukka boots. At the French, in contrast, the faces of the clientele were deathly pale, they wore shades and looked like artistic gangsters. They were drinking wine and pastis and there was not one mention of agriculture. It was wonderful.

This book is set largely in the West End; it is there that the magnet which draws people into London is located. The bohemia of Fitzrovia and Soho during the war years drew in the next generation: poets like Michael Horovitz graduated from Oxford and moved straight to small flats in Soho. The beatniks of the early sixties congregated around Goodge Street in Fitzrovia, giving the One Tun as their mailing address, thereby making it the destination of the next wave hitch-hiking in from Newcastle and Glasgow. The underground scene of London in the sixties was perceived as a West End phenomenon: that was where the UFO Club, Middle Earth, Indica Books, the IT offices, the Arts Lab and other centres of activity were located, but by then most of the contact addresses scribbled on grubby bits of paper would have had W10 or W11 postcodes because that was where the cheap housing was.

Only in the nineties did the focus shift further east to E1 and E2, as artists colonized the grim industrial wastelands and tower blocks of the East End proper. Writers such as Iain Sinclair, Peter Ackroyd, Stewart Home and Patrick Wright have staked a claim to the East End as a dynamo of cultural ferment, crossed by ley-lines, studded with vertical time pits connecting the present with the eighteenth century, inhabited by eccentrics and bohemians. Sinclair's psychogeographical wanderings are especially valuable in making this disparate part of London coherent. But there was pitifully little there in the eighteenth century except market gardens and meadows. It was, and remains, suburban. They have made the best of a landscape of flooded air-raid shelters, the floorplans of long-gone Nissen and American Quonset huts and post-war emergency prefabs; vistas enlivened by the occasional remaining detail on a graffiti-covered Victorian town hall or an unusual allotment hut. They even have a Hawksmoor church or two, but until recently this was not the London that pulls people halfway across the world.

The London of dreams is Swinging London: the King's Road of rainbow-crested punks and Austin Powers; tourists on the zebra crossing at Abbey Road; Big Ben and the statue of Eros at Piccadilly Circus. It is more specifically the West End, which has been the cosmopolitan centre of London for 300 years: the impeccably dressed old man slumped in the back of a shining chauffeur-driver Rolls-Royce powering up Hill Street in Mayfair at 3 a.m.;

drunks trying to find their way out of Leicester Square; it is the late-night drinkers emerging from Gerry's on Dean Street, blinking in the sunlight as people push past them on their way to work. It is Chris Petit's *Robinson*, Colin Wilson's *Adrift in Soho*, Michael Moorcock's *Mother London* and the Jerry Cornelius novels. Swinging London lives on in the imagination. But the scene has now shifted eastward. Recently, walking down Great Chapel Street in Soho, I overheard two young men talking. 'You know,' one of them said, 'looking at this, you could easily be in Shoreditch.' It is true; the vast acreage of the East End is now the artistic neighbourhood of London, though it is too spread out to have any real centre: artists have studios everywhere from Hoxton to Stoke Newington to Bow. They do engage with the older residents, but often their studios – where many of them live – are in semi-industrial areas with few people living nearby. There are scores of small galleries, but as soon as they become successful they usually move to the West End.

This book concentrates on the role of London as a magnet and its clubs and pubs as energy centres. With the advent of the internet, Eurostar and cheap European air flights, the importance of London as a location has been reduced as people travel to Barcelona, Berlin, Paris and all over for shows and art fairs, keep up to date with the latest events in New York, Sydney and Moscow on the net, and use Skype to chat to friends working in Vancouver or Amsterdam. Globalization and cheap instant communications mean that no matter how outrageous and cutting edge an event might be, people all over the world can know all about it seconds later; a true underground is impossible now unless the participants are sworn to secrecy. For the same reason, though many artists and musicians use London as their theme, many more could just as easily be working out of Paris or Berlin. This is the twenty-first century, and things have changed.

Before World War Two, London was the greatest city on Earth; by VE Day, 8 May 1945, it was devastated: damaged buildings standing in a sea of stones, bombsites overgrown with weeds, dunes of brick dust, rubble piled alongside hastily cleared streets. Condemned structures stood windows open to the sky, strips of wallpaper hanging in flaps, stairs leading to nowhere. More than a million houses had been destroyed in the blitz, leaving one in six Londoners homeless. Many buildings were occupied by squatters who bravely set up house between walls shocked into strange angles by the bombs, sometimes propped up by wooden buttresses. Cellars were flooded with stagnant, murky water bobbing with detritus and the corpses of rats, and equally dangerous were the emergency static water tanks, large rectangular iron cisterns placed

near vulnerable buildings to counter the German incendiary bombs when the water mains were shattered: four foot deep and filled to the top, enough to drown a child. Sheep grazed on Hampstead Heath, there was a piggery in Hyde Park and the flowers of Kensington Gardens had been replaced with rows of cabbages. The city was beaten down, it was drab and monochrome, joyless. There was stringent rationing of even basic food and fuel, poverty was apparent everywhere from the skinny kids playing on the bombsites, the muttering tramps sleeping rough on the Embankment, many of them unhinged by the war, to the tired whores in Soho and Park Lane. But despite the greyness and the smog, some of the pre-war spirit prevailed. The old bohemian areas of Fitzrovia and Soho still had flickers of life in them.

There were communities overlapping in Soho: the local people who worked in the markets, restaurants and small workshops; the sex workers and artists' models, along with a few painters and writers and the bohemians and eccentrics who patronized the bars and clubs from mid-morning until after midnight. Soho was desperately run down and parts had been badly bombed. Ninety per cent of its population used the Marshall Street baths; Friday afternoon was the usual day for waiters. A first-class hot bath was 6d and second class 2d, cold baths were half-price. People arrived with brown-paper parcels containing their clean clothes, soap and towel. Most of them were the families of Italian waiters who lived in cramped rooms in Dean Street and Greek Street, saving every penny to retire back to Italy and buy a farm. With Mediterranean staples like olive oil and wine virtually impossible to get, these restaurateurs performed miracles daily to produce a semblance of Continental cuisine and provide the ambience necessary to keep the spirit of Soho alive.

Soho was still very much a village despite wartime evacuation and the bombing. The same laissez-faire attitude that had always attracted artists and writers, students and journalists, also attracted strippers and brothel keepers, gamblers and pornographers. Throughout the war it was sustained by thousands of British and American troops who were there more for the brothels and gambling dens than the food but who kept Soho alive, giving it a reputation as a red-light district that still remains in the popular imagination. Hardly a street in Soho was without bomb damage; even St Anne's was destroyed, leaving its tower standing alone in a mountain range of rubble.

Despite the destruction, many people never left its streets; they would have felt like refugees anywhere else. There is a story about an artists' model, a regular at the Highlander on Dean Street, who appeared one Saturday morning formally dressed complete with gloves and stockings. She even wore

a hat, a previously unseen occurrence. Asked if she was going to a wedding, she replied: 'No. Going away for the weekend. To Swiss Cottage.'[3] As Sammy Samuels, the owner of a series of spielers or gambling clubs, wrote about one of his clients: 'he found his way into Soho and so far as I know, has not been able to find the way out. And Soho does get some types of people that way. Maybe it's the air, or the feeling that you've gone "foreign" like in Africa or India, and it's too good to change.'

There were some artists and writers who were locals but mostly they arrived by taxi, tube or bus to eat and, most importantly, to take up their favourite positions at the bars. The bohemian community of London conducted its business in the pubs and cafés of the streets between Charlotte Street in Fitzrovia and Dean Street in Soho; a few minutes walk. It never took long to find someone you knew because no matter where people actually lived, they always travelled to Soho to meet their friends. The pubs were dingy and uncomfortable and everybody stood. They did not go there for comfort; they were there for the conversation, the ideas, the alcohol and the atmosphere of male bonhomie which few women were permitted to enjoy. Beer was from the barrel, people drank whisky and Guinness and the air was a thick fog of Craven 'A' and Senior Service. Soho and its environs were the stage, the various cafés, pubs and clubs were the stage sets, and in them, propping up the bar, were the characters, talking and talking. George Melly: 'Soho was perhaps the only area in London where the rules didn't apply. It was a Bohemian no-go area, tolerance its password, where bad behaviour was cherished.'[4]

Part One

1 A Very British Bohemia

It was from the nests in **Whitfield Street, Howland Street** and **Fitzroy Street**, with the **Fitzroy Tavern** for home run, that the idea of Fitzrovianism in the verbal sense was first born... the idea of our group as vagabonds and sadhakas or seekers, as the Buddha was at the start... The fact that the name I gave, Fitzrovia, persists, does not surprise me, because of the unity of spirit and atmosphere which made it unique in London in those days.

TAMBIMUTTU, 'Fitzrovia'[1]

The underground scene in London didn't spring into being, ready-formed, at the end of the war. It grew slowly, the product of many factors, and in the early days there were precious few individuals who could really be considered particularly unconventional. The colourful characters of the time like Tambimuttu and Julian Maclaren-Ross would not perhaps have merited so much attention had they lived a few decades later but in the mid-forties they constituted bohemian London.

'Fitzrovia' as a name for the neighbourhood was coined just before the war by Tambimuttu, one of the central characters of wartime literary London, a unique publisher and editor, whose magazine *Poetry London* was a magnet to the most talented of writers in Britain at the time. Meary J. Tambimuttu, known universally as Tambi, was a Jaffna Tamil, born in Ceylon (now Sri Lanka) in 1915.[2] He was an attractive, romantic figure, with long silky black hair that required constant jerks of his head to keep it from his eyes. The art dealer Victor Musgrave said that he and Tambi were the only two men in the second half of the forties in London to wear shoulder-length hair. Tambimuttu had tremendous charm, and a naive belief that everything would always work out: printers would be paid, drinks would be forthcoming, he would not starve to death. He was a literary hustler of exceptional ability. He loved literature, particularly poetry, though he encouraged a rumour to develop that he never actually read the manuscripts he was sent, relying instead on instinct and the feel and quality of the paper. Certainly he was known to inform complete strangers that he would publish their poetry, despite never having read it.

I first met him in the sixties when he came into my bookshop. We had numerous friends in common, including Timothy Leary, and he had gossip about them all. Then he quite casually suggested that he wanted to publish my poetry, a suggestion which I found quite extraordinary as I didn't even write poetry. Despite this he was a superb editor. Unfortunately he was also untrustworthy and dishonest, he borrowed money constantly and did not repay it, he was sloppy and disorganized and lost manuscripts entrusted to his care. On one occasion the only copy of one of Dylan Thomas's new poems was found in the chamber pot beneath his bed. This is not as surprising as it might seem as, when he finished reading a manuscript, he would reach down the side of his bed and stuff it into the chamber pot, which was used as a rudimentary filing cabinet. He later invested in a cardboard box. He lived mostly in Fitzrovia: 45 Howland Street, 2 Fitzroy Street, and 114 Whitfield Street in a house filled with poets next door to Pop's café; all now gone, bombed or levelled for office blocks.

His magazine, *Poetry London*, began publication in 1939. At the end of the war he had offices at 26 Manchester Square (now number 4). The publishers Nicholson and Watson had the first floor and they paid the running costs of *PL*. Editions Poetry London occupied the front room on the third floor, with Nicholson and Watson in a smaller room at the back. *PL*'s long windows looked out over the square through the trees to the Wallace Collection opposite. Their room led off a large carpeted landing at the top of a gracious curving staircase. There was an elaborate marble mantelpiece cluttered with invitation cards and memorabilia. Tambimuttu's desk was between the windows, facing the door.[3]

Tambimuttu wore the same clothes until his staff could no longer stand the smell and would insist on him talking a bath. His secretary Helen Irwin remembered the occasions:

> In the middle of the morning I would scrub his back. Such was the din – the shouts, the howls, the splashings of water – that you would have expected help to rush up from below. Like a schoolboy Tambi made the most of it, calling through the open door: 'Nick, Gavin! She's raping me!' To which, after a bit of banter, they replied they rather doubted it.[4]

Whenever he spent a weekend in the county with friends he liked to run naked through their houses.

Lucian Freud was a frequent visitor to the offices. One of his projects there was to illustrate Nicholas Moore's *The Glass Tower*. Freud used to disappear into the green bathroom for up to an hour at a time. When asked what he did

in there he replied that he lay in the empty bath and thought. Other visitors included Henry Moore, who did numerous illustrations for the magazine, Edith Sitwell, Elizabeth Smart and Roy Campbell, who was shunned by many on the Fitzrovia–Soho scene because, as a Catholic, he supported Franco's side in the Spanish Civil War.

The Hog in the Pound, on the corner of South Molton Street and Davies Street, off Oxford Street, was their local. The landlord, George Watling, was sympathetic and never fazed by their outrageous behaviour. When the pub closed at 2.30 in the afternoon they would make their way to the Victory Café, on the left-hand side of Marylebone Lane for a late lunch of sausage and mash or spaghetti bolognese. Before six o'clock, however, Tambi and some of the office staff would set out on what was known as the 'Fitzrovia' pub crawl. Tambi originally invented this word to define the action: the Fitz-roving, but it quickly became used by his circle of friends to define the area stretching roughly from Fitzroy Square to Soho Square which had no precise name: it was North Soho, East Marylebone or West Bloomsbury, none of which were satisfactory. Thus Fitzrovia.

The first stop on the pub crawl was, of course, the Hog in the Pound, an hors d'oeuvre before they headed east down Oxford Street first to the Fitzroy, then the Wheatsheaf and on down into Soho, usually finishing at the Swiss Tavern. Tambi ate little and drank a lot, but his contribution to English literature was enormous: he edited fourteen issues of *Poetry London*, and more than sixty books of poetry and prose, often beautifully illustrated, always well designed, produced from 1938 to 1949, featuring everyone from Dylan Thomas, Louis MacNeice and Stephen Spender to Lawrence Durrell, W. S. Graham and Katherine Raine, He published the first books of Herbert Read and David Gascoyne as well as Henry Moore's *Shelter Sketchbook*. He recognized the genius of Elizabeth Smart and published her *By Grand Central Station I Sat Down and Wept*, the brilliant autobiographical account of her disastrous marriage to Soho poet George Barker that enraged Barker because it was so much better than anything he could ever have written. Tambi introduced British audiences to Nabokov, Henry Miller, Anaïs Nin and scores of other little-known foreign writers.

Tambi died in 1983, when he was living at the October Gallery on Old Gloucester Street, but his spirit lives. Tambimuttu: 'It was only an attitude of mind that comes to each generation in every country, and in different ways, but for me it happened in lovely Fitzrovia.'[5]

*

The morning after VE Day, in May 1945, the Scala Café on Charlotte Street was filled with artists nursing their hangovers from the celebrations of the night before. The artist Nina Hamnett found the Fitzroy Tavern open but the Wheatsheaf and other local pubs were closed, probably having run out of drink. She lived just two blocks away in two rooms on the top floor of 31 Howland Street, and had to pass the Fitzroy on her way to Soho. She always looked in, but even if that did not detain her for very long, she sometimes got no further than the panelled rooms of the Wheatsheaf. Nina Hamnett more than anyone represented the pre-war spirit of Fitzrovia.[6] Born in Tenby, Wales, in 1890, she had studied at a number of art colleges in both London and Paris, where she famously danced naked as a model for her fellow students, and also became a respected artist in her own right. She experimented with various styles but the majority of her paintings and drawings were portraits: solid, almost sculptural affairs of friends, lovers and often just of people she liked the look of. She exaggerated and simplified her compositions to create what she called 'psychological portraiture'. She had numerous West End gallery shows and sold quite a bit of her work in the twenties and thirties, but by the forties her work began to suffer badly from her fondness for drink and her busy social life.

Often described as the 'queen of bohemia', she had posed in the nude for Sickert, became a close friend of Augustus John and was Roger Fry's mistress. She had an affair with Henri Gaudier-Brzeska, who made several marble torsos of her and a sculpture of her dancing naked – she was proud of her body and liked to strip off at parties. Artists liked her long slender figure and she was a much sought-after model. She introduced herself to the poet Ruthven Todd by saying: 'You know me, m'dear. I'm in the V&A with me left tit knocked off', a reference to a Gaudier-Brzeska bronze torso of her which had been damaged when the original plaster cast was made. In Paris before the Great War and in the twenties, she knew all the most important artists from Modigliani and Picasso to Diaghilev and Stravinsky. She had countless affairs, and had sex with anyone she fancied. Aside from artists and writers – she took the virginity of 21-year-old Anthony Powell – she had a particular fondness for boxers and sailors. When asked what she liked about sailors she exclaimed: 'They go back to their ship in the morning!' By the late thirties she was spending virtually all of her time in the pubs of Fitzrovia and Soho, and hardly any at her easel. She was a great raconteuse, and anyone prepared to buy her a drink was treated to endless – often salacious – anecdotes about her life in the studios of Montparnasse.

By 1945, the tensions of the war years and the effects of alcohol had

made a pathetic creature of her. She lived in squalor in Howland Street, with cockroaches and bedbugs, and visitors even reported seeing rat shit on her bedcovers. There was no bathroom – only a communal one on the ground floor – but there was a small washbasin in the corner of the staircase. In February 1947, when her landlady, Mrs Macpherson, took her to court in an effort to empty her house on Howland Street and sell it with vacant possession, she claimed that Nina had 'misused the sink'. But the magistrate would hear none of it; he interrupted her testimony, saying: 'What do you mean, a woman urinating in the sink? It is not possible', and refused to accept her evidence. This caused great hilarity among Nina's friends in Fitzrovia, who knew that her landlady was perfectly right in her accusation.

A convenient fire in the building shortly afterwards caused her to move out. She took two rooms on the second floor of 164 Westbourne Terrace, near the railway lines leading to nearby Paddington Station. The Westway had not yet been built and there were pleasant walks to the nearby canal basin, where she painted some views of the canal bridges. The area was popular with younger artists and writers but she remained loyal to Fitzrovia and Soho. She never really adjusted to the move from Howland Street and did little to make her new apartment habitable. Her wire-link bedstead was covered with old newspapers to keep in the heat and make it less uncomfortable and she hung her clothes on a piece of rope strung across the room. She had a rolltop desk but no comfortable chair or sofa. Her books were kept in a row on the mantelpiece and on a shelf above, which was propped up with a pile of Penguins. The threadbare carpet was badly stained with spilled drinks and was scattered with empty bottles, cigarette ash and opened books.

In the mid-twenties, she, Augustus John and Tommy Earp had been responsible for consciously making the Fitzroy Tavern on Charlotte Street a meeting place for artists in the spirit of a Paris café, and establishing a rival claim to that of Tambimuttu in having given the neighbourhood a name. With the war over, Nina still remained loyal to the Fitzroy, even though it was now better known as a pick up place for gay servicemen than for artists; an element of protection was afforded by its more celebrated regulars: the gay MP Tom Driberg, Hugh Gaitskell, Scotland Yard detectives Jack Capstick and Robert Fabian ('Fabian of the Yard'), as well as the official hangman, Albert Pierrepoint. Most days Nina could be found at the bar and, if drinks were forthcoming, she would sometimes stay there all evening. If not, it was on to the Wheatsheaf, the French or the Swiss House on Old Compton Street.

There she would sit, perched on her stool, in her twenties coat with a fur

collar, her beret cocked on the side of her head, often looking the worse for wear. In her autobiography Janey Ironside, professor of fashion at the Royal College of Art, described her as wearing 'a very shabby navy suit with a rusty black shirt and grubby wrinkled cotton stockings. She was dirty, smelt of stale bar-rooms, and very pathetic.'[7] Her conversation became increasingly abrupt and bizarre, her opening gambit inevitably: 'Got any mun, deah?' delivered in her cut-glass public school accent while rattling the tobacco tin in which her friends, and anyone else she could beg from, were expected to contribute to the price of the next double gin. When she did try and clean herself up the results were disastrous. 'I took my grey dress to the dry cleaner's and my dear, it just shrivelled up because of the gin soaked into it over the years. All they gave me back was a spoonful of dust.'[8] She was only sixty-six when she died in 1956, falling on to the iron railings outside her flat in Paddington; almost certainly a suicide.

After six o'clock the northern reaches of Fitzrovia became depopulated as the nomadic tribes moved south in a tidal drift towards Soho and the pubs of Rathbone Place: the Wheatsheaf, the Marquis of Granby and the Bricklayer's Arms. London boroughs had different opening times for their pubs. Through a quirk of the asinine licensing laws, the Fitzroy Tavern, the Wheatsheaf and the Bricklayer's Arms all closed at 10.30 p.m. because they were in Holborn so that as closing time drew closer there was an exodus to the nearby Marquis of Granby which, being on the other side of Rathbone Place, was in Marylebone and stayed open until 11 p.m.. The more energetic hotfooted down Rathbone Place and across Oxford Street to Soho, where all the pubs stayed open until eleven. The nearest acceptable one was the Highlander (now inexplicably called the Nellie Dean), on Dean Street.

The Wheatsheaf on Rathbone Place is famous as the home from home of another fixture of that period, the writer Julian Maclaren-Ross as well as being one of the many watering holes frequented by Dylan Thomas. They were on friendly nodding acquaintance, having worked together writing film-scripts during the war, but both demanded their own courtiers and the loyalties and allegiances of the Wheatsheaf's patrons were much fought over so they never stood at the bar together. Maclaren-Ross had a fixed routine: from midday until closing time at 3 p.m. he drank at the Wheatsheaf, standing in his habitual place, propped against the far end of the bar near the fireplace. If he thought he would be late he tried to send someone to take up the position for him; it would have been intolerable to him to have to join the jostling crowd in the middle of the bar, where the service was not so good.

He stood beneath one of the tartans – not his own, as he often pointed out, (unnecessarily, as most people knew this was not his real name; he was born James Ross in South Norwood in 1912 – the Julian was an affectation, and was the name of a neighbour who assisted with his birth).[9] Dressed in his usual moth-eaten teddy-bear coat, dark sunglasses despite the pub gloom, a fresh pink carnation in his lapel, his black wavy hair swept back, waving a long cigarette holder housing a Royalty extra-large gold-tipped cigarette and sometimes gesticulating with his gold-topped malacca cane, Maclaren-Ross had successfully reinvented himself as a member of London high bohemia. Before the war, he had been a lowly door-to-door vacuum-cleaner salesman in Worthing, a tragedy retold in *Of Love and Hunger* (1947), but his stories of war-time conscription had been well received by both the critics and the public. Now he was a fixture of Fitzrovia, drinking beer with whisky chasers which he ordered using the Americanism 'Scotch on the rocks' that he had picked up from the popular films and thrillers he loved so much. When red wine once more became available after the war he switched to that.

After a late lunch at the Scala restaurant on Charlotte Street he would stroll around the bookshops on Charing Cross Road, where the only shop that sold Royalty cigarettes in Soho was located. He was back at the Wheatsheaf for opening time. He drank until 10.30 closing, then came a quick trot down Rathbone Place to the Highlander on Dean Street for a final half-hour drinking. He then walked back to Fitzrovia for supper and coffee at the Scala and home to wherever he was staying at the time: hotel, flat or park bench. Throughout all these hours, Maclaren-Ross would have been talking non-stop; virtually anyone would do as an audience. 'At the sound of his booming voice, the habitués of the back tables, accustomed though they were to its nightly insistence, looked up in a dull horrified wonderment. There was no getting away from that voice,' wrote Henry Cohen in *Scamp*.

Even at closing time, Maclaren-Ross would avoid going home, and would stop off for a nightcap with any of his long-suffering friends who would let him in. The writer Dan Davin and his wife were a frequent target and it never occurred to Maclaren-Ross that they might need to rise at a normal hour. He would settle down, drinking their whisky, an endless flow of anecdotes, some entertaining, others boring, and descriptions of movies recently and not so recently seen, emitting from his mouth until the bottle ran dry or his hosts nodded off to sleep in their armchairs. When he finally got home he would write, taking more amphetamines to keep him alert. In the middle of the night, using his gold Parker fountain pen, which he always referred to as 'the

hooded terror', he would fill endless sheets of paper with his tiny meticulous handwriting, always writing two drafts, and correcting neither. They were always perfect, ready to be typeset.

Maclaren-Ross was known for his series of witty, cynical, largely autobiographical short stories collected as *The Stuff to Give the Troops* (1944), *Better Than a Kick in the Pants* (1945) and *The Nine Men of Soho* (1946). These days his reputation rests on his evocation of London's wartime bohemian literary scene in Soho and Fitzrovia, *Memoirs of the Forties* (1965). Sadly he had only completed 60,000 of the projected 120,000 words when he died of a heart attack on 3 November 1965, but these chapters alone are regarded as masterful. The critic Elizabeth Wilson wrote: 'For bohemians such as Maclaren-Ross, life was an absurdist drama, a black joke. This bleak, stiff-upper-lip stoicism was a rather British form of bohemianism, and Fitzrovia was a very British Bohemia.' This was a view echoed by the critic V. S. Pritchett: 'There is nothing else that more conveys the atmosphere of bohemian and fringe-literary London under the impact of war and its immediate hangover.'

Anthony Cronin worked for the literary magazine *Time and Tide* and employed Maclaren-Ross to write the occasional piece. Sometimes he would appear in the office quite broke, unable to write because 'the hooded terror' and his malacca cane, both heirlooms from his father, or so he claimed, were in pawn. His friend Anthony Powell, then on the *Times Literary Supplement*, gave him a regular supply of book reviews and 'middles' to write, which kept him going, and later, when Powell moved to *Punch*, he employed Maclaren-Ross to write literary parodies. Powell used Maclaren-Ross as X. Trapnell in *A Dance to the Music of Time*, now probably the main reason why people remember his name. Anthony Carson called him Winshaw in *Carson Was Here* and he appears in many memoirs of the period. Dan Davin wrote: 'To be a friend of his meant not being a friend of a good many other people. He was arrogant and exacting in company. He did not like to take his turn in conversation; or rather, when he took his turn he did not let it go.'[10]

Maclaren-Ross's snobbery and pretensions meant that the moment he had any money he would move into a suite at the Imperial or some other luxury hotel with no thought that in a week the money would run out and he would find himself on a park bench, a friend's couch, or railway station concourse – he regarded Marylebone station waiting room as the most comfortable. He felt the same way about the newly established National Health System, preferring to owe money to a private doctor, and to have applied for unemployment money was not even considered. He was constantly on the move, pursued by irate landladies, hoteliers, bailiffs and tax collectors, rarely staying more

than a week in a rented room before declaring that he had no money. It then took two weeks to legally evict him, during which time he sought his next accommodation. Some landladies fell for his hard-luck stories and extended him credit; one, who had finally to set the law on him, allowed him to run up an enormous rent arrears, £100 of it being paid off by the Royal Literary Fund, which paid the landlady directly knowing that she stood little chance of seeing it if they made the cheque out to Maclaren-Ross.

Despite his boorish and imperious manner, Maclaren-Ross could also be very funny. Wrey Gardiner, publisher of the Grey Walls Press, recalled:

> Maclaren-Ross is tall, handsome and amusing. He came into the back of Subra's bookshop the other day showing me round an imaginary exhibition of new painting. 'Board with Nails,' 'Apotheosis', 'Coming of Spring' – a bucket and brush, pointing all the time to real articles in the room. The painter, he said, was one Chrim. He will be immortal.[11]

Though he regarded the fifties as 'a decade which I could well have done without', it did produce one of Maclaren-Ross's more highly regarded books, *The Weeping and the Laughter*. But mostly it was a period spent in decline; he never stayed anywhere more than a few weeks before running out on the rent, dodging the bailiffs, living off a constant stream of advances for BBC radio scripts, talks, and parodies or articles and commissions that he rarely completed, all the while berating his long-suffering publishers and the producers at the BBC who had bent the rules for him.

The BBC Third Programme was the great unsung saviour of British bohemia. It came into existence in September 1946, directly after the war. Designed to propagate culture in its highest forms, it immediately became a major, and sometimes the only, source of funds for poets, playwrights, essayists, composers, short-story writers and public speakers. In his book *In Anger* the historian Robert Hewison identified a 'BBC Bohemia' but the majority of its inhabitants did not live in London; like an American 'commuter campus', it was a commuter bohemia. This was truly 'London calling'. They included Hugh MacDiarmid, who lived in Scotland; Dylan Thomas, who spent most of his time in Wales when not touring America; W. H. Auden, who visited from New York; Laurie Lee, who lived in the Cotswolds; Robert Graves visiting from Majorca and Lawrence Durrell from Corfu; the travel writer Rose Macaulay; and a few London residents such as Muriel Spark, C. P. Snow and George Orwell. Hewison concluded: 'The features department spent most of its time out of the department and in the pubs where virtually all BBC business

was conducted in a miniature BBC bohemia.'[12] For many of the Fitzrovia and Soho regulars this necessitated a change in drinking habits, though they only had to walk a few blocks to the pubs surrounding the BBC, where the commissioning took place.

Though the BBC Music Department was in Marylebone High Street, the new BBC Third Programme staff quickly adopted the George on the corner of Great Portland Street and Mortimer Street, which had long been the traditional watering hole of the classical music fraternity. BBC producers, writers and actors joined motor-car salesmen from their showrooms on Great Portland Street, and orchestral players from the nearby Queen's Hall. Sir Henry Wood, musical director of the Queen's Hall (and director of the Promenade concerts), is said to have named the George 'The Gluepot' because he could never get his players out of it. BBC classical music producer Humphrey Searle remembered it in his memoirs: 'It was then a real *rendezvous des artistes* not usually overcrowded; many BBC programmes were discussed and settled within its walls.'[13]

This area was the centre for London's classical music: visiting conductors traditionally stayed at the Langham Hotel – now the Langham Hilton, across from Broadcasting House – and before the war they walked across Portland Place to the Queen's Hall to rehearse and perform. The Queen's Hall had the finest acoustics in London. When it was bombed, the government promised it would be rebuilt but inevitably an ugly sixties hotel, the Saint George's Hotel, went up in its place (though the view from its top-floor bar, 'The Heights', is superb). The much smaller Wigmore Hall, a few blocks away, was spared and is still in use. The George continued for many years as the meeting place for musicians and BBC producers but was taken over eventually by Regent Street Polytechnic students and by the sixties it had lost its charm.

For the written words the principal BBC Radio commissioning editors were the poet Louis MacNeice, John Arlott, later better known for his cricket commentaries, and the right-wing demagogue Roy Campbell. Writers and essayists began frequenting the pubs surrounding the BBC while waiting to rehearse or to broadcast, to meet producers and editors or simply to waylay producers in the hope of persuading them to give them work. As a consequence the Wheatsheaf, the Bricklayer's Arms, the Highlander and the Marquis of Granby gradually fell from favour. The new pubs of choice became the Horse and Groom on Great Portland Street, nicknamed 'The Whore's Lament', after the despair of the whores when the American servicemen left London at the end of the war (you have to drunkenly slur the pub's name to reach this particular derivation), the George or Gluepot, the Dover Castle on

Weymouth Mews on the way to Marylebone High Street, and the Stag's Head on New Cavendish Street. In her memoirs, the BBC television presenter Joan Bakewell called the BBC commitment to the pub as a cultural institution 'Dublinesque': 'the background to good, even inspirational talk, the setting in which to exchange and develop ideas, commission programmes, cast plays, transact business, pursue love affairs, avoid involvement in the bureaucracies that were even then shaping up inside the BBC.'[14]

For someone like Dylan Thomas, the Third Programme was a lifeline. His first solo broadcast for them was a reading from the work of Keats and in their first year he did fourteen more broadcasts for them as well as a further thirty-two for other BBC radio services such as the Eastern, and Light services. Dylan's carefully enunciated rather upper-class tones quickly became well known to the educated British public. He was often employed to recite the work of other writers and he took a malicious delight in collecting other poets' worst lines and using them in conversation. One evening in 1950, at the Stag's Head, Dylan read aloud sentences and whole passages from George Barker's *The Dead Seagull* which struck him as unbearably funny, as they did his audience. In 1953 for one of his many BBC broadcasts, Dylan was to read a poem by Edith Sitwell. That midday, after rehearsal, Dylan went to the Stag's Head and did an imitation of Dame Edith bleating her poetry that had everyone in stitches.

Such was Dylan's fame – he made over 200 broadcasts for the BBC and several television appearances, most of which the BBC didn't bother to keep – that even a decade after Dylan's death, it was still possible to run into people in the local pubs who would turn to you at the bar and begin: 'When I was drinking with Dylan...' Of course, some of the drinking stories are deservedly legendary, such as when, in October 1953, during a particularly drunken binge, he lost the only copy of the work by which he is best remembered, *Under Milk Wood*. His producer at the BBC, Douglas Cleverdon, traced his movements from bar to bar and recovered it from the Admiral Duncan pub on Old Compton Street.

Dan Davin, who spent a lot of time with Dylan in those days, remembered a day when Dylan met up with Henry Miller, who was visiting London:

> They did a protracted round of the pubs and finished up at the little dairy on Rathbone Place which served sandwiches. The staff wore white and blue uni-forms and the dairy was spotlessly clean but Henry Miller was not only drunk, but also short sighted, and got it into his head that Dylan had taken him to

some particularly sophisticated brothel. Despite the waitresses protestations and Dylan's wild attempts to set him straight, Miller refused to believe otherwise and it took a lot of Welsh tact to avoid the appearance of the police.[15]

Davin has many insights into the man:

In adult life the drive towards the extreme, for he could do nothing by quarters and never drank a half, meant that when he was not at home writing poetry, one and the most intense pole of his being, he was in the pubs among the hard men. And hard men they were as long as they lasted: people like Roy Campbell, John Davenport, Louis MacNeice, Bertie Rodgers, Julian Maclaren-Ross, to name only those whose iron is now rusting in the grave.[16]

2 The Long Forties: Soho

Soho is always changing and always stays the same.

GASTON BERLEMONT

Before the war, many artists and writers lived in Fitzrovia, mostly in the streets surrounding Fitzroy Square, but only a few of them lived in Soho. It has always been a destination and as a consequence is the one constant throughout this book. With the highest concentration of restaurants and cafés in the country, Soho remains an unchanging stage set, its late-night clubs and gay bars, its pubs, dives and coffee bars welcoming each new generation, listening to their shouts and tears, their boasts, their curses and their endless stories.

VJ Day was celebrated in August 1945 with an all-night party on the specially reopened rooftop bar of David Tennant's Gargoyle Club at 69 Dean Street, Soho. Had Messrs Novello, the sheet music printers, not strengthened the walls and floors to resist the vibration of heavy printing machinery decades earlier, several nearby bombs might easily have caused the 1732 building to collapse. As it was, the Gargoyle had stayed open throughout the war; customers would troop down to the cellar to continue drinking by candlelight if it became particularly 'noisy'. The club occupied the two new floors added to the top of the building by the Novellos; beneath that was David Tennant's own apartment and the club's wine cellar. The printing works remained on the ground floor. A narrow side door on Meard Street led to a short dark passage, at the end of which was a tiny rickety elevator with sliding metal gates to trap fingers and bits of clothing. After an interminable journey upwards, the guests would emerge from the opposite side of the lift into a hall hung with lithographs by Henri Matisse.

Here were the reception desk, the telephone booth and toilets and seats

for those waiting anxiously for a member to sign them in. Beyond the hall was the bar, the club's main meeting place, with its vermilion settees and two Matisse lithographs of ballet girls. To the right, a pair of double doors led to the private reception room used for banquets and large parties. This had not been used much during the war but was reopened when hostilities ceased. To the right of the bar was a flight of steps, lined with mirrors, some cracked or missing, leading down to the dance floor and dining room.

The club had been founded by David Tennant in 1925. The restaurant seated 140 at its scrubbed oak tables and benches. For the main salon, Tennant had designed a ceiling, inspired by the Alhambra in Granada and painted with 22-carat gold. He described it to Matisse, who suggested that the walls be completely covered with a mosaic of mirrored glass to give a shimmering effect. Matisse knew of a chateau with two very large eighteenth-century mirrors for sale. These were cut into thousands of tiles, each about six inches square, to line the walls. The chair and curtain fabrics were also based on designs by Matisse and his large 1911 canvas *The Red Studio* had pride of place. The painting spent the duration of the war stored in the basement of the Redfern Gallery, but Tennant now decided to dispose of it and the Redfern sold it to the Museum of Modern Art in New York, where it remains. The other great Matisse from the room, *The Studio, Quai Saint-Michel* (1916), was bought by the predatory Douglas Cooper, who paid a trivial sum for it at a time when Tennant was feeling a financial pinch. (Now in the Phillips Collection, Washington DC.) However, the dozen lithographs of dancers remained scattered about the club. Francis Bacon described the effect of people entering the main room: 'They looked for a moment like birds of paradise coming down this beautiful gold and silver staircase into what was a multiplicity of mirrors made into a very beautiful room. I've never been a great admirer of Matisse, but this room really worked as a setting.'[1]

Before the war this was home to the Bright Young Things, young men in dinner jackets and flappers in cloche hats dancing the night away, champagne glasses in hand; now it was shabby and had become the centre of what passed as London bohemia. Tennant was still in charge and the membership committee included Augustus John – a foundation member – Philip Toynbee and Clive Bell. The 2,000 or so members each paid four guineas a head (seven for husband and wife); many of them were writers such as Dylan Thomas, Patrick Leigh Fermor, Angus Wilson, Olivia Manning, Cyril Connolly and Elizabeth Smart. There were photographers like Lee Miller and many artists. Half the BBC talks department would gather there after work, and MPs such as Tom Driberg would stroll up to Soho from the House after

a debate. The long-suffering manager was Courtney Merrill, and Charles, from the French region of Haute-Savoie, was maitre d'. But in the post-war years the formal dress code was relaxed, and hardly anyone wore a dinner jacket. Many of the members were gay and this contributed a lot to the club's atmosphere.

Music was provided by the Alec Alexander Quartet, a Greek Cypriot combo who played innocuous dance music that it was possible to ignore unless they played the Charleston or the Black Bottom for some of the older members to dance to, when they would increase the volume. The core membership of writers, artists and intellectuals were sometimes pitted against the remnants of the pre-war fashionable society, known to the regulars as 'the dentists', who drove into town for dinner and a show. One evening a 'dentist' approached Lucian Freud, who was sitting minding his own business, pulled him to his feet and landed him a punch to the jaw shouting: 'There's one for you', and, before anyone could intervene, pulled him to his feet again and gave him another one, saying: 'And another one for your beastly old grandfather.' Clearly Sigmund Freud's findings had caused some anxiety in the suburbs.

Although their gossip could be vicious the regular members were often entertaining. On one occasion, Robert Newton, who played Long John Silver in Byron Haskin's 1950 movie *Treasure Island*, stripped naked on Alexander's bandstand and performed an imitation of Long John diving into the sea for a refreshing dip before dinner. He returned to his table flopped back in his chair and fell asleep, still naked. One of the waiters put a lit cigar between his teeth. Another Gargoyle regular was the philosopher A. J. Ayer. Ayer: 'Suddenly, after the war, I developed and began to know all sorts of people I hadn't known before – writers, painters and so on. The Gargoyle was very largely responsible for that... the beginning of my life as a kind of social figure.' At the Gargoyle the clientele were rude and argumentative and there were times when the gilt chairs were flung across the room. Francis Bacon particularly enjoyed the arguments: 'they were nightly. They went on, not only for hours, they went on for days. It was like one of those instalments where it says tomorrow you'll get such and such – well you certainly did at the Gargoyle. It was great fun, really, in spite of the rows.'[2] The Gargoyle occupied much the same position in Soho then as the Groucho Club, also on Dean Street, did from the mid-eighties.

The ladies' lavatories had full-height mahogany doors, ideal protection for an intimate moment. Lucian Freud was once spotted leaving one with Henrietta Law (later Moraes). Henrietta – born Audrey Wendy Abbott, renamed

when she married Michael Law – was one of the great energy sources of the place. On one occasion Tony Strickland Hubbard, a Woolworth's heir, spun her on the dance floor by her legs, and when he let go she shot between the kilted legs of the painters Robert Colquhoun and Robert MacBryde and collided head first with Alex's bass drum, going straight through.

Henrietta Moraes lived just a few doors away in 1951 and went to the Gargoyle all the time:

Every night there would be fighting, insults were lobbed into the air. Brian Howard could lob an insulting remark accurately as far as twenty yards... Everyone was very critical of one another, but there was a high standard of wit and, provided you were resilient enough, it would act as a stimulus rather than an inhibitor.[3]

Clearly she was not among the inhibited:

I was dancing with Lucian [Freud] in the Gargoyle one night and said to him, 'I want you.' We made a date to meet at lunchtime the next day in a basement off Brewer Street and there consummated, on the edge of an unwieldy kitchen sink, our friendship.[4]

Next to the Matisse lithographs there was a mural by Johnny Minton (assisted by others), a professor of painting at the Royal College of Art.[5] Whenever Minton entered the dining room, accompanied by his usual entourage of sailors, Alexander always struck up with 'My Very Good Friend the Milkman Said' or 'I'm Gonna Sit Right Down and Write Myself a Letter' as these were his favourite tunes. Minton always responded by sending drinks to the band. This was one of the few places where he could take his boyfriends without fear; the club was tolerant of most things. It was Minton who first introduced Francis Bacon to the Gargoyle in the late forties, before Bacon's fame outstripped his own.

Ruthven Todd, in his memoir, wrote:

One person I connect particularly with the Gargoyle is Johnny Minton. In my pictorial memory I have a coloured movie of his long sad clown's face, lashed by breakers of dark hair, as he danced a frenetic solo on the otherwise unoccupied dance floor. His arms and legs were flying this way and that... Clapping and encouraging him was a ringside audience of the faceless nonentities whom he gathered as an entourage as a magnet does rusty filings.[6]

Johnny Minton features in many memoirs of the period as a 'character'. John Lehmann, the editor of *Penguin New Writing* and a well-known poet,

novelist and literary critic, described his face as having an 'element of the grotesque in its narrow axe-like boniness under the untidy mop of black hair – a face seen in an elongating fun-fair mirror'.[7]

Henrietta Moraes was his best friend. They never had an affair but they were always together. She did, however, sometimes try his patience. He fell in love with an amateur wrestler and bodybuilder called Norman, who moved in with Minton at 9 Apollo Place, a two-storey building in a cul-de-sac off Cheyne Walk, originally bought with money inherited from his mother. Henrietta: 'After some party or other, I found myself with Norman and without a thought we became lovers. This lighthearted affair continued for some time until Johnny found out, and then there was an uproar.'[8] Despite this, she was the person closest to Minton and he left her his house in his will. With few exceptions like Norman, Johnny preferred the company of sailors, in particular one called Arnie, from Hull, but he often had great groups of them, attracted by his wealth.

Minton's colleague at the RCA, Rodrigo Moynihan, was another regular, along with his wife, Elinor. Rodrigo was a society painter and Elinor essentially painted chocolate box art, but they lived a bohemian life with many affairs and liaisons. They moved into 155 Old Church Street, near the Chelsea Arts Club, in the autumn of 1945, when the area was still suffering from the war: the houses across the street had been demolished by a landmine and the Fulham Road was still a mass of ruins from the blitz. They decorated their walls with paintings by themselves and their friends, and also with etchings by Whistler and Goya. They ran an open house and Colin MacInnes, Louis MacNeice, Ben Nicholson and the writer Elizabeth Taylor could all be found in their living room, drinking cocktails and listening to Frank Sinatra records.

In 1946 Rodrigo was commissioned by Buckingham Palace to paint Princess Elizabeth, now the Queen. The princess, accompanied by her mother, sat to him in the mornings, whenever the racing meetings would allow, causing something of a traffic jam outside as Chelsea residents lined up to see the Queen. His 1975 portrait of Francis Bacon is probably his best work. In the years directly following the war, this enormously social couple were to be seen virtually every night at the Gargoyle or other Soho haunts.

Minton, Rodrigo and Elinor liked to dance and the Gargoyle allowed them to combine energetic jitterbugging with drinking with their friends. It was also a safe place for Minton to take young men. He was ever conscious of the fact that his sexual preference was not only illegal but also despised by conventional society. At one Royal College dance Elinor Moynihan found

him sitting in a chair, his head in his hands, sobbing his heart out while students stood around jeering and laughing at him. She took him home to his bed.[9] It was a very real problem for him and others like him and one that was only to get worse. In August 1953, Sir John Nott-Bower took over as the new commissioner of police at Scotland Yard and vowed to 'rip the covers off all London's filth spots' as part of a new drive against 'male vice' announced by Sir David Maxwell Fyfe, the Home Secretary, in the wake of the Burgess and Maclean spy scandal. Henrietta Moraes told Minton's biographer, Frances Spalding: 'I think he was very secretive and never even told his closest friends that he was obviously frightfully unhappy. I suppose if you are always breaking the law it creates a lot of pressure.'[10] Michael Wishart summed him up: 'Johnny was very obviously manic. In frantic pursuit of love or even companionship, he dissipated himself to the hilt, while spending a useful inheritance on useless pursuits, such as nights of black dejection or blacker oblivion. The waste of self and money amused his followers.'[11]

Minton and Moynihan were part of the new wave of change at the RCA. They were hired by Robin Darwin, who took over as Rector on 1 January 1948 and began replacing the reactionary old guard, in particular Gilbert Spencer, the professor of painting, who had advised his students not to visit the 1945–6 Picasso and Matisse exhibition at the V&A. Even after the war these artists were regarded as dangerously modern by the British art establishment. Darwin managed to sever the connection with the Ministry of Education and set the RCA up as an independent foundation. Minton's work was of an illustrative style, more suited to the book jackets, posters and illustrations that he became known for than to painting. He was a good teacher, very witty, and students would always gather round afterwards to hear his wildly exaggerated stories which mixed art history with gossip and fantastic invention. Talk was possibly his best medium.

In the fifties the Gargoyle still retained its mirrored walls and balls on the ceiling and became home to Francis Bacon, Dan Farson, Antonia Fraser and a younger crowd. Francis Bacon:

> I used to go up there after the Colony Room closed with Muriel Belcher and Carmel, with so many people who used the Gargoyle. People like George Barker, Rodrigo Moynihan and Gerald Hamilton, and of course Natalie Newton and Henrietta Law (later Moraes)... Cyril Connolly went there a lot... I miss the Gargoyle very much. It was a sympathetic place to go.[12]

In 1952 It was bought by John Negus and for a while nothing changed. The Gargoyle was sold to Michael Klinger and Jimmy Jacobs in 1955, and they

turned it into the Nell Gwynne Revue, a strip club. It had a resurgence as a New Romantics club twenty-five years later.

Before going to the Gargoyle, many people would first stop off at the French pub: partly to see their friends, partly because it was cheaper to drink there. The York Minster, known to everyone as the French pub, on Dean Street, was started in 1914 by Victor Berlemont, the first foreigner to hold a publican's licence in Britain. After his death in 1952 his son Gaston took over. Both men sported fierce handlebar moustaches and a Gallic manner, though Gaston was in fact born above the bar in the family flat in 1914, making him Soho born and bred, and his father was actually Belgian. However, to his customers Gaston was the epitome of Frenchness; something he encouraged by much kissing of ladies' hands and grooming of his magnificent moustaches.

The pub was known for its champagne and stock of different wines by the glass. There was nowhere else in London you could walk in and ask for a glass of Alsace and be served immediately. During the war it quite naturally became the headquarters of the Free French; de Gaulle was said to visit, and a reproduction of de Gaulle's famous call to arms, issued from his headquarters at 4 Carlton Gardens, still hangs on the side of the staircase today: 'A tous les Français. La France a perdu une bataille! Mais la France n'a pas perdu la guerre!' In the French tradition, the French does not serve beer by the pint, possibly the only pub in Britain not to do so. Over the years the walls became covered with signed photographs of French vaudeville stars, boxers, cyclists and personalities, all of whom, according to Victor Berlemont, had drunk at the bar, from the youthful Lena Horne to the boxing champion Jack Dempsey, who drank there in 1926. No more photographs were added to the display after Victor's death.

Before the war, the vicar of St Anne's church across Dean Street would pop out of the sacristy door and run into the French for a quick drink in the middle of Sunday service while his congregation was singing a hymn. In the blitz, the church sustained a direct hit, leaving just the tower standing in the middle of a bomb site; the same bomb destroyed the façade of the French. Then the traffic began to go in the other direction for it was said that Lucian Freud had found a way to gain access to the ruined church tower and after lunchtime closing time had taken a dazzling blonde there to make love. Others quickly followed in his footsteps. Because of its French connections, the pub was a haven for many of the Soho prostitutes until the Street Offences Act of 1959, which was designed to clear prostitutes from the streets but forced them into the hands of pimps. Up until the war, a large number

of them were French, easily recognizable by their immaculate clothes, and known as Fifis. They would gather at the French for a split of champagne, a Pernod or a Ricard. If anyone dare approach them at the bar they would appeal to Gaston for help and he would immediately intercede. As long as they were in the pub, they would not be bothered. He told Judith Summers they were 'lovely girls – the best in the world. In here was sacred. I'd tell the men to hop it.'

In addition to Lucian Freud and Francis Bacon, who first went to the French pub in 1949 because he heard it attracted a lot of artists, there was a group of regulars once typified as 'artistic gangsters'. The sportsmen and entertainment figures still frequented the French after the war. Gaston told Judith Summers: 'The crowd we have now is just a carbon copy of the same crowd that was coming in 40 or 50 years ago when I was a boy. They are the same type of people… They themselves create an atmosphere.'[13] Some extraordinary things had happened in the French. One day Dylan Thomas and Theodora Fitzgibbon sat at the bar drawing doodles; then they turned each other's doodles into a cartoon. They were interrupted when the barman brought them a sheet of paper, sent by a figure sitting across the room. It was an identical drawing. Dylan immediately grabbed Theodora and rushed out into Dean Street, where he explained that the man was the Great Beast himself, Aleister Crowley, up to his tricks. He had no wish to get involved in Crowley's magical workings.

Upstairs was a small restaurant with French waiters where typical Soho food was served: steak tartare or kidneys washed down with a rough red Corbières. After a break of many years, it was reopened by Fergus Henderson in 1992 as the French House Dining Room where he perfected his 'nose to tail' dining, specializing in offal and other forgotten elements of British cooking. (In October 1994 he opened the much larger St John restaurant in Smithfield, and has since become a celebrity chef known for his warm pig's head and his roast bone marrow.)

Gaston's retirement on Bastille Day, 14 July 1989, was celebrated by a huge Soho street party organized by Jeffrey Bernard's brother Bruce. Gaston took the signed photographs with him, but not until they had been carefully photographed and replaced with copies, so that for many years the French retained much of the same atmosphere. The strange metal dispenser that dripped water through a cube of sugar on a leaflike spoon into a glass of absinthe departed from the bar in the seventies but is still brought out on special occasions. Visitors still stand at the south side of the bar, while regulars still sip splits of champagne on Saturday morning at the north side.

At the time of writing little has really changed except that the windows are now always open so that the smokers standing outside can reach in and get their drinks.

The York Minster was not the only French bar in Soho. The Caves de France, (pronounced in the French manner) was opened just after the war at 39 Dean Street by the Philippe family, *mère, père et fils*. It was on two floors, entered by a dark doorway guarded by two doormen who queried whether you were a member but never seemed to bother much if you were not. On the ground floor was a dark low-ceilinged smoke-filled room featuring an enormously long, American-style, high bar dimly illuminated by a string of coloured lights hanging above. Across from the bar was a row of battered seats and some small plastic-topped drinks tables surrounded by circles of cigarette ash and dog ends. On each table stood a jar of highly salted gherkins, designed to make the customers even thirstier. The room was decorated with wine barrels and the walls featured some of the worst painting ever seen in Soho: semi-surrealist works by a monocled old fraud called 'Baron von Schine', who presided over them, night and day, frequently irritating the bartender by rearranging them. No-one ever saw him make a sale even though a notice gave a rather suspect list of galleries in which he had exhibited.

A short flight of steps led to a small basement bar but it was the ground floor that was favoured by the Sohoites. It was packed with regulars during the afternoon: Nina Hamnett often managed to get this far, Caitlin Thomas, usually looking for her husband, the Roberts Colquhoun and MacBryde, the impecunious poet Paul Potts, the writers Stephen Fothergill and Gerald Hamilton, and later Dan Farson. Julian Maclaren-Ross, after he had been banned from the Wheatsheaf, had a habitual position at the far end of the bar beneath a particularly repellent painting of a young nymphet staring in awe at a giant snowman sitting on a rock and brandishing a red furled umbrella. Though the owners took turns to serve behind the bar, the regular barman was Secundo Carnera, the younger brother of Primo Carnera, the heavyweight boxer; their mother had decided on the expedient of numbering her sons rather than finding names for them. Elaine Dundy described it in *The Old Man and Me* as 'a sort of coal hole in the heart of Soho that is open every afternoon, a dead-ended subterranean tunnel... an atmosphere almost solid with failure'.[14]

By about 5.30, the bar had thinned out, as customers headed to other pubs and the Caves prepared itself for a more genteel evening clientele. A palm court trio, incongruous in evening dress, mounted the bandstand and played pre-war dance numbers, occasionally joined by Mme Hortense, the

owners' middle-aged daughter, who attempted to add class to the proceedings by singing light opera. The photographer John Deakin often acted as an impromptu MC for these events, twirling imaginary moustaches and filling his introduction with malicious double-entendres: 'And now,' followed by a roll on the drums, 'let me present Mademoiselle Hortense, the girl...' and he paused, melodramatically and looked her up and down with increasing incredulity, 'with the most incomparable voice in the world. What you've done to deserve this I really don't know.' As she began fluttering her eyelashes and running up and down a few scales, Deakin bowed to the audience and beat a hasty retreat.[15]

Most people seemed to agree with George Melly's description of John Deakin as 'a vicious little drunk of such inventive malice and implacable bitchiness that it's surprising he didn't choke on his own venom'; the kind of remark made by Deakin himself on a daily basis. He is now known, not for his rudeness and acerbic personality, but for his photographs. He was a superb portrait photographer but, unfortunately for posterity, he was careless with both prints and negatives and many have been lost while others exist only in a folded or bent print or ripped and scratched negative; he threw them under his bed or loose into drawers, even walked over them. He began life as a painter, travelling the world, including the South Pacific, with a wealthy patron. In 1939, in Paris, he bought a used camera and immediately switched to photography. During the forties and fifties he worked for *Vogue*, where his work was appreciated even though he often rubbed people up the wrong way. He took great enjoyment in hurting people's feelings, but in his photographs there was an unexpected humanity. Colin MacInnes, reviewing Deakin's 1956 show of Paris photographs for the *Times*, identified his sitters as 'crushed by life, and the artist, quite without condescension or sentimentality, sees the poignancy of their desperate will to live on in a world that has quite defeated them.' He said: 'the beauty of these photographs lies in the fund of affection, and at times of pity, that the artist clearly feels for his fellow mortals', a sentiment most of Deakin's friends found surprising.

Daniel Farson first met Deakin in the French. Deakin was not in good shape: 'I swallowed a raw egg but it was half way down before I realized it was bad.'[16] Farson gave a cruelly accurate description of the man:

He must have cut his ear while shaving for a ridge of congealed blood lay underneath and some of it had fallen on to the heavy polo-necked sweater that had once been white. His pock-marks were livid in the light and dandruff lay in drifts around his hair and even flecked his forehead. The fly buttons of

his jeans were open. He seemed to have eaten all his finger nails, and his nose was battle scarred from alcohol. But the seediness was eclipsed by his huge Mickey-Mouse smile.[17]

The two Roberts, Robert MacBryde and Robert Colquhoun, arrived in London from Scotland in 1941 and were befriended shortly afterwards by Peter Watson, a wealthy arts patron who was instrumental in launching their careers as painters. In the forties they were stars of the much publicized English Neo-Romantics along with John Minton, Keith Vaughan, John Craxton and Michael Ayrton. But this was a short-lived movement, replaced by the equally dull 'kitchen sink' school, and Colquhoun's last show at Lefevre was in 1951. They had a few patrons, notably John Minton, but much of the time they subsisted on handouts. Colquhoun showed a few monotypes at the Caves de France and there was the occasional sale. Unfortunately they had grown used to having money, so when they did get some, they spent it. Usually on drink.

Anthony Cronin wrote: 'MacBryde had, and retained to the end, a capacity to abandon himself gently and totally to the drink and the moment, so that in the right company he achieved incandescence.'[18] He described him as having a beautiful voice and a repertoire of Scots songs that 'he was seldom reluctant to perform.' Whereas MacBryde was known for his Burns, Colquhoun was famous for his recitatives, usually taken from the last acts of Shakespeare's tragedies. People would gather hopefully at the French pub to listen to his deep baritone: he did a deeply moving Macbeth.

The Roberts were a curious couple: MacBryde was very much the bon viveur whereas Colquhoun's Presbyterianism gave him a very neurotic personality. MacBryde was a small man, with a round head, prominent bushy eyebrows and expressive, mobile features like a clown. Cronin described him as 'constantly in deft movement, even the way he picked up a glass or handled a cigarette suggesting precision and sensitivity to nuance and detail'.[19] He was an excellent chef and had the ability to conjure up gourmet food from unpromising ingredients. He extended his improvisational skills to his housekeeping: boiling handkerchiefs in salt and ironing shirts with a heated tablespoon. He could be vindictive and at times thoroughly unpleasant, such as when he shook hands with the poet George Barker for the first time, and had concealed in his right hand the shards of a broken wine glass, which cut Barker's palm. When drunk he would giggle and titter, wheedling and begging his friends for money to buy a beer. Colquhoun, on the other hand, according to Dom Moraes, 'was terrifying in his cups: his thin body seemed

to buckle forward at the hips, while his legs weaved a wild way across the floor. In a thunderous, bullying voice, his eyes unfocused, he would demand to be bought a drink.'[20]

When the pubs opened at 5.30, MacBryde would go off on his own, leaving Colquhoun at the Caves. When MacBryde returned later in the evening, after making the rounds of the Gargoyle, the French, the Swiss or the Colony, he was usually drunk and in a mood to pick a quarrel with Colquhoun. They had a limited range of topics: Colquhoun's Presbyterianism and 'the La-adies', for Colquhoun was not immune to the advances of an attractive woman, something that drove MacBryde wild with jealousy. The arguments were pathetic, with Colquhoun jumping and skipping to avoid MacBryde's petulant kicks. At home these arguments would occasionally develop into real fights and they sometimes appeared wrapped with bandages and plasters. It was generally thought, among the Roberts' friends, that Colquhoun was not really homosexual. He was repressed, shy and inarticulate and had met MacBryde at a formative age when they were both at art school in Glasgow. He was then too scared to approach women and accepted warmth and friendship from MacBryde. Now, however, he would stagger around the Caves when drunk, asking women: 'What colour are yer bloomers?' and, more aggressively: 'I want ma hole!' after which he would double up in quiet mirth, shocked by his own impudence. As Anthony Cronin surmised, these were probably the sort of comments the really forward boys said to the girls at Kilmarnock High School and that he only now felt confident enough to say.

Robert Colquhoun was generally thought the better painter. His work is usually described as deriving from Picasso but it takes more from Braque, particularly *Woman with a Birdcage* from 1946 flattens the picture plane and concentrates more on decorative surfaces than the British would normally permit. The Roberts were both criticized for this. Their careers were short-lived but there seemed to be a chance of revival when Colquhoun was offered a retrospective at the Whitechapel Gallery to be held in March 1958. One condition was that he also show some new work. He told Dan Farson: 'This should mean a new lease of life. It may be a bit early to have an exhibition like this, but the moment a painter has a retrospective there's a move forward. I want to do something that looks like something'[21] (he was born in 1914).

Colquhoun was excited by the commission and sequestered himself in his studio. He began painting much larger canvases than normal 'because it's such a big gallery'. After completing a quantity of new pictures, the Roberts left for a well-earned holiday, but while they were away thieves broke into

the studio and vandalized all their possessions, mutilating all the paintings. His life's work was destroyed. On top of this blow, the Council decided to condemn the building and they were evicted. This double whammy killed his spirit and Colquhoun never recovered. He died at his easel in 1962 and MacBryde died in Dublin four years later, drunkenly dancing the Highland fling in late-night traffic.

There was one other Soho Club where the forties bohemian crowd gathered. The Mandrake was started not long after the war by Teddy Turner ('volatile and Jewish' according to George Melly[22]) and Boris Watson, a huge taciturn unkempt Bulgarian refugee with swivelling, suspicious eyes, formerly called Boris Protopopov. It began as a chess club, since chess was Watson's great love and he managed to keep an eye on the club while simultaneously playing a game. He had previously run the famous wartime hangout the Coffee An' (named after his demand 'Coffee an' what?'). For his new venture he rented an underground room at 4 Meard Street, (always pronounced 'merde' by the regulars), on the north side of the street, almost next door to the Gargoyle, which he envisioned as being filled with patrons quietly plotting their end games. In order to finance this activity the place obviously had to have a bar and food but inevitably the drinkers and the drunks took over the place. Gradually Watson occupied more and more basement rooms until he had six in a row. In 1953, the club advertised itself as 'London's only Bohemian rendezvous and the largest club. Application for membership (10s 6d p.a.) must be made to the secretary in advance and the fact of advertising does not mean that everyone is accepted.' The advertisement featured a photograph of the interior showing an artist busily sketching a guitarist standing in front of a large painting of a voluptuous nude. Several men are huddled over a chess game.

Entrance was gained down a narrow flight of steps, where the door was protected by a rusty metal grille. Once inside, the customer passed through the restaurant and into a much larger room. A piano stood in the right-hand corner, and an angled bar, presided over by a barmaid called Ruth, described by Daniel Farson as 'Soho's version of the barmaid at the Folies Bergère'.[23] Here Nina Hamnett and the regulars like the acerbic Brian Howard had their smoky kingdom. Julian Maclaren-Ross was a regular and became a great friend of Boris, sharing his love of chess. The Mandrake was not entirely free from prejudice; when Quentin Crisp arrived one day Watson said 'Buy him a meal and get him out of here.'[24]

Watson made sure his customers remained loyal by an arrangement

whereby half the value of any cheque he cashed would be in the form of credit at the bar. As few of his customers had bank accounts, Maclaren-Ross included, this was very effective. Outside pub hours, the only way that drinks could be served was with a meal so a collection of dry sandwiches were kept behind the bar for the purpose. When someone complained about the state of them, Boris would glare and explain: 'This is a sandwich for drinking with, not for eating!' The next room was for those who wished to drink coffee and read books and magazines. After this came the 'quiet room', and the chess players, who by now had been banished to the most distant back room of all. By the sixties they had been joined by most of the painters and poets, who used to gather there for talk and a glass of cider. Watson brought in fruit machines and served more expensive food. Where there was once live music – guitar and lute recitals – there was now a jukebox. However, by the late fifties the Mandrake became the venue for late-night impromptu jam sessions for jazz musicians and so enjoyed a new lease of life.

3 Sohoitis

I used to enjoy going up to the Colony Room, in Dean Street. It was run by a woman called Muriel Belcher, and Lucian was in there, and Francis Bacon, and so on, many writers and painters. She was a funny old woman, Muriel, very handsome, Bacon painted her a lot... She was a foul-mouthed old thing, but witty, and famous. It was the centre for us in Soho.

GEORGE MELLY[1]

The French pub was very small and could become unbearably crowded. A favoured alternative was the Helvetia in Old Compton Street, always known as the Swiss, which was much larger. The bar was decorated in olive green with concealed lighting. A full lunch was available upstairs but in the snack bar tongue, lobster, crab, fish and chips and pickled cabbage were all available at reasonable prices, as well as sandwiches. Bert, the Cockney bartender, was famous for his patter and his grimy white jacket. The Swiss had a reputation for being a bit tough but it was never allowed to get too boisterous; the landlord, ex-Detective Inspector Bill Buckley, never let anyone step over the line. It was in the Swiss that Maclaren-Ross first met Tambimuttu in 1943 and Tambi famously told him to beware of Soho: 'It is a dangerous place, you must be careful.'

'Fights with knives?'

'No, a worse danger. You might get Sohoitis, you know.'

'No I don't. What is it?'

'If you get Sohoitis,' Tambi said very seriously, 'you will stay there always day and night and get no work done ever. You have been warned.'[2]

The prime example of Sohoitis at work was to be found in Muriel Belcher's Colony Room. One of the best descriptions of the club in the fifties came from Colin MacInnes, who, changing Muriel's name to Mabel, wrote: 'To sit in Mabel's place, with the curtains drawn at 4 p.m. on a sunny afternoon, sipping expensive poison and gossiping one's life away, has the futile

fascination of forbidden fruit: the heady intoxication of a bogus Baudelairian romantic evil.'[3]

Muriel was clearly a genius at creating atmosphere and was once described as conducting the bar like an orchestra, keeping tabs on whose turn it was to buy a round, and making sure that those who deserved drinks but were too broke to buy them were treated by those too parsimonious to offer. 'Open your bead bag, Lottie,' she would cry, or, if they were less than forthcoming, put them in an intolerable position by declaring: 'Come on everyone, this vision of loveliness is going to buy us all a drink!' George Melly told Oliver Bennett: 'Muriel was a benevolent witch, who managed to draw in all London's talent up those filthy stairs. She was like a great cook, working with the ingredients of people and drink. And she loved money.' As Melly said, Muriel was able to make every quip appear good, even when it wasn't exactly a Wildean epigram. Her camp delivery made everyone's sentences sound witty and she could keep it up for hours at a time. She called all men 'she', including 'Miss Hitler', and established a long-standing cult of rudeness in the club. For Muriel, 'cunt' (her favourite word) was a term of abuse, whereas 'cunty' was meant affectionately. If you were really in her good books she would call you 'Mary'.[4]

Muriel Belcher was from Birmingham, where her parents, wealthy Portuguese Jews, owned the Alexandra Theatre. She was brought up with a nanny and a governess. When her father, whom she detested, died in 1937, Muriel, her mother and her brother moved to London. There, a year later, she started the Music Box on Leicester Place in partnership with Dolly Myers. The Music Box was a theatrical and society club that catered to the more bohemian of the upper classes and the better sort of gay Guards officer. It was much appreciated for its discretion. In 1947, when she was still running the Music Box, Muriel met Ian Board, a commis waiter at the Jardin des Gourmets. Board was thinking of starting a valet service so Muriel made her membership list available to him, thinking that many of her more wealthy members might wish to use his services. There were too many; it all became too much for him, so when she opened the Colony on 15 December 1948 he became the club's first manager.

In January 1949, few weeks after the Colony Room opened, Francis Bacon ran into Brian Howard in Dean Street outside the Gargoyle and Howard told him that there was a new club opening across the street. Together they climbed the stairs. Bacon enjoyed it so much that he returned the following day. Muriel clearly liked him and she made him an offer he could hardly refuse: 'I'll give you ten pounds a week and you can drink absolutely free

here, and don't think of it as a salary but just bring people in.' She somehow knew that the people that Bacon knew were the kind of people who would make a good club. Muriel: 'But he always spent his money in the club as soon as he got it. You have to remember he was getting far less for his pictures in those days.'[5] Francis called her 'mother' and she used to call him 'daughter'. Bacon brought in John Minton, Edward Burra, the two Roberts, Colquhoun and MacBryde, Keith Vaughan and the Moynihans. They were all painters, but could be guaranteed not to talk about art all the time, which would have been boring.

The Colony Room Club at 41 Dean Street was originally the first-floor reception room of a domestic dwelling built in 1731 though now much altered. The space retained its domestic proportions which is perhaps why people felt so at home there. Muriel sat perched on a high chair at the far left of the bar, next to the door, head tilted back to display her fine aquiline nose, imperiously waving a cigarette in a long holder as she barked 'Members only!' at anyone she didn't recognize. This was quickly followed by 'Fuck off!' if they did not turn immediately to leave, followed by 'Get a face-lift on the way.' Members, however, were welcomed with an endearing: 'Hello, cunty!' She was a formidable presence; one afternoon a local gangster entered the club looking to set her up for protection money but he had barely announced his purpose before Muriel screamed: 'Fuck off, cunt!' so loudly that he backed out of the door and down the stairs.

The bar had a bamboo front with a bamboo screen above and potted plants above the gin bottles and shelves. There was a row of barstools with mock leopard skin seats and a green carpet. Muriel's girlfriend Carmel was Jamaican and the decor was supposed to suggest a Caribbean 'colony' theme. The walls started off cream-coloured but became so stained by nicotine that in the mid-fifties Muriel painted them in green gloss, renewed regularly. Michael Wojas celebrated the new millennium by painting them one shade lighter, which upset some of the old-timers. There were curtains and lace curtains prevented anyone from seeing in from across the street. There was no clock because otherwise drinkers would always be thinking about the train they had to catch. Muriel had a licence to open from three in the afternoon at a time when pubs closed at 2.30. She closed at 11 p.m., like a normal pub. It would have been possible to extend the licence until one o'clock, but as Michael Wojas, manager of the Colony Room from 1994 until 2008, recalled: 'Muriel always said that by 11 the punters are pissed and skint and we've had the best from them. Send them on their way and let someone else cope with them.'[6] An attitude summed

up by the club's attractive motto: 'Rush up, drink up, spend up, fuck off.'
He explained:

> It's a perfect space; it's very well worked out. Muriel would sit by the bar in her
> special seat. If you keep the mirrors clear you can see what's going on behind
> you without having to twist your neck round. You can talk to people at the bar
> and you're in contact with whoever's behind the bar. You're also right by the
> door just in case someone you don't want comes walking in. You don't want the
> music too loud, you need to hear everything.[7]

Muriel's initial clientele included many of the gay military men from the
Music Box and her girlfriend, Carmel, had many gay friends who quickly
joined, but there was no intention of making it into a gay club. The Colony
was one of the few places where it was safe to be openly homosexual but
Muriel was looking for an interesting mix. Encouraging Francis Bacon to
introduce his friends was a master touch; even though, as she said: 'I know
fuck all about art'[8], Muriel had a good eye for people and knew that artists
would add excitement and atmosphere to the club. Bacon loved it there and
told Dan Farson: 'It's a place where you can lose your inhibitions. It's differ-
ent from anywhere else. After all, that's what we all want isn't it? A place to
go where one feels free and easy.'[9] John Minton described it as 'like being in
an enormous bed, with drinks'.[10] The evil-smelling Canadian poet Paul Potts
introduced a chapter in *Dante Called You Eurydice* with a dedication: 'For
Muriel Belcher, because of many not so small kindnesses, and one very big
one, over a very long period of time.'[11] Potts told Daniel Farson: 'The relatively
small room which is her domain and where she is absolute sovereign must
be one of the most unique rooms anywhere. It is not like other clubs at all,
more like a continuous cocktail party.'[12]

Muriel was not the only entertainment at the club; there was a black café
society pianist, Mike Mackenzie, who tinkled away at 'We'll Have Manhattan'
or 'These Foolish Things' or 'Give Me the Simple Life' and 'On the Sunny Side
of the Street'. When he left, his place was taken by Ted Dicks, who studied
under John Minton at the Royal College and shared rooms with another Royal
College student, Len Deighton, who was then studying to be a book illustra-
tor. Minton loved the Colony, which quickly replaced the Gargoyle for him
when it was sold in 1952. At the Colony, Minton and Bacon would vye with
each other in buying bottles of champagne but whenever possible they stayed
out of each other's way. Minton was less able to contain himself, probably
because, though he was a highly regarded artist in the forties, he was not
seen as developing his talent whereas Bacon was slowly becoming recognized

as a genius, so that today no-one has heard of Minton and Bacon is thought of as a giant in post-war British painting. Even in the early fifties, Bacon was seen to have depth and vision whereas Minton's work was little more than attractive illustration. But for both of them it was a haven, a home where they could let down their guard, though Bacon was described by Dom Moraes as having a 'curiously anxious look' as he leaned against the bar in jeans and sweater. Moraes: 'The eyes always seemed watchful, though the strong round face often broke into laughter, or frowned with sudden concentration. Bacon had extremely good manners... He gave an impression of great strength and great aloofness: when most kindly he seemed also most remote.'[13]

Inevitably, the Colony Room is now most associated in people's minds with Francis Bacon. Bacon was a painter of figures in rooms, and it was rare that Bacon himself was not enclosed by four walls, in his studio, at the French or the tiny space of the Colony Room. He needed that sense of enclosure, that was where everything important happened in his life.

In the forties Bacon lived at 7 Cromwell Place near South Kensington tube station, a large studio which had previously belonged to Sir John Millais. The cavernous room was sparsely furnished with worn velvet sofas and divans and faded chintz. Two huge Waterford chandeliers hung from the ceiling, giving an air of faded Edwardian grandeur to the scene. There was a dais for a model, upon which stood an enormous easel. Here he held illegal gambling sessions, presided over by his old nanny, who slept on the kitchen table. His friend Michael Wishart enjoyed visiting the studio and recorded some of his observations:

> Seated on the edge of his bath I enjoyed watching Francis make up his face. He applied the basic foundation with lightning dexterity born of long practice. He was more careful, even sparing, with the rouge. For his hair he had a selection of Kiwi boot polishes in various browns. He blended these on the back of his hand, selecting a tone appropriate for the particular evening, and brushed them through his abundant hair with a shoe brush. He polished his teeth with Vim. He looked remarkably young even before this alchemy.[14]

When Michael Wishart married the painter Anne Dunn in 1950, the party was held in Bacon's studio. He painted the chandeliers crimson for the occasion and tinted his face a delicate shade of pink. Wishart invited 200 guests and provided 200 bottles of Bollinger but Ian Board had to quickly bring more supplies from the Colony Room. Anne's roommate Sod was maid of honour. Sod, known during the war as 'the bugger's Vera Lynn' for her drinking club catering to gay servicemen, liked to lie on the divan naked, sleeping off her

morning intake of gin while Anne's Australian fruit bat hung upside down above her, squirting everything with jets of diarrhoea.[15] Muriel Belcher, Graham Sutherland and others were all guests and the party continued for two days and three nights. Francis gave the couple 100 Waterford glasses as a wedding present. David Tennant described it as 'the first real party since the war'.

Bacon's father was a horse breeder and loved to hunt and was consequently very disappointed in young Bacon's aversion to horses and the countryside in general. He never seems to have made the connection between his son's asthma attacks and the presence of dogs and horses. According to Lady Caroline Blackwood, a homosexual friend of hers told her that Bacon had revealed that his father had arranged for his son 'to be systematically and viciously horsewhipped by his Irish grooms'. Bacon told Dan Farson that he had been 'broken in' by 'several' of his father's grooms and stable lads when he was about fifteen.[16] He hated Ireland and developed a neurotic asthma attack whenever he boarded a plane to go there even though he was able to fly anywhere else. Perhaps not surprisingly, given his upbringing, Bacon was a masochist. He enjoyed being whipped but the S&M sessions, fuelled by alcohol, not infrequently got out of hand and it was not unusual for him to show up at the Colony covered in cuts and bruises which he explained away as a slip on the bathroom floor.

Bacon belongs with the greats of the School of Paris: Picasso's *Desmoiselles d'Avignon*, Soutine's carcasses, Modigliani, Degas, whose late pastels he particularly admired. There is a formal beauty in his canvases that is in tension with the convulsions of the images within so that no matter how grotesque, how distorted or abbreviated the subject matter, the sheer painterly qualities of its execution seduces the eye. He is a master painter, true to oils, no plastic for him. His manipulation of the picture plane is unerring. He is a gorgeous colourist in the manner of Matisse, his translucent flesh tones are as good as Ingres and there is a sensual quality to his brushstrokes – the tonking and scrubbing – that brings to mind De Kooning, Bonnard and the reds of Courbet.

Bacon's *Three Studies for Figures at the Base of a Crucifixion* was exhibited at the Lefevre Gallery on New Bond Street in the first week of April 1945, four weeks before the defeat of Germany, as part of a group show which included Graham Sutherland, Henry Moore and Matthew Smith. The public reaction was one of shock and horror: the screaming nameless creatures, one of which had soiled bandages wrapped around its blinded eyes but which had turned to face the viewer, caused the utmost consternation. The full facts of the Nazi

horror, the concentration camps, the mass hangings of Russian peasants, the rape and torture were just beginning to emerge. It was clear that nothing was ever going to be the same again: Europe had changed irreversibly.

The human condition was Bacon's subject matter:

> It's something that lies long and far below what is called coherence and consciousness, and one hopes the greatest art is a kind of valve in which very many hidden things of human feeling and destiny are trapped – something that can't be definitely and directly said... the whole coagulation of pain, despair.[17]

He believed that 'There is an area of the nervous system to which the texture of paint communicates more violently than anything else.'[18] He thought the essence of ourselves is buried deep in the unconscious and can only be dragged into consciousness and given form by stealth: the use of controlled accident or trance states. In the early days he frequented medical bookshops, looking for material illustrating extreme emotional states. When he was very young, in the mid-1930s, he bought a secondhand medical book, *Diseases of the Mouth*, in Paris; beautiful hand-coloured plates depicted the open mouth and the examination of its inside surfaces. Bacon told David Sylvester: 'They fascinated me, and I was obsessed by them.' He retained a few pages of hand-coloured illustrations from it to the end of his life. Another book, called *Positioning in Radiography*, was also very influential.

Over the years he assembled a collection of several thousand photographs and was able to put his hand on the one he wanted even though they were often torn and paint-spattered. 'I think of myself as a kind of pulverizing machine into which everything I look at and feel is fed. I believe that I am different from the mix-media jackdaws who use photographs etc. more of less literally or cut them up and rearrange them.'[19] Bacon thought that the pop artists did not digest and transform their material sufficiently for any really new powerful images to emerge. He thought that photographs were so strong and literal then even if only a fragment was used it would prevent any personal vision from emerging. Bacon: 'In my case the photographs become a sort of compost out of which images emerge from time to time. These images may be partly conditioned by the mood of the material which has gone into the pulverizer.'[20] It was not just still photography that interested him: Eadweard Muybridge's *The Human Figure in Motion* was very influential, as was Eisenstein's 1925 film *Battleship Potemkin*, with its famous scene of the nurse with the smashed spectacles on the staircase. Fragments of all these images appeared in his work.

Bacon and his circle were by no means the only artists working in London in the immediate post-war period. Some of the most interesting were the remnants of the pre-war Surrealist group, a movement which still had some life in it in 1945, largely through the efforts of Roland Penrose and the ICA and of the Belgian Surrealist E. L. T. Mesens (Edouard Léon Théodore), whose London Surrealist Group met every Monday night in the private dining room of the Barcelona Restaurant at 17 Beak Street, Soho. Mesens' collages are now highly regarded, but at the time he was much better known as an editor and exhibition organizer. Throughout the war years he worked for the Belgian service of the BBC and in 1945 reopened his London Gallery, featuring Surrealist works. Short, a little overweight, his thinning black hair oiled and brushed back, meticulously shaved and manicured, fastidiously clean, Mesens was described by George Melly as looking like 'a somewhat petulant baby' or 'a successful continental music-hall star'.[21] He dressed conventionally in suit and tie, his shoes highly polished, his only Continental mannerism being to splash himself with expensive cologne which in those days was a habit confined almost exclusively to homosexuals and very much frowned upon.[22] His wife Sybil was in her mid-thirties when Melly met them. She had olive skin and fine aquiline features. She was fashionably well dressed, unusual just after the war, but had a gypsyish air about her that Melly found very attractive.

The London Surrealist Group, just after the war, included Eileen Agar, though she kept her distance from Mesens, who had caused her problems in the past with his lies and trouble-making; Feyyaz Fergar, the well-known Turkish poet, editor and translator; the long-faced pipe-smoking French actor Jacques Brunius; Edith Rimmington; and the translator Simon Watson Taylor. After they had dined, Mesens would usually propose a subject for discussion and sometimes the meeting would break up in noisy argument, but most meetings were calm, often devoted to games of 'Exquisite Corpse' (known to children as 'Heads, Bodies and Tails') in which the Surrealist ideas of chance opposition come into play. This could be a three-part drawing, in which the player draws a head, then folds it out of sight and the next person draws a body and so on, or a three-part text, where each player has no knowledge of what the others will write. Melly was astonished to find someone had written 'Love is fucking.' A shocking thing to say in mixed company in the forties. One evening Melly read aloud one of his poems which contained the line 'You are advised to take with you an umbrella in case it should rain knives and forks.' He had collected a handful of cutlery from the restaurant sideboard and on reaching that line he threw them in the air. The noise was

tremendous as they fell to the floor. The Surrealists applauded loudly but the proprietor, M. Carbonell, was not amused. He rushed into the room to investigate the source of the noise and threw them all out. Mesens was delighted by this as it gave him, and the others, an excuse to engage in another Surrealist activity: the 'gratuitous act', which in this case was to insult the proprietor. Naturally the insults were quickly forgotten as the restaurant did not want to lose their custom each Monday and by the middle of the week normal relations had been restored.

The young George Melly was much taken by Mesens, and even took him to stay with his parents in Liverpool. Melly's parents were less impressed by Mesens' three-hour morning toilet, during which he hogged the bathroom, but by the end of the weekend it had been arranged that George would work for Mesens at his new gallery on Brook Street and that George's father would give him £900 to invest in paintings. Magritte's *Le Viol* was his first purchase. Even though this is an iconic Magritte work it is unusually misogynistic for him: by replacing her face with her sex organs the woman's entire personality is stripped away, rendering her nothing but an object for men's play. Sybil Mesens did not like the painting and refused to allow Mesens to hang it at home; this did not mean, however, that she was puritanical about sex. In 1946, during one of George Melly and Mesens' long discussions about sex – the surrealists believed that they should have the right to act out their desires without the constraints of bourgeois society – Sybil interrupted the seemingly endless conversation by telling George: 'For Christ's sake, stop going on about sex. If you want a fuck, George, come in the bedroom.' George looked at Edouard, who gave a Gallic shrug of the shoulders and said: 'Why not?' Up until that moment, George had been exclusively homosexual, but he had been informed of what to do by his fellow shipmates and found that everything went according to plan. At one point Mesens entered the room, naked except for his socks, and in a state of arousal. 'You are fucking my wife!' he bellowed, with delight. George and Sybil managed to achieve a simultaneous orgasm, whereupon George was replaced by Edouard. Watching him in action renewed George's desire. He wrote: 'I was particularly impressed by his orgasm, during which he shouted French blasphemies and rolled his eyes like a frightened bullock cornered in the market place. Indeed for some years I consciously affected this performance until Mick Mulligan persuaded me that it looked absurd rather than convincing.'[23] George replaced Edouard and they continued in various combinations as the evening drew in. It was the first of many threesomes. As he put it: 'and so, high above Brook Street, we made love in various combinations and positions while the light faded,

and on many other occasions too.'[24] Mesens was bisexual, and though Melly, Mesens and Sybil had only half a dozen or so threesomes, Melly's sexual involvement with Mesens continued for many years. On one occasion when Mesens was away, Melly and Sybil got together but she asked him to keep it a secret in case Mesens became jealous.

George Melly had arrived in London from Liverpool in 1948 fresh from his National Service in the Navy. His ruddy face was dominated by his lips, which were wide, fat, wet and red, invariably smiling or talking. His navy haircut was cropped short at the back so that a plume of well Brylcreemed spikes stood up from the crown of his head like a Mohawk. He wore a very tight blue suit which sported in the buttonhole a pink celluloid doll with its buttocks turned uppermost.[25] He carried a walking cane, the ivory handle of which was carved into a scene featuring at its centre a terrified, plump crouching mouse.

In addition to his job in the London Gallery, for two or three evenings a week he was the vocalist with Mick Mulligan's Magnolia Jazz Band, using a battered biscuit tin as a megaphone which, according to him, gave perfect amplification to his traditional country blues. The Magnolia Jazz Band sounded surprisingly authentic considering that, rather than having grown up in the Mississippi delta, Melly was a public schoolboy, educated at Stowe, and Mick Mulligan had been educated at Merchant Taylor's and worked during the day as the director of a wines and spirits distributor. George rented a room in Chelsea in a house belonging to the writer Bill Meadmore. They got on well except when George allowed so many people to sleep on his floor that Meadmore could not get into the shared bathroom; then, his patience at an end, he would run into George's room and order everyone out.

The Barcelona's prices were reasonable, and it attracted an artistic crowd. Regulars included Jacob Epstein and the thriller writer Leslie Charteris, who mentioned the restaurant in several of his 'Saint' books. There was usually a knot of Surrealist painters and sculptors arguing loud and long at a corner table, some of whom tried to improve on the wall murals with sketches of their own. With most sorts of olives, olive oil, and even rice and flour in short supply, most of the ingredients for Spanish food were unavailable. Mr J. Carbonell did his best, and even managed to save some Machurnudo 'La Rive' Fino dry Spanish sherry all through the war, then offered it at three shillings a glass when peace was declared.

The younger crowd went to Wheeler's, Francis Bacon's favourite restaurant. It was just half a block down the street from the Colony Room and round the corner from the French pub. It quickly became the meeting place of the

so-called 'School of London' artists: Bacon, Lucian Freud, Frank Auerbach, Michael Andrews and whoever else Bacon invited to join in his entourage in the procession from the French or the Colony to Old Compton Street. The proprietor was Bernard Walsh, a large genial man with a striking laugh and sometimes known as Mr Wheeler. The war made his fortune: oysters were not rationed and he could easily serve them below the five-shilling limit on the cost of a meal imposed by government restrictions. He managed to get a drinks licence to go with the food and, though he was away in the armed forces, his wife kept the place open throughout the Blitz, continuing to serve Pyfleets, West Merseys and Whitstables even as Old Compton Street was half destroyed by bombs.

Their oysterman, Tim from Brighton, could open 400 shells an hour and 600 if pushed during a really busy period. Walsh managed to keep his cellar filled with Chablis, champagne, hock, beer, stout and of course draught Guinness, but the place was never cheap. After the war Bernard Walsh opened up the disused second floor and began to serve hot food. Because of its proximity to the Colony Room, the Gargoyle, the French and the Coach and Horses, Wheeler's became the obvious place to eat for Francis Bacon, Colin MacInnes, Lucian Freud, Frank Norman and the other Soho bohemian intellectuals who could afford it. There were rows of polished teak tables with check tablecloths, often stolen by customers to use as neckerchiefs. A row of high chairs at the bar was filled with oyster eaters. In the years after the war one regular customer came in to swallow six dozen in a sitting, three days a week. The manager was Peter Jones, who presided over the place in a dark funeral director suit. The back lounge had its own small bar and claret-coloured settees in the waiting area, where the menu could be studied. The walls were decorated with paintings of fish and other maritime creatures. The large green menu contained thirty-two sole dishes as well as turbot and lobster but no desserts. The head chef was Mister Song, a Chinese. Francis Bacon always asked after his health just to hear him say: 'Mustn't glumble.'[26] Bacon was often broke and signed the bill. Walsh trusted him implicitly, knowing that when he sold a painting he would settle up, which he always did. Bacon also promised to give him a painting but when he did – a small self-portrait – Walsh didn't like it and quickly sold it, receiving £17,000.[27]

In the fifties and early sixties the all-male Thursday Club used to meet in a small top-floor room to eat oysters and lobster thermidor and drink brandy. The club was the idea of the photographer Baron – Sterling Henry Nahum – who was famous for the sex orgies he organized at his flat in Piccadilly. Baron would have loved the swinging sixties but he died in 1956. The club, however,

continued. Well-known members included Prince Philip, Gilbert Harding, James Robertson Justice, Michael Eddows, MP, Iain MacLeod, MP, the leader of the House during the Profumo affair, and Stephen Ward, a key player in the same affair.

Then, as now, people bemoaned the loss of cheap clubs and cafés and as far back as 1946 people like Stanley Jackson were complaining that Soho was no longer what it used to be. He wrote then:

> If you are in search of the Bohemianism of the novels, Soho will disappoint you today. The restaurants in Old Compton Street cater for the film people, the shopkeepers, business men, bookies and visitors who don't mind paying a cover charge for a 'Continental' atmosphere. They are too dear for the struggling artists, writers and musicians who used to line their stomachs for a florin at the Chat Noir, then cross the road to the Café Bar and chatter until midnight over a couple of mugs of Brazilian coffee. Now they find it cheaper to live in Chelsea, Pimlico or Hampstead.[28]

People, of course, are still saying the same thing today.

4 The Stage and the Sets

'Just like home – filthy and full of strangers.'

RONNIE SCOTT describing his jazz club onstage

A favourite destination for art students such as myself, hitching up to London and in need of an address to meet people, was Jimmy's on Frith Street. Hitch-hiking could be slow, but it was usually possible to make London in time to meet someone at Jimmy's for lunch. Jimmy Christodolous opened his restaurant in August 1949 and it quickly became another haven for those seeking escape from the grim reality of post-war Britain. Housed in a white tiled barrel-vaulted basement with whitewashed walls it was cheap and very Continental. There were plain wooden chairs and gingham tablecloths. Wine was served in virtually unbreakable glass tumblers, and half a loaf of bread was slapped down beside each diner. Jimmy's specialty was moussaka, salad and chips followed by thick sweet Greek coffee. Jimmy used to stand at the kitchen door, beneath the 'No smoking' sign, chewing on a cigar, surveying his slightly grubby domain.

The cheap cafés and restaurants were one of the chief attractions of Soho, and one that features in many fifties memoirs was the Torino on the corner of Dean Street and Old Compton Street. Mr and Mrs Minella always opened the Torino at 8.30am on the dot. The marble-topped tables were so much a home for exiled Spanish Republicans, anarchists and communists plotting the overthrow of Franco that it became known in some circles as the Madrid. Others referred to it as the Avant-Garde café because so many artists and designers hung out there. The prices were rock bottom and the kindly Minellas even extended credit. Here, also, could be found the staff of David Archer's bookshop, the drinkers from the French in need of solids and gay couples seeking a change from the As You Like It on Monmouth Street.

The playwright Bernard Kops and his wife Erica were regulars, as were Paul Potts and Colin MacInnes.

It was the cafés where the Soho bohemians really racked up the hours. They were cheaper than pubs, and the rent was the price of a cup of coffee every hour. One much frequented was the French on Old Compton Street; as it was only a short walk from the French pub, any confusion over a proposed rendezvous was easily corrected by visiting both. The French café was described by Quentin Crisp as 'a human poste restante... cosy, friendly, poverty stricken people, ill-equipped to live', some of whom he did not expect to live through another winter.[1] He was, of course, one of them, sitting proudly at a table strewn with crumpled newspapers, with posters for poetry readings and jazz clubs tacked on to the wall behind him, a faint smile on his lips, eyebrows arched, the two great waves of purple hair giving him a strangely streamlined look. George Melly said that Crisp had 'the courage of a lioness' to walk the streets dressed and looking as he did. Melly first met Quentin Crisp at the Bar-B-Cue restaurant on the King's Road, Chelsea. Melly: 'Being in Chelsea he was unshaven and rather grubby, the nail varnish on both finger and toe nails, peeping through gilt sandals, cracked and flaking, his mascara in need of attention, his lipstick of renewal.' He had, Melly said, 'a wicked wit'. Crisp was an exhibitionist with his mincing gait, and his silk scarves, velvet jackets and wide-brimmed hats. He was a great raconteur, and preferred the cafés to the pubs, saying that on the days he was not working as an art school model he would have happily whiled away the time from midday to midnight in the Scala and other cafés on Charlotte Street, drinking pale weak coffees, as long as he could find people to listen to him talk.[2] He cruised through the streets of post-war London like a galleon in full sail, before eventually moving to New York City, where he found a more congenial home. In his own 1976 publicity handout he described himself by saying:

Quentin Crisp has lived for thirty-five years in Chelsea in one room without ever cleaning it. Now in the winter of his life he describes himself on his Income Tax forms as a retired waif. In the past he has been unsuccessfully an illustrator, a writer, a televisionary and is currently an artists' model. His hobby is taking the blame.[3]

Despite vicious treatment from a vociferously homophobic society, Crisp remained a beacon of courage and individuality, and never gave up on people: 'I've spread my love horizontally, to cover the human race, instead of vertically, all in one place. It's threadbare, but it covers.'[4]

Soho embraced many different social scenes that did not necessarily

overlap. And they all had their gathering places. For example, at the west side of Soho, almost on Piccadilly Circus, was the S & F Grill at 6 Denman Street, a coffee shop much frequented by actors and producers in the years just after the war. It was situated in Shaftesbury Buildings, an elegant 1898 structure with marble columns on the frontage. Inside was bright and modern and served good coffee, something of a rarity in those days, but toasted sandwiches were the safest bet as far as food was concerned. Though the regulars assumed that 'S & F' stood for Stage and Film, it was in fact named after its owner, Stan Freeman, who allowed young hopefuls to sit for hours nursing an empty coffee cup in front of them, hoping to be discovered or at least befriended by one of the big names like Robert Morley who often came in. Digby Wolfe and Harry Fowler – who had already appeared in ten movies by 1947 – were regulars, as was Diana Dors, who lived close by in Jermyn Street with her boyfriend Michael 'Kim' Caborn-Waterfield. She and Kim liked to spend their afternoons there, fooling around with Fowler and Wolfe. Dors, then seventeen, was already making films: *The House at Sly Corner* was her first, in 1946, when she was a fifteen-year-old. Her friend Pete Murray, later a well-known TV disc jockey, came in every day, even though he lived out of town, and sometimes stayed over at her flat. The S & F closed at 6 p.m. and Dors and Kim, Fowler, Wolfe and the others would transfer themselves across the street to a small drinking club called the White Room.

Just around the corner from Denman Street was the Windmill Theatre on Windmill Street, famous as the strip joint that 'never closed' during the war. Nudity onstage was forbidden by law, but in order to accommodate art schools and art studios, nudity was permitted provided the models didn't move. Club owners adapted to these absurd rules by creating acts where the stripper would freeze when the last garment dropped or a seedy MC would drag the curtains back to reveal a static tableau of naked girls. But the girls couldn't keep still that long, and there were often plainclothes men or some uptight Christian moralist in the audience just waiting to bust them, so the nudity was alternated with music and live comedy.

The strip clubs alternated the strippers with comedy acts and some of Britain's finest performers got their start in these venues, among them the comedian Harry Secombe. In the army during the war, performing for the troops, Secombe had developed a comedy routine where he would dash onstage apologizing to the audience: 'Sorry I'm late – I haven't even shaved yet.' Then he would begin to shave, imitating a whole range of different people so that by the end of his act the stage was awash with soapy water and the audience was roaring with laughter. Once out of the service, he

performed as a comedy singer on a part-time basis. Then, in 1946, he auditioned his shaving act at the Windmill. The theatre's manager, Vivian Van Damme, was notoriously hard to please but Secombe gave it his best and was afterwards called to Van Damme's office. Secombe:

> I didn't know what to expect, but as I walked in he just said to me 'How much do you want a week?' I remembered the advice that Norman Vaughan had given me to ask for more than you expect and then you could always come down. So I asked for 40-quid and he said 'Alright'.[5]

Harry was given a three-month contract and was able to turn professional.

It was at the Windmill that he met the comedian Michael Bentine, who in turn introduced him to Spike Milligan. After sharing the stage with mostly naked girls, Secombe went out on the road in variety but his act was not always well received by theatre owners; when one of them paid him off after the show he said: 'You'll not work my theatre again. In future you'll shave in your own time and not in mine!' In November 1946, Secombe made his first billed TV appearance. He teamed up with the radio scriptwriter and agent Jimmy Grafton who was also the owner of the Grafton Arms, now known as the Strutton Arms, at 2 Strutton Ground, off Victoria Street, Westminster. It was here that Secombe, Bentine and Milligan met another like-minded comic, Peter Sellers. The pub has gone down in the history of British comedy because it was there that the four of them came up with a brilliant idea for a radio comedy programme. When it first went on the air on 28 May 1951 it was called *Crazy People*, but on 22 June 1952 the BBC let them change the title to *The Goon Show*, making all four of them famous and becoming a vital influence on British comedy. Bentine was the first to leave – in November 1952 – but the other three continued throughout the fifties until 28 January 1960, when the final episode, 'The Last Smoking Seagoon', was broadcast. This anarchic, surrealist and very British humour has permeated British comedy ever since.

Around the corner from the Windmill, a few doors from the S & F Grill, was the Caribbean Club, at 12 Denman Street. This was a West Indian club on the second floor of a building filled with small drinking clubs above the Argentina Restaurant. You had to ring a bell and a shutter would slide open to inspect you, like in a speakeasy. The club was opened in May 1944 and quickly gained 3,000 members. Non-members were firmly turned away. It was open from 3 p.m. until 11 p.m. and consisted of a lobby bar and a dining room

where check-clothed tables surrounded a small dance floor with a bandstand at one end. The bar was crowded, mostly with whites and a scattering of black GIs and East End pimps, while the small dance floor was used mainly by West Indians, dancing to the music of the Dick Katz Trio: double bass, electric guitar and piano. The owner-manager, Rudi Evans, explained: 'My band has got plenty of life but I don't allow drums. Drums mean trouble. They're a dangerous drug in a place like this.'[6] Evans was born in Panama of French colonial extraction. He had been a singing teacher on the Continent and had acted in films in France, Belgium and Britain, at one time playing alongside Paul Robeson, who must have been an influence on him. He was described by George Melly as 'one of those between the war blacks whose English was exaggeratedly Oxbridge, whose clothes were excessively formal, and who once a night would sing, in the rich baritone of Paul Robeson, such sophisticated night club ballads as "East of the Sun and West of the Moon"'. Melly would sometimes join in and sing a blues; he was deeply influenced by Bessie Smith at that time and, as he wrote, he was 'tolerated by the clientele' for his 'gauche sincerity'.[7]

Tambimuttu, in his memoirs remembered: 'Rudi... the proprietor always sang Jean Sablon's "J'attendrai" for me, his moon face glowing in the half dark.'[8] Tambimuttu enjoyed dancing at the Caribbean Club and his antics were described by his secretary Helen Irwin, who sometimes accompanied him there, as 'solo performances, short and arbitrary', based on the Keralan war dance of Kathakali and involving many little jumps and a heavy frown. 'He danced eyes closed, and alone, remarkable because in those days ballroom dancing consisted entirely of couples.'[9] Johnny Minton was also a habitué who liked to sit and muse during the late-afternoon hours when the club was empty and quiet. For him it was a refuge.

The Rockingham was another example of clubs of the period, a discreet gay club in Archer Street started in 1947 by Toby Roe, a man of impeccable taste. Having grown up in the country he never bothered to lock his premises until one day he heard people moving about downstairs in the middle of the night. They were unable to find the light switch and left without taking anything. Toby looked around for a door key but couldn't find it, so he decided to nail the door shut until the morning. Unfortunately this attracted the attention of a passing policeman who naturally got the wrong end of the story even though Toby was dressed in an expensive silk dressing gown. Fortunately he was not arrested and the next day found the keys. At first he was taken up by the Princess Margaret set, who loved the squalid little street, but fortunately they did not stay long. The name Rockingham came from a porcelain

catalogue and seemed suitable for a club, so he bought a Rockingham vase and called the club after it. After the vase got smashed, Toby discovered that a horse called Rockingham had won the St Leger in 1833 and managed to find a painting of the horse by Herring. Most members thought this was inspiration for the name.[10] The club had flock-striped wallpaper and chandeliers. Quentin Crisp described it as the 'closet of closets... [where] top drawer queers' danced together discreetly. Bacon found it dull and one day when he, Dan Farson and Deakin were drinking there, Deakin passed out and had to be carried drunk up the stairs while the regulars clucked in disapproval. Bacon turned and shouted back down the stairs: 'Even unconscious, he's more fun than you lot!'[11] It was used in the sixties by art dealers like Robert Fraser as a discreet but slightly louche place to meet clients.

In December 1948 a group of musician friends got together to start a venue where they could play their own new brand of jazz. There were ten musicians: Johnny Rogers, Tony Crombie, Leon Calvert, Lennie Bush, Hank Shaw, Joe Muddell, Bernie Fenton, Laurie Morgan, Tommy Pollard, Ronnie Scott and the manager, Harry Morris; so they called it Club Eleven. It was the first club in Britain to feature modern jazz entirely. It was housed behind Mac's theatrical rehearsal rooms in Mac's Club, in Ham Yard. You entered through 41 Great Windmill Street, next door to Phil Rabin's Salt Beef Bar, halfway between Archer Street and Shaftesbury Avenue and came out of the back door into Ham Yard, where the actual entrance to the huge basement club was located. Membership was five shillings and it cost 3s 6d to get in. The doorman was a huge black boxer called Charlie Brown but anyone with a genuine interest could usually talk their way in. Later, in 1950, it became Cy Laurie's Jazz Club.

There is an evocative account of how news of the club spread around Soho in the autobiography of Raymond Thorp – *Viper, the Confessions of a Drug Addict* – published in 1956. He remembered the excitement in 1948 when it opened and attracted the coolest customers away from Feldman's Swing Club at 100 Oxford Street:

> 'Say man,' he said excitedly. 'You heard about the Club Eleven? Was there last week. Man, but man it makes this 'ole town look like a Model T Ford.' His eyes sparkled and soon he was telling us about a new jazz club that had opened in Great Windmill Street – a few yards from Piccadilly Circus. About the cool cats who were going there and the hot music that 'really gets the joint a jumping.' Within weeks everyone was discussing the new club.[12]

Thorp described the clientele as 'crazy, really gone'. He distinguished between the Club Eleven customers and the people who went to Feldman's: 'These were *professional* layabouts as distinct from the kids from the suburbs.'[13] Many of them were musicians, many were pot smokers, or junkies or cocaine users; there were American servicemen on leave, petty crooks, teenage girls who liked the music and the atmosphere, and likely lads such as Thorp. The new club was instantly popular and soon began to open every night of the week. It was at Club Eleven that Raymond Thorp first used pot, and not long afterwards he was dealing it. He finished up in Pentonville for larceny. Another major dealer there was Big Dave, who lived in one of the bombed houses in Phoenix Street, off Charing Cross Road.[14] The compere was Cecil 'Flash' Winston, whose jokes prefigured Ronnie Scott's own terrible puns. There was something totally Soho about Club Eleven, – it could not have existed anywhere else. There was a nice story of the club manager, Harry Morris, who was once taken as far as Marble Arch. He looked at the expanse of grass in Hyde Park and said: 'I've had enough of this, let's get back to town.'

Within a few months the club had become so successful that it moved to new, larger premises at 50 Carnaby Street, where they decided to feature acts other than themselves and began booking American acts. Things were going all right when, on 15 April 1950, Ronnie Scott was just blowing his way through the final choruses of Charlie Parker's 'Now's the Time'; when he opened his eyes he found the place full of cops. As he wrote: 'We were being raided by the drug squad – and the joints were jumping', in this case being thrown on the floor, along with small packets of powder. A dozen musicians and customers spent a night in the cells at Savile Row police station – where a decade later Robert Fraser used to buy his hash – and Ronnie Scott was charged with possession of cocaine as well as the marijuana. The chief inspector explained to the magistrate that bebop was 'a queer form of modern dancing – a Negro jive'. They were all fined between £5 and £15 and the club closed shortly afterwards. Ronnie Scott explained that it 'eventually got out of hand, none of us being businessmen. It developed into a sort of organized chaos.'[15] It was not until 30 October 1959 that Ronnie Scott and Pete King opened Ronnie Scott's at 39 Gerrard Street. They moved to their bigger, now legendary premises on Frith Street on 17 December 1965.

Club Eleven was opened essentially as a bebop alternative to Feldman's Swing Club that operated every Sunday. One regular player was the trumpeter Humphrey Lyttelton, then an art student at Camberwell. He joined the

Dixielanders in 1947 along with fellow art student Wally Fawkes, later a cartoonist for the *Daily Mail*. In January 1948 Lyttelton and Fawkes started their own band, the Lyttleton Band, to play at the newly opened Leicester Square Jazz Club. Most of the audience were Camberwell students and they invented their own dance steps to go with the up-tempo music. Lyttelton recalled: 'We brought along with us a strong contingent from Camberwell Art School and John Minton, now recognized as a distinguished painter, was among the most formidable and dangerous of the first school of dancers.' Lyttelton was taught painting by Johnny Minton (who also taught Frank Auerbach). George Melly: 'Johnnie [sic] Minton [...] would caper wildly in front of the bandstand. And Lucian Freud [...] might raise a hand in greeting while staring with obsessive interest in another direction.'[16] The Lyttelton Band then moved to the old Club Eleven basement at 41 Great Windmill Street, before transferring to 100 Oxford Street, which was then renamed Humph's.[17] Music is still played at 100 Oxford Street, which has seen everything from the British blues revival to the 1976 Punk Festival and is one of the few venues to have remained in the same location since the war.

Revivalist jazz was the mainstay of the clubs because it was such good-time music and people could dance to it. One of the popular bands was Mick Mulligan's Magnolia Jazz Band with vocalist George Melly. In fact it was Mick Mulligan and his manager, Jim Godbolt, who first used the term 'rave' to describe their 'all-night raves' on Saturday nights at the club on Gerrard Street. George Melly: 'It took several forms, the verb meaning "live it up", "a rave" meaning a party where you raved, and "a raver" i.e. one who raved as much as possible.'[18] The term is of West Indian origin, meaning party-goer, but it quickly entered the language and it was not long before the *Melody Maker* named its weekly music gossip column 'The Raver'. Ravers were often bearded and wore ex-army greatcoats but could be distinguished from beatniks by the fact that they frequently carried a banjo or clarinet and were fond of sporting battered top hats. They were usually welcomed to parties whereas beatniks were not. Beatniks were a little too dangerous: they fooled around with drugs and poetry, a lethal combination.

5 This is Tomorrow

**To make our movement sound international I suggested that
we should mention the London Psychogeographical Committee.
It was just me... It was a pure invention, a mirage.**

RALPH RUMNEY on the first meeting of the Situationist International in Cosio
d'Arroscia, July 1957[1]

At the end of 1955, Britain went through a period of sudden dramatic change:
in just twelve months commercial television made its debut, the Angry
Young Men suddenly filled the newspapers and radio waves, the Suez crisis
marked the end of Empire and rock 'n' roll reached Britain. There were
already signs of change: rationing ended in 1954, almost ten years after
the end of the war; there were milk bars, and coffee bars began to appear,
the Moka, 29 Frith Street, being the first, in 1953. Ian Fleming's James Bond
books – *Casino Royale*, (1953), *Live and Let Die* (1954), *Moonraker* (1955) – began
to be published; skiffle reached the radiowaves in 1954 with Chris Barber's
'New Orleans Joys', featuring Lonnie Donegan on vocals. In the next three
years British society was in turmoil, and when it was over, the country had
changed, though not to everyone's liking. We had Pop Art (*This is Tomorrow*,
1956), the Free Cinema movement (1956), CND (1958) and home grown rock
'n' roll bands: Tommy Steele (1956), Marty Wilde (1958), the Vipers (1956),
Hank Marvin (1956), Cliff Richard (1958), Terry Dean, Wee Willie Harris,
Adam Faith and others. Boys still had to endure two years' National Service,
which was to remain compulsory for another six years, meaning that it
would be very difficult to hold a rock 'n' roll group together until conscrip-
tion ended. This restlessness was expressed, as usual, by a youth movement:
before the Goths, the New Romantics, the Punks, the Hippies, the Mods and
the Rockers came the first British post-war rebels: the Teds.

In the late forties 'Debs Delights', upper-class young men, instructed their
Savile Row tailors to make Edwardian-style long jackets with velvet collars

and narrow trousers. These they wore with embroidered waistcoats and curly-brimmed bowler hats. Many of them already had the waistcoats that denoted membership of Pop at Eton. The working-class appropriation of this upper-class style first emerged from the heavily bombed streets of the Elephant and Castle as early as 1951, where it had been taken up and exaggerated: the jackets grew longer, the trousers narrower, the hats dispensed with, replaced by an extravagant creation based on the Tony Curtis hairstyle. These were the Teddy boys. They added a few touches of their own: the guardsmen's long narrow tie was replaced with the riverboat gambler's string tie, held in place by a medallion, a death's head, skull and crossbones, an eagle, silver dollar or other American image such as a silver miniature Texas longhorn skull, or even a swastika if they really wanted to upset people. Their drape jackets were worn with narrow drainpipe trousers terminating in a pair of brothel creepers. These American-style shoes were also known as crêpe boppers or beetle crushers after their thick crêpe rubber soles. These gave them a lot of bounce, good for dancing, fighting and running away from the police. Socks in bright fluorescent colours – lime green, shocking pink – set them off nicely.

The hair was worn long as a reaction to National Service and the army – servicemen were forbidden to wear Teddy boy suits off-duty – with the hair at the sides swept back and fixed in place by Brylcreem. The two sides met at the back of the head with the hair swept back from the top to make a Y-shaped triangle known as a DA, or duck's arse. Sometimes the hair from the top of the head was allowed to reach the neck in a fringe known as a Boston cut or square-neck. After many experiments based on Elvis Presley's black-dyed quiff, the Teds finally decided on a symmetrical model made by parting the hair from ear to ear and combing the hair forward into two matching quiffs and the back into a DA, before pushing the sides back in a streamlined sweep. The American Latino jellyroll, a long quiff brought forward in a snood that projected out over the forehead, held in place by a considerable weight of grease, was less common. Sideboards were worn long in the manner of the American General Burnside himself. As a complete outfit could easily cost £100, and, as the average wage for a young man was about £6 a week, the Teddy boy look was quickly associated with crime; no-one but a gangster could afford to dress like that.

In November 1953 the *Daily Mirror* reported:

> Up and down St. James's, heart of Jeeves country, you may today see furrowed brows under the hard hats of young men about town. Reason is that

the Creepers have pinched the latest fashion of the young men of St. James's. And in doing so, they have made it desperately, appallingly unfashionable. Edwardian suits with high, narrow lapels and drain-pipe trousers, which for some time have been the hallmark of young men at the speakable end of Jermyn Street, are now appearing on Saturday nights from Leicester Square to Hammersmith. With (My dear sir, I assure you!) special hair-cuts.[2]

The Teddy boy look was an entirely male style, unlike that of the hippies or punks. There were Teddy girls who wore very tight skirts and ponytails but that style was not specific to the movement. The appropriation of upper-class attire appears to have particularly outraged the establishment. As early as March 1954 a sixteen-year-old youth convicted of robbing a woman by 'putting her in fear' was told by the Dartford Magistrate: 'There are a lot of things and so-called pleasures in the world which demand a lot of money. You tried to get hold of money to pay for ridiculous things like Edwardian suits. They are ridiculous in the eyes of ordinary people. They are flashy, cheap and nasty, and stamp the wearer as a particularly undesirable type.'[3] The Teds' manner of rebellion was a form of controlled violence expressed usually in fights with each other, or in some type of relatively minor vandalism. Flick knives, razors and bicycle-chains were used largely as props; no-one wanted to seriously hurt the members of rival gangs. Broken bottles, boots and sticks, however, were regarded as acceptable in the fights, which were usually pre-arranged by gang leaders at suitable venues.

Most of the fun was to be had in seeing the pedestrians part before them when a group of Teds swaggered down the street. They were the first post-war youth group and succeeded in drawing attention to themselves beyond their wildest dreams. An article by 'a family doctor' in the London *Evening News* on 12 May 1954 was a classic reaction:

Teddy Boys are all of unsound mind in the sense that they are all suffering from a form of psychosis. Apart from the birch or the rope, depending on the gravity of their crimes, what they need is rehabilitation in a psychopathic institution... Because they have not got the mental stamina to be individualists they had to huddle together in gangs.

In April 1954 the *Daily Mail* reported:

Cinemas, dance-halls and other places of entertainment in South East London are closing their doors to youth in 'Edwardian' suits because of gang hooliganism... The ban, which week by week is becoming more generally applied, is believed by the police to be one of the main reasons for the extension of

the area in which fights with knuckle-dusters, coshes and similar weapons between bands of teenagers can now be anticipated... In cinemas, seats have been slashed with razors and had dozens of meat skewers stuck into them.[4]

Two years later, with the release of the film *Rock Around the Clock* in Britain in September 1956, the Teds went wild, turning on fire hoses and slashing the cinema seats, dancing in the aisles and in the streets outside. Flying bottles injured two police when they engaged a crowd of Teds singing and jiving in the New Kent Road near the Elephant and Castle after a screening of *Rock Around the Clock* at the Trocadero cinema. Four shop windows were smashed and fireworks aimed at police. Nine Teds were arrested.

At the Lewisham Gaumont one Ted climbed onstage and waved his arms, yelling: 'Rock! Rock! Rock' and Teds started jiving in the aisles; seats were smashed out of the way. When 120 Teds were thrown out of the Stratford Gaumont in East London, they continued to dance all over the municipal flowerbeds in front of the cinema. Sir Malcolm Sargent told the *Times*, 17 September 1956:

> Nothing more than primitive tom-tom thumping. The amazing thing about rock 'n' roll is that youngsters who go into such ecstasies sincerely believe that there is something new or wonderful about it. Rock 'n' roll has been played in the jungle for centuries. Frankly I think if rock 'n' roll is capable of inciting youngsters to riot and fight then it is quite obviously bad.

Sargent's own Proms, of course, incited stirring feelings of flag-waving patriotism and were quite obviously good.

Towns across the country quickly banned *Rock Around the Clock* and pundits stepped forward to condemn it. On the radio show *Any Questions* Lord Boothby said: 'One of the purposes of us old fogies in life is to stop young people being silly.' He was later involved in some silliness of his own when his homosexual involvement with gangster Ronnie Kray became known. Jeremy Thorpe, MP, described the film as 'Musical Mau Mau' and was worried that 'a fourth rate film with fifth rate music can pierce through the thin shell of civilization and turn people into wild dervishes'. He was of course later disgraced for his involvement in a homosexual murder and some unpleasantness involving a German shepherd (dog). It took the Bishop of Woolwich to reveal what they were all really worried about. Writing in the *Times* he said: 'The hypnotic rhythm and the wild gestures have a maddening effect on a rhythm-loving age-group and the result of its impact is the relaxing of

all self-control.' In other words, we must ban it because it might encourage young people to have sex.

George Melly offered an eloquent explanation for the whole phenomenon, one that would continue to apply for the next forty years. He held that the street fights and cinema riots, the extramarital sex and random vandalism were produced by a 'claustrophobic situation'. He wrote:

> They were result of a society which still held that the middle classes were entitled not only to impose moral standards on a class whose way of life was totally outside its experience; of an older generation who used the accident of war as their excuse to lay down the law on every front; of a system of education which denied any creative potential and led to dead-end jobs and obligatory conscription; of a grey colourless shabby world where good boys played ping pong.[5]

As the art critic Kenneth Coutts-Smith wrote in 1970:

> The 50's saw a social phenomenon that had never previously existed at any moment of the past, the appearance of a working-class bohemia. The Teds were the vanguard, the first thin wedge of an emergent social group that was soon to count within the body politic. The unshakable personal awareness of the Absolute Beginner, his sense of solidarity with his peers, his passionate if quirky insistence on justice and dignity, and above all, his total rejection of 'bank clerk values' was to become something of an archetype.[6]

Teddy boy style and attitude was not entirely confined to the working class. It had a certain resonance in the art schools, where a new generation of young people were up against an even more thickheaded and obdurate establishment. Sadly, unlike in the USA or Germany, the art schools were still in the hands of ex-colonials and public schoolboys, which, as Richard Hamilton wrote, led to the 'dismal design standards' of the Festival of Britain.[7] At the Royal Academy schools, the new president, Sir Alfred Munnings, stamped into the studios wearing jodhpurs, hacking jacket and riding boots that he thwacked with his riding crop. He would accost students and demand to know if they were 'one of those buggers that talks about Picasso?' If they were he would yell: 'Then get the hell out of here!' No wonder the RA schools remained a joke, certainly until the end of the sixties. Richard Hamilton's appreciation of the new teacher Thomas Monnington got him expelled:

> Monnington could be hilarious. His deadpan delivery of the line 'Augustus John could knock spots off Cezanne' was masterly. Another time I fell off my

drawing donkey laughing at what I mistakenly took for broad humour – 'They are not even good honest Frenchmen, they're a load of fucking dagos.' My open amusement at these antics got me into difficulties and I was expelled for 'not profiting from the instruction being given in the painting school.'[8]

The pathetic state of art education gave extra importance to the creation in 1947 of the Institute of Contemporary Arts (ICA).

The ICA was founded in 1946 by the artist and critic Roland Penrose, the poet and art critic Herbert Read, the Cornish poet and editor Geoffrey Grigson, and two sponsors: the art collector and benefactor Peter Watson, who had financed Cyril Connolly's *Horizon* magazine (and subsidized the early efforts of Lucian Freud, among others), and Peter Gregory, the owner of Lund Humphries, then the best art printers in the country. Penrose, Grigson and Read were the ideas men and the other two paid for them: at the end of the year the overdraft was calculated and they split it between them. It was originally conceived of as an alternative arts centre to the Royal Academy. Penrose and Read both had backgrounds in Surrealism, having been organizers of the London International Surrealist Exhibition of 1936, a direction that showed in the early ICA exhibitions. Watson, who put up most of the money, was an unconventional old Etonian whose boyfriend, Denham Fouts, was once described by Christopher Isherwood as 'The most expensive male prostitute in the world'. In 1956, Watson drowned in his bath, possibly murdered by his lover, Norman Fowler.

The ICA launched itself with two remarkable exhibitions, held in rented galleries: *40 Years of Modern Art*, which reflected Penrose's interest in Cubism, and *40,000 Years of Modern Art*, which showed his interest in African sculpture. The Institute's first premises were on the first and second floors of 17–18 Dover Street: a main exhibition space with polished wooden floors, windows to the right of the stage, audience seated in rows of six on stacking tubular metal chairs with canvas seats and backs, very functional and modern, and a separate club room for members. It had the atmosphere of an intimate club and because it was so small conversation and the exchange of ideas were easy. Most people seemed to be regulars and knew each other. In the early fifties the artist Jack Smith wrote: 'I feel that the wilderness starts ten miles from the centre of London in any direction.'[9] Walking around the ICA's early exhibitions of Picasso or Jackson Pollock it was easy to agree with him.

One of the more active members at the ICA meetings was Ralph Rumney, a painter and theoretician who is best known as a co-founder of the Situationist

International (SI), though Tate Britain has an important abstract by him – *The Change* (1957) – in its collection. In 1952 he was one of the few voices to oppose Professor Buchanan's plans for rebuilding London; a scheme which gave precedence to the car and involved cutting roads through residential neighbourhoods and building monolithic high rise blocks. Rumney wanted to apply Situationist ideas to London planning. Instead of destroying communities, he wanted a London made up of pedestrian zones: 'I would have liked it to become a grouping together of different districts, as it was in the beginning. I thought that the main roads should be built on the periphery of the villages that made up London.'[10] In *The Consul* he describes how the Independent Group invited him to present his ideas:

> At the ICA there was a group of individuals who had formed themselves into a sort of gang, a private club, something that was obviously quite sectarian... I was invited once to give a seminar on the way in which the architects – the Design architects who were the nucleus of the Independent Group – had to some extent collaborated in the destruction of London.[11]

Many of the architects involved with the ICA were the very people who believed in the Los Angelization of London and his views were regarded with derision: 'No one listened to me. I was seen as a little jerk.'[12] And so the Westway was cut through Notting Hill ripping away large sections of Little Venice and Paddington Green and new highways forced through Tower Hamlets. Many of the tower blocks have since been pulled down. In the fifties and sixties 'developers' tore down the majority of the beautiful eighteenth-century houses that had survived the Blitz. It was to be expected; this is the nation that bulldozed Nash's Regent Street in pursuit of money. Despite the animosity of the architects, Rumney was permitted to organize some exhibitions at the ICA by Wols, Baj, Michaux, Yves Klein and Fontana, with the last two giving talks to the members.

In 1955, in order to promote his various ideas, he decided to start his own weekly arts review, *Other Voices*, 'to get myself heard and to squire a certain legitimacy'. It was a precursor of the London underground press. Rumney was both editor and publisher. He published several pieces by Stefan Themerson as well as Bernard Kops, Hugo Manning and C. H. Sisson. He was living at the time in a squalid block of flats in Neal Street, Covent Garden, in a building not yet wired for electricity, just gas lighting, and with a toilet in the hall. (There were many streets like this in central London even in the mid-sixties. I had a flat on Gilbert Place, just off Museum Street, in 1965, where not only the buildings but the street itself still lacked electricity. Each

evening a lamplighter turned on the street lighting. With no hi-fi, television or radios the loudest disturbance was a local sculptor hacking at a giant tree trunk.) Rumney was painting at the same time as editing *Other Voices* and was under contract to Rex Nankivell, at the Redfern Gallery, who once a week would send his chauffeur round in a Bentley convertible to take Rumney to the gallery to collect his cheque and take him to the bank. But much of his time was taken up with the newspaper: he did everything – assembled the copy, typeset the articles, and did the layout; he had a Polish printer who was already working for Stefan Themerson but set all the headlines himself by hand. Every week he produced six large-format pages and distributed them himself to bookshops. After six weeks he was so exhausted he contracted pneumonia and had to cease publication. Rumney: 'It was fantasy, really, but at least it existed.'[13] By a curious coincidence, he chose as his headline typeface the same font that the New York underground paper *East Village Other* used a decade later, making an even closer connection between *Other Voices* and the sixties phenomena of the underground press.

In July 1957, the founding members of the Situationist International held their first meeting, in the Italian village of Cosio d'Arroscia. There is a set of photographs of them all posing together: Walter Olmo, Michèle Bernstein, Elena Verrone, Gallizio, Asger Jorn, Piero Simondo, and founder Guy Debord. Ralph Rumney is missing because it was he who took the photographs. Rumney joined on behalf of the London Psychogeographical Committee, which he had just made up, though psychogeography itself was an invention of the Letterists. Considering how many scholarly essays and books have been written about the SI, Rumney's own assessment was surprisingly modest: 'At the level of ideas, I don't think we came up with anything which did not already exist. Collectively, we created a synthesis, using Rimbaud, Lautréamont and others, like Feuerbach, Hegel, Marx, the Futurists, Dada, the Surrealists. We knew how to put all that together.'[14]

Back in London, Rumney organized lectures on the SI and put on a screening at the ICA of Guy Debord's film: *Hurlements en faveur de Sade* (*Howls for de Sade*). The film has no images whatsoever but consists of about twenty minutes of spoken dialogue, during which the screen remains white, intercut with long passages of silence, totalling one hour, during which time the screen, and therefore the cinema, remains dark. Rumney: 'After the lights went up after the first show, the audience protested so loudly that their shouts could be heard by those waiting outside.' The first audience tried to convince the audience for the second show to go home, but their arguments had the opposite effect and the second screening was full to capacity.[15] Less

than a year after the formation of the SI, Rumney was expelled by Debord, 'politely, even amiably'. The reason given was that he had failed to complete a projected psychogeographical report on Venice. (He was a few days late.)

Rumney spent little time in Britain after this, preferring to live in the South of France and Italy. His influence extended in many directions and it may be that he was responsible for some of Manzoni's most notorious artworks. Rumney:

> [Manzoni] was doing horrible paintings when I knew him. He was even younger than me, a student... One evening when I was round at his place I said to him: 'If you want to be an artist you won't do it by making paintings. You must live the life of an artist. It is a practice, so that even your shit should be a work of art.' A little while later he was putting shit in tins![16]

Rumney was not invited to join the Independent Group, which had a closed membership and whose discussions were not published. The committee members were Lawrence Alloway, the assistant director of the ICA from the mid- to the late fifties; the architects Peter and Alison Smithson – inventors of the ghastly 'streets in the sky' concept for urban housing, whose style was described as 'the new brutalism' – and Reyner Banham, best known for his sympathetic study of Los Angeles; Toni del Renzio, a freelance graphic designer who taught at Camberwell School of Art and worked part-time at the ICA; and the artists Richard Hamilton, John McHale and Eduardo Paolozzi (who was then teaching fabric design at Central School of Art). Other participants included Victor Pasmore, William Turnbull and Nigel Henderson, who was best known as a photographer. Peter Blake, though not central to the group, also attended many of their meetings. The group first met in April 1952, when the meeting featured projections by Eduardo Paolozzi of pages from his large collection of American illustrated magazines using 'a rather hot epidiascope'. Though the ICA was founded as an alternative to the art establishment, the new generation saw its founders as out of touch. 'How pompous, formal and antiquated the art establishment was. The Independent Group was for practicing artists and critics and no one else. They even talked tough, in a certain way – the linguistic equivalent of Brutalism', wrote Richard Lannoy.[17]

Richard Hamilton: 'If there was one binding spirit amongst the people of the Independent Group, it was a distaste for Herbert Read's attitudes.'

Toni del Renzio wrote: 'At the time, we were more united by what we opposed than by what we supported. "Antagonistic co-operation"... constitutes the most accurate description of the Group.'[18]

Some, such as Eduardo Paolozzi, saw the group as actively researching a new iconography: Paolozzi: 'Group members such as del Renzio, Alloway, Reyner Banham and myself were bound together by our enthusiasm for the iconography of the New World. The American magazine represented a catalogue of an exotic society, bountiful and generous, where the event of selling tinned pears was transformed into multi-coloured dreams...'[19] In 1953, Paolozzi exhibited collages made from American magazines at the ICA in a show, *Parallel between Art and Life*, described by him as containing 'imagery from the budding worlds of admass and new technology. This material, seen in an unfamiliar context and on an inflated scale, suggested an area of visual delight unsuspected at the time by most of the audience.'[20] To a British audience still experiencing food shortages, the luscious coloured advertisements for food worked on more than just the visual level: they posed questions concerning Britain's relationship with the USA, which now had the world's highest standard of living whereas Britain was virtually bankrupt. All the young artists wanted to go to America, the land of huge fruit salads, whipped cream, chewing gum, cars with enormous fins, white teeth and hamburgers. British pop art, in some ways, can be seen as a strategy to deal with the imagery of this unattainable dream. *Parallel between Art and Life* revitalized the Independent Group, which by then had almost ceased to exist. In 1955, Richard Hamilton organized *Man, Machine and Motion* at the gallery, featuring twentieth-century images in photographs: speed, stress and man–machine relationships are predominant. The result of all this activity was the *This is Tomorrow* exhibition out of which came the British Pop Art movement.

The exhibition, held at the Whitechapel Gallery in August 1956, was designed by Theo Crosby, the editor of *Architectural Design*, who had been inspired by attending a congress in Paris in 1954 which drew together artists and craftsmen, fine and applied arts. Crosby conceived the exhibition as twelve teams of artists, architects, musicians and graphic designers working together to express their view of the contemporary environment and its effect on the human senses. As Alloway put it: 'a symbol-thick scene, criss-crossed with the tracks of human activity'. Each team contained people from different disciplines, a radical idea at the time, and they were told go away and talk amongst themselves, and decide who they wanted to work with. Less than half of the exhibitors were from the Independent Group, but their influence was all-pervasive. The thirty-eight exhibitors included Germano Facetti, Eduardo Paolozzi, Alison and Peter Smithson, Victor Pasmore, Erno Goldfinger, Kenneth Martin, Mary Martin and Toni del Renzio.

The lavish spiral-bound catalogue was designed by Edward Wright and included essays by Reyner Banham and Lawrence Alloway. Each team had its own area. The displays varied from purely architectural assemblages to communications and information theory, but only one group dealt with symbols of popular culture. It was the room designed by Group Two that attracted the most attention and controversy. Richard Hamilton, John McHale and John Voelcker displayed the billboard-size film poster for the new science fiction film *Forbidden Planet*, released that spring, featuring an actual size Robby the Robot, a prescient move by Hamilton as Robby has since gone on to become one of the most famous film robots of all time. Pasted over the poster was a life-size still of Marilyn Monroe with her dress blowing up, from *The Seven Year Itch*. There was also a jukebox, seen, in 1956, as the symbol of American decadence but recognized by Hamilton as an extraordinary piece of futuristic design. It was also here that Hamilton first exhibited his *Just What is It That Makes Today's Homes So Different, So Appealing?*, which was also used as the exhibition poster; a piece now generally regarded as the first work of pop art. Unfortunately, by the time the show opened, Hamilton and McHale were no longer getting on. When the idea of teams was first proposed, Hamilton and John McHale knew they would enjoy working together. John Voelcker, the architect who designed the structure, was someone Hamilton knew slightly and whom he liked very much so he was asked to build the room. McHale left for America on a two-year scholarship shortly after the exhibition was planned, and though he was able to send masses of visual material to Hamilton, his contribution was of necessity conducted via correspondence. Hamilton: 'We could only correspond by letter, and their tone became increasingly acrimonious. Finally, we were no longer friends.'[21] In fact, McHale contributed many of the ideas, and according to Magda Cordell the material in Hamilton's famous *Just what...* collage came from John McHale's files.[22]

Their installation explored the newly introduced elements in the British visual environment: American comics, Marilyn Monroe and the jukebox. As the jukebox was free, people made so many selections that it took an hour before your record came on. Hamilton: 'There were all these games with sound, optical illusion and imagery. One chamber in the fun house was even a kind of space capsule. There were portholes from science fiction which showed aliens looking through the windows.'[23] Reyner Banham explained: 'The key figures of the Independent Group were all brought up in the Pop belt somewhere. American films and magazines were the only live culture we knew as kids.'[24]

There are conflicting claims as to who named Pop Art; Lawrence Alloway is usually given the credit. It took some time to become a fully defined movement, and certainly when Richard Hamilton gave his famous definition in a letter of 16 January 1957 to Peter and Alison Smithson he did not mean it as an art movement. He said that there was no such thing as 'pop art' at the time and his use of the term was to refer solely to art manufactured for a mass audience as distinct from hand-crafted folksy art.[25]

Pop Art is:
Popular (designed for a mass audience)
Transient (short-term solution)
Expendable (easily forgotten)
Low cost
Mass produced
Young (aimed at youth)
Witty
Sexy Gimmicky
Glamorous
Big business

But in 1957, the term still referred to the products of mass culture; and though both Paolozzi and Hamilton were making collages of advertisements and American comics, it took a few more years for Pop Art as a movement to emerge. When it did, it transformed the British art scene.

6 Bookshops and Galleries

How many books that were once notorious now serve as instruction for youth!

WALTER BENJAMIN, *One Way Street*

One of the artists in Group One of the *This is Tomorrow* show was Germano Facetti, an Italian designer who, at the age of sixteen, was arrested in Italy in 1943 by the Germans as an armed member of the resistance and deported to the Mauthausen death camp in Austria. He survived. While working for a Milan architectural practice he met Mary Crittal, an English architect, and in 1950 moved with her to London. He became the art director of Aldus Books, and spent most of his free time at the Café Torino on Old Compton Street. It was here he was commissioned by David Archer to design his new bookshop on Greek Street. His cool, modern, very Italian design sensibility – bands of rainbow colours, enlarged black-and-white photographs, single colour spaces – had a big impact on British graphic design in the early sixties. He was asked by Allen Lane to redesign Penguin Books in the early sixties and in 1964 he designed the new paperback section of Better Books on New Compton Street.

David Archer's Bookshop opened early in 1956 at 34 Greek Street, opposite the stage door of the Palace Theatre almost on the corner with Shaftsbury Avenue. Archer was a tall, thin man who held himself rigid as if he was afraid he might break. He was nervous, always moving, courteous, always trying to help, smiling, his large, deep-set eyes blinking behind large spectacles. He spoke with an impeccable upper-class accent, marred by a slight stutter. He had a withered arm that he disguised by always using it to carry a pile of books and magazines. Before the war he owned the Parton Bookshop, from which he ran the Parton Press, where he was the first to publish Herbert Read, Dylan Thomas, George Barker, David Gascoyne and W. S. Graham.

The shop cost £3,000 to open, a huge sum in those days. Much of it went on the fittings: Germano Facetti designed the shop façade on clean modern lines and, as the walls were covered in bookcases, he pasted portraits of poets, both historical and contemporary, chosen by himself and Archer, on the ceiling. The shop comprised a long rectangular room with new books in the front, in the middle a small specialized lending library containing many rare first editions, a coffee bar in the back and a gallery in the basement. The real reason for the bookshop was to act as a literary salon.

When Archer was out book-buying, the shop was manned by a series of impecunious poets and painters: George Barker, Robert Colquhoun, Dom Moraes or Tristram Hull, the editor of *Nimbus*. Not long after it opened, Archer appointed as manager Ralph Abercrombie, the son of the poet Lascelles Abercrombie. Henrietta Moraes ran the coffee bar. At Facetti's request, Archer's boyfriend, John Deakin, blew up a photograph of Henrietta to nine feet by seven and used it to fill the alcove at the back of the shop in the coffee bar. The coffee bar was very cheap, and as Henrietta bought all the tarts and cakes from Floris, the expensive patisserie on Brewer Street, it lost money on each sale. Christopher Logue described the shop in his memoirs: 'David's was open, fresh, friendly, with people standing about talking, trying to catch the eye of the black-haired sumptuous beauty, whose name I soon learned was Henrietta.'[1] Dom Moraes: 'She discharged her duties with a sort of ferocious efficiency, and was constantly surrounded by young writers, with whom she carried on bantering flirtations.'[2]

Archer was still wealthy enough not to be interested in making money; he just wanted a salon. Bernard Kops: 'David owned a third of Wiltshire, and could not wait to give it away.'[3] Anyone rash enough to attempt to buy a book was firmly discouraged and asked 'Are you sure you want to buy it? I'm sure Foyles or Better Books would have it' and given directions. Even at the height of the Angry Young Men sensation, when customers came in looking for Colin Wilson's *Outsider*, he would direct them to the competition, despite having sixty copies in stock and Wilson himself probably sitting in the back of the shop willing to sign them. Colin MacInnes, Michael Hastings, Robert Nye, Christopher Logue with his hat, cloak and stick, looking every inch the poet, all came in to pass the time of day and drink endless free cups of coffee, but they never bought a book. The poet Dannie Abse worked as a doctor and had his surgery in Soho, so he was a frequent visitor. As Dom Moraes said: 'Every young writer in town used it as a club, drank free coffee there and borrowed the books.'

George Barker was there most days, whether he was working there or

not. Barker was once championed by T. S. Eliot and published by Faber, but is now largely forgotten. He was violent towards women, particularly when he was taking benzedrine, and could not get over the fact that Elizabeth Smart, the mother of four of his fourteen or fifteen children, was a more celebrated writer than he.[4] Her *By Grand Central Station I Sat Down and Wept*, the brilliant account of their disastrous love affair, is now taught in schools as a twentieth-century classic. He forbade his next girlfriend, Betty Cass, to write, work or drive. He believed that society should look after the poet, which in his case meant that even after fathering his fifth child he was still living at home, being looked after by his mother, leaving his wives and children to look after themselves. Barker wore an American leather jacket and a peaked cap to hide his baldness. He affected absurd pseudo-American mannerisms of speech: 'Get that, baby!', 'Silly baby', picked up during his time in New York with Smart, which he felt made him appear something of a hipster but in fact made his friends laugh at him behind his back. When he left the bar the Roberts would mock him mercilessly: 'Silly baby, Colquhoun!', 'Silly child, MacBryde!' It infuriated Francis Bacon to be referred to as 'baby' but there were some who put up with him.[5]

For weeks, to their considerable inconvenience, nobody was able to enter the lavatory because Bernard Kops, then penniless and newly married, had locked himself up in it to write a play. From time to time he emerged from his small room and drank some coffee, the caffeine only serving to further increase his exhilaration. Normally very talkative, he now became increasingly over-stimulated, his skin flushed and his blue eyes bulging with excitement. And for due cause, because the play, *The Hamlet of Stepney Green*, was to bring him considerable success and launch his career. Kops was first introduced to Archer by Dom Moraes, who, though he had not read a word of Kops's work, praised him as a genius to Archer. Kops: 'I was not embarrassed, and did not contradict him. I asked David about his ability to recognize talent. "Dear boy, I know absolutely nothing about poetry. I just have a certain instinct for certain people."'

Just before lunchtime Archer would raid the till and head across the street to the Coach and Horses. The shop was losing so much money that in the end Archer agreed to let Abercrombie buy a cash box for the takings to which he would not have the key. One day Henrietta returned to the shop after closing to get something she had forgotten and found Archer jumping up and down in rage on the cash box in an attempt to burst it open. He looked at her, embarrassed and murmured: 'Silly old me.' Most of his money went on Deakin, who lived off of him shamelessly, but any

hungry poet or writer would be the beneficiary of his largesse, which, in order not to cause untoward embarrassment, came in the form of a ten-shilling note folded into a matchbox and slipped unobtrusively into the young man's pocket, though few of the recipients were likely to feel any awkwardness at relieving him of money. In some cases the matches were probably discarded without the treasure ever being found. It was in this way that he funded Allen Ginsberg and Gregory Corso when they found themselves penniless on Soho's streets in 1958, self-consciously explaining it was 'for poetry's sake'.

It soon became obvious that Ralph Abernathy needed an assistant so Archer employed a young painter who had recently been discharged from a mental hospital. The first day the painter attacked the shelves with a feather duster, dusting indiscriminately. The second day he had dusted all the books so he began to dust Archer himself. Archer, characteristically, fled to the Coach and Horses. The painter began to dust Ralph, then Henrietta and finally Dom Moraes. One by one they followed Archer across the street, where they peered anxiously through the pub window at the shop. They saw potential customers enter and then quickly exit, pursued by the painter with his duster. Ralph telephoned the hospital and that evening a van pulled up outside the shop, filled with men in white coats, who took him away.[6]

The bookshop played a role in many people's lives. It was there that Dan Farson met Colin Wilson, which helped launch his career as a television presenter. Farson joined Associated Rediffusion and, in September 1956, Wilson was the first person he interviewed. This was well received and led to an interview with Cecil Beaton and then one with Paul Getty. John Deakin, who had befriended Farson, was outraged that Farson should be successful and did his best to undermine his show, feeding Caitlin Thomas so many drinks before her appearance that she had to be taken off the air, though these days her drunken performance would be regarded as good lively television. As Farson said: 'Deakin is almost physically sick at the thought of someone's success.' Deakin worked hard to build disunity between friends, spreading false rumours and undermining friendships with pernicious innuendo and gossip. Farson: 'He was treacherous to his friends, and possessed a skill in playing one off against the other. Archer and myself were constant victims.'[7]

It was altogether appropriate then, that when Lucian Freud's portrait of him was reproduced in the *Daily Telegraph* it was under the heading: 'Studies of Compelling Nastiness.'

Though Deakin's photographs were well known from his work in *Vogue*,

he did not have an exhibition until David Archer showed his pictures at the bookshop. The opening of the *John Deakin's Paris* show was in the afternoon of 7 July 1956, in the Parton Gallery, named by Archer to commemorate his previous bookshop and press. There were two exhibitions, two months apart, the first of Paris and the second of *John Deakin's Rome*. The first was hung by Deakin's friend Bruce Bernard – Jeffrey's brother – fifty-five pictures, many of them of graffiti or street people. After Deakin's death in 1972, Bruce Bernard retrieved several cardboard boxes of negatives and tatty prints from under Deakin's bed at his flat in Berwick Street. It is on these, and the archive of commissioned prints still owned by *Vogue* magazine, who employed him for fashion and portrait shoots from 1947 until 1954, that his reputation rests.

His *Vogue* years were marred by frequent arguments, lost, stolen and missing equipment, models in tears and enormous bar bills, but he did some extraordinary work. He had a confrontational approach that many sitters found highly uncomfortable, but no-one could deny that his deep black shadows, his tightly framed head shots and raw, unforgiving portraits were among the best being produced at that time. There was no flattery of his often famous subjects; indeed, the results sometimes took on the quality of police mug shots. He photographed Humphrey Bogart, Gina Lollobrigida, John Huston, Dylan Thomas, W. H. Auden, Yves Montand, as well as all the artists and writers of his Soho circle. Deakin wrote:

> Being fatally drawn to the human race, what I want to do when I photograph it is to make a revelation about it. So my sitters turn into my victims. But I would like to add that it is only those with a daemon, however small and of whatever kind, whose faces lend themselves to be victimised at all. And the only complaints I have ever had from my victims have been from the bad ones, the vainies, the meanies.[8]

His pictures of the Soho scene are the best record there is of the habitués of the French pub, the Colony Room and the Soho streets and clubs. He took dozens of pictures of Bacon, in Soho, in his studio, in the *Vogue* studio, in Limehouse and even on the Orient Express. In *Eight Portraits* he described Bacon: 'He's an odd one, wonderfully tender and generous by nature, yet with curious streaks of cruelty, especially to his friends. I think in this portrait I managed to catch something of the fear which must underlie these contradictions in his character.' Before the war Deakin had some small success as a painter, but a show in the fifties at the Mayor Gallery drew nothing but contempt, even from his friends.

In *Not a Normal Man*, Dan Farson reports a conversation between Deakin and Archer:

With my usual naivety I could not understand why Archer should pay the rent until Deakin made a casual reference to the previous night when Archer fumbled in a chest of drawers. 'What are you doing?' Deakin demanded. 'I'm looking for my favourite whip' Archer had explained. 'Oh for God's sake!' 'You're not supposed to shout at me,' Archer protested. 'I'm supposed to shout at you.'[9]

One afternoon in 1963 at the French pub, Henrietta Moraes was drinking with Francis Bacon, Deakin and some other friends. Francis told her: 'I'm thinking of painting some of my friends and I'd like to do you, but I can really only work from photographs, so if it's OK, Deakin will come round to your house and take them. I'll tell him what I want. You are beautiful, darling, and you always will be, you mustn't worry about that.'[10]

A few days later Deakin presented himself at 9 Apollo Place in Chelsea, the house that Johnny Minton had bequeathed to Henrietta, and after a few drinks they moved to the bedroom, where he said: 'he wants them naked and you lying on the bed and he's told me the exact positions you must get into.' Though she knew he had no interest in women, she was still somewhat shy about stripping off in front of him, and after undressing sat on the edge of the bed with her arms and legs crossed. 'For God's sake, sweetie,' he exclaimed. 'That's not exactly inspiring. I mean, he's not into the Pietà phase.' He explained that Francis wanted her on her back, arms and legs thrown open wide. Deakin at once began shooting pictures of her sex. Henrietta was concerned and told him: 'Deakin, I know you've got it wrong. Francis can't possibly want hundreds of shots of these most private parts in close-up',[11] but Deakin insisted that this was the pose that Francis wanted so she had a couple more drinks and then let him continue.

When she next saw Francis he was irritated with Deakin. The poses had been correct except he wanted them all shot with her head in the foreground. Would she do them again? Francis was an old friend and she had spent countless hours in his company, enjoying champagne and oysters at Wheeler's at his expense, drinking with him at the Gargoyle, the Colony and the French. Of course she was happy to repeat the performance. A week later she came across Deakin in a Soho drinking club, selling the explicit photographs of her spread-eagled naked for ten shillings each to sailors. He was caught red-handed and even managed a sheepish grin. He bought her several drinks.[12]

In April 1972, after a supposedly successful operation for early cancer, Deakin was intending to go on a recuperative holiday to the Greek island of Poros, paid for by Bacon, where he was to meet up with Dan Farson. Farson flew there from Romania, where he was researching a book on his great-uncle Bram Stoker, author of *Dracula*, but after waiting three days in Poros he decided that Deakin was not going to arrive so he flew back to London. When he walked into the Colony Room, Muriel greeted him cheerfully with 'Buried him this morning, dear!'[13] With one lung missing, he could not find any airline to take him, so Deakin had spent a week in Brighton, where he ill-advisedly went on a heavy drinking tour of the local pubs with an old friend. At the hospital he had given Francis Bacon as his next of kin so poor Bacon had the unenviable task of identifying the body. He told Farson:

> It was the last dirty trick he played on me... They lifted up the sheet and there he was, his trap shut for the first time in his life.
>
> 'Is that Mister Deakin?' they asked.
>
> 'It most certainly is,' I said.[14]

As next of kin he was liable for the funeral costs, but when he explained he was not a relation, the coroner told him that Deakin had thousands of pounds in his bank account. The endless charade of biting coins, or holding notes up the light as if he had never seen one before, and the continuous protestations that he was broke were all an elaborate lie.[15]

One of the visitors who made a close critical study of Deakin's 1956 show of Paris photographs at Archer's Bookshop was the photographer Ida Kar, who was also documenting Soho's bohemia. Ida Karamian arrived in London with her husband Victor Musgrave in 1945 from the Old Town of Cairo, where they had lived in the beautiful seventeenth-century Darb el Labana artists' colony. Ida was born in 1908 in Tambov in Russia, and grew up in Iran until her parents moved to Egypt when she was thirteen. She moved to Paris in 1928 to study and became part of the avant-garde of the Left Bank. It was here she discovered photography, but not until she had first trained as a singer. It was only when she damaged her voice that she considered photography as a career.

Victor Musgrave was twelve years younger than Ida, a tall, thin man, habitually dressed in a black corduroy suit and a blue sweater. He changed to a white sweater for evening wear. Colin MacInnes described him as having 'a mild, quizzical, amiably insinuating face with two candid, limpid and dispassionate brown eyes – in which one could sometimes detect, however,

a penetrating, steely glint'. He was a poet, painter and writer, and during the war had published and edited *Contact* magazine. In Cairo he exhibited in Surrealist exhibitions in 1944 and 1945. He was an early member of the Barrow Poets and won the first prize in the André Deutsch Poetry Award in 1953, but his greatest love was art.[16]

They settled first in Devonshire Close, a small mews off Devonshire Street close to Regent's Park, but it was not until they moved to Litchfield Street, between Upper Saint Martin's Lane and Charing Cross Road, that their life in London really began. This row of old houses between Covent Garden and Soho was home to a number of artists, and in number one the painter John Christoforou had opened a small ground-floor gallery to show his own work. Ida and Victor Musgrave moved in; Ida opened a photographic studio on an upper floor and Victor ran the gallery when Christoforou was in his studio painting. In 1953, Christoforou departed London for Paris and then the South of France, leaving 1 Litchfield Street to Musgrave and Kar. The building was condemned, the floor was missing floorboards, the stairs were unsafe, so Musgrave did the obvious thing – in December that year he opened Christoforou's old gallery as a commercial art space, naming it after his street address. He had no money, but his enthusiasm and his already large circle of friends enabled them to just about get by without starving, even though, throughout the gallery's ten-year history, Musgrave refused to show anything that people already knew. Stephen Spender introduced him to Francis Newton Souza, and his 1955 show at Gallery One marked a turning point for both the artist and the gallery; it was a sell-out, establishing the gallery on a much firmer footing.

Ida was already thirty-six when she married Musgrave; it was her second marriage. She had lived in the bohemian quarters of Alexandria, Cairo and Paris but it was Soho she loved. They drank at the Mandrake, where Victor won the 1947 chess championship, the French pub and the Colony Room, though Muriel was not very taken with Ida, who, like her, was a very forceful woman. Ida belonged in bohemia with her French Armenian accent, her loud, non-stop talk, her eccentric clothing and flamboyant attitude. According to her biographer, Val Williams, she did not read or take any interest in film or the theatre. Her friends and her photography were the only things that mattered. She knew all the market traders in Berwick Street fruit and vegetable market and was friends with a group of elderly French prostitutes, with whom she liked to speak French. Both she and Musgrave took a great interest in prostitutes: she spoke at meetings on their behalf, and Musgrave, in his nocturnal ramblings around Soho and Mayfair in the

days before the law drove them from the streets, appeared to know every one of them personally. Sometimes if the night was cold he would push a newspaper up under his trademark sweater to ward off the cold as he wandered aimlessly through the dark city streets. Victor and Ida's flat in Litchfield Street became a bohemian meeting place, always filled with people sleeping over or lodging – the 'Angry Young Men' writer Bill Hopkins lived there in 1952, before the gallery even opened. He told Val Williams that Ida 'filled the room with enormous warmth and laughter and mockery. She was a wonderful companion.'[17] He also told her of the problems Ida had in being a photographer, which in those days was not regarded as an art form. She couldn't sell her photographs. 'All she could do was peddle abrasive ideas that no-one wanted to hear anyway. A middle-aged, dumpy, foreign woman who was too self-opinionated by half.'[18]

Ida persevered with her work and throughout the early fifties she took the series of portraits of British artists upon which her reputation as a photographer rests. For her Christmas card of 1953 she used a picture of Jacob Epstein modelling a head of Bertrand Russell, and sent it to a number of artists, asking them to pose for her. Ivon Hitchens, Barbara Hepworth, Reg Butler, Victor Pasmore, Lynn Chadwick, Henry Moore, Patrick Heron and others responded favourably and she took a number of pictures that have become iconic of the period. She made a trip to Paris to photograph Giacometti, Marc Chagall, Le Corbusier and others, and in October 1954 her show *Forty Artists from Paris and London* opened at Gallery One. But her sitters were not celebrities; nor was she known as a portraitist; and the show received little in the way of reviews. But despite her lack of success as a photographer, Ida was always surrounded by friends. She sang operatic arias and Armenian folk songs in a deep powerful trained contralto as she cooked huge Eastern European meals of her own invention for their many guests.

Victor and Ida had an open marriage and kept separate rooms, which enabled their various lovers to live with them. Sex was a subject that interested them both greatly, and was the usual subject of conversation when Ida was getting to know a sitter before taking their portrait. Val Williams: 'She was autocratic and demanding, but derived no pleasure from manipulating or scandalizing.' Victor and Ida's love life did scandalize some people but in Soho no-one was concerned; they were often doing the same things themselves.

In March 1956, Victor moved Gallery One to a large corner building at 20 D'Arblay Street, in the middle of Soho, that he found through a prostitute who was being evicted from the building. Bill Hopkins had left to travel

in Europe so he did not move with them. His place as lodger was taken in D'Arblay Street by Colin MacInnes. Ida had three rooms on the top floor which she made into a bedroom, sitting room and photographic studio and she converted one of the basement rooms into a darkroom. As before, lovers, lodgers and friends became all mixed up together in the sleeping arrangements as those with not enough money to eat stayed to eat, and those with nowhere to stay stayed over, lovers came and went and lodgers brought in their own companions. Victor managed to find backers for the gallery but money remained a problem.

Shortly after the move, Victor and Ida had the good fortune to meet John Kasmin, who later opened one of the most significant London galleries of the sixties. He had just arrived back in Britain after a long stay in New Zealand. He had quickly settled into the Soho lifestyle, hanging out at David Archer's bookshop and drinking at the Caves de France, the Colony Room and the French pub. He enjoyed visiting Gallery One, particularly in the afternoons, when Ida would have a tea party going and there were many interesting people to meet. He told Val Williams: 'I thought this looked like the perfect lodge for me to nest in.'[19] Kasmin had very little money, and Victor couldn't afford an assistant, but Kasmin, nonetheless, quickly became part of the household. He worked as the gallery assistant and at the same time took over Ida's career, acting as her business adviser. He arranged for the *Observer* newspaper and the monthly *Tatler* to use her pictures of London life on a regular basis and got her other photojournalist jobs. He also arranged for her to sell prints of her photographs, providing another income for the household. It was not easy for Kasmin to work for Ida, but it was good training for dealing with difficult artists in his future career as a gallery owner. Ida cared little who her sitters were and often, as in the case of T. S. Eliot, whom she ordered around in a most autocratic way, had no idea what they did. Kasmin was often embarrassed, and he told Val Williams that after they left the shoot 'We would have a terrible shouting match in the street – she had this tremendous, strong, hooting voice.'[20]

As the result of Kasmin's efforts, in 1958 Bryan Robertson offered Ida a show at the Whitechapel Gallery, but first he gave her letters of introduction to enable her to take more portraits of artists to round off the series. The exhibition opened on 22 March 1960 and included 114 works, mostly artists and writers, some of which were blown up to enormous size, sometimes four by five feet. The show received good reviews, but mostly they concentrated on the discussion of whether or not photography was an art form. Ida had great expectations of the show, but although it made her better known, nothing

really changed, and it was, in fact, the pinnacle of her career. However, the sixties brought a new appreciation of photography to Britain and by the middle of the decade her work began to be appreciated: the V&A bought sixteen large prints and the University of Texas bought 100, but by this time she was showing signs of psychological disturbance. She and Victor Musgrave had effectively been living apart for many years but she did not recognize this fact. She told a reporter: 'We are not separated. We have taken separate houses. We started in the same bed, then we had separate beds. Then separate rooms, then separate floors, now different houses.'[21]

In April 1961, Musgrave had moved Gallery One to more sumptuous premises at 16 North Audley Street in Mayfair. However, he still ran the most avant-garde space in London. Among his more memorable shows was his 23 October 1962 *Festival of Misfits* featuring Fluxus artists Robert Filliou, Dick Higgins, Alison Knowles, Arthur Köpcke, Gustav Metzger, Robin Page, Daniel Spoerri and finally Ben Vautier, who lived exposed to the public in the gallery window for two weeks. Victor Musgrave had a very specific vision and his was the first British space to give shows to Enrico Baj, Jean Dubuffet, Henri Michaux, Robert Filliou, Yves Klein, Dieter Roth and Nam June Paik. He also discovered UK artists such as Gillian Ayres, Peter King, Bruce Lacey, David Oxtoby and Bridget Riley.

His meeting with Bridget Riley was a fortuitous accident. She had studied at Goldsmiths from 1949 to 1952, followed by three years at the Royal College of Art, but had not had much luck in selling her work. She was thirty years old, and lived and painted in one small room in South Kensington, heated by a small paraffin stove. One day in late autumn, she was on her way home from her day job as a draftsman at the J. Walter Thompson advertising agency when a sudden storm blew up. She sheltered in the doorway of a gallery in North Audley Street and, as she glanced in the window, she became aware of a man beckoning to her. 'Why don't you come in and look properly?' he asked. She later recalled: 'I gave him a very stiff review of what I saw. I don't recall the work any more, and he said, "Well, what makes you so sure, and what have you got there?" I undid this bundle, and I had some of my black-and-white gouaches in it.'[22]

Her first show at Gallery One, called *Shadowplay*, opened in May 1962. Just one painting sold, but Musgrave believed in her and her 1963 show sold better and attracted more reviews. By 1965 her work was on the cover of the catalogue of the New York Museum of Modern Art's now legendary exhibition, *The Responsive Eye*. In 1968 she became the first woman to win the international prize for painting at the Venice Biennale. By then Gallery One

was closed. After a decade promoting the work of others, Musgrave decided to devote more time to his own poetry and closed the doors in October 1963, emerging occasionally for specific projects such as co-producing Yoko Ono's *Bottoms* film. His other great interest was so-called 'Outsider Art', or *Art Brut*, and beginning in 1981 he and his second partner, Monika Kinley, assembled an enormous collection of work by psychiatric patients and prisoners which is now housed in the Tate. Ida Kar died on Christmas Eve, 1974; Victor Musgrave died ten years later.

David Archer's bookshop did not last long. He literally gave all his money away, and when he was broke his so-called friends all drifted away. At first he worked for a rival bookstore, telling them: 'You don't have to pay me a lot of money.' There, some of his remaining friends visited – John Minton and the Roberts – and they would go off for noisy lunches, but he sometimes attempted to pay and of course his cheques bounced. He was next to be seen serving in the lampshade department of Selfridges, where his plummy upper-class accent contrasted strongly with the accents of his superiors. By then he was living in a dingy basement off the Edgware Road, reading by candlelight because the electricity had been cut off. His fair-weather friends like Deakin had abandoned him, having sponged off him for decades. When asked if he knew where Archer was living, Deakin told Dan Farson: 'I do not know and I do not care.'[23] He repeated his mean-spirited view to Marilyn Thorold: 'He can die in the gutter for all I care.' Archer could not pay his rent and finished up in a Rowton House, a homeless men's hostel in the East End. This was too much for him to bear and after writing thank you letters to the few remaining friends who had offered him help and kindness he killed himself with an overdose of aspirin. He left £1 10s 0d. At one point his bank had refused to loan him even 7s 6d for food.

He was buried in the family plot at Castle Eaton in Wiltshire, which caused a mention in the parish magazine. This was seen by the governor of a school that had been endowed by Archer's grandfather. The school was closing, leaving a substantial sum of money, and the governor wrote to Marilyn Thorold, one of Archer's remaining benefactors: 'We had been trying to contact him for some time wondering if he could make some use of this considerable sum of money himself.'[24] It was estimated that he gave away about £80,000 in total, most of it to impoverished friends or parasites like Deakin.

7 Angry Young Men

**London was a wonderful and bewitching city for me.
On odd visits earlier I'd just sat in pubs, certain that at
any moment something marvellous would happen that
would change my whole life.**

JOHN BRAINE[1]

Despite being largely a media construct, the Angry Young Men (AYM) found a natural habitat in David Archer's bookshop, and also in nearby Better Books on the Charing Cross Road. The Angry Young Men were a loose-knit group of writers who had little in common except their youth: the phrase was first used in association with John Osborne's *Look Back in Anger* but was quickly applied to Colin Wilson, whose *The Outsider* was published in the same week. The press always likes a label and soon Kingsley Amis, Michael Hastings, John Wain and John Braine read in the papers that they, too, were Angry Young Men as Amis and Braine, in particular, had written novels that identified this new restless spirit.

Kingsley Amis's *Lucky Jim* was published on 25 January 1954 and ran to twenty impressions in four years as well as being translated into nine languages. It became one of the most successful first novels in the English language. The book's hero, Jim Dixon, did well as a scholarship boy in the new post-war welfare state and the book, essentially, dealt with the breakdown of the English class system as a new generation were educated to a level beyond their traditional position in society. As Amis put it, Jimmy Dixon's aim in life is to have the privileges of the old ruling class without any of the responsibilities. Walter Allen, in his famous review in the *New Statesman* said:

> A new hero has risen among us... he is consciously, even conscientiously,
> graceless. His face, when not deadpan, is set in a snarl of exasperation.
> He has one skin too few, but his is not the sensitiveness of the young man
> in earlier twentieth-century fiction: it is the phoney to which his nerve ends

are tremblingly exposed, and at the least suspicion of the phoney, he goes tough.[2]

John Braine came to London after giving up a steady job in a Yorkshire library to try his luck as a freelance writer. His parents thought that he had gone out of his head. Braine:

> I had £150 saved up and I took a room in Kensington. In that land of the bedsitter and the old men and women who wander up and down the high street muttering to themselves... I learned... what it was like to be lonely, to come home to a solitary meal of a boiled egg and a cup of coffee made over a gas ring.[3]

The writing did not come easily and he has described how frightening it was to close the door to his bedsitter and realize that he had nothing he wanted to write about.

In the event he did most of his writing in a sanatorium suffering from tuberculosis, and by the time he left hospital, in 1953, he had finished the first draft of *Room at the Top*. Despite his being taken for an angry young man of the mid-fifties, the novel was set in 1946, a decade earlier. He told Kenneth Allsop: 'Joe Lampton isn't meant to be of this period... to some extent Joe's ambitions to further himself socially are a reaction to the extreme austerity of the immediately postwar years.'[4] However, the character of Joe Lampton struck a chord with the reading public; Braine had, as they said in the sixties, 'caught the zeitgeist'.

John Osborne was the first AYM. In August 1955, lying on the deck of his houseboat on the Thames, he read in *The Stage* that a new company, the English Stage Company, had been formed to produce new plays by new writers. He sent a copy of *Look Back in Anger* off to the artistic director, George Devine, and almost forgot about it, not expecting a reply for weeks or months. Within days the ESC contacted him, offering him £25 for an option on the play and asking for a meeting. It was arranged for Devine to visit him on the houseboat but as the time approached for Devine's arrival there was no sign of him. Osborne had tried to explain that the tides in the basin made it impossible for anyone to come aboard at certain hours of the day but either he had not made himself clear or Devine had not understood. Osborne:

> I put on a blazer I'd bought in Corby and a pair of grey flannels and a clubbish-looking tie. The tide rose and the barge bobbed out of access. After two hours,

> as I was about to take off my Loamshire wardrobe, George appeared through the trees from the river, rowing himself in a small boat.

Devine was wildly enthusiastic about his play and defended it from the opprobrium of the establishment theatre critics.[5]

The English Stage Company opened its doors to the public at the Royal Court Theatre, Sloane Square, on 2 April 1956. Its third production – following after Arthur Miller's *The Crucible* – was John Osborne's *Look Back in Anger*, which opened on 8 May 1956, directed by Tony Richardson. The reviews were, in the main, bad. The *Times* grumbled that Jimmy Porter was 'a thoroughly cross young man, caught in an emotional situation where crossness avails nothing'[6], but business improved enormously after the Royal Court's publicist, George Fearon, coined the phrase 'Angry Young Men', and the press jumped on the bandwagon. The first use of the term in print was as the title of an interview with John Osborne by Thomas Wiseman in the *Evening Standard* of 7 July 1956, two months after *Look Back in Anger* opened. Wiseman liked the play: 'I, however, think highly of Mr. Osborne's talent. I only hope he never stops being angry.' Before that the houses were appalling. Perhaps the best review came from Kenneth Tynan in the *Observer*:

> Look Back in Anger presents post-war youth as it really is... To have done this at all would be a signal achievement; to have done it with a first play is a minor miracle. All the qualities are there. Qualities one had despaired of ever seeing on the stage – the drift towards anarchy, the instinctive leftishness, the automatic rejection of 'official' attitudes, the surrealist sense of humour... the casual promiscuity, the sense of lacking a crusade worth fighting for... It is the best young play of its decade.[7]

What really caused all the publicity and success was BBC television, which, in attempting to deal with the Angry Young Men phenomenon, televised a 20-minute excerpt from the play on 16 October, with an introduction by Lord Harewood... By then the play had been replaced at the Royal Court by *The Good Woman of Setzuan*, but the ESC was able to quickly transfer *Look Back in Anger* to the Lyric, Hammersmith. Michael Halifax, stage director of the Royal Court, told Irving Wardle: 'After the TV extract, all these people started arriving. People you never see in theatres. Young people gazing around wondering where to go and what the rules were. A completely new audience: just what we were trying to find.'[8] A month later, the entire play was screened by Granada television, ensuring guaranteed success and completely vindicating George Devine's faith in his discovery in the face of a slow box office and a

lukewarm reception from most of the critics – who all later claimed to have loved it from the start.[9]

The speech that made George Devine stage the play was in the last act. Jimmy Porter: 'There aren't any good, brave causes left. If the big bang does come, and we all get killed off, it won't be in aid of the old-fashioned, grand design. It'll just be for the Brave "New-nothing-very-much-thank-you..."' It was the first articulation of a questioning new attitude by the new, post-war generation.[10]

Kenneth Allsop gave us a description of John Osborne in 1958:

tall and slender with wavy hair and a feminine, delicately horsy face which is given a satanic edge by an amused, malicious mouth. He dresses in a somewhat démodé foppish manner (hound's-tooth check 'sports' jacket and paisley scarf in open neck white shirt) which suggests the pink clean-limbed character who strides on at the start of British drama and cries: 'Who's for tennis?'[11]

Though hardly a bohemian, Osborne had an unconventional sense of humour. In 1951, when the parents of Osborne's first wife, Pamela Lane, objected to the marriage they went as far as to recruit her friend from drama college days, Lynne Reid-Banks, to attempt to persuade Pamela that Osborne was in fact gay. There was no truth in the accusation; Osborne's sometimes camp manner was designed to shock, not to communicate a sexual prefer-ence. He got his own back on Reid-Banks years later when her novel *The L-Shaped Room* had made her famous and he was a successful playwright. Reid-Banks gave a house party to which he was invited and, in the course of the evening, he offered her a cream cheese and smoked salmon sandwich, which she accepted. He had gone to some considerable trouble to insert a used condom into the sandwich and Osborne remembered with delight the result when she bit into it: 'The unbelieving repulsion on her face, the prig struck by lightning, was fixed forever with me.'[12]

Christmas Day, 1954, was overcast and gloomy. It barely got light at all. In a bedsitter in South London, a tall, thin 23-year-old man with tousled hair and pale blue eyes sat on his bed with an eiderdown wrapped around his feet to keep out the penetrating cold. He wore thick horn-rimmed spectacles and a roll-neck sweater. His girlfriend had returned to her parents for Christmas but he couldn't afford the train fare to Leicester to see his own family. He had eaten a Christmas meal of tinned tomatoes and fried bacon and began leafing through his journal, glancing at his notes. It occurred to him that they were

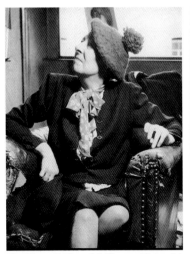

Nina Hamnett, Fitzrovia's 'Queen of Bohemia', photographed by David C. Hermges c.1945 at home at 31 Howland Street.

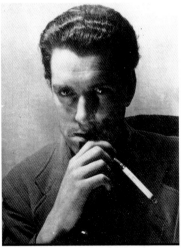

Julian MacLaren-Ross in January 1956 demonstrating the correct way to smoke a Royalty extra-large gold-tipped cigarette.

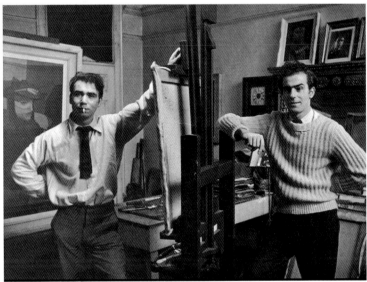

Painters Robert MacBryde, left, and Robert Colquhoun, right, in their Kensington studio c.1945. Colquhoun's life work was vandalized by thieves just before his restrospective at the Whitechapel Gallery.

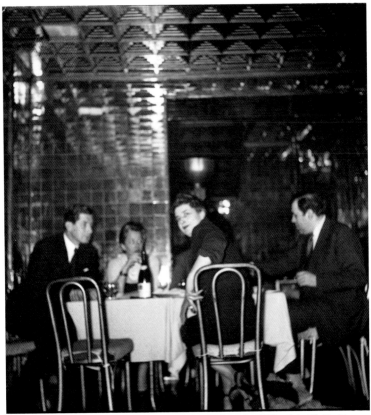

The Gargoyle Club on Dean Street, showing Matisse's mirrored wall tiles. Art critic David Sylvester is seated on the far right and the painter Elinor Bellingham-Smith is second from the right, looking at the camera.

Bringing the Mississippi Delta to a Soho pub: George Melly in full flight with Mick Mulligan's Magnolia Jazz Band, c. 1949.

Ralph Rumney, the founder member of the Situationist International, in July 1957. He joined as a representative of the London Psychogeographical Committee, of which he was the only member, but failed in his attempt to introduce the British 'Brutalist' architects to Situationist architectural values.

The term 'Angry Young Men' was first used in conjunction with John Osborne's *Look Back in Anger*, launched at the Royal Court in May 1956. Osborne was photographed a few months later on the houseboat where George Devine first told him he wanted to put on the play.

On the publication of his first novel, *Room at the Top*, the press quickly added novelist John Braine to their list of Angry Young Men, even though it was set in 1946. Here he looks suitably angry.

Twenty-four-year-old Colin Wilson preparing coffee in his famously grubby kitchen at 24 Chepstow Villas in 1956. *The Outsider* made him famous overnight.

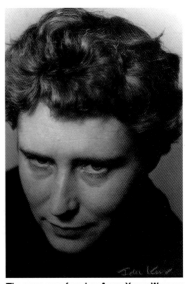

The press even found an Angry Young Woman: Doris Lessing was photographed for *Vogue* in the late fifties by Ida Kar.

Kingsley Amis celebrating the success of *Lucky Jim* in the days before his anger turned to grumpiness.

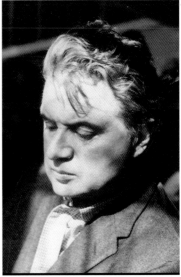

Francis Bacon photographed in the late fifties/early sixties by his friend and biographer Daniel Farson.

Frank Auerbach photographed by Jorge ('J. S.') Lewinski in 1965: a core member of what R. B. Kitaj called the 'School of London'. The other members were Kitaj himself, Lucian Freud, Michael Ayrton and Francis Bacon.

Colin MacInnes, author of *Absolute Beginners*, photographed by Ida Kar in 1960. MacInnes was Kar's lodger at 20 D'Arblay Street, Soho, in the late fifties and a good friend.

Pauline Boty, at home surrounded by pop memorabilia, in July 1963. Were it not for her untimely death in 1966 she would be regarded today as the foremost British pop artist.

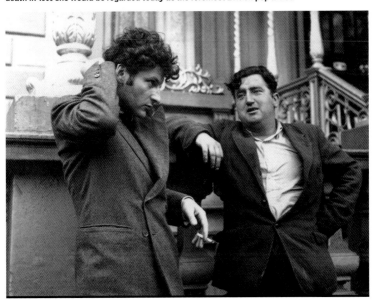

Lucian Freud (left) photographed in Dublin with Irish writer Brendan Behan in August 1952 by Daniel Farson for *Picture Post*.

William Burroughs at the Rushmore Hotel in Earl's Court in 1964 at the time of the publication of *Nova Express*. Burroughs lived in London for more than ten years.

Alexander Trocchi plotting the 'invisible insurrection of a million minds' at his flat in St Stephen's Gardens, Notting Hill, 1965.

all on one theme. 'It struck me that I was in the position of so many of my favourite characters in fiction: Dostoevsky's Raskolnikov, Rilke's Malte Laurids Brigge, the young writer from Hamsun's *Hunger*: alone in my room, feeling totally cut off from the rest of society.' Suddenly, he saw that he had the makings of a book: 'I turned to the back of the journal and wrote at the head of the page: "Notes for a book *The Outsider in Literature*".' Inspired he began to rapidly scribble notes, and in little more than an hour he had outlined chapters on Sartre, Camus, Hemingway, Hermann Hesse, Dostoevsky, Tolstoy, Blake, Ramakrishna, Gurdjieff and others. 'It seemed one of the most satisfying Christmas days I'd ever spent.'[13]

Colin Wilson moved to London from Leicester in 1951 with his new wife Betty. He was twenty and she was pregnant. London landladies in those days were notorious in their prejudices: signs on boarding house windows read 'No Dogs, No Blacks, No Irish, No Children.' After living in four dingy rooming houses in eighteen months, Betty and baby Roderick returned to Leicester in January 1953. It was the end of the marriage.[14]

Wilson decided to save rent by buying a tent and sleeping outdoors. His friend Jonathan Abraham gave him a bicycle and suggested that he buy a waterproof sleeping bag that would cover an ordinary kapok sleeping-bag so that it wouldn't matter if it rained. He bought a huge ex-paratrooper rucksack from one of the many war surplus shops that filled London at the time and a groundsheet. After a night on the edge of a golf course near the plastics factory where he worked he thought his tent was too conspicuous, so he relocated to Hampstead Heath. His job at the factory ended so he devoted his entire time to study and writing, spending the day in the British Museum reading room and his nights on the Heath. His evenings were a problem. The library closed at eight o'clock and there was nowhere he could go to spend a few hours in warmth and quiet until midnight, when he retired. 'I always felt exhausted and ill at ease as I cycled around London with my sleeping bags rolled up on the back; it was a strange sensation, having nowhere to go, nowhere to retire to at night, nowhere to spend the evening reading.'[15]

He cycled each morning to Chalk Farm where there was a busman's café on Haverstock Hill that did a breakfast of bread and dripping and a cup of tea for tuppence ha'penny, and from there he went to the British Museum. The cloakroom attendant made some fuss over the rucksack but nothing came of it except ill-feeling. When he told his friend Bill Hopkins that he was sleeping on the Heath and writing each day in the Museum he responded: 'That's the idea, Col. Build up the legend!' It was at the Museum he met Angus Wilson, author of *Hemlock and After*, who worked there. He encouraged his

namesake and offered to read his book when a draft was ready with an eye to suggesting a publisher. When Wilson ran short of cash he took a job at the Lyon's Corner House in Coventry Street but continued to sleep on the Heath to save money. Towards Christmas the weather made sleeping out impossible so he took a cheap room in New Cross. All this time he had been working on a novel, which was finally published as *Ritual in the Dark*. However, it was that Christmas that he had his epiphany, when *The Outsider* suddenly appeared to him as a separate book, rather than notes towards his fiction.[16]

In May 1956, Colin Wilson was living at 24 Chepstow Villas in Notting Hill with his girlfriend Joy. It was a two-room slum overlooking an overgrown garden. He lived on sausages, beer and chocolate biscuits. His sleeping bag had been exchanged for an inflatable green rubber mattress. The walls were lined with rows of secondhand books and the door had an Einstein formula and Egyptian hieroglyphics graffitied on it. Wilson never read newspapers, and did not own a television or listen to the radio. The normal political and social debate of society passed him by as he studied long-dead thinkers. However, knowing that the Sunday papers intended to review his book, Wilson went to the corner newsagent and bought the *Observer* and *Sunday Times* and hurried home without opening them:

> I gave Joy the *Sunday Times*, while I read the *Observer*. Philip Toynbee's review was splendid, comparing me to Sartre, and saying that, on the whole he preferred my style and method. Joy read aloud bits from Connolly's review in the *Times*; it was as good as Toynbee's. At this point someone from down-stairs came up to compliment me on my review in the *Evening News*.[17]

John Connell's review in the *News* was headed: 'A Major Writer – and he's only twenty-four'. The phone downstairs began to ring as friends began to call in their congratulations. Wilson was famous overnight. The first edition sold out on Monday. The *Sunday Times* offered him book review work at £40 a review: 'I gasped at the sum.' Radio and television producers called to ask if he was available for appearances. Reporters banged at the door at a rate of four a day.[18] His ubiquitous polo-neck sweater, corduroy trousers and brown leather sandals became a uniform for the young intellectuals of the period. Though Toynbee and Connolly later repudiated their views, the astonishing thing was that they all, without collaboration, were considerably impressed upon first reading the book. It was only later, with all the newspaper and radio attention surrounding Wilson and the Angry Young Men, that Toynbee and Connolly felt they should distance themselves from the media circus.

This was caused mostly by Wilson's frequent announcements of his own

talent. He told Kenneth Allsop that he began to write seriously when he left school at the age of sixteen because 'I hadn't the faintest doubt of my genius, and could see no good reason why I shouldn't become either the greatest writer or greatest scientist the world has ever known. Sometimes a feeling of my talent so overwhelmed me that it gave me a headache!'[19] This was an attitude that the English found intolerable.

Daniel Farson met Wilson at David Archer's bookshop on the Saturday the first review of *The Outsider* appeared in the *Evening News*. They got on well and Wilson invited him back to his flat at Chepstow Villas. Farson described the chaos, the graffiti, a 'pin-up' of Nietzsche, a table covered with a plastic cloth with sauce bottles, unwashed plates and chocolate biscuits. Wilson cooked on a small stained Primus stove, the sort you had to pump up first and carefully light with meths. Over this he would heat a dirty saucepan filled with week-old fat, into which he would dunk sausages. Farson: 'A parade of vague young girls came in and out. I visited this room constantly over the next few weeks, infected by his excitement, and amusement over his success.'[20] Farson took Wilson to see *Look Back in Anger* but he disliked it and in the middle of one of Jimmy Porter's tirades he leaned over and whispered to Farson: 'I'd give him a good clout.' Farson also brought Osborne and his wife, the actress Mary Ure, to a party at Wilson's where Wilson's criticism of the play reduced Ure to tears. However there was enough cheap drink for the party to be a success with everyone going suitably out of control.[21]

In interviews Wilson often talked in terms of the need for a strong leader and he and his followers were sometimes accused of neo-fascism, so he was jumped on when he mentioned that he had taken lunch with Sir Oswald Mosley and thought him a 'rather decent chap'. When questioned by a journalist about Mosley it turned out that there were many gaps in his wide reading. Kenneth Allsop:

> It emerged that Wilson had no knowledge whatsoever of the history of Mosley and the British Union of Fascists, and, even more amazing, nothing but the vaguest notion of the big political issues of the Thirties and Forties... I think it has often been his genuinely innocent ignorance of the complex, dangerous forces of publicity he has blunderingly stirred up which has been mistaken for arrogance and impudence.[22]

Angry Young Men was a good sobriquet; there were few women involved. Aside from Doris Lessing, who was regarded as an Angry Young Woman on the strength of her play, *Each His Own Wilderness,* appearing at the Royal Court, Shelagh Delaney was the only one to be recognized by the public.

Delaney was only nineteen when she wrote *A Taste of Honey*. At first she constructed it as a novel, but then realized that it would work better as a play. It was accepted by Joan Littlewood for the Theatre Workshop and opened at the Theatre Royal in Stratford East on 27 May 1958. It transferred to Wyndham's in the West End, where it enjoyed a long run, and to the Lyceum on Broadway. Set in the north of England it features a dissatisfied teenage girl who refuses to conform to her surroundings. Colin MacInnes hailed it as the first play to portray a black man and a homosexual young man as perfectly normal characters.

If it can be said that any benefit accrued to London from the rise of the Nazis then it was that they caused a group of young European Jews to flee to London to avoid persecution and death who, when they reached maturity, were to transform Britain's literary scene with a series of independent publishing houses: George Weidenfeld arrived in London in 1938 from Vienna; Peter Owen, whose original surname was Offenstadt, came from Nuremberg in 1933; Paul Hamlyn, born Paul Hamburger, was born in Berlin and moved to London with his family in 1933, Fred Warburg started Secker & Warburg, and André Deutsch came from Budapest and started his own imprint.

Tom Maschler came to London from Vienna with his parents at the age of six. After the war, he took a job with André Deutsch at five pounds a week and learned the trade. He moved to McGibbon & Kee and, inspired by all the publicity that the AYM were getting, decided to cash in with an anthology of their views. Called *Declaration* it was for the most part not very interesting. Most of the contributors did not see themselves as part of any movement and John Braine refused to contribute altogether. Doris Lessing recalled how Maschler became friends with them all. She wrote: 'Some of us gave him advice. Since he wanted to be a publisher, then it would be a good thing if he read some books. He should also try to read a newspaper a day...' He was the type of publisher, rather like Tambimuttu before him, who operated more from instinct, flair and publicity; who would get a feeling about a book by weighing the manuscript in their hands.[23]

Declaration was launched at the Pheasantry on King's Road. It had been originally intended to have the launch party at the Royal Court, but when they saw the book, the management refused on the grounds that John Osborne had insulted the Royal Family when he wrote: 'My objection to the Royalty symbol is that it is dead, it is a gold filling in a mouthful of decay.'[24] The party filled the huge club, mixing Labour politicians such as Aneurin Bevan and Michael Foot with the Royal Court set and actors such as Rod Steiger, though

Doris Lessing amusingly recalled the roar of the crowd being silenced by the icy, disapproving, aristocratic tones of a young woman, standing at the top of the stairs, who demanded of her escort: 'And who *are* all those furry little people?' The Chelsea Set did not yet mix with the working class as it would in the sixties; there was still shock value in the encounter.[25]

The press loved the Angries, particularly in the silly season when there was not much news. Doris Lessing wrote:

The AYM was entirely a media creation but no matter how many times its so-called members denied it, the newspapers would not let it die. Then the academics got hold of it until so many people had a vested interest it could not be allowed to die. It had to exist, too many people had written scholarly books and articles about it, there were too many reputations at stake.[26]

8 Pop Goes the Easel

Not a soul cares what your class is, or what your race is,
or what your income, or if you're a boy, or girl, or bent,
or versatile, or what you are – so long as you dig the scene...

COLIN MacINNES, *Absolute Beginners*[1]

Bernard Kops first ran into Colin MacInnes, the author of *Absolute Beginners* (1959), at the Colony Room. MacInnes was sucking a strange fruit that Kops didn't recognize. It was a passion fruit. MacInnes offered him a bite but Kops passed it back. 'It's so wrinkled,' he said.

'Yeah! Just like a black boy's balls,' MacInnes said, and then introduced himself.[2] He was the son of the novelist Angela Thirkell, his great-grandfather was the painter Edward Burne-Jones and other family members included Stanley Baldwin and Rudyard Kipling. It was a privileged background that he totally rejected. He was a homosexual, alcoholic anarchist who hated all forms of hypocrisy and called himself 'the best off-beat journalist in London'. He was not an Angry Young Man; rather he was a precursor of the youth counter-culture of the sixties; the first to write about rock 'n' roll, the youth scene, and, above all, the first to describe the lives of the newly arrived West Indian community in London. In 1948, Colin MacInnes was working as art critic for the *Observer* and living at 4 Regent's Park Terrace. At the Anglo-French Arts Centre in St John's Wood, he met a fellow art critic, the young David Sylvester, and shortly afterwards Sylvester rented his spare room to him for twenty-five shillings a week. They got on very well, but according to MacInnes's biographer, Tony Gould, MacInnes took a romantic, idealistic attitude towards Sylvester's Jewishness which Sylvester found very claustrophobic. It was this same attitude that MacInnes exhibited toward blacks, never really accepting them as fellow human beings.[3] MacInnes, like Francis Bacon, was a masochist. He basically liked to be raped by a black man, preferably a ponce. It was pain and humiliation he sought, not love, but it

was mostly conducted in such a way that MacInnes did not get too seriously hurt. Usually the active partner was paid and, more often than not, was West Indian rather than African. Bryan Robertson told Tony Gould: 'He could not, it seemed, have a sex relationship with an equal... He was by nature a warm, tetchy queen, but he would have hated such a description.'[4] He frequented the Paramount dance hall on Tottenham Court Road (the Cosmopolitan in *City of Spades*) and any cafés or pubs where West Indians gathered. He roamed the streets, stopping to chat with any black person he met as if he were the local vicar patrolling his parish.

He was memorable for his death-like pallor: pale eyes and lips and a chalk-white face as if all the blood had drained from his body. He was large, way over six feet tall, but always carefully dressed in the latest fashions. He was a complete outsider, described by Bernard and Erica Kops, the models for Mannie Katz and his wife Miriam in *Absolute Beginners*, as 'the most alone and lonely man we ever met'.[5] The publisher Thomas Neurath once described MacInnes to me as a 'large, threatening man, who could be charming but also came across as something of a thug to those who dealt with him'.[6]

In 1955, MacInnes was arrested on a drugs charge at a black East End gambling club. The arresting officers were CID, not the local police, and Colin was concerned to note that the West Indian who was interrogated before him returned in tears. 'Negroes do not often cry,' he wrote.[7] His apprehension proved well founded; the moment he entered the room he was chopped expertly on the back of the neck, knocking him to the floor, and when he refused to be fingerprinted they began to do him over properly. Arrogant as ever he told them: 'You've been watching too many American films', which miraculously did the trick and they stopped beating him.[8] It was only when he appeared in court that he found out they had all been arrested on drugs charges, falsified evidence in his case, and probably for many of the others present. Colin and one other were the only ones not to be convicted, though it cost him over £200 in legal fees, a huge amount of money those days.[9] Later he wished that he had had the courage to explain to the court that the police had framed him; instead his lawyers picked holes in the police evidence and got him acquitted. Years later, in 1966, MacInnes was the only white member of Defence, an organization set up to counter police harassment of the West Indian community in Notting Hill.

In 1956 he took a room above Victor Musgrave's Gallery One at 20 D'Arblay Street in Soho, though he retained his Regent's Park flat. In Soho he was in easy walking distance of places like the West Indian Myrtle Bank Club

on Berwick Street, where one could eat chicken and rice, and drink coffee and Coca-Cola until 4 a.m.. There was no licence for alcohol, but that did not mean you couldn't get it. It was there MacInnes met Terry Taylor,[10] who, according to Tony Gould, was interested in 'jazz, soft drugs and hustling'. Taylor lived in Soho and worked at the Wardour Street amusement arcade running the passport picture concession. There was no art involved in taking passport pictures, and Taylor, then in his early teens, had no interest in photography. However, one day MacInnes introduced him to the photographer Ida Kar, at Gallery One, on the ground floor below his flat. Ida Kar, born in 1908, was twice Taylor's age but they quickly hit it off together and within a week he had moved in with her and Victor Musgrave and was working as her photographic assistant. Shortly afterwards he became her lover, something that Musgrave had no objection to. For several years they lived as a ménage à trois, with Taylor learning about a whole new world of artists and poets, galleries and writers. Ida Kar encouraged him to paint and MacInnes presented him with a series of edifying books, intended to stimulate him to write. Musgrave and his assistant, Kasmin, showed him how the art world worked. Taylor wrote a novel, *Baron's Court, All Change*, but it was MacInnes who gained the most from the relationship because he based the photographer hero in *Absolute Beginners* on Taylor, and gave much of Taylor's experience as a ponce and hustler to his protagonist in *Mr Love and Justice*.[11]

After the Notting Hill race riots in August and September 1958, many show business people felt the need to use their influence to prevent such a thing ever occurring again. The Stars Campaign for International Friendship committee was set up, numbering among its members leading jazz players Johnny Dankworth and Cleo Laine, Chris Barber, Ken Colyer and Humphrey Lyttelton, and from the pop world Tommy Steele, Lonnie Donegan and Frankie Vaughan as well as Eric Hobsbawm from the *New Statesman* (who wrote his column and his jazz books under the name Francis Newton). Colin MacInnes had the richest contacts and, as he was experienced in raising money for his own uses, he soon built up a war chest. The committee published an unashamedly populist eight-page newsletter called *What the Stars Say* which looked like a celebrity glossy except that the stars were all talking about race relations. Colin took over the job of distributing it to the riot area, where it was most needed. Victor Musgrave persuaded Don Cammell, then a portrait painter, to drive them through Notting Hill in his Austin Seven and wait, with engine running as their 'get-away driver' as Colin and Victor pushed the newsletter through letter boxes. Musgrave told Tony Gould: 'Afterwards Colin

said to me that we two between us had prevented a second Notting Hill race riot – and said it in all seriousness.'[12]

It was because of actions such as this that MacInnes claimed to be very active in civil liberties for blacks, a kind of 'one man Council for Civil Liberties', but it came at a price; his attitude to blacks remained condescending and exploitative; he boasted that every afternoon he would go to Hyde Park and pick up a boy, usually but not always black, and take him back to his basement flat in Harrowby Street, off the Edgware Road. Though he sometimes went out in the evenings he usually slept after his sex session. His MO was to rise at 5 a.m. and write until about half past ten. After a nap and lunch, he returned to Hyde Park.[13] It was not just West Indians who felt that a friendship of equals with him was impossible. Michael Law described him as having 'anger, temper, petulance and exasperated violence' and being 'socially destructive with friends'.

But there was another side of MacInnes that was often overlooked. He was a sponge and a parasite at times, but he could equally be generous. Frank Norman remembered that, despite his success with *Fings Ain't Wot They Used T'Be*, his follow-up, *A Kayf Up West*, had flopped leaving him close to bankrupt. He wrote:

He sidled up to me one lunchtime in the French pub and tucked ten, unasked for, ten pound notes into the top pocket of my jacket. 'Just a little present,' he said. 'Don't hate me.' Before I could utter a word he fled and I didn't see him again for weeks.[14]

Even if he could not treat people as his equal, he dreamed of being able to do so. This was why he was so keen on jazz clubs and the world of the teenager; he thought that there he could overcome the class barriers and the problems of background. As his hero said about the jazz world in *Absolute Beginners*: 'You meet all kinds of cats, on absolutely equal terms, who can clue you up in all kinds of directions – in social directions, in culture directions, in sexual directions, and in racial directions.'[15] MacInnes would have loved to live like that.

In London in the late fifties the most interesting art being produced was by the painters of the so-called 'School of London', a sobriquet coined by R. B. Kitaj to describe the group which included himself, Francis Bacon, Lucian Freud, Frank Auerbach and Michael Ayrton. They were all of them great painters of London, though none of them except Ayrton was actually born there.

For Bacon, the fifties was not a happy time. It was the decade of his disastrous relationship with Peter Lacy, whom he met in 1952. Bacon was by then over forty but maintained that he had never fallen in love with anyone before meeting Lacy. Unfortunately Lacy's real interest was young boys, whereas Bacon was older than him so their relationship was never one of mutual attraction. Bacon:

> Of course, it was a most total disaster from the start. Being in love in that extreme way – being totally, physically obsessed by someone – is like having some dreadful disease. I wouldn't wish it on my worst enemy. He was marvelous-looking, you see. He had this extraordinary physique – even his calves were beautiful.[16]

Lacy was a worldly man, he had been a test pilot and had flown combat missions during the war. Bacon found him tremendous company, admired his piano-playing and enjoyed Lacy's endless flow of witticisms. Lacy was a bad drunk but because of the nature of the relationship – Bacon liked to be whipped and beaten up – Bacon obviously was not in a position to get him to temper his drinking, which got up to three bottles of whisky a day. Eventually Lacy moved to Tangier, where he fell in love with an Arab boy and became the piano player at Dean's Bar, one of William Burroughs's favourite gay bars. Bacon often visited him in Morocco but terrible arguments always ensued and on one occasion Lacy destroyed thirty of Bacon's paintings destined for a show at the Marlborough in New York.[17] They did not see each other again after Lacy found Bacon in bed with Lacy's Arab boyfriend.

In 1962, Bacon had a retrospective at the Tate which received rave reviews. When Daniel Farson walked into the Colony Room, having just returned from a trip to Paris and missed the opening, he found everyone drunk and some of them in tears. He assumed, incorrectly, this was in celebration of Bacon's success. Elinor Bellingham-Smith, wife of Rodrigo Moynihan, was sobbing and asked Farson if he'd heard the news.

'Yes,' Farson exclaimed. 'Isn't it wonderful?' Whereupon she slapped him across the face. Bacon beckoned to him and led him to the small lavatory at the back of the club and told him that he had received a pile of congratulatory telegrams that morning, but the last telegram he opened contained the news that Peter Lacy had died in Tangier the night before. Lacy's death marred what should have been the pinnacle of his achievement.

Throughout the fifties and sixties Bacon and Lucian Freud were as close as Braque and Picasso: they were the leading members of the School of London, they went gambling together and were both full-time Sohoites, frequenting

the French pub and the Colony Room. They sat for each other and over the years Bacon painted twenty-five portraits of Freud and no doubt destroyed far more. Their mutual friend John Richardson described them as being very different from each other in temperament, as well as in sexual orientation and in artistic style. He suggested that their friendship was based on their shared characteristics:

> Baudelairian dandyism (in intellect and manner as well as clothes); a quirkish and mordant wit; a keen ear for fine writing and an incisive but irreverent eye for fine painting; a rejection of middle class values in favour of very low and, on occasion very high life; and not least, a passion for big-time gambling.[18]

When their friendship broke up, it was unpleasant. It was largely to do with the appreciation of each other's work. Freud thought Bacon was resorting to gimmicks and easy solutions and Bacon thought Freud's latest work was dull and boring.

Lucian Freud was born on 8 December 1922 in Berlin, where his father, Ernst, was an architect. When Adolf Hitler became Chancellor in 1933, the Freud family, including Lucian's grandfather Sigmund Freud, Lucian's brother Clement and his aunt Anna, Sigmund Freud's daughter, recognized the danger and moved to London. Lucian attended Dartington Hall and Bryanston and studied art at the London Central School of Art and at Goldsmiths. By 1939, 17-year-old Lucian had had several drawings published in *Horizon* and was socializing with Stephen Spender, Cyril Connolly and Peter Watson, the leaders of what had passed for the avant-garde in wartime London. After a spell in the merchant marine, in Atlantic convoys, Lucian had his first show at the Lefevre Gallery in 1944.

Lucian Freud spent much of the late forties and early fifties in Paris, where he had patrons and was fêted by, among others, the legendary Marie-Laure de Noailles, who was famously the great-granddaughter of the Marquis de Sade. As Lucian was the grandson of Sigmund Freud, she invited him to accompany her to Vienna, where she wished to place a commemorative plaque on Freud's house. Notoriously manipulative, she arranged a meeting with a direct descendant of Baron Sacher-Masoch, after whom masochism was named. When the three of them got together she announced: 'Du bist Masoch, er ist Freud, und ich bin Sade', whereupon the Sacher-Masoch fled in terror.[19]

In the mid-fifties Freud returned to London and set himself up in

Paddington surrounded by the peeling façades of bomb-damaged, boarded-up buildings, their cheap bricks revealed where the Regency mortar had fallen away. Many of the buildings were unsafe, shattered by the vibrations from the Paddington Gun, part of London's anti-aircraft defences, which possibly did more damage itself to the surrounding buildings than did the incendiaries. Most of the buildings repaired by the war damage crews had been patched up on the cheap: cracks filled with torn newspapers and plastered over, floors crudely jacked up to make them level with little in the way of structural repair. Freud liked the shabby, seedy ambience and has remained in the area ever since, buying several buildings there, including a top-floor studio in Holland Park and a Georgian townhouse complete with studio and garden.

In addition to being celebrated as Britain's greatest living artist, Lucian Freud has been reviled, in almost equal measure, as one of Britain's most notorious womanizers. The latter claim is based on the fact that he has fourteen children, twelve of them illegitimate (the *Sunday Telegraph* of 1 September 2002 claimed there were forty). His first wife was Kitty Garman, Jacob Epstein's ex-wife, whom he married in 1948. (She had been Epstein's lover since 1921 and was the mother of three of his children.) They had two children, Annie and Annabel. This ended when Freud began an affair with Lady Caroline Blackwood, the daughter of Lady Dufferin, who very much opposed the match. They were nevertheless married in 1957. He also had children with Jacquetta Lampson, the daughter of the first Baron Killearn; Bella and the writer Esther Freud by Bernardine Coverley; five children by Suzy Boyt, including Rose and Susie Boyt; and two by Margaret McAdam. Freud once said: 'I've never been able to do that thing of courting. I need rather instant reciprocation.'[20]

After his unsuccessful experiments with marriage and despite all his many children and ultimately grandchildren, Freud has chosen to live alone. He has led an almost monastic life, painting in his studio until midnight, using a rotating series of five regular sitters whose appointments are arranged weeks ahead. He keeps a rigid control over his social life: whenever he wants to see his friends, he calls them; they are not given his telephone number, though this probably does not apply to people like Frank Auerbach, who became his best friend after Freud and Bacon drifted apart. Francis Bacon had introduced Freud to Auerbach in 1956 and they quickly found a lot in common, though Freud was difficult to be friends with. They were both early risers and occasionally they still meet at Freud's for one of his gourmet breakfasts: gull's eggs, Cumberland sausages, roast parsnips, game and good claret.

John Russell wrote:

Then as now [Freud] was *homo Londoniensis* in an exceptional degree: a man who used all London as the bison uses the long grass and lived with an absolute minimum of circumstantial baggage. As far as possible in the late twentieth century, Freud owns nothing and lives nowhere, though it could be said with equal truth that he has everything he wants and is at home everywhere.[21]

Most of his time is devoted to painting. He famously sleeps very little, avoids holidays and travel, and has rarely left North and West London. He is the master of the nude and the portrait, always preferring friends and lovers rather than professional models:

I don't use professional models because they have been stared at so much that they have grown another skin. When they take their clothes off, they are not naked; their skin has become another form of clothing... I paint people not because of what they are like, not exactly in spite of what they are like, but how they happen to be.[22]

Each painting takes eight to nine months and he works only when the sitter is present. He uses standard studio procedure, with his subject sitting to him once or twice a week for several hours, with a rest every half an hour. He said: 'The subject matter is autobiographical, it's all to do with hope and memory and sensuality and involvement, really.'[23]

Both Freud and Frank Auerbach were from Berlin, but whereas Freud arrived with his family, Auerbach came as a nine-year-old boy in 1939, leaving his parents behind, where they were consumed by the Holocaust. He spent a year at Borough Polytechnic, studying with Bomberg, then four years at St Martin's and three at the Royal College of Art. He became obsessed with the damage to London caused by the German bombing and spent years sketching the workers clearing dangerous sites. He told Richard Cork: 'London looked marvellous in those days. There were endless vistas in the gaps between buildings, and the sight of houses sheared away by explosions was very dramatic.'[24]

For fifty years he has lived in and painted Camden Town, not the most beautiful neighbourhood of London. Auerbach: 'I live in Camden Town and I pass those streets everyday and it's my part of London, so I've become extremely fond of it.'[25] He uses only six models and these he paints time and

time again; one of them has been sitting regularly for twenty years. These include his wife Julia, David Landau and Catherine Lampert.

There were many other painters on the London fringe; some had been badly affected by the war, others were alcoholics, unfashionable, unattractive, or mentally unstable. Gerald Wilde was all those things. He was a classic Soho figure: deranged, unpredictable and difficult, and in the latter half of the fifties he spent some time in St Ebba's Mental Hospital, where he was given electric shock treatments. These caused him to abandon painting. Jungian analysis seems to have helped to stabilize him and in the seventies he began painting again after a twenty-year gap. He was blind in one eye from a childhood accident and presented a curious figure: long body, long arms which almost touched the floor, short legs and an elongated face topped with a dome-like skull. His friend Corinna MacNeice described him:

> As he spoke, the left of his formidable electric light blue bulging eyes would swivel sideways and up to the heavens, his hands carefully carving the air. The large, almost pendulous mouth, trumpet-shaped in moments of outrage, would transform into a direct and sweet smile before giving way to gleeful laughter.[26]

Wilde was long thought to be the real-life model for Gully Jimson in Joyce Carey's *The Horse's Mouth* but in fact they did not meet until 1949, five years after the book was published. Wilde was an old-style Soho drunk, yelling and screeching at the bar of the French, giving away pictures for drinking money or to friends on impulse. He was represented by Erica Brausen's Hanover Gallery but even though she gave Wilde a one-man show in 1948, it was not of his best paintings. All the best things were gone, lost, given away, probably destroyed.

Wilde too was inspired by the London Blitz and did many drawings and paintings of burning buildings, many of which were in turn destroyed by German bombs. He sold paintings for next to nothing and on one occasion, in order to show that he wasn't dependent on the gallery system, when he did get paid he famously threw the money on an open fire. Wilde was an abstract painter before it was understood in Britain, and may have even been moving in the direction of the young Jackson Pollock. He held strong opinions on painting and accused Bacon of stealing his colours. The St George's Gallery arranged for him to make a print, but of the edition of 100, not one sold; his colours were just too bright and aggressive for the English. As David

Sylvester put it: 'We are a nation that evidently finds it difficult to live with difficult art.'[27]

In the late fifties and early sixties the property speculators had a field day; in the name of progress they were permitted to demolish many beautiful terraces and listed buildings and slap up ugly office blocks and tower blocks in their place; while all over London bomb sites still scarred the landscape. It seems that the bombs had inconveniently not fallen on the most commercial sites. In 1959 a group of teachers and students from the Royal College of Art calling themselves the Anti-Uglies finally decided to demonstrate against the terrible buildings that were making London into such an eyesore.

Their first demonstration was held in December 1958, when Caltex House on the Brompton Road and the new National Farmers' Union building by Ronald Ward on Knightsbridge were targeted. The former had low-relief sea-horses that the Anti-Uglies suggested would be more suitable for an Italian railway station, the latter was a neo-Georgian non-entity; the Anti-Uglies' point being that the war damage should be replaced with something new that reflected the spirit of the times. It was 'just the sort of thing that Joseph Stalin would have liked'.[28] 'Outrage! Outrage! Outrage!' they chanted, the title of Ian Nairn's famous attack on 'subtopia' published in 1955 in *Architectural Review*. The Anti-Uglies were not looking for polite traditional anodyne architecture, they wanted energy, guts, to 'make it new!'

E. Vincent Harris's new Kensington library was an early target; 250 students, mostly from the Architectural Association, the Royal College of Art and the Regent Street Polytechnic, assembled in February 1959 to march from the Natural History Museum to Kensington High Street. The organizer, Kenneth Baynes, was a painter and stained-glass student from the Royal College of Art, where he later became head of the Design Education Unit. He led the parade seated in a bath chair and dressed as Christopher Wren carrying a banner proclaiming '300 Years Old and Still Going Strong'. Other banners demanded: 'Kensington! Where's your sense of beauty?' and 'Scythe it down!!'

His bath chair was pushed by Pauline Boty, the Honourable Secretary, known to fellow students at the RCA as 'the Wimbledon Bardot'. A television interviewer approached Pauline and, typically, asked her: 'What's a pretty girl like you doing at this sort of event?' Instead of breaking his microphone, she grinned and told him that the building was an expensive disgrace. The interviewer said that the people who worked there thought that it was 'very efficient inside'. 'We are outside,' Pauline said, defiantly. Then the architect,

E. Vincent Harris, made an appearance. He called the demonstrators 'stupid, duffle-coated, long-haired students' and said his library was 'a well-mannered building in the best contemporary-traditional style'.[29]

'It's an outrage!' yelled the crowd. 'Pull it down!' Then John Betjeman arrived. He was on the side of the Anti-Uglies. 'The art of architecture is at last getting the attention it deserved,' he said, smiling at Pauline.[30] The march was accompanied by a fourteen-member traditional jazz band, mostly members of the Alberts, one of whom, Barry Kirk, dressed as a town crier complete with silver buckles on his shoes, bellowed their message aloud.

The early marches of 100–250 people all attracted press attention but inevitably the press grew bored, and the members of Anti-Ugly also moved on to other things. Their biggest success was their 1959 fight to stop the wholesale demolition of the Piccadilly Circus site, including the Trocadero and the London Pavilion, which caught the public attention and resulted in the government getting involved, scuppering the LCC's old chums acts. Their last demo was on 23 March 1960 to protest at two ghastly new buildings by Fitzroy Robinson, the Stalinist box (now demolished) that the BBC erected next to Nash's All Souls on Regent Street, and the equally pedestrian post office planned to blight St Martin-in-the-Fields.

Sadly the movement did not grow. Had it won national support, thousands of appalling sixties buildings might never have been constructed and we would have been saved from the monstrosities of Seifert and his gang.

Pauline Boty was born 5 March 1938 in Carshalton, Surrey, and did four years at Wimbledon School of Art followed by three at the RCA. In common with many other art school girls, Boty modelled herself on Bardot, whose naked scene in *Doctor at Sea* and free spirit as portrayed in *And God Created Woman* helped usher in the sixties. (Even the title of the latter was censored in Britain, where the film was called *And Woman... Was Created.*) The architect Edward Jones, who knew Boty in the late 1950s, said: 'She looked just like Bardot, with a few extra pounds – charming, direct and very flirtatious. There were other beautiful girls who could paint at the time, but none who were quite as wonderful as her.' Peter Blake was one of many failed suitors.

The autumn 1959 term at the RA featured David Hockney, Derek Boshier, Peter Phillips, Allen Jones and Ron Kitaj and it included Pauline Boty, though she was supposed to be in the stained-glass department. Painting had been her first choice, but she had been advised to take the stained-glass course instead as painting was too competitive. Less than a third of the painting students were women, even though they won more than half the firsts. She was

ahead of them and left the RA in 1961 when she turned to painting full-time. She exhibited at the AIA Gallery at 15 Lisle Street and the show, *Blake Boty Porter Reeve* (Peter Blake, Pauline Boty, Christine Porter, Geoffrey Reeve), can probably claim to be the first pop art exhibition in the world. It opened on 30 November 1961 and ran until the end of the year. Like many of the pop artists (Blake, Jones), she used the imagery of female glamour and pin-ups, but as a woman she looked at these representations in a different way. Her use of them was joyful, exuberant, with none of the dull masturbatory 'male gaze' of the male pop artists. She used them to celebrate her own sexuality, to seize control of them, and was one of the first, if not *the* first, to explore this area. Her work was playful, and sometimes she was accused of triviality, but pictures such as *It's a Man's World*, an early feminist critique of both male dominance and the Vietnam War, show that her work operated on a number of levels. She painted Brigitte Bardot, Monica Vitti and Marilyn Monroe as powerful women, not sex toys; and as Alice Rawsthorn points out, in her 1963 portrait of Marilyn Monroe, *The Only Blonde in the World*: 'The smiling Monroe strides confidently across the canvas as a strong, vibrant woman – much as Boty is remembered by her friends.'

She was not only commenting on the inchoate pop scene but played an active part in it: she and her partner, Derek Boshier, were chosen as dancers on the TV pop series *Ready Steady Go!*, prompting her to use the presenter Cathy McGowan as the subject for a painting. And as an actress she flirted with Michael Caine in *Alfie* (though she lost out to Julie Christie for the lead in *Darling*) and starred in television plays and on the stage at the Royal Court Theatre. When Ken Russell made *Pop Goes the Easel*, his 1962 BBC *Monitor* documentary on four young pop painters – Peter Blake, Derek Boshier, Peter Phillips and Pauline Boty – it was Boty that the camera lingered on, and not just because of her extraordinary beauty; she was the most playful, the most experimental, the one most prepared to enter Russell's vision and consequently appears pursued by a sinister wheelchair-bound villain, running down endless curving corridors and in a wrestling match with the other three artists. Her handling of bright pop colours and iconic sixties imagery made her the purest, and perhaps the best, of the British pop artists of the time. In June 1963 she married Clive Goodwin, left-wing activist, actor, writer and literary agent. Their flat in Cromwell Road became a fashionable salon for the early sixties scene where you could meet everyone from Harold Pinter to Bob Dylan. Sadly, her time was brief and she died of a rare form of cancer in 1966 at the age of twenty-eight. One of her brothers stored her canvases in his barn and her career was almost forgotten until the curator David Mellor

tracked them down and exhibited them in his *The Sixties Art Scene in London* show at the Barbican in 1993.

The musical accompaniment to the Anti-Uglies marches was provided by the Alberts, in one line-up or another; they were also an indispensable element in the early CND Aldermaston marches which would have been incomplete without their tuba and their skinny whippet. The core of the Alberts consisted of the painter and sculptor Bruce Lacey, and the brothers Tony and Dougie Gray. When the occasion called for it, they would assemble the Massed Alberts, which looked like a reunion of Boer War veterans and consisted of many of the musicians who later became the Temperance Seven. They were a major influence on the Bonzo Dog Doo-Dah Band. The Boer War was a subject of special interest to them and they ended one of their numbers, 'Goodbye Dolly Grey', with an explosion and the delighted scream: 'Ladysmith has been relieved!', an incident from the year 1900. They dressed in Victorian clothes with capes and deer stalkers and appeared onstage accompanied by a variety of props – penny-farthing bicycles, horns and hooters, as well as tubas and euphoniums and other Victorian instrumentation.

Bruce Lacey studied at Hornsey Art College and then the Royal College of Art, where he arrived at a college dance in 1952 with a dummy dance partner; her feet were attached to his shoes. As an encore he did a trapeze act with another puppet. After the RA he worked on special effects and props for both the *Goon Show* and for Michael Bentine's *It's a Square World*. The Alberts later appeared on several of Spike Milligan's television series, and when the BBC launched its second television channel, the Alberts had their own show, called *The Alberts' Channel Too*. The highlight of their career was probably their theatrical extravaganza, *An Evening of British Rubbish*, which also featured Joyce Grant and the dry wit of Ivor Cutler. They had a residency at Peter Cook's Establishment Club, where they presented a Dadaist quiz show. Lacey was the question master. The competitor was asked a question, and then immediately a bucket of whitewash was poured over his head. After wiping his eyes and mouth the competitor asked: 'Could you repeat the question, please?' Theirs was a particularly British form of surrealist anarchism.

In 1955 Lacey listed the contents of his attic as:

1 elephant's tooth, 1 elephant's toenail, 1 elephant's mating horn, 8 magic lanterns, 2 whale's ear drums (left and right), 9 family photograph albums, 3 stereoscopes, 1 boy's head (wax skin, glass eyes, human hair – full size), 2 moustache cups, 1 boarskin complete with head, 1 Prof. King's Perpetual

Calendar (0 BC – AD 3,000), 1 early Admiral Fitzroy's barometer (with atmospherical anecdotes), 1 painting of my grandfather (on my mother's side), 2 Edison-Bell photographs (one large, one small), 1,006 magic lantern slides, 56 statues, figures and carvings, 1 harmonium, 14 one-string fiddles, banjoes, guitars, mandolins, pianos, etc., 263 miscellaneous, 19 weapons, 1 fireman's helmet, 1 American Civil War uniform, 5 bowler hats, 4 silk top hats, 1 policeman's helmet (genuine), 1 Admiral's cocked hat.[31]

Bruce had a parallel career as an artist; Victor Musgrave exhibited his robots at Gallery One, including one that sang 'I'm Forever Blowing Bubbles' and blew bubbles, a precursor to David Medalla's bubble machines. Another was 'The Womanizer', now owned by the Tate, which was inspired by 'wondering what it would be like to be a hermaphrodite and make love to myself. It had six breasts and rubber gloves that inflated every 30 seconds'. He was described as a neo-Dadaist by the critics, 'which surprised me because I didn't know what Dada was. At the Royal College, art history had stopped with the Impressionists.' He later said he was glad when the term 'performance art' was invented, 'because it finally explained what I'd been doing all my life'. One 1964 robot was called 'Old Money Bags' and was triggered by shouting at it. Lacey used to bellow 'Get to work, you bastard' and the cogwheels would spring into action, moving two-shilling pieces through the 'heart' like white blood corpuscles. This same year he appeared as Paul McCartney's gardener in the 1964 Beatles film *Help!* where he trims the small grass lawn inside the Beatles' house using nothing but two pairs of clockwork chattering teeth. In his 1968 *Cybernetic Serendipity* show at the ICA, Lacey exhibited his sex simulator, a bit like the orgasm machine in Roger Vadim's *Barbarella*, made the same year. It was a participatory work: the viewer climbed into a sort of capsule where they were rocked and tilted like a fairground ride while being shown what Lacey called: 'non-specific erotic images. Meanwhile, through a sheet of red rubber, rollers ran over your breasts and a soft thing would fall into your crotch and vibrate.'[32] Apparently women liked it more than men, though many men were willing to give it a try, including Lord Snowdon, then married to Princess Margaret.

The skewed humour of the Alberts and Bruce Lacey in which elements of Britain's imperial past are collaged in a kind of ferocious surrealist camp critique of Victorian values paralleled that of the Goons. It was a demystification of the imagery of the State: the uniforms, the medals, the military bands, the hypocrisy, the repressed rage, the colonial attitudes of superiority and self-righteousness. It was the spirit of the sixties being given form.

Its influence was considerable, from the Monty Python crew to the Bonzo Dog Band to young married couples buying a gramophone with a huge horn and mounting enamelled Victorian advertisements on their living room walls. It became a major element in the pop art of Peter Blake, with his paintings of Victorian boxers, and the Union Jack jacket worn by the Who's Pete Townshend. Many of the stereotypical images have since been wittily recycled by Mike Myers in his Austin Powers films.

9 The Big Beat

Viewed as a social phenomenon, the current craze for Rock and Roll material is one of the most terrifying things ever to have happened to popular music ... It is a monstrous threat, both to the moral acceptance and the artistic emancipation of jazz. Let us oppose it to the end.

STEVE RACE, *Melody Maker*, 5 May 1956

In October 1955, Mary Quant, her boyfriend, later husband, Alexander Plunket Greene, and Archie McNair, a former solicitor turned photographer, opened a dress shop called Bazaar on the King's Road, Chelsea. Using £5,000 that Plunket Greene had inherited on his twenty-first birthday and money put up by McNair, they bought a lease on Markham House, next door to the Markham Arms, intending to use the basement for an upmarket jazz club, the ground floor for the shop, and the rooms above as workshops. Archie McNair had recently opened Fantasie, London's second ever coffee bar, at 128 King's Road, where he also lived and ran his photographic studio. Among his team of photographers was Anthony Armstrong-Jones, who later married Princess Margaret. After the opening of Bazaar, Quant moved from her bedsit in Oakley Street to rooms above the Fantasie, where she both lived and worked. Her living space was restricted because they had to hire more and more people to work the sewing machines providing clothing for the shop, which was an immediate success. Quant's designs were revolutionary in terms of fashion, from her short hem-lines to her use of bright colours she ran contrary to the fixed ideas of the haute couture fashion houses. Quant arrived at a time when English girls left school and dressed like their mother. As George Melly put it: 'Only tarts and homosexuals wore clothes which reflected what they *were*.'[1] Quant chucked all the accessories in the dustbin and enabled young women to look young. Away went the white gloves and the hat and the matching bag and shoes. She was a precursor of sixties ideas and attitudes.

Bazaar's window displays caused astonishment in the King's Road. They

would do anything to attract attention, including hanging the mannequins upside down. Once they filled the window entirely with empty milk bottles and the back of a departing tailor's dummy with a sign saying 'Gone Fishing', and another time re-created Gerard de Nerval taking his pet lobster for a walk on a gold chain.

Though Alexander and Mary had decided not to join McNair in his coffee bar venture – the new coffee bar craze seemed like too much of a fad – they still spent much of their time socializing there because, as Mary revealed: 'Some nights at the Fantasie the espresso coffee was laced with vodka.' The trio were unable to get an entertainment licence for a jazz club in the basement of Bazaar so instead they opened a restaurant, named Alexander's, after the proprietor. Groundbreaking like the shop, this was a precursor of the sixties bistros, with a relaxed friendly atmosphere, totally unlike the fussy formal restaurants of the period. Often the customers finished up at midnight upstairs in Bazaar drinking brandy. McNair was experienced in the catering trade and the combination of the restaurant and dress shop was a great success, so much so that they kept running out of stock. One woman grabbed a dress from Quant as she carried new supplies down the street, following her into Bazaar to pay for it without even trying it on. Bazaar, Alexander's, the Fantasie and the Markham Arms became the gathering points for the Chelsea Set. The Fantasie features in Elizabeth Russell's wonderful surreal movie *Food for a Blush*, which also features a brief appearance by Colin Wilson. One gets a glimpse of the Chelsea scene before the chain stores and high prices, when it was still a haven for artists and young people and had an almost village atmosphere.

One attraction of the Fantasie was the Chas McDevitt Skiffle Group, who had a regular gig there. It was very handy for them as they all lived in the area and were too young to go to pubs. Chas McDevitt lived nearby on the King's Road. In his history of skiffle he recalls liberating fifteen bottles of wine from a party given by West End villain Eddie Chapman where McDevitt and the Mick Mulligan Band had been hired to play. He describes how the empty bottles were to remain for weeks on end floating in the bath along with the dirty dishes in their Chelsea flat. McDevitt: 'The flat in the King's Road was an ideal pad in an ideal position. It provided a haven for many an itinerant jazzer, visiting American folkies and unsuspecting embryo groupies.'[2]

There are amusing parallels between Mary Quant's Bazaar and her partner's promotion of Chas McDevitt's Skiffle Group, and Vivienne Westwood's Seditionaires (aka SEX, and Too Fast to Live, Too Young to Die) and her partner's promotion of the Sex Pistols: both represented a do-it-yourself working-class

music form that was hugely influential, and both emerged from a dress shop on the King's Road. They were both centres of the youth scene: Andrew Loog Oldham, the Rolling Stones' manager, first worked for Mary Quant; Bernie Rhodes, manager of the Clash, first worked for Malcolm McLaren. Can a revolution start from a dress shop in the King's Road? McLaren certainly thought so, and so, to an extent, did Mary Quant. In *Quant on Quant* she wrote:

> Nobody has ever been able to make up his mind precisely what 'the Chelsea Set' was but I think it grew out of something in the air which developed into a serious attempt to break away from the Establishment. It was the first real indication of a complete change of outlook.[3]

The dance music of the early fifties was traditional jazz and most of the musicians who later joined the skiffle craze began by playing New Orleans-style. Lonnie Donegan was one. He got his name when the Tony Donegan Band played at a National Jazz Federation event at the Royal Festival Hall on 28 June 1952. Also on the bill was the American jazz guitarist Lonnie Johnson: the compere mixed the two names up and Tony was for ever after called Lonnie Donegan. In 1953, Chris Barber, Lonnie Donegan and Monty Sunshine all joined Ken Colyer's Jazzmen and it was then that a little unit at the centre of the band – Colyer, Donegan and Barber – began playing a pared-down mid-set interlude. Colyer called this looser trio the Breakdown Band, but Colyer's older brother, Bill, who knew his jazz, said they were playing skiffle. Bill Colyer worked at Collett's bookshop, which imported left-wing books, and folk and jazz records. One record he got in was by Dan Burley and His Skiffle Boys.

Skiffle was originally played by American blacks who could not afford much in the way of instruments and so made do with a tea-chest and broom-handle bass and a washboard for percussion. It began around the turn of the century and was played during the Depression, mostly at rent parties where neighbours and friends got together and all contributed money to pay the landlord. The Breakdown Band was now introduced as a 'skiffle group'. The following year, Ken Colyer and Chris Barber's musical differences came to a head, Colyer, the absolute purist, left to start a new band, and the old lineup became the Chris Barber Jazz Band.[4]

Chas McDevitt played banjo with the New Crane River Jazz Band and around 1952–3 began singing with the rhythm section of the band during the mid-set break. They had no name for these interludes so when Ken Colyer began to call them 'skiffle' they adopted that name for what they were doing. McDevitt's skiffle group was called the St Louis Trio.[5] They played the coffee

bars of Chelsea and Soho, the Fantasie, the Breadbasket, and the Gyre and Gimble, and had a regular spot at Cy Laurie's Jazz Club in Windmill Street. Cy Laurie's was a small club in the basement of Mac's Rehearsal Rooms in Great Windmill Street. When he started holding 'All-nite rave ups', closing at 6 a.m. when the tubes started up, the tabloids immediately went on the attack, appalled at the idea of young people staying up all night. The Fleet Street hypocrites were right about one thing: there was a lot of sex and a lot of pills – dexedrine or benzedrine – at Cy's.

Good-time jazz was much closer to popular music than the small-group improvisations of later years. It needed a lot of energy to keep up the momentum so the mid-set break was a welcome innovation and it began to be featured by all the traditional bands playing at the time. At first, skiffle groups relied on numbers for volume as none of the instruments – washboard, tea-chest bass, acoustic guitar – were amplified; in fact six acoustic guitars was not unknown. Then Lonnie Donegan changed all this by the introduction of Denny Wright's electric guitar to his lineup. Promoters and club owners began to wonder if they could just hire the skiffle group and forget about the trombones and clarinets.

The Gyre and Gimble in a basement at 31 John Adam Street, just off Villiers Street at Charing Cross, was the first skiffle bar. The manager was John St John Crewe. Regulars included Tommy Hicks (later renamed Tommy Steele by Larry Parnes), Lionel Bart (who wrote Cliff Richard's number one 'Living Doll' as well as many hits for Adam Faith and Tommy Steele), the Vipers, and members of the Chas McDevitt Skiffle Group. The Gyre and Gimble, and also the Farm, began staying open all night, establishing a late-night West End culture. Chas McDevitt recalls that sometimes, if the weather was fine when they finally emerged blinking into the breaking dawn, a group of them would take a taxi to London Bridge station and take the 4.40 a.m. milk train to Brighton. They called themselves the Brighton Buskers. Chas McDevitt: 'When the sun came up they would busk on the beach. Their record bottle was £7 in 40 minutes, not bad for 1956.'[6]

Tommy Hicks was a merchant seaman who had been hanging out in Soho with Lionel Bart and Mike Batt on his shore leave, often sitting in on jam sessions at the Gyre and Gimble and other coffee bars. One of his shipmates had taught him a few chords and on one of his trips to the States he saw Elvis Presley play live. He tried out his Elvis act at the Gyre and Gimble, but the regulars there were hard-line traditional jazz, skiffle and folk fans and it was a disaster. Michael Moorcock, the science fiction writer who was then the washboard player for the Greenhorns Skiffle Group, said:

I was one of the people, including Charlie Watts, who shouted to Tom Hicks to go up the 2i's and get discovered one evening in the Gyre & Gimble – and Tom took his white Gretsch (or it might have been a Hofner) up to the i's and became Tommy Steele. So I suppose I've been around since the beginning of British rock 'n' roll.[7]

Nonetheless, it was at the Gyre and Gimble that Tommy Steele was really discovered. Roy Tuvey and Bill Varley, two retired air stewards, had set up a small recording studio in Denmark Street called Trio Recordings. They had an EMI TR 50A tape recorder that was just about portable and hauled it down to the Gyre and Gimble to record some of the regulars playing live: they taped the Vipers, Jim Dale, and the Chas McDevitt Skiffle Group. It was here that Roy Tuvey met Tommy Hicks and realized his potential. Tuvey and another business partner, Geoff Wright, signed him up to a personal management contract and soon had him playing Al Burnett's Stork Room, which was where his future manager, Larry Parnes, first saw him.[8] Parnes found out that Tommy was underage when he signed the contract with Tuvey and Wright, so he went behind their backs to Hicks's parents and signed a five-year contract with them. He changed Tommy's name to Steele and within weeks he was in the charts.

Tommy Steele's days at the Gyre and Gimble came to an unexpected end. They had a relaxed attitude there and people could buy a coffee and nod off to sleep at the tables. One of them was Ralph Rumney, founder of the London Psychogeographical Society and in 1957 a founder member of the International Situationists. Rumney told Alan Woods:

Tommy Steele used to come in there and twang on his guitar and make an awful racket, and all of us were just trying to have a quiet kip and we kept telling him to shut up and he wouldn't. And I had a very large friend at that time – Gerald, he was called – who was a bit of a thug... he came down one night and Tommy Steele was twanging away as usual – Rock Island Line and skiffle – it was really tiresome, because he didn't have much of a repertoire in those days. And from the top of the stairs Gerald yelled out STOP THAT RACKET, and Tommy Steele didn't. So Gerald just put his hand on the banister, leapt over it and landed on Tommy Steele, feet first, and cracked about four of his ribs, so he had to be taken to hospital. Which got us barred for about three days. And we never saw Tommy Steele there again.[9]

One afternoon, early in the summer of 1956, two Australian wrestlers, Rebel Ray Hunter and Paul Lincoln, who worked under the name of Doctor Death,

were training at the YMCA with their friend Tom Littlewood, an ex-stunt man and judo black belt. They were all three looking for something new to do and one of them mentioned that the 2i's steak house at 59 Old Compton Street was up for sale. They decided to club together and run it as a coffee bar, cashing in on the new craze. The 2i's was named after the two Irani brothers who started it and who later went on to open the Tropicana on Greek Street, which in turn became the Establishment Club. The new partners liked the name and decided to keep it. Freddy Irani continued to live in one of the flats upstairs. It was the rooms above that appealed most to Paul Lincoln, who was looking for somewhere for foreign wrestlers to stay when they came over to fight in his promotions. He needed somewhere as temporary accommodation until they found proper flats of their own. Later, when the 2i's became a rock venue, the wrestlers and the rock 'n' rollers all got to know each other really well. According to Brian Gregg, bassist with Johnny Kidd & the Pirates: 'They were a good bunch and became almost like family.' Ray Hunter already had an interest in the Cromwellian Club on Cromwell Road, where many young rockers, including Georgie Fame, Eric Burdon, Alan Price and Zoot Money, liked to jam the night away, so he knew the catering trade. It was left to Tom Littlewood to run the place.

Even though the building dated from 1731, they went for the modern look, doing it out in cheap Formica like a milk bar, right down to plastic peel-off ads for milkshakes on the walls behind the counter. At first Tom thought a Spanish guitarist would bring in customers, but quickly replaced him with a large American jukebox, which at least made money. Compared to the other coffee bars in Soho, the 2i's looked pretty tame. They were no competition for Heaven and Hell next door: there the ground floor was heaven, painted brilliant white, while the basement was decorated in black, and featured a skiffle group called The Ghouls. Just round the corner on Meard Street was Le Macabre, which used coffins as tables and bakelite skulls for ashtrays. There were skull-shaped milk jugs, murals of skeletons and graveyards, and the jukebox featured the 'Funeral March'. Not far away the Kon-Tiki had a full Pacific Island makeover complete with palm trees and fishing nets.

The 2i's had been open three weeks when Soho held its second annual Soho Fair, to coincide with the 14 July 1956 Bastille Day celebrations. The Vipers skiffle group were among the groups in the procession as it wound through the streets. When a downpour of rain made them jump down from their flatbed truck and take refuge in the 2i's, the nearest coffee bar, Paul Lincoln suggested they continue playing there. Immediately a large

crowd came in from the street, drawn by the music as much as to shelter from the storm. Paul Lincoln realized that live music was what was needed to pull in the customers and hired them on the spot to play a regular gig from 7 p.m. until eleven, four nights a week. At first they were paid only in spaghetti, Coca-Cola and any tips they were able to collect, but their leader Wally Whyton soon decided that a proper fee was required as the place was crammed to its eighty-person capacity every time they played. People were queuing all down Old Compton Street. Paul Lincoln made a derisory offer and Wally, bravely, said he would wrestle him for double or nothing. Lincoln was impressed by his guts, strapped on his Doctor Death mask and lost the fight hands down, presumably intentionally. The Vipers got their wages.[10]

The Vipers skiffle group were formed in London in the spring of 1956, named after the 1936 recording by the 'King of Swing Violin', Stuff Smith & His Onyx Club Boys, 'Youse a Viper', which went: 'Dreamt about a reefer / Five feet long / Mighty Mezz, but not too strong / You'll be high, but not for long / If youse a viper...' Viper was common London slang for a pot-head in the mid-fifties so their name was an in-joke; a bit like Freddy Mercury, a well known homosexual, calling his band Queen. The Vipers began as a trio of singer-guitarists: Wally Whyton, Johnny Martyn and Jean Van den Bosch. Wally Whyton grew up almost next door to the Breadbasket coffee bar at 65 Cleveland Street, Fitzrovia, and it was there he first met Johnny Martyn, who was then managing the Gyre and Gimble. By the time they took up their residency at the 2i's they were a five-piece.

The 2i's was the first place I went to in London when, in 1958, I spent the summer staying with relatives in Wembley. My cousin Stuart was taking guitar lessons from Peggy Seeger – she taught him the claw hammer pluck – and together we explored Denmark Street looking for the particular picks she recommended. At the 2i's we sat drinking coffee from glass cups, playing with the brown sugar in the bowl, staring out at Old Compton Street, thinking this was the centre of the world as 'Dream Lover' by Bobby Darin played on the jukebox and various sleazy Soho types drifted in and out. It had obviously not changed much since it opened. The ground floor was smaller than the cellar because in addition to the counter there was a toilet and a small store room. The performance area downstairs was a very small space, very hot and sweaty, reached by a narrow staircase. The stage was wider than the room because it extended under the staircase, where there was also a notorious cupboard, large enough to stand up in and remembered with nostalgia by many musicians who used it for private talks with their female

fans. The stage was just eighteen inches high so only people standing in the front row could see the performers. The equipment, microphone and amps, was all very old. People were constantly asking to sit in and each night ended in a jam session. It was always packed.

Johnny Martyn knew Lionel Bart from the Gyre and Gimble and suggested to Paul Lincoln that he might decorate the basement to make it look more like a music venue. Bart, who had studied at St Martin's School of Art, painted the ceiling black and a cubist design behind the tiny stage. On the walls he painted huge, stylized eyes in the manner of the day. Unfortunately he used oil paint, which takes a few days to dry, and people leaned against the walls and got paint all over the clothes. Paul Lincoln had to pay their cleaning bills because this was long before the days of casual clothes; people dressed in their best to go out and clothes were not cheap.

Naturally, the Vipers were looking for a recording contract so they invited Hugh Mendl, a Decca record producer, to come and see them at the 2i's. Thinking it might help, they asked Tommy Hicks to sing with them. The producer loved Tommy but not the Vipers. He signed Tommy and just ten days after the release of his first record, 'Rock with the Caveman', written by his friend, the ubiquitous Lionel Bart, Tommy was a star. The ensuring publicity made the 2i's famous at the same time, even though he only played there that one time.

The Vipers need not have worried. They were causing such a buzz that Parlophone producer George Martin came to see them and in September that year, 1956, offered them a recording contract. He released their first single the following month: 'Ain't You Glad'/'Pick a Bale of Cotton'. They were the only serious competition for Lonnie Donegan and there was considerable rivalry between the two groups. Donegan heard the Vipers play the traditional 'Don't You Rock Me Daddy-O' at the Breadbasket and quickly made plans to change the words slightly and release it himself, in that way claiming the publishing copyright. The Vipers got wind of this and managed to get their version out first. The Vipers' 'Don't You Rock Me Daddy-O' made the Top Ten but, even though Lonnie Donegan's version got higher in the charts, Whyton and the Vipers' manager, Bill Varley, got the publishing on both. The funniest Vipers v Donegan story involved one of the bass player John Pilgrim's pet monkeys, Elvis and 'Iggins. The Vipers included in their entourage a menagerie of animals including monkeys, skunks and a coatimundi. At a party, a monkey perched on Lonnie Donegan's shoulder as he sat talking, making him even more the centre of attention than usual. Then the monkey began to shit, all down Donegan's back. No-one said a word. Everyone in the

room was focused on him but Donegan thought the attentive silence meant they were enthralled by his words and kept on talking.

Skiffle introduced a younger crowd to the London bohemian mix; though Francis Bacon and the Colony Room crowd sometimes went to the 2i's, their visits were usually brief. The spread of coffee bars and skiffle clubs introduced another layer, like a palimpsest, over the pubs and cafés of Soho and, to a certain extent, Fitzrovia, bringing more street life to a city that, even in the late fifties, was still badly scarred by war damage. There is a photograph of the 1958 Soho Fair, taken from the 2i's showing that most of the north side of that part of Old Compton Street was still an enormous bomb site; the backs of buildings on Dean Street shockingly revealed.

Tommy Steele was Britain's first home-grown rock star, and the press was filled with the – largely made-up – story of his discovery at the 2i's. In Newcastle, a young guitarist called Bruce Welch read an article about the 2i's and decided to visit London for the weekend and have a look at the place. A couple of months later, in April 1958, Welch and his friend, Hank Marvin, also from Newcastle, moved down to London and took a single-room flat in Finsbury Park. Every day they would go down to Soho and hang around the 2i's and quickly became part of the scenery. The 2i's was open all day and even in the afternoons people would go in and jam. Tom Littlewood let them play four nights a week from 7 until 11 p.m.; the 2i's was never a late-night place. Sometimes they sat in with the Vipers. When they weren't working, Littlewood let them man the coffee and the orange juice machines upstairs, for which he paid them eighteen shillings after deducting a 10 per cent commission.

Paul Lincoln was still involved in the wrestling business and in promoting bouts. He hired Bruce Welch to help him install the wrestling rings in places like the Wimbledon Palace. Welch: 'It nearly killed me but I'd have done anything for two or three quid.'[11] That summer 'The Geordie Boys', as they were first known, were joined by two new musicians, Jet Harris and Tony Meehan, and became the Drifters. By this time they had honed their act. Bruce could play note perfect Buddy Holly solos, which was just what British promoters were looking for at the time. That September, 1958, someone showed up looking for a backing group for his act, having heard there was a good guitarist playing at the club. It was Harry Webb's (Cliff Richard's) manager Johnny Foster and soon Harry was singing with them at the 2i's. When a promoter from Derby wanted to book Harry as a solo act, he decided that the name Harry Webb was not showbiz enough and

appropriated the name of one of the 2i's resident singers, Rick Richards from the Worried Men, dropping the final 's'. Harry Webb became Cliff Richard and his single 'Move It' was a huge hit. The Drifters changed their name to the Shadows, and had hits both as an instrumental group and as Cliff's backing group.

Meanwhile the 2i's went from strength to strength. It became the place for aspiring musicians to hang out: Marty Wilde, Vince Taylor, Johnny Gentle, Screaming Lord Sutch, Adam Faith and Lionel Bart, who used to play washboard in pick-up skiffle groups. Mickey Most, who was in the Most brothers with Alex Murray and later produced the Moody Blues' 'Go Now', was there most nights, often serving behind the counter. Terry Williams from the Elephant and Castle changed his name to Terry Dene and was discovered there; his first single, 'A White Sports Coat', was an instant success. Wee Willy Harris started his career at the 2i's sweeping the floor and serving Coca-Cola before Paul Lincoln persuaded him to get a red suit made up on Berwick Street and to dye his hair pink – an idea he took from an American wrestler, Gorgeous George. He was soon in the charts. A large American jukebox stood just inside the door, and outside, keeping an eye on things, was Big Roy, the doorman. The 2i's must be the only coffeebar in London to ever employ a doorman. Sometimes he was needed, such as when one of the Vipers got on the wrong side of the Curly King gang, who turned up with axes and a shotgun to settle an argument. Roy made sure no-one was hurt. Later, in 1958–9, it was Lofty, in his special uniform, who guarded the door. By the time Peter Grant, later to be Led Zeppelin's oversize manager, worked there the job description was more realistic; he was the bouncer. Business was good – it cost two shillings to go down the narrow stairs to the cellar – and on busy nights they would clear the room and do a second set halfway through the evening.

The 2i's attempted to cash in on its fame by opening a second venue, the New 2i's at 44 Gerrard Street, in what had been John Hasted's 44 Club, a folk and skiffle club that had been used as rehearsal space by Eddie Cochrane and Gene Vincent, as well as by many of the people who played the 2i's, two blocks away. But there was clearly a disagreement with the local gangsters, probably over protection money, and one day the doorman, one of Paul Lincoln's wrestlers, was attacked with a hatchet, leaving him scarred for life.

Larry Parnes – known in Denmark Street as Mr Parnes, Shillings and Pence – seemed to find most of his stars, and boys, there. After Tommy Steele came Reg Smith, who Parnes signed on the strength of Lionel Bart's recommendation without even hearing him sing. He changed his name to Marty

Wilde and they had a string of hits. Parnes delighted in creating showbiz names for his acts: Dickie Pride, real name Richard Knellar; Duffy Power, real name Ray Howard; Johnny Gentle, real name John Askew, Terry Dene and many more, including Georgie Fame, Lance Fortune and, the only one who resisted getting a new name, Joe Brown, whom Parnes wanted to call Elmer Twitch.

Larry Parnes started his boys at £20 a week on a steadily, but slowly rising scale. Parnes had it all worked out. Newcomers would first of all have their hair professionally cut – that was very important – and a beautician would attend to their skin. He took them shopping for clothes; in his words: 'I like to give them a touch of luxury from the start...'[12] As Simon Napier-Bell points out, it was almost identical to the way Sultan Selim III groomed new entrants to the royal harem in Constantinople. But though he loved them all, it was Ron Wycherley who really caught Parnes's eye. He was discovered in September 1958 in Marty Wilde's dressing room at the Essoldo Cinema, Birkenhead, where he asked if he could audition. Parnes changed his name to Billy Fury. He was obsessed with Fury and started him off at £65 a week, clear of expenses, a huge amount back then. After he had a couple of small hits, Larry increased this to £130 and then £150. In 1960, he switched to a percentage basis, giving him even more. Lee Everett was Billy's girlfriend for eight years and Parnes was so fixated on Billy that he had to let her move in, otherwise Billy would have quit. She told Simon Napier-Bell:

> So there I was living in Parnes's house full of boys. A lot of them smoked grass, and did pills, thousands of them. Billy smoked grass from when he got up in the morning to when he went to bed at night. Larry hated it so much he fooled himself he didn't know about it, just refused to let himself see it.[13]

Most of the first wave of British rock 'n' rollers started out in skiffle: Alexis Korner's first record was with the Alexis Korner Skiffle Group in February 1957, followed in April 1958 by his first as Alexis Korner's Blues Incorporated. Van Morrison's first band, the Sputniks, had a lineup of Van on vocals, plus washboard, kazoo, tea-chest bass and guitar. They played youth clubs and school concerts. Hank Marvin got his start in the Crescent City Skiffle Group, and Chris Farlowe, then called John Deighton, won the final of the 1957 All England Skiffle Contest when he was in the John Henry Skiffle Group. Cliff Richard was, rather reluctantly, in the Dick Teague Skiffle Group before returning to his career as an Elvis imitator. Joe Brown was in the Spacemen skiffle group and John Lennon's Quarry Men featured washboard

and tea-chest bass in its original lineup until John smashed the washboard over his friend Pete Shotton's head. The first tune they rehearsed when Paul McCartney joined the band was 'Don't You Rock Me Daddy-O'. George Harrison, meanwhile, was already playing in the Rebels, which featured a tea-chest bass and mouth organ.

Skiffle had been around in the clubs since the early fifties, but it was not until 1957 that it suddenly became popular. Adam Faith: 'Skiffle hit Britain with all the fury of Asian flu... Anyone who could afford to buy a guitar and learn three chords was in business as a skiffler. It grew in cellars, nice dark cellars, and it shot up like mushrooms.'[14] Anyone who could play E, A and B7 on a guitar was suddenly in a group. Specialist clubs opened all across town. The City Ramblers had a residency at the Princess Louise pub on High Holborn, until their leader, Russell Quaye, opened the Skiffle Cellar at 49 Greek Street on 14 April 1957. It quickly became *the* place to play. The Skiffle Cellar featured two groups each night, owner Russell Quaye's own band the City Ramblers, or someone like the Cotton Pickers, Lonnie Donegan's old sidekick Dickie Bishop, Steve Benbow or singers like Robin Hall and Jim McGregor. They all played there regularly, and then there would be a support act, playing for pennies. The audience was more bohemian and serious than that at the 2i's and were very knowledgeable about folk music. Noting the success of Cy Laurie's all-night jazz sessions at his Windmill Street Club, Quaye began to promote all-night sessions himself. The club remained the centre of British skiffle until skiffle's demise in 1960, when the club closed.[15]

The 44 Club at 44 Gerrard Street, in what is now Chinatown but was then a street of warehouses for the porn industry and shops selling used ex-war department electrical equipment, became a folk and skiffle centre until it was taken over by the 2i's. Chas McDevitt used the money he made from his hit 'Freight Train' to open a coffee bar on Berwick Street named, naturally, Freight Train, and in May 1959 a new skiffle club, called the Top Ten, opened in the cellar across from the Freight Train beneath Sam Widges' coffee shop and began to attract many of the old 2i's gang.

On 1 June 1957, about three years late, the BBC began broadcasting an hour-long live show called *Saturday Skiffle Club* to replace the usual morning organ recital. For sixty-one weeks it featured name bands, visiting guests, the occasional folk singer and at least nine appearances by the Vipers as well as Lonnie Donegan, Ken Colyer and more than forty other bands. This valuable document of the British scene is, of course, lost as the BBC with its usual disdain for popular music did not record any of the shows for posterity. We

would not need to pay a broadcasting licence had the BBC been far-sighted enough to record all the performances by the Beatles, the Stones, Dylan and the rest that it transmitted over the years. But they were nearly all wiped or, in the case of live shows like the television music show *Six-Five Special*, not recorded in the first place. Not one episode exists, though a spin-off film starring Lonnie Donegan, Petula Clark, and the John Barry Seven, was released in 1958.

Running a parallel course with skiffle was rock 'n' roll. Though the 2i's is generally credited with being the first Soho rock 'n' roll venue, the first was probably Ken Colyer's Studio 51, which, like many of the other skiffle venues, began putting on rock groups like Tony Crombie's Rockets and Rory Blackwell's Blackjacks that summer. This was met with the usual whinnying from the conservative music press. Writing in *Melody Maker*, 5 May 1956, Steve Race exposed the dreadful danger of rock 'n' roll to Britain's music scene:

> Viewed as a social phenomenon, the current craze for Rock and Roll material is one of the most terrifying things ever to have happened to popular music... I hope the gimlet-eyed men of commerce who are at present trying to bring about a Rock and Roll boom in this country are aware of what they are doing. I also hope that the BBC song committee will be more vigilant than ever when vetting the cheap, nasty lyrics on which the Rock and Roll movement thrives... It is a monstrous threat, both to the moral acceptance and the artistic emancipation of jazz. Let us oppose it to the end.[16]

Fortunately there were havens where musicians could live their lives free from both the authorities and pompous jazz critics. The Nucleus was one of them.

The Nucleus Coffee House was in a basement off St Giles High Street at 9 Monmouth Street. It was promoted as a 'meeting place of London's top jazz men, painters, writers, sculptors, poets (and layabouts)'. The club was open from midnight until 5 a.m., membership five shillings a year. Because of its opening hours it was a favourite among musicians as a place to go after work. They would drift in between 2 and 3 a.m. and often impromptu jam sessions would take place. The manager was Gary Winkler, who later took over from 'Little Bear' Sutton as washboard player for the Cottonpickers. The combination coffee bar and late-night club meant that a wide cross-section of Sohoites passed through: Angel, a transvestite who braved it out years before the public learned to accept such things, and an astrologer called George

with a long, flowing white beard who carried ancient charts with him which he would consult in order to read someone's horoscope. It was truly an oasis in sleeping London. The Nucleus is wonderfully described by tenor player Dick Heckstall-Smith in his autobiography, *Blowing*:

> The Nucleus was a coffee bar with a thriving jazz basement, a place where people would come creeping in – morose, subversive, in-group, overcoat-collar-turned-up exiles carrying strange shaped boxes – who would mumble and avert their eyes until, canonically, they came across a fellow outcast with whom to exchange incomprehensible mutterings and cynical half-looks. I was one of them.[17]

There was also the House of Sam Widges, run by the poet Neal Oram on D'Arblay Street, that catered to the Campaign for Nuclear Disarmament (CND) crowd and was filled with itinerant poets nursing cups of cold coffee. At the Partisan at 7 Carlisle Street, which opened in 1958 with the editorial offices of the Left Book Club above it, a huge noticeboard featured radical activity from poetry readings and lectures to concerts and CND demonstrations. It was decorated by an interior designer and was more modern and futuristic-looking than any of the other coffee bars. In the basement folk singers sang with their finger in their ear to hear themselves better, while, upstairs, chess players mused over complex end-games. It was the regular hangout for the playwright Arnold Wesker and the Centre 42 activists, but the noticeboard became dominated, more and more, by notices of demonstrations against nuclear weapons tests and the other activities of the CND.

CND was something which united the emerging London underground – art students and folk musicians, students and Hampstead intellectuals. There had been many organizations protesting against nuclear weapons tests, but in January 1958, at a meeting held in the residence of the Dean of St Paul's Cathedral, these groups formally amalgamated to become the Campaign for Nuclear Disarmament. One group, the largely pacifist Direct Action Committee against Nuclear War, had already begun organizing a march, to be held that Easter, from London to the British weapons-testing labs at Aldermaston, where they hoped to talk with the workforce and make them question what they were doing. CND was too recently formed to help organize the march but many of its members went and later that year they formally adopted the symbol that the Direct Action Committee had commissioned for the march. The symbol, which was to spread across the world to become universally known as the peace symbol, was created by Gerald Holtom, a Christian pacifist from Twickenham, where he had a design studio. Most of

his work was in designing tapestries and fittings for churches being rebuilt after the bombing. Charged with finding a shorthand design to express the idea of unilateral nuclear disarmament to be used in public demonstrations he came up with the now familiar symbol, a cross whose horizontal arms had dropped 45 degrees downwards. He explained that the symbol was made up of the British navy semaphore letters for N and D. One flag held vertically and the other pointing directly down signified N while two flags at 45 degrees from horizontal was D. Thus the symbol embodied an encoded message calling for nuclear disarmament. The enclosing circle signified the unborn child in Gothic symbology.[18] The first march was from London to Aldermaston but the next year, with CND in charge, this was reversed so that the final rally could be held in Trafalgar Square. In some circles it was inexcusable not to be wearing the small tin CND badge, white on a black background, or even better to have one of the original badges, made from ceramic and capable of withstanding all but a direct nuclear blast. As Alan Brien writing in the *Spectator* suggested, it was probably the case that the main attraction of the march was the 'tremendous stimulation of ideas and arguments and witticisms and friendships and love affairs. Perhaps it would be more tactful to keep this revelation a secret – but the Aldermaston March is the rare phenomenon of a physical and social pleasure which yet has an intellectual and moral justification.'[19]

As the fifties came to an end, London had changed. We now had espresso coffee bars, indoor plants, skiffle, jeans, full employment, jukeboxes, interminable detergent ads on a new commercial television channel, game shows, the *Goon Show*, widescreen cinema, horror comics, rock 'n' roll and sputnik bleeping overhead. Change was in the air, it was time to move on and build a new society. In 1958 Kenneth Allsop wrote that it was time for an end to all the anger:

> In this technologically triumphant age, when the rockets begin to scream towards the moon but the human mind seems at an even greater distance, anger has a limited use. Love has a wider application, and it is that which needs describing wherever it can be found so that we may all recognise it and learn its use.[20]

He was right, the next decade would be known as THE decade of love.

Part Two

10 The Club Scene

The room was rounded with seats and small tables ale-house fashion. One shilling was the price and call for what you pleased. There was very good musick.

ROGER NORTH, *The Musicall Grammarian*, 1728, on the first public concerts in London inns in 1672

The old guard were not happy with the way Soho and Fitzrovia were changing. The October 1961 opening of Peter Cook and Nick Luard's Establishment Club at 18 Greek Street was objected to vociferously by Colin MacInnes, who saw it as another of the enterprises that was killing Soho by making it commercial. When they mounted an exhibition of photographs by Robert Colquhoun, who in fact was often barred from the Establishment Club's doors, he wrote in *New Society*:

> The display seeks to create a legend profitable to the Establishment, irrelevant to Robert Colquhoun. This is the legend of Soho and of a 'Soho figure'. Both these existed until places like the Establishment moved in. Now Soho is dead, except commercially. Soho, at one time, owed its reputation to its people: now the area bestows a bogus reputation on almost anything.[1]

(One thing that didn't change was the £10 a week the Establishment paid to the Krays, though it was a token amount compared to that paid by the strip club that was in the building before; the Krays liked to be seen to be supporting West End culture.) It was the beginning of a transformation of the area: on the 25th of the same month *Private Eye* opened its offices in rooms next door to the Partisan in Carlisle Street (where it remains), and began a long tradition of lunches and drinks in the area. The Establishment Club brought over people such as the radical comedian Lenny Bruce and was very much a centre of ideas: TV shows like *That was the Week That Was*, which launched the career of David Frost, came from the people associated with the club.

*

The pubs and clubs began to be taken over by rock 'n' rollers. As Sara Maitland wrote in her memoir: 'Music was central, crucial I believe, especially in the early sixties, to creating and communicating a mood and meaning among people of my age. Far more than books, or even fashion, music was the marker, the expression of what we wanted.'[2]

British rock 'n' roll was born in a handful of small clubs in the early sixties. The Scene Club was in Ham Yard off Windmill Street in Soho, run by Ronan O'Rahilly, who later started Britain's first pirate station, Radio Caroline. It was the mod Mecca. They played white soul music till dawn in a dark smoky room. Peter Meaden took John Paul Jones, bass player with Led Zeppelin, to see the Who there for the first time. Jones: 'It was brilliant, the Scene, smoky, loud, and very punky in those days... It was all pills. Pop music was all pills in those days.'[3] The original amphetamine pill was Preludin, which was followed by what were known as blues in the jazz world but called purple hearts by rock musicians. These were Drynamil, speed, and could keep you awake for three days.[4] Later, when the TV show *Ready Steady Go!* started, the dancers were hand-picked from the regulars at the Scene. It was speed that produced the loudness, the swaggering about, the restlessness, energy and aggression. It caused the blocked stuttering and twitching that characterized the mods. It also lowered the sex drive and promoted obsessiveness: the fine detailing on their clothes – the number of buttons, how many inside pockets – became very important, as did the detailing on their scooters. Purple hearts were made illegal in 1964, which pushed the street price up from 6d to 9d (2½p to 3¾p).

The Flamingo, sometimes known as 'the Mingo' to regulars, run by Rik and John Gunnell, was at 33–37 Wardour Street, in the big square basement beneath the Whiskey-A-Go-Go (abbreviated in 1982 to the WAG club). The Flamingo was described by Andrew Oldham as catering to 'an exotic melange of Soho sex and underground sorts, gangsters really'. At the midnight to dawn All Niters John Gunnell was on the door and Rik's wife used to do the burger stand with Andrew Loog Oldham, who was on the after-midnight shift. On Saturdays it was the only place serving drinks through the night. They had no drinks licence so Scotch was served in coke bottles. The police, who were taking pay-offs, used to call ahead if they were going to raid. Because it was risky they only served alcohol on Saturdays; other nights you had to bring your own, though there were plenty of people with pockets filled with overpriced miniatures for sale, in particular a very sharply dressed West Indian couple called Big Time and Doll Girl who only sold whisky. The club was very popular with black American GIs, who distributed packs of Camels

and Lucky Strikes as if it was still wartime, earning the gratitude of the kids, some of whom had nowhere else to go until dawn. I would sometimes spend a night there before hitch-hiking back to the Cotswolds. By 4 a.m. the big concrete room was pretty bleak; there was nowhere to sit down and the crowd had thinned out so it was sometimes quite cold but the pills helped, and the wonderful music made it all worth while.

The Flamingo was funkier and jazzier than the other clubs. All the jazz-men who played R&B performed there: Georgie Fame, Geno Washington, Brian Auger, Sonny Rollins, Roland Kirk, Alexis Korner. The DJ played black R&B, early Atlantic and early Stax, and Ray Charles's 'What Did I Say' was played several times a night. The Mar-Keys played there, and Sugar Pie De Santo, who according to John Paul Jones put on 'a very risqué show'.[5] When blues singer Jimmy Reed (born in 1925) played the Flamingo the kids couldn't believe it was him, they idolized him so much. He and his manager were very wary, so much so that Jimmy didn't take his overcoat off the whole time he played. They were ready to grab the money and split because this kind of adulation had never happened before. The Gunnells managed Georgie Fame and His Blue Flames, Geno Washington and the Ram Jam Band and the vocalist Chris Farlowe, so they never had any problems finding acts.

Les Cousins, at 49 Greek Street, across from the Younger's pub, began life as a skiffle club. It was run by Andy Matheou for his father, a Greek Cypriot who owned the Dionysus restaurant above, probably the origin of the fishing net draped above the stage. The club was more in the folk and blues end of the spectrum as opposed to the Flamingo's jazz and R&B but it was still regarded as 'cool'. Bert Jansch, Roy Harper, Paul Simon, Ralph McTell, John Martyn, Eric Anderson, Ewan MacColl, Alexis Korner, Cat Stevens and Donovan all played there. Jimi Hendrix arrived with Chas Chandler at an all-nighter in 1967 organized by Alexis Korner, paying admission to get in, but then blew everyone off stage. Dylan was a visitor in the early sixties.[6]

The short-lived Ad Lib was one of the most celebrated of the early sixties nightclubs, probably because it was the first to cater specifically for the young rock 'n' rollers and their ilk; the other London supper clubs were more traditional, catering to an older, more international clientele. It opened in February 1964, in top-floor premises on Leicester Place off Leicester Square. It was reached by a small lift, which meant that people could not blunder in off the street. The club had previously been called Wips, a high society club owned by Lord Willoughby and Nick Luard from the Establishment Club. But despite its fur walls and tank of carnivorous fish not enough of the jet set came. They sold it to Bob and Alf Barnett, who installed John

Kennedy, to run it. He got rid of the fish and the fur and hung huge mirrors everywhere, knowing that his clients loved nothing better than looking at themselves. He replaced the chairs with stools and built banquettes along the walls, cut down the legs of the tables to coffee table height, and, crucially, installed a state-of-the-art sound system, which was operated at high volume. The ceiling was low, with inset coloured lights, but it was not claustrophobic because there was a huge window looking out over the rooftops of the West End. Marianne Faithfull says she used to like to spend a whole evening sitting there, looking out, talking to no-one. Drinks were miniatures, twenty-five shillings for the first and ten shillings after that; ice, a coke or soda was included. A steak and chips was about a pound. John Lennon was the first Beatle to go there, then came Ringo, and within seven weeks it was the in-place to be.[7] It was a transitional club catering for the newly emerging class of rock 'n' roll aristocracy, but also frequented by younger film stars like Michael Caine and people from the sports world. Only later were there enough rock stars to enable the Scotch of St James and the Speakeasy to provide suitable royal courts.

New bands were moving to town and these clubs were their stamping ground. Some were more bohemian than others. One R&B band, the Rolling Stones, started their London life living in total squalor, but it was this contrast with their middle-class upbringings that helped to bond them together as a group. Mick Jagger, Keith Richards and Brian Jones moved to 102 Edith Grove, SW10, in 1962. They had two rooms on the middle floor of the house, the rent paid for by Brian's job at Whiteley's department store on Queensway. It was at Edith Grove that the Stones encountered the legendary Phelge, whose name they appropriated for their song-writing pseudonym, Nanker-Phelge. Keith:

> You would walk into this pad and he would be standing at the top of the stairs, completely nude except for his underpants, which would be *filthy*, on top of his head, and he'd be spitting at you. It wasn't a thing to get mad about, you'd just collapse laughing. Covered in spit, you'd collapse laughing.[8]

Whiteley's eventually fired Brian for stealing and conditions at Edith Grove deteriorated rapidly. The kitchen smelled so much that they decided to seal it off and taped the door shut with gaffer tape; there was never anything to eat or drink in there anyway, not even tea, coffee or sugar. Mick and Keith moved to Mapesbury Road in September 1963 to share a flat with their manager, Andrew Loog Oldham, and Brian moved in with his girlfriend in Windsor.

In 1965, Brian moved to Elm Park Lane, a mews off Chester Street, SW3, and lived there for about two years. Keith often stayed there, having no place of his own, and divided his time between Brian's spare room and Mick's. John Lennon was one of the many visitors to the place and the machismo and misogyny of Jones and Lennon combined was sometimes so intolerable that, in order not to hear it, John's wife Cynthia would lock herself in the lavatory until it was time to leave.

In the early sixties London was also dotted with small private gay clubs: the Calabash in Fulham, run by the photographer Leon Maybank, was popular with film stars. Businessmen favoured the Festival off St Martin's Lane in Covent Garden because they had their own private key, like the Chelsea Arts Club, so they didn't have to wait outside and be seen entering. The Rockingham Club was favoured by old Etonians like the art dealer Robert Fraser. It had dancing on Sunday evenings but you had to bring a female to partner you. The A&B in Soho was predominantly filled with show business people; it stood for Arts and Battledress, having been started during the war when many patrons were in uniform. But because homosexuality was still illegal, and punishable by a long prison sentence, most gays preferred the privacy of private homes. Simon Napier-Bell wrote: 'As far as the music business went, the centre of the universe was Lionel Bart's house in Reece Mews.'[9]

Because Britain still had an official theatre censor, the Lord Chamberlain, who had to approve all scripts and had the power to make changes before they could be performed, the only way experimental improvisational theatre could be staged was in a private club. One of the earliest experimental spaces in London was In-Stage, started in 1958 by the American director Charles Marowitz, who persuaded Peter Carpenter of the British Drama League to allow him to convert a tiny studio at the top of their building on Fitzroy Square into an experimental theatre. The room seated about fifty. The audience gathered in an ante-room on the floor below, where Marowitz's girlfriend, Gillian Watt, served them tea and biscuits. When the actors were ready, the audience climbed, single file, up the steep narrow staircase to the rooftop studio. There was no admission charge and the actors were not paid, but Gillian stood at the bottom of the staircase holding a wicker basket as the audience left and some would drop coins into it. On good nights there might even be notes and on one remarkable occasion someone donated a 50-pound note, the first they'd ever seen. They mounted the British premiere of Samuel Beckett's *Act Without Words II*, William Saroyan's *The Cave Dwellers* and Arthur

Miller's *The Man Who Had All the Luck*. Marowitz: 'The fare was remorselessly off-beat and highbrow; and before long it became known throughout London that a night at the In-Stage would be oddball, idiosyncratic and different.'[10] Its regular audiences were the forerunners of the public who were to support experimental drama a decade later at the Roundhouse, the Soho Poly, the Jeanetta Cochrane Theatre, the Arts Lab and so on.[11]

When Marowitz arrived in London in 1956 he found it poverty-stricken and beaten down, still recovering from the war, but with the advent of the sixties London changed out of all recognition. He found there were so many new places opening up, so many new cuisines to try out, new people to meet arriving from all over the world, so many new ideas, and artifacts and trends to assimilate, that:

> it was if a small but dynamic segment of the population had invited the entire nation to a party and, because it was noisy and precluded the possibility of getting any sleep, neighbours felt obliged to leave the sedateness of their own homes and join in. Those who participated got an enormous charge out of the sixties; the po-faced grumps who shut their windows and pulled down the blinds never quite realised what they missed.[12]

One thing they missed was Britain's first happening. At the Edinburgh Drama Conference at the MacEwan Hall, organized by the publisher John Calder in 1962, Ken Dewey, Charles Marowitz and Mark Boyle enlivened a tedious and boring conference with a happening. Although there were many different elements to the nine-minute event, the one the papers naturally seized upon was the quick glimpse the audience got of a nude model – Anna Kesselaar – being whisked across the organ loft on a wheeled spotlight stand. As Adrian Henri later pointed out: 'Ever since then, the Great British Public has associated happenings with naked ladies.' It had the intended effect: fusty Edinburgh society was outraged and both Calder and Kesselaar were charged with various offences against public decency, which were later dismissed. Naturally, after this, happenings spread like wildfire.

In the fifties and early sixties, I and all my friends listened to Radio Luxembourg or the American Forces Network in Frankfurt, even though Luxembourg faded out, sometimes for minutes at a time, depending on weather conditions. There was no other way of hearing rock 'n' roll or R&B. Britain has no guaranteed freedom of speech and this applies particularly to the airwaves. The government has always retained complete control over who broadcasts what: the chairman of the BBC is appointed by the government, making

it essentially a branch of the civil service, though it likes to pretend it is independent (until someone criticizes the government too much; then heads roll). The commercial stations toe the line because they want their licences renewed. The BBC monopoly prevailed until the invention of the transistor radio. In 1960, less than 4 per cent of cars had radios but then transistors made music portable with transistor sets and cheap car radios. The BBC, however, made no adjustment to its programming. This is why it was a welcome breath of fresh air when on Easter Sunday, 1964, tens of thousands of people tuned in to hear Chris Moore and Simon Dee announce: 'This is Radio Caroline on 199, your all-day music station.' BBC Radio's monopoly was shattered and finally Britain had some music worth listening too. Within a matter of weeks Caroline had 7 million listeners. Until then, most young people had ignored the BBC altogether as it made no effort to cater to their needs.

The British public had always had to do this; before the war even though they were forced to pay for the BBC, the majority of listeners tuned in to one of the Continental stations: Radio Lyon or Normandy (home of Captain Plugge, whom we visit later), Radio Athlone, Radio Méditerranée and of course Radio Luxembourg. Despite the fact that the BBC could be heard loud and clear across the Continent, to listen to Continental stations in Britain was regarded as an affront. The government pressurized British newspapers not to print programme details of overseas stations, leaned on royalty organizations to overcharge them for playing copyright material, and suggested, subtly, that the BBC should not employ any artist or presenter who had worked on an English-language Continental station. In spite of all this, by 1938 the BBC only had 35 per cent of the Sunday listening audience – radio prime time – whereas Radio Luxembourg had 45 per cent, and the others divided up the rest. The war put an end to all this, of course, but after the war Radio Luxembourg staged a strong comeback, and probably had as many listeners as the BBC. The problem was that Luxembourg leased blocks of time to the major record companies, who only played their own releases, which were often dire. There was no room for independents, so no experimental or new music was played. Nonetheless, Luxembourg was hugely popular; anything rather than listen to the BBC.

The world of BBC radio producers consisted of light entertainment, mindless pap for the masses, and proper classical music for the middle classes who ran the country. Programmes for the former divided into *Housewives' Choice* for women, *Music While You Work* for factory workers, largely men, and *Children's Favourites*. The Northern Dance Orchestra, the NDO, played soulless, pathetic versions of popular hits when what the public wanted to

hear was the originals by Elvis Presley, Fats Domino or Little Richard. To hear one of the BBC orchestras – they had a number – grinding their way through 'Tutti Frutti' was enough to make you vomit. To listen to the Shadows themselves play their hits you had to sit first through 'Nellie the Elephant' and 'The Runaway Train' on *Children's Club*. The idea that teenage music was serious never occurred to the grey suits who ran the corporation. When the penny finally dropped, they found kindly patronizing-uncle types to act as comperes on *Saturday Club* as if they were running a youth club.

But then came the pirates. Ronan O'Rahilly found five city millionaires to back him in buying a ship, and hiring engineers, catering staff and two ten-kilowatt transmitters at £50,000 apiece. In launching Radio Caroline he described himself as being 'part of a revolution... against the establishment', and though it was an entirely commercial venture, he was.[13]

Seeing his success, a second ship, Radio Atlanta, opened up, mooring close to O'Rahilly's ship. He started up a second ship off Ramsey in the Isle of Man to reach audiences in Liverpool and Manchester. Then came Radio London, a well-financed American commercial operation, and a whole fleet of imitators: Radio Britain, Radio King, Radio Victor, Radio England, Radio 227, Radio 270 and Radio 390, the 'easy listening' pirate. Not to be outdone, Screaming Lord Sutch established himself on an abandoned fort in the Thames estuary and broadcast rock 'n' roll interspersed with readings from *Lady Chatterley's Lover*. They created an excitement about pop music that had not previously existed in Britain, helped, of course, by the fact that the music was coming from reconditioned boats, bobbing up and down outside British territorial waters, in storms and inclement weather. Listeners felt that the music must be important if people were prepared to put up with conditions like that to broadcast it. Once outside the three-mile territorial limit, the boats were in international waters, subject only to the laws of the country in which they were registered. Panama had no laws which forbade broadcasting.

The British establishment reacted in an entirely predictable manner. The sensible thing to have done would have been to recognize that the BBC had failed miserably in providing for this massive audience and to issue broadcasting licences to the pirates and let them get on with it. The money could have been used to fund more operas and live cricket matches, lectures by their cronies, and all the stuff the BBC liked. But the freedom to broadcast is not recognized in Britain, unlike the USA, so the government introduced new laws to close them down; but not immediately. Even they could see that this would be unpopular with the voters, a third of whom, 20 million people, were tuned in to the pirates. They needed to somehow discredit the romantic

pirate image they had and erode public support. The Radio London DJ Dave Cash said years later: 'they could not act against us... They needed something heavy like drugs or murder, we gave them murder.'

David (Screaming Lord) Sutch sold his Radio Sutch operation on the sea fort to his manager, Reg Calvert, who changed the name to Radio City. As the result of some business disagreement, a Major Oliver Smedley occupied Calvert's fort and the radio station. Calvert went round to Smedley's house in London and attacked him, throwing a heavy stone ornament at his head. Smedley produced a shotgun and killed him. It was the chance the government were looking for. They had just been voted in for a five-year stretch and the news of the murder portrayed the pirates not as romantic buccaneers but as murderous gangsters. The 1967 Marine Broadcasting Offences Act was quickly pushed through and became law on 14 August, making it illegal to supply, advertise or in any way aid the pirates, depriving them of staff, supplies and income. One by one they began closing down. The BBC launched its own watered-down pop channel complete with jolly station-ID jingles which they had to have recorded in America as they were incapable of making anything like that themselves. Many of the now unemployed DJs were forced to work for 'auntie'.

Ronan O'Rahilly, however, did not give up. In a long and convoluted series of operations, he reopened Radio Caroline with Swiss backing as Radio North Sea International. The Postmaster General, John Stonehouse, reacted by jamming their signal, just as the Russians jammed the BBC. Ronan O'Rahilly had thoroughly enraged the Prime Minister, Harold Wilson, over the years, and at one meeting he had screamed at O'Rahilly, telling him that he was 'finished'. This was a foolish move because the Labour Party had forgotten its own new legislation, which enabled young people between the ages of eighteen and twenty-one to vote. They constituted a major percentage of the 20 million listeners who had been deprived of their music by the arrogance of the Labour politicians. When the next election came around, O'Rahilly sent battle buses into all Labour marginal constituencies and pasted up tens of thousands of anti-Labour posters. He instigated a rolling telephone campaign to recruit anti-Labour voters and got supporters to jam the phone lines into Labour HQ with hoax calls. The Labour Party had been confident of an easy victory but instead they were voted out. Shortly afterwards, O'Rahilly accidentally bumped into Ted Short, a Labour politician on the street. Short recognized him and asked, simply: 'Why did you do it?'

'Listen, baby,' replied O'Rahilly. 'If you hurt Caroline, I hurt you.'[14]

11 The Beat Connection

I'm sure we'll have some fun yet in London.

ALEXANDER TROCCHI to William Burroughs, 12 October 1963

Happenings did not appear out of thin air; among their precursors in Britain were the mixed-media events staged by Brion Gysin, Ian Sommerville and William Burroughs, the first of which was a show called *Action Painting and Poetry Projection* held at the Heretics Club at Corpus Christi College, Cambridge University, in 1960. This was an attempt by Gysin – the principal organizer – to produce the 'derangement of the senses' that he and Burroughs had spent long hours discussing, by combining painting with sound poetry and light projections in a theatrical performance. In December 1960 they put on a performance at the ICA in Dover Street, where a light show by Sommerville using both slide projectors and an epidiascope was combined with a cut-up tape by Burroughs called 'Brion Gysin Let the Mice In', featuring, in addition to Burroughs's flat Midwestern voice, radio static and distorted Arab drumming, while Gysin pranced about the stage, painting a vigorous sloppy abstract on a huge sheet of paper. An enormously improved version of this performance was repeated at the ICA five years later, when, to Sommerville's great satisfaction, about half the audience left, unable to stand the volume of Burroughs's collaged recordings of pneumatic drills, radio static and wailing Moroccan flutes. At the end of the performance, Brion slashed the painting to pieces, causing several small cries of alarm among the already jittery audience for whom this was tantamount to a book burning.

Brion Gysin added a touch of the pre-war, high-modernist, European avant-garde to the London scene with his reminiscences of the expulsion of his paintings from a Surrealist exhibition in 1935 on the instructions of

André Breton, who thought the large calf's head in Gysin's poster looked rather too much like himself; of his friendship and travels with Paul Bowles; of buying his marijuana from Billie Holiday in New York, and providing Alice B. Toklas with the recipe for hashish fudge she used in her celebrated cookbook: 'She neglected to say you had to cook it!' He was described by Allen Ginsberg – though not to his face – as 'a high tea-cup queen', which Ginsberg explained thus: 'wherever you go in the world there will always be an old queen who knows where to get the best antiques, the best rugs, the best olive oil and the friendliest boys. Brion's like that.'[1]

Gysin was born in Taplow, Buckinghamshire, in 1916, was raised in Canada, became a naturalized American, and lived most of his life in Tangier or Paris. His longest periods in London were in the early seventies, when he moved into William Burroughs's building in Duke Street, St James's. His impact on sixties London came largely through his sound poetry:

> I understand poetry really mostly as is called in French *poésie sonore*, and what I preferably have called 'machine poetry,'... I don't mean getting up there and saying it once off, or declaiming it, or even performing it the way people do nowadays, but actually putting it through the changes that one can produce by tape recording and all of the technology, or even the just *minimal* technology that one has had in one's hands in the last few years...[2]

In 1959, Gysin had accidentally discovered the cut-up technique by slicing through a pile of newspapers while mounting a picture and noticing the different slivers of newsprint could be read as a text. Burroughs took this technique and began to collage together his own writing with that of Rimbaud, Shakespeare, *Time* magazine and any other texts on his bookshelves, some of which were published the next year as *Minutes to Go*, an anthology of cut-ups by Burroughs, Gregory Corso, Sinclair Beiles and Gysin. In 1960, George Macbeth, the Director of Talks at the BBC Third Programme, came across a copy and thought that Gysin's permutated poems would be suitable for broadcast. He contacted Gysin, who was living at the legendary Beat Hotel on the rue Gît-le-Coeur in Paris, which was also then the home of William Burroughs. Anxious to get his hands on some sophisticated sound equipment, Gysin waited until the summer, by which time the BBC had installed a new eight-track machine in their 'Footsteps' studio in Shepherd's Bush. This was where the BBC recorded the sounds for their radio dramas: the squeaking floorboards, the galloping horses, flocks of birds and striking matches, all of which required skilled sound technicians to record and implement as they needed very elaborate overdubbing.

Gysin's producer was Douglas Cleverdon, who had made the acclaimed recording of Dylan Thomas's *Under Milk Wood*. They spent three days recording a 23-minute programme, devoting a whole day to *I Am That I Am*, which involved speed changes, very difficult to achieve in those days. At one point Cleverdon was slowing up the machine gradually by pressing his finger against the capstan. To speed it up they would record the section backwards then slow it down. When played correctly it would become a speed-up. These techniques were done dozens of times and layered on the multi-track tape in what must have been the most complex overdubbing ever attempted by the BBC. *The Permutated Poems of Brion Gysin* had the second-worst reception ever received from the BBC's panel of listeners. However, as the worst was a programme by W. H. Auden on the state of Britain, Gysin was in distinguished company.

That same year, 1960, Gysin met a young English film-maker in Paris. At the age of ten Antony Balch screened his home-made films in his living room, charging the family admission and preceding the main feature with a rented newsreel. His mother, Delta, worked in the film industry and he grew up fascinated with all aspects of the business, from exhibiting to distribution to editing and film-making itself. He worked as a production assistant on television commercials, which gave him experience in lighting, print grading, cutting, editing and eventually directing; the first film he made was a television commercial for Kitekat cat food. He bought a 35mm wartime De Vry camera and in 1959 shot footage of an old would-be ballet dancer dancing under the bridges of Paris, and of his friend Jean-Claude de Feugas naked on a funereal couch with candles all around him. Balch: 'It was terribly pretentious.'[3] He was disappointed with the footage and never completed it. He also wrote reviews for *Continental Film Review* and ran two London cinemas: the Jacey on Piccadilly and the Times in Baker Street.

Balch was tall and slim and his manner was somewhat stereotypically camp; he had full wet lips and a rather arch way of speaking with a public school accent. He was always beautifully dressed. He and Brion Gysin became good friends and in the course of their conversations, Balch became more and more intrigued by the cut-up technique, seeing it as a way to cut through to a deeper reality. He was impressed by Burroughs and Gysin's early experiments with cutting up political speeches and they were amazed at how the real intentions of the speaker – usually insidious – came through; a case of literally reading between the lines. Over the next few years Balch was to adapt the technique to film-making and made three experimental films: *Towers Open Fire*, *The Cut Ups* and *Bill and Tony*, the latter featuring just himself and

Burroughs in a film designed to be projected on to their actual faces while their lips synched the voice of the other person.

Towers Open Fire was Burroughs's first acting job. In it he plays Colonel Bradley, a commando figure dressed in camouflage fatigues, tin hat and gas mask, and armed with a large ping-pong ball gun bought at Hamley's toy shop in Regent Street. Another section, filmed in January 1963, featuring Alexander Trocchi, was shot in the boardroom of the British Film Institute. Burroughs and Ian Sommerville, then his boyfriend, assembled the sound-track in their room at the Empress Hotel in London using Gysin's recordings of Jajouka trance music, radio static and Burroughs reading from his own text of the same name which finally appeared in his novel *Nova Express* in 1964. There was no synchronized sound, as such, though the radio static corresponds, more or less, with white noise static on screen. Balch: '"Towers Open Fire" went round to the censor, and the exception slip said "Remove words fuck and shit". So I had to, for the English version.'[4]

But the most important collaboration with Burroughs and Gysin was *The Cut Ups*, in which the cut-up idea is taken to its final, logical conclusion. Balch had about twenty-five minutes of film of Burroughs and Gysin, shot at the Beat Hotel in Paris, the Hotel Chelsea in New York, the Empress Hotel in London and the Hotel Muniria in Tangier, from the abandoned, unfinished *Guerrilla Conditions* and he used this as the basis for the film. In addition to a normal print, he had about half of it printed in negative. Lengths of film, usually from the same shot, were superimposed on each other out of sequence. Sometimes three separate lengths of film would be superimposed, and sometimes negative film would be used. The triple and negative superimpositions were done last and included footage taken from other films, such as *Bill Buys a Parrot*, a 16mm colour short filmed in August 1964 at John Hopkins's house in Tangier. Burroughs and Balch simply showed up one day and asked if they could film Bill talking to Coco the parrot. The footage appears in black-and-white negative in *The Cut Ups*. Then all the assembled footage was literally cut up.

Balch explains:

I cut the original material into four and then gave it to a lady who simply joined it... [she] was employed to take a foot from each roll and join them up. I didn't actually make the joins; they were a purely mechanical thing for laboratory staff. Nobody was exercising any artistic judgement at all.[5]

The length of the shots except for the last is always a foot, the only variations being when a shot change occurs within one of those foot-long

sections. Balch: 'That's rather like a train going over points.' A foot was long enough for people to see what's there, but not to examine it in detail. Ian Sommerville, Brion Gysin and William Burroughs recorded the soundtrack. The film was 20 minutes and 4 seconds long so they produced permutated phrases to just that, including the final 'Thank you'.[6] The text consisted of quotes from the Scientology classes which Burroughs was attending at that time in London.

The Cut Ups screened for two weeks at the Cinephone in Oxford Street, where half the audience loved it and the other half hated it. People sat head in hands, members of the audience ran out to complain, saying: 'It's disgusting', to which the staff would reply: 'It's got a U certificate, nothing disgusting about it, nothing the censor objected to, what are you objecting to?' Balch: '*The Cut Ups* is too long, though; the 12 minute version was much better... We shortened it because Provior and the staff had to put up with this five times a day: it was alright in the evenings when they got an appreciative audience, but in the afternoons customers would walk out.'[7] The assistant manager, Roy Underhill, told Balch that during the run of *The Cut Ups* there was an extra-large number of articles left behind in the cinema – hats, coats, bags, shoes – forgotten in the hurry to leave.

Even now Balch is rarely acknowledged as the first of the British sixties experimental film-makers, probably because he exhibited in ordinary cinemas. He was never part of the underground film-makers' community; he did not want to join the London Film-Makers Co-op when it started and he was probably not invited. Balch: 'I find I operate best when I'm doing it all myself... it's a matter of temperament.'[8] From the very beginning he had decided that he had to be his own producer, director, editor, distributor, cinema exhibitor, businessman and everything else. He said: 'I hate being turned down, as it were, and so I'd rather turn myself down.'[9] Balch was not just a precursor of the British underground film-makers, *The Cut Ups* deconstructed the whole process of film-making; his ideas were a good deal more radical and challenging than most film-makers that followed him, but the combination of cut-ups, an illegal sexual preference, and a friendship with both Burroughs and Gysin – then seen as dangerous drug-taking characters – made most people shy away. Not that Balch wanted to be a part of an underground film-making scene; he saw them all as scruffy hippies who, instead of just getting on with it, were always bleating about getting grants. He preferred his independence and his own smart high-flying gay friends. They were two different worlds.

An influential, though largely inactive, figure on the sidelines of the London scene in the sixties was the novelist Alexander Trocchi, who had made a name for himself in the fifties as the editor of *Merlin* magazine in Paris, where he also helped to revive the career of Samuel Beckett by publishing his novels in Merlin Editions. From there he went to New York, where he moved in Beat Generation and Greenwich Village circles, lived on a barge or scow on the Hudson River and took heroin; this was the subject of his 1960 novel *Cain's Book*, the powerful personal testimony of his addiction assembled from his notes by his wife Lyn. Trocchi returned to Britain after escaping from the United States in April 1961 by jumping bail and using his friend Baird Bryant's passport to reach Canada. George Plimpton was left to pay the $5,000 bail bond that he had unwisely guaranteed. Police had found a heroin prescription in Trocchi's name that he had given to a sixteen-year-old girl and he had been arrested for supplying drugs to a minor, an offence punishable in New York State by death in the electric chair; Trocchi was guilty and the police would have made it stick.

The writer Ned Polsky remembered Trocchi's time in New York:

> In one sense Alex was an evil man, because he made junkies out of people. Alex begged me, on more than one occasion, to try heroin... there were plenty of weak-willed people, including some of the women he was involved with, whom he turned into junkies. That was a terrible thing. Given the lives that junkies had to lead then, and still do, it was condemning them to a terrible life and I felt that was an evil thing. Heroin became the focus of all his objections, all his anarchistic existentialist objections to the powers that be and anything he could do to promote it, he did.[10]

Polsky and Trocchi eventually fell out because Trocchi asked Polsky to forward letters to Lyn Trocchi. She was living with her parents, trying to get off heroin, and her parents were opening any letters coming from her husband. Trocchi enclosed heroin for her in the letters, which not only endangered Polsky, who was being used as an unwitting courier and could have gone to jail had US Customs intercepted the letter, but also angered him. Polsky saw it as a clear case of Trocchi trying to undermine Lyn's efforts to stay off junk.[11]

After some problems with the law in Glasgow, Trocchi, now joined by Lyn and his young son, Marcus, moved to London in March 1962 and rented a flat in Kilburn. He made a little money as a reader for Weidenfeld and Nicolson and did the occasional lecture or broadcast. Until then Trocchi had spent very little time in London but he was assisted in getting to know the city

by Guy Debord, the founder of the Situationist Internationale (SI). Trocchi's involvement with the Letterist International in Paris from 1955 onwards had made him an early member of the SI. He survived a remarkably long time, not being expelled by Debord until 1964. Trocchi told Greil Marcus:

> I remember long, wonderful psychogeographical walks in London with Guy... He took me to places in London I didn't know, that he didn't know, that he sensed that I'd never have been to if it hadn't been with him. He was a man who could discover a city... There was a magical quality to Guy. Distances didn't seem to matter to the man. Walking in London, in the daytime, at night, he'd bring me to a spot he'd found, and the place would begin to live. Some old, forgotten part of London. Then he'd reach back for a story, for a piece of history, as if he'd been born there.[12]

Trocchi and Lyn moved to flat in Baring Street, north of now fashionable Hoxton, found for him by his new friend Michael de Freitas, the slum-landlord Peter Rachman's enforcer. De Freitas quickly found him a better place in Notting Hill, in St Stephen's Gardens at the top end of Chepstow Road, the heart of the Westbourne Grove 'scene'. There was a pleasant balcony, where Alex and Lyn could sit outside and play with Marcus, now six years old, and Alex could pipe-dream about world domination.

In 1963 he came up with a magnificent junkie idea: Project Sigma. In essence this entailed Alex taking credit for other people's ideas and actions by adding them to his 'Sigma Portfolio', a cheaply mimeographed set of documents available only by paying a hefty subscription. Alex was a very persuasive writer; he would have done well in advertising. His sales pitch for the *Sigma Folio* was masterful:

> The sigma portfolio is an entirely new dimension in publishing, through which the writer reaches his public immediately, outflanking the traditional trap of publishing-house policy, and by means of which the reader gets it, so to speak, 'hot' from the writer's pen, from the photographer's lens, etc. In a sense you might be said to be subscribing to an encyclopaedia in the making; in another sense you will be participating in a tactical historigem, to coin a word. In subscribing to the sigma portfolio, you are stimulating the growth of an interpersonal log constructing itself to alert, sustain, inform, inspire, and make vividly conscious of itself all intelligence from now on. You will receive various future informations and tactical objects and can judge for yourself at what points you can participate. Again, the portfolio is what we call a 'futique' (what will be prized as an antique tomorrow); you will possess

a first edition of this new dimension of publishing, the expanding file of our activities.[13]

The majority of people who should have been his readers could not afford the high-priced subscription, and when new pages were added to the portfolio, few subscribers received them because Trocchi inevitably could not afford the postage to send them out. Whether he ever actually believed in it is hard to determine. The couple in the flat below Trocchi in Westbourne Grove, Marcus and Sally Field, became good friends. Marcus became Trocchi's 'secretary', taking care of the of burgeoning paperwork generated by Sigma, though a secretary was hardly needed to help bring out a mimeo magazine one page at a time; there wasn't even any collation to do and Alex naturally got people like Jeff Nuttall to do all the actual mimeograph printing. In three years he produced thirty-nine pamphlets, often single pages, many of which were simply given to him ready-made by the author or by another publisher – *The Invisible Generation* by William Burroughs, for instance, was first published in *International Times*, where it reached a probable 50,000 people but Burroughs asked that an offprint be run off to be given to Trocchi as he had been pressuring Burroughs for a text for months. About a hundred were distributed by Sigma.

William Burroughs told Allan Campbell:

I wasn't ever involved with it really and it never went anywhere at all. ... I think in many ways it was just an excuse not to write. ... as far as I know he never wrote a book after Cain's Book. ... It was a big idea of getting all sorts of pivotal people together, like Ronnie Laing and, I don't know, others. ... Sigma never got off the ground.[14]

However, Trocchi's flat rapidly became a centre of underground activity, with visiting American poets such as Robert Creeley, Jack Micheline and Gregory Corso dropping by, as well as local Notting Hill artists and activists, house guests and, of course, drug addicts and dealers. When Burroughs moved to London in 1965, he was still using heroin: 'When I met him in London, he used to help me shoot up. See my veins were gone in my arms. Old Alex could find a vein in a mummy.'[15] A visit to Trocchi's pad was not for the faint-hearted as he was an exhibitionist junkie who loved to shoot up in public, once even attempting to do it on American television. Trocchi:

One thing that heroin does for me, is I am immediately transported into a world where I am immune from all these worries that besiege me. I can then, without the least diminution in the sharpness of my intellect, apply

my whole intellectual... and emotional organism to whatever problem is at hand. At the same time, experiencing a tremendous, artificial if you like, but tremendous elation, and an inviolability. Things that come from the outside don't worry me. I see them as not important to the problem in hand. And therefore, I am able to... with this very good feeling inside me, to get on with the job.[16]

Trocchi was full of plans and in many ways this must have been the happiest time of his life since his days in Paris. He was so relaxed that he even returned to his old hobby of collecting stamps. Despite the fact he had no art training, he lectured at the sculpture department of St Martin's School of Art, but mostly he cultivated his image as London's premier junkie so that whenever a radio or television producer needed 'the junkie viewpoint' Alex would be wheeled out to pontificate – for a fee. He was very good at it. In his autobiography Christopher Logue remembered:

When he was invited to appear on television to justify his views, he began by announcing his self-appointment as Drug Addict to Her Majesty the Queen. Then defended his right to take any drug he chose to take. The murderous behaviour of most modern states – Auschwitz, Katyn, Hiroshima, Dresden – having led him to find contemporary societies so vicious, any drug that weakened the loyalties they aroused was holy, a blessing.[17]

Had Sigma actually amounted to something, it would have inevitably ended in chaos because Trocchi would not have been able to work alongside anyone. As Ned Polsky said: 'Alex didn't want to be part of any political party, Alex wanted to be the star of the show.'[18]

In 1966, Alex and Lyn moved to a luxurious penthouse apartment in Observatory Gardens between Holland Park and Kensington Church Street. The rent was only £245 per annum but Trocchi had to find £1,000 key money. It was a fortuitous discovery and quickly became another centre of cultural and drug-taking activity. Alex presided over his visitors in a wonderfully gloomy book-lined study. The shelves were fronted by his painted 'futiques', driftwood painted in garish primary colours, crushed paint tubes, used syringes, and discarded manuscripts and papers littered the floor, over which prowled the Burmese and Siamese cats that he loved. Trocchi took to wearing a long purple, green and blue embroidered gown and a tasselled fez or smoking cap. Near to hand was a large hookah, the brass mouthpiece of which he used to gesture at his guests. He certainly had a high opinion of himself and could be rather humourless should anyone contest it.

Lyn was quoted as saying: 'Alex, who is a great man, but no bargain, says "I will not tolerate a world that rejects me." He thinks he is God, he really does.'

Though he was getting his heroin and cocaine legally from Lady Frankau's clinic in Wimpole Street, the police still focused their attentions on Observatory Gardens because they knew him to be supplying others. One raid netted £2,000 in jewellery, stolen from the Hilton Hotel by one of Trocchi's house guests. The police also found opium and residue of hashish in the hookah but by now Trocchi was the recognized authority on drugs, the BBC's 'tame junkie'. Trocchi knew many public figures and police found it hard to make charges stick against him because he claimed to be giving 'drug advice and counselling', even though in reality he was trying to get as many people addicted as possible. Dan and Jill Richter were finally persuaded to try heroin by Alex with disastrous results. They lost a child and Dan remained hooked for many years. Lyn herself lost a baby when she accidentally suffocated it in the night. Normally a mother's reflexes prevent her from rolling on to her child, but her senses were so dulled by heroin that the baby died. It was attributed to cot death. After several heroin-related breakdowns, Lyn herself died on 9 November 1972 of liver failure caused by hepatitis. Then, at the age of fifteen, Alex and Lyn's son Mark was diagnosed with throat cancer and three years later, on 21 May 1977, he too died. Being around the Trocchis was not a life-enhancing experience. Trocchi himself died of pneumonia on 15 April 1984, followed nine months later in December by his eighteen-year-old son, Nicholas, who committed suicide by jumping off the roof of Observatory Gardens.

The mimeographing for the Sigma portfolio was done by Jeff Nuttall on the school duplicating machine where he taught art in Barnet, in North London. One of his fellow teachers, a poet and cultural organizer, Bob Cobbing, was also using it, in his case to publish poetry booklets in his Writer's Forum series. Nuttall quickly saw the possibilities:

> I turned out *My Own Mag: A Super-Absorbent Periodical* in November 1963, as an example of the sort of thing we might do. My intention was to make a paper exhibition in words, pages, spaces, holes, edges, and images which drew people in and forced a violent involvement with the unalterable facts... You can't pretend its not there if you're throwing up as a result.[19]

Nuttall used vomit, shit and piss as ways of shocking his readers into some clearer view of reality; unfortunately his own sexual obsessions, such

as his fixation on stockings, suspenders and old-fashioned ladies' bloomers, tended to make the results more amusing than shocking, scatological though they were: more Donald McGill than Hans Bellmer. However, his drawings of vomiting individuals were a sort of precursor of the bad behaviour of the punks.

He wrote to William Burroughs, then living in Tangier, to ask him to contribute to *My Own Mag*, recognizing that what Burroughs was trying to do with *Naked Lunch* was make people see what was 'really on the end of the fork'. Burroughs agreed with Nuttall's belief that individuals needed to be shocked into seeing the true horror of the human condition and for several years became his most regular contributor, often using the last two pages of the magazine as his own newspaper called *The Burrough*. When they finally met, they found they had little in common; Nuttall was not interested in drugs or guns, Burroughs's two major preoccupations; nor was he gay. Nuttall's working-class nostalgia for pubs and old men in cloth caps supping their pint cut no ice with Burroughs, who bemoaned the lack of service in British bars, the early closing times, the tiny measures, and the lack of ice; 'The only service you get in Britain is Senior Service,' he growled (referring to his brand of cigarettes).

Aside from *My Own Mag*, Nuttall's main contributions to the London scene both involved Better Books, the avant-garde bookshop at 92 Charing Cross Road on the corner of New Compton Street. Throughout the fifties and early sixties this was where the Angry Young Men came to catch up on the little literary magazines; where the directors and actors involved with the British Free Cinema came to buy copies of *Cahiers du cinéma* and obscure imported Hollywood titles; it was where Beatniks could find everything published by City Lights Books and artists could catch up on the latest abstract expressionist works in the American art magazines.

Better Books was opened by Tony Godwin and John Clarke in the autumn of 1947. John Clarke had trained as an actor at RADA and served in the Intelligence Corps and later the Combined Forces Entertainment Unit. After a year of bookselling, he left Better Books, taking the stage name of Bryan Forbes to become a successful actor and appearing in Michael Powell and Emeric Pressburger's *The Small Back Room* (1948). Bryan:

> When I came out of the Army I had a small gratuity, I think about 250 quid, which I'd accumulated, and I fell in with a friend of mine called Tony Godwin, who ran a wonderful bookshop called Better Books in Charing Cross Rd, and I went into it with him. And it was really him and his assistant Ken Fyffe... who

led me to people like John O'Hara, Hemingway, Dashiel Hammett, you name it. They widened my reading horizons.[20]

Better Books quickly became a regular meeting place for writers, including Denton Welch, Gerald Kersh and Osbert Sitwell, and the nude photographer Harrison Marks, whose studio was on nearby Soho Square.

In November 1964, Tony Godwin enlarged Better Books, taking the three shops at 1, 3 and 5 New Compton Street adjoining the original shop on the corner with Charing Cross Road to use as a dedicated paperback bookshop – paperbacks had only recently become acceptable in Britain and some companies, such as T. S. Eliot's Faber & Faber, still coyly referred to theirs as 'paper covered editions'. He hired Germano Facetti, who had designed David Archer's Greek Street bookshop a decade before, to design the shop. Facetti was now working in the art department at Penguin, where Godwin was editor-in-chief. Godwin wanted number 5 to be used as a coffee shop and space for readings, film shows and drama, but wanted the whole shop space to be flexible. He had a vision of books 'floating in a silver mist'. Facetti devised large freestanding bookshelves on wheels that could be pushed to one end of the room, freeing up the space. These were made of expanded metal grilles, weighed an enormous amount, and were designed only to take Penguin-sized books – Facetti had not examined the actual stock and had made no allowance for trade-size paperbacks. Consequently many of the books were damaged by being forced back on the shelves, which were sprayed silver. The silver paint rubbed off on the books, leaving a black mark, and the expanded metal sometimes cut the books or the customers' fingers. Sometimes the units fell over if someone leaned against them. They were a disaster.

Facetti's graphic design was better; he did some nice contemporary-feeling paper bags, bookmarks and, a wonderful innovation in bookselling, huge display posters for the local tube stations. Godwin installed the American poet Bill Butler to be the manager and the paperback section opened. Facetti's design for the coffee room was also a bit of a catastrophe as the surface of the tables was made up of different shapes and colours of wood like a Joe Tilson, which looked nice but they were not level. Neither was the floor. The tables wobbled and the horrible chewed plastic beakers of tea and coffee spilled their contents over the books, rendering them unsaleable.

As soon as the new department was open, Jeff Nuttall asked if he and his collaborators could put on a happening in the form of an installation, to be housed in the basement of the new store. Godwin agreed and by

Christmas, 1964, work was underway on sTigma, as they called it: Sigma without Trocchi. Working with Nuttall was Bruce Lacey, whose experience with bubble-blowing robots was invaluable, and the artist John Latham, who, after a fire at Better Books, had been given the charred and singed books, which he made into book towers and other constructions involving damaged books that he called Skoobs – 'books' backwards. One construction, tall chimneys made from burning books, evoked both the nazi extermination camps and nazi book burnings in one very powerful image.

To enter the sTigma environment it was necessary to squeeze through three doorways built by John Latham, the frames of which were composed of old copies of the *Economist*, spines attached to the door jamb so that the pages filled the passage and you had to push through them. The last door was very narrow and completely blocked by the magazines which were mounted at an angle making it possible to push through, but impossible to return, trapping the viewer on the far side like a wasp trap. Viewers now found themselves in a passage made by Jeff Nuttall and lined with his characteristic sado-erotic, scatological images: photographs of war atrocities, bloody heads, pornographic Victorian postcards, stained underwear, tangled soiled clothing, sanitary towels, and used condoms. The corridor narrowed and grew dark; this section was built by Nick Watkins. As it was impossible to turn back, the participant had to enter an area of complete darkness, filled with sponge rubber, wet bread, tin and glass, before entering a zigzagging polythene tunnel, made by Bruce Lacey, through which could be glimpsed a room with figures, also by him. The figures surrounded an anthropomorphic dentist's chair with sponge rubber breasts, a shaven head and, on the seat of the chair, a bedpan lined with hair and containing slabs of cod's roe, through which detergent bubbles spluttered, representing an offensive and extremely misogynistic depiction of a cunt. After four weeks the smell was probably a health hazard. Much of the inspiration for the installation came from reports from America of happenings by Claes Oldenburg and Allan Kaprow and of Robert Delford Brown's 1964 *Meat Show*, which involved gallons of blood and about a ton of meat and had received a lot of publicity.

A corridor of flickering television sets led to Dave Trace's greasy spoon café, containing the festering remains of a meal. Next to this was a suburban living room filled with china dogs and ornaments installed by Jeff Nuttall; the sideboard drawer contained human toes. Unseen speakers relayed the voices of William Burroughs, Alexander Trocchi, Mike Osborne's sax-playing and snatches of the BBC. After exiting down a corridor of old clothes, made by Keith and Heather Musgrove, the route took one through a red womb

cylinder, filled knee-deep with chicken feathers. The only way out was to crawl down a vaginal tunnel made from rubber inner tubes, liberally scented with Dettol. People emerged into a maternity room in a cloud of feathers to see a plastic model of an aborted foetus nailed to the wall surrounded by Catholic and political propaganda, presided over by a smiling photograph of the celebrity BBC DJ David Jacobs. By the time the event was half over, Bill Butler had left to start his own Unicorn shop in Brighton and I had taken over as manager of the paperback section. I got to know the installation very well as staff had, on occasion, to enter in order to rescue members of the public who were so nauseated by the images or the smell or both that they had hysterics and began screaming. The organizers were initially satisfied with the results but, as the weeks went by, obscene graffiti appeared, the installation was vandalized, the entrance money was stolen, and guitar-strumming hippies squatted the living room.

Nuttall: 'We realised by the graffiti that what was hell to puritans was heaven to sadistic fetishists, as the toes we had reeled from and steeled ourselves to use were drawn on the living room walls in erotic contexts.'[21] sTigma closed at the end of March 1965 to the great relief of the bookshop staff and myself, who were fed up with pacifying upset customers, with the feathers being tramped all through the shop, with books being defaced by unstable members of the public who raved and threw coffee about after emerging from the womb tube, and most of all with the stink of the rotting fish. Even Tony Godwin realized we had a point.

12 The Albert Hall Reading

**It was dark on stage, and we were looking up at this huge crowd.
It was the first time we got into the realms of rock concerts.
Since then there have been huge readings all over the world.**
LAWRENCE FERLINGHETTI[1]

It changed poetry for ever in the UK.
ADRIAN MITCHELL[2]

The 1965 Albert Hall poetry reading *Poets of the World/Poets of Our Time* has taken on perhaps more significance than it deserves, but it was nonetheless a key event in the creation of what became known as the London underground. Peter Whitehead made a documentary film of the event and called it *Wholly Communion*; over the years the event itself has come to be known by this title even though this was not the name of the actual reading. The evening came about as a direct result of a reading given by Allen Ginsberg at Better Books. I had not long taken over as manager from Bill Butler after working next door at Joseph Poole's academic bookshop. As I spent all my breaks and lunch hours in Better Books, I got to know Tony Godwin, the owner, and he hired me when Bill left, knowing I would continue the tradition of readings and events. Bob Cobbing, who joined the staff just after me, organized screenings of films such as Kenneth Anger's *Fireworks* (1947), made when he was only seventeen; Ian Hugo's *Bells of Atlantis* (1952), featuring a bare-breasted Anaïs Nin, that was supposedly banned; *Dog Star Man* (1964) by Stan Brakhage; and films by Jean Cocteau and other hard-to-find classics. I organized a 'pataphysical' evening to launch a collection of Alfred Jarry's work and arranged readings by Stevie Smith and Basil Bunting, as well as a fun evening of Diana Rigg reading the poetry of William McGonnagall, 'the world's worst poet'.

Tony Godwin had an arrangement with his friend Lawrence Ferlinghetti that he would ship us boxes of City Lights publications in return for boxes of used Penguins, which Tony seemed to be able to acquire in enormous numbers. I extended this arrangement by making a similar deal with Ed Sanders,

owner of the Peace Eye bookshop in New York, and so from time to time we received a box containing battered mimeo magazines with titles like *C, Lines* and *Mother*, all of which I immediately contacted for back issues. Sanders himself was the publisher of the Fuck You Press editions, which, in addition to his excellent poetry magazine *Fuck You, a Magazine of the Arts*, with work by Ginsberg, Burroughs, Fainlight, Berrigan and so on, published titles such as W. H. Auden's homoerotic *The Gobble Poem*, an anthology called *Bugger* and Sanders's own collection, the *Toe Queen Poems*. Godwin was ecstatic: 'Where do you *get* these things?' he marvelled. On a more commercial angle, I also ordered Henry Miller paperbacks directly from the States, technically not allowed into Britain, but the Grove Press warehouse staff didn't realize this and we regularly received boxes of fifty copies of Henry Miller's *Sexus*, which was still not published in the UK. I would put twenty-five on sale at ten shillings and, with Godwin's approval, take the others to the dirty-book shop on the corner of Moor Street and Old Compton Street, where they would pay me £2 10s each and sell them for £5. This extra income covered the cost of the obscure poetry magazines I was importing, which were hardly bestsellers.

When Allen Ginsberg set off on his travels in 1965, Ed Sanders gave him my name as a contact if he finished up in London. After being deported from Cuba to Czechoslovakia he went from there to Moscow and Warsaw. He returned to Prague, where he was crowned King of May, then deported to London after the secret police stole and read his diary. And so, one day in May, he strolled into Better Books and asked for me. We arranged an impromptu reading, which, even though we made no announcement, was so packed that a crowd of people listened through the open door. Andy Warhol, Gerard Malanga and Edie Sedgwick, visiting on their way to Rome, sat in the front row. Donovan and his friend Gypsy sat on the doorstep and provided the pre-reading entertainment: 'Cocaine, all ar-round my brain...' While in Cuba earlier in the summer, Ginsberg had met Tom Maschler, an editor at Jonathan Cape, and was staying with him in Hampstead. Hospitable though Maschler was, to Ginsberg 'Hampstead is like being stuck out in Queens' so he moved in with my wife and me in Fitzrovia, ten minutes' walk from Better Books. Each day he sat in the back room at the wobbly wooden tables, giving interviews and advice, chatting with people and enjoying the Charing Cross Road scene.

One afternoon he was surrounded by a group of people including the American poet Dan Richter, who had recently arrived in London from Athens, where he and his wife Jill had run a bookshop and published the literary magazine *Residu*. Also there was Barbara Rubin, Ginsberg's 'occasional'

girlfriend, who seemed to have followed him to London. We were discussing the success of Ginsberg's reading when he told everyone that both Lawrence Ferlinghetti and Gregory Corso were due in London; naturally the idea of a reading came up as there had never been a major Beat Generation reading in London before. Better Books was far too small. Barbara, in her usual exuberant way, asked: 'What's the biggest venue in town?' to which my wife Sue replied: 'The Royal Albert Hall.'

Barbara strode to the cash desk, grabbed the phone and within minutes had booked the hall for ten days' time. The rent was £400 plus £100 an hour over-run time. At that time I was earning £12 a week at Better Books so these sums were astronomical. This was where American positive thinking, to say nothing of a little *chutzpah*, won out. With the hall booked, there was nothing more to do except organize the reading and make sure we got enough people to pay the rent. After a few phone calls, Ginsberg, Ferlinghetti and Corso were certainties. Then began the wrangling about who else should be on the bill. Privately, Ginsberg confided, he didn't think any of the British poets he'd ever read were good enough, but he recognized that the host country could not be snubbed like that. At Ginsberg's request Alexander Trocchi was brought on board to run the event. Ginsberg knew Trocchi as an organizer from when he ran his 'amphetamine university' in the Lower East Side of New York: groups of speed freaks seated under high-intensity neon lights focused with enormous concentration on painting bits of driftwood with abstract shapes to make Trocchi's futiques, his 'antiques of the future'. Ginsberg had been so amused by it that he took Norman Mailer to visit.

An organizing committee, the Poets' Co-operative, was formed and the number of poets reading rose alarmingly to fourteen, many of whom had never before read anywhere larger than the upstairs room of a pub. The line-up was international: Americans: Ginsberg, Ferlinghetti, Corso, Paolo Lionni, Dan Richter; British: Harry Fainlight, Adrian Mitchell, Pete Brown, Michael Horovitz, Christopher Logue, Spike Hawkins, Tom McGrath, George Macbeth; the New Zealander John Esam; Dutch: Simon Vinkenoog; Finnish: Anselm Hollo; and Austrian: Ernst Jandl. But though no-one thought to comment at the time, it was also 100 per cent white male. The Poets' Co-op wrote a collaborative poem, though the majority of it came from Ginsberg's pen; he could be very persuasive when it came to poetry. The principal organizer, the poet Michael Horovitz, remembered: 'We sat in Alex Trocchi's sordid flat – there were heroin needles on the floor – and took it in turns to speak lines that Ginsberg wrote down. That formed our manifesto. But we had no idea if anyone would come. Nothing like this had been done before.'[3]

'England! Awake! awake! awake!
Jerusalem thy Sister calls!

　　　*　*　*

And now the time returns again:
　　Our souls exult, & London's towers
Receive the Lamb of God to dwell
　　In England's green & pleasant bowers.'
World declaration hot peace shower! Earth's grass is free! Cosmic poetry
Visitation accidentally happening carnally! Spontaneous planet-chant
Carnival! Mental Cosmonaut poet-epiphany, immaculate supranational
Poesy insemination!
　　　　　　　Skullbody love-congress Annunciation, duende concordium,
effendi tovarisch illumination, Now! Sigmatic New Departures Residu of
Better Books & Moving Times in obscenely New Directions! Soul revolution
City Lights Olympian lamb-blast! Castalia centrum new consciousness
hungry generation Movement roundhouse 42 beat apocalypse energy-triumph!
　　　　　　You are not alone!
Miraculous assumption! O Sacred Heart invisible insurrection! Albion!
awake! awake! awake! O shameless bandwagon! Self-evident for real naked
come the words! Global synthesis habitual for this Eternity! Nobody's Crazy
Immortals Forever![4]

John Esam was in charge of the finances and John Hopkins ('Hoppy') took
publicity photographs of the poets seated around the statue of Shakespeare
on the Albert Memorial across from the Albert Hall. Hoppy was able to
get stories about the reading into the *Sunday Times* and other newspapers.
Ginsberg was interviewed by the BBC. Tickets began selling. The reading was
on 11 June 1965 and all 7,000 tickets had sold.

'I am about as surprised to see you here as you are to see us,' said Trocchi
opening the event. The *New Statesman* praised Trocchi for 'compering the
proceedings with schoolmasterly firmness'. As Trocchi was taking twenty
grains of heroin and seven of cocaine per day it certainly took a lot to faze
him. Kate Heliczer and some of her friends, their faces painted in paisley
patterns and wearing antique granny dresses, handed out flowers to the lines
of people waiting to get in. The Royal Albert Hall is a large circular Victorian
concert hall with several tiers of boxes, including a royal box. Some people
had booked a whole box and brought a picnic – throughout the evening the
sound of corks popping could be heard. One box kept its curtains drawn all
night. People shared what they had brought, which in many cases was pot.

A centre dais stood where a boxing rink was often employed meaning that the poets needed to keep turning round in order to address the whole hall, and seated in the rows of seats surrounding it were the poets, organizers and their friends. There was no real division between the audience and the poets. The floor was strewn with armfuls of flowers, salvaged after the Floral Hall at Covent Garden Market closed for the day. Bottles of wine and glasses circulated, three-paper joints were passed discreetly round, thick clusters of joss-sticks masking their smell, and people visited; it was a social occasion, like an Edwardian opera.

Ian Sommerville played a William Burroughs tape during the intermission (Burroughs was in New York), which got lost in the echo of the hall's great dome; Davy Graham played virtuoso folk guitar; R. D. Laing brought along a group of his schizophrenic patients, some of whom danced, including one young woman in a white dress who found rhythms in the poetry no-one else could hear; and Bruce Lacey's huge papier-mâché robots staggered about in the aisles vibrating and buzzing threateningly. Sadly none of them lasted out the evening. There was also to have been a happening. Jeff Nuttall: 'John [Latham] and I were to have a battle. We dressed in blue paint and huge Aztec costumes of books which we were to tear off one another. Trocchi forgot to signal our entrance. As we waited in the wings, John passed out.'[5] Al Cohen and Jeff had a fight with one of the British Legion attendants who attempted to prevent them from using a door as a stretcher to carry John to Sir Malcolm Sargent's dressing room. The paint had clogged Latham's pores and he and Nuttall needed to wash quickly as this can be deadly (or so it was popularly believed after *Goldfinger*). They jumped into Sir Malcolm's bath and began sloshing water over each other. Nuttall: 'It was the same attendant, pulverized by the goodly Anglo-Saxon pouring forth from Jewish lips down in the auditorium, who burst into Sir Malcolm's bathroom, found John and I giggling and washing one another, assumed the worst and staggered away in an advanced state of shock.'[6]

Not everyone could see the stage; on the web Paul A. Green remembers: 'High in the tiers we could only glimpse a beaky profile of MC Trocchi down there on the flower-strewn promenade, where a fey girl in a white dress undulated to the chime of Ginsberg's finger-cymbals.'[7] As a reading there were too many poets, many of whom did not know how to project to a large audience, and the best performances were often by the lesser stars: Ernst Jandl, Pete Brown and Michael Horovitz's performance of Kurt Schwitters' sneeze poem were perfect for the occasion, whereas Gregory Corso, famous for witty, audience-pleasing poems such as 'Hair' or 'Marriage' chose instead

a long thoughtful new poem which he read sitting down so half the audience only saw his back. Ferlinghetti's poetry is written to be read aloud and he did a brilliant job, bellowing out 'To Fuck is to Love Again' to the horror of the British Legion attendants. Adrian Mitchell was the surprise star of the show with his easily accessible blast against the Vietnam war, called 'To Whom It May Concern (Tell Me Lies about Vietnam)'.

At this time Adrian was known as a poet and pacifist; he had a pamphlet out from Fantasy Press as early as 1955 and in 1964 Jonathan Cape published his *Poems*, which was well received. Cape had earlier published his novel *If You See Me Coming* (1962), and Calder & Boyars had published his acclaimed adaptation of Peter Weiss's *The Persecution and Assassination of Jean-Paul Marat as Performed by the Inmates of Charenton under the Direction of the Marquis de Sade*, which consolidated his reputation in avant-garde circles. He was already well known at Better Books, where he took part in the symposium, 'The Theatre and it's Future' along with Peter Brooks and John Arden, that inaugurated the weekly Writers' Night held in Better Books' basement.

The audience also loved Ernst Jandl, the Austrian sound poet who, with his short grey hair, looked like a rocket scientist or technician mounting the stage until he opened his mouth and delivered his humorous, universal sound blasts: '… schist schleisch scheschlorden schund schat schlunter schluns scheschlohnt…', one of which, 'schmerz durch reibung (pain through friction)' clearly ended in an orgasm.

Harry Fainlight had never before read to a large audience. Instead of picking some short, easy pieces he chose to read 'The Spider', an account of an LSD trip, a subject in 1965 unfamiliar to 99 per cent of his audience. Nervous at the best of times, Harry mumbled and the audience couldn't hear. They began to shout for more volume, then cat-call. Harry grimaced and twitched before coming to a grinding halt mid-poem amid clamour from the audience. The Dutch poet Simon Vinkenoog, high on mescaline, sensing Harry's anxiety, began chanting: 'Love! Love! Love!' to direct positive vibrations in Harry's direction to help him and calm the crowd. Harry began to leave the stage then decided that he needed to explain what the poem was about and turned back. But Trocchi, in full dominie mode, had climbed on to the dais and now tried to take Harry's microphone away. 'Thank you, Harry, I think we've all heard enough of that now.' Simon continued chanting: 'Love! Love! Love!', eyes wide as he circled the dais. It seemed to work, and the audience was quieted.

The Russian poet Andrei Voznesensky sat in the audience but his minder from the embassy had told him that if he read with this reactionary crowd

he would never leave Russia again. He had been forbidden even to attend and sat, hunched over, looking glum as, quite unreasonably, both Ginsberg and Ferlinghetti took exception to his refusal to read and berated him from the stage. Ginsberg, dressed soberly in a dark suit for the occasion, wearing my straight, woollen knitted tie which he never returned, became more and more irritable as the event ran on and a parade of what to Ginsberg were second-rate poets climbed on to the dais. He became more and more drunk. This was unusual for him; in fact, 1965 was the only drunken year of his life. When he finally took the stage, an hour late, he began with a sloppy drunken reading of Anselm Hollo's translation of Voznesensky's 'The Three-Cornered Pear/America'. Most of the audience did not understand his slurred introduction and thought that the poem was his, so they reacted badly at lines like 'Does it hurt Mr Voznesensky?' which they thought Allen was directing at the Russian. After Allen read his poem, Voznesensky left the hall. Being onstage sobered Ginsberg and the remainder of his reading was fine, though not the great Blakean occasion he had dreamed of. Most people didn't notice; it was the social occasion that counted. The tribe had suddenly recognized itself and was delighted. No-one wanted to leave, they wanted to carry on to the party afterwards. 'Go back to your homes – if you have any,' yelled the exasperated attendants, angrily shooing people along the aisles.

The hire of the hall had cost £600: £400 for the evening plus two hours' overrun at £100 an hour. Jill Richter's mother put up the front money at the request of Dan and Jill but whether she got it back is not known. The Co-operative spent £200 on drinks and stationery, and Gregory Corso had managed to get a £100 fee in advance. John Esam was paid £100 by the BBC for filming rights which they apparently never exercised, though they did record the event on their fixed live feed from the hall. It was this recording that Peter Whitehead used for his film *Wholly Communion* as his own sound was unusable. The money was the subject of something of a free-for-all after the event, with poets and hangers on grabbing handfuls, but the serious money was in cheque form and had been handled by John Esam. Strangely, Esam was uncontactable after the event and none of the estimated £1,000 profits was ever seen again. Christopher Logue consulted his solicitor and Michael Horovitz wrote to the *TLS* but Esam was apparently on holiday in Greece.

Ginsberg was very depressed by his own performance, by the bad poetry and by Voznesensky's failure to read. He exchanged some heated words with George Macbeth, one of the poets he felt should not have been there, which ended by Ginsberg very unchacteristically screaming: 'Fuck off!' Eight days

later he composed a letter to the editor of the *Times Literary Supplement* (unpublished), in answer to their largely sympathetic coverage of the event:

> A participant in the poetry reading, I woke up early next morning depressed, disgusted by almost all the other poets and disgusted most by myself. The audience had been summoned by Blakean clarions for some great spiritual event, there was a hint of Jerusalemic joy in the air, there were great poets near London, there was the spontaneity of youths working together for a public incarnation of a new consciousness everyone's aware of this last half decade in Albion (thanks to the many minstrels from Mersey's shores & Manhattan's), there was a hopeful audience of sensitive elders and longhaired truly soulful lads and maids. The joy, the greatness of the poets, & the living spirit coming to consciousness in England, have never been adequately defined in public, and here was an opportunity to embody this soulfulness in high language...
>
> There were too many bad poets at Albert Hall, too many goofs who didn't trust their own poetry, too many superficial bards who read tinkley jazzy beatnick style poems, too many men of letters who read weak pompous or silly poems written in archaic meters, written years ago. The concentration & intensity of prophesy were absent except in few instances...
>
> By the time I got up to read I was so confounded by (what seemed to me then) the whole scene turned to rubbish, so drunk with wine, and so short of time to present what I'd imagined possible, that I read quite poorly and hysterically...[8]

For Ginsberg it had been a disaster, but for the youth of London it was a catalyst: the birth of the London underground. From this event came the *International Times* (*IT*), the UFO Club, the psychedelic posters of Osiris Visions, the 14 Hour Technicolor Dream, BIT, the Roundhouse as a venue, and by extension the British underground papers that followed: *Oz*, *Ink*, *Friends*, *Frendz* and *Gandalf's Garden*. There were other factors, of course, and the people who started *Oz* were not even in Britain when the Albert Hall reading happened, but it created a community and a scene, the framework within which everything happened. Hoppy:

> It was at the Albert Hall Poetry Reading with Allen Ginsberg in 1965. That was when we first saw each other. You walked in, saw 6,000 people just like you and thought, 'Shit, are there that many of us?' It was a turning point and gave us a lot of confidence.[9]

Hoppy and I set up a company called Lovebooks Limited in order to bring out little poetry magazines and spoken-word records: our first publication

was Lovebooks Records 001: *Allen Ginsberg, Gregory Corso, Lawrence Ferlinghetti and Andrei Voznesensky at the Architectural Association*, an album recorded a few days after the Albert Hall which, in poetry terms, was everything that the Albert Hall wasn't: terrific, accessible poetry read by four world class poets to an enormously appreciative audience. This we followed with an anthology called *Darazt*, designed as a companion to the poet Lee Harwood's magazine *Tzarad* (dedicated to Tristan Tzara). It contained a long poem by Harwood, a three column cut-up experiment by William Burroughs, some collages by me and a series of nude photographs by Hoppy. It was hand-set and so the illustrations all required plates. The problems of censorship, delay and price that we encountered with this led to Hoppy buying a £100 offset litho press which gave Lovebooks the ability to run off two-colour flyers and political pamphlets for the community as well as our art publications.

Hoppy had trained as a scientist at Cambridge and had worked at Harwell Atomic Research Lab as a reactor scientist before his involvement with CND, and a trip to Moscow in a bright yellow 1936 hearse with nine other people branded him as something of a security risk. Hoppy somehow got separated from the others in Moscow and was eventually deported to Helsinki by the Soviet authorities. The British government was not pleased to see his picture on the front page of the *Daily Mirror* under the headline: 'Atomic Scientist Thrown Out of Russia'. The security services sent for him and after a five-hour grilling made an inept attempt to recruit him to their cause, vaguely suggested he might work for them, informally, that is, pass on anything he might hear, sort of thing. He knew it was time to leave Harwell.

Hoppy's godfather had given him a 35mm camera as a graduation present from Cambridge and he had been using it a lot. He submitted a picture of children at a Henry Moore sculpture exhibition to the *Guardian* and three weeks later was surprised and delighted when he received a letter containing a press clip of his photograph and a cheque for £15 – a week's wages in those days. On the strength of this one publication he finally quit the Atomic Energy Authority and moved to London to become a photographer. He sold pictures to the *Sunday Times*, the *Observer*, the *Melody Maker* and *Peace News*. The Fleet Street photographers did not yet know how to deal with the new rock 'n' roll stars, and because Hoppy was of the same generation he was able to get intimate shots of the Beatles and Rolling Stones where the older Fleet Street establishment photographers failed. His photographs of visiting jazz musicians, of the Aldermaston marches, and the Beatles and Rolling Stones are now collectors' items.

Our next project was *Long Hair*, a literary magazine named by Allen

Ginsberg and featuring his book-length Cambodian journals later published as *Ankor Wat*. It was very much an Anglo-American edition as I asked both Ted Berrigan and Gerard Malanga to gather material for us in New York. We – mostly Hoppy – printed, collated and perfect-bound the eighty-page magazine ourselves. Our real aim was to produce a newspaper along the lines of the *Village Voice*. Then, during the New York newspaper strike which began in September 1965, some friends of mine in New York started an alternative paper they called the *East Village Other*, in a joking reference to the *Village Voice*, though it quickly became known just as *EVO*. I was their London correspondent. *EVO* was printed by offset litho and you could see that they just stuck down typewritten text and collaged pictures and headlines straight on to the layout page, sometimes with handwritten annotations. It was just what we wanted to do. *EVO* was printed in New York's Chinatown by printers who could not read English, so they got away with all kinds of obscenity and libel. Britain, however, only had eight offset presses, all owned by big respectable printers.

We sent out flyers announcing that we were going to publish 'a monthly anti-newsletter' to be called *THE Global moon-edition Long Hair TIMES*. The flyer ended: 'We send you love, & hope to receive cosmic signals.' Paul McCartney offered a twenty-guinea prize for a competition, the jazz critic Ron Atkins wrote a column, Hoppy wrote a drugs column under the pseudonym Bradley Martin that he was later to use in *International Times* and I gathered together my recent correspondence: a newsletter from Ed Sanders about his bust, a letter from John Wilcocks and another from a member of the La Jolla Pump House Gang of Californian surfers. We reproduced everything facsimile on foolscap size (legal) paper, stapled them together and the next day we were all on the 1966 CND Easter Aldermaston march selling *THE Global moon-edition Long Hair TIMES*. A lot of copies were sold by the London Rastafarians, many of whom used to frequent Hoppy's flat, but Hoppy sold the most. It was the forerunner of *International Times*.

The next significant underground event of the period was the three-day international 'Destruction in Art' Symposium (DIAS) held at Africa House in Covent Garden during the week beginning 9 September 1966, with numerous planned and unplanned outdoor performances in the weeks before and afterwards. It was organized by Gustav Metzger, the founder of the Auto-Destructive Art movement, who brought to London a collection of like-minded artists from Europe and the USA.[10] Among the speakers were the concrete poet (and monk) Dom Sylvester Houédard, happenings artist Jean-Jacques Lebel, Bob

Cobbing, sound poet Henri Chopin, action artists Otto Mühl, Wolf Vostell and Hermann Nitsch and Yoko Ono. Following a press conference the day before the symposium, the Canadian artist Robin Page did a piece called *KRAW!* in the basement of Better Books which consisted of digging a large hole with a pickaxe and shovel. The piece came to an unexpected end when he struck water. The council had to be called, the water tapped and Better Books had to get planning permission to fill in the hole again. John Latham fired up three large 'skoob towers' called *The Laws of England*, made from piled-up books, outside the British Museum without getting permission. The police and fire brigades were mustered in a hurry as clouds of smoke drifted across the forecourt. Yoko Ono, who came over specially for the symposium and stayed, performed her *Cut Piece* inviting the audience to cut away her clothing with a pair of scissors fitted with contact microphones which amplified every snip. The Puerto Rican action artist Ralph Ortiz played an old upright piano with an axe in Jay Landesman's house until it was completely destroyed, declaiming as he performed: 'Each axe swing unmakes this made thing called a piano. Each destruction unmakes my made relationship to it. It is no longer for playing; it is no longer beautifully designed or ugly...' The London Free School children's playground, on land cleared to build the Westway, was the site of many events, including Pro Diaz's action *Painting with Explosives*. On 1 September, Mark Boyle and Joan Hill presented *Projections* at the Jeanetta Cochrane Theatre, in which live insects were trapped between slides and projected. The heat from the projector killed them, and their death struggles, hugely magnified, filled the screen.

The main objective of DIAS was to focus attention on the element of destruction in happenings and other art forms, and to relate this to destruction in society. It was Gustav Metzger's moment of triumph, presenting his ideas to the public and generating a lively public debate. It also, predictably, resulted in a court case. Gustav Metzger and John Sharkey were prosecuted under the Obscene Publications Act for organizing Hermann Nitsch's *Abreaktionsspiel No. 5* at the St Bride Institute as part of his contribution to DIAS. This consisted of a film showing male genitals controlled by wires and dipped in various liquids projected on an eviscerated lamb carcass used as a screen. Nitsch's work is very confrontational and he was attempting to counter the rhetoric of the warmongers by shocking the audience into a realization of the mass murder taking place in Vietnam. It was not pretty but it certainly was art. After a four-day trial at the Old Bailey, Metzger was fined £100 and Sharkey given a conditional discharge.

Gustav Metzger was born in Nuremberg in 1926. He escaped from Germany

to Britain as a twelve-year-old on one of the *Kindertransport* trains, when Great Britain responded to *Kristallnacht* by taking about 10,000, mostly Jewish, children from Nazi Germany and occupied Austria, Czechoslovakia and parts of Poland. (The USA was asked to do the same but the project never made it out of the Congressional committees debating the issue.) The transports stopped two days before Britain and Germany declared war. Gustav and his brother Max were placed in a hostel in Willesden but his parents perished at Buchenwald in 1943.

In 1959, he moved to London from King's Lynn, where he had been living. Perhaps not surprisingly, given his background, Metzger was an early activist in the Campaign for Nuclear Disarmament, and a founder member of the Committee of 100; it was Metzger who gave it its name, a reference to the Guelph Council of 100. It was in this year he published his first Auto-Destructive Art manifesto, an attack on capitalist values and the commodification of art by the gallery system. He wrote:

> Auto-destructive art is a comprehensive theory for action in the field of the plastic arts in the post-war period. The action is not limited to theory of art and the production of art works. It includes social action. Auto-destructive art is committed to a left wing revolutionary position in politics, and to a struggle against future wars.[11]

His own art works confounded the gallery system by self-destructing, leaving nothing to be bought and sold or to appreciate in value. Using exclusively materials from industrial or machine production, his sculptures fell apart or corroded or were eaten away. His best-known early work was an action on 3 July 1961 on the South Bank, when he painted three enormous nylon canvases with hydrochloric acid. The acid took about thirty minutes to dissolve the fabric, first burning holes, then leaving the material in ever-decreasing tatters. A demonstration of his belief that art should embody 'change, movement, growth'. Gustav Metzger: 'Auto-destructive art is intended as a slow time bomb to be placed in Bond Street and equivalent "centres de luxe".[12] Auto-destructive art is public art.' One of his biggest fans was Pete Townshend of The Who:

> When I was at art college I got fantastically interested in auto-destructive art. Gustav Metzger did a couple of lectures and was my big hero. He comes to see us occasionally and rubs his hands together and says, 'How are you?' I got very deeply involved in auto-destruction, but I wasn't too impressed by the practical side of it. When it actually came to being done,

it was always presented so badly: people would half-wittedly smash some-
thing and it would always turn around so the people who were against
it would always be more powerful than the people that were doing it.

Before The Who got big, I wanted them to get bigger and bigger and
bigger and bigger until a number one record and then wrap dynamite around
their heads and blow themselves up on TV. It's just been one of those things.
Well-presented destruction is what I call a joy to watch, just like well-presented
pornography or obscenity. Although destruction is not as strong as obscenity,
it's not so vulgar but it's rare, you don't see destruction so often, not malicious
destruction just for the sake of it, and so when you do, you normally stop and
watch. I've always thought that high class, high powered auto-destructive art,
glossy destruction, glossy pop destruction, was far far better than the terrible
messy dirty disorganized destruction that other people were involved in...
I've really done it, on a couple of occasions, glossily and flashily.[13]

One of the most difficult and intellectual artists working in post-war Britain,
John Latham used books as his primary medium. He cut them up, burnt
them, covered them in paint and embedded them in glass. Books are the
repository of knowledge and learning, and are symbolic of these associ-
ations as physical objects, which is why, even now, the idea of burning
books is abhorrent; a reminder of the Nazi book-burnings. His treatment
of books has often got him into trouble, the most celebrated case being his
reworking of Clement Greenberg's *Art and Culture*. Like most artists, John
Latham had to supplement his income by teaching, in his case at St Martin's
College of Art on Charing Cross Road. In August 1966, a group of his stu-
dents gathered at his home to consider the ideas of the American art critic
Clement Greenberg, who had dismissed British art as being 'too tasteful';
he believed that all the best avant-garde art was American and that Pollock
was the greatest painter alive. Latham disagreed and he and his students put
Greenberg's book *Art and Culture* to the taste test. They sliced out the pages,
tore them into small pieces and chewed it over, spitting out the resulting
pulp which was then collected, mixed with yeast and various chemicals
and allowed to ferment. This took several months but when the art college
library sent a final demand for the return of the book, Latham presented
them with a small glass phial containing distilled 'essence' of Greenberg.
The administration at St Martin's did not appreciate this artistic gesture and
dismissed him from his post; his art was recognized, however, by the Museum
of Modern Art in New York, who bought the phial, along with its accom-
panying documentation of letters and the overdue library notice, which

Latham had made into a work of art entitled *Still and Chew: Art and Culture 1966–1967*.

Latham was born in 1921 in Zambia, at that time Northern Rhodesia, where his father was District Commissioner. He attended Winchester school, then served in the Royal Navy during the war and witnessed the sinking of the *Hood* (1,415 dead), followed, three days later, by the sinking of the *Bismarck* (more than 2,000 dead). He ended the war as a lieutenant-commander with his own motor torpedo boat. He studied painting at Chelsea College of Art, graduating in 1950. As a result of his wartime experiences, his principal theme was the ending of human conflict. He was looking for a synthesis between art and science, a commonality of belief systems, an end to differences in political ideology. His quest was for the unified field, a single theory that explained the universe and humanity's position in it. It has to be said that his explanations were at times baffling; however, his final great work, *God is Great*, was clear to all. Consisting of torn copies of the Bible, the Koran and the Talmud embedded in a six-foot-high sheet of plate glass, it was an attempt to unite the three main Western monotheist religions: Judaism, Christianity and Islam, and the god that they share. Latham:

> I thought God is the opportunity to align who the hell it is that people think that they're talking about when they use their particular word for the Almighty... It doesn't really convey anything but a rooted prejudice which is taught with enormous energy from institutionalized religion. And it's become quite dangerous in many ways. It needs synthesising into one. It needs bringing together by an image. That's what I'm bringing the glass into it for, that it's such a good equivalent for the mysterious being.[14]

Using glass to represent 'God' or the shared concept of God, he made a number of variants using the three sacred books of the three central theologies. He took the books and:

> put them all through the glass or to make them emerge from that glass, as if extruded from it. And in that way, to say that glass is where the truth is and the written material is vulnerable. The written material is contentious and liable to provoke hostilities if one is not very careful... The pieces that I'm calling 'God is Great' are there to indicate that underneath the theologies is a real source from which they all are extruded.[15]

In 2005 the works were shown at the Lisson Gallery to critical acclaim. As Andrew Hunt wrote in *Frieze*: 'This collection of work was timely owing to the current level of extreme political tension and fundamentalist belief within

the world.'[16] But books proved contentious in his life to the end. In September 2005 the Tate put on a show called *John Latham in Focus* which featured a 1991 *God is Great*. After Muslim fanatics bombed London, this work was removed from the exhibition without his sanction or that of the curator of the show. The Tate thought the work endangered public safety; Latham, and most of the art world, thought otherwise: that the Tate was self-censoring, running scared and submitting to the unspoken threats of fundamentalists. Latham's comment was: 'To say we can't have this in here when they know it's right in the middle of the art track is a failure of common sense. It's an interrupted discourse, and therefore it's a form of assault for purposes which are nothing to do with the art.' Latham died while still in dispute with the museum. Damien Hirst commented: 'He proves it is possible to be an enfant terrible for ever.'[17]

13 Indica Books and Gallery

I went up the ladder and I got the spyglass and there was tiny writing there... and you look through and it just says 'YES'.

JOHN LENNON on Yoko Ono's show at Indica[1]

Shortly after the Albert Hall reading, Tony Godwin let it be known that he was selling Better Books to Hatchards of Piccadilly, a very traditional bookseller. His enlightened policy of happenings, readings and film shows, as well as the concrete poetry and American Beat Generation mimeo-magazines seemed unlikely to last and so, accompanied by Sue Sarkozy, who also worked at Better Books, I left to start a new shop where we could continue the tradition. It turned out, in fact, that Hatchards did not make the expected changes and Bob Cobbing,[2] who took over as manager of the paperback section, managed to continue the events and activities for some time. Bob had been a conscientious objector during the war and wrote his first poetry in 1942. He had organized and participated in exhibitions, readings, screenings and publishing ventures ever since the mid-fifties. In 1951 he got involved with the Hendon Writers' Group, later to evolve into Group H, which put on art shows and in 1954 he co-founded a literary magazine called, confusingly, *And*. But his most ambitious and long-lasting creation was Writers' Forum, officially launched in 1963, which published poetry booklets mostly by unknown writers using the mimeograph machine at his school. It took a decade to reach *WF100*, a poetry anthology. *WF500* was another anthology and he was preparing for *On Word*, Writers' Forum's 1,000th publication, when he died in 2002 aged eighty-two. Not all the poets were unknown: in 1965 he first published Allen Ginsberg's *The Change*, and released books by Lee Harwood, John Cage, Ernst Jandl – the star of the Albert Hall reading – as well as his own distinctive concrete poetry. His performances utilized that space between words and music, a distinctive chanting but of sounds, rather than words:

a form of scat poetry very much in the tradition of the Dadaist sonic poetry of Hugo Ball. On the page Cobbing used the materials he had, exploring the possibilities of the mimeograph machine: sometimes letting the skin wear out so that the words merged into shapes and textures that could be seen as text, but no longer read. He would have doubtless agreed with Ball that:

> The next step is for poetry to discard language... In these phonetic poems we want to abandon a language ravaged and laid bare by journalism. We must return to the deepest alchemy of the Word, and leave even that behind us, in order to keep safe for poetry its holiest sanctuary.[3]

Despite dealing with some of the most avant-garde and experimental materials, Bob remained every inch the old-fashioned schoolteacher. At the conclusion of some extraordinary screeching sound poetry or happening at Better Books, he would take the stage clutching a great sheaf of papers, place one foot up the chair to reveal a hairy calf almost up to his knee, peer at the audience through his glasses, clear his throat and announce: 'Now, future activities', as if he was going to give the details of the school trip and open day.

From the moment he joined Better Books, Bob organized screenings of avant-garde and underground films and it was out of these that the London Film-Makers Co-op emerged. It was formally organized on 13 October 1966, with a structure based very much upon that of the New York Co-op. As well as Cobbing, organizers and members included Steve Dwoskin, Simon Hartog, Raymond Durgnat and Dave Curtis. Two weeks after its formation, the Co-op joined with the newly formed *International Times* to hold a Spontaneous Festival of Underground Film at the Jeanetta Cochrane Theatre from Halloween to Bonfire Night. From then on, Dave Curtis or Bob Cobbing screened films at UFO, the 14 hour Technicolor Dream and the last Christmas on Earth Revisited at Olympia. When Cobbing was fired from Better Books, the Co-op transferred its energies to the Arts Lab, where Dave Curtis was already programming the cinema.

One of the people who read at Better Books was the American poet Paolo Leonni, a friend of Gregory Corso's. He introduced me to John Dunbar, recently down from Cambridge, who was planning on opening an art gallery. It seemed sensible to combine our activities and so a company called Miles Asher and Dunbar Limited (MAD) was formed with John's best friend, the singer Peter Asher, as the silent partner. The gallery-bookshop was called Indica, a reference to 'Indications' – the name of our group shows – or 'to

indicate' but mostly named after *cannabis indica*, or marijuana. Indica had strong links with rock 'n' roll: as well as Peter's role in Peter and Gordon, John was married at that time to Marianne Faithfull. But the connection of most interest to the press was the involvement of Paul McCartney. Peter still lived with his parents in a large house at 57 Wimpole Street. Other occupants included his sister Jane, the actress and broadcaster, and her boyfriend Paul, who lived in a small maid's attic room next to Peter's L-shaped room with its Norwegian wood panelling. I used the Asher's basement as a place to store books while we looked for premises. McCartney, coming in late from a gig or a night club, would browse through the stock and leave a note of books he'd taken. He was Indica's first customer, before we even had an address.

Indica was at 6 Mason's Yard, off Duke Street, St James's. The yard was over-looked by Dalmeny Court, the apartment block where William Burroughs, Antony Balch, Brion Gysin and the Animals' singer Eric Burdon lived. A short alley led to the studio of Gered Mankowitz, who took so many wonderful pictures of the Stones, Marianne Faithfull and Jimi Hendrix. In the centre of the yard was a large, square, humming, electricity sub-station and built as a lean-to against its east side was a gentlemen's lavatory, very popular for cottaging (there was also a convenient all-night Turkish baths at the end of Gerard's alley). On the same side of the square, across the corner from Indica, was the Scotch of St James nightclub

John Dunbar had first discovered the premises for Indica after leaving the Scotch late one night with Marianne Faithfull, and he first showed it to me in similar circumstances. Once the lease was signed we moved in. Paul McCartney helped out on painting the walls and putting up shelves. On the day the bookshop opened he pulled up in his Aston Martin and heaved an enormous package from the back seat. He had designed and hand-lettered the wrapping paper for the shop: stark black letters on rather high quality white paper. As soon as the American fan magazines heard about this we began to get requests for it from American fans, all enclosing useless – to us – American stamps. Another gallery helper was Mark Feld, who shortly afterwards changed his name to Marc Bolan and became a pop star. We opened in November 1965 and the gallery quickly became famous: our first proper show – after two group shows – was of the Groupe de la recherche d'art visuel, whose leader, Julio Le Parc, won the grand prize for painting at the Venice Biennale shortly after our show opened. He fainted upon hearing the news. The gallery was inundated by the press and collectors. John was still in Venice and Julio, who had not expected to sell anything from this obviously eccentric underground gallery, had left a joke price list with one

item at £10 and another for £8,000. Nevertheless, one American collector persisted and we eventually shipped off a huge piece to Cincinnati in a large wooden crate.

The gallery was in the basement, which extended out under the street and the bookshop occupied the ground floor. Shortly after we opened the shop, Paul McCartney brought John Lennon in to buy books. I had just received a shipment of the *Psychedelic Experience*, Timothy Leary's reworking of the *Tibetan Book of the Dead*, and gave Lennon a copy to look at while I hunted for something by Nietzsche that he had requested. John made himself comfortable, lying on the old settee that stood in the middle of the shop. On page 14 of Leary's introduction John came across the line: 'Whenever in doubt, turn off your mind, relax, float downstream.' With only slight modification this became the opening line of 'Tomorrow Never Knows', the Beatles' first truly psychedelic song.

It quickly became obvious that the gallery needed ground floor space, and the bookshop needed to be somewhere with passing trade, so before a year was out Indica Books relocated to 102 Southampton Row, one block from the British Museum in Bloomsbury, and Indica Gallery took over the ground floor of Mason's Yard. John's lifestyle meant that he was often in the gallery late at night and people leaving the Scotch would tap on the window, demanding to see the exhibition, so he had a number of celebrity visitors. The main reason that the Indica Gallery is remembered, however, is because it was there that John Lennon met Yoko Ono.

We had always sold Fluxus publications at Better Books and I continued to do so at Indica. We also sold Yoko's own, privately published *Grapefruit*. When she came to Britain for the 'Destruction in Art' Symposium, it was only natural that she should come to visit us. Unlike the commercial galleries in Cork Street, John Dunbar preferred not to schedule his shows very far ahead; that way he could respond to what was happening and show new artists shortly after he discovered them, in the first flush of excitement and enthusiasm. Yoko's *Unfinished Paintings and Drawings* opened on 9 November 1966, less than two months after she arrived in London.

Yoko had quite a forceful manner but she was mild compared to her husband, Tony Cox, who accompanied her. During one visit John had to eject him from the gallery because he was shrieking and hyperventilating, the result of strenuous arm-flapping exercises conducted in the gallery to the astonishment and consternation of visitors. John Lennon and Yoko's first meeting occurred on the evening before the private view while the show was still being hung. John Lennon:

I got there the night before it opened. I went in – she didn't know who I was or anything – I was wandering around, there was a couple of artsy type students that had been helping lying around there in the gallery, and I was looking at it and I was astounded. There was an apple on sale there for 200 quid, I thought it was fantastic – I got the humour in her work immediately... John Dunbar insisted she say hello to the millionaire, you know what I mean. And she came up and handed me a card which said 'Breathe' on it, one of her instructions, so I just went (pant). This was our meeting.[4]

All the objects in the show were either white or transparent, with one exception, *Add Colour Painting, 1966*, where the viewer was allowed one colour to add to the painting. A white chair was provided with the painting to hold the paints and brushes. *Apple* consisted of an apple on a transparent perspex stand and the catalogue featured a photograph of John Dunbar eating it; the apple was replaced daily. The show also contained a 1964 piece called *Pointedness* consisting of a small sphere on a perspex stand. The most popular piece in the show with the public was an all-white chess set – all the pieces, and all the squares on the board were white – set on a white table with two white chairs. The actress Sharon Tate and film director Roman Polanski visited the show several times, late at night after an evening at the Scotch, to play long games of white chess, but they did not buy the piece.

One of the most acclaimed shows at Indica was by Mark Boyle – the pieces were all jointly made by him and Joan Hills but the male-dominated art world was not yet ready for a husband and wife team. Boyle was then known largely for his happenings and light shows and few people had seen his large-scale 'paintings'. Mark and Joan gave their first public performance of their light projections in a show called *Suddenly Last Supper* in 1964. They invited a group of friends to their flat at 114 Queensgate, for a meal and a film show. Guests included Pauline Boty, Michael and Sarah White, Christopher Logue, Clive Goodwin, Derek Boshier and Jo Cruikshank. Mark Boyle and Joan Hills: 'The landlord hated us working there and hated our pictures, but we invited about 60 people who had been to our place and knew what it meant to us, both as a home and a studio.'[5] After the meal Mark told his guests that a film called *Ends* would be shown in the large basement room which, aside from the 16mm projector, was empty. The theme of the film show was destruction and creation, birth and death. At one point a slide of Botticelli's *Birth of Venus* was shown projected on to the nude body of a woman. The slide was allowed to burn in the projector and through the disintegrating image there emerged a real woman. Most of *Ends* turned out to be just that,

lengths of film retrieved from the waste bins of the Wardour Street cutting rooms, spliced together in random order and accompanied by a soundtrack of distant traffic. It lasted twenty minutes, just long enough for the novelty to wear off and the audience to begin thinking about another drink.

Someone turned on the light and the audience trooped back upstairs. Christopher Logue: 'However, while we had been watching, without making a sound, the Boyles had moved. Chairs, tables, sideboards, carpets, beds, kitchen equipment, pictures, books, crockery, clothes, television, drinks and glasses – all gone, the house empty, the front door open, the keys in the lock.'[6] The bewildered audience found themselves in a dark empty flat; the Boyle family had moved and taken all traces of their life there with them. A member of the audience recounted: 'We were left alone, a group of self-conscious strangers, without anybody left to say goodbye to or thank for an extraordinary evening.'[7] The Boyles had been evicted, and had used the occasion to create a happening.

At one 1965 event at the Theatre Royal in Stratford East, Mark asked the audience in the stalls to come up on to the stage through the side door, then raised the curtain and left them there facing the audience surrounded by stage props and costumes. They had twenty minutes to do what they wanted, though most were too self-conscious to perform. He got better results with an event at the ICA on Dover Street. The room was darkened, then Boyle shouted through a microphone that if anyone wanted an event they would have to do it themselves. Then some spotlights were turned on to illuminate various props. This time the audience reacted immediately: they bounced about on the trampoline, danced with the ballet dancers, honked and banged away on an assortment of plastic instruments and attacked the piano. The piano became the centre of the liveliest activity and by the end of the event it had been smashed and rebuilt several times to create an extraordinary sound machine. The audience were also given control of the lighting, including slide and movie projectors. The audience made their own film of the event and in the end wrote a press release describing their work.[8]

The Boyles' best-known work was *Journey to the Surface of the Earth*,[9] a series begun in 1964 that includes many different projects, among them the *London Series*, the beautiful *Tidal Series* made from impressions made by the tide on Camber Sands on the Sussex coast, the *Thaw Series*, the *Japan Series* and the Boyle Family's endless lifelong project, the *World Series*. In each case random-selection techniques were used to isolate a rectangle of the Earth's surface. The *World Series* was launched at the ICA in 1969, when it was expected to take twenty-five years to complete. A 13-foot-wide map of the

world was displayed on the wall and members of the public were blindfolded and given darts to throw at it. The Boyles' stated intention was to visit 1,000 of these randomly selected sites. A larger-scale map was then obtained of each area indicated by a dart and a second series of darts thrown in order to pinpoint an exact location. Mark, Joan and their children, Sebastian and Georgia, then travelled to each site and selected a six-feet-square at random by throwing a large set-square. This way the artists became 'presenters' of our earthly environment as they had no subjective say over which segment of the planet was going to be chosen as representative of the whole, what they called 'motiveless appraisal'. The presentation of the site was then constructed by using photographic and film records, samples collected from the site, by collecting live specimens, plants and seeds, digging and taking surface casts in Epikote resin. When the site was beneath the sea, as many inevitably were, surface studies were to be made using film and, where possible, surface coatings of the seabed, though many of the sea-sites were obviously non-starters, such as the middle of the Pacific Ocean.[10] This project was obviously impossible to realize, but impressions have been taken from a surprisingly large number of locations: they braved the heat and dust of the Australian Outback, avoided becoming road-kill on a four-lane highway in New York, and survived the sub-zero temperatures of the Vesterålen Islands off the Norwegian coast. The most dangerous work was to take a cast of the surface of the Negev Desert while Israeli tanks swerved around them.

Making a perfect copy of a location, including whatever objects are littering it, is virtually impossible, just as it is impossible to prevent some elements of subjective selection creeping in. In some cases they removed the flattened tin-cans, pebbles, cigarette ends, small stones and dust and used the actual objects, incorporating part of the location in their piece, thus changing the location itself. They worked mostly in fibreglass and painted resin, using a method so secret that they have been known to request that security cameras be turned off during certain stages of installation in a gallery. They always achieve their aim: to make the observer look closely at something they have never examined or noticed before: broken tiles, a patch of rippled sand, a heap of twisted rusted metal:

> We want to see if it's possible for an individual to free himself from his con-
> ditioning and prejudice. To see if its possible for us to look at the world or a
> small part of it, without being reminded consciously or unconsciously of myths
> and legends, art out of the past or present, art and myths of other cultures. We
> also want to be able to look at anything without discovering in it our mothers'

womb, our lovers' thighs, the possibility of handsome profit or even the mak-
ings of an effective work of art. We don't want to find in it memories of places
where we suffered joy and anguish or tenderness or laughter. We want to see
without motive and without reminiscence this cliff, this street, this field, this
rock, this earth.[11]

In the course of assembling the stock for Indica Books in the basement of
Peter Asher's family house I got to know Paul McCartney. He often visited
my flat, which was five minutes' walk from Wimpole Street, and borrowed
copies of *Big Table*, *Evergreen Review* and other magazines of experimental
literature. One evening he suggested that we should do the same thing
for sound; instead of a magazine, we should issue a record each month
containing new poems, rehearsals or demo tracks by bands, the interesting
bits from conversations, collage and cut-up tapes we had made, and so on.
It seemed a brilliant idea; the Beatles had the organization in place to press
and distribute such a magazine through NEMS and EMI, their management
and record companies. What was needed was a recording studio so that
AMM, or the latest R&B band, or a visiting blues singer, could just drop by
and cut a few tracks. There were very few independent studios in London at
this time – unlike the USA – and even poorly equipped ones were expensive.
Paul decided that, as it only needed to have the most basic facilities, we could
set up our own. This gave rise to two problems: where to put it and who was
going to operate it?

34 Montagu Square had been bought by Ringo in 1964 but before long
so many fans knew where he lived that he moved to Weybridge in the
stockbroker belt. The flat consisted of the ground and lower ground floors
of a converted elegant 1820s town house. The ground floor master bedroom
was white-carpeted with grey, watered silk wallpaper and had an en suite
bathroom with a pink sunken bath. The panelled downstairs bedroom had
its original fireplace and access to a small outside courtyard. The downstairs
bathroom had two entrances, one from the kitchen and the other off the
dressing room. Paul McCartney rented the flat from Ringo in the autumn
of 1965 and used the downstairs bedroom as an experimental recording
studio. It happened that Ian Sommerville had recently moved out of William
Burroughs's flat and needed somewhere to live. Ian was a mathematician and
knew about tape recorders; he was the one who had first turned everyone
on to the Philips cassette machine when it was put on the market. With Ian
actually living in the flat, he would be on the spot whenever anyone wanted
to record a few tracks.

Paul authorized the purchase of a pair of Revox A77s, a selection of microphones, stands, speakers, tape and editing equipment. Ian and his boyfriend Alan moved in and set up in the basement living room. In practice no-one knew how to contact Ian and so the only real use of the studio was by William Burroughs, who conducted a number of stereo experiments and cut-ups there, and by Paul McCartney, who made all the early demos of 'Eleanor Rigby' there using Ian as tape-op. Many evenings were spent with people such as John Dunbar, Peter Asher, Paul and myself, banging on assorted objects with echo turned on full, but it hardly justified the studio. In the end Paul gave one of the Revoxes and the speakers to Ian and returned the keys to Ringo.

After this, in September 1966, Ringo rented the flat to Chas Chandler and Jimi Hendrix. Jimi and Cathy Etchingham took the downstairs bedroom, where they had tremendous rows, with much plate throwing and screaming, resulting in complaints from the neighbours. The party for Chas Chandler's twenty-eighth birthday on 18 December got so out of hand that the next day Ringo had to ask them all to vacate. One of the many incidents that night involved the large Christmas tree falling on Bill Wyman and his girlfriend, who were sitting beneath it. Ringo's next tenants were John and Yoko when John moved out of his house in Weybridge after Cynthia discovered him with Yoko. They were busted in Montagu Square on 18 October 1968 for pot, having hidden or disposed of the heroin. Finally the Portman Estate, owners of the ground lease, had had enough and Ringo was told to either sell his lease or forfeit it. He sold it. As the site of so much cultural activity the building deserves a blue plaque.

14 Up from Underground

I had brought with me from America a quantity of LSD,
about half a gram, or enough for 5000 sessions.

MICHAEL HOLLINGSHEAD, *The Man Who Turned On the World*[1]

The Scene was the prototype early-sixties mod club, the model for dozens more that sprang up in the suburbs and other towns. The Scene, in Ham Yard, Soho, had been the site of Club Eleven until 1950, when it transformed into Cy Laurie's jazz club, the first club to hold Sunday afternoon record sessions; people sat on cushions or the floor of the large room and listened to American blues and British pop. During the day, it was used as Mac's Dancing Academy, a school for 'hoofers', and as a rehearsal space. Cy's club itself specialized in 1920s-style traditional jazz with Cy leading his own band on clarinet. Though despised by the modernists, they still dropped by because it was somewhere to go and there were loads of drugs available. In the early sixties it became the Piccadilly Jazz Club before switching to its most famous incarnation: the mod R&B club, the Scene. The Scene's DJ was Guy Stevens, who had one of the most extensive collections of R&B records in the country. He featured loud Motown and Stax for the dancers but also played more obscure cuts. They also had live bands: beginning in August 1964 the Who did a five-week residence, every Wednesday night. There were still loads of drugs available but now they were mostly amphetamines. This was the centre of mod culture: they parked their scooters in Ham Yard and paraded their clothes to each other, pilled out of their minds. The Scene was a great club, but as rock 'n' roll musicians became more famous, they found it more and more difficult to visit places like the Scene because they were pestered by fans and autograph seekers. As usual, market forces provided, and in 1966 three clubs opened to cater to their needs.

The discotheque craze began in Paris with the Whiskey à Go-Go, which

opened in 1947. 'Whiskey' meant Scotch, and so, thinking laterally, tartan was used as the decor. In 1961, Hélène Cordet, Prince Philip's childhood friend from Paris, opened the Saddle Room, London's first discotheque. She naturally used tartan. Then came Le Kilt, at 90 Frith Street, which was fully decorated in tartan and even had a tartan carpet. Le Kilt was much favoured by Swedish au pair girls but people like the Beatles would visit if someone interesting was playing such as the Lovin' Spoonful. It was owned by a Mister Bloom and Louie Brown, whose next venture, the Scotch of St James, opened in the summer of 1966. In keeping with its name, it too was decorated with Scotch tartan, sporrans and swords. It was a split-level discotheque with a restaurant and bar on the ground floor and a disco in the basement. There was a small sliding panel in the middle of the wooden door, guarded by iron bars, through which you were inspected before being permitted to enter, like a speakeasy. It quickly became the in-place for the rock 'n' roll community to gather from 11 p.m. until 3 a.m..

The manager of the Scotch was Rod Harrod, who had previously been at the Cromwellian on the Cromwell Road. The club was very dark – you almost had to feel your way to a table – and the music, played by a DJ in a carriage of the sort that horses used to pull around as taxis, was Motown or Stax, Otis Redding or Wilson Pickett. Regulars included the Beatles, the Stones with their manager Andrew Loog Oldham, the Animals and virtually everyone who had a record in or near the charts. Every Friday night Vicki Wickham would show up, fresh from the television studio in Wembley, with the stars of that week's *Ready Steady Go!*, particularly the female ones: the Shirelles, the Ronnettes, the Toys, the Supremes, Sonny and Cher. There was a small stage for live acts.

Simon Napier-Bell wrote:

> The Scotch was more than just a club or a place to show off your status and position – it was a positive celebration of being part of what was happening in the world's most 'happening' city. It was a nightly indoor festival, a carnival, a theatrical event, and everyone played their part to the full, co-operating with all the other stars around them in trying to make this the longest running show of all time.[2]

Downstairs the tiny dance floor was usually dominated by Tom Jones. In his memoir Napier-Bell recalls slipping drunkenly off his chair on to the floor. He lay there for a while, feeling comfortable, and then opened his eyes to see John Lennon crawling towards him on all fours beneath the tables and chairs. Eric Burdon remembers encountering Lennon in a similar situation at

a party in Mayfair where Burdon was administering amyl nitrate to two half-naked girls prior to breaking raw eggs over them; Burdon was the Eggman in Lennon's song.[3]

The Scotch was the first of the very dark, very loud clubs. It was too loud to talk, all you could do was drink; Scotch and coke was very popular as it was the Beatles' drink. I went there once during the day with Paul McCartney, looking for somewhere to play a new album by the Fugs that had just arrived in the post at Indica Books, next door. With the unshaded house lights on the club looked unbelievably tatty: the walls had not been painted in decades, the banquettes were filthy and the brass plaques, reserving certain booths for Stones or Animals, looked like tourist junk. The atmosphere at night was created by the clientele, a few coloured lights, and a top of the line music system.

The Speakeasy, at 48 Margaret Street, just north of Oxford Street, opened shortly afterwards, and for several years musicians moved, often several times a night, between the Scotch, the Speak and the Bag O'Nails, which had also opened in late 1966. The Speak and the Bag were within easy walking distance of each other but most rock stars preferred to travel by car or cab. The Speakeasy was co-managed by the owner Roy Flynn and Mike Carey. The promoter and publicity manager from 1968 for the next ten years was Laurie O'Leary, the Speak's public face. The Speak was in a basement. At the bottom of the stairs was the cloakroom, presided over by Avril, and a large coffin, located between the toilets, with a brass plaque that read: 'Ashes to ashes, dust to dust, if the women don't get you, the whisky must.' The Speak had a tacky Chicago speakeasy theme with huge blow-up pictures of Al Capone and other gangsters and some of the ugliest wallpaper ever made, featuring a pattern of coloured hearts. You entered next to the large horseshoe-shaped bar, which had a few fruit-machines on the far side. Beyond the curved end of the bar was the dance floor with booths on the side and a stage. To the right of the stage was Luigi's restaurant, a long room separated from the bar and dance floor by a partition, the top half of which was glass so that diners could see the whole of the club, including the stage.

The Speak was more relaxed than the Scotch and allowed Keith Moon to walk naked over the tables holding a bottle of champagne, and groupies to crawl under the tables. These things may have happened at the Scotch but it was too dark to see them. At one point Moon installed a walkie-talkie on the bar and another in the restaurant so he could order without having to summon a waitress. The Speak was great for jam sessions: Hendrix played there often as the featured guest, and jammed whenever he could, not

minding if he had to play bass if no guitar was available. On New Year's Eve, 1967, Jimi played a thirty-minute version of 'Auld Lang Syne' which reduced everyone to a stunned silence. Like the Scotch, the Speak was so exclusive that there was no need for a VIP area and the long bar would be crowded with Bee Gees, Beatles, Stones, and members of the Who. I saw Frank Zappa act as compere and introduce Cream to the audience as a 'Natty little combo' just before they left for their first US tour. They played with massive stage amplification and deafened everyone. The Speak was famous for its groupies, who had a harder time getting into the Scotch or the Bag O'Nails if they did not arrive with a musician. There were sometimes fights: the drummer Ginger Baker from Cream was often fractious but most people managed to ignore him. The biggest problems were between the old and new guard. At a 1967 'happening', not long after the club opened, Daevid Allen, from Soft Machine, read a poem called 'The Death of Rock Music' which proclaimed the superiority of psychedelic music over pop, prompting Georgie Fame to challenge Allen to a fight in front of the stage. This further illustrated the difference between the old Soho rockers and the new peace-loving underground: Daevid Allen would never fight anyone.

The final club on the evening crawl was the Bag O'Nails at 9 Kingly Street in Soho. This had been a brothel in Victorian times and the Downbeat Jazz Club operated from its premises from 8 February 1948. The Downbeat often featured the Tito Burns band and Ray Ellington and his quartet made their debut there. But the club only lasted six months or so before the Bag reverted to its old use. Rik and John Gunnell bought it in 1966 as a rock 'n' roll club. Less known than the Scotch or the Speakeasy, the Bag was less trendy and more music-oriented, which attracted a wider range of people. The stars certainly flocked there: one Hendrix concert drew a guest list which included John Lennon, Paul McCartney, Ringo Starr, Brian Epstein, Pete Townshend, Mick Jagger, Jeff Beck, Eric Clapton, Brian Jones, Jimmy Page, Lulu, the Hollies, the Small Faces and the Animals. The club consisted of tiered banquettes surrounding a small stage so everyone could see everyone else as well as the stageshow. It was very much a club for picking up people, in fact John and Christine McVie from Fleetwood Mac first met there, as did Paul McCartney and Linda Eastman (while watching Georgie Fame and the Blue Flames).

The Bag was where the Beatles went at 3 a.m. after the *Sgt Pepper* recording sessions to unwind and get a bite to eat. Musicians work while everyone else is at play so their hours are correspondingly later. Assorted Beatles, usually accompanied by their roadies Mal Evans and Neil Aspinall, would

often show up just as the club was closing. I was with them one night when the very last customers were being shooed out into the narrow street. Seeing Paul McCartney and his entourage arrive, the management quickly dragged the bemused clubbers back in the door and pushed them downstairs. As we entered the small lobby we heard the music start up again in the basement. A typical Mal Evans diary entry was for 19–20 January 1967 and read: 'Ended up smashed in Bag O' Nails with Paul and Neil. Quite a number of people attached themselves, oh that it would happen to me.'[4] They would order standard club food, which was the least likely to poison them: steak, chips and mushy peas. Neil Aspinall inspected everyone's plate with a flashlight to make sure everything was in order and gave the bill similar scrutiny.

In 1964 an ex-policeman, Bill Bryant, and his partner, Geoffrey Worthington, opened a discreet gay bar called The Lounge in Whitehall. It was too close to Scotland Yard and didn't work, so they took premises on D'Arblay Street and tried again, this time modelling themselves as a gay version of the nearby Scene Club in Ham Yard. Le Duce had a coffee bar on the ground floor and a basement club with a small dance floor, a jukebox and a seating area screened off by a huge fishtank, though the fish kept dying because the mods threw their pills into it every time there was a police raid. The manager, Peter Burton, who joined in 1966, played non-stop Motown, with some Blue Beat thrown in: Dusty Springfield's 'You Don't Have to Say You Love Me' and Jimmy Ruffin's 'What Becomes of the Brokenhearted?' were both very popular. For about four years it was the trendiest place in London and where all the dancers went after filming at Rediffusion TV's *Ready Steady Go!* on Friday nights (only the stars could afford the Scotch of St James).

The clientele were gay mods dressed in John Stephen's Carnaby Street finery with brightly coloured shirts and trousers or jeans, and elastic-sided Cuban heeled boots from Anello and Davide. There were a few rent boys and some straight dolly birds. The drugs were purple hearts, lots of them. Derek Jarman described it as 'the most exciting club of the sixties'.[5] They stayed open all night on Saturday. Derek was a regular: 'the sun was up before it closed its doors. I used to walk back home, there were no late buses.'[6] He featured, along with Ossie Clarke and Keith Milow, in Patrick Proctor's painting of Le Duce called *Shades*. At first there was no licence, but as business picked up they turned the coffee bar into a restaurant and were able to serve drinks until 1 a.m. provided you ate something. The club had a tough door policy to keep out predatory older men but could not keep out the police. They rarely made arrests – homosexuality was still illegal but it was hard to prove – but

they enjoyed intimidating people by taking down their names and addresses. It also encouraged the club owners to pay protection.

In the late sixties the Krays and Maltese Paul moved into Soho and many of the small gay clubs moved to West London and to Chelsea, where the Gigolo had operated safely in the basement beneath the Casserole on the King's Road since 1967. The narrow death-trap staircase down to the club led directly on to the tiny red-tiled dance floor, bringing members straight into the action. No-one was allowed to touch and, if they did, the doorman would intervene and remind them: 'Come on lads, you know the rules.' The walls were painted white and there was a bar which served only Coca-Cola or weak Nescafé in glass cups. At the back was a dimly lit, raised area, about ten feet square, leading to two toilets. The doorman appeared to be unable to see what went on in this area and customers stood around with their flies undone and openly gave each other blow jobs. It would have been hard for police to get to the back quickly because the dancing in the front of the bar never stopped.

When they did arrive there was chaos. The clientele was lined up and waited their turn to be frisked – obviously everyone had emptied their pockets by the time this happened and the floor would be littered with pills which crunched underfoot as people shuffled forward to be humiliated – afterwards they were given a numbered piece of paper which they had to show at the door upstairs before they were permitted to leave. Jarman recalled that the raids continued right into the seventies: 'they were designed to frighten us, stop the less adventurous leaving their homes.'[7]

The continual police harassment of gays made them take refuge in illegal drinking clubs where they were not so visible. These were often establishments run by West Indians who were sympathetic to lesbians and gay men because, like them, they were regarded as outsiders. Though hard to prove, some people think that in the late fifties and early sixties before the law was changed there were more gay clubs in London than there are now.

There were certainly more drinking clubs back then, and, as usual, most of them appear to have been in Soho. Aside from the Colony, Francis Bacon used to occasionally visit the Kismet, next door to the Pickwick Club on Great Newport Street off Charing Cross Road. It was primarily an afternoon drinking club patronized by the usual Soho crowd. Jeffrey Bernard told the story of a stranger entering the Kismet and asking: 'What's that smell?' Without even looking up from his drink, John Bey shouted 'Failure!' Regulars at the Kismet included Frank Norman, John Deakin, Marty Feldman, Jeffrey Bernard, Francis Bacon, Dan Farson and Christine Keeler. It was presided

over by the tough manager Eddi McPherson, described by Jay Landesman as a 'strapping, good-looking, big-bosomed, tough young woman who filled the drinker's need for a basement madonna'.[8] On one occasion Bacon was there with Dan Farson and a group of other people and startled them with the revelation that one of the 'coppers' who drank there on a regular basis had a 'thing' about him after finding out that Francis wore fishnet stockings and suspenders beneath his fashionable trousers.[9] The Kismet was just across Charing Cross Road from the Premier Club, on Little Newport Street, which was also frequented by police, in fact Freddie Foreman described it as 'a policemen's canteen'. In conversation with Tony Lambrianou, an associate of the Kray twins, Freddie Foreman described how it was used as a meeting place for criminals to sort out their affairs with the police: 'If ever you had to do a deal with the Old Bill, you know, to part with a bit of readies and get out of trouble, that was the club you went to.' He described how you got your introduction, then went over into a corner and sorted out your business. 'Full of coppers in there.'[10]

Another, more underground, club in London in the mid-sixties was the World Psychedelic Centre, run by Michael Hollingshead, the man who first introduced Timothy Leary to LSD. The British-born Hollingshead had been given one gram of Sandoz acid by Dr John Beresford in 1961, and after his first experiment he contacted Aldous Huxley, who in turn put him in touch with Leary. From September 1961 he worked with Leary on a number of projects, including guiding people through their trips at Leary's upstate New York Millbrook centre, until departing for London in September 1965. Inspired by reports of the 1965 Albert Hall poetry reading, it had been Leary's original intention to rent the Royal Albert Hall – or Alpert Hall, as Leary dubbed it after his colleague, Dr Richard Alpert – in January 1966. It was to be a psychedelic jamboree presided over by Leary, at which, naturally, the Beatles or the Rolling Stones would be invited to perform. This gave Hollingshead three months to make the arrangements. But in his heart Leary knew it would not happen; it was really just a way of getting rid of the troublesome Hollingshead. On the quayside, Leary handed Michael his instructions, which were headed 'Hollingshead expedition to London 1965–66. Purpose: Spiritual and Emotional Development', and included as item four of the plan: 'Centre for running LSD sessions'.

When I visited Tim Leary's headquarters in Millbrook in 1967, Tim described how he and Dick Alpert saw Michael Hollingshead off to London in the summer of 1965: 'When Dick and I stood on the dock in New York waving him goodbye, I said to Dick, "Well, that writes off the psychedelic

revolution in England for at least ten years".[11] They gave him 300 copies of the *Psychedelic Experience* by Ralph Metzner, Richard Alpert and Tim Leary, 200 copies of the *Psychedelic Reader*, edited by Gunther Weil, Ralph Metzner and Tim Leary, and half a gram of LSD to take with him; enough for 5,000 sessions. Unfortunately Leary's assessment of Hollingshead's chances were accurate.

With the backing of some wealthy friends, Michael quickly set up the World Psychedelic Centre (WPC) in a large, rather magnificent flat, in Pont Street, Belgravia; very handy for Harrods. LSD was not yet illegal, but the authorities were already muttering about it in a threatening way so the idea was to introduce the drug to as many influential people in the shortest possible time in the hope that they would inform the public debate; making the drug available on prescription, possibly, or for research purposes through an institution even if it was not available to all.

Hollingshead emptied the front room of furnishings except the carpet and structured the décor along the lines suggested by Sutra 19 of the *Tao Te Ching*. Flowers, bowls of fruit, hand-woven cloth, uncarved wood, a fire burning with naked flames, good bread, cheese, wine, candles, temple incense, goldfish and antique objects 'over 500 years old'. There were pillows, tapes of classical and oriental music, hi-fi equipment and a slide projector. Hollingshead used this room to guide people on trips, usually twelve at a time and the setting had to be right and anxiety free. Hollingshead: 'The session was not to be thought of as some kind of show, a piece of theatre, an entertainment, but a demonstration and a sharing of novel energy levels and unusual forms of perception. And the décor was to assist the voyager in his experience.' The trips were relatively high doses, 300 micrograms, served in grapes impregnated with acid. The trip lasted between eight and twelve hours.

The president of the WPC was an old Etonian Lloyd's underwriter, Desmond O'Brien, who was joined a little later by Joey Mellen as vice-president. Mellen was a law graduate from Oxford and another old Etonian. Pont Street became a popular place to frequent; you never knew who might stop by. There were talks and presentations at the WPC and by no means everyone who visited actually took a trip. There was a strong Chelsea contingent: Victoria and Julian Ormsby-Gore, Michael Rainey, Nicholas Gormanstone, Suna Portman and the American folk singer Julie Felix. Naturally there was a strong old Etonian contingent, including Christopher Gibbs and Robert Fraser, and many visiting rock stars, including Paul McCartney – the only Beatle to attend – Donovan, Eric Clapton and Peter Asher. Victor Lownes, who co-founded the Playboy Club with Hugh Hefner, was a frequent visitor and brought along many of the

Americans passing through London. William Burroughs, Ian Sommerville, Alexander Trocchi, George Andrews, Feliks Topolski, Roman Polanski and Sharon Tate all visited. Workshops in 'Consciousness Expansion' were held by the WPC at the Institute of Contemporary Art and St Martin's School of Art, which attracted many visitors to the centre, including Sir Roland Penrose, who in addition to co-founding the ICA was also a director of the Tate Gallery. The so-called 'anti-psychiatrist' Ronnie Laing and American psychiatrist Joseph Berke, his assistant at the Philadelphia Association, showed great interest and LSD became the talking point of literary salons and art studios across the city. I found Michael to be a good host: charming, funny, cosmopolitan, with a great fund of amusing stories about mutual friends.

For several months the centre seemed to be doing its job until Hollingshead began to crack up. As he put it in his autobiography:

> There was a problem, a self indulgence of mine which earned me some social suspicion, if not also social ostracism, and which led me – though against all my instincts – well over that line which divides the normal from the abnormal. I refer, of course, only to my taking of methedrine.[12]

He was shooting speed seven times a day, smoking large quantities of pot and taking acid, in doses in excess of 500 micrograms, three times a week. Sometimes he would drift into a zombie-like state of catatonia and have to inject himself with dimethyl-triptamene to jolt himself back to life again. It became obvious to visitors that the flat was going to be busted; not for the LSD, which was still legal, or for the amphetamine, which he had on prescription, but for all the bags of marijuana and the chillums and blocks of hash in every room. A well-known sequence of events went into operation: first came the 'exposé' by the Sunday gutter press, then came the knock on the door by the police. 'THE MEN BEHIND LSD – THE DRUG THAT IS MENACING YOUNG LIVES,' screamed the headline in the *People*. 'The Centre was deserted and in a state of considerable chaos when our investigator gained entry on Thursday,' they wrote. 'There were used hypodermic syringes, empty drug ampoules and a variety of pills. Among the litter of papers were dozens of phone numbers, some of them of well-known show-business stars and personalities.' Did this mean they'd broken in and searched the place, we wondered?

But instead of cleaning up the squalor and ridding the flat of illegal drugs, Hollingshead let things drift. There had been a number of problems: complaints about the noise from neighbours who objected to the constant music played at high volume and the party where eighty guests – some of whom, 'police spies masquerading as hippies', got accidentally turned on

when someone spiked the fruit-and-wine punch. Detective Sergeant Dalton and his men arrived in January 1966, three months after the centre opened. There were six people living there when they were busted. The same indifference to being busted condemned Hollingshead during his trial. He took a tab of acid before arriving at the court and made frivolous remarks and jokes during the proceedings, all of which went against him. He was given a 21-month sentence for possession of less than an ounce of hashish and a negligible amount of grass. It was thought that the jokes were responsible for six months of that. There was plenty of hash and LSD in prison, brought to him by Owsley Stanley and Dick Alpert when they visited him in Wormwood Scrubs. He shared the hash but kept the psychedelics to himself with one exception: the convicted double-agent George Blake who had already served five years of a draconian 44-year term for betraying dozens of British MI5 agents to the KGB.

Hollingshead and Blake became friends and Michael eventually gave him a trip. Blake knew that the likelihood of his being released or swapped for another spy was slight, but the trip made him realize that he could not handle many more years of incarceration without going mad, despite the fact that he had been permitted a carpet, curtains, books and a short-wave radio to 'listen to the Arabic language stations'. He was still in contact with the Russian embassy and a few weeks after his trip Blake escaped by scaling the wall using a rope ladder thrown over by an accomplice who had contacted him on the short-wave service of Radio Cairo. He reappeared in Moscow as a colonel in the KGB, with the Order of Lenin, a government pension, and a large rent-free apartment. As his trial in Britain had been held in camera, the public never did find out exactly what he had done to merit such a harsh sentence. The whole story was like something from a John le Carré novel.

Joey Mellen, the vice-president of the World Psychedelic Centre, was the first British convert to the ideas of Bart Huges, a Dutch medical student who advocated the use of trepanning as a method of raising one's consciousness. According to Huges, when the human race began to walk upright, it lost certain benefits as well as making the more obvious gains. The effect of gravity caused by walking upright reduced the amount of blood flowing through the brain, which in Huges' view reduced the range of human consciousness. People had found ways to counter this: certain yogic postures, such as standing on one's head, jumping from hot water into cold water as practised by the Romans and Scandinavians, or the practice of trepanation – cutting a hole in your skull – which was used by many ancient peoples as well as in the

European Middle Ages; it is, in fact, the oldest surgical procedure for which there is evidence. Children's skulls are unsealed; it is not until adulthood that the membranes surrounding the brain are restrained by an immovable layer of bone, inhibiting their pulse. According to Huges, it is this that causes the adult to lose contact with the visionary imagination and dreams of childhood. The removal of a small disc of bone allows more blood to reach the brain's capillaries, inducing a permanently high state. After spending two years trying to find a surgeon who would perform the operation on him, Huges did it himself; an action which earned him a few months in a Dutch mental hospital. But not everyone thought he was mad, and when Joey Mellen met Huges in Ibiza in 1965, Mellen became convinced that his theories were sound, and that Huges really was in a permanently high state.

Bart Huges arrived in London in 1966 after money was raised to bring him over and provide lodgings for him. LSD, and to a lesser extent trepanation, were subjects of great interest in London at the time and both he and Joey Mellen were in great demand as speakers. After they gave a talk at Better Books they were approached by two reporters from the Sunday tabloid the *People*. They foolishly thought these people were seriously interested in the subject and spent most of the night explaining their theories, only to see the headline on Sunday: 'THIS DANGEROUS IDIOT SHOULD BE THROWN OUT'. The police obliged and the Home Office placed Huges on the list of undesirables to be denied entry to Britain (along with Timothy Leary).

One convert was the American folk singer Julie Felix, then the resident singer on David Frost's television show *The Frost Report*. She set a number of Joey Mellen's songs to music, including 'Brainbloodvolume', 'The Great Brain Robbery' and 'Sugarlack', but does not appear to have included them on any of her albums; nor, for that matter, did she trepan herself. During the course of his visit, Bart Huges had become very close friends with Amanda Feilding, and when she accompanied Huges back to Amsterdam, leaving Joey alone in charge of her Chelsea flat, Mellen saw this as the ideal time to trepan himself. It took three separate attempts. The details of the operations are not for the squeamish but are contained in both Mellen's 1975 account, *Bore Hole*, and in John Michell's essay 'The People with Holes in Their Heads' in his *Eccentric Lives, Peculiar Notions*. When he finally achieved his aim, after several failed attempts and one burnt-out electric drill, he felt a sense of serenity that stayed with him. In the late sixties, he and Amanda got together and she was so impressed by the results of his operation that she performed one on herself, with Joey filming it. The resulting film, *Heartbeat in the Brain*, is regarded as an underground classic. At one London showing a film critic

reported members of the audience 'dropping off their seats one by one like ripe plums' at the sight of so much blood.

Amanda had studied mysticism and comparative religion at Oxford with Robert Charles Zaehner, Spalding Professor of Eastern Religions and Ethics, whose specialty was Zoroastrianism. The investigation of higher realms of consciousness was her primary interest and, despite the danger involved, she felt it was worth the risk. She too has been in what could be called an elevated state ever since. Amanda stood several times for Parliamentary election in Chelsea campaigning for trepanning operations to be made freely available on the National Health. Her first attempt received forty-nine votes but she more than doubled this to 139 votes the second time she stood. Now Lady Neidpath, having married James Charteris, Lord Neidpath, Amanda still runs the Trepanation Trust, and the Beckley Foundation, described as 'a charitable trust that promotes the investigation of consciousness and its modulation from a multidisciplinary perspective. It supports world-class research into the science, health, politics and history of practices used to alter consciousness, ranging from meditation to the use of psychoactive substances.'

Acid became part of the London underground scene; never in a big way as it was in San Francisco, but enough to profoundly affect the rock 'n' roll community. Nik Cohn wrote in *Awopbopaloobop*:

> After acid, you walked around bulging with your new perceptions and you thought you'd been some place nobody else had ever seen. You knew all kinds of secret answers and you were smug, you couldn't help it. In this way, acid formed its own aristocracy and pop was part of it, pop was its mouthpiece. Not all of pop, of course. Just the underground.[13]

There were certain buildings in London associated with underground activity and LSD, among them 101 Cromwell Road, in West Kensington. Set in a crumbling Regency terrace near the West London Air Terminal where passengers would check in before leaving by coach for Heathrow airport, 101 was filled with creative young people just arrived in London, hoping to transform their lives. On the ground floor lived Nigel Lesmore-Gordon and his new wife, Jenny. They had moved there from Cambridge because Nigel wanted to become a film-maker. It was a large flat and they rented out several of the rooms to friends. One of these was the poet John Esam, one of the organizers of the Albert Hall reading, who had arrived in London in the early sixties from Wellington, New Zealand. As all the spare rooms were full, he built an airless, windowless shack in the corridor to sleep in. John

was tall and thin, with jet black hair slicked back like a raven's wing. He had a store of thousands of LSD trips, brought over by an American friend, and was evangelical about its beneficial qualities. He also had a further 4,000 trips concealed in a doorknob in another flat nearby. Esam, along with Hollingshead, was the main source of LSD before it was made illegal. When visiting him, it was advisable not to eat an orange or drink juice from the fridge unless you wanted a trip. Everything was spiked.

His altered vision meant that his conversation often appeared to be elliptical, even far removed from everyday reality, and some people, women in particular, found him a bit frightening and nicknamed him 'The Spider'. He wrote dense, classically inspired poetry, including a major work called *Orpheus Eurydice*. John, and 101 Cromwell Road, was at the receiving end of the first attempt by the police to bust someone for LSD.

As the police smashed their way into the flat, John threw the acid – which was in sugar cubes – out of the window into the garden, where it was caught by a waiting policeman. LSD was still legal at the time, but the police tried to circumvent this by charging Esam with possession of ergot. LSD is a semi-synthetic derivative of ergot, which is a controlled poison, so they charged him with conspiring to manufacture poisons, a charge which had a frightening unlimited sentence under the Poisons Act. The case went to the Old Bailey and the prosecution brought over Dr Albert Hofmann, the chemist who discovered LSD, from Basel, Switzerland. But what was seized was LSD, not ergot. As Steve Abrams put it: 'The government were essentially saying that if you boiled instant orange juice you'd wind up with an orange.' The defence then brought in a chemist called Professor Chain, who set out to prove that the ergot Hofmann used to create LSD was not genuine ergot, but some form of synthetic. Abrams, reporting the case to Jonathon Green, said:

> At one stage the four expert witnesses stood up, got into a sort of football huddle, told the judge to piss off and stood there for ten minutes arguing among themselves. Then they all approached the bench together and told the judge that they had decided that Hofmann was wrong and Chain was right and they had to let Esam go.[14]

Afterwards, John Esam was a changed person; he had been so traumatized by his experience that he didn't touch another drug for at least ten years. The police, of course, fairly soon afterwards managed to demonize LSD, largely through the Sunday tabloids, and it was made illegal. All the potential benefits of its use in psychiatry have been hampered ever since.

Over the years Nigel and Jenny had a good cross-section of the London scene living in the spare rooms of their Cromwell Road flat: Peter Roberts, known to his friends as 'Pete the Rat', and George Andrews, an American friend of Dan Richter who had reached London via jail in Tangier. Andrews was a poet with a strong interest in drug culture. In 1967, together with Simon Vinkenoog, he edited *The Book of Grass: An Anthology of Indian Hemp*, probably the best anthology of essays on marijuana ever assembled.

There was a close connection between 101 Cromwell Road and the Pink Floyd. Nigel Gordon knew Syd Barrett and Roger Waters from Cambridge, and one of his earliest films was of Syd tripping on mushrooms in the Gog Magog Hills outside Cambridge. Barrett and Waters came down to London together in 1964: Syd to study painting at Camberwell School of Art and Roger to study architecture at the Regent Street Polytechnic. At the Poly, Roger met the painter Duggie Fields, who lived in the top-floor duplex at 101 and let him have one of the spare rooms, so Roger was the first to move there. Roger and Syd needed somewhere to rehearse their band and Roger was the only one with enough space. Duggie Fields: 'They used to rehearse in the flat and I used to go downstairs and put on Smokey Robinson as loud as possible.' Roger went to live with his girlfriend and Syd moved into the building with his friend Scotty, another friend from Cambridge. It was Syd who came up with the name Pink Floyd by joining the Christian names of bluesmen Pink Anderson (1900–1974) and Floyd 'Dipper Boy' Council (1911–76). He first used it as the name of his cat, so the band is actually named after a tomcat. By the time Syd moved into 101, he had been taking a lot of acid for some months so when he told reporters that the name was transmitted to him by a UFO while he sat on the ley line crossing Glastonbury Tor he may have believed it.

Barrett was a highly stylized and original songwriter. He took as his subject matter English fairy tales, nursery rhymes, an innocent child-like view of life contrasted with adult confusion, verses from the *I-Ching or Book of Changes*, a surreal juxtaposition of psychedelic musical passages against straightforward statements of fact, 'I've got a bike' and a description of its bell and its basket. He was a master of the abrupt mind-bending change, the use of strange musical instrumentation, trance-like strumming, the whole imbued with a terrible, slightly frightening urgency. Syd was losing contact with everyday reality: the use of LSD may or may not have exacerbated his rapidly progressing schizophrenia, but it was not long before he was forced to leave the band and, after a couple of brilliant but very patchy solo albums, leave the music scene altogether.

15 Spontaneous Underground

Counter culture is a product of the way adults demonize young people. Each generation of young people are a soft target, so young people, in order to protect themselves from the battering they get from the establishment, has to create a counter culture. Each generation is going to be demonized, especially in a culture which hates children as much as British culture does.

CAROLINE COON, 2008[1]

Responding to the need for somewhere that the audience at the Albert Hall poetry reading could meet, a group of poets including Pete Brown set up the weekly Goings-On club in a gambling club on Archer Street, Soho. But after the fifth week, so many gamblers had mistakenly wandered back in that the club closed. It was then that Steve Stollman arrived from New York, charged by his elder brother Bernard with the task of finding and signing underground groups for his ESP-disc label. Steve quickly contacted Hoppy, and all the people associated with the Albert Hall poetry reading. He decided that the best way to discover new talent was to open a showcase; somewhere that experimental groups could come and perform. He hired the Marquee, then at 90 Wardour Street, for the afternoon of Sunday, 30 January 1966. Admission was by invitation only and a flyer was mimeographed and sent round to the combined address lists of Hoppy, myself, Alex Trocchi and various other people involved with the original Albert Hall reading, which claimed:

> Among those taking part will be Donovan / Mose Allison / Graham Bond / Pop / Mime / Kinetic Sculpture / Discotheque / Boutique.
>
> THIS TRIP begins at 4.30 and goes on. Liquor licence applied for. Costume, masque, ethnic, space, Edwardian, Victorian and hipness generally... face and body makeup – certainly.
>
> This is a spontaneous party, any profit to be held in trust by Louis Diamond, Solicitor, that such spontaneities may continue. Invitation only, donation at door 6/6.

That day Hoppy used his contacts at the *Sunday Times* to get them to preview the event:

> The invited *are* the entertainment... Who will be there? Poets, painters, pop singers, hoods, Americans, homosexuals, (because they make up 10 per cent of the population), 20 clowns, jazz musicians, "one murderer", sculptors, politicians and some girls who defy description are among those invited. For Stollman their identity is irrelevant because this is underground culture which offers everyone the opportunity to do or say anything without conforming to the restrictions of earthmen...[2]

Mose Allison didn't show, but Donovan and Graham Bond did. Donovan was a little the worse for wear and the next day had no memory of being there at all. Surrounded by six sitar players and a conga drummer he sat cross-legged at centre stage wearing make-up: each eye drawn with a red and black Egyptian Eye of Horus. The audience happily sang along with the line about the violent hash smoker from Sunny Goodge Street on his recent album, *Fairy Tale*. Graham Bond made a great deal more noise. Jack Bruce and Ginger Baker were still in his band – they did not leave to form Cream until later that year. With Graham's Mellotron, and Dick Heckstall-Smith honking away on the saxophone, the group dominated the proceedings. Graham's gravelly vocals were always pretty rough, but his live performance made up for it as he scowled and grimaced at the audience and bugged his eyes at them, dressed in his pirate costume with flowing sleeves. All he needed was a parrot on his shoulder. The Graham Bond Group was an early favourite of the underground and he even played at Seed, the macrobiotic restaurant that Craig and Greg Sams opened in the basement of the Gloucester Hotel on Westbourne Terrace, after a tremendous struggle to get his organ down the steps. The music fitted right in with the slowly chewing patrons who were seated on cushions around tables made from old wooden cable reels, listening attentively.

It was really the audience that counted at the Marquee events. Pete Brown was still thought of as one of the few genuine beatniks in London, having had his poems published in *Evergreen Review*, the Beat Generation bible where Ginsberg, Corso, Kerouac and Burroughs filled the pages. Pete was bearded and carried a trumpet; he looked the part and his poems were funny. Performing from the audience were Poison Bellows, the name given by Johnny Byrne, who co-authored *Groupie* with Jenny Fabian, and the poet Spike Hawkins to a slapstick act involving an old pram containing a wind-up gramophone, Charlie Chaplin clothing, and conjuring tricks in which

broken eggshells and other objects were retrieved from Pete Brown's father's collapsible silk top hat.

Steve's next invite to the Marquee was printed in barely decipherable two-colour Roneo over a large square advertisement for ESP Records. Careful examination revealed: 'In memoriam. King Charles. Marquis de Sade. Superman. Supergirl. Ulysses. Charlie Chaplin. All tripping lightly looning phoenician moon mad sailors – in character as IN characters – characterised in costume at the Marquee this Sunday at 5 o clock...' By now no acts were advertised; the audience itself was the act. It was at the Marquee events, for instance, that the peculiar underground tradition of making huge jellies began.

Although always referred to as the Spontaneous Underground, it was only the first event that had this title. The one for 13 March was called The Trip: 'TRIP bring furniture toy prop paper rug paint balloon jumble costume mask robot candle incense ladder wheel light self all others march 13th 5pm.' The main reason people remember the Marquee events is because it was here that the Pink Floyd first met their management, and, at the same event, that Syd Barrett first saw Keith Rowe play. It was sometime in June 1966, and both the Pink Floyd and AMM were booked to perform.

AMM were one of the most controversial groups of the time because they disposed of both melody and rhythm, giving the listener very little to grasp hold of except that received by their ears. They used to annoy people enormously, as this contemporary report by Michael Vestey shows:

> The AMM's manager, Victor Schonfield, watched as his group spread-eagled themselves around the floor with musical instruments – I saw drums, a clarinet and a piano – and a weird collection of objects which they banged together with ear-piercing clarity. It was rubbish. For two hours people listened as though it were a concert at the Festival Hall. Sometimes through the banging, grinding screeching came the noise of a radio which one of the group switched on.[3]

Victor Schonfield told him: 'We are exploring the indeterminacy of sounds and forms. It is like watching the sea, waves breaking on the shore, sounds rising and dying in all directions, yet somehow part of an organic whole.'[4]

AMM transformed non-musical materials into instruments such as the collective gong and a contra-bass drum made from sheet metal and a discarded wine barrel. Lisle Street, Soho, was then home to many army surplus stores where cheap electronic components could be found and ingeniously transformed into sound-sources. They used contact microphones to explore the usually inaudible parts of instruments such as the strings of a guitar

below the bridge or non-musical parts of a piano. Drums were used like guitar sound-boxes to amplify the sound as they bowed small cymbals, bells and other objects capable of sound-making. Normal instruments were played in unconventional ways, piano strings stroked 'until they squeal in delight'[5] or plucked or glass bottles placed on them which vibrate or distort the sound when the keys are played. These new sounds threw up new questions. As Eddie Prévost asked: 'how do you present the sound of a plastic yoghurt carton being bowed within a sonic aesthetic, how can such a sound be used?'[6]

There was very much an art college sensibility about AMM; in fact, both Keith Rowe and Lawrence Sheaff had been to art school and were making their living as graphic designers and Lou Gare was a mature student studying art. As Eddie Prévost points out, art school in those days was as much to do with examination and enquiry and an experimental voyage of personal discovery as it was to do with making 'art', a situation which no longer pertains as the art colleges have been absorbed into the universities and the creation of art commercialized.[7] Rowe described the way AMM music was made as 'painterly' and continued his appreciation and practice in the visual arts alongside his music-making. Prévost says that Rowe and Sheaff were influenced by ideas associated with American abstract expressionism, particularly the work of Pollock, De Kooning and Franz Kline, in the manner of musical execution; a gestural approach but intellectually he felt that AMM were closer to 'analytical cubism', the approach to an object in which many different facets of the object are shown at the same time. 'This non-hierarchical concept became reflected in the manner in which sounds and musicians were placed, perceived and understood. Out went the classical concerto model, and also the bebop model of featured soloist supported by a rhythm section.'[8] Prévost acknowledged the debt to Jackson Pollock in particular, pointing out that even the method of creation is similar. Pollock laid his canvas on the ground and dribbled paint on it; Rowe laid his guitar flat on its back to 'enable certain "actions" to be carried out, to let dribbles of sound meander, collect in drowning pools of volume or run off the edges into congealed silences'.[9]

All members of AMM used these techniques: Sheaff used tops and wind-up toys placed on different surfaces or amplified, Prévost scratched and scraped objects, bowed anything that was likely to produce a note, dropped a handful of drumsticks on to the skin as if casting the yarrowstalks for a reading of the I-Ching, and drummed so fast that it was 'designed to fall, through an impossible momentum, into chaotic and unknowable sequences'.[10] The

most unpredictable sound source of all was Keith Rowe's radio, which he faded in and out, a station chosen by a random flip across the frequencies so that everything from a Churchill speech to rock 'n' roll entered AMM's music. Prevost: 'The unpredictability of the radio tests the ensemble's ability to accommodate whatever emerges (sometimes almost to breaking point).'[11] They became masters of the 'controlled accident', like the imperial Chinese potters who allowed the glaze to run. Sometimes they purposely allowed the music to go out of control to see what would happen, and had the courage to fail if need be. Prévost:

> For AMM these 'controlled accidents' were practiced variously: through random radio frequency switching: rolling empty tin cans across (and often off) the stage: testing the bowing qualities of an unknown metal sheet. There is a dynamic relationship of intention and creativity in Pollock's work that is matched, if not excelled, by the flashing brush strokes of the best imperial Chinese calligraphers.[12]

It is interesting that Syd Barrett, who so admired Keith Rowe's guitar techniques, was himself a painter and was still at art school when he first saw AMM play. Two of Syd Barrett's signature guitar techniques were taken from Keith Rowe. The use of ball bearings, rolled down the strings, and the detuning of the strings as a musical effect during a solo, though as Syd's illness progressed, he sometimes detuned the strings until they hung down like limp washing lines, incapable of producing a note at all.

The importance of AMM is often overlooked, though to his contemporaries abroad Cardew was a towering figure. Morton Feldman, in *Conversations Without Stravinsky* (1967), said:

> [Any] direction modern music will take in England will come about only through Cardew, because of him, by way of him. If the new ideas in music are felt today as a movement in England, it's because he acts as a moral force, a moral center. Without him, the young 'far-out' composer would be lost. With him, he's still young, but not really lost.

Cardew remained committed to the underground, teaching courses in experimental music at the Anti-University in 1968–9 and at Morley College, where everyone was encouraged to join, whether or not they had a musical education.

Hoppy returned from a visit to New York in 1965 filled with information about the Free University of New York and plans for a London equivalent. The

idea of an educational institution outside the usual controls of the authorities was very appealing and Hoppy used his prodigious energy to organize some public meetings to see how the Notting Hill community felt about starting one of their own. The usual suspects were rounded up: Hoppy's flatmates Ron Atkins and Alan Beckett – both jazz critics – Kate Heliczer – Hoppy's girlfriend – Joe Boyd, the economist Peter Jenner, Andrew King, Graham Keen – a photographer and old friend of Hoppy from CND and jazz days – Michael de Freitas – later known as Michael X,[13] then Michael Abdul Malik – and John Michell, the landlord of a building the London Free School could use.

Hoppy: 'The idea was to make whatever skills we had, such as painting or photography, available to kids in the neighbourhood.' People were canvassed and asked to participate. In his autobiography Michael de Freitas recalled: 'The educational side of the project was basically simple: to hold free classes on as many subjects as there were available teachers and to establish a sort of dialogue – a pooling of experience and knowledge – between teachers and pupils so that both would benefit.' When Hoppy asked if Michael would take a class he agreed to teach basic English: 'I chose this subject because I knew the area was swarming with illiterates who didn't like the idea of people teaching them anything and I felt that if this two-way system got going they would find it acceptable.'[14] Michael's classes were filled, not with West Indians but older Irish people from the area and some Africans. Michael: 'I learned more social history, more vividly, than I'd have got out of any book.'[15] He wrote what they told him on the blackboard, and they in turn laboriously copied down their own stories.

The London Free School (LFS) was launched at a public meeting at St Peter's Church Hall, at the corner of Elgin Avenue and Chippenham Road (now demolished), on Tuesday, 8 March 1966. The red and black flyer printed by Hoppy on the Lovebooks offset machine read: 'The LFS offers you free education through lectures and discussion groups in subjects essential to our daily life and work.' It promised that 'The London Free School is not political, not racial, not intellectual, not religion, not a club. It is open to all.' Michael had been using the basement of 26 Powis Terrace as a gambling club but had been forced to close it down. He gave it to the LFS free for eighteen months with the blessing of the landlord, John Michell, who lived on the top floor. Michell had himself offered courses in UFOs and ley lines, the subject of his *The Flying Saucer Vision* published the next year. Michael's own office was across the street in the same block as David Hockney's studio.

A musician, Dave Tomlin, moved in and used the room for jam sessions; rehearsals were not really required for free-form jazz. The walls were painted

with psychedelic designs and the Free School headquarters quickly became associated with the emerging hippie lifestyle. The Free School had two distinct sides: the community work, citizens' advice, children's play groups and so on; and a late-night scene where people hung out in the psychedelic basement and played music and took drugs. In order to get everyone involved locally, Hoppy had somehow gained access to Holland Park Comprehensive School and invited all the kids to come and hang out. Two that took up his offer were Emily Young, the daughter of Wayland Young, who was shortly to inherit the title of Lord Kennet, and her friend Anjelica Huston, John Huston's daughter, who lived with her mother in Little Venice. Emily quickly became Dave Tomlin's girlfriend and began to spend most nights there, sneaking out of her parents' house at 11 p.m. to make bonfires on waste ground, take acid and hang out with the strange band of older men that the LFS had attracted: the poets Neil Oram and Harry Fainlight, and Mike McCavity, as he called himself, who was an old-style Irish tramp. She would creep home at five or six in the morning ready to go off to school as if everything was normal. After studying at Chelsea and St Martin's art schools, Emily Young went on to become one of Britain's most important sculptors, best known for her work in coloured marble.

Anjelica Huston became a well-known actress but remembers playing:

a good deal of hooky in the basement of a fish and chip shop in Powis Terrace called the London Free School. We used to spend many a happy afternoon with a bunch of bright hippies doing what I care not to remember... To come into one's age in London... I remember hearing Bob Dylan for the first time and Otis Redding for the first time and going to see Ike and Tina Turner at the Revolution. Not to mention the Beatles, the Rolling Stones, the Roundhouse, Eel Pie Island. It was something that was unprecedented and I think it threw everyone into a state but it was awfully good fun if you were on the cusp of it.[16]

In order to involve local people, the LFS began to knock on people's doors, one of which belonged to Rhaune Laslett. It turned out that she was a person of formidable energy and organizational skills and, being eminently respectable, she was also the perfect interface between the LFS and the local council. Many people were impressed in the apparent change in Michael X, who really did appear to have become a reformed character: gone were the days when he ran illegal gambling dens, pimped a number of working girls and acted as an enforcer for the slum landlord Peter Rachman. He now involved himself in the production of *The Grove*, the LFS newsletter, and when Muhammad Ali,

then the heavyweight champion of the world, arrived in the country for his fight with Henry Cooper, Michael somehow managed to bring him to visit the fifty children in Rhaunie Laslett's Free School play group and to talk with some of the locals.

By this time whole streets of houses were being demolished to make way for the Westway, blighting the whole area, which took decades to recover. The cleared land looked like a bombsite and quickly filled with rubbish. Sometimes, on a warm night, Dave Tomlin, playing the saxophone, would lead a procession of people there to build a bonfire. People would sit around it and take acid, smoke pot, play music and improvise poems as the smoke drifted in clouds around them. One early LFS project was to raise money to build an adventure playground for the local children at Acklam Road, on the wasteland of demolished houses. The council agreed to remove the burned-out cars and lumps of rusty scrap metal that littered the area but then suddenly seemed to lose interest. It turned out that they did not like the involvement of Michael X in the Free School. Michael's colleagues received visits from Special Branch, who told them he was a subversive element and a dangerous character and they should have nothing to do with him. The Free School called a meeting to discuss what had happened and voted categorically not to be pressured by the police. Hoppy went to Scotland Yard to complain and received a verbal apology. Volunteers from the Free School cleared the wasteland themselves without assistance from the council, and built their own playground. It was 'opened' on 12 September 1966 with an auto-destructive art performance by Gustav Metzger called *Painting with Explosion*, described by one writer as 'basically local kids burning a pile of rubbish'.

The council had also promised considerable funding for the rebirth of the Notting Hill Fair and Pageant, which had not taken place for more than a hundred years, but once more the money was contingent upon them getting rid of Michael X. Michael wrote: 'The School had been really depending on the money and I felt they would have to yield under this sort of pressure. But they refused point blank. I was happy about this and it made me work that much harder.'[17] In July 1966 the fair happened anyway, without the council's help. A Caribbean steel band led a parade of floats and children in fancy dress. There was a real carnival atmosphere with jazz bands and poetry readings and, according to Michael X, about 1,000 West Indians and 1,500 white people filled the streets. The Fair continued for a whole week and there were remarkably few arrests, despite a heavy police presence and the strange insistence by the police that a fire engine follow immediately behind the steel

band wherever they went. There are conflicting memories over numbers. Darcus Howe recalled 'five hundred revellers and a makeshift steel band in a swift turnaround along Great Western Road, Westbourne Park and thence on to Powis Square'. As Pete Jenner was a lecturer at the London School of Economics, he was appointed as the Carnival's first treasurer and keeper of the chequebook. Rhaunie Laslett and her team did most of the work. From this humble beginning, the Notting Hill Carnival has grown to become the largest festival in Europe, attracting more than a million people to the streets of Notting Hill every August Bank Holiday weekend.

The LFS needed to raise money to print *The Grove*, and to pay for some of the LFS's other projected activities. Pete Jenner, as a vicar's son, knew that the correct way to raise money was by holding events in the church hall. The vicar of All Saints church hall had always been supportive of the LFS's community efforts and had allowed them to establish their first under-five playgroup there – the first in the country. Jenner suggested that they put on a series of Friday night church Hall dances and that they feature the band he saw at Steve Stollman's Sunday afternoon Marquee event, the Pink Floyd, that he and Andrew King were now managing. One of the people at the first LFS meeting was Joe Boyd, an American record producer who had been the stage manager at the Newport Festival when Dylan went electric. He had a lot of experience of touring with blues packages and knew exactly how to put on a weekly musical event. The first Friday only attracted a handful of people, LFS regulars like Emily Young and Anjelica Huston, but very few paying customers. The band discussed mixed-media and light shows with the audience afterwards. The next week, word of mouth almost filled the hall. Two Americans, Joel and Toni Brown, showed up from Tim Leary's Millbrook centre bringing their light show with them and projecting it on to the Floyd with magical effect. The third week was so crowded that it was uncomfortably hot and at the fourth people were turned away. The Pink Floyd had found their audience. The audience had its effect on them as well, because Emily Young became Syd Barrett's muse: their single 'See Emily Play' was written in her honour.

Rock 'n' roll was not the only thing presented at All Saints hall. Keith West from Tomorrow put on a performance of Langston Hughes's *Shakespeare in Harlem* there, featuring local artists such as Horace Ove, who became a well-known film-maker. West's interest in theatrical performance led him to write 'Excerpt from a Teenage Opera', which made the charts in the summer of 1967. There were Charles Dickens amateur dramatics and an 'old tyme music hall', an evening of 'international song and dance', as well as folk

nights and jazz concerts. Dave Tomlin's 'Fantasy Workshop' also performed. Recent scholarship has played down the importance of the LFS because not much actual teaching was done. This is true, but as a catalyst of activity and a focus of attention it was of great importance and paved the way towards *International Times*, the UFO Club and the other sixties underground manifestations. At the time Hoppy told Richard Gilbert:

> In the end I regard activities like the [London Free] School and IT as crucial because they bring people together. A focus like this is bound to be impermanent but the interaction that follows is justification enough. The Free School left its mark in the area and we created a huge variety of activities. The school certainly helped the Pink Floyd get off the ground.[18]

The London Free School also established 'The Grove', as the local West Indians called it, as London's underground neighbourhood (Ladbroke Grove was the main street). The decrepit buildings were cheap to rent and the Portobello Road had an inexpensive food market. The writer Elizabeth Wilson remembered it as the golden age of West London, which she defined as the area bordered to the west by Ladbroke Grove, to the east by Queensway, by Notting Hill Gate to the south, and a less defined boundary around the Harrow Road to the north. Writing in 1982 she said:

> It was a big druggy 'head' scene. In the peeling shells of those enormous pompous houses a new culture spread like golden lichen, a new growth which was actually a symptom of decay. Every Saturday long haired men and women in flapping, droopy clothes thronged the pavements of the Portobello Road...[19]

There was a real sense of community, like a village.

To extend lines of communication with every country where an underground exists. To help in the creation of one where it doesn't.

IT 26 editorial[1]

The Indica bookshop had moved to 102 Southampton Row in the summer of 1966. Bookcases were built and a false ceiling installed, made from stretched Melinex: silver-coated plastic sheeting that shimmered with the movement in the room. There was a large community noticeboard, which over the years was used by everyone from Yoko Ono – needing babysitters – to William Burroughs – wanting volunteers for him to practise Scientology auditing upon – as well as the usual announcements of readings, concerts and demos. Fulcrum Press had their own bookcases, with their complete line of poetry titles, and we stocked everything in print by William Burroughs, Paul Bowles, Allen Ginsberg, Lawrence Ferlinghetti and the other Beats, as well as books by Charles Bukowski, and all new Black Sparrow and City Lights titles – Tim Leary, Richard Alpert, Ralph Metzger, and other psychedelic texts. We had everything by R. D. Laing and Wilhelm Reich, Buckminster Fuller and Marshall McLuhan. Aleister Crowley had to be kept behind the desk because of theft. Whenever possible we stocked American and European underground papers, but the supply was patchy. We carried *Evergreen Review* and even the *Village Voice*, though by the time it arrived it was seven weeks out of date. We specialized in American small-press poetry magazines such as *C*, *Lines*, *Mother*, *Now*, *Grist* and so on, as well as the British *Poetmeat* and *P.O.T.H.* *Underdog*, and European concrete poetry magazines and publications. Three times larger than the Mason's Yard premises, the shop also had a basement and more rooms accessible from the block of flats above. The extra offices were donated to worthy causes: one was used as a script-reading room for the Jeanetta Cochrane Theatre and, as Trocchi was always complaining about

lack of space in his flat, another was given to Sigma. Trocchi accepted it but never worked there. I used the smaller room below the shop for paperwork and in the large basement room the underground paper *International Times*, usually known as *IT*, had its first office. The large back room was initially used for exhibitions organized by Indica Gallery, beginning with a large installation of musical sculpture by the Baschet brothers, François and Bernard.

Over the years, I have had scores of people tell me how much Indica changed their lives: they found books and magazines there that transformed their ideas and gave them new perspectives on life. Pete Frame, author of the *Rock Family Trees* inscribed a copy of his book to me as follows: 'To Miles – if it wasn't for your fucking bookshop I'd still be a happily married man, with a good job, a flash car and lots of money.' Many of them have also told me how they stole books from Indica, 'liberating books' as they called it, knowing that we would never prosecute them if they were caught. It was thanks to them that we finally had to go into liquidation. During the five years of its existence Indica was also a popular meeting place and became one of the London sights, mentioned in all the 'swinging London' guides. To me the function of a bookshop was the propagation of ideas and I was pleased that there was continuity from Better Books to us, and that we were in the tradition of great pre-war London bookshops like Harold Monroe's Poetry Bookshop and David Archer's Parton Street bookshop. When Indica closed on Saturday, 29 February 1970, the staff went on to work for Compendium Books in Camden Town, which continued the tradition for several more decades. At Indica, we caught the last of the old guard: visitors included Colin Wilson, Krishnamurti, Tambimuttu, Cecil Beaton and people like Peggy Guggenheim's sister, Hazel Guggenheim McKinley, who would settle in a chair and hold court, though she bought no books; her friend Sir Francis Rose, the painter whom Gertrude Stein ranked alongside Picasso, sometimes joined her.

After the success caused by the quick *Moon Edition* newssheet that Hoppy and I put together for the 1966 Easter Aldermaston march, we had decided to bring out an actual underground newspaper. Our model was primarily the *East Village Other* in New York, for which I already wrote as their London correspondent, though the *Village Voice* was also a great influence. Ed Fancher and Dan Wolfe, the founders of the *Voice*, made a point of stopping off at Indica whenever they passed through London. Hoppy and I enlarged the number of directors of Lovebooks Limited, who published the paper, to include Jim Haynes, the American founder of the Traverse Theatre in Edinburgh, and

his friend Jack Henry Moore, the theatre's artistic director. We brought in Tom McGrath as the editor, a job that neither Hoppy nor I had the time to do. Tom had previously edited *Peace News*, and had been resting up at Adrian Mitchell's cottage in Wales when he received a fateful telegram: 'Call Hoppy'. He was a friend of both Hoppy and Jim Haynes; unfortunately we were not aware of the fact that he was a heroin addict, which was the reason he insisted that he get £20 a week when everyone else was being offered only £12. In every other respect he was brilliant, with a thorough grounding in Burroughs, Charles Olson and the Black Mountain School, the international peace movement, jazz, the modern theatre, and virtually every other subject of concern to Hoppy and myself.

In the *Riverside Interviews*, Tom McGrath explained:

> We had only the vaguest notion of what we wanted to do and how we were going to do it. There had been talk of a new 'newspaper' for years, but somehow no one before had felt impelled to actually start one. Now there was a new mood around, difficult to define or estimate the strength of. We could see it, we could feel it, we thought and acted within it. There were even manifestations – the London Free School in Notting Hill, project sigma, the Beatles' Revolver LP, R. D. Laing's experimental community in Kingsley Hall, Provos in Holland, weird mass happenings in America, and so on. And everywhere – to us it seemed like everywhere – the startling effects of LSD...
>
> Thus we were a revolutionary movement, but clearly distinguished from the Marxists, anarchists, pacifists, what-have-you by our tactics and our basic outlook... we coupled something of the fervour of a revolutionary movement with something of the mystique of Zen. It was a wonder. Something new was arriving, something old was dying. Just about totally dead were all those cold committee meetings, dreary demonstrations from CND and the Committee of 100, inter-faction poverty in the small radical newspapers, all those grim-faced political puritans, just about dead, on the way out, their demonstrations their own funeral marches... The emergence of this new movement and the birth of *International Times* are closely interwoven. The one could not have happened without the other.[2]

At first IT shared my typewriter, then Sonia Orwell made Jim Haynes a gift of George Orwell's old typewriter; at least, that's what she said it was. Our biggest problem was that we had yet to find an offset printer and so the whole paper was set in hot metal, which meant any illustrations or photographs had to have copper plates made of them. There is film of Hoppy and Tom at the printers, surrounded by machinery which looks as if it was installed in

Victorian times. The results were blurry and sometimes hard to decipher – Jeff Nuttall's cartoon strip was unreadable – but it was our newspaper, totally independent of Fleet Street. The first issue was dated 14 October 1966. It was so exciting to actually have a copy of *IT* in our hands, it felt that a counter-culture, parallel to straight society, might just be a possibility. Hoppy: 'Once we had our own media it began to feel like a movement.' At first it was more like an arts newspaper, with reports on Niki de Saint Phalle's huge *Woman* sculpture in Stockholm and an advance report on Yoko Ono's first show at the Indica gallery, two reports on Gustav Metzger's 'Destruction in Art' Symposium and Jean-Jacques Lebel's obituary of his friend and mentor André Breton. But there was also a column of drug news, called 'Interpot', and news coverage of China, Warsaw and Provo activity in Amsterdam. Jim Haynes:

> We started IT because we wanted somewhere to announce underground and avant-garde events; and we wanted to tackle topics like drugs that were treated with such hysteria in the commercial press... I don't think people should try to be lucid; one should try to be puzzling, to make people think.[3]

IT was launched with a fund-raising party at the Roundhouse in Chalk Farm, the first time it had been used as anything other than a warehouse or train shed.

In 1960 the Trades Union Congress had passed Resolution 42, to encourage and promote working-class theatre. The playwright Arnold Wesker was given a grant of £10,000 to set up an organization – called Centre 42 – to translate the resolution into action. Michael Henshaw, who was then working for the Inland Revenue, was doing Wesker's accounts on a freelance basis. He was now asked to become the organization's administrator. Henshaw immediately left the Revenue and threw himself into Centre 42. By 1966 he not only acted as accountant for half the playwrights in London, but he was on the editorial board of *International Times*, invited to participate by Hoppy and me; he had been Hoppy's accountant for several years and helped set up Lovebooks Limited, the publisher of *IT*. Centre 42 had acquired the Roundhouse in Chalk Farm, an old railway roundhouse they intended to convert into an arts centre once they had raised £280,000. In the meantime it stood empty. Michael Henshaw, however, had the keys. The building was fundamentally unsafe: there was no proper floor, and great jagged pieces of metal stuck up from a thick layer of grime. There were only two toilets, and the electricity supply was about the same as that of a small house, powerful enough only to light the building. There were several large doors opening out on to the railway freight yards, but the entrance staircase from Chalk Farm

Road was so narrow that only one person at a time could enter or leave. At the *IT* launch party there were 2,000 outside, attracted by the flyer:

STRIP?????HAPPENINGS//////TRIP//////MOVIES

Bring your own poison & flowers & gas-filled balloons & submarine & rocket ship & candy & striped boxes & ladders & paint & flutes & ladders & locomotives & madness & autumn & blowlamps &

POP / OP / COSTUME / MASQUE / FANTASY / LOON / BLOWOUT / DRAG BALL SURPRISE FOR THE SHORTEST/BAREST COSTUME.

When people emerged from that claustrophobic stairwell, which took many long minutes to slowly ascend, they found themselves in a large version of the Spontaneous Underground or All Saints hall: Hoppy, myself and several volunteer girls in tiny silver mini-skirts took the tickets and handed out sugar cubes. None of them had acid in them even though some people believed they did and acted accordingly. Clouds of incense masked the slightly acrid smell of hash. Films and light shows were projected on to plastic sheets hanging from the heavy wooden balcony constructed many years before to store Gilbey's gin and now unsafe. People paraded in costume. Most conversations were held on the move because it was October and there was no heating; the cold night air whistled under the huge locomotive doors, some of which were little more than corrugated iron. Marianne Faithfull, there with Mick Jagger, won the 'shortest/barest' contest for an extremely abbreviated nun's outfit (these were pre-PC days, though there were several men who were in the running). People wore refraction lenses to indicate their third eye; they wore silver headdresses and long robes, spaceman outfits and rubber bondage wear. I wondered how they got there. Glitter dust rose in clouds as people kissed each other in greeting. Paul McCartney, dressed in sheik's robes, strolled around with Jane Asher, Monica Vitti was with Michelangelo Antonioni, Alexander Trocchi tried to get in free by walking all the way up the railway tracks to the British Rail entrance; Mick Farren says someone saw a camel there but it seems unlikely. There was a huge jelly, evidence that when they get beyond a certain size they never properly set and are unstable. This one had splashed all over the floor after the Pink Floyd's roadie removed a vital piece of wood that supported its plastic sheeting container. Some people ate it, Mike Lesser stripped off and dived in, which was a brave thing to do as it was very cold and there were no bathrooms to clean up in. The two toilets flooded immediately and their doors had to be taken off to use as duckboards. Volunteers blocked the doors to preserve

people's privacy. A steel band warmed up the crowd and was followed by the Soft Machine.

The Softs' drummer, Robert Wyatt, told Daniel Spicer:

> In those days there was no seating in the Roundhouse so there was lots of space. A friend of the organist was a motorcyclist and, as another member of the group, his contribution was to ride around the room to add a bit of enjoyable sound. He was very sensitive in the way he drove his motorcycle and it fitted in with the tunes perfectly, as I remember.[4]

My memory is that the bike was also mic-ed up, as described by the group's singer, the Australian poet Daevid Allen, who wrote:

> That was our first gig as a quartet. Yoko Ono came onstage and created a giant happening by getting everybody to touch each other in the dark, right in the middle of the set. We also had a motorcycle brought onto stage and would put a microphone against the cylinder head for a good noise.[5]

The San Francisco poet and anarchist Kenneth Rexroth was visiting London so I invited him to the party. He mistook the Soft Machine for an audience jam session and was terrified by the whole event. He wrote an unintentionally funny report in his column in the *San Francisco Examiner*:

> The bands didn't show, so there was a large pickup band of assorted instruments on a small central platform. Sometimes they were making rhythmic sounds, sometimes not. The place is literally an old roundhouse, with the doors for the locomotives all boarded up and the tracks and turntable gone, but still with a dirt floor (or was it just very dirty?). The only lights were three spotlights. The single entrance and exit was through a little wooden door about three feet wide, up a narrow wooden stair, turning two corners, and along an aisle about two and a half feet wide made by nailing down a long table. Eventually about 3,500 people crowded past this series of inflammable obstacles. I felt exactly like I was on the Titanic. Far be it for me to holler copper, but I was dumbfounded that the police and fire authorities permitted even a dozen people to congregate in such a trap. Mary and I left as early as we politely could.[6]

In fact there were several huge manned doors opening on to the goods yards in case of fire and we had a doctor on hand in case anyone hurt themselves, but we understood Kenneth's anxiety.

Hunter Davies reviewed the event in the *Sunday Times* providing the first national press for the Pink Floyd:

At the launching of the new magazine IT the other night a pop group called the Pink Floyd played throbbing music while a series of bizarre coloured shapes flashed on a huge screen behind them. Someone had made a mountain of jelly and another person had parked his motor-bike in the middle of the room. All apparently very psychedelic...

The group's bass guitarist, Roger Waters, [said] 'It's totally anarchistic. But it's co-operative anarchy if you see what I mean. It's definitely a complete realisation of the aims of psychedelia. But if you take LSD what you experience depends entirely on who you are. Our music may give you the screaming horrors or throw you into screaming ecstasy. Mostly it's the latter. We find our audiences stop dancing now. We tend to get them standing there totally grooved with their mouths open.' Hmm.[7]

The second issue of *International Times* gave them a warm review:

The Pink Floyd, psychedelic pop group, did weird things to the feel of the event with their scary feedback sounds, slide projections playing on their skin (drops of paint ran riot on the slides to produce outer-space/prehistoric textures on the skin), spotlights flashing in time with the drums.[8]

This was probably the first time most of the audience had seen a light show and many stood staring open-mouthed as the amoeba-like organic bubbles pulsed and merged with each other. As an unintentional but dramatic climax to their act, the Floyd blew the fuses, right at the end of a long, inspired version of 'Interstellar Overdrive', plunging the building into darkness. Afterwards I paid the bands: the Soft Machine received £12 10s but the Pink Floyd got £15 because they had the extra expense of a light show. *IT*'s editor, Tom McGrath:

Those early days were wonderful. The IT office was crowded with people offering their help or just coming to thank us, share the feeling of union. New forms, strange inventions, poster art reborn in startling colours, digger communities founded on vows of poverty and love, clothes weird and wonderful, everywhere the outrageous colours exploding shapes of psychedelia.[9]

We hadn't really a clear idea who our audience was, but they quickly found us. It turned out that there were huge areas of interest that Fleet Street was just not covering, even though thousands of people were interested, and these were not entirely to do with drugs. In fact *IT*'s drug coverage was largely informative: the price of hash in Athens, for instance, but it was certainly non-judgemental and most of the staff were involved with the drug

counter-culture. The notice pinned to the office door gave this away: 'Have you turned out the lights? Put away everything important? Turned on?' *IT* provided a meeting point for all the new ideas under discussion. McGrath told Richard Gilbert:

> We seem to have struck something that's really happening in London – it's the living out socially of an artistic philosophy that I suppose goes right back to Dadaism. I think this is partly due to the way that writers' ideas have finally filtered right through society. We're now at the stage where the message carried by writers like Burroughs isn't all that far away from the message carried by the Beatles, although they operate at different levels.[10]

The Beatles agreed. Paul McCartney told a Granada TV crew:

> I remember sitting in his [Miles's] flat putting the paper together. That was the news organ of the time, where you could get your little piece of news in and do your interview and swear without anyone minding. Because, again, it was a studenty-type thing. You knew it wasn't going to be tut-tutted at by grown-ups. It was good to be involved with Miles on *IT*, and with his friends, like Ginsberg. We were very interested in all of that because we'd come up through the pop world and had become known as the cute little head-shakers, and that had submerged that slightly offbeat 'arty' side of us. *IT* was the other side of us.[11]

Derek Taylor, the Beatles' press officer, commented in the same programme:

> It had such romance, hard to imagine now... Without a glimmer of pretension *IT* did have great contemporary cachet. It was a privilege to be published in it, but just about anybody could be if they were thinking well. It had absolutely rock-solid "street cred" and yet it was really good fun. There was no cynicism.[12]

IT quickly ran out of money, of course, and even though UFO was up and running by this time, *IT* decided to put on a jumble sale, in the best English fund-raising tradition. The 'Uncommon Market' was held at the Roundhouse on the afternoon of Sunday, 19 March 1967, and drew 800 people. It featured Ivor Cutler, singing his strange ironic ditties to the accompaniment of a harmonium, and one of Biddy Peppin's 56-gallon jellies. It flopped and spread out over huge sheets of silver Melinex. Some ate it, others stomped in it and threw it around. Barry Fantoni conducted an auction and everyone had a pleasant afternoon though not much money was raised. It was at events such

as this that the village community spirit of the London underground scene was best appreciated.

The early heady days of the underground couldn't last, of course, and it was not long before the police targeted *IT*. The establishment is threatened by even the slightest demonstration against its all-pervasive control over people's lives and the police were incensed at some of the news items that we ran: the first issue, for instance, carried a report which said: 'Pusher named Nigel in Chelsea area reportedly being supplied with anything he wants by the fuzz in order to set people up. Has red hair.' On 9 March 1967 the door of Indica was flung open and a mob of a dozen policemen pushed customers out of the way and demanded to know where *IT*'s offices were. When Tom McGrath heard the thudding of approaching policemen's boots, he grabbed his briefcase – 'which held an assortment of things that would have been of great interest to them' – and headed up the stairs to the bookshop, passing the lead policeman on the way. 'Excuse me,' said Tom, politely. He didn't look like a hippie, he was respectful, and so they did not stop him. He walked calmly up Southampton Row to Cosmo Place and the Cosmoba Italian restaurant, where the staff frequently ate. He asked the proprietor if he could leave his bag behind the counter for a little while then returned to the office, which was now filled with police sniffing at ashtrays and emptying their contents into plastic bags even though they had only arrived with an obscene publications search and seize warrant, a rarely used form that empowered them to take away anything they wanted. One of the policemen patted down Tom's secretary, feeling her breasts as he did so. They wanted to know the contents of the next issue, to be published the next day, warning Tom that they would be back to bust that too if there was anything in it they didn't like. There was no pretence that they were there to do anything other than close the paper down.

The police brought a three-ton truck round to the front of the building and loaded it with virtually the complete contents of the *IT* office: everything from the London telephone books to all 8,000 copies of the back issues. They seemed more interested in disrupting the running of the paper than actually taking away anything that might be obscene. They took all the book-keeping records, the correspondence files, all the subscription files, half the address stickers for mailing the next issue and even an uncashed wage cheque belonging to one of the staff, but left a photograph of a nude which, for all they knew, we might have been intending to publish. They took personal address books and advertising invoices. When they left, the room was almost empty. There could be no better way to close down a business. They also snooped

around the Indica bookshop, taking away all the usual suspects: *Naked Lunch* by William Burroughs, *Memoirs of a Shy Pornographer* by Kenneth Patchen, *I Jan Cramer* by Jan Cramer, offprints of Burroughs's 'Invisible Generation' essay from *IT*, a bundle of *IT*s, and thirty other books and poetry magazines. When they were eventually returned they were damaged, mixed in with *IT*s; though judging by the grubby thumbprints, one officer must have enjoyed *Naked Lunch*.

The original warrant was issued on the pretext that someone, thought to be the right-wing Christian MP Sir Cyril Black, organizer of the Billy Graham campaigns in Britain, had objected to an interview with an American comedian, Dick Gregory, a write-in presidential candidate, in which he used the word 'motherfucker'. The MP Tom Driberg told me that the police were encouraged to go ahead by Lord Goodman, Harold Wilson's private lawyer, who hated *IT* despite his knowing that the Home Secretary, Roy Jenkins, would object to the raid. Goodman had sponsored Jim Haynes in his move from the Traverse in Edinburgh to the Jeanetta Cochrane Theatre and had taken it as a personal betrayal that Jim had left and was involved with *IT* and planning to start his own Arts Lab. The police were delighted because the fact was that they had declared war on the underground. It was no longer just an easy target for the drugs and porn squad to use to make up arrest numbers. They were personally offended by its threat to their value system. This had been demonstrated in the previous week, when plain-clothes and uniform police raided a house in Gloucester Road, off Primrose Hill, but finding that the people they were looking for were not there, they knocked on the door of another flat and asked if they could search their premises instead. They were told no; they had no warrant or reason to search the place. The landlord telephoned the local police station and demanded to know what was going on. He was told that they would 'eventually put a stop to the Round House and all that it stood for'.

The Sunday after the raid saw the acting out of the 'Death and Resurrection of *International Times*' as directed by Hoppy and performed by Harry Fainlight. Surrounded by about thirty mourners, Harry climbed into a red coffin at the Cenotaph in Whitehall and was then symbolically buried: the surprisingly heavy coffin was carried to Westminster Underground station, where the rebirth journey took place on the tube train as people played music and danced around it. Naturally the police arrived and ordered them off the train. They obeyed, but, undeterred, soon caught another and Harry was able to spend a further four hours on the Circle Line before his rebirth in Notting Hill. A procession made its way down Portobello Road through the market,

led by Mike McInnerney and Mike Lesser carrying flowers. March policy was that when stopped by the police, which was inevitable, they should be handed flowers. The police stopped them and some people attempted to offer them a few limp blooms, but some observers noticed that other mourners were throwing their flowers instead of giving them in a spirit of love and peace. Irritated by the delay in his rebirth, the corpse of *IT* suddenly sprang from his coffin, startling everyone, and began to harangue the police. The event ended with two arrests, one of them Harry, who was detained, cautioned and let go. The *Daily Mirror* fulminated about 'Sacrilege at the Cenotaph', but far from insulting the memory of the dead of two world wars, the funeral ceremony had been conducted with respect for the freedom of speech that the soldiers had so valiantly protected and was now being eroded.

Publication of issue 10 was suspended for five days while we took legal advice; meanwhile, as a temporary measure, *IT* transformed itself into a dramatic event at that Friday's UFO and the articles were read aloud to the audience and the pages projected as a light show. £100 was collected from the audience. Members of the National Council for Civil Liberties were present to give advice in the event of a police raid on the club. In the delayed issue Tom McGrath wrote a long, well-reasoned editorial in which he came as close as anyone to defining the new movement: except that you couldn't define it:

1. It can never be suppressed by force or Law; you cannot imprison consciousness. No matter how many raids and arrests the police make, on whatever pretence – there can be no final bust because the revolution has taken place WITHIN THE MINDS of the young.

2. It is impossible to define this new attitude: you either have it or you don't. But you can notate some of its manifestations:

a) Permissiveness – the individual should be free from hindrance by external Law or internal guilt in his pursuit of pleasure so long as he does not impinge on others. The conflict between the importance of the individual's right to pleasure (orgasm) and his responsibilities towards other human beings may become the ultimate human social problem...

5. The new movement is slowly, carelessly, constructing an alternative society. It is international, inter-racial, equisexual, with ease. It operates on different conceptions of time and space.[13]

Some academics agreed with him, including Peter Fryer, writing in *Encounter*:

It is a thoroughgoing revolt by a section of young people against the habits, manners, standards, morals, politics, taste, taboos, and lifestyle of their elders. Youthful rebellion is not new, as trend-sporting vicars are constantly reminding us. But no previous expression of adolescent frustration has been so comprehensive, so self-assured, or so cynical.[14]

To others, it was nothing new at all. Diana Athill, editor and director of the publisher André Deutsch, wrote in her memoir *Stet*:

Most of the people I knew had been bedding each other for years without calling it a sexual revolution. Jean Rhys agreed, saying that people were using drugs like crazy when she first came to London before the First World War, the only difference being that the papers didn't go on about it.[15]

She saw the sixties as an invention of the media, and little different from any other decade.

An emergency two-sided half-issue of *IT* was produced by Hoppy, Mike McInnerney, Mike Lesser and others, but while it was being printed, the printers, Pirate Press in Whitfield Street, were visited by plain-clothes police. The owner, Terry Chandler, quickly bolted the doors and called the police to report a group of men trying to break into the press. Several squad cars arrived and minutes of delicious confusion occurred while uniformed cops confronted CID officers bearing a forgery warrant. When this was sorted out, they made a combined effort, broke in through a window, and seized $20,000 – in fake dollar bills, printed in lurid colours with an anti-war message on them, but none the less they took Chandler to court, where he was found guilty and conditionally discharged for three years. With paranoia already running high, the *IT* people thought they were trying to seize the half-issue, but it seems in this case it was otherwise.

By issue 12, the pressure had become too much for Tom McGrath and, without informing anyone of his intentions, he upped and left, talking *IT*'s only typewriter with him. None of us knew where he'd gone as he was careful to cover his tracks. At the time we were angry that he had deserted us without warning or explanation. Then *IT* 42 of 18 October 1968 carried a news item: 'Tom McGrath, IT's first editor, is alive and well and living in Glasgow after being incommunicado for over a year.' By then *IT*'s circulation had risen to 40,000, with an estimated readership of six times that figure.

17 **UFO**

Everything was so rosy at UFO. It was really nice to go there after slogging around the pubs and so on. Everyone had their own thing.
SYD BARRETT[1]

After the success of the All Saints hall events in raising money for the LFS, Joe Boyd proposed to Hoppy that they take their venture to the West End. They were very fortunate in finding a perfect location: the Blarney Club, an Irish dance hall located at 31 Tottenham Court Road, halfway between Goodge Street and Tottenham Court Road tube stations and on many bus routes. They called it UFO, pronounced 'you-fo', and tested the water by committing to just two Fridays, one either side of Christmas, 1966. The rent was £15 a night but no music was permitted until 10.30 because there was a cinema above and the sound leaked through the ceiling, disturbing the audience. The Pink Floyd played on both nights. The entrance was down a grand staircase, wide enough to be used for people to sit out on when the heat and noise became too much for them. Halfway down, a theatre lighting unit was installed which produced the effect of continuously falling snow, it was like driving through a snow storm. As Hoppy pointed out: 'Stand in it for a minute or two and you become disorientated... definitely hypnotic.' Incense burned and the hippies gave off clouds of patchouli oil. And this was before you reached the pay desk. Admission was 10s (50p). UFO was run as a club and memberships had to be bought or checked at a small table at the bottom of the steps. This caused tremendous bottlenecks until Mick Farren took over the door and quickly cut through the hippie discussions about whether money was immoral or uncool or whatever and simply took what they had on them and pushed them in.

It was a traditional ballroom, with ceiling fans and a revolving mirror ball that the light show operators used to great advantage. It had a polished

dance floor and the only serious argument that Mr Gannon, the owner, had with the UFO management was when Jack Henry Moore asked to pile sand on the floor as part of a theatrical event. Apparently in the old days of cut-throat competition between ballroom owners, one of the ways of sabotaging a rival was to put sand on his dance floor. The room was dimly lit, both in order to see the light shows and to make it more friendly. There was a cloakroom and to the left Greg Sams's macrobiotic food counter. There was no alcohol. There were a few stalls selling underground newspapers and other underground paraphernalia. The main room was adjacent to the door on the right, with the stage at the far end. The stage was wide but not very deep, protected from the audience by a thin wooden fence: a wooden rail, held twelve inches above the stage by wide-spaced 'X'-shaped supports which make photographs of UFO easy to identify. There were four upright WEM speakers on stands in the four corners of the room which could be very loud if you sat too close, and which gave an exaggerated stereo separation, sometimes used to great effect by the groups. However, the music was never so loud that conversation was impossible, except right in front of the stage.

A lighting gantry, managed by Jack Henry Moore, stood at the back of the room. Light shows, films and projections were very much part of the UFO experience and continued whether there was a band onstage or not. From here Jack Bracelin's Five Acre Lights kept the back half of the room bathed in moving lights. It was named after his nudist colony, a collection of caravans, lived in mostly by local teachers, in a muddy field near Watford, north of London. There he had a wooden clubhouse near the gate where the residents could relax with a cup of tea and watch the 'trip machine', a revolving wheel on the ceiling from which strips of silver Melinex hung down to the floor, upon which coloured lights played. As the wheel slowly turned, the assembled tripping nudists watched the flashing colours to the accompaniment of a very scratched copy of *Freak Out*. The Pink Floyd played there on 5 November 1966, Guy Fawkes Night – stopping off to see the fireworks on their way back to London from a concert in Bletchley. It was all very English, and the time I went there it was freezing cold and the path was ankle-deep in mud. Jack first developed his light shows for patients at mental hospitals. He would play some records and give them a cup of coffee followed by an hour of slide projections. According to Alph Moorcroft the best of these were made by a girl who was a patient at Knapsbury mental hospital: 'The slides consisted of bright heaving masses of colour and produced amazing emotional reactions, tears and often a state of disturbance which lasted for days. Because of these reactions some of the hospitals he visited decided that his shows were "too

loaded" emotionally and therefore stopped them.'² Jack often achieved the same effect at UFO as people danced for hours surrounded by the swirling dots and blobs of light.

Other light show projectionists were Dermot Harvey, described by Hoppy as 'an errant biochemist, discoverer of many immiscible liquids', and Joey Gannon, then a teenager, who had evolved his ideas at Mike Leonard's Sound/Light workshop at Hornsey College of Art. Roger Waters and Nick Mason from the Pink Floyd had lived in rooms at Leonard's house in Highgate, and he played in an early incarnation of the band known as Leonard's Lodgers. This was the origin of the Floyd's interest in light shows and spectacle. The most celebrated light show was by Mark Boyle and Joan Hills. During 1966 they had developed a series of *son et lumière* events which they presented at the Jeanetta Cochrane Theatre, then directed by Jim Haynes and Jack Moore, who had first shown their work at the Traverse Theatre in Edinburgh. Hoppy originally hired them to stage their 'Son et Lumière for Bodily Fluids and Functions' at UFO. It was a light show involving phlegm, semen, piss and tears and for which Mark had apparently even managed to cough up a bit of green bile. Afterwards, Hoppy had suggested that for a bit of extra money they might like to stay on and project their slides on to the groups.

The Soft Machine quickly claimed Mark as their own and even took him with them when they toured America with Jimi Hendrix. Their singer, Daevid Allen, explained in his book *Gong Dreaming*:

> The light show we used for our UFO gigs was run by Mark Boyle, a Scottish sculptor turned liquid light show alchemist. The combinations of liquids he sandwiched between the twin glass lenses, that began to alter as they were heated by the projector lamp, were his professional secret. He worked inside a tent so nobody could see what he was doing. Some said he used his own fresh sperm mixed with the colours and other liquids and fluids. He felt a special affinity for our music and although it could not be logically programmed, his lights synchronized with our stops, starts, peaks, and lows, as if it had all been pre-organized by a wizardly Atlantean re-incarnate.³

Mark had tremendous control over his projections and I remember one evening when he made small green bubbles emerge from Roger Waters' tightly stretched flies; something the band was of course unaware of.

The club was open until the tubes began running again at around 6 a.m., which, as Hoppy pointed out, was 'conveniently about the length of an acid trip'.⁴ By 5 a.m. there were people huddled together asleep on the floor in

the darkest corners while snow-light flickered over them. Though there were usually at least two bands playing two sets, there was plenty of time for films and other activities. Joe Boyd:

> The object of the club is to provide a place for experimental pop music and also for the mixing of medias, light shows and theatrical happenings. We also show New York avant-garde films. There is a very laissez faire attitude at the club. There is no attempt made to make people fit into a formula, and this attracts the further out kids of London. If they want to lie on the floor they can, or if they want to jump on the stage they can, as long as they don't interfere with the group of course.[5]

Films included Marilyn Monroe or Charlie Chaplin classics, experimental films by Kenneth Anger, Andy Warhol or Stan Brakhage screened by Bob Cobbing or Dave Curtis, or old UFO favourites, Antony Balch and William Burroughs's *Towers Open Fire* and *Cut Ups*. In an essay for the Manchester Futuresonic Festival in 2007, Hoppy recalled:

> One almost forgotten favourite was Chinese animation movies hired on 16mm film from Contemporary Films – shown silent & projected on the walls rather than the white curtain across the stage that we also used between sets. The audio could be something quite different. The detail was ravishing to the tripping eye. The scaffolding projection tower was strategically placed so that projectors could be occasionally swung round causing the watchers to move round to continue watching – a subtle way to keep people moving.[6]

David Z. Mairowitz, an American playwright then on the staff of *IT*, presented a weekly semi-improvised drama, like an underground soap opera, called *The Flight of the Erogenous* which always attracted a reasonable crowd, perhaps because it involved a lot of bubbles and foam being thrown about and female clothing being removed. People sometimes brought in props, the biggest of which was a silver weather balloon which they inflated in the club. With difficulty it was squeezed through the double doors and up the stairs to freedom.

When Yoko Ono was looking for people to participate in an expanded remake of her film featuring nothing but the buttocks of her friends, *Film No. 4 (Bottoms)*, she naturally turned to the UFO audience. She rented a room in a nearby hotel and set up a film camera. Volunteers were ferried to and from the club in the middle of the night to participate. They stripped below the waist and mounted a revolving table while Yoko's cameraman filmed their moving buttocks, like peasants on a treadmill. She was aiming

to get 365 participants and had already exhausted all her friends and acquaintances.

It was at UFO, also, that the biggest demonstration against the *News of the World* originated. When Judge Block handed down vicious sentences on Mick Jagger, Keith Richards and Robert Fraser following the police raid on Redlands, Richards's house near Chichester, it was decided that some form of protest was in order. It was widely known that it was the *News of the World* that had tipped off the police that Richards was having a party that night and so they were the obvious target. There had been a spontaneous demonstration in Fleet Street at ten o'clock on the night the sentences were given, but on Friday night at UFO resentment was still running high. A large section of the audience left the club after midnight and made their way to Fleet Street, meeting up with people from other clubs en route, all of them intending to disrupt the paper's press day operations (as it was a Sunday paper, Saturday was press day). The City of London police were waiting and a nasty encounter ensued, with the police setting their dogs on the crowd – several hippies sustained nasty bites – a number of arrests and Mick Farren, whom the police saw as the organizer of the demonstration, being taught a lesson. He wrote:

> They dragged me to a dark doorway and began working me over with short jabs to the body, in that unique law-enforcement manner that causes the most pain with the fewest visible marks. Battered and decidedly bowed, I was left with a final admonition: 'Now, you little cunt, maybe you'll think twice about coming down our manor and causing aggravation.'[7]

Most of the hippies made their way back to the club, where Tomorrow took the stage for the most soaring, inspired rendition of 'Revolution' they ever performed. Stones fans had also gathered at Piccadilly Circus, chanting 'Free The Stones!'

The music at UFO tended to be album tracks, and sometimes entire albums, played with the gaps between tracks rather than the seamless roar of music of today's clubs. The spaces between tracks or singles gave people time to think and to begin conversations. The dancers just kept on dancing anyway though certain tracks, such as the Purple Gang's 'Granny Takes a Trip' or Tomorrow's 'My White Bicycle', would always fill the floor. Twink, drummer with Tomorrow, told Ivor Truman what it was like:

> It wasn't very big but it had a great atmosphere; light shows, incense burning, theatre groups, people just doing things. People in costume and obviously the

glittering sparkling things in their faces – the make up. It was fantastic – it was really great and as soon as I saw it I wanted the band that I was with to play there and it affected me immediately, I started to get new ideas myself – things like mime, more free form playing, using light shows, things like that.[8]

It was the mix of things that most people remembered about UFO. Nick Mason, drummer with the Pink Floyd: 'Endless rock groups, that's what "underground" meant to the people, but that wasn't what it really was. It was a mixture of bands, poets, jugglers and all sorts of acts.'[9] He told *Zigzag* magazine:

It gets rosier with age, but there is a germ of truth in it, because for a brief moment there looked as if there might actually be some combining of activities. People would go down to this place and a number of people would do a number of things, rather than simply one band performing. There would be some mad actors, a couple of light shows, perhaps the recitation of some poetry or verse, and a lot of wandering about and a lot of cheerful chatter going on.[10]

It was this mix of events and input that Hoppy wanted to maintain throughout the long hours of night. Hoppy:

We tried to keep alive the spirit of the Happening which purposely injects uncertainty into the event, which seemed to fit with the experimental zeitgeist. Mixing different sensory inputs was certainly fun and it didn't always work out. But one essential was always kept in mind, to keep an overview of whatever was going on and to be sensitive to the vibe going down. That way there were never any fights and hardly any bad scenes even when someone freaked out and had to be led away and talked down.[11]

A substantial percentage of the audience was high on something. There were dealers there but they kept a very low profile. It is said that the large German dealer Manfred always gave away his first 400 trips, but as people always bought more than one, he presumably did well. Tottenham Court Road police station was just down the road and there was a constant fear that they would raid, so Tony Smythe from the Council for Civil Liberties was always on hand, usually conducting meetings in a back room. Mostly the police were bemused by the crowd that UFO attracted. They seized one hippie only to find that, rather than the young runaway girl they were looking for, they had captured a 22-year-old man. Sometimes people freaked out on acid and were stopped outside by the police before they got run over.

Usually the police would telephone: 'We've got one of yours', and Mick Farren would thank them and tell them: 'Just hang on to him. We'll send someone up to get 'im.' There was a quiet room at the back where people could be talked down.

Celebrities could mingle with the crowd without fear of harassment; Paul McCartney spent several evenings there, on one occasion being almost deafened by sitting too close to the Soft Machine's speaker stack during one of Mike Ratledge's Lowry Holiday Deluxe organ solos. Paul: 'UFO was a "studenty" place, so we had no problems getting around. It didn't matter if you were famous because students didn't want to let on they knew you anyway. They wanted to be cool: "Hey, we're talking about Marx over here, man."'[12] Jimi Hendrix always arrived very late, but would sometimes sit in and jam. The most excitement was not caused by a rock musician at all but by Christine Keeler, who arrived accompanied by several impassive pot dealers. The most famous regular was probably Pete Townshend, who came every week unless the Who had a gig. His girlfriend, Karen Astley, was featured on the very first UFO poster: a monochrome close-up of her face with the words 'Nite Tripper' painted across it by Michael English. To Who fans, Pete was the guitar-smashing mod, but at UFO he discussed mystical texts, took LSD and wore hippie garb:

I remember being in the UFO Club with my girlfriend, dancing under the influence of acid. My girlfriend used to go out with no knickers and no bra on, in a dress that looked like it had been made out of a cake wrapper, and I remember a bunch of mod boys, still doing leapers, going up to her, and literally touching her up while she was dancing and she didn't know that they were doing it. I was just totally lost: she's there going off into the world of Roger Waters and his impenetrable leer, and there's my young lads coming down to see what's happening: 'Fuckin' hell, there's Pete Townshend, and he's wearing a dress.'[13]

There were a number of house bands: in addition to the Soft Machine, Pink Floyd and Tomorrow, there was the Crazy World of Arthur Brown. Arthur would paint his face as a mask, pre-figuring Kiss by several years, and enter wearing a flaming headdress, which, on occasion, had to be extinguished by the application of several pints of beer as his cloak caught fire (the beer was from backstage). He was an energetic dancer, with much dipping and diving and sideways 'Egyptian dancing'. Compared to other acts at the time, Arthur was absolutely unique, combining both stagecraft and a powerful rock 'n' roll drive. It was at UFO that Pete Townshend first saw the Crazy World of Arthur

Brown. He liked Arthur so much that he arranged for him to be signed to his label, Track Records, and produced his hit single, 'Fire', which in August 1968 went to number one.

Procol Harum played their second and fourth gigs at UFO. By the fourth gig they were already in the charts with 'A Whiter Shade of Pale'. Hearing it performed live was a memorable experience; it was very loud and yet it created a stillness in the audience, almost as if they were sitting at home on their living room floor. The UFO audience liked to sit and listen, as Robert Wyatt, drummer with the Soft Machine, remembered:

> One of the biggest influences was the atmosphere at UFO. In keeping with the general ersatz orientalism of the social set-up you'd have an audience sitting down... Just the atmosphere created by an audience sitting down was very inductive to playing, as in Indian classical music, a long droning introduction to a tune. It's quite impossible if you've got a room full of beer swigging people standing up waiting for action, it's very hard starting with a drone. But if you've got a floor full of people, even the few that are listening, they're quite happy to wait for a half hour for the first tune get off the ground.[14]

It sometimes did take that long to get going, but that was all right.

This was confirmed by Nick Mason: 'We could only play in London, because there the audience was more tolerant and was willing to withstand ten minutes of shit to discover five minutes of good music. We were at an experimental stage. We set out for unbelievable solos where no one else would dare.'[15]

Rick Wright, the Floyd's keyboard player: 'The band was an improvising group in the beginning. A lot of rubbish came out of it but a lot of good too. A lot of that was obviously to do with Syd – that was the way he worked.'[16] It is unfortunate, in some ways, that the Pink Floyd came to be regarded as the epitome of London psychedelic music because, with the exception of Syd, although they came up through the Spontaneous Underground and the London Free School, they were not part of the underground scene. Unlike bands like the Jefferson Airplane or the Grateful Dead, they did not play endless benefits for the community; nor did they live communally in Notting Hill, ready for a rap session with their fans at any hour of the night. Their music received a better reception in underground circles and they certainly relished the publicity that being associated with the underground brought them, for instance their appearances on John Peel's *Top Gear* show were very important to their career. John Peel: 'The first time I ever saw them was at the old UFO club in Tottenham Court Road, where all of the hippies used to put

on our Kaftans and bells and beads and go and lie on the floor in an altered condition and listen to whatever was going on.'[17]

Syd Barrett, however, was another matter. Syd was an active part of the scene; he even featured in Jenny Fabian's *Groupie*. She first saw the Pink Floyd, whom she dubbed Satin Odyssey in her lightly fictionalized roman-à-clef *Groupie*, at UFO: 'They were the first group to open people up to sound and colour, and I took my first trip down there when the *Satin* were playing, and the experience took my mind right out and I don't think it came back the same.' Her boyfriend, Andrew King, was one of the Pink Floyd's managers, called Nigel Bishop in her book, but it was Syd, whom she calls Ben, she really wanted: 'He was tall and thin, and his eyes had the polished look I'd seen in other people who had taken too many trips in too short a time. I found him completely removed from the other three in the group; he was very withdrawn and smiled a lot to himself.' Syd always had trouble with his shoelaces, which he usually left undone, but when Jenny writes that she got him home to her bedroom and 'Finally Ben reached down and untied his gymshoes...', the reader knows exactly what is going to happen.

A regular group at UFO doing their own thing was the free-form jazz outfit the Giant Sun Trolley, which was assembled from the audience by Dave Tomlin and usually went on around 4 a.m. because, as Tomlin described it in volume two of *Tales from the Embassy*: 'Only when the dancers are completely exhausted will they be in a fit state to hear what we have for them.' The music was completely free-form and consequently consisted of 'whatever happens when we get up there'.[18] Sometimes the drummer continued to play after the others had left the stage and had to be informed that they'd finished. When Tomlin was busted, the drummer Glen Sweeney – distinctive in his goatee and shaved head – joined another free-jazz group at UFO called Hydrogen Jukebox, a group of musicians that eventually transmuted into the Third Ear Band. Sweeney, described as 'group unifier', told 'Legolas':

What we're into now with the Third Ear Band really began when we were on a gig, and some kind person. Or mysterious force. Or whatever it was, stole all our amplification equipment and just left us our instruments. This seemed so significant that we took it as a sign. Apparently we had been going in the wrong direction by going electric, and that event caused a tremendous change in our whole way of approach.

I met Dave Tomlin, a multi-instrumentalist who, it seemed to me, had become a kind of musical guru. And he turned me on to an aspect of music that I had long been searching for. He was the first guy I ever met who used

his music to influence people, to turn them on, or freak them out. When I used to play with Dave's group, the Sun Trolly, at UFO Club, just two or three of us would take on up two thousand people, with no amplifiers or anything – and Dave could get them all with him and do incredible things to their heads. I had never seen music used that way before. So when he split from London to take up gypsy caravanning on the Mark Palmer scene, the Third Ear seemed a logical extension of what Dave had been doing.[19]

He explained what set the Third Ear Band apart from the usual psychedelic groups at UFO:

Once or twice when we've played this thing ['Druid'] we've gone into a weird sort of experience we call 'time-shift'. ... It happened once at the London Arts Lab, and as we played, it seemed as if time had slowed down and we had drifted into a completely different dimension. And when we finished nobody moved at all. They were kind of stuck there. So I felt that perhaps it had happened to them too. So that's the thing we are trying to get into. Although it can be quite a strain during public performance, like living on the edge of a cliff, since nobody knows what might happen. To be on stage and feel it happening can be quite frightening. You go out of yourself, and when you come to, you discover yourself on stage with hundreds of people staring at you. You get this split second thought: 'Have I been playing? Have I ruined the whole thing?' In a way, it's very similar to meditation and mantra chanting, which is why I feel what we are doing has a very religious depth.[20]

There was no MC at UFO, no-one mounted the stage or did anything show-bizzy like that; nor was there any security, except the check at the door. What announcements there were came from the lighting tower, more or less anonymously, and usually from Jack Henry Moore in his rather camp Southern accent: 'If you can't turn your parents on, turn on them' or 'Maybe tonight is kissing night. Don't just kiss your lover tonight, kiss your friends', rather like the running heads in *International Times* itself. Another good example was an announcement made by Suzy Creamcheese (Susan Zeiger, Hoppy's girlfriend) in her best Los Angeles drawl: 'Some of you may be uncool, and we may be getting busted tonight. Now I know the usual thing in clubs is to kind of throw everything on the floor. But we don't want the fuzz to close UFO down. So, like, if you're uncool, will you please go out, and come back when you're cool.'

To most people on the scene, UFO and *IT* were part of the same organization, but in fact the two were separate corporate entities. When Pete

Townshend arrived and gave £20, or on at least one occasion £100, 'to the cause', he thought the money was going to *International Times*. UFO was run by the *IT* staff, providing at least some semblance of a regular wage, but it was owned by Joe and Hoppy as a private company. They donated a decent sum of money to *IT* but it was not the underground community club that everyone, including me, thought it was and we never knew what Joe and Hoppy made out of it. When Mick Farren found out about UFO Limited, he was livid. Mick had a problem with Joe Boyd anyway because Joe had refused to let Mick's band, the Social Deviants, play UFO, even though he was manning the door. To now find that Joe was profiting from the underground scene really shocked him. He wrote:

> I'd been running the goddamned door at UFO on no set salary, just what Joe or Hoppy decided to hand me at the end of the night... In my mind – and, I was quite certain, in the minds of 99 per cent of the people who read the paper and went to the club – the two were indivisible: the weekly gathering and the communications medium, the two spearheads of the underground, mutually dependent and mutually supportive...[21]

Mick began to take a tithe – or a 'skim' might be better way of putting it – off the door takings which he used to buy office supplies and pay other essential bills for *IT*, including a contribution to rent and salaries of some of the harder-up staff. The underground scene was not as simple as myth and legend would have it; nor were all the players close friends.

Every week UFO grew in size until it became unpleasantly crowded. At the same time, Fleet Street ran 'exposés' on UFO, where their undercover reporters saw people kissing, and even 'smoking a joss-stick'. Now that the gutter press had the story – six months late – the police had to act. They warned Mr Gannon that his liquor licence was in danger if he continued to rent to hippies, and UFO suddenly had no home. Paul McCartney arranged for me to meet with Brian Epstein and Robert Stigwood, who offered the use of the Saville Theatre, but for some reason Joe decided against it; maybe they couldn't reach a financial agreement. In fact the Saville, on Shaftesbury Avenue in Covent Garden, would have been perfect; a London equivalent of Bill Graham's Fillmore Auditorium, with hardly any of the security overheads of the Roundhouse, which was where UFO moved to.

Centre 42 had been quite quick to realize the potential of the Roundhouse after the *IT* launch party and they had done it up enough to legally rent it out as a venue by installing toilets, a floor, new wiring and an entrance that met fire regulations. There had already been another large event featuring

the Pink Floyd, a happening called 'Psychodelphia Versus Ian Smith. Giant Freak Out' on 3 December 1966, organized by the Majority Rule for Rhodesia Committee. Ian Smith was the pro-apartheid right-winger who had declared independence from British rule in Rhodesia. The audience was encouraged to 'bring your own happenings and ecstatogenic substances', causing the *Daily Telegraph* to demand what 'ecstatogenic substances' were. The organizer, Roland Muldoon, told them they were 'Anything which produces ecstasy in the body. Alcohol was not allowed for the rave-up, unhappily, and nor were drugs... All it means really is that you should bring your own bird.'[22] Large parts of Fleet Street never fully understood what the sixties were all about.

UFO at the Roundhouse was not the same; the small dark Tottenham Court Road venue had encouraged intimacy, whereas the Roundhouse was huge. In order to pay the much higher rent, bigger-name groups were hired – even the Pink Floyd were now charging £400 – which in turn caused a security problem because the building had so many doors and they all had to be manned. Whereas Tottenham Court Road was in the West End, and therefore safe and with good transportation; the Roundhouse was in Chalk Farm, near Camden Town, which was then a fairly rough area, unsuitable for stoned hippies to be wandering around. There was also the problem of the local gangsters. When Hoppy was jailed for six months for a couple of joints, he asked if I would bank the takings for him. Not long after UFO moved to the Roundhouse, I was robbed in a carefully planned attack: car stolen to order, when I got home two men waiting in my doorway with pickaxe handles and ammonia. They only got £62 as everyone had been paid before I left and the riches the Camden mob thought they would get did not exist. The next day I received a threatening phonecall warning me to take my business out of Camden Town. This was especially galling as it was not my business; naively I thought I was doing it for *IT*. Michael X took over security at the Roundhouse and his uniformed Black Power men certainly stopped anyone getting in for free and any fights but they cost so much that UFO began to run at a loss. It closed in October 1967. It had lasted nine months but entered popular culture history.

Perhaps another reason why the UFO became so legendary is that it produced the only English equivalent of the American Family Dog and Bill Graham posters. Most were done by Michael English and Nigel Waymouth, operating under the name of Hapshash and the Coloured Coat, a derivative of the Egyptian Queen Hatshepsut who organized the legendary journey to Punt, only with her name changed to incorporate the word 'hash'. The early posters were silk-screened by hand, and some had no solid colour; each

colour field was a rainbow, running from blue to green or silver to gold. Day-Glo pink was another favourite colour, particularly in the poster by Michael English.

George Melly was puzzled why UFO displayed posters inside the place they were intended to advertise and was not very keen on psychedelic art at all. He wrote:

> The Underground poster is not so much a means of broadcasting information as a way of advertising a trip to an artificial paradise. The very lettering used (a rubbery synthesis of early Disney and Mabel Lucie Attwell carried to the edge of illegibility) reinforces this argument, and suggests that, even in the streets, the aim of the Underground artists is to turn on the world.[23]

Melly was critical of their appropriation of images, which he thought were 'a collage of other men's hard-won visions' taken from the work of Mucha, Max Ernst, Dulac, William Blake, René Magritte and Bosch as well as from comic books, Walt Disney and old engravings of Red Indians, all 'boiled down to make a visionary and hallucinatory bouillabaisse'. On the other hand, he thought that underground posters had:

> succeeded in destroying the myth that the visual imagination has to be kept locked up in museums or imprisoned in heavy frames. It has helped open the eyes of a whole generation in the most literal sense. It has succeeded, however briefly, in fulfilling the pop canon; it has operated in 'the gap between life and art'.[24]

Michael English, Nigel Waymouth, Martin Sharp and Michael McInnerney no doubt agreed with him.

18 The 14 Hour Technicolor Dream

After we had finished I wandered about among the huge crowd. All my life I had felt an outsider, a freak, totally at odds with my time. Now, suddenly, I realized for the first time that I was not alone. I was surrounded by thousands of other versions of myself. I was part of a tribe, a movement, and a gigantic soul.

DAEVID ALLEN, Soft Machine[1]

IT had been planning a benefit concert to raise money, and now with a possible law suit looming over them, this became an urgent necessity. Hoppy, Dave Howson and a crew of volunteers now devoted their entire time to organizing what became the 14 Hour Technicolor Dream. Hoppy got the idea of holding it in Alexandra Palace, a huge Victorian glass and steel pleasure palace in North London, from the all-night jazz raves he had covered there when he was a jazz photographer.

Michael McInnerney made a magnificent poster for the event, with a rainbow silk-screen ensuring that no two posters were alike, and Michael English and Nigel Waymouth, who did the psychedelic UFO posters, designed a huge black-and-white silk-screen poster for major ad sites. Taking our cue from a similar publicity-seeking event in San Francisco, four girls walked down Portobello Road wearing white T-shirts, each with a letter painted on the back: Sue had 'F'; Zoe had 'U', Kitty was 'C' and Pru was 'K'. The police, ever vigilant, reacted at once and asked the girls to 'arrange themselves in less provocative groups', which had the desired effect of getting the story into the newspapers. The event, to be held on 29 April, was billed as the 14 Hour Technicolor Dream: a 'giant benefit against fuzz action', as the *Melody Maker* ad read. 'Kaleidoscopic colour' and 'beautiful people' were promised as well as a 'free be-in on Sunday'.

An impressive number of performers donated their time to the event: the Pink Floyd, Alexis Korner, the Pretty Things, the Purple Gang, Champion Jack Dupree, Graham Bond, Yoko Ono, Savoy Brown, the Flies, Ginger Johnson's Drummers, the Crazy World of Arthur Brown, Soft Machine, the

Creation, Denny Lane, Sam Gopal, Giant Sun Trolley, Social Deviants, the Block, the Cat, Charlie Brown's Clowns, Christopher Logue, Derek Brimstone, Dave Russell, Glo Macari and the Big Three, Gary Farr, the Interference, Jacobs Ladder Construction Company, Lincoln Folk Group, the Move, Mike Horovitz, 117, Poison Bellows, Pete Townshend, Robert Randall, Suzy Creamcheese, Mick and Pete, the Stalkers, Utterly Incredible Too Long Ago to Remember, Sometimes Shouting at People, Barry Fantoni, Noel Murphy and various others; many of these were poets, performance artists or dance groups, but there were so many bands that two stages were erected, one at each end of the giant hall in order to accommodate them all. For some reason there was confusion concerning Tomorrow's appearance. Twink told Ivor Trueman:

> We weren't booked to play, we just drove up & played. We just said 'We're Tomorrow & we're playing' – bluffed our way onto the stage; and did a really good set, I think. We enjoyed it anyway. But that was the kind of thing you had to do at the time, if you were trying to get into something which had already started, you had to push your way in.[2]

In fact, as it was a benefit, the bands all volunteered to play; they weren't booked. Presumably Tomorrow's management hadn't offered their services because they were more than welcome; the UFO audience loved them.

Alexandra Palace – 'The People's Palace' – had opened in 1873 but burned down just sixteen days later. It was reopened on 1 May 1875 and now covered seven acres, centred on the Great Hall. This was where *IT* held the 14 Hour Technicolor Dream. Unfortunately the Great Hall, together with many other parts of the building, was completely destroyed in a second fire in January 1981 so the evening can never be re-created there. The benefit was announced by fireworks shooting into the evening sky over Muswell Hill, calling the freaks to come like a psychedelic bat-signal. The galleries on either side of the enormous hall were hung with white sheeting for the light shows by Binder, Edwards and Vaughan, Mark Boyle, 26 Kingly Street and Hornsey College of Art. Running around the gallery was a light board, like the one on Times Square, which spelled out moving messages the way the news was displayed on the *Times* building, except these were more like the running heads that crept subversively along the top of each page of *IT*; messages you were unlikely to see in Times Square. 'Why must we wait until they die off to fix the world?', 'Honesty is the best police', 'Wm Blake is on the wing', 'This is the coming revolution', 'The best way to change society is to replace it one man at a time', 'The only undeniable private properties are your mind and

your body', 'There are no leaders', 'Convert the man on your left', 'Every day more of them die and more of us are born'.

Hoppy, Dave Howson, Jack Henry Moore and their staff controlled the lights and sound mix from a huge scaffolding gantry in the middle of the hall which was also the point where sound from the two stages met at equal volume. Some chemically enhanced individuals were fascinated by this effect and turned their heads first one way, then the other, took a step one way, and then the other, for hours. There was a free fairground helter skelter which was very popular and many hippies relived their childhood by waving their arms and shrieking as they slid down on their mats; poets set up their pitch and read; folk singers strummed in quiet corners, attracting a moving audience who stopped for a while then drifted on. Fantastically attired people cast the I-Ching and doled out tarot cards. David Medalla and the Exploding Galaxy danced 'Fuzzdeath' surrounded by a ring of friends; their first public performance.

Yoko Ono did her 1964 *Cut Piece* performance, in which members of the audience were given a pair of amplified scissors and asked to cut away a part of her clothing. For this performance she hired a model to sit in, perched on a stepladder with a bright spotlight on her body. At the DIAS performance at the Africa Centre the previous year, the audience had been rowdy and excited and had cut off all of her clothes. This piece raises an enormous number of issues concerning violence towards women: victim and assailant, sadist and masochist; women as objects; disrobing and exhibitionism; passivity and sexuality; the relationship between artist and observer; and of course racism. This time it attracted in my view a large, mostly quiet, thoughtful crowd, though Keith Rowe from AMM, who performed that night, disagreed: 'I remember the 14-Hour Technicolor Dream was very violent. There was violence towards Yoko quite often when she performed these pieces with the men ripping away her pants. I found it unpleasant. A quite powerful emotion.' He told Julian Palacios: 'We had a very good relationship with Yoko. She used to stay at Cornelius Cardew's flat, and the AMM played at the opening of her exhibition. We knew her quite well.'[3]

There was a long length of inflated plastic tubing, almost human height, for people to climb over and play with like a modern-day bouncy castle. There was free candy floss and sweets as well as free fruit and vegetarian food. A fibreglass igloo was presided over by Hoppy's girlfriend, Suzy Creamcheese, in a tiny mini-dress. She handed out joints rolled from dried banana skins for people to smoke and supposedly get high – that month's harmless hippie fad. Most of her customers were high already so no-one could really tell if it

worked or not (not). By most accounts, at least half the people there were high on drugs, most of them tripping. In fact the drug use even alarmed the organizers, who could see that some people were seriously out of it. Unfortunately, an underground chemist chose that night to launch STP on the London scene, a very powerful hallucinogen that takes three or more hours to realize its full effect so people often overdose, thinking that the initial dose was not sufficient. There was possibly more amphetamine in the doses distributed that evening as many were energized rather than sent on a contemplative trip. John Lennon and John Dunbar were watching the BBC TV nine o'clock news at Lennon's house in Weybridge and saw footage of the event, called the chauffeur, jumped in the Rolls and arrived high on acid. They had forgotten it was on.

There were a few skinheads who had somehow obtained tickets (they were unlikely to buy them) and strutted in, hoping to cause a spot of aggro but they were love-bombed by a group of girls in lace and velvet dresses and were soon seen skipping hand in hand with the girls, out of their heads on acid. A more serious incident occurred around midnight. The famous Henry Willis organ in the palace was undergoing restoration and its pipes were covered with scaffolding. People began climbing up the steel bars, some of them clearly out of their heads, and could have been killed if they fell. Naturally, the event was not insured and in the end the music had to be stopped to make them get down. The Ally Pally was like an enormously enlarged UFO Club and felt very familiar and comfortable to the regulars. As John Dunbar remarked, everyone he had ever known in his life seemed to be there. There were an estimated 10,000 people, but the hall held far more and there was plenty of space for people to promenade about, meeting friends, talking and smoking, dressed in their King's Road finery or full hippie regalia.

The bands were mostly UFO regulars: Arthur Brown gave an inspired performance in his flaming headdress; the Soft Machine dressed up specially for the occasion, Daevid Allen in a miner's helmet, Mike Ratledge in his Dr Strange cape, Kevin Ayers with rouged cheeks and wide-brimmed hat, and Robert Wyatt with a short back and sides. They played a fine set but Daevid Allen's memory was not of their own set but of seeing the Floyd. Daevid Allen:

> As I recall, the Floyd played at Alexandra Palace at four in the morning. It must have been one of the greatest gigs they ever did, and Syd played with a slide and it completely blew my mind, because I was hearing echoes of all the music I'd ever heard with bits of Bartok and God-knows-what.[4]

The Pink Floyd arrived around 3.30am having played a gig in Holland that evening and returned on the ferry. They were tired and exhausted and both their manager, Pete Jenner, and Syd Barrett were tripping. Peter Jenner:

> I dropped a tab on the way to the gig and it started coming on as we were being directed in. I was having to steer the van through something very tiny and lots of people were wandering about all absolutely out of their crust. There were people climbing over scaffolding and it was an extraordinary building, with all the glass in the Alley Pally... as the light came up, because it was the summer... it was a wonderful, really a psychedelic experience. The whole world was there and every band was playing and it was a magical occasion.[5]

The Floyd had requested to go on at dawn, and just as the first fingers of light glanced through the enormous rose window on the south-east front of the building, Roger Waters began the throbbing bass line of 'Interstellar Overdrive'. I recalled the event in my book on the Floyd written in the late seventies, saying:

> Their music was eerie, solemn and calming. After a whole night of frolicking and festivities and too much acid came the celebration of the dawn. Throughout the hall people held hands with their neighbours. The Floyd were weary and probably did not play so well but at that moment they were superb. They gave voice to the feelings of the crowd. Syd's eyes blazed as his notes soared up into the strengthening light and the dawn was reflected in his famous mirror-disc Esquire, the light dancing in the crowd. Then came the rebirth of energy, another day, and with the sun a burst of dancing and enthusiasm.[6]

As people left to walk the mile and a half to Wood Green tube station, Hoppy stood at the entrance shaking hands with everyone as if it had been a private dinner party. When they entered they had been greeted by Hoppy and Suzy, and also Norman Pilkington – a writer for IT – who gave many of them his address. In the following weeks he received more than forty visitors. It was a beautiful sunny summer day and many people stayed on for the Be-in, sitting on the grass of the large park surrounding Alexandra Palace, looking at the wonderful view out over London. Some hippies appeared with a ten-foot-long joint rolled from photo-studio backdrop paper and filled with flowers and leaves and began running around on the grass with it. The skinheads, having now come down again, stole it from them and spent a happy hour kicking it to pieces.

Though the story has been told many times, the raid on Keith Richards's house by the drugs squad belongs here because it acted as a rallying point for the underground, and raised concerns among some establishment figures. On 12 February 1967 police acting on a tip-off from the weekly scandal sheet the *News of the World* raided a weekend house party at Redlands, Keith Richards's Tudor manor house near Chichester. They first waited for George Harrison and Patti Boyd to leave as the Beatles still had a degree of immunity because of their MBEs. Then a large number of West Sussex constables rushed in and seized sun-tan lotion, particularly Ambre Solaire, small bars of soap from hotels, Earl Grey tea and other suspect substances for analysis, and even a few traces of pot. There was one person present whom no-one knew very well, an American called Dave 'Acid King' Schneiderman, who was later generally thought to have been the *News of the World*'s informant. Schneiderman had with him an aluminium flight case filled with all manner of drugs, including hash, pot and LSD. Mysteriously the police didn't examine it and Schneiderman was allowed to leave the country with no charges brought against him. The tabloid press seized upon the fact that Marianne Faithfull had just taken a bath and was wearing nothing but a fur rug when the police arrived. The police also regarded antique dealer Christopher Gibbs's attire as unorthodox until it was pointed out that it was the Pakistani national dress. The art dealer Robert Fraser tried to make his escape across the lawn but was rugby-tackled by a policewoman, who found twenty-four jacks of heroin on him. There was no mention of the raid in the daily press so the usual approaches were made. It turned out that £10,000 could make the small amount of drugs found disappear, but though the money was handed over, a news story in the next issue of the *News of the World* – a carefully worded report, 'Drug Squad Raid Pop Stars' Party' – put a stop to the payoff.

Four months later, on 27 June, after a farcical trial, the cartoon character reactionary Judge Block found Mick Jagger, Keith Richards and Robert Fraser guilty: Jagger for the illegal possession of two mild amphetamines found in his jacket that he bought over the counter in Italy for travel sickness but for which he would have needed a prescription to buy them in Britain – his doctor said he would willingly have written one; Richards of allowing his Sussex house to be used for smoking hemp; and Fraser for possession of heroin. The next day, 29 June, the London *Evening Standard* reported:

> Rolling Stones Mick Jagger and Keith Richard and Mayfair art gallery director Robert Fraser were jailed this afternoon at Chichester for drug offences at Richard's house party in Sussex four months ago. The sentences imposed

at West Sussex quarter sessions were Richard: one year; ordered to pay £500 towards costs. Jagger three months; £100 costs. Fraser: six months; £200 costs.

Mick was taken to Brixton jail, Keith and Fraser to Wormwood Scrubs. That evening there were demonstrations outside the *News of the World* against their role as police informants in their war against the hippies. After a night in jail, Mick and Keith were granted bail in the High Court of £7,000 each. Robert stayed in jail and began serving his four months, allowing for good behaviour.

In an unprecedented move, the editor of the *Times*, William Rees-Mogg, defied the sub-judice rules and wrote a stinging editorial, condemning Jagger's sentence. Published on 1 July 1967, and headlined 'Who Breaks a Butterfly on the Wheel?', it described the offence as 'about as mild a drug case as can ever have been brought before the courts' and gave an example of the dangers to the public if such minor technical transgressions were to be prosecuted: 'If after his visit to the Pope, the Archbishop of Canterbury had bought proprietary air sickness pills on Rome Airport and imported the unused tablets into Britain on his return, he would have risked committing precisely the same offence.' In the politest possible language he labelled Judge Block as a vindictive fool who was dragging the law into disrepute, ending by saying: 'There must remain a suspicion in this case that Mr Jagger received a more severe sentence than would have been thought proper for any purely anonymous young man.'

This fuelled considerable public debate. Even the *Sunday Express* expressed astonishment, saying: 'He merely had four benzedrine tablets, legally purchased abroad, which, with the knowledge and approval of his doctor, he took to keep him awake while he worked.'[7] Meanwhile the threat of jail hung over them until their appeal on 31 July. The Appeals Court lifted the sentences against Mick and Keith: Mick was conditionally discharged, Keith's sentence was quashed because Judge Block did not warn the jury that there was only tenuous evidence that Keith knew anyone was smoking pot. That evening Mick appeared on ITV's *World in Action*. He arrived by helicopter for an outdoor discussion with William Rees-Mogg, the editor of the *Times*; Lord Stow Hill; Dr John Robinson, the Bishop of Woolwich; and Father Thomas Corbishley, a Jesuit priest. Mick told them: 'I am a rebel against society, but not an obvious one. Many people like me feel that things are wrong. Society has pushed me into this position of responsibility.' The appalling Judge Block's reaction was seen when he addressed farmers in an after-dinner

speech at a ceremony organized by the Horsham Ploughing and Agricultural Society, at Rudgwick in Sussex, shortly afterwards, saying: 'We did our best, your fellow countrymen, I and my fellow magistrates, to cut these Stones down to size, but alas, it was not to be, because the Court of Criminal Appeal let them roll free.'

Meanwhile, Robert Fraser's artists gathered together to keep his gallery open. Richard Hamilton commented:

> I had felt a strong personal indignation at the insanity of legal institutions which could jail anyone for the offence of self-abuse with drugs. The sentence in the case of my friend Robert Fraser was blatantly not intended to help him through a sickness, it was to be a notorious example to others. As the judge declared 'There are times when a swingeing sentence can act as a deterrent'.[8]

The best thing to come out of the Rolling Stones solidarity demonstration outside the *News of the World* was the meeting of Caroline Coon and Rufus Harris. It was dawn, and a lot of young people had gathered in Piccadilly Circus under the statue of Eros after marching from Fleet Street up Whitehall, through Trafalgar Square to the Dilly. Caroline and Rufus began chatting and discovered they were both art students – Caroline was at Central St Martin's – and that they both had strong feelings about the iniquitous drug laws. The next evening Rufus visited Caroline in her studio, and that was the beginning of Release.

Caroline's outrage at the drugs laws came from witnessing the treatment of her boyfriend:

> The first time I went to court for a drugs trial was in 1965 at the Old Bailey. I was 20. I saw a 25-year-old black Jamaican friend of mine being tried for possession of cannabis. He was sentenced to three years in prison. I thought what happened to him was about racism and prejudice against the working class.[9]

She told *Life* magazine:

> Too many people I knew were getting busted and sent to prison, and on too little evidence, because they made foolish statements to the police or they couldn't find a solicitor to represent them or the magistrate wouldn't allow legal aid money. We were all feeling the pressure, so we called a meeting.[10]

Release, the world's first 24-hour underground legal aid organization aimed at assisting young people arrested for drugs, began in Caroline's

basement flat in Shepherd's Bush in the summer of 1967. It answered a huge need. More and more young people were growing their hair and dressing in hippie fashions, which meant more and more of them were being stopped and frisked by the police. Young people were becoming alienated and the police were treating it half as a sadistic game, and half as a war.

The next year, 1968, Release moved to Princedale Road, next door to *Oz* magazine's offices, which was handy whenever *Oz* was raided. A blue-painted door led up two flights of stairs to the Release office. The furniture was all second-hand: yellow oakwood desks and two ancient sit-up-and-beg typewriters, four chairs and a battered settee. Bright psychedelic posters decorated the walls. In addition to Caroline and Rufus there were two secretaries and a librarian. The running costs were about £100 a week. The office opened from ten until late at night and the phone was manned twenty-four hours a day.

They rapidly expanded their activities to include underage runaways, advice on abortion, homelessness and squatting, and other types of legal aid, and Princedale Road quickly became a drop-in centre, always crowded with people waiting to see Caroline or Rufus. Caroline described it as 'the underground with office hours' but in fact she probably devoted twice as much time to the job as most office workers, spending all day on the phone to lawyers and court officials as well as trying to raise money in the evenings. The cases were handled by six volunteer lawyers, paid by Legal Aid. UFO and Middle Earth gave part of their profits to Release. Jeff Dexter, who ran Implosion, gave them sixpence on every ticket sold. There were benefit concerts but large ones were difficult to organize because of establishment hatred of hippies. The Royal Albert Hall, for instance, refused to let them hire the hall for a benefit as 'not being an organization with which we wish to deal'. Fortunately some of the wealthier members of the underground scene contributed: George Harrison gave £5,000 in 1969 after Release helped him with his drug bust, enough for them to expand their offices.

The drug squad took to dropping into the office, unannounced, which meant that Release had to stick firmly to the office 'no drugs' rule, which caused some more extreme members of the underground to criticize them. Rufus became very good at befriending the police and rapidly steering them out of the office and into a nearby pub. It was in this way he received advance notice of a planned late-night raid on Release, presumably intended to seize their paperwork. Rufus and a solicitor camped out in the office overnight and when the police arrived he calmly announced 'no need to break down the door, officers,' and showed them amiably around the office.

By 1969 Release was taking fifty to sixty cases to court each month and had processed 2,000 cases in the previous eighteen months. In Britain, 17 per cent of first-time cannabis offenders were being sent to prison, but none of those assisted by Release received jail terms. Of the other cases they represented, only 10 per cent received custodial sentences, compared to a national average of 26 per cent. It paid to call Release.

Ufo was followed by Middle Earth, at 43 King Street, in Covent Garden market, a straight commercial operation but one where the businessmen backers stayed very much in the background. Dave Howson, who had co-organized the 14 Hour Technicolor Dream with Hoppy, was the front-man manager. They made a point of booking the right underground groups and contributing to Release and other underground causes. It never had quite the full flavour of UFO, largely because it was never able to become the social centre of the underground, but it was all there was. But then, on 3 March 1968, the drugs squad launched one of their biggest raids ever against the underground. One hundred and fifty police swarmed into Middle Earth, at 2 a.m., just as Tom Pickard's group King Ida's Watch Chain were playing. The music stopped, the lights went up, and the police took more than five hours to search 750 or more people. The cost must have been enormous but they only made eleven arrests, seven for drugs and three for 'offensive weapons'. The Arts Lab organized emergency accommodation with Jack Moore's 25-strong Human Family theatre company acting as runners between Bow Street police station, Middle Earth, and the Arts Lab where over 200 people finished up, some of them badly shaken by the experience. *IT* reported: 'Whatever else, the Middle Earth raid provided an opportunity for the community to work together and come together in the spirit of love.'[11]

The rise of the underground press had been a gift to the obscene-publications squad; it gave them a number of easy targets, whereas previously they had to cover up their partnership with the Soho pornography dealers by staging a series of raids on art exhibitions and bookshops which stocked literature with sexual content (Henry Miller, Burroughs, etc.). In retrospect, the two most amusing raids were on the work of Aubrey Beardsley and Jim Dine.

In August 1966 a vanload of police crammed into a greetings card shop on Regent Street and seized all the Aubrey Beardsley postcards they could find.[12] In vain the shop manager explained that the very same images were on display at the Victoria and Albert Museum. Either to go along with the farce, or because he was genuinely astonished by the assertion, the Metropolitan

police commissioner, Sir Joseph Simpson, marched into the V&A without giving advance notice to the directors, in order to inspect the exhibition himself. It was this highly praised exhibition that had launched the sixties 'Beardsley craze' that put his delicate black and white images on student walls across the country and profoundly influenced poster artists such as Michael English and Nigel Waymouth. Naturally there was a public outcry at a police 'raid' on a national public institution and the home secretary, Roy Jenkins, had to placate outraged MPs and the media, while the Director of Public Prosecutions made the police return the seized postcards to the shop immediately.

But the police didn't learn and on 20 September 1966 Inspector Bill Moody and his men raided the Robert Fraser Gallery on Duke Street, Mayfair, and seized twenty-one drawings by Jim Dine which showed male and female genitals (in fact some were abstract). Though they raided with an Obscene Publications Act warrant, Fraser was charged under the Vagrancy Act of 1838, designed to prevent war veterans from displaying their wounds in public to collect money. This way the police were able to avoid being embarrassed in court by expert witnesses attesting to their artistic value as none were permitted for this offence. A policeman claimed that he had been offended because, on looking through the gallery window, he was able to see the word 'cunt' used in a collage. Robert, true to form, informed the magistrate that he 'didn't give a damn for the opinion of some tuppenny-ha'penny policeman', and on 28 November 1966 he was found guilty at Marlborough Street Magistrates Court of staging an 'indecent exhibition' at his Duke Street art gallery and fined £20 and 50 guineas costs. The magistrate was particularly concerned that some of the organs were somewhat larger than life-size. Robert scribbled a cheque and tossed it on the table. The police carefully noted his details for later.

Once more MPs and the press were outraged; this time the artist's work was hanging in the Tate, which officers had visited after the raid. The Minister for the Arts, Jennie Lee, wrote to the Home Secretary expressing her dismay, asking: 'Can I be sure that no policeman, plain-clothes or uniformed, will again set up as an expert on works of art?' Lord Goodman, chairman of the Arts Council and Harold Wilson's private lawyer, asked:

> Can there be any argument at all for a police officer invading a national collection such as the Tate? Surely here simple instructions could be given to the police that with accredited national collections – they could be given a list of them – they simply do not visit them to inspect alleged pornographic portraits.

If the director of the gallery is exhibiting pornography and not art, his trustees can be expected to deal with him and not the police.[13]

Jenkins was embarrassed and said that he had already told them to 'steer clear of borderline cases in the arts and instead concern themselves wholly in enforcing the law on hard-core pornography'.

It was apparently the raid on *International Times* that finally set Roy Jenkins against Scotland Yard's 'dirty squad'. Jenkins had no firm opinion about *IT* itself, and didn't seem to mind the crude police attempt to close the paper down. What concerned him was that they had also simultaneously raided Indica Books and seized William Burroughs's *Naked Lunch*, a book that the Attorney General had already cleared on 'literary merit' in a 1965 ruling that it was 'reckoned to be obscene but to have literary merit' under the 1959 Obscene Publications Act; an act that Jenkins himself had spent considerable effort to place on the statute book. The Labour MP Tom Driberg wrote to Jenkins in his usual laconic way to say:

> I am a bit worried about the recent police raid on the offices of *International Times*. As is usual when the police of any country take any sort of action against works of art or literature, their selection of books to remove seems to have been a fairly silly and random one. They took, for instance, a book called *Memoirs of a Shy Pornographer*. I do not happen to know this book, but I am told it is not pornographic at all! They also took copies of *The Naked Lunch*. I hope this does not mean there is any question of action against this book or its publishers.[14]

The dirty squad's Detective Sergeant Terry Beale had reported: 'All these books are, in my opinion, grossly obscene.'

A note exists in the Home Office files written by one of his aides:

> It seems to him [the Home Secretary] a matter for deep concern that officers of the obscene publications office should think fit to seize copies of *The Naked Lunch* without apparently being aware that this book is by a serious author; that it has been on sale in reputable bookshops in this country for a number of years; and that it has been respectfully reviewed in serious journals and newspapers; and that a decision was taken some time ago by the director [of public prosecutions] not to proceed against it.
>
> This incident reinforces the home secretary's view that the officers in the Metropolitan police, as unfortunately in some other forces also, concerned with this sort of work are not sufficiently well chosen; and he is particularly

A happy Francis Bacon with his old friend Muriel Belcher, founder of the Colony Room, pictured by Peter Stark in 1975, about to leave Wheelers on Old Compton Street after a good lunch.

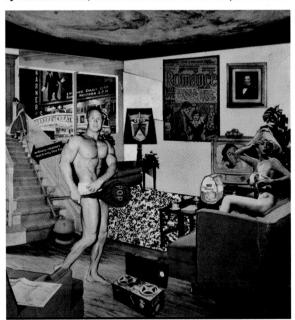

Richard Hamilton's *Just What is It That Makes Today's Homes So Different, So Appealing?*. Generally thought of as the world's first pop art collage, the title was found among the trimmings on the floor as he was clearing up.

The Fool, the art and fashion group, were comprised of three Dutch members and one English. Dedicated to 'improving the vibrations', they ran the Beatles' Apple Boutique. From left to right are: Simon Posthuma, Barry Finch, Marijke Koger and Josje Leeger.

The Exploding Galaxy performing at the Electric Garden in King Street, Covent Garden in July 1967. *IT* reported: 'Never have so many been so nude, so early, and for such good reason.'

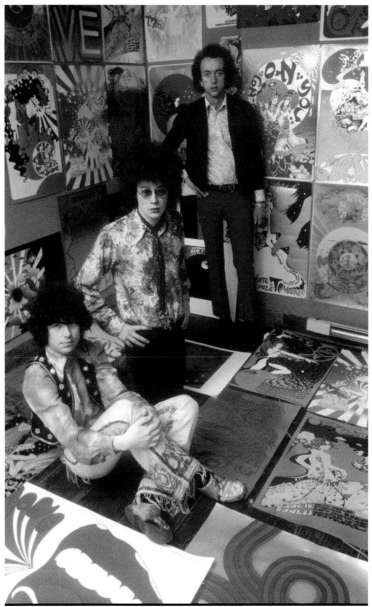

Hapshash and the Coloured Coat: psychedelic poster artists Michael English (seated) and Nigel Waymouth (kneeling) with some of their work in December 1967. Record producer Guy Stevens, standing, produced their album.

Anita Pallenberg and Mick Jagger surrounded by King's Road finery as Pherber and Turner in Donald Cammell and Nicolas Roeg's classic sixties film *Performance* – thought by many to be one of the best London films of all time.

Gilbert and George, as 'singing sculpture', perform Flanagan and Allen's old vaudeville song 'Underneath the Arches' (1932), which they sang while standing on a small office table. Taken in 1971 by Lord Snowdon.

Leigh Bowery onstage with Minty in 1993, wearing his famous 'birth dress' just prior to giving birth to Nicola Lane who was strapped to his body in a harness beneath the dress.

disturbed that this incident should have occurred after the assurances he was given following the Beardsley seizure.[15]

There were heated exchanges between the Home Secretary and the commissioner of Scotland Yard over the competence of the dirty books squad which resulted in the material seized from IT being returned with no charges brought against the paper. At lunchtime on Friday, 9 June 1967, a botched attempt was made to deliver the material. Detective Beale objected to the presence of press photographers and eventually decided to drive off. Jack Henry Moore, IT's new editor, jumped in the back of the truck, protesting that this material was ours and had to be delivered. A struggle ensured in which Jack was pushed out of the moving van. He called Scotland Yard to protest, but they, of course, knew nothing. The files and back issues were eventually delivered on the 14th but with ill-concealed hostility on Beale's part. But the raid had alerted the squad to a whole new arena to use as a smokescreen, and from then on they became avid readers of both IT and Oz.

The dirty squad was then a unit within the CID's central office, known as C1, and getting into it was essentially the gift of the C1 commander or the superintendent leading the squad. According to Martin Short, membership of the Freemasons was a prerequisite.[16] From 1964 until 1972 it was led by Detective Superintendent Bill Moody, who, in a move worthy of the East German Stasi, was appointed to head the biggest ever investigation into police corruption while it was well known, on the street at least, that he was collecting enormous bribes from the pornographic bookshops in Soho to allow them to stay in business. In 1977, at the police corruption trials at the Old Bailey, he was convicted of conspiring to make money from pornographers over an eight-year period. He was shown to have been collecting about £40,000 a year in bribes for a number of years. One sample charge involved a one-off payment of £14,000. These were enormous sums at a time when the average wage was about £1,000 a year. He was jailed for twelve years. Five other members of the dirty squad went down for between five and ten years. In 1972 the newly appointed Sir Robert Mark set up an anti-corruption squad called A10 and over a five-year period forced the resignation or dismissal of almost 500 officers, as well as bringing many of the most corrupt ringleaders to trial. The three Old Bailey trials of 1977 resulted in two commanders, one chief superintendent and five inspectors being sent to prison. One of the top bent cops was Commander Wally Vigo, head of the serious crimes squad, who was jailed for twelve years for corruption

but not only managed to keep the proceeds but was freed not long after on a 'technicality'.

These were the men who the underground had to deal with, and it was not pleasant. Detective Sergeant Peter Fisher, for instance, who himself did time, apologetically told the staff of *IT* that 'I'd rather be out catching the real villains' as he raided *IT*'s offices in April 1969 and carried away all their gay small ads.[17] This piece of harassment resulted in a long stressful court case that led ultimately to the House of Lords. Though being gay was now legal, Graham Keen, Peter Stansill and David Hall were charged with conspiring:

> to induce readers... to meet those persons inserting such advertisements for the purpose of sexual practices taking place between male persons and to encourage readers thereof to indulge in such practices, with intent thereby to debauch and corrupt the morals as well of youth as of divers other liege subjects of Our Lady the Queen.[18]

The police added a count of 'conspiring to outrage public decency by inserting advertisements containing lewd, disgusting and offensive matter' in case they wanted to plead guilty to a lesser charge. Conspiracy carried a possible life sentence. The straight press, as usual, distanced themselves from *IT*. It was to be expected; that was what being underground meant: not playing the establishment's stupid games. The gay community, however, rallied round. David Hockney told Peter Stansill to go to the Kasmin Gallery, where one of his paintings would be waiting for him. He should then give it back to the gallery, who would pay him a large, already agreed sum as Hockney's contribution to the bust fund. No-one had realized that even though it was legal to be homosexual now, it was still regarded as 'disgusting and offensive' in law, and therefore illegal to even run a small ad service to allow gays to contact each other.

The *IT* Three were convicted on both counts and were sentenced to eighteen months, suspended for four years. The Appeal Court upheld the verdict in June 1971, with the judge ruling that while the acts in question might be legal, public encouragement of such acts was not. The trio took it to the House of Lords, which a year later upheld the view of the appeal court, though the conviction on the lesser charge was quashed. As Peter Stansill wrote: 'It was the last victory in the rearguard action to legally enforce an antiquated morality.'[19] None of the defendants ever fully recovered from the anxiety and stress caused by the case. Detective Sergeant Fisher, however, later went down for four years, guilty of conspiring to accept money from

persons trading in pornography, so at least one of the 'real villains' was caught. The squad was so corrupt it had to be disbanded. At the end of the police corruption case in December 1976, Justice Mars-Jones said: 'Thank goodness the Obscene Publications Squad has gone. I fear the damage you have done will be with us for a very long time.'[20]

19 The Arts Lab

At the Arts Lab, it was not unknown for a play to reach its climax as the audience reached theirs, all unconcernedly intertwined with each other.

RICHARD NEVILLE[1]

When the Free School put on the first Notting Hill Festival in 1966, they suggested that Jeff Nuttall present a People Show performance, which gave him just one week to prepare a show. Jeff had just moved into the Abbey Art Centre in New Barnet, a National Trust-protected reinforced-concrete clock tower surrounded by shacks. He had no performers for the show so he knocked on the doors of the assortment of huts and chalets surrounding the clock tower. Thus the original People Show consisted of his neighbours Mark Long, Syd Palmer, John Dod Darling, Laura Gilbert and Jeff himself. The performance was held at the church hall in Powis Gardens and was a success, though Jeff was annoyed that, although his script called for nudity, the girls wore 'drawers' as he always called them. A polythene sheet was draped over the audience and Jeff called for a variety of bizarre objects to be brought to him onstage to the accompaniment of frenzied drumming. A plant in the audience screamed and ran from the room. Music was provided by the Mike Westbrook group, which then consisted of Westbrook, Gaz Griffiths, Mike Osborne and John Surman. Nuttall: 'A saxophone and I performed a duet for music and disintegrating narrative, merging this into a full band ensemble.' Meanwhile Mark Long and Darling sold strawberry-jam-smeared newspapers to the audience. Nuttall: 'Although I was angry about the funked nudity I was nonetheless well pleased, excited that something had taken place that was not bourgeois culture applying art as a thinly smeared cosmetic, but was, *in its nature*, right in the middle of creativity.' In the van back to the arts centre Syd Palmer suggested that they stick together. Bob Cobbing, the sound poet and by then the manager of Better

Books on Charing Cross Road, offered the use of the basement, giving them a regular venue.[2]

The first show was in December. The cellar had crumbling walls and had not been painted in decades. The 'Destruction in Art' Symposium had not yet occurred, so the floor was intact, though the plumbing and drains were exposed and the ceiling was just the floorboards of the shop above. The far wall of the cellar was divided into three alcoves. The group screened them off with cardboard and carefully cut holes in it to display parts of their bodies: Nuttall's fat beer belly protruding through a large circular hole, one of Laura's breasts through another, smaller, hole, Mark's feet stuck out through a hole at the bottom of the third alcove. Don was wrapped in disgusting rags and Syd stood, masked, on a pedestal. The audience wandered around, sometimes prodding them, wondering if they were real or models. Then Mark and Syd began to speak, monosyllabic grunts gradually turned into personal remarks about the audience. Then Nuttall burst through and began haranguing the audience while Mark produced a whip, made from old soiled underwear, and began lashing out at the audience, screeching about human vanity. The event was judged a great success. Jeff wrote: 'The show was, like many of my poems then, an angry last ditch attempt to rub people's noses in their own meat to such an extent that they would come to embrace their condition without cosmetic, deodorant, without modification or rationalisation.' Of course, such a show was not to last long; there are not enough masochists in the avant-garde theatre audience to keep such a theatre troupe going.

Jack Henry Moore was there from the Jeanetta Cochrane Theatre, and immediately made sure that they were included in a Granada TV programme then being made about the emerging underground scene. Unfortunately their segment, filmed in Better Books basement, was less likely to make viewers turn away from the screen, overcome by a shocking realization of the true horror of the human condition, than to rush from the room in sheer embarrassment at their gauche amateurism. But Jeff liked it: 'Something quite new had begun in London and begun well. It was a good feeling.' But Nuttall only remained in London until Easter, 1967, before returning to live with his family in Norwich. This meant that, though he wrote the scripts, he only appeared in the first ten People Shows. His lack of involvement in the actual performance eventually estranged him from the group. In his *Memoirs* he wrote: 'the performers know that, for a man who insisted on his scripts being carried out to the letter, I was avoiding an awful lot of the hard labour, public risk, and sheer nervous strain of performing.'[3] Naturally, the

performers began to interpret the scripts to emphasize their own areas of interest or special skills such as mime.

When Jim Haynes and Jack Henry Moore suggested that they become the resident drama group at the newly opened Arts Lab they jumped at the chance.[4] Jeff was still involved, but he and the performers were growing more and more apart. The performers were not as keen on outright confrontation as Jeff. *People Show 15*, performed in November 1967 shortly after the Lab opened, featured more contact than the audience normally likes. Nuttall shut them inside four cages, where they were deafened alternately by the actors hammering on the bars or by the Mel Davis group playing free-form jazz while being, not always successfully, encouraged by Nuttall to join in the improvisations on the subject of paranoia, faulty communications between people and the games people play with each other.[5]

Nuttall described *People Show 15* in his memoirs:

An early show at the Arts Lab involved four huge cages wrought of chicken wire and old bedsprings. The audience were locked in the cages and were to be let out one at a time to be interrogated. Their interrogation thus formed the central event. Each interrogation was to be something of an ordeal, the interrogator (Syd) accusing each person of being Mrs Meadows and insisting that they prove otherwise. There was to be a telephone on hand for people to ring witnesses. Syd turned the interrogation into a farce, skimped over it to make room for a whimsical sketch about the man in the moon.[6]

Sergeant Major Nuttall wanted to berate and torture the audience, make them grovel until they recognized the horrific nature of reality.

People Show 15 also called for offal to be thrust through the chicken wire on to the audience. Nuttall had a fetish about offal, as he did about large-size ladies' underwear and nudity. As Jeff was not a performer, the People Show substituted water pistols and other weak stunts. Jeff was outraged: 'Only Laura, at that time, shared my wish to turn human activity out to grass, or my other wish to wrench human-response off-centre. Only Laura shared my contempt for the cuckoo land of Flower Power.' Throughout this time Jeff had held on to his job as a teacher at a secondary school in Norwich. Then in October 1968 he joined the teaching staff at Bradford Art School. 'I was glad to get out of the psychedelic south where dope, vanity and commercial pop were already to erode the so-called alternative society. The crumbling black stone, rough pubs, heavy beer drinking, regional humour... animated and revived me to a very welcome degree.'[7]

When we started *IT*, I naturally tried to involve Jeff Nuttall, who had

contributed so much energy to the emerging counter-culture. In the end he decided that he would like to draw a fortnightly comic strip, which, unfortunately, didn't really get much reaction because it was very hard to tell what was going on. For some strips he became Jeff Sodall or Jeff Farkall and once used his friend Criton Tomazo's name, as he was unsure that he wanted to be involved with *IT*. In fact Jeff soon began to distance himself from the *IT* staff, the main problem being his determination to remain stuck in the era of trad jazz and warm beer. He claimed it was a class problem, but most of the staff were just as working class as him. He summed up his position accurately enough: 'Physiodelics, not psychedelics, I prefer a good pint to LSD.' He also had no interest in rock 'n' roll, whereas many of the new people involved with *IT* were part of the rock 'n' roll revolution. He hated Mick Farren in particular, as he, to Nuttall, was the epitome of this new attitude. In Jonathon Green's *Days in the Life* Nuttall spelled it out: 'Mick Farren was a bad man – I thought he was a bad man anyway...'[8] In his autobiography Mick revealed how shocked he was: 'Until that point, I didn't really suspect quite how much the man loathed me.'[9]

In 1968, Jeff was commissioned by Granada Publishing to write *Bomb Culture*. Nuttall: 'I wrote it because I wanted to distance myself from the underground on a number of scores, because I wanted to make it clear publicly that there were a number of aspects of the underground that I wanted none of – particularly marijuana and rock 'n' roll.' As he said: 'I had no idea that I was stepping so far into the enemy camp.'[10] Straight society loved it; here was a tame sociologist that they could talk to and reason with. The underground disliked the book, in part for its factual inaccuracies, such as putting Venice Beach in San Francisco or misspelling the names of people like Lawrence Ferlinghetti, which showed Jeff's relatively slight knowledge of the Beats. Jeff left London; it was too much for him.

After spending four years with the American Air Force, working as a Russian translator in an American spy base at Kirknewton, just outside Edinburgh, Jim Haynes stayed on to study at Edinburgh University. In 1959 he opened The Paperback, at 22a Charles Street, off George Square, probably Europe's first paperback bookshop. He advertised it as 'Europe's new international bookshop, coffee-cellar and gallery'. The gallery mostly showed pottery and tapestries. There was free coffee and conversation and Jim was quite likely to ask anyone who happened to be in the shop to keep an eye on it while he popped out, sometimes not returning for hours. He began putting on evening performances: poetry readings, David Hume's *Dialogues Concerning Natural*

Religion, Fiona McCullough's *Trial of the Heretics* or Plato. His next move was to open the Traverse Theatre at Long Acre in Edinburgh, in a medieval building with room for an audience of fifty-eight – plus a couple of seats for the actors – sitting on two banks of thirty seats facing each other with the stage in between. He put on some of the most obscure plays ever seen in Edinburgh, by Mrozek, Pinget, Eveling, Duras and Alfred Jarry, to name the most well known. The theatre was a direct extension of the bookshop.

Lord Goodman was instrumental in Jim being offered the new Jeanetta Cochrane Theatre in London as an extension of the Traverse and in 1966 he and his favourite director, Jack Henry Moore, moved down to London. The London Traverse Theatre Company was formed by Haynes, Charles Marowitz and Michael Jelliott, the two latter having directed plays at the Traverse in Edinburgh. During their one year at the Cochrane they put on Joe Orton's *Loot*, the Marowitz *Hamlet* and plays by Saul Bellow. But Jim was not satisfied:

> I was frustrated because I wanted to bring in other activities like music, poetry, films and social painting. For architectural and other reasons it was almost impossible to do this at the Cochrane. It became pretty difficult and about last summer (1966) I began looking at warehouses in central London. I had a flat in Covent Garden (Long Acre) and I was very aware of it as an interesting area, and it has none of the overtones that Hampstead, Kensington or Chelsea have.[11]

In the meantime, he concentrated his activities on helping to start up *International Times*, finding backers, using his enormous list of contacts to contact writers, illustrators and advertisers. Once *IT* was fully up and running, from March 1967 Jim worked solely on the Arts Lab project and in seven months he managed to raise the £3,000 necessary to get it open. Jim:

> I found the Arts Lab building in Covent Garden and started on the mechanics of getting the lease and gathering people around me to make it work. I sent out a letter to 800 people, telling them what the ideas were behind the scheme and asking them to become members. The letters raised about £3,500 – about a quarter of the amount needed. Rather than wait until you get it all, I believe in plunging. So we began.[12]

Jim left the Cochrane officially in February 1967 and took over the Drury Lane building that July. The Arts Lab opened at 182 Drury Lane, on Monday, 25 September 1967. The front door led into a large rectangular space, subdivided into two galleries; one for art, the other for the theatre run by Jack Henry Moore. In the basement was the cinema, programmed by David Curtis

and featuring underground, cult and classic movies. Shortly after the opening there was a season of Doris Day movies. Upstairs was the restaurant/coffee bar run by my then-wife, Sue Miles who later moved on to more serious catering. Jim's role was very much that of a genial host, creating a stimulating atmosphere for his guests so that some evenings developed into wonderful parties. 'You must keep moving, remain flexible,' said Jim. 'I call it my toy. This whole place is my flat. I just live in the back and work in the back. But the rest is my flat and the people who come here are, I hope, my friends and they're welcome to stay as long as they want.'[13] It was this aspect, the Lab as a community centre for creative individuals, a place to meet and talk and make contacts, that set the Arts Lab apart from other performance spaces. Jim:

The thing that the bookshop, the Traverse, and the Arts Lab had in common was their humanity. There were not fixed hours of entering and leaving, people came in and lingered and talked and met each other. I keep stressing this fact that love affairs began there but it's true. That's probably why the puritan elements in the country were against the bookshop, the Traverse and the Arts Lab. The ecstasy count, the sensuality count, was very high, whereas at the Cochrane, which is a pure theatre situation with 350 seats in rows facing the stage, people rush in at 7.30 and rush out at 10. There's no contact among the audience themselves, or between the audience and the performers. And by contact, I'm talking about physical contact – touching, meeting, grabbing, holding. When I used the word contact, I meant *contact*.[14]

Jim was thinking in terms of sensual contact, unlike Jeff Nuttall, whose early People Show performances at the Arts Lab set out to confront and torture people. Jeff's approach was not suited to the more positive vibe Jim and Jack were looking for; they wanted human communication. One of the most successful Arts Lab productions was not held in the Arts Lab at all. It was called *Tea with Miss Gentry*. Jim told Derek Taylor:

People would arrive to go to a theatre performance, buy a theatre ticket, and then we would lead them down Drury Lane and up some rickety stairs where they would have tea with this incredible woman and talk to her, and she would talk to them. I think she had once designed hats for theatrical productions. People came from Holland, Germany, Spain, France... We paid for the tea, and Miss Gentry served it... She would ask where they were from and talk to them and it was an outstanding production.[15]

In the cinema Dave Curtis began daily screenings of classic European and American films by directors such as Jean-Luc Godard and John Cassavetes. The

Lab was the first cinema in England to show uncut versions of Andy Warhol's two-screen film *Chelsea Girls* (1966) and Kenneth Anger's *Inauguration of the Pleasure Dome* (1954–66). When Better Books closed in August 1967, the London Film-Makers Co-operative screenings were transferred to the Lab and the cinema intensified its emphasis on the avant-garde. The close involvement of the members of the London Film-Makers Co-op led to the installation of film-processing equipment and the distribution of independent and underground films – fulfilling the function of the place as a 'lab'.

Jack Henry Moore's theatre troupe, the Human Family, grew and evolved and in the early summer of 1968 went on an extended tour of Europe. To the dismay of the staff, they took much of the Arts Lab's equipment with them. Then, on 15 November 1968, a notice was posted in the Lab to say that Jack Henry Moore and the Human Family, thirty people plus their equipment, would be arriving on 10 December and that they would be living there until after Christmas. During that time Jack would make the schedule and policy decisions: 'time and space will be minimally available throughout the building which will probably be open around the clock.' The Human Family had been travelling in Europe for six months and had drained money from the Lab. Basically this proved that the Arts Lab was Jim and Jack's fiefdom, and even though the staff had devoted immense amounts of time and energy to the project, it was not theirs but Jim's. The theatre alone, directed by Will Spoor, had mounted around 1,000 performances of eighty productions, and the cinema felt that there was no way that the safety of the films or equipment could be guaranteed with the building in the hands of Jack's hippie commune. Jim and Jack's proprietorial attitude caused the break-up of the Lab. Most of the key people resigned in protest, intending to set up a new Arts Lab of their own.

Statement issued by staff members of the Arts Lab:

Arts Laboratory, 182 Drury Lane, WC.2

THE FOLLOWING ARTS LAB CO-FOUNDERS AND STAFF HAVE BROKEN ALL CONNECTION WITH JIM HAYNES' ADMINISTRATION OF THE ARTS LAB.

David Curtis	Cinema director
David Jeffrey	Technical director
Philippa Jeffrey	Administrative co-ordinator
Biddy Peppin	Gallery director and publicity
Pamela Zoline	Gallery director

Martin Shann	Master of works
Will Spoor	Theatre director
John Collins	Accountant
Ellen Eitzinger	Administration
Rosemary Johnson	Administration
David Kilburn	Cinema

On November 15th a notice was posted in the Lab signed by Jack Moore (who has been on tour in Europe for the past six months) and Jim, vetoing all proposals for decentralizing Lab administration, and announcing that from December 10th Jack will make all "schedule and policy" decisions and that the building will be only "minimally available" to groups other than the Human Family.

We believe that people working in all media must have freedom of access to the Lab's facilities, and that this cannot be guaranteed under any dictatorship, however benevolent.

November 18th '68.

In *IT* 46, 13 December, David Curtis reported: 'Jim summarised it as "art v people". Another way of putting it would be "laboratory v entertainment centre". The most important of the proposals that were vetoed by Jack and Jim had been the setting up of movie processing and printing equipment (film co-op), a darkroom and an electronics workshop.' Jim was really most interested in the social life that the Arts Lab gave him and the hundreds of young women he was able to lure into his apartment in the back of the building. As he told it:

I look upon myself not as an artist, because I don't really like that category any more, but as an experimental educationalist… I'm interested in media. I'm interested in how the media can be used to fight for certain ideas that I think are worth fighting for – spread of tolerance, curiosity, brotherhood, internationalism, social sex, physical contact, generosity, asceticism, communal use of property.[16]

The Lab struggled on but without the key members of staff, it failed before a year was out. On 28 October 1969, Jim sent a duplicated *Newsletter number one* to his friends and contacts:

The Arts Laboratory located on Drury Lane for the past two and a half years is closed. The Arts Lab was many things to many people: a vision frustrated by an indifferent, fearful, and secure society; an experiment with such intangibles

as people, ideas, feelings, and communications; a restaurant; a cinema; a the-
atre (Moving Being, Freehold, People Show, Human Family, etc); underground
television (Rolling Stones at Hyde Park, Isle of Wight, Dick Gregory All-Night
Event); a gallery (past exhibitions include Yoko Ono & Lennon, Takis, et al);
free notice boards (buy/sell, rides to Paris); a tea room; astrological readings;
an information bank (tape, video, & live-Dick Gregory, Lennie Bruce, Michael
X, Michael McClure...); happenings (verbal and otherwise); music (live and
tape including The Fugs, Donovan, Leonard Cohen, Third Ear Band, Shawn
Phillips, Kylastron, etc.); books, magazines and newspapers (Time Out, IT,
SUCK, OZ, Rolling Stone); information. People flowed through – young, old,
fashionable unfashionable, beautiful, bored, ugly, sad, aggressive, friendly –
five bob if you can afford it, less if you can't. A few people in a position to help
financially took but never gave. They asked, 'What's the product? What's its
name?' The real answer was Humanity: you can't weigh it, you can't market it,
you can't label it, and you can't destroy it. You can touch it and it will respond,
you can free it and it will fly, you can create it and it will grow, if you kill it – it's
murder. The kids here don't believe it's the end and they're right for it will
reappear in another form. 'We are the seeds of the tenacious plant, and it is
in our ripeness and our fullness of heart that we are given to the wind and
are scattered.'

20 The Summer of Love

It always seems to have been summer. All the memories seem to be of gardens, leaves in full bloom, grass very long, flies in the air, things humming.

PAUL MCCARTNEY on the summer of 1967[1]

The fact that London was going through a subtle change was broadcast to the world in the cover story of the 15 April 1966 issue of *Time* magazine. An article by Piri Halasz called 'London: the Swinging City' revealed that 'In a once sedate world of faded splendour, everything new, uninhibited and kinky is blooming at the top of London life.' It began with a trickle, but young people looking for 'everything new, uninhibited and kinky' began to arrive in London from Australia, the USA, and Europe. When they couldn't find it – Halasz had only been in London a few weeks to write the piece – they had to create it themselves. Among the larrikins – wonderful Australian slang for 'frolicsome youth' – were the *Oz* crowd. The first issue of *Oz* appeared in Sydney, Australia, on April Fools Day, 1963, and 6,000 copies were sold in twenty-four hours. It had not been long before the summonses began to arrive, the issue being in breach of the New South Wales Obscene and Indecent Publications Act. They were fined £20. The February 1964 issue caused far more trouble. The New P&O Shipping building featured a showpiece fountain set in a wall. The *Oz* cover showed three men standing, facing the wall, which was immediately seen to resemble a urinal. Though they could not be seen to be pissing, in fact almost certainly were not, the issue was deemed to be obscene and Richard Neville was sentenced to six months with hard labour and artist Martin Sharp to four months. The sentences were quashed on appeal but it was certainly a worrying time. Richard:

> Martin (Sharp) rang me up and I just said 'Let's get the hell out of here, so we caught the next boat to Malaya and then we hitched across, stayed

in Kathmandu for a bit; it took us about six months. Then we got here and thought 'Great, this is it!' But we found nothing was happening so we got enough, and borrowed enough, to get the first issue [of UK *Oz*] going. It was all done on a big bluff really.[2]

Richard's sister, the novelist Jill Neville, was already established in London and he was able to drop into an existing social scene. Australian *Oz* was closer in feel and look to *Private Eye* than to *IT* or any of the American underground newspapers, and when Richard started UK *Oz*, it began in more or less the same vein. The first issue included a parody on the hippies in the form of a strip cartoon, using photographs by an Australian photographer, Bob Whitaker, shot in the Indica Bookshop, with speech bubbles added. It was not long, however, before Martin Sharp took acid and became a proselytizer for the new hedonistic hippie lifestyle which was ideally suited to these middle-class Australian dropouts escaping from strict Australian Puritanism. There were enough of them for there to be a distinct Australian scene, like the Americans in Paris in the twenties – (relatively) wealthy, often very creative people: Robert Hughes, Germaine Greer, Robert Whitaker, Clive James, et al. *Oz* became a forum for the ideas of the underground scene, but was never really a part of it, probably because most of those involved in the early days were Australian and had a different cultural background. Felix Dennis, who joined *Oz* a little later, explained:

Though advertised as 'the periodical for the discerning freak'... [i]t never really set out to be a community paper. It was underground, but it was an altogether more middle class production than *IT*. It started off as a satirical magazine – our first issue had six pages satirising *Private Eye*. Ingrams attacked us viciously after that, even newspapers in Sydney were quoting him, and he tried to put pressure on our distributors not to take us. The big change was when we came into contact with John Wilcock fresh from the American underground scene. Also we began to consume large quantities of certain substances. The visual approach to *Oz* was partly as a result of drug experiences.[3]

Oz became known more for its graphics than for its editorial content, which was often unreadable as the various rainbow overlays were sometimes ill-calculated and rendered the text illegible. By the summer of 1967, *Oz* had become the magazine of the flower children, and for a few brief months *Oz* and *IT* were like the newspaper and colour section of the same publication as far as editorial content went, except *IT* had hands-on contact with its

readership through the UFO Club and its jumble sales, film shows and fund-raising events, including the 14 Hour Technicolor Dream. Richard Neville, interviewed in September 1967 by Michael Thomas said:

> We use psychedelic art because it's the most exciting graphic art. Once you get through the incense fog and the gaudy clothes there are a lot of genuinely talented people on the scene. The thing that interests me, though, is the definite possibility of a totally separate society, not just flowers and music, but hippie banks, hippie employment agencies and so on. I'm obsessed with that possibility, the dialectics fascinate me. Certainly all the pretension, the eroti-cism, the arrogance of the hippies is preferable to the dreary, self-conscious, earnestness of the drab ex-intellectual thing of the fifties... Hippies are cre-ating social tensions, which Oz breeds on, and anyway, hippies are a good market, obviously.[4]

But, even in 1967, Richard recognized that *Oz* was not a product of the actual underground community. He told Maureen Green:

> Perhaps we've only got one foot in the underground. It's alright for IT, which is a newspaper, to report everything that happens, but we are a magazine. We're still old fashioned enough to try to evaluate. I think that the under-ground should try to be more self-critical. Only one happening in ten will really be any good. We're looking for that one. ... the joke around the Oz office is that it's [the tiny typeface *Oz* used] kept so small so that no–one over 30 *can* read it.[5]

Oz became more the magazine of the King's Road, Chelsea and Kensington hedonistic end of the underground, leaving the grubby revolutionary hippies in Notting Hill, Camden Town and, increasingly, the East End to *IT*. The won-derful thing for the underground was that there were now two magazines, not just one lone voice.

The Dutch went for underground hippie culture in a big way. I attended a 1967 love-in in the Vondelpark in Amsterdam and never in London had I seen such long hair – I never figured out how they managed to grow it so quickly – such short skirts, such big joints, and rather than carrying one flower or a bunch like some King's Road hippies, they carried entire boughs taken from flowering trees. The Paradiso and the Melkweg (Milky Way) had more psychedelic décor than the Family Dog in San Francisco or the UFO Club (which had none, except the light show). When two Dutch designers, Simon Posthuma and Marijke Koger, arrived in London in 1966 from Morocco,

where they had sourced quantities of exotic fabrics, they outdid everyone in psychedelic patterns and finery: Marijke – in dark eyeliner, hennaed hair, long Renaissance-sleeved tight-waisted tops like Maid Marion made from bright Moroccan prints, panels of silk and satin – wore the shortest ever mini-skirt over brightly coloured tights. She was a pantomime figure, a ballet dancer, not someone you expect to find on the streets. Simon wore similar clothes; with long, carefully coiffeured hair, baggy sleeves, tights or baggy pirate trousers, a swirling cloak, he modelled himself on Peter Pan, the god Pan, a panjandrum sometimes pictured on a white horse. Felicity Green, fashion editor of the *Daily Mirror*, described Simon: 'longer hair than either of the girls, wearing a pendant, a purple velvet tunic, pale yellow peep-toe sandals, and some extremely form fitting pants in pink and lime satin stripes, bias cut'.[6]

They first set up a tiny boutique in Gosfield Street, Fitzrovia, called Karma, where they sold Marijka's dresses and psychedelic posters, Simon's paintings, incense, Moroccan bowls and other appurtenances of the hippie life. They were brilliant self-publicists, committed, certainly, to the ideas of the counter-culture but always with an eye on the main chance: 'It's all due to the conjunction of Pluto and Uranus. The approach of these two planets is dynamite. It's behind London's new intellectual direction and the religious revival based on love that is coming,' said Richard Gilbert writing about them in *Town*, in March 1967.

Together with Josje Leeger and Barry Finch, they launched themselves on London as 'The Fool', their name taken from the Tarot pack. Simon was the mentor of the group. He had been the organizer of the Pot Art Company in Amsterdam in 1965 before making a long visit to North Africa and then moving to London. He was a psychedelic painter whose work was poorly executed though often imaginative. His later work became very repetitive and stylized. Mostly he was known for his role as guru and for his non-stop talking. Marijke Koger was the better painter and had been a commercial artist in Amsterdam before designing posters – the famous 'Love' and 'Dylan' psychedelic posters were hers – and clothes. Josje Leeger was a clothes designer in Holland, where she marketed her own fashions. Her boyfriend Barry Finch was the only British member. They met when the Fool designed a poster for Brian Epstein's Saville Theatre, where Barry did publicity. He became their organizer. With posters, interior design, clothes and their own publicist they could hardly fail, because the clothes were so beautiful.

It worked; they were seen as the spirit of the new age. Marijka had an affair with Paul McCartney; they were commissioned to paint lush vegetation

and reclining figures all over the fireplace of Kinfauns, George Harrison's Beverly Hills-style bungalow in Esher, and John Lennon had them in to paint his piano. It was a short step onward to Ginger Baker's drums (with Cream), and album sleeves for the Hollies and the Incredible String Band. The Fool became the designers to the underground scene. They made stage clothes for Procul Harum and a dress for Marianne Faithfull. Patti Boyd and Cynthia Lennon were astonished by their gorgeous clothes and quickly commissioned some for themselves.

Soon the Fool were living in luxury in Montagu Square and the Beatles had been persuaded to finance a boutique which they were to design and stock. Simon:

> It will have an image of nature, like a paradise with plants and animals painted on the walls. The floor will be imitation grass and the staircase like an arab tent. In the windows will be seven figures representing the seven races of the world, black white yellow green red, etc. There will be exotic lighting and we will make it more like a market than a boutique... When they used to open shops it was just after the bread of people, not after turning them on. We want to turn them on. Our ideas are based on love. If you are doing things for people you must be part of the people, not set yourself up as something extraordinary.[7]

Barry: 'We want to plough back what we earn to give more entertainment to people – even cheaper. And to get people to do things for themselves is the final thing.'[8] In fact, the Fool had spent £100,000 by the time the Beatles pulled the plug, about a million in today's money. Most of it was lost through incompetence and lack of proper costing. When someone from Apple finally began to examine the manufacturing accounts, it turned out that the silk label in the clothes was costing more than some of the dresses. Somehow the underground scene in London never really accepted them; they were just a bit too pushy. Of all the psychedelic boutiques it was only the Fool that asked *International Times* to write about them. Had they been part of the community they could have written something about themselves and their beliefs and *IT* would have gladly published it, but to ask *IT* to send someone round, as if they were an ordinary paper, caused a lot of resentment on the staff. Their ideas would have made a perfect article for *IT*. Simon:

> We believe in reincarnation. It is the only logical idea. Once we thought about it we just knew it was true. You are what you made yourself. Every race and nationality is joined. There is a general spiritual revival going on. In

future people will have more leisure and they will have to develop their inner eye. They will want to get to know the supreme power, love.[9]

But somehow, the hippies were suspicious of them, it may have been a cultural thing, a difference between the Dutch and the English, or maybe it was because they were trying so hard to move in the top rock 'n' roll circles that they were seen as hustlers. Soon they moved on to Los Angeles, where they made an album and painted 'the world's largest psychedelic mural' on the side of the theatre playing *Hair*.

The soundtrack to the summer of love was, of course, *Sgt. Pepper*. With this album the Beatles managed the impossible: to be both the most commercial band on Earth and the underground princes of psychedelia. The album sleeve became a psychedelic icon in its own right, and brought many of the personalities on the scene together in one place. The concept for the sleeve grew out of Paul McCartney's original idea for the album. Paul:

> We were fed up with being the Beatles. We really hated that fucking four little mop-top boys approach... I got this idea, I thought, 'Let's not be ourselves. Let's develop alter-egos so we're not having to project an image which we know. It would be much more free.[10]

He came up with the name for the new band: 'Sgt. Pepper's Lonely Hearts Club Band'. His original idea for the sleeve was to have the group seated in a living room, with portraits of Brigitte Bardot, James Dean and other stars on the walls:

> I wanted a background for the group, so I asked everyone in the group to write down whoever their idols were, whoever you loved... folk heroes like Albert Einstein and Aldous Huxley, all the influences from Indica like William Burroughs and of course John, the rebel, put in Hitler and Jesus, which EMI wouldn't allow, but that was John. I think John often did that just for effect really.[11]

The idea developed:

> I had the idea to be in a park and in front of us to have a huge floral clock which is a big feature of all those parks: Harrogate, everywhere, every park you went into then had a floral clock... So the second phase of the idea was to have these guys in their new identity, in their costumes... I did a lot of drawings of us being presented to the Lord Mayor, with lots of dignitaries and lots of friends of ours around, and it was to be us in front of a big northern floral clock,

and we were to look like a brass band... We had the big list of heroes; maybe they could all be in the crowd at the presentation![12]

Paul showed the art dealer Robert Fraser the drawings, and he suggested that the perfect people to execute it would be two of his artists: a couple, Peter Blake and Jann Haworth. Paul:

> They changed it in good ways. The clock became the sign of the Beatles in front of it, the floral clock metamorphosed into a flower bed. Our heroes in photographs around us became the crowd of dignitaries. So the idea just crystallized a bit. Which was good. It took a lot of working out but it's one of the all-time covers, I think, so that was great.[13]

Over the years the sleeve has come to be credited to Peter Blake, but the concept was already there, and the photographs of the heroes had already been collected by the time he and Haworth were brought in. Also, over the years, the role of Jann Haworth as co-designer has been overlooked, as is so often the case with women artists. Haworth told the *Observer*'s Geraldine Bedell: 'If there's a couple involved in something, it's bound to be the guy who did it. I've even had my own brain doing it. But I have a very clear memory of the thought processes and conversations, and I know the parts, the 50 per cent, that I was responsible for.'[14] On a lighter note she told *Tate* magazine: 'Best not to get me started. I'm the person who didn't do 50 per cent of the cover... I did the other 50 per cent.'[15] As for the album itself. Allen Ginsberg described it as: 'One of the few opera triumphs of the recording century', and said the Beatles 'were giving an example around the world that guys can be friends. They had, and conveyed, a realization that the world and human consciousness had to change.'[16]

1967 was definitely the summer of love in the public's mind, and though to many an underground activist that title should have gone to 1966, it was in '67 that the hippie notion of loving everyone – the Beatles' 'All you need is love' – began to be explored. David Widgery, who worked as a doctor in the East End and normally had a very unromantic, strictly Marxist analysis of events, conceded that: 'The Love Generation does aim at real community rather than boozy conviviality, a public total art rather than low culture, and gentleness and warmth rather than pre-heat love and a Saturday Evening Post family.'[17] And though the underground press irritated everyone on the left, from the *New Statesman* to the *Socialist Worker*, Widgery saw some value in it:

Certainly the exuberance of the underground's anti-censorship, anti-Grundy-ish hedonism did something to heave Britain finally out of the monochrome doze of the 1950s with its fearful snobberies of class and sex, if only by rather flippantly proselytising battles others had won... The bohemian communism *worked*: it was self supporting, unsubsidised and you didn't just get involved for the sake of your CV.[18]

Barriers seemed to be breaking down, new models for living were being explored; no-one expected them all to work – in fact, some proved to be dead-ends or even positively dangerous, such as the Mel Lymon and Manson cults in the USA. In Britain there were many experiments in communal living, and attempts to destroy traditional sex roles and authoritarian relationships. The *IT* writer David Robins remembered:

We were really into non-sexist co-operatives. We actually had a house meeting because we had all these radical women. And they said that we should have mattresses in all the rooms, so nobody belonged to anyone else, so there weren't couples. We were united against coupling, couples were bad. Multiple relations were good. We even had a meeting about removing the loo doors. Loo doors were bourgeois. I used to get woken up in the night by young women. One night I was just too depressed, so I said, 'I'm sorry, I'm too depressed.' She went next door and the guy there turned her down, and so did the next one, and she shouted: 'You're all a load of boring old farts!' And we were a bit.[19]

A similar regime existed with the Exploding Galaxy's commune. The Galaxy, described by *IT* as a 'love-anarchist dance group', lived communally in a house co-owned by Paul Keeler and David Medalla at 99 Balls Pond Road. Keeler went to Central School of Speech and Drama before starting the influential Signals Gallery in Wigmore Street, specializing in kinetic art. His friend the Filipino artist David Medalla showed kinetic sculpture at the gallery and edited *Signals* magazine, a glossy broadsheet format, highly influential art magazine which ranged well beyond the concerns of that particular gallery. In 1966, Paul Keeler's father, Charles, withdrew funding from the gallery on the grounds that it was being run 'incompetently', but it was long suspected that he didn't like the content of *Signals* magazine, in particular David's decision to reprint Lewis Mumford's 1965 anti-Vietnam war address to the American Academy of Arts and Letters, and also a letter from Robert Lowell declining an invitation to the White House because of the war.

When Signals closed, Indica Gallery showed many of its artists, including Takis and Medalla. David's show at the Indica Gallery featured bubble machines and sand machines; the latter he described as 'a kind of lament; the death of metal, stone, all the materials of the past, they're all dying, all changing.'[20] The rice machine included 'bits and pieces of rice which, when they vibrate, gain a kind of life'. The ever-changing bubble machines produced a long sausage-like tube made from tiny bubbles that slowly made its way down the side of the machine and twisted around on the floor until finally disintegrating. Even their traces continued to transform before disappearing. It was always moving, always changing, always beautiful.

The Galaxy was formed on 1 January 1967 by David Medalla and Paul Keeler from people they met at the UFO Club. Early members included Edward Pope, Michael Chapman, Malcolm le Maistre and Larry Smart. Within six months it had grown to fifty people, though they did not all dance at once; nor could they all live together, but those that did shared everything. There was not a great deal to share. There was no telephone, no electricity, no gas, and sometimes not even any water. In the early days Paul Keeler tended to be the group's spokesman, saying things like: 'The Exploding Galaxy does not have any specific aims' or 'the Exploding Galaxy is a theatre which is becoming an art form. We are developing not only our own language but probably a new form of communication.'[21] Among these new forms was a new way of writing known as 'scrudge'.

Everything was questioned and challenged: relationships, sexual identity, clothes and costumes. Exploders could not sleep in the same room for more than one night, or with the same person. They couldn't eat at the same time, or cook the same food. There was a big chest containing costumes and clothing; whatever you pulled out determined not only what you wore that day but also your sex: if a man pulled out a skirt he was a female all day. Edward Pope explained:

> Every one of us became a walking justification for his own life, and honesty became a necessity for those who wished to inspire others with the creative way of life. You might see one of us on a bus, wearing clothes that could neither be called respectable nor bohemian, but you might call them bizarre were they not also full of inventive imagination and poetry.

He explained that by wearing a cushion for a hat or turning an umbrella into a newspaper, 'one penetrates the pretence that life is humdrum, and comes to see ones own life transformed as part of the life of the imagination, the life that gives meaning and makes history.'[22]

The bathroom was without a door so that anyone using the bath or toilet would have to do so in full view of the others as part of a communal experience. Paul Keeler: 'As far as we are concerned the Galaxy is an extension of our own existences. There is no division between our private lives and what we are creating, you just cannot make a division.'[23] They experimented in almost all the art forms: poetry, dance, film, performance art, spontaneous happenings, sculpture, painting, kinetic drama. The *Evolving Documents* show at the Arts Lab involved poetry by Michael Chapman and dance by David Medalla played to an audience of 300. They did a five-hour dance at the Roundhouse and an audience participation theatre piece at Middle Earth. In the 28 July 1967 issue of *IT*, Jack Henry Moore reported: 'The Exploding Galaxy gave a performance which must constitute London's most liberated theatrical performance in history. Arthur Brown, singing, while wallowing on the floor with four Galaxy nudes, reached an all time high in erectile music... Never have so many been so nude, so early, and for such good reason.' Keeler commented: 'We hope the Galaxy will continue to expand until it contains one thousand, two thousand or even three thousand people. Then the audience as such will cease to exist.'[24]

A typical dance was performed at the UFO Club in October 1967 after it moved to the Roundhouse. Watched by about a thousand people, four men and three women danced bare-breasted for about half an hour to bongos and a flute against a background of strobes and a projected light show. They wore a sash of flowers around their necks and had ankle bands made of tiny bells to emphasize each step. When they finished the first dance people applauded and threw money onstage. It was all very innocent. The British art scene was fortunate that David Medalla chose to live in London: he enlivened and stimulated the scene with an uncontrollable flow of creative energy. Comparisons have been made between the Exploding Galaxy and the American Living Theatre, but the Living Theatre were tame in comparison and much too fond of staying with their wealthy patrons as they made their way around the world. At a Living Theatre performance at the Roundhouse in 1967, not long after the Galaxy formed, the performers left the stage to walk among the audience, complaining that society would not let them travel without a passport or take their clothes off in public or smoke pot, a whole chorus of 'don'ts'. Up jumped Michael Chapman, six and half foot tall with wild curly hair, and yelled: 'Well, I can!' and proceeded to strip off, giving a loud commentary as he did so and apologizing for his spotty body while all the time shouting: 'You can if you want to!' in response to the Americans' liturgy of prohibitions. Then he lit a joint and puffed at it as he walked around with

them naked, rather undermining the supposedly radical Americans and reducing their act to a shambles. Keith Milow and one of his banker friends were in the audience and ran up to invite him to dinner. 'Why the fuck would I want to do that?' snapped Chapman, and spat at the banker, right between the eyes.

Another side of the Galaxy's commitment to art and culture came when their musical director, Richard Topp, performed Eric Satie's rarely played *Vexations* at the Arts Lab shortly after it opened; it consists of the same musical piece repeated 840 times. A support team fed him sandwiches and drinks through the night and someone was on hand to substitute for him when he had to make unavoidable breaks.[25]

The idea of people living freely and communally, creating art together, naturally attracted the police, who harassed the Galaxy continually to the extent that in the end they simply didn't bother to put the front door back on its hinges. *IT* even editorialized on their behalf: 'A secure and free place to live is what makes life possible for them. The police actions to deprive them of this constitutes state censorship of the lowest form – to deprive artists of their most basic needs in order to suppress what they have to say.'[26] Paul Keeler was quoted, saying: 'The Galaxy are threatening because they completely disregard all accepted standards in art and living. We are not prepared to accept the society in which we live.'[27] Sadly one of these standards was hygiene.

The members of the Galaxy lived together along with half a dozen unhouse-trained cats that were allowed to piss and shit where they would. The residents had little awareness of basic hygiene and the place soon became infested with lice. The smell and dirt was so bad that a couple of the Exploders decided that measures needed to be taken to improve the living conditions.

To directly suggest cleaning the place up would have been an authoritarian, hierarchical approach which would have certainly resulted in a long discussion and nothing being done. After much thought, they decided that the reason it was so dirty was that the other members of the commune had not seen the filth. The answer, of course, was to increase their awareness, and what better way than to administer a communal dose of hash. This would bring about enhanced perception and bring the more ugly aspects of the house to their attention. The hash was passed around one morning and had its desired effect: 'the entire house was cleaned, disinfected, and actions taken to ensure the restoration of hygienic conditions.'[28]

It was at Balls Pond Road that Medalla began his *Stitch in Time* series. He gave an account of it in an interview with Gavin Jantjes in 1997:

'A Stitch in Time' started in 1968, I had two lovers who by chance arrived in London at the same time. One was going back to California and the other was going to India, and in those days you had even longer waits in airports. I had to see both of them at the same place and I had nothing to give them. I had two handkerchiefs, this is how it started, and I had some needles and thread and I'm very bad at stitching things by the way, I couldn't even stitch a button, so I said 'Hey listen, just in case you get bored along the way why don't you just stitch things', because I understand that if you do some needlework it's very therapeutic and waiting for aeroplane flights becomes less boring. I gave each a handkerchief, and at first I sort of embroidered my name and the date and love and all that, and I didn't see them again, neither the lovers nor the handkerchiefs, for many many years. Then one day I was at Schipol airport in Amsterdam and there was a young, very handsome, tanned Australian who was lugging something which looked like a very crazy sort of totem and it looked very interesting. He said 'Somebody gave this to me in Bali and you can stitch anything on it'; it had become a column of my 'Stitch in Time'. I looked at the bottom of it, and it was my original handkerchief. The people had stitched in a vertical way because it's small. I said to him 'You know, I think I know the person who did this', but he had to go and catch a plane, so I haven't seen those works again. Things were stitched on like bones and Chinese coins, all sorts of things. After that I started to make different versions of 'A Stitch in Time' in different places.[29]

There were a number of artists involved with the Galaxy. One of them, John Dugger, exhibited his multiples at the Whitechapel Gallery in 1970 and the tankas and ritual objects he collected during his travels in Nepal with David Medalla were shown at the Hayward Gallery in 1971. Another artist was Gerald Fitzgerald, who also showed at the Indica Gallery. After a particularly nasty drugs bust in February 1968 in which, according to Medalla's biographer, Guy Brett, cannabis was planted by a plain-clothes police infiltrator ('He wore jeans but they were new'), three Galaxy members were sent to trial. (Though they were happy to use it, the Exploders rarely had enough money to eat, let alone buy drugs.) David was in Holland at the time. A Member of Parliament, Benn Levy, gave a statement in their defence at the trial, saying:

They are unacquisitive, as oblivious of elementary comfort as a classical religious order, unselfconsciously ascetic. Their boarding house is furnished with mattresses, sleeping bags, packing cases, bookshelves and little else. There they live in cheerful penury working away like beavers on projects

that offer no prospect of serious remuneration, that may at best earn them a week's supply of baked potatoes, raw carrots, bread, jam, cabbage, Mars bars and occasional eggs. They dress and coif themselves egregiously, prompted not by fashion but by individual fancy. Their clothes are not only a proclamation of non-conformity but often an expression of surrealist humour.[30]

Two of the three were acquitted, but the police achieved their aim: they destroyed the commune. The members dispersed and Medalla, his new friend the American artist John Dugger, and several other Exploders left the country for India, a trip paid for by a wealthy admirer. David and John did not return for eighteen months.

The Balls Pond Road building was sold, but one of the Galaxy members, the artist Gerry Fitzgerald, moved the remnants of the commune to a building in Islington Park Street, and assumed the leadership role vacated by David. It was at this location that both Genesis P-Orridge and Derek Jarman spent time in the Galaxy Mark II.

Urban communes like Balls Pond Road experienced many problems, police harassment being the major one, and more and more their members decided that the city was not conducive to communal living. The Tribe of the Sacred Mushroom, who had a commune in Notting Hill, were the first to move, and left town in January 1968. Their scribe, Lynn Darnton, wrote in *IT*: 'We all had the same vision of a small, isolated village with nature as our garden, populated by organic, rhythmic people instead of mechanical synthetic ones in it... we find the combination of beautiful country surroundings and a macrobiotic diet has made the use of acid totally unnecessary.'[31] She was inundated with letters from readers wanting to join the tribe and had to appeal in *IT* to say that they couldn't take anyone else, nor reply to all the letters.

Some communes took things more gradually, By the spring of 1968 Sid Rawle's Hyde Park Diggers had over 200 members but as many of them had jobs, and the commune was loosely spread out over a large number of rented flats, he recognized that their long-term plan of moving to the country would take time to realize. It had been part realized in 1967 when John Lennon bought the island of Dornish, in Chew Bay, Co. Mayo off the West Irish coast on an acid trip and afterwards hadn't known what to do with it. He contacted Sid, known in the press as the King of the Hippies for his long robes and beard, round granny-style glasses (not unlike Lennon's) and necklace of ritual objects, and offered him the custodianship of Dornish 'to be used for public

good'. Sid agreed and a group of twenty-five adults and a baby travelled to Dornish to see if it was feasible. Sid Rawle:

> We decided we would hold a six-week summer camp on the island. Then we would see what came out of that and decide if we wanted to extend our stay. It was heaven and it was hell. We lived in tents because there were no stone buildings on the island at all. Most of the time was really good.[32]

They stayed for two years, growing their own vegetables and buying groceries in bulk, but the local people on the mainland were hostile to them, and in 1972 the hippies left. Rawle and his fellow communards set up the famous Tipi Valley commune in Wales where 150 people lived for twenty years. Meanwhile scores of hippies made the move to North Wales and the border country near Newport, Monmouthshire, where they established communal houses, workshops, yoga centres and the like. The wealthier ones moved to Glastonbury and its surroundings, in order to study ley lines, flying saucers and Arthurian vibrations.

The biggest difference between the hippies and straight society, apart from the drug usage, was sex. Nicola Lane told Jonathon Green:

> There was a lot of fucking going on. It was paradise for men in their late twenties: all those willing girls. But the trouble with the willing girls was that a lot of the time they were willing not because they particularly fancied the people but because they felt they ought to... There was a lot of misery. Relationship miseries: ghastly ghastly jealousy, although there was supposed to be no jealousy, no possessiveness. What it meant was that men fucked around... There were multiple relationships but usually in a very confused way; usually the men wanted it.[33]

David May told Jonathon Green of going to see a film of Richard Neville and Louise Ferrier fucking:

> I couldn't get over that. Richard and Louise fucking and the cinema was filled with people watching Richard's arse going up and down and these squelching noises and him licking her tits. They put on a great performance. It was a genuinely extraordinary act, wonderful, the stuff of legends – but does it count for anything now?[34]

Though many men misused the situation, many women regarded it as beneficial. Sara Maitland in her sixties memoir wrote: 'Libertarianism was of course fun (at least for a great many women), but part of the fun was the conviction that it was brave, important and socially useful, liberating at a

global level, to do these things.'[35] There was a sexual revolution going on; a confused, sometimes exploitative, sometimes predatory one, but one that ultimately led to a more positive attitude towards sex in Britain. The hippies said you shouldn't feel guilty about having sex, or having sexual thoughts. They revealed that women have sexual needs – a shocking idea to many establishment figures. They proclaimed that sex was good, not evil and sinful. They practised and preached free love. Marriage was seen as to do largely with property and passing on the male name; as having little to do with love or loving people. They attacked Victorian prudery and British uptightness, leading to a situation where at least a substantial portion of British society now regards sex as a positive thing. If this was all they achieved, then it was worth it.

21 Dialectics

The history of post-war subcultures is a lurid one, and all of it has at one time or another washed up at the shop.

ELIZABETH YOUNG on Compendium[1]

Though not strictly underground, the Dialectics of Liberation Congress, held from 15 to 30 July at the Roundhouse in the summer of 1967, gave a platform for many of the ideas being discussed at that time. Described by David Widgery in *New Society*, in 1989, as:

> R. D. Laing, David Cooper and their collaborators, known mainly for their exegesis of Sartre and work on the families of schizophrenics, announced that the aim of their conference was to link the internalized violence said to be characteristic of psychotic illness with the mentality which fuelled the American war on Vietnam. The conference was to be nothing less than 'a unique gathering to demystify human violence in all its forms.' The intellectual equivalent of levitating the Pentagon.[2]

Of the four psychiatrists who organized the conference, Ronnie Laing, the 'anti-psychiatrist', was best-known. His controversial ideas on the nature of schizophrenia were very much part of the public debate in the late sixties, known through such books as *The Divided Self* (1960) and *The Politics of Experience and the Bird of Paradise*. He had a strong Glaswegian accent and could be very persuasive. Joan Bakewell described him as 'an eager young doctor with a shock of unruly black hair, a gaunt restless body and brown eyes of commanding intensity. In three minutes on air he outlined his theory that a dysfunctional family might be a prime cause of schizophrenia.'[3] His powers of persuasion were sometimes marred by whisky and he would sometimes shout people down rather than reason an argument. He was closely associated with the older generation on the underground scene; giving

interviews to *IT* and treating many of the waifs and strays who wandered, disoriented, into the UFO Club or the *IT* offices.

At the conference people were lined up in sleeping bags inside the doors, pot smoke rising, like an encampment of Mongolian nomads. For two weeks, the Roundhouse became a prototype for the occupations and teach-ins that occurred during the Events of May in 1968 in Paris. Everywhere small groups of people were engaged in animated discussion. The subjects covered by the conference were wide-ranging: R. D. Laing and David Cooper both talked about dealing with the pressures of society on the individual; Gregory Bateson proposed the theory of global warming, saying it would be at least twenty-five years before its effects started to be seen; John Gerassi, Paul Sweezy and several others discussed monopoly and global capitalism; Herbert Marcuse spoke on 'Liberation from the Affluent Society'; Julian Beck represented the Living Theatre, Michael X represented the British black community, Allen Ginsberg spoke on enhanced consciousness, and there were events by the performance artist Carolee Schneemann.

The debates polarized between hippies and blacks, a subject argued by the American black power leader Stokely Carmichael, who dismissed hippies as middle-class kids who played with long hair and flowers for a year or two before returning to their class backgrounds. He said they could not be compared to the black community, who were genuine outsiders and had nowhere to go back to. He was interested only in revolution: 'I do not feel that a reform movement will solve the socio-economic problems facing us...' His extreme misogyny helped form the women's movement. When asked what role women could play in the liberation movement, he replied 'a horizontal one'. It was this type of remark that made women activists realize that they needed their own movement, that they would never achieve equality within any of the existing organizations. Allen Ginsberg was the most successful in at least debating these issues with him: Carmichael knew and respected Ginsberg, and though he didn't agree with many of his positions, he recognized his genuine desire to change the situation faced by American Blacks. (Ginsberg had often been criticized for his support for LeRoi Jones/Amiri Baraka). Ginsberg's own speech quoted heavily from William Burroughs on the subject of control systems. Burroughs himself had refused to participate. When the proceedings of the conference were released in a series of long-playing records, it was the Burroughs quotes that caused a woman working at the pressing plant to complain of obscenity and stop the presses. That volume was pressed elsewhere. The continuous debate – which carried on late into the evening at 'Dialectics House', where many of the delegates gathered to

eat, drink whisky and take drugs with Ronnie Laing after each day's proceedings – was very stimulating, and in order to continue the discussions the London Anti-University was formed the next year. But first, some of the overheated rhetoric and elitism of the events was deflated by Mick Farren's Social Deviants, who had been hired to close the event. The organizers seem to have been expecting a British folk-rock version of the Fugs, something socially relevant but with a beat; instead they got prototype punk at astonishing volume. Mick Farren: 'When we slammed into a teeth-grinding fuzz-tone thrash, a few people actually blanched.'[4]

More serious was the trick played upon the conference by Emmett Grogan, the 'leader' of the San Francisco Diggers. He received an enthusiastic reception, and after the handclapping died down he delivered a stirring revolutionary speech, speaking strongly and clearly as if delivering a Shakespearian soliloquy. It was just what the revolutionaries in the audience had wanted to hear:

> Our revolution will do more to effect a real, inner transformation than all of modern history's revolts taken together!... Nobody can doubt the fact that during the last year, an enviromental revolution of the most momentous character has been swelling like a storm among the youth of the West... Power to the people.[5]

His speech lasted for just over ten minutes and at the end the audience rose to their feet and gave him an enthusiastic standing ovation. He described what happened next in his autobiography, *Ringolevio*:

> He stood there and waited for the crowd to settle back down so he could finally tell them what he *really* came there to say... 'I neither wrote nor was the first person to have ever given this speech... I do know who was the first man to make this speech. His name was Adolf Hitler, and he made his delivery of these same words at the Reichstag in, I believe, 1937. Thank you and be seein' ya.'[6]

The audience sat in stunned silence for a full half-minute before exploding with fury. Arguments raged and fights even took place between the righteous angry who thought he had pulled a cheap trick on them and those who thought that Grogan had revealed how phoney most of the revolutionary rhetoric they had been listening to really was. But most of the anger was directed at Emmett, who, as he put it, 'got his ass out of there real quick'.[7]

The Dialectics of Liberation Congress was described by David Cooper as 'really the founding event of the Anti-University of London'. This was an

attempt to continue the dynamics of debate and learning that had prevailed during the fortnight of the congress. Premises were found at 48 Rivington Street, Shoreditch, EC2, and a cast of the usual suspects rounded up as teachers. Some interesting things were promised: Cornelius Cardew was to give a fortnightly course in experimental music: 'My aim would be to identify the experience and expand and prolong it. Speaking for myself, the concert hall is one of the less likely places to find a musical experience'[8]; Steve Abrams, director of Soma, the outfit that put the pot ad in the *Times*, was to talk on methods of altering consciousness; Bob Cobbing taught sound poetry; R. D. Laing committed to four meetings over three months on politics and religion; David Cooper lectured on psychology and politics; Joseph Berke spoke on the anti-institutions and the need for a 'counter-society'; there were poets like Lee Harwood, Ed Dorn, John Keys and Calvin Hernton and artists like John Latham and Barry Flanagan. Alexander Trocchi used his 'Invisible Insurrection' text as the basis for his anti-university prospectus statement:

> I take it that the anti-university is an experiment in relation to the urgencies of the invisible insurrection, that what we are consciously undertaking is an exploration of the tactics of a broad (r)evolt. Speaking personally, I for one am quite sure that I can express lucidly and comprehensively the main features of this cultural transition, and I can describe in immaculate intellectual terms, the spiritual attitudes and the new economic scaffolding which must be brought into play as the tactical bases of any possible evolution of man.[9]

He was to speak fortnightly on Tuesdays at 9.30 p.m..

One of the founding members of the Anti-University was Juliet Mitchell, who organized seminars with women, one of the first of the political women's groups of the late 1960s. Juliet Mitchell:

> One of the people in this class inherited two thousand pounds, and she was going to put it towards a refuge for women, because violence against women was quite a topic. I persuaded her to put the money into a bookshop instead, so she opened a very good bookshop in Camden Town called Compendium Books, which became a very important alternative political bookshop.[10]

The woman in Juliet Mitchell's class was Diana Gravill and she and her partner, Nicholas Rochford, opened Compendium in a small shop at 240 Camden High Street in late August 1968. The people involved in the Dialectics of Liberation conference and with the Anti-University were very supportive of the shop and also acted as an influence on their initial choice of stock; they specialized in experimental and radical fiction and psychology, as well as

second-hand books. Diana was to run the philosophy and criticism sections for the next fourteen years. Their initial staff came from Indica Books: Nick Kimberley and Ann Shepherd. Nick specialized in poetry and published two issues of the poetry mag *Big Venus* while he was at Indica. When Indica Books closed on 29 February 1970, Nick became Compendium's first employee, opening a poetry section in a poky room in the basement, and later in a larger space upstairs. Their second hiring was Ann Shepherd who first went to Watkins, the occult bookshop on Cecil Court, before joining Compendium early in 1971 to start an esoteric book section next to Nick's poetry books in the cellar. It was this system of hiring specialists in each field to run those sections that kept the shop vital and exciting for decades. In those days there were no specialist comic shops, and Compendium soon had the best line in American underground comics in the land. This was the period of growth of the women's movement and soon there were enough titles in print for Compendium to open the first Women's section in any British bookshop.

Throughout this time Camden Town itself was changing. Until then it had been a working-class Greek and Irish community – even now a few Greek restaurants and Irish pubs remain – and Camden High Street was just that, with ironmongers, fish shops and greengrocers. Camden market did not exist. The Roundhouse was the initial attraction in the area. First with the UFO Club on Friday nights, then Implosion on Saturdays. Kenneth Tynan put on *Oh! Calcutta!* at the Roundhouse, and as it was open every day Compendium opened a bookstall there. Then in 1971 Tony Macintosh and a group of friends including Tchaik Chassey opened Dingwalls Dance Hall, the live music venue, restaurant and bar, in the old buildings at Camden Lock, across the street from Compendium and, after a while, Camden market began in some of the outbuildings.

In 1972, Compendium expanded across the street to a building at 281 Camden High Street which, in the spirit of the age, became the first Mind–Body–Spirit bookshop in the country. In the mid-seventies, Compendium acquired much larger premises at 234 Camden High Street and gave up the old shop at number 240. People came and went, some got strung out on drugs or went to prison, or set out to start their own specialist bookshops, but Compendium managed to remain at the cutting edge in virtually every subject area, from radical politics, with a bias towards situationist and anarchist publications, to Beat Generation and post-Beat Generation fiction, critical theory, Surrealism, drug literature and the women's movement. In 1976, just as punk was beginning, the Clash had their rehearsal studio across the street in the Camden Lock complex and were often seen browsing in the

shop. Compendium naturally carried all the Xeroxed punk magazines like *Sniffin' Glue* as they came out. It was one of the world's great bookshops but the success of the Roundhouse, Dingwalls and Camden market eventually pushed rents up so high that in early October 2000, after thirty-two years as purveyors of revolution, anarchy, literary experimentation, the counter-culture, occult mysteries and racial equality, they finally had to close their battered black door.

The Roundhouse had all the makings of a concert venue doubling as an underground community centre, like the Milky Way (Melkweg) in Amsterdam or the Fillmores East and West or Family Dog and for a few years it was like that. Jeff Dexter ran Implosion there every Saturday night, donating half the profits to whatever underground organization most needed them: Release, *IT*, the Mangrove defence fund and so on. The other half went towards the restoration of the building itself. All bands, including the Who, played for just £25, knowing the money was going to fund the scene. There was one exception: the Rolling Stones, who insisted on the complete take. The focus on the building helped make Camden High Street into a prime shopping street. Naturally, once it became popular the landlords forced out all the hippie tea rooms, vegetarian cafés and ultimately the Compendium book shop that had established the street as a commercial destination and replaced them with shops who could pay very high rent, some of them, allegedly, the kind of leather goods shops where it is very easy to launder money. The market, however, retains a vestige of its old hippie flavour, now mixed with a distinct cyberpunk element; enough for William Gibson to use it as one of the settings for his 2004 novel *Pattern Recognition*.

The hippie counter-culture continued to grow and by the summer of 1968 the Worlds End area of the King's Road had also acquired a distinct hippie flavour: there was Granny Takes a Trip run by Victorian clothing collector Sheila Cohen, her boyfriend, the portrait painter Nigel Waymouth, and the Savile Row-trained tailor John Pearse. They began with antique clothing, then started to make up their own designs. Nigel Waymouth: 'One morning we were sitting around cross-legged on the floor, passing a joint around, and these two blokes came in. They looked around and said, "This is a nice place isn't it?" We looked up, and of course it was John and Paul.'[11] Soon they were dressing the Beatles, the Stones, Jimi Hendrix and the Pink Floyd. The original Victorian décor included a vintage gramophone with a large horn. Nigel and his design partner Michael English enlarged pictures of the American Indian chiefs Low Dog and Kicking Bear to fit the window, and followed this

with a Warhol-style portrait of Jean Harlow. Their final window was one with the front end of a 1947 Dodge protruding from it. John Pearse once owned the whole car but it broke down in 1968 in Notting Hill and they decided to chop it in half for the window. They had recently seen Claes Oldenburg's *Lovers in the Back Seat of a Dodge* and were inspired by it. The council objected strenuously and this exacerbated the arguments that John had been having with Nigel about the amount of time he was devoting writing for their band Hapshash and the Coloured Coat. John Pearse left in 1968 and the shop continued under the management of Nigel Waymouth and Sheila Cohen until 1970, when they sold it to Freddie Hornick. He brought in Gene Krell and a branch specializing in glam rock attire opened in New York, but by then the original 1965 shop and everything it stood for had long gone.

The future novelist Salman Rushdie lived upstairs and described the shop as 'pitch dark. The air was heavy with incense and patchouli oil and also the aromas of what the police called Certain Substances... it was a scary place.'[12] He avoided it. However, when John and Yoko's white Rolls-Royce pulled up outside the shop one evening, he decided a more friendly approach might be called for. But when he knocked on the door to introduce himself and suggested that he might come in 'for a chat', Sheila Cohen snapped: 'Don't you know the art of conversation's dead, man?' and slammed the door in his face.[13]

Across the street, at 1 Dartrey Terrace, was Gandalf's Garden Shoppe, Muz Murray's hippie commune who had taken over the old Home and Colonial Stores shop and were busy redecorating to get rid of 'the old butcher shop vibes'. Muz told *IT*: 'When the place is looking like it ought, we are having a "VIBRATION CHANGING CEREMONY" with mantra chanting and incense burning and Chinese tea all round.'[14] The walls were painted with Tibetan iconography and the visitors sat on mats. In an ad for *IT* Muz wrote: 'You really do meet the gentlest people at Gandalf's Garden Shoppe. Some days someone wanders in with his sitar and plays awhile. Others bring guitars and sooth us all. Some days you come in and bring your flute or play our ocarinas...'[15]

Just on the turn in the King's Road, at number 402, was Town Records, one of the hip record stores that specialized in American album imports (the others were One Stop and Musicland). Next door to Michael Rainey's Hung on You clothes shop was the Green Dragon at 436 King's Road, open 11.30 a.m. to 2 a.m. for 'food, rice, and Dragon specials, exotic teas, grass walls, clouds moving across the ceiling, nice sounds playing. Sit on floor on cushions and meet your friends.' The outside window and wall were painted with a huge Chinese dragon.

The Baghdad House on the Fulham Road (the BDH as it was always known) served yogurt and honey while you sat on cushions in a basement surrounded by Moroccan hangings. It was a favourite place for people to smoke hash as it would be difficult to raid without plenty of advance notice of the police arriving. It was a central meeting place for the King's Road people: Michael Rainey, Jane Ormsby-Gore, Robert Fraser, Christopher Gibbs, Mick Jagger, Marianne Faithfull, members of groups like Procol Harum. Cecil Beaton described a visit in his diary for June 1967:

> At 11.30 we went off in taxis to the Baghdad House restaurant in Fulham Road. Here in the club-like atmosphere of the basement we found others of the gang, Mark Palmer [Sir Mark Palmer, 'gypsy baronet' and former pageboy to the Queen], more rodent-like than ever with his greasy blond hair over his nose, Michael Wishart, looking as if he needed to go back to the nursing home, the youngest Tennant girl [the Hon. Catherine Tennant, Palmer's wife and future mother of today's 'rebel supermodel' Iris Palmer].

Greg Sams's macrobiotic restaurant at 136a Westbourne Terrace was open from 6.30 until midnight and always had free food available for those who genuinely had no money. Though usually filled with hippies slowly chewing their brown rice, it was also patronized by John and Yoko, who did a full macrobiotic course, and other visiting musicians like Graham Bond, who once trapped everyone in there when his Hammond organ got stuck on the stairs as he dragged it down to the basement to play. Greg and his brother Craig were the forerunners in the organic food business, tirelessly promoting healthy food in a society that had only recently enthusiastically embraced soggy white bread.

On 15 August 1967 the government's Marine Offences Bill became law, marking an end to independent broadcasting throughout the country. It was, of course, aimed at closing down the pirate radio ships that had been transmitting from outside British territorial waters and threatening the monopoly of the BBC. John Peel, whose *Perfumed Garden* show on Radio London was a particular favourite of the underground, told *IT*:

> I don't think the public is aware of the difference the passing of offshore radio will make. It will certainly mean an end, on radio, to the sort of music I am putting out. Although disc jockeys are virtually the jackals of the pop scene, living off other people's work, pirate radio did at least provide a certain medium of self-expression to anyone who cared to use it, but it seems that the

BBC's new pop channel is going to be totally restrictive, particularly in view of the heavy censorship which has been placed on the recorded programme tapes that the BBC have already made.[16]

John began to write a regular *Perfumed Garden* column for *IT*, beginning in issue 19, of 5 October 1967, which, considering how busy he was and the fact that he wasn't paid, showed a strong commitment to the cause. After urging everyone to support Release, he wrote:

Our main problem still seems to be one of personal communication. UFO and other ways have helped and I've been blessed with a multitude of hobbits, elves, dibblers, sparrows and assorted gods and goddesses through the Perfumed Garden. I know the idea of wearing a homemade PG badge seems futile or childish in many ways but think of it as being 'childlike' rather than 'childish' and I believe we must be 'childlike' if we are to survive and exert any real influence on the terrifying, murderous society in which we gasp for expression.

John wrote many thousands of words for *IT*, embodying the most consistent and genuine belief in the idea of love and peace of all *IT*'s writers, often appearing surrounded by more strident voices where he was an island of calm.

He died before completing his autobiography and his widow, Sheila, completed the text, often quoting from his diary. She included one oddly moving entry from 20 October 1967, written after a visit to the Arts Lab in Drury Lane:

Many creative people there, so I felt my usual pangs of inferiority coming on. In the presence of so many talented, creative and constructive people on the underground scene I feel that I'm regarded as something of a hanger-on and bore. I hope this is not so because I want people to realise that I'm doing as much as I can in my foolish way to further their several causes.[17]

In reality, to the UFO and Arts Lab crowds, it was John who was the mentor. Music was enormously important to the underground scene and his editorial sensibility was impeccable. They could depend on his judgement, and it was through John that they first heard Captain Beefheart and Marc Bolan (who let him down disgracefully once he was no longer of use to him), as well as numerous lesser-known artists. His late-night programme was the soundtrack to their lives, the only source of independent music on radio.

Unfortunately John paid for his association with *IT* by being harassed

by the police. He was already a famous BBC Radio One DJ when the heavy mob arrived one evening in 1969 and kicked in the door of his flat on Park Square Mews, perhaps not realizing it was Crown Estate property or that he would have opened it had they knocked first. But John had been expecting it. He was a non-smoking vegetarian who cared very little for either drugs or alcohol, but his position as a promoter of obscure experimental bands and – perhaps more suspect – as a columnist for *IT* meant that he was bound to be targeted by the police and so he had in place a plan of action. As soon as the drugs squad arrived each one was tagged by a member of the household and followed to make sure they did not plant anything; a common occurrence in those days. They searched everywhere, dismantling the famous hamster cage and even tearing open an apple pie that Sheila, John's wife, had just finished baking. Next they turned their attention to the family Dormobile. Naturally the police had brought along the press, but this time it worked against them as their presence prevented anything being planted without immediate denial from the household. Annoyed at not pinning anything on them the police kept up a policy of intimidation. Sheila Ravenscroft wrote in her section of Peel's autobiography that every trip to the shops was a cause for anxiety: 'We'd be ambling home with bags of groceries only for a police car to screech up to the kerb and disgorge a couple of officers, who would then search us and go through our shopping before driving off again. It happened so frequently, but it never stopped being humiliating.'[18]

IT grew and almost prospered and throughout 1968 it came out regularly and even managed to pay its contributors. Articles were often followed in subsequent weeks by a lively exchange in the correspondence pages and it seemed to be fulfilling its original aim of putting like-minded people in touch and fuelling public debate. One example of how avidly it was read came with issue 44 in November 1968,[19] when a small news item appeared asking readers to send any old spectacles they had to the Albert Bailey Mission in Farnborough, which refurbished them, graded them and forwarded them to poverty-stricken people in Africa and Asia. A week later Albert Bailey wrote to say that he had so far received 1,575 pairs of specs from *IT* readers and that 'Christ would not be a stranger among you.' Two months later he had received more than one hundredweight.

In September 1969 the London Street Commune took over a 100-room mansion at 144 Piccadilly at Hyde Park Corner. The only entrance was via a ladder to clear the top of the balustrade protecting the area, then over a well-made drawbridge to a window. Posted next to the window was a tourist poster showing a drawing of a London policeman with the words, 'are wonderful'

beneath it. The other ground floor windows were boarded up. (Later the 1791 building was demolished by property speculators and replaced by the ugly Intercontinental Hotel.) The London Street Commune was the same group that had occupied the *International Times*, called in by two or three freelance writers who had hopes of taking over the paper rather than starting one of their own. They accused *IT* of becoming bourgeois. As they hadn't the slightest idea of how to bring out a newspaper they left after a few days but not before the police had arrived, called to prevent them stealing the IBM compositing machine. The office manager, Sue Small, hid the address files and subscription lists by sitting on them. The underground was plagued by these factional fights, the counter-cultural equivalent of corporate raids, the worst being an attempted takeover of Release by a group affiliated to Mick Farren's White Panther Party who could not possibly have run it themselves. In fact, it was all good training for the straight world but we didn't know it at the time.

22 Performance

**The most disgusting, the most completely worthless film
I have ever seen since I began reviewing**

RICHARD SCHICKEL, *Time* magazine

Indescribably sleazy, self-indulgent and meretricious.

JOHN SIMON, *New York Times*

Performance by Donald Cammell and Nic Roeg has been called the best-ever British gangster movie, the best psychedelic movie and the best 'Swinging London' movie, and has become a cult classic, taught in university courses and with numerous books written about it. *Performance* is the best portrait ever made of the late-sixties Chelsea scene. Marianne Faithfull: '*Performance* was truly our Picture of Dorian Gray. An allegory of libertine Chelsea life in the late sixties, with its baronial rock stars, wayward jeunesse dorée, drugs, sex and decadence – it preserves a whole era under glass.'¹ The filming of *Performance* was completed in December 1968 and truly captures a cast of characters in a moment in time: Mick Jagger, James Fox, John Bindon, Keith Richards, Donald Cammell, Anita Pallenberg, Christopher Gibbs, Jack Nitzsche, David Litvinoff. As such, it is worthy of detailed analysis.

Donald Cammell was a society portrait painter who had trained with Pietro Annigoni, and though he had written two previous screenplays, he had never before directed a film. Recognizing his lack of experience he approached his friend Nic Roeg to co-direct. Cammell:

> We made an agreement that Nic shouldn't talk to the actors if I wouldn't talk to the camera crew. I spent a lot of my time talking to the camera crew because I wanted to learn all about cinematography, all the things that Nic knew and I didn't, which was a hell of a lot at the time.

Donald persuaded his brother David, who made television commercials, to take a year off to associate-produce the film with Sandy Lieberson. Warner Brothers put up £1.8 million, thinking they were getting a 'Swinging London'

film. In fact they even tried to get Jagger on their payroll as a 'youth advisor' and enquired whether 'any of the other boys' would like to be in the film.

The publicity handout described the film as featuring the story of 'a strange electronic poet, a latter-half-of-the-twentieth-century writer who had retired from the pop scene and established himself in an opulent life-style accompanied by two young women. His privacy is shattered by the unexpected arrival of a gangster, on the run from both the police and his underworld colleagues for murder, who is seeking shelter.' James Fox plays Chas Devlin, who is a henchman of a gangster called Harry Flowers, played by Johnny Shannon. Chas sees himself as a 'real man', c.1968, with his neat suit, his immaculately tidy bachelor flat with *Playboy* neatly arranged on the coffee table, and a subservient girlfriend called Dana who works as a nightclub singer. He is a thug: we see the violence in his private life through his self-absorbed sado-masochistic sex with Dana, and at work, menacing a Soho porno film distributor and the owner of a mini-cab firm that his boss wants to take over.

Chas, along with two of Flowers's other henchmen, Moody, played by John Bindon, and Rosebloom, played by Stanley Meadows, is sent along to put the frighteners on someone who might involve their boss in a court case currently in progress. They intercept the man, along with his barrister, outside a respectable gentlemen's club in St James's and reinforce their warning by ambushing the barrister's chauffeur, roughly shaving his head and pouring acid over the Rolls-Royce. All along, the scenes of mayhem and violence used by Flowers to expand his business are contrasted by court scenes in which a hotly contested merger is described by the barrister as not only legal but also essential for economic growth.

Flowers sends Rosebloom to smash up a betting shop that he wants to acquire, owned by one Joey Maddocks. However, the next day it is Chas who collects Maddocks for a meeting with Flowers and so they think it was he who demolished the place the night before. The most violent scene in the film follows. Maddocks and two of his henchmen attack Chas in his own flat. In the course of the fight Chas manages to get free and shoots Maddocks dead. Chas flees, knowing that Flowers will have him killed for involving him in a murder. In Paddington Station, Chas overhears a conversation about a room available in nearby Powis Square. He goes to the address and the film makes an abrupt change of style. Up until this point there had been a straightforward linear narrative but now we have jump cuts, montages of images, fast-forward and backwards shots, and random edits.

Chas is let into 81 Powis Square by Pherber, played by Anita Pallenberg.

The house is owned by Turner a reclusive, semi-retired rock star, played by Mick Jagger, who lives there in a ménage-à-trois with Pherber and Lucy, played by Michèle Breton. Turner and Pherber don't believe Chas's implausible claim that he is a nightclub juggler and initially Turner wants him out before realizing that Chas's violent edge, his 'demon', might be just what he needs to shock him out of the lethargy that has becalmed him and get him back to writing music. He and Chas find that gangsters and rock stars have a lot in common. Chas knows that Flowers will track him down and plans to leave the country. He needs photographs to get a false passport and asks Pherber and Turner to take them. They dose him with hallucinogenic drugs and play identity games with him, dressing him first as an archetypal gangster, then in more feminine clothes. Pherber flirts outrageously with him and at one point holds a mirror to Chas's body so that her bare breast is reflected there to show how he would look with breasts. The gangster's macho façade begins to break down and they eventually get him to wear a wig and make-up to explore another side of his sexuality.

Disoriented by the drugs and role-playing games, he goes off with Lucy and they have sex. Unlike the sadistic performance we witnessed with his girlfriend, he shows tenderness and concern towards Lucy and the next day, in an uncharacteristic display of kindness, goes to his room to get her some shampoo. Rosebloom and 'some of the chaps' are waiting for him, having tracked him down from his attempt to get a false passport. Knowing they are going to kill him, he asks if he can pop upstairs for a second. He goes to Turner's room and says he has to go. Turner says he wants to come with him. 'You don't know where I'm going,' he tells him. 'I do,' Turner replies.

Chas draws his gun and shoots Turner in the head and, in a celebrated, much discussed sequence, the camera follows the path of the bullet into Turner's brain. Next we see Chas being led to Flowers's Rolls-Royce parked outside, but as the car pulls away, it is Turner's face we see through the window. They have become one.

In the film Turner supposedly lived at 81 Powis Square, but the exterior shots were filmed at number 25. The house at 15 Lowndes Square was chosen for the interior shots because David Cammell remembered it from losing rather a lot money there in a poker game and it was proving hard to find a large house that had not been converted into flats. The house was owned by Lenny Plugge, the 85-year-old father of the man who had organized the poker game, and was filled with what was euphemistically known as 'the Plugge Collection', which included pictures by Rembrandt, Rubens and Velasquez.

Plugge was very pleased to rent the house but insisted that his pictures be insured for £2 million.

Leonard Plugge had been a Conservative Member of Parliament and was the first person to broadcast commercial radio to Britain. He started IBC, the International Broadcasting Corporation, in 1931 and transmitted his English language Radio Normandy to Britain every evening. It is thought that he had 80 per cent of the radio listeners on Sundays when the BBC broadcast nothing but religious programming. He explored every potential source of income, and in addition to paid advertising he was happy to receive money in order to promote a record by putting it on his playlist. The term 'plugging' a record comes from Leonard Plugge's early exercise in payola. He went to the opera every night wearing an ermine coat and usually had a beautiful girl on each arm even though he was constantly pursued by creditors. Plugge had two daughters, twins, one of whom, 27-year-old Gale Benson, was later murdered by Michael de Freitas – Michael X – in the Caribbean.

The house was looked after by a caretaker who carried a Luger and was accompanied everywhere by a lice-ridden mongrel. One of the first things to do was fumigate the caretaker's room. The pictures were then wrapped in blankets and stored in the caretaker's flat.[2] One of the many complications during filming was a telephone call to Cammell from the police to say that the Plugge Collection had disappeared. He first thought it was one of the gangsters having a joke, probably David Litvinoff, but it was true. Then the crew remembered that the caretaker had recently bought himself a new car and no-one had seen him for a few days. He was on the run for two weeks before being captured at Paddington Station. He had the nerve to ask Cammell to stand bail, which he absolutely refused to do. The man had sold the paintings at auction, where they had realized a mere £3,800 as they were all copies or fakes. The next problem came from a neighbour who brought an injunction against Plugge for lowering the tone of the neighbourhood by bringing in a film company. In court it then turned out that Plugge had double-mortgaged the house and had no right to rent to a film company. He had only eighteen months left on his lease and the Sun Life Insurance Company were delighted to have an excuse to terminate it. Plugge agreed to give up the remainder of the lease and the film company was allowed to continue its work.

Neither Nicolas Roeg nor Donald Cammell had directed a film before, Sandy Lieberson had never before produced a film, Jagger had not acted in one, and neither had Michèle Breton, except for a television series in France

the previous year, and most of the gangsters were being played by real gangsters, just as the charlady's little girl, Lorraine, who runs errands, was really a little girl (Laraine) who ran errands for Cammell in Chelsea.

The sets were designed by Christopher Gibbs, assisted by Cammell's girlfriend, the American model Deborah Dixon. Christopher simply reproduced the style he had given Mick and Marianne for their Cheyne Walk house and Brian Jones for Courtfield Road: the walls were dark red and partly hung with antique tapestries; there was an incredibly elaborate Moroccan bed – which Anita later bought for her and Keith – next to which stood an antique wooden rocking horse, a mosaic table supporting a pair of heavy gold candlesticks, a pink conch shell and a packet of Rizla cigarette rolling papers. The oriental carpets were scattered with cushions. In the marble fireplace stood a pair of lion shaped firedogs.[3] The housekeeper in the film was named Mrs Gibbs, as an acknowledgement to Christopher.

Performance has a multitude of influences, from Joseph Losey's *The Servant* (1963), which had first made James Fox a star, to John Boorman's *Point Blank*, which Cammell insisted the whole cast and crew went to see. He claimed film-maker Kenneth Anger as 'The major influence at the time I made *Performance*', much of which is 'directly attributable to him'. The final edit was based to an extent on the random cutting in Antony Balch and William Burroughs's film *Cut Ups*; Cammell went to see Balch to ask how it was done. Although credited entirely to Cammell, the screenplay of *Performance* was written while they were sitting on the beach at Saint-Tropez by Cammell, Deborah Roberts and Anita Pallenberg. (At one point a gust of wind blew the whole script into the sea and Anita had to iron each page to dry them out.) Collaboration was a strong part of the sixties ethos and it was Cammell's favoured method of working; it was a way of avoiding his self-destructive tendency to sabotage whatever he was doing. Turner's domestic arrangement in the film, living with two women, was taken directly from Donald Cammell's own situation.

Michèle Breton had been part of Donald's ménage in Paris, where he, Michèle and Deborah Dixon lived together. Anita Pallenberg, who played the other woman, had only a couple of years earlier had an affair with Donald and Deborah which, Cammell said, was still ongoing when *Performance* was made. According to Marianne Faithfull: 'That was Donald's thing. Threesomes.'[4] Cammell described Michèle Breton as being a 'great sexual catalyst in the film'. He said she was very beautiful, very intelligent but with no education at all. He said she worked very well with James Fox. 'She was about fourteen when Deborah and I met her and then we took her back to

Paris and she was already destined for a bad end.'[5] At the time of filming she was seventeen, and Cammell had to lie about her age.

To make life on the set even more complicated, both Cammell and the producer Sandy Lieberson hinted in interviews that James Fox and Jagger were having some sort of affair. Lieberson would only say they had 'an intense personal relationship. Everyone on the set knew each other. They were all, er, intimate friends.'[6] Cammell told Carey Schofield: 'It was a joy to watch.' Then, during one ten-minute break three days into filming Jagger's scenes, everyone returned to their dressing rooms and James Fox was shocked to find Mick and Anita having sex in Mick's room.[7] Fox knew that Anita was Marianne's best friend and that Marianne was pregnant with Mick's child, and that Keith Richards, who was supposed to co-write the film's theme song with Jagger, was obsessively in love with Anita.

Marianne had been considered for a role in the film, but as she was pregnant it was felt that to be involved with the problems and excitement of film-making would have been too much stress for her, so she was packed off to a 100-guineas-a-week mansion in Tuam, outside Galway in the Republic of Ireland, rented from Molly Cusack-Smith, the Master of the Galway Blazers. Anita Pallenberg was also pregnant, but she had an abortion and showed up on set the very next day according to Christopher Andersen. To heighten the tension between Jagger and Fox, Roeg had initially wanted them to move into the house on Lowndes Square where the film was shot, but as they already had a complicated relationship it wasn't necessary.

Jagger was concerned about becoming an actor; he had no training and knew that a great deal was expected of him. His task was not made easier by the fact that Roeg and Cammell were working from an outline, not an actual script. Roeg: 'It was very organic, growing out of the relationships between the characters as we went along. You couldn't do that today.'[8] Roeg and Cammell encouraged Jagger to take the androgynous, bisexual character as far as he could. They persuaded him to wear a body stocking, frilly blouses and make-up: lipstick and blue eyeshadow. Roeg: 'Mick would resist at first but eventually he'd come around.'[9] The directors told him not to try to act at all but just be himself, but Marianne Faithful knew better:

> I suggested Mick start forming his character based on Brian [Jones], but to dye his hair. His hair should be a very strong, definite colour. To do Turner as a blond would have been too much. In the end he died it black, very black, a Chinese black, like Elvis's hair. Brilliant, straight away it gave him a strong

graphic outline. His tights and costumes gave him a tinge of menace, a slight hint of Richard III.[10]

As soon as rehearsals began it became obvious that this characterization was too simplistic so Marianne proposed adding some of Keith's strength and cool to the mix: 'You've got to imagine you're poor, freaked-out, deluded, androgynous, druggie Brian, but you also need a bit of Keith's tough, self-destructive, beautiful lawlessness.'[11] She said: 'You simply can't play yourself because that would be a disaster.'[12] It was a character that Jagger adopted so completely that it stayed with him for years to come. In her autobiography Marianne wrote: 'He did his job well, so well in fact he became this hybrid character, and never left it. What I hadn't anticipated was that Mick, by playing Brian and Keith, would be playing two people who were extremely attractive to Anita and who were in turn obsessed with her.'[13]

Jagger expected some antagonism from the film crew, who he rightly assumed were expecting a rock 'n' roll prima donna. He listened carefully to Cammell and worked hard at his rehearsals with Jimmy Fox, never objecting to the endless retakes and repeats which were usually caused by technical problems: someone was out of frame, the set looked wrong, the lighting cast the wrong shadows and so on. Jagger always knew his lines – singers have to memorize hundreds of lines of song lyrics – and knew where he was supposed to be on the set – again he was used to this onstage, where his movements would be co-ordinated with the lighting cues. One day the head cameraman, Mike Molloy, asked one of the grips to hammer small 'termites' into the floor, small wooden pegs to indicate where he should be in a complicated shot. This meant that he could feel his position with his toes rather than have to look for chalk marks on the floor. 'I don't need those fucking things,' Jagger told him, and he didn't. He went through the scene without a hitch. The film was, unusually, shot in the sequence it would be shown, which enabled the directors to exploit the growing relationship between the two principals. His first shot therefore was of him hidden behind a screen, telling Jimmy that there was no room for him in the house. Cammell cleverly reversed the class backgrounds of the two male actors: making Jagger the aristocratic, cultured one and James Fox the working-class hoodlum. Cammell wanted a real tension between them and encouraged Fox to delve deep into the character.

Donald Cammell's childhood friend David Litvinoff was hired to educate James Fox into the character of the gangster. Litvinoff was a wild character

who had been on the scene since the forties. George Melly met him then at Cy Laurie's jazz club in Soho:

> the fastest talker I ever met, full of outrageous stories, at least half of which turn out to be true, a dandy of squalor, a face either beautiful or ugly, I could never decide which, but certainly one hundred percent Jewish, a self-propelled catalyst who didn't mind getting hurt as long as he made something happen, a sacred monster, first class.[14]

In *Owning Up* he told the story of one of his encounters with Litvinoff. The night before Melly got married, he gave a lecture at the ICA on Dover Street on the subject of 'Erotic Imagery in the Blues,' after which he was to catch the midnight express to Edinburgh from King's Cross. Melly had prepared a serious talk, intending to play records under various headings, including 'The Machine as a Sexual Image', 'Animal Symbolism in Erotic Blues,' 'Sexual Metaphors in Rural and Urban Blues' and so on. The meeting was chaired by Charles Fox and Vic Bellerby, both respected jazz critics, and Melly was a little nervous. Mick Mulligan handed him a glass of water, which he swallowed straight down. It contained four neat gins. When the introductions were over, David Litvinoff stood up in the audience to question the chair: 'Is it permitted for the audience to wank during the recital?'[15] Half the audience froze in silent disapproval, the other half shrieked with laughter. Mulligan continued to feed Melly gins and though he stuck resolutely to his text, at least in the early part, he very soon began to enthusiastically sing along with the records. When Ian Christie criticized a Bessie Smith record, Melly objected and threatened to throw him down the stairs. After the interval things degenerated completely, Melly delivered an attack on the ICA, calling it the 'Institute of Contemporary Arseholes', Litvinoff sang a song of his own composition and a Dubuffet sculpture was destroyed in the struggle between ICA staff and Melly's wedding party. Somehow he was put on the train and the porter bribed to look after him.[16]

Mim Scala remembered: 'What Litvinoff liked best was little boys, particularly naughty, run-away borstal boys.'[17] He was physically ugly, with a prematurely bald head that he attempted to disguise by greasing a few hairs from the back of his head up over the top. He had a huge nose and thin lips, but his most distinguishing feature was a pair of razor scars which extended his mouth out into his cheeks; ugly cuts given to him by the Kray twins for being a big mouth. They sent a couple of their enforcers over to his flat in Kensington High Street and they stripped him naked, tied him to a kitchen chair and razored the corners of his mouth to let everyone know he was a

snitch. Then they hung him, still naked and tied to the chair, out of his third-floor window, where he dangled all night, terrified, dripping blood on to the pavement.[18]

James Fox prepared himself for the role by cutting his fashionably long sixties hair, buying his suits from a Jewish tailor much favoured by gangsters, near Waterloo Station, and immersing himself for three months in the world of London gangsters. Litvinoff introduced him to boxing promoter Johnny Shannon and asked him to show him the ropes. Fox moved into a small flat over a pub owned by Shannon in the Commercial Road in the East End. In a brilliant piece of casting, Johnny Shannon was then recruited to be Harry Flowers. Three times a week Fox trained with the locals in the gym above the Thomas À Beckett pub over the river on the Old Kent Road. He seemed to become the sadistic gangster so completely that when he made an unscheduled visit to the office of Sandy Lieberson, the film's co-producer, Lieberson's secretary was terrified of him. Even Shannon became concerned at Fox's obsessive quest for the authentic character and telephoned to tell Cammell he thought James was over-identifying with the locals: the previous day Fox had gone along on a heist, climbing over rooftops with a gang, to more fully understand his character's feelings. To have the film put at risk by Fox being arrested was not what Cammell needed, and he tried to stem Fox's enthusiasm, but not until after he had introduced him to Johnny Bindon, a huge man, frightening because of his size, whom Cammell described as 'very highly strung, a real psychopath of the greatest kind... very excitable'. Just the person to play Moody.

John Bindon earned himself quite a reputation as a television and film actor, nearly always playing the hard man, and he simultaneously had his own patch around Fulham and Chelsea, where he ran a protection racket covering about 200 pubs. He was his own enforcer and anyone who didn't pay up could expect a dislocated jaw. He performed the same function, on request, for the Kray brothers, who sometimes helped him out. There was a fascination with London gangsters among the new media and pop stars – he was very close friends with Bob Hoskins as well as Angela Bowie, who described him as 'the instigator of a fair amount of spontaneous sex. I'd use the more familiar "casual sex" in this context, but to me the term has always seemed inappropriate for any activity as wild, strenuous and mind-blowing as the kind of sex I'm familiar with.'[19] Even royalty was not immune. In 1975, Princess Margaret invited Bindon to Mustique, where, by royal command, he demonstrated his ability to hang five empty half-pint beer mugs from his erect penis (Angie Bowie says three pint mugs). Margaret's lady-in-waiting

summoned him to one side and murmured: 'My lady knows of your advantage in life and would like to see it.' Followed by Lady Tennant, they walked about twenty yards down the beach where, in full view of the lunch party, Bindon unzipped and, according to his biographer, Wensley Clarkson, 'she examined it rather like a fossil.'[20]

'I've seen bigger,' said Lady Tennant.[21] This display, which shocked the luncheon party, was designed to cover up the fact that Bindon and Margaret had been having sex for months. They had met on a previous visit to Mustique and in between times the princess had sent a limousine to transport him to Kensington Palace. When it looked like she was seeing rather too much of him, Special Branch sent four of their heavies over to put the frighteners on him and this normally very hard man admitted that he was 'well worried'.[22] He only ever mentioned the affair with the princess to a few close friends, certainly not the press. At one point the Palace issued a statement saying that Margaret had never met him, which resulted in red faces when a photograph of the two of them sitting next to each other in Mustique – Bindon wearing a T-shirt with 'Cocaine' written on it in Coca-Cola lettering – appeared in the tabloids.

Aside from his being a violent psychopath who enjoyed nothing better than putting complete strangers in hospital, his exhibitionism was another reason to avoid his company. He liked to flash his cock, widely reported as being a foot long, flopping it into people's pockets, into their beer, and on at least one occasion, among the uncooked frankfurters at a picnic. It was his performance in Ken Loach's *Poor Cow* that launched his career and *Performance* that consolidated it. He was twenty-four years old when he did *Poor Cow* and had spent seven of them in jail, usually for acts of violence. On the set of *Performance* he even managed to shake up the normally implacable Mick Jagger. Jagger went for a night on the town with Bindon, who, as per normal, got into a drunken fight. The next morning Jagger looked ashen and Bindon, always good for a laugh, shook a matchbox in his face and chuckled. It contained the last knuckle of someone's finger. 'They wanted me to give it back so they could have it sewn back on,' he said, 'but I ain't gonna.'[23] Jagger should have known what to expect. When Keith Richards was busted at Redlands and Jagger was arrested for possession of four amphetamine tablets, it was his friend David Litvinoff who decided to track down the man paid by the *News of the World* to set them up for a bust. When they decided Nicky Cramer was the guilty party it is said that Litvinoff and Bindon paid him a visit and administered a beating. According to one of Bindon's friends interviewed by his biographer, Wensley Clarkson: 'John [Bindon] said Jagger

was a little freaked out when he heard what had happened', particularly as Cramer was entirely innocent.[24] A few years later Bindon got himself into serious trouble over a knife fight in a night club in which he stabbed Johnny Darke to death, almost decapitating him in what was reportedly a commissioned hit.[25]

With a cast of characters who were, for the most part, playing themselves – Jagger really was a rock star, the gangsters, except James Fox, were real, there were real drug addicts and a real seductress – filming began on 22 July 1968. In order to give greater authenticity to the drug scenes Jagger and Fox smoked DMT in their dressing room, which only made their relationship more tempestuous. Cammell loved it. The more Jagger got into the role of Turner, the more arrogant, mocking and contemptuous he became of James Fox. Describing the role of Turner, Jagger said later: 'He's completely immersed in himself, he's a horrible person really.'[26] Donald Cammell told Carey Schofield: 'Mick was constantly trying to do James Fox in, because that's the only way Mick can operate.' The relationship between Jagger and Fox grew very tense; Jagger was continually rude and dismissive of the actor so that if Fox wanted to do a scene again he would have to plead with Jagger, usually ineffectually. Jagger would simply sneer 'Fuck off, Jimmy' and slam his dressing room door in Fox's face. Jagger:

> It isn't me really. You just get into the part – that's acting isn't it? You just get into the feeling of that person and I got into feeling like that... After a while you really get into thinking like that and driving everyone crazy. I drove everyone a bit crazy, I think, during that time. It was all taken for granted that I would do anything![27]

By shooting the film in the correct sequence of scenes, Cammell was able to change the script as he went along. In fact, halfway through the film he was still not sure how it would end. He rewrote the script every night, based on what had happened in front of the cameras that day and what he thought they might do next. This made life very difficult for both actors. Fox, as a trained actor, stuck word for word to the script, finding ways to make it his own. It was incredibly hard for Fox to work like this; he was going through a tremendous change of identity. He was also under pressure from his agent, his father Robin Fox, who didn't think it was right that he should be dressing up in wigs and makeup. James did not want to argue with his father about it because his father was ill with cancer at the time and in fact died shortly after the film was made.

Jagger had no preconceived ideas about acting or how a film set should be and treated it a bit like a rock performance, preening himself, sometimes improvising wonderful lines. Jagger:

> You had to know what you were doing before you got on camera, it wasn't just a question of improvising for hours and hours. We had to work it all out before otherwise you just got in a mess. We'd suddenly stop shooting one day because I'd say I wasn't going to say those lines. There were all kinds of situations like that and the regular technicians would go 'Blimey! I've never seen anything like it!' and all that. Donald's whole thing is casting people for what they are and how they fit into the part, to make them work out and create the part, to work on things that were already in their own minds.[28]

There were several sex scenes involving Jagger, Pallenberg and Breton. Stills from the bathtub threesome are the most reproduced but Jagger didn't think the scene was particularly convincing:

> I don't think there's many people like that individual. I found his intellectual posturing very ridiculous – that's what sort of fucked him up. Too much intellectual posturing in the bath when you're with two women is not a good thing; that's not to be taken too seriously! It made me skin go all funny.

The most authentic was the bed scene, filmed as soon as Anita arrived on set, which begins with Anita sticking her tongue up Mick's nose and continuing with him, Anita and Michèle Breton having a threesome. There has been much teasing debate about whether it was the real thing or not, but as it took seven days to shoot, it is obviously mostly simulated even if Jagger and Anita did sometimes get carried away. Much of it was filmed under the sheets, with the light filtered through a blanket, giving a warm sensual light. As the Stones' pianist and roadie Ian Stewart saw it, it was real enough. He told Victor Bockris: 'When the big sex scene of the movie was filmed, instead of simulating sex, they really got into each other... There was a lot of very explicit footage of Mick and Anita really screwing, steamy, lusty stuff.'[29]

Though *Performance* itself won no awards, ten minutes of out-takes from the scene called *Performance Trims*, mostly close-ups of Jagger's cock and various parts of Anita's anatomy, won the Hung Jury Award at the 1970 Wet Dreams Festival in Amsterdam. This was not stolen footage; it was given to them by Sandy Lieberson. *Performance Trims* went on to win the Golden Phallus Award at a Frankfurt porn festival. When Keith got hold of a copy he was very angry and for a while things were strained between him and Mick, and of course things were pretty rough with Anita.[30]

A female lab technician was so shocked by the graphic sex in the footage that she complained to her boss. He telephoned Nic Roeg in the middle of the night, saying that it was illegal and he would have to destroy it. Roeg managed to hold him off until he could get there. The lab's director was convinced that the material was pornographic and that he could go to jail for printing it. Roeg tried unsuccessfully to talk him out of destroying the print, but he was adamant and Roeg had to watch as he cut it up.[31] Fortunately Roeg was able to rescue the negative and have the film printed at a less puritan lab.

Anita Pallenberg and Keith Richards were living in Robert Fraser's flat on Mount Street, for which they were paying him a huge amount of money. Fraser, recently released from Wormwood Scrubs after his heroin conviction, was supposed to be looking for a new flat. But Robert didn't move out. He was enjoying the scene surrounding the film so much. Keith had tried his best to prevent Anita from being in it, offering to pay her whatever her fee would be, but she insisted. Keith was so jealous of Jagger, and what he knew must be going on, that he refused to visit the set. Keith knew that if he went to the set there would be a head-on confrontation with Mick, which would have destroyed the Stones and everything he cared about. Instead he parked his blue Bentley, known as the Blue Lena, outside in Lowndes Square each day, and fumed. Robert Fraser acted as his spy, running in and out with messages to Anita, plotting and spreading stories, but eventually Cammell banned Robert from the set because his scheming was becoming too disruptive.

The flat was filled with tension and, encouraged by Fraser, who had begun to use heroin once again, Keith began to use it regularly for the first time. Fraser: 'Basically smack's a pain killer. It de-inhibits you, desensitizes you and your paranoia. Keith and I are probably pretty paranoid people.'[32] Many people think that Keith began using smack to control his jealousy and insecurity caused by Anita and Mick's affair. Keith was supposed to be writing a song for the film with Mick but now he refused to finish it. Consumed by jealousy, he submerged himself in his work, writing much of the Stones' next album, the brilliant *Beggar's Banquet*.

With the film's main song, 'Memo from Turner', held up, Cammell and Roeg took Mick to a pub in Berwick Street and insisted that he sort things out and somehow mend his relationship with Keith. Mick's reaction was to break down in tears at the bar. 'I'm sorry,' he told them. 'I blew it.' Some of Mick's friends thought that he was secretly in love with Keith and the tensions that had arisen between him and his writing partner were more than just jealousy on Keith's part over Anita's fling with Mick. According to Marianne Faithfull, Anita didn't help because she knew that the two men were more important to

each other than she could ever be so she concentrated on stirring up trouble between them. Anita, for her part, has always denied that anything ever happened between her and Mick.

Mick called in Jim Capaldi and Steve Winwood from Traffic and after a few days of sessions at Olympic Studios they had completed the track and delivered it to Jack Nitzsche, the musical director. Though the Beatles' films to accompany 'Strawberry Fields', 'Penny Lane' (January 1967), directed by Peter Goldmann, and the earlier 'Paperback Writer' and 'Rain' (May 1966), directed by Michael Lindsay-Hogg, are obviously earlier, the film sequence that goes with 'Memo from Turner' must be regarded as ground-breaking, leading the way to music videos in its brilliant integration of music and imagery.

Warner Bros held a private screening for studio executives and their families just before Thanksgiving for what they still thought was a Rolling Stones equivalent of a Beatles romp. Shortly after the film began, several uptight mothers ushered their complaining teenage sons and daughters from the cinema, and one of the women was so upset at the sex scene that she threw up on a vice-president's shoulder. One of the things that really concerned them was whether Michèle Breton was a boy or a girl as she was so flat-chested. Warner Bros hated it; they hated the lack of conventional morals and the casual sex, the drugs, the violence and the tone of the picture and refused absolutely to release it unless it was recut in a very different way. Jagger and Cammell telegrammed Warners:

> Re: Performance: This film is about the perverted love affair between Homo Sapiens and Lady Violence. In common with its subject, it is necessarily horrifying, paradoxical and absurd. To make such a film means accepting that the subject is loaded with every taboo in the book. You seem to want to emasculate (1) the most savage and (2) the most affectionate scenes in our movie. If Performance does not upset audiences then it is nothing. If this fact upsets you, the alternative is to sell it fast and no more bullshit. Your misguided censorship will ultimately diminish said audiences both in quality and quantity.[33]

Most of all, Warners wanted to make money. They wanted more of Jagger and they wanted him to appear in the picture early on instead of halfway through. Donald Cammell found an unused scene of Jagger spray-painting a wall and stuck that in at the beginning to try to pacify them. Cammell also took trim footage, some of it featuring Jagger, and edited it randomly, using the Burroughs cut-up technique, and spliced it in at the beginning. William Burroughs is continually referenced and casts his presence over this film:

Jagger uses the title of his novel *The Soft Machine* in his song 'Memo from Turner'; when Mick and Anita find how badly injured James Fox is, Anita suggests they call 'Dr Burroughs to give him a shot'; Hasan-I-Sabbah's maxim, 'Nothing is true, everything is permitted', is used in numerous Burroughs texts, beginning with *Minutes to Go* (1960), and is quoted in the film along with the story of the Old Man of the Mountain himself.

The other major literary reference is Jorge Luis Borges, whose book *A Personal Anthology*, published in March 1968 and already a cult classic in 'hip' circles, is read from aloud by Jagger. Other contemporary markers include Martin Sharp's poster of an altered collage by Max Ernst and Bill Butler's Dylan silhouette poster. The film is filled with references and in-jokes, for instance Jagger's 'Memo from Turner' emerges from a tape deck supplied by the Muzak Corporation of America, the makers of elevator music.

Warner Bros finally released it in the UK on 1 January 1971, two years late, with the X rating normally reserved for soft porn and horror and a category that many newspapers refused to even review. *Performance* was made at great personal cost: Marianne Faithfull suffered a miscarriage and shortly after attempted suicide in Sydney; Keith Richards got addicted to heroin and remained on it for a decade with adverse effects on the Rolling Stones' music; Anita Pallenberg became a heroin addict; James Fox had a nervous breakdown, retired from films, and joined an obscure born-again Christian sect called 'The Navigators'; after the film was finished Cammell drove Michèle Breton to Paris and abandoned her after three days with a drug habit and no money. She now lives in Berlin. Cammell did not make another film for three years and eventually killed himself in Hollywood.

> It's important to analyse horror imagery; to confront and
> come to terms with the darkest recesses of 'human nature,'
> if there is such a thing.
>
> J. G. BALLARD

London in the sixties saw a breakthrough in literature, with authors challenging almost every aspect of what a piece of writing was. Foremost among them was J. G. Ballard, who believed that an entirely new writing was required to deal with the modern industrial world. He wrote in his 1974 introduction to the French edition of *Crash*:

> Primarily, I wanted to write a fiction about the present day. To do this in the context of the late 1950s, in a world where the call sign of Sputnik 1 could be heard on one's radio like the advance beacon of a new universe, required completely different techniques from those available to the 19th century novelists... Science and technology multiply around us. To an increasing extent they dictate the languages in which we speak and think. Either we use those languages, or we remain mute.[1]

Ballard's principal vehicle was *New Worlds* magazine, which became one of the most important sources of new writing. Published in London, *New Worlds* began as a science fiction magazine in July 1946 under the editorship of E. J. Carnell. The board meetings took place every Thursday evening in the White Horse Tavern in Fetter Lane, off Fleet Street. Carnell bought the title in 1948 and he and five associates set up Nova Publications to publish it. Carnell and his five other directors continued to hold editorial meetings in the private bar of the White Horse, while the fans and other interested parties met in the crowded saloon bar, hoping to waylay one of the directors after they had concluded business.[2] Michael Moorcock became editor in May 1964 at issue 142 and in October 1968, after a protracted period of financial

problems, Moorcock took over the magazine and published it himself. Ballard became the fiction editor.

Doris Lessing remembered being taken to the White Horse and described it in volume two of her memoirs:

> There was a room full of bespectacled lean men who turned as one to look warily at me – a *masculine* atmosphere… This was a clan, a group, a family, but without women… What they were was defensive: this was because they had been so thoroughly rejected by the literary world. They had the facetiousness, the jokiness of their defensiveness… My disappointment with what I thought of as a dull group of people, suburban, provincial, was my fault. In that prosaic room, in that very ordinary pub, was going on the most advanced thinking in this country.[3]

She points out that the Astronomer Royal had said it was ridiculous to think that we would ever send men to the moon whereas these people were talking about rocket science, satellite communications systems and space exploration.

The tradition of regular surgeries with the readers continued under Moorcock's editorship, only with a change of venue. On the first Thursday of each month a group of grumpy disillusioned readers would gather at the Globe in Holborn and tell Moorcock how terrible the new writing was (Ballard, Brian W. Aldiss, John Sladek, Thomas Disch and Norman Spinrad; the 'new wave' in science fiction), often causing him to get drunk and abuse them. Moorcock dropped 'Science Fiction' from the magazine's title.

It was Moorcock who created the most enduring underground character in modern fiction: Jerry Cornelius, who was to star in *The Final Programme* (1969), *A Cure for Cancer* (1971), *The English Assassin* (1972) and *The Condition of Muzak*, and four subsequent titles as well as becoming the hero of stories by Aldiss, Spinrad, James Sallis, M. John Harrison and others. Moorcock and his character became both an inspiration to other writers and a profound influence on the Notting Hill underground rock 'n' roll scene. Michael Moorcock:

> Jerry Cornelius began as a version of Elric of Melniboné, when, in late 1964, I was casting around for a means of dealing with what I regarded as the 'hot' subject matter of my own time – stuff associated with scientific advance, social change, the mythology of the mid-twentieth century. Since Elric was a 'myth' character I decided to try and write his first stories in twentieth century terms.[4]

He wrote the first draft of *The Final Programme* in ten days in January 1965. For the narrative he rewrote his first two Elric stories, 'The Dreaming City' and 'While the Gods Laugh', but stylistically it was very different: 'I borrowed as much from the Hammett school of thriller fiction as I borrowed from SF and I think I found my own "voice" as a writer.'

Jerry is a long-haired, underground James Bond, knowledgeable about weapons and fast cars, constantly travelling to exotic places, a jack-the-lad who moves among spies and 'dolly birds', a cockney chancer with a bit of Ronnie Kray thrown in, whose mother still lives in squalor in Ladbroke Grove. Neil Spencer reviewing the *Condition of Muzak*, described him as 'beautiful, ageless, bisexual, multi-talented, murderous, drug-sodden, an eternal adolescent who is privy to the secrets of time-travel and semi-immortality'.[5] *The Adventures of Jerry Cornelius*, a cartoon strip drawn by Moorcock's friend Mal Dean, appeared in *IT* (Cornelius looked remarkably like Mal Dean in the drawings). After Moorcock had first introduced the character in *IT* 58[6] he let his character roam free for months with the words written by friends of Moorcock such as M. John Harrison and Richard Glyn Jones. But before Moorcock hit his stride with Cornelius, his colleague Jim Ballard had been exploring a landscape largely unknown to writers.

In the early sixties Ballard began investigating a new terrain: he marked out the desolate semi-industrial suburbs for his own. He became a psycho-geographer of the deserted industrial estate, the slip roads leading to the motorway, the cracked concrete and overgrown runways of wartime Battle of Britain aerodromes, the between-wars stucco villas, front gardens seized in road-widening schemes, now just metres from the busy expressway, decaying warehouses, empty car parks, the bleak rainswept vistas of the roads around Heathrow airport. He lived in Shepperton, in the middle of such a landscape, but the imagery had been with him since his childhood in Shanghai. He told Charles Platt a childhood memory of visiting his best friend, a little boy called Patrick Mulvaney who lived in an apartment block in the French concession:

> I remember going there and suddenly finding that the building was totally empty, and wandering round all those empty flats with the furniture still in place, total silence, just the odd window swinging in the wind... it's difficult to identify exactly the impact of that kind of thing. I mean, all those drained swimming pools that I write about in my fiction were there.[7]

They had all left, presumably to escape from the Japanese. He was not so lucky and lived in an internment camp throughout the war, arriving in

Britain in 1946 at the age of sixteen, to a landscape of bombed buildings over-grown by weeds, shabby houses and a beaten-down, depressed population.

Recognizing that the traditional form of the nineteenth-century novel was no longer relevant, he began to experiment. At one point he became so disillusioned with modern fiction that he told Vale at *RE/Search* maga-zine: 'It's just not necessary to read anybody except William Burroughs and Genet.'[8] His breakthrough came with *The Terminal Beach* in 1964, the memories and unsettling dreams of a bomber pilot, stranded alone on an abandoned Pacific island which had been used to test fire an H-bomb. A series of long panoramic shots and flashbacks marked a new beginning for him. Then the June 1966 issue of *New Worlds* printed the first of what he called his 'condensed novels', 'You:Coma:Marilyn Monroe', where the story was reduced to a series of images, a mood, a landscape made up a collage of advertising, Hollywood and media images, entirely lacking in narrative, character devel-opment or any of the usual elements of fiction writing. Fifteen of these were collected as *The Atrocity Exhibition* (called *Love and Napalm: Export USA* in the States). As a collection they were like a cubist montage, relating subtly to each other, building up a powerful series of disquieting images. Ballard told John Platt:

> It was very much a product of all those dislocations and communication overlays that ran through everything from 1965 to 1970. We've moved from a period of high excitement to low excitement and its very hard for people who are younger to realise just how flat life is today, and how pedestrian are people's concerns.[9]

He published mostly in *New World* and the literary magazine *Ambit*, where he could do anything he liked. With the advent of the underground press, he took advantage of their radical stance on freedom of the press and published 'Why I Want to Fuck Ronald Reagan' in *IT* (reprinted in *Atrocity Exhibition*). When the second-rate actor, Ronald Reagan, became Governor of California in 1967, Ballard had the prescience to realize how significant this was and used his analysis of the influence of Hollywood and the mass media in politics in the USA to accurately predict that Reagan would become a future president of the USA. Thirteen years later Ballard was proved right. Amusingly his text was reprinted as a serious-looking leaflet bearing the official seal of the Republican Party headed 'Official Republican 1980 Presidential Survey' and distributed at the Republican Nominating Convention in 1980, when Reagan was selected as the presidential contender. Situationists were thought to be the guilty party. Even *Newsweek* was concerned by the direction politics was

taking: 'increasingly our politics has become the politics of impersonation... the marketing of sheer illusions... the sitcom politics everyone so enjoys. Cliché that it is by now, it is surely no accident that an accomplished actor sits in the White House.'[10]

Ballard caused further confusion with a series of advertisements he placed in *Ambit*, *New Worlds*, *Ark* – the magazine of the Royal College of Art – and some European alternative magazines. He did the artwork himself, arranged for blocks to be made (the days before offset litho), then delivered the block to the magazine as any commercial advertiser would. They looked just like regular ads, perfectly in place with their surroundings, until you tried to figure out what exactly they were advertising. Ballard:

> Of course I was advertising my own conceptual ideas, but I wanted to do so within the formal circumstances of classic commercial advertising – I wanted ads that would look in place in Vogue, Paris Match, Newsweek, etc. To maintain the integrity of the project I paid the commercial rate for the page, even in the case of Ambit, of which I was, and still am, prose editor.[11]

He would have liked to have placed ads in *Vogue* and *Newsweek*, but the high cost prevented him. An application for a grant from the Arts Council for the purpose was rejected. Several of the ads featured his girlfriend Claire Churchill. One showed a closeup of a photograph of her face by John Blomfield with copy reading:

> HOMAGE TO CLAIRE CHURCHILL, Abraham Zapruder and Ralph Nader. At what point does the plane of intersection of these eyes generate a valid image of the simulated auto-disaster, the alternate deaths of Dealey Plaza and the Mekong Delta. The first of a series advertising (1) Claire Churchill; (2) The angle between two walls; (3) A neuralinterval; (4) The left axillaray fossa of Princess Margaret; (5) The transliterated pudenda of Ralph Nader. A J. G. Ballard Production.[12]

In this way he used the most immediate and sophisticated method of communication of the time to get his message across. He began finding sources outside literature. He took a description of a facelift word for word from a textbook of cosmetic surgery, except that he made it all happen to Princess Margaret instead of the textbook patient. It was published in *New Worlds* 199[13] as 'Princess Margaret's Facelift'. For a piece called 'The Side Effects of Orthonovin G' he used promotional literature sent by a company manufacturing birth control pills to Dr Martin Bax, who as well as being a GP was the editor and publisher of *Ambit* magazine. These consisted of

autobiographical pieces by women who used their product. One was by an American woman, settled in London, and described her efforts to make friends by studying English football. The other was by a woman who lived in a sexually open relationship with her husband: 'We have a very independent and honest relationship with a sexual code that is flexible and permissive.' Ballard used these texts for a reading to the students at the Kingston Polytechnic organized by Martin Bax. Instead of Ballard reading them himself, they were performed by a friend of theirs, a beautiful, tall Trinidadian stripper called Euphoria Bliss. She looked at the first one and decided she would read it dressed in football boots and shorts. After reading the other text she told them: 'I'll read that *naked*.' Bax announced the reading: 'And now Euphoria Bliss is going to read for us J. G. Ballard's "The Side Effects of Orthonovin G".' Euphoria was seated, wearing a big hat and a green coat. She approached the microphone. Martin Bax stood behind her and helped her off with the coat. The students fell into an astonished silence as she read the peculiar found text. Afterwards she sat down, still naked, and asked Ballard and Bax if she had looked good. They agreed that she had.[14]

When Ballard was researching his book *Crash!*, there was one book that provided particular inspiration to him. Jacob Kulowski's *Crash Injuries: The Integrated Medical Aspects of Automobile Injuries and Deaths*, a 1960 American medical textbook filled with gruesome photographs of car crash victims, categorized by car maker, which compared the injuries sustained in a roll-over in a 1953 Pontiac with those sustained in a roll-over in a 1953 Chevrolet (in the days before mandatory seat-belts). Ballard:

> Upon viewing the photographs in Crash Injuries taken immediately after violent car crashes – all one's pity goes out to these tragically mutilated people... But at the same time, one cannot help one's imagination being touched by these people who, if at enormous price, have nonetheless broken through the skin of reality and convention around us... and who have in a sense achieved – become – mythological beings in a way that is only attainable through these brutal and violent acts.

In this way Ballard parallels Andy Warhol's fascination for the victims of everyday violence: the huge canvases in Warhol's *Car Crash* series are a visual counterpoint to Ballard's *Crash!*

Ballard also shares this sensibility with Francis Bacon, who was very influenced by a medical textbook of coloured illustrations of diseases of the mouth. In the case of all three artists, the violent face of everyday life is

revealed more or less without comment. Ballard: 'My fiction really *is* investigative, exploratory, and comes to no moral conclusions whatever. Crash! is a clear case of that; so is Atrocity Exhibition.'[15]

Ballard used the car not only as a sexual image but as a metaphor to stand for humanity's role in present-day society. This gave the book a political meaning in addition to its sexual content but he liked to think that it was the 'first pornographic novel based on technology'. Ballard believed that pornography was the most political form of fiction because its subject matter was manipulation and gender role playing: 'how we lie and exploit each other in the most urgent and ruthless way'.[16] *Crash!* took on a life of its own, being made into a controversial film by David Cronenberg that was seen as so threatening to the stability of British life that the *Daily Mail* launched a campaign to prevent it from being released in Britain. Long before that, Ballard had himself proved how unexpectedly volatile the subject was by exhibiting crashed cars at the New Arts Lab.

The team of people who had resigned from the old Drury Lane Arts Lab remerged in the middle of the summer of 1969 with a brand new Lab (the old one had closed nine months after they left). Called the New Arts Lab, it was the result of heavy politicking and the enthusiasm of a Camden councillor, Christine Stewart Monro. Camden Council gave them a four-storey one-time pharmaceutical warehouse at 1 Robert Street, on the south-west corner of Hampstead Road, on a short-term, rent-free lease. Its official name was the Institute for Research in Art and Technology (IRAT) and had thirteen directors, including Hoppy, Fred Drummond, David Curtis, Pamela Zoline and Biddy Peppin, who was company secretary. The patron was Lord Harlech, with Lord Burgh as sponsor, and among a long list of trustees – or 'trustys', as Hoppy called them – were the artist Joe Tilson, the architectural historian Reyner Banham and J. G. Ballard, who remarked that its open concrete floors were 'the perfect setting for its brutalist happenings and exhibitions, its huge ventilation shafts purpose-built to evacuate the last breath of pot smoke in the event of a drugs raid'.[17]

The ground floor cinema was run by David Curtis and held 100 people and could project both 16mm and 8mm films. Open screenings for filmmakers were held on Tuesdays, the New Cinema Club on Wednesday, London Film-Makers Co-op shows on Thursdays and programmed attractions at weekends. Dave Curtis:

> From 1969 to 1971... we ran three programmes a night seven days a week then and it was a very remarkable programme that we did. It was almost entirely

avant-garde – we did occasional classic features as late night features but apart from that it was simply avant-garde programming without any subsidy at all.[18]

Carla Liss and Malcolm Le Grice ran the London Film-Makers Co-op film distribution office from the New Lab. Sharing the ground floor was the art gallery directed by Biddy Peppin and Pamela Zoline, which was also used for poetry readings, light shows and other events. Victor Herbert donated equipment so that black-and-white film could be developed on the premises. Hoppy, writing in *Friends*, enthused: 'This means that at last the bottom is knocked out of the film processing/censoring price fixing racket.'[19] The Arts Council donated £150 towards a darkroom, which was used by photographers in three four-hour shifts seven days a week at low cost. They had to supply their own paper and chemicals. At Christmas, 1969, a screen-printing department opened where posters could be made. There was also a duplicator for flyers and press releases and Hoppy intended to install an offset litho press.

Roland Miller, later Martin Russell, ran the theatre on the first floor and there was also a rehearsal room that was a good deal cheaper than renting in the West End. The theatre was also used by the Asia Music Centre and Will Spoor, who did mime. Martin Shann, later Bernard Rhodes, ran a plastics workshop, and John and Dianne Lifton ran an electronics and cybernetics workshop. Hoppy had his own TVX video workshop in the lab and by March 1970 had a nucleus of fifteen people in the video co-op. There was a coffee bar serving macrobiotic food, a small bookshop, and a family room at the top of the building where people could meet and talk. It took the team about six months to complete the installation of walls, telephones, heating and electricity, but some departments, like the Art Gallery, opened earlier. Their approach was very different to Jim Haynes's original Lab, which was based very much around his personality and contacts; the New Arts Lab was community-based and saw itself as providing a service to the arts community in a very real way.

From 4 until 28 April 1970, Pamela Zoline arranged for Ballard to exhibit three crashed cars at the New Arts Lab under the heading *New Sculpture*. It was a very easy show to install: the gallery was on the ground floor and the technology for moving cars around is very advanced. He paid for the floor to be painted black and had Charles Symmonds's Motor Crash Repairs deliver three carefully chosen wrecks. There was a crashed Mini Minor, the symbol of the swinging fun-loving sixties, and its antithesis, an Austin Cambridge A60, the solid family saloon sometimes used by the police. The third car was

a 1950s Pontiac from Detroit's mannerist phase which had been in a massive front-end collision.[20] In conversation with Frank Whitford and Eduardo Paolozzi[21] (who had himself made a sculpture called *Crash* in 1964 from a pile of cylinders and pipes), Ballard described the car as being from 'that last grand period of American automobile styling, around the middle 50s. Huge flared tailfins and a maximum of iconographic display.' In the handout accompanying the show, Ballard wrote:

> Each of these sculptures is a memorial to a unique collision between man and his technology. However tragic they are, automobile crashes play very different roles from the ones we assign them. Behind our horror lies an undeniable fascination and excitement, most clearly revealed by the deaths of the famous: Jayne Mansfield and James Dean, Albert Camus and John F. Kennedy. The 20th century has given birth to a vast range of machines – computers, pilotless planes, thermonuclear weapons – where the latent identity of the machine is ambiguous. An understanding of this identity can be found in a study of the automobile, which dominates the vectors of speed, aggression, violence and desire.
>
> In particular, the automobile crash contains a crucial image of the machine as conceptualized psychopathology. Apart from its function of redefining the elements of space and time in terms of our most potent consumer durable, the car crash may be perceived unconsciously as a fertilizing rather than a destructive event – a liberation of sexual energy – meditating the asexuality [sic] of those who have died with an intensity impossible in any other form. In 20th century terms the crucifixion would be enacted as a conceptual car crash.

At the opening there was a strange edgy atmosphere. Ballard had hired a girl to interview people on closed circuit television. He originally intended her to be naked but on seeing the exhibition she would only appear topless. Ballard: 'She saw the sexual connection.'[22] Nonetheless, the members of the audience could see themselves on a TV screen with a topless girl, surrounded by crashed cars; all three powerful sixties icons. Ballard: 'This was clearly too much. I was the only sober person there. Wine was poured over the crashed cars, glasses were broken, the topless girl was nearly raped in the back seat of the Pontiac by some self-aggrandizing character.'[23] He had never seen a hundred people get drunk so quickly. In the weeks that the show was open the cars attracted massive hostility from the public. They were attacked, those windows that weren't already broken were smashed, one of the cars was up-ended, another splashed with white paint. Ballard:

I had speculated in my book [*The Atrocity Exhibition*] about how the people might behave. And in the real show, the guests at the party and the visitors later behaved in pretty much the way I had anticipated. It was not so much an exhibition of sculpture as almost of experimental psychology using the medium of the fine art show. People were unnerved, you see. There was enormous hostility.[24]

The topless model was Jo Stanley, who reported in *Friends*:

On 3rd April he held a private view at the lab in Robert Street – flashing promises and wine and a semi-naked chick (me) in the faces of the establishment media unfreaks – who remained completely undazzled... the scene was really friendlying up all around (like all around my tits, plus a kind offer to fuck me in the foyer (!)). Other people thought they might undress and groove around too but – well – it *was* pretty cold there.[25]

She thought that his £3,000 asking price for the complete installation was outrageous. According to Simon Ford, Ballard later changed his position on *Crash!* and came to recognize that perhaps it was not a cautionary tale after all: '*Crash!* is what it appears to be. It is a psychopathic hymn.'[26]

The public reaction proved to Ballard that his theory was right and that there was a tremendous amount of sexual energy and violence embedded in people's relationship to cars which was released through car crashes. He knew he could use this. He told Iain Sinclair: '"It's the green light, Ballard" I said. "You can get straight down to work." That was when Crash really began: the Lab experiment, the test drive, had proved my point. Had people been bored I might have had different thoughts.'[27] He had been working on *Crash!* since 1970, but now had concrete material to work with. *Crash!* was published in 1973.

Charles Marowitz's Open Space Theatre was tight on funds – its Arts Council grant was a mere £1,500 a year, £32,500 less than the kitchens at Covent Garden received – with one of the problems being that it had no source of income while it was rehearsing a new play. John Trevelyan, the Secretary of the British Board of Film Censors, sought to rectify this by suggesting that it screen Andy Warhol's latest movie, *Flesh*, and introduced Marowitz to its distributor, Jimmy Vaughan, who specialized in avant-garde and underground films. Trevelyan thought they were both interested in exploring the same territory. *Flesh* was actually directed by Paul Morrissey but it emanated from the Factory and had Andy's name on it. It starred Joe Dallesandro as a

male hustler and did surprisingly well, screening three or four times a day, attracting an audience that was, in part, the porn cinema crowd from nearby Soho. Then, on 3 February 1970, just before the film ended, thirty-two police constables accompanied by a superintendent from Scotland Yard rushed in, stopped the film and proceeded to take down the names and addresses of all seventy-five people in the audience. The film, projector, club books, receipts and paperwork were all confiscated in the usual heavy-handed manner.

At the onset of the raid Marowitz had contacted John Trevelyan on the phone and he immediately rushed to the theatre, two blocks away from his office in Soho Square. He told the gathered press: 'I cannot understand why it should be raided. This is a intellectual film for a specialized audience. I have seen it, and though it is not my cup of tea, there is nothing corrupting about it.' Even the press were puzzled why a small Arts Council-subsidized theatre in the West End that specialized in non-commercial, experimental drama should merit a raid by thirty-two policemen. Questions were asked in the House, but the Labour Home Secretary, James Callaghan – (known as 'Jim, the Policemen's Friend' after being a lobbyist for the Police Federation) – said he would support the police whenever they investigated complaints about pornography from the public. This was quite often because of Mary Whitehouse, the right-wing Christian self-appointed guardian of public morality, who complained constantly. She even counted how many times the word 'bloody' occurred in the TV show *Till Death Do Us Part*, in order to complain about it on a weekly basis even though it was the most popular programme on television.

There had been a lot of attacks on art by then, for instance John Lennon's *Bag One* series of lithographs, on exhibition at the London Arts Gallery, had been prosecuted for 'exhibiting indecent material'. This moved the Labour MP for Vauxhall, George Strauss, to ask if the recent seizures were carried out with the Home Secretary's authorization. Callaghan tried to evade the question, saying: 'These are matters for the police, not for me.' Strauss continued his questioning:

Does not the Home Secretary consider it ridiculous that the Metropolitan Police, who are understaffed and overworked with the increasing crime problem on their hands, should send a force of 32 constables to a small experimental theatre which received an Arts Council grant to seize a film suggested to them by the British Board of Film Censors and seize the projector and the screen? Can he give an assurance that this was a regrettable isolated incident

and does not mean that there is to be a campaign to restrict this sort of thing: a repressive, Mrs. Grundy-campaign in London?[28]

This was greeted by cheers from his fellow MPs but Callaghan stuck to his guns in the face of considerable opposition. Jim was a cop at heart. The police did not prosecute and Marowitz, being American and believing in British justice, applied for a High Court writ against the superintendent who conducted the raid to attempt to get back their film, projector, books and paperwork. Within a few weeks *Flesh* was showing again and the attendant publicity meant it played to consistently full houses, solving the Open Space's financial problems. Even Lord Snowdon telephoned to see if a copy of the film could be sent to Kensington Palace.[29]

The Open Space, was also the venue where William Burroughs made one of his rare public appearances when he played President Nixon in David Z. Mairowitz's *Flash Gordon and the Angels* in December 1970. In the play, the comic book character Flash Gordon is brought up to date and made into an astronaut. Mairowitz: 'He's become a send up of Neil Armstrong, and the kind of half human, half robot people that he represents.'[30] Burroughs appears on a monitor in the spaceship and gives a malignant snarling performance as the President, terminating the mission because Gordon's been showing too many human characteristics: 'We think you've been playing with us... you've been running strange... you've let us down... poisoned our trust.'[31] 'Surely no-one could fail to enjoy William S. Burroughs's performance as the 38th president of the US,' enthused the *Financial Times*. Burroughs later told me that he had to have quite a few drinks to 'bring out the ugly American'[32] in him, a fact confirmed by Mairowitz, who was anxious that Burroughs had entered the role so enthusiastically that he might not be able to perform at all.[33]

Burroughs lived in London from 1965 until 1974, but rarely made public appearances unless he was on a mission. After witnessing the police riot at the Chicago Democratic Party Convention in Chicago in 1968, which he covered for *Esquire* magazine, Burroughs became more interested in the practical applications of his cut-up technique:

Deconditioning means the removal of all automatic reactions deriving from past conditioning... all automatic reactions to Queen, Country, Pope, President, Generalissimo, Allah, Christ, Fidel Castro, The Communist Party, the CIA... When automatic reactions are no longer operative you are in a condition to make up your mind. Only the deconditioned would be allowed to vote in any thinking society and no hostess can be asked to put up with the man

who has not been deconditioned there he is on about student anarchy and permissiveness such a bore. Very promising techniques now exist suitable for mass deconditioning and we'll all be less of a bore.[34]

The actual methods used to achieve this deconditioning were the subject of many of Burroughs's articles. He spoke at length about the use of tape recorders as a revolutionary tool:

It's more of a cultural takeover, a way of altering the consciousness of people rather than a way of directly obtaining political control... Simply by the use of tape recorders. As soon as you start recording situations and playing them back on the street you are creating a new reality. When you play back a street recording, people think they're hearing real street sounds and they're not. You're tampering with their actual reality.[35]

He found that by making recordings in or near someone's premises, then playing them back and taking pictures, various sorts of trouble occurred. He immediately set out to exploit his discovery.

'I have frequently observed that this simple operation – making recordings and taking pictures of some location you wish to discommode or destroy, then playing recordings back and taking more pictures – will result in accidents, fires, removals, especially the last. The target moves.'[36] By 1972, Bill decided that his dissatisfaction with the Scientologists merited an attack on their headquarters. Burroughs carried out a tape and photo operation against the Scientology Centre at 37 Fitzroy Street and, sure enough, in a couple of months they moved to 68 Tottenham Court Road. However, subsequent operations carried out there did not work and at the time of writing they still occupy the building. It is possible they erected some form of defence after the inconvenience of their first move.

Encouraged by his initial success at making the Scientologists relocate, he turned his weapons on an easier target: the Moka Bar at 29 Frith Street, Soho; London's first-ever espresso bar. He began the attack on 3 August 1972. The reason for the operation was 'outrageous and unprovoked discourtesy and poisonous cheesecake'. Bill closed in on the Moka Bar, his tape recorder running, his camera snapping away. He stood around outside so the proprietor could see him. 'They are seething in there. The horrible old proprietor, his frizzy-haired wife and slack-jawed son, the snarling counterman. I have them and they know it.'

Bill played the tapes back a number of times outside the Moka Bar and took even more photographs. Their business fell off and they kept shorter

and shorter hours. On 30 October 1972, the Moka Bar closed and the premises were taken over, appropriately, by the Queen's Snack Bar.

Buoyant from the effectiveness of his attack, Bill went on to hypothesize what could be done in a location such as a rock festival:

> You could cause a riot easily. All you have to do is take the tape recorders with riot material already recorded and then record any sort of scuffle that goes on. When you start playing it back, you're going to have more scuffles... a recorded whistle will bring cops, a recorded gunshot when they have their guns out – well – it's as simple as that.[37]

It was once seen as astonishing that Warhol could set up a camera and walk away, letting the machinery get on with the job of making the film: no-one attended the whole of the making of the 8 hour 6 minute *Empire* (1964), and very few bothered to watch it all the way through, including Warhol himself. Now, in modern police state Britain, hundreds of thousands of surveillance cameras, clustered like metallic fruit on lighting poles and purpose-made derricks, continue Warhol's work, recording and storing millions of films that will never be watched by anyone. But do they, as Burroughs suggests, disrupt the time-space continuum? The writers Iain Sinclair and Peter Ackroyd repeatedly stress the danger of disrupting the sacred geometry of the city: the Temple of Mithras rebuilt to the incorrect alignment, London's rivers redirected, Temple Bar leading nowhere, the graveyard of Pancras Old Church – the centre of Blake's Jerusalem – covered by railway tracks, the Roman gateways to the city blocked or diverted, surveillance films flattening reality, draining energy from the built environment, turning Londoners into consumer zombies.

Burroughs was then living at 8 Duke Street, St James's, just down from Piccadilly. He shared his apartment with John Brady, a young Irish Dillyboy to whom he paid £5 a day. The film-maker Antony Balch lived in the same building and they often dined together; in 1972, Brion Gysin also moved in, taking Burroughs's flat while Burroughs moved to a smaller one at the top of the building. Apart from making tea and taking a light lunch of his usual salted biscuits and a glass of milk, both obtained from Fortnum and Mason, his local food shop, Burroughs did not cook. His social life consisted of eating dinner in a restaurant, sometimes alone, but usually with friends: Balch, Gysin, Ian Sommerville, Eric Mottram, sometimes Alexander Trocchi, though he tried to avoid Alex, who was always trying to involve him in various schemes in which Burroughs would do the work and Trocchi get the kudos.

Occasionally Burroughs would venture to the French pub or the Colony to see Francis Bacon, whom he knew from Tangier. Burroughs:

> I met him through Paul Bowles. I saw a lot of Francis in Tangiers, I've seen a lot of him over the years. I was very interested. He's charming and also he's got a lot of very interesting things to say about modern painting. He said so much of it is nothing, it's decoration, it's not painting, and as to what painting actually is, his views were hard to understand but very interesting to hear... He likes mature men.[38]

The sixties was the time of Bacon's second great love affair, which began two years after the death in Tangier of Peter Lacey in 1962. George Dyer was to be the subject of dozens of his paintings. They met in 1964, when Dyer saw John Deakin and Francis Bacon enjoying themselves at the bar and approached them. 'You all seem to be having a good time,' he said. 'Can I buy you a drink?' Dyer was a petty criminal, he had served time, but was a weak, emotional individual, far from the hard man front he hid behind. He had a drink problem and quickly became dependent on Bacon for emotional and financial security. When Bacon suggested they should see each other less often, Dyer reacted by planting cannabis in Bacon's studio and tipping off the police. Bacon didn't take drugs and particularly did not smoke cannabis because of his asthma, but Dyer hid some among Bacon's canvases and telephoned the police. They arrived with two sniffer dogs and quickly found 2.1 grammes wrapped in silver paper in a paintbox beneath a pile of underclothes. This could have been a very costly business for Bacon; if he was convicted then he would not be able to travel to the USA for shows.

Marlborough Gallery engaged one of the best, and most expensive, QCs in the country to defend him. He appeared in Marlborough Street Magistrates Court in October 1970, where it was quickly revealed that Detective Sergeant Carol Bristow had been tipped off by George Dyer, an unreliable witness who had been in borstal and in jail and who, though no longer employed by Bacon, constantly returned to the house and tried to batter the door down. Dyer was described as a handyman and Bacon testified that Dyer was an alcoholic and often made allegations against him when drunk. 'When he is drunk he feels I don't pay him enough. Sometimes he has broken down my front door and broken into my flat. I pay him a regular wage but that doesn't suffice because of his drinking and he comes and asks for more. Sometimes I give him some, sometimes I don't.'[39] On 27 August 1970 he had refused Dyer's demands and so Dyer attempted to find revenge. Bacon told the court he bore no animosity towards Dyer. 'He is a very sick man. I still employ him

and I have kept in contact with him while he was in hospital... Naturally I am relieved this whole business has cleared my name. It has been a great strain.'[40] Judge Leslie still smelled something of a rat, sensing it was homosexual quarrel, and refused to award costs.

Dyer accompanied Bacon to Paris for the opening of Bacon's 1971 retrospective at the Grand Palais by the President of France, Georges Pompidou. Like his Tate retrospective, this celebratory occasion was marred by death. Dyer returned early to their hotel room from the celebration party and committed suicide.

Despite his great wealth, Bacon lived a remarkably simple life: 'People think I live grandly you know, but in fact I live in a dump.' Bacon may well have used Château Pétrus to make sauces – he was an exceptionally good cook – but he spent no money on his accommodation. Number 7 Reece Mews was essentially a bedsitter: a modest kitchen-bathroom with a tub in the corner, a sitting room where the settee was splattered with paint, and a main room used as a studio, which was always in a state which appeared to be total chaos, though Bacon was able find things among the deep piles of discarded paint tubes, torn photographs, clothes, books and magazines. He rarely cleaned his brushes, rubbing them on the wall or wiping them on his dressing gown or on old clothes or socks. He told David Sylvester: 'I throw an awful lot of paint onto things, and I don't know what's going to happen to it... I use anything. I use scrubbing brushes and sweeping brushes... I impregnate rags with colour, and they leave this kind of network of colour across the image. I use them nearly always.'[41] His last boyfriend, John Edwards, would sit in there with him, talking to him while he painted: 'He held his brush like a sword and stood far back from the canvas, like he was fencing with an unseen opponent.'[42] In the winter he would sit in the kitchen with the gas oven door slightly open to warm him while waiting for the bath to fill.

He used old socks and bits of corduroy trousers to achieve certain textures on his canvases and at one point lost a valuable Patek Philippe watch that he had hidden in a sock; it must have been thrown out with the other hardened socks and paint-stiffened corduroy scraps. He loved the small room and always said he could work better there than in any other studio he ever had. He never drank in there while he was painting but would join John Edwards for a glass of wine in the kitchen afterwards.

He left Reece Mews to Edwards when he died in 1992 and, despite Bacon's well-known antipathy towards Ireland, in 1998, Edwards donated the studio and what was left of its contents after numerous beachcombers had rifled

through it to the Hugh Lane Municipal Gallery of Modern Art in Bacon's home town of Dublin. In-depth examination of its detritus revealed a number of sketches and drawings for paintings, something Bacon had always sworn he never did, claiming that each picture was totally spontaneous.

24 The Trial of *Oz*

**The freedom of the press is being forcibly stifled by policemen
who have taken it upon themselves to enforce, not the law,
but their own dismal and hypocritical standards of morality.**

RICHARD NEVILLE

The *Oz*[1] trial which took place in London in 1971 came to symbolize the division in British society between the large sections of the middle class who felt they had the right to impose their bourgeois values on everyone in the country, as symbolized by Mary Whitehouse, and the liberal intelligentsia, who advocated greater freedom for the individual, freedom of speech, sexual freedom and the like. It was accurately described by the *Daily Telegraph* headline: 'Underground versus Establishment Clash'. It was a typically British trial in that it contained a large element of farce: the main subject matter under discussion was a cartoon drawing of a little bear with a very large penis, but the entire court pretended it was something serious under discussion. The trial was also very convenient for the dirty squad, who used it as a smokescreen for not prosecuting the Soho porn barons. The *Oz* trial was the most expensive and the longest obscenity trial ever held in Britain to date. It was also a travesty.

Oz was not an underground newspaper at all: as a monthly it did not appear frequently enough to report underground news, which in any case was done perfectly well by *IT* and later *Friendz* and *Ink*. *Oz* was a full-colour glossy, and as such it nurtured many of the illustrators and young artists who are well known today. Rather than report news, it tended to fuel the debate between the underground and the left, and to discuss in more depth the issues touched on by the underground papers. It also ran an enormous number of articles about sex, which is why it sold so well. *Oz* had a number of themed issues: a gay issue, a feminist issue guest edited by Germaine Greer, a flying saucer issue, an issue devoted entirely to Martin Sharp's graphics, and

so on. It was on this idea of themed issues that the following advertisement appeared in issue 26, their 'Pussy Power' issue of February 1970: 'Some of us at Oz are feeling old and boring. So we invite any of our readers who are under 18 to come and edit the April issue... you will receive no money, except expenses, and you will enjoy almost complete editorial freedom.' As Neville recalled: 'There was the idea that perhaps children were starting to pick up on some of the moods and ideas of the sixties. There was a bit of restlessness in the secondary schools so we thought we would turn an issue over to them.'[2] Some Oz staff members have also suggested that Richard liked the guest-edited issues because it meant less work for himself.

But, as Deyan Sudjic, now director of the Design Museum but then sixteen years old and one of the schoolkid editors, wrote: 'Everybody knows that children are dirty-minded little beasts', and what they produced was enough to give Mary Whitehouse a conniption, that is if she ever saw any of the things she objected to. The magazine contained a cartoon that both ridiculed and sexualized Rupert Bear, that symbol of middle England that had run, a panel a day, in the Daily Express ever since 1920. Virtually every child in England received a Rupert Annual at Christmas. He was a part of the national psyche. To give Rupert a penis was worse than suggesting that the Queen had a sex life. The characters in the Rupert cartoons are anatomically bizarre: the badger, the pug, the bear, are all the same shape as little boys only with animal heads. To paste Rupert's head on to one of Robert Crumb's more extravagantly endowed characters was truly shocking.

On 8 June 1970, Detective Sergeant Fred Luff and his dirty squad boys raided Oz magazine's office at 52 Princedale Road under the Obscene Publications Act, with a simultaneous raid on the premises of Moore-Harness, Oz's distributor. That issue had been very popular, having rather more sexual images than usual, and the police could only find 500 copies of the magazine to seize. They took all the subscription files, correspondence, advertising folders and so on. When it finally came, the charge was 'Conspiracy to produce a magazine containing diverse obscene, lewd, indecent and sexually perverted articles, cartoons, drawings and illustrations with intent thereby to debauch and corrupt the morals of children and young persons within the Realm and to arouse and implant in these minds lustful and perverted desires.' Richard Neville, Felix Dennis, Jim Anderson and their staff began to prepare for an expensive court case.

On 30 October 1970 the three editors appeared in court dressed in short schoolboy trousers and school blazers, carrying satchels and caps. The public gallery found this hilarious; the police were aghast; the officers of the court

studiously ignored their attire. All representatives from the underground press were cleared from the public galleries on the grounds that they didn't possess sufficient credentials, leaving a bunch of tired Fleet Street hacks whose reporting on the case was spectacularly poor. The defendants were granted bail only over police objections. The case was set to open at the Old Bailey the following February, though after several adjournments, it did not in fact get underway until 23 June 1971. The application by the defendants to get the trial moved to the Tower of London was rejected.

In the middle of the morning of 18 December 1970, the phones at *Oz* went suddenly dead. The newly promoted Detective Inspector Luff, as he was now, arrived once more with a mob of dirty squad police, ordered the staff not to leave the building, then left to take a second platoon to raid the offices of *Ink*, the new newspaper that Richard Neville and others intended to publish later that year, but which had not yet hit the streets. The staff of *Ink* were also ordered not to leave the building though they could not possibly have published anything obscene as they hadn't published anything at all yet. Next Luff, accompanied by eight plain-clothes policemen and two police sniffer dogs, raided Richard Neville's flat on Palace Garden Terrace, where they arrested him and Louise Ferrier for cannabis – that was why the dogs were there. They ransacked the flat, removing personal papers and correspondence, back issues of *Oz*, the cassette player on which Richard was recording the raid, and a few sex aids and books, including a copy of *Portnoy's Complaint*. Then he raided Felix Dennis and Jim Anderson, where Luff confiscated the artwork and articles for the next issue. Their tactics were redolent of the Gestapo.

With everyone rounded up, Luff now returned to Princedale Road and yet again removed everything from the *Oz* office, including distribution, advertising and subscription files and more than 4,000 back issues. This was the third set of subscription lists and advertising files they had seized. This time Luff even took the file cabinet itself that they were housed in. It was a good start to the new decade. Luff had carefully timed his raid for the Friday before Christmas. Knowing that the only court open on Saturday would be the West London court of notorious 'mad' Justice Melford Stevenson, the magistrate with the hardest attitude towards drugs in the whole of London. Luff's mean-spirited plan was to get the *Oz* editorial team charged under the Obscene Publications Act and in jail for the Christmas recess for 'continuing to publish obscene materials' even though the first trial had not yet reached the Old Bailey. It did not work; the court overruled the police objections to bail for both Felix and Jim, but Richard was remanded in custody on the pot

charge, even though it was his first offence. Someone managed to scream 'fascist bastard' at the judge before the court was closed and everyone thrown out. The only reason Richard was not in jail for Christmas was that Stevenson was so crazed and prejudiced that he refused to even hear the defence's application for bail and Neville's lawyer was therefore able to contact a sympathetic judge in chambers who released him on bail the following day.[3] Nonetheless Luff managed to spoil many people's Christmas celebrations, which was his intention.

The Metropolitan Police had arrested 2,807 people on drugs charges in 1969, up a third on 1968, so they had a high target to better. Of course, irritating as all this harassment was, it was nothing compared to that experienced by young black people; whereas a hippy might be stopped and searched on the street once every week or so, one Trinidadian friend of mine was stopped seventeen times in one week in Notting Hill and said that was not abnormal.

In 1971 it was still a legal requirement that all jurors had to own property, effectively making them middle class and older than the defendants; none of the *Oz* jury was under forty and many were much older. Judge Argyle was a laughable stereotype of a crusty, old-fashioned, Tory establishment figure, known for his severe sentencing, whose palpable dislike of *Oz*, the defendants, their ideas, their haircuts and everything they stood for would have been hilarious except that he had the power to jail them all for many years; and was obviously determined to do so. The *Oz* Three decided that if the establishment wanted a battle with them, it would be fought on their terms: the pompous bogus respectability of court was shattered by the defendants turning up in bizarre costumes and by calling a number of celebrity defence witnesses who provoked and poked fun. John Mortimer, their barrister, commented: 'The more like a circus it got, the better. If people laugh, your clients are more likely to get off.' While the Friends of Oz cavorted outside with banners and balloons, and organized marches, one of which was led by John Lennon, inside the court was entertained by the comedian Marty Feldman, who spoke so rapidly that the court stenographer couldn't keep up and he had to be tape recorded. 'I don't suppose it matters, but I cannot hear the witness,' complained Judge Argyle. 'Am I speaking loud enough for you now?' Feldman yelled. 'Or am I waking you up', and commented: 'He wasn't listening anyway.'

The funniest witness was George Melly, who was asked by Richard Neville – who was conducting his own defence – to define 'cunnilingus', which the judge was pronouncing as 'cunnilinctus'. 'Gobbling, going down, sucking

off,' said Melly helpfully. 'Or as we used to call it in the Navy, "yodelling in the canyon".' A parade of experts took the stand, but the judge appeared to sleep through them all. At one point, when the address of *Oz*'s printer on Buckingham Palace Road was discussed, Judge Argyle shook himself and complained: 'Can't we leave the Royal Family out of this case?' The trial lasted six weeks, taking twenty-six days in court, the longest obscenity trial ever. There were well-argued statements from reputable witnesses, but the essence of the case remained simple: did the three editors 'conspire to corrupt public morals by publishing something obscene'. It was the definition of 'obscene' that caused the problems and it was here that the judge blatantly misled the jury.

After two and half hours, the jury requested a further definition of 'obscene'. Visibly annoyed, Argyle read aloud from the *Shorter Oxford Dictionary*: 'Repulsive. Filthy. Loathsome. Indecent. Or lewd. Or any one of those things.' What he did not say was the dictionary went on to say that 'Repulsive, filthy and loathsome' were archaic meanings of 'obscene', which left only 'indecent' and 'lewd', but the same dictionary defined 'lewd' as 'indecent', which, as the court had already agreed, was a matter of opinion. Eventually the jury threw out the conspiracy charge but found them guilty on a majority verdict of 10–1 of publishing an obscene article and of sending it through the mail. Argyle decided to hold the three of them in custody pending interviews by the probation office and until full prison medical, psychiatric and social reports had been prepared.

Their barrister, John Mortimer, immediately objected, saying it was inhuman to keep them in suspense before sentencing. But Argyle was inhuman, and must have known that the appeal court would condemn his biased summing up and directions to the jury so that unless they served some time in prison now, they never would. It was for this reason that he also instructed that his directions to the jury should not be tape recorded, only taken down by the court stenographer. This way an appeal would have to wait months before getting a complete court transcript, during which time the defendants would be in jail. It must have given him great satisfaction to know that as soon as they arrived at Wandsworth Prison they were forcibly shorn of their long hair. On 5 August, after they had spent eight nights in jail, Argyle deigned to give his sentences: Richard Neville, fifteen months in prison and recommended for deportation; Jim Anderson, twelve months in prison; Felix Dennis, nine months in prison.

Lord Soper thought the verdict was right but the sentence 'savage'. John Lennon simply called it 'disgusting fascism'. John Trevelyan, the former film

censor, said: 'I think the sentences are much too severe in relation to the offence.' John Braine, former Angry Young Man: 'I don't see why these people should be singled out for this severe treatment.' The National Council for Civil Liberties said: 'The sentences are savage and vindictive.' Kenneth Tynan thought: 'Obviously battle has been joined between Judge Argyle's England and a free England. Mr. Neville and his companions are the first prisoners of war.' Colin MacInnes commented: 'By younger generations the trial will be seen as yet another proof of their elders' mistrust and dislike of them, which they will increasingly reciprocate.'[4] Seventeen Labour MPs tabled a motion in the House.

Up until this point, the public, led by the right-wing tabloids, had been against the defendants but the severity of the sentences, for such a trivial offence, provoked a sea change. Richard Neville:

> I think people on the whole were against us. I mean, we represented long-haired, dope-smoking, anti-establishment wackos, and we were Australians to boot – at least, two of us were. But I think that after the judge sent us to jail before we were actually sentenced and ordered our hair to be cut, this wonderful kind of British sense of fair play came into motion, and, almost overnight, they switched. And, suddenly, from being kind of deadbeat criminals, we became, you know, potential martyrs.[5]

After initially welcoming the sentences, the right-wing press now ran headlines like: 'Fury over Oz Jailings. Angry MPs Join the Wave of Protest' (the *Sun*); 'Storm over Oz Sentences' (*Daily Mail*); 'Fury As Three Editors are Jailed' (*Daily Mirror*); 'Outcry As Oz Editors are Jailed. Labour MPs Attack "Act of Revenge"' (*Daily Telegraph*) – it wouldn't do to be out of step with the public mood. It had also finally dawned on Fleet Street editors that, as Felix Dennis remarked: 'they thought it was us first and them next. If they managed to put us away for publishing a magazine, next it would be the *Guardian*.'[6]

Then, in an almost unprecedented move, after a total of twelve days in prison, the three were released pending appeal. This extremely unusual step was undoubtedly as a result of the huge public outcry at the draconian sentencing. When the case finally reached the Appeal Court, Lord Widgery, Appeal Court Chief Justice, reversed their convictions and dismissed their sentences. Richard's deportation order was also cancelled; the three justices taking less than fifteen minutes to reach a decision. They did uphold the guilty verdict under the Post Office Act for sending 'Obscene and Indecent' material through the mails. On this they suspended the defendants' six-month

jail sentences for two years. Lord Widgery said that the original trial judge, Michael Argyle, had made 'a very substantial and serious misdirection' of the jury by giving them the dictionary meaning of the word 'obscene' rather than the legal one. He also stated that Argyle 'found time far too often to have a dig at the witnesses and to say something derogatory about them...' The £1,000 fine against Oz Ink Ltd was reduced to £100 and their court costs reduced from £1,200 to £50. The appeal hearing lasted three days, the first day of which the defendants wore long wigs, a reference to the days before their hair was forcibly shorn in Wandsworth prison and to the phoney long hair worn by the judges. The decision established a precedent for obscenity in magazines, that the articles must be judged separately but if one of them is obscene, so is the magazine.

Naturally Mary Whitehouse called the Appeal Court decision an 'unmitigated disaster... if the children of this country cannot be protected by the law from this sort of thing, then the law should be tightened up. I am going to get on to the Attorney General about this.'[7] Presumably he binned her letter. Neville and Whitehouse had met ten days before the decision was handed down at a debate on the subject of porn at Cambridge Students Union. Whitehouse was joined onstage by the eccentric Christian moralizer Lord Longford, known to the press as 'Lord Porn', who had his own unofficial commission 'looking into pornography'. Neville's team, which included his solicitor John Mortimer, won by a vote of 442 to 271. Richard used the fame from the trial to write a column for the right-wing *Evening Standard* billed as 'the Alternative Voice of the Standard', along with a disclaimer saying that his views were his own and not theirs.[8] The prisoners of war were released, but the fight would go on. (Crumb's cartoons were prosecuted again in 1996 by HM Customs, who seized a shipment of *Zap* comics – published in the sixties and in print for almost thirty years – and took the distributor, Knockabout Comics, to court. *Zap* was finally passed for sale on 30 January, after a trial, described by the *Guardian* as a 'preposterous obscenity case',[9] which cost Crumb's distributor £6,000 and thousands in lost profits.)

The *Oz* kids were not the only people in court in London for speaking out on love and sex. As they waited for their appeal hearing, the Reverend Father Fuck[10] was defending his religion from uncomprehending magistrates. The Reverend Father Fuck ran the Church of Aphrodite in Tooting and when the straight Christians announced their intention to hold a Festival of Light in Hyde Park, he decided his contribution to the festival would be to bake a sacrificial cake in the shape of a phallus, using half an ounce of pot as one of the ingredients to share with the people. The reverend father wrote:

Some six people took part in the baking of it and three of us took it to Hyde Park in the afternoon. Then I got up on our sacrificial altar and told the crowd of about 100 heads gathered around me that the prick is the symbol of our church because the prick with a lovely pair of balls is the symbol of life and the cross is the symbol of death. The heads were saying 'Let's have the sacrament now.' I thought it was a bit too early so I put it to a vote... some 50 pairs of hands shot up so I said OK.[11]

He broke the glans off the cock and crushed it, scattering the crumbs on the ground as he prayed for peace. Then, after taking some for himself, he distributed the rest among the crowd. 'It just disappeared in ten seconds. Great! Great! Great happiness all round! We joined hands and danced "Ring a Ring of Roses" – great, beautiful, everybody having a great time. A true festival of life.'

However, when the reverend father attempted to erect his sacrificial altar a second time, six police constables moved in and dragged him to a waiting police van. When a passing member of the audience, a psychiatrist, asked why he was being arrested, they bundled her into the van as well. The police refused to book him under the name of the Reverend Father Fuck, occupation, minister of religion, and locked him in the cells over the weekend. At Marlborough Street Magistrates Court he turned his back on the magistrate and addressed the public gallery: 'The prick with a lovely pair of balls is the symbol of life and cannabis is our sacrament...' He was remanded to Brixton prison for a week. On 5 October 1971 he was returned to magistrates court, where he once again addressed the public gallery. 'Do you want to ask anything?' shouted the magistrate.

'You're not fit to sit in judgement over religion, you bloody fool!'

'Case proved,' said the magistrate, fining him five pounds, which they took from the money they had removed from his pockets. The Reverend Father Fuck commented in *Frendz*: 'If it is right to speak in the park, then, when prevented by the police, it is right to continue this speech in court.'[12] Sadly the system always wins.

The London underground press carried on well into the seventies. By 1973, Chris Rowley, *IT*'s business manager, revealed: 'We're in a perpetual state of crisis, always on trial or preparing for a trial. We have to push everything. But then the whole function of the underground is to push.' Each issue cost about a £1,000: £500 printing costs, £50 rental of the IBM typesetter, £50 materials and photographic equipment, £35 a week rent, £25 a week

overheads and seven full-time staff on £15 a week. Advertising brought in about £400 an issue and the rest had to be made up from sales. By producing and distributing themselves, wholesaling, street-selling and store-selling they cut out all the middlemen and the financial equation just about made sense. For a time *IT* was stable financially and was a really effective alternative publication. It was housed in Wardour Mews, a dead end alley in darkest Soho, known locally as Murder Alley. The front door was purple with a large white 'IT' painted on it. The office was down a flight of stone steps into a dark basement with light bulbs strung from a network of cables looping across the ceiling. By 1973, *IT*'s colleagues: *Frendz, Oz, Ink, Red Mole, Black Dwarf* – they were never really regarded as rivals – were all out of business. In the summer of 1973, *IT* was selling 20,000 fortnightly, about half its 1968 sale. By then the editor was Roger Hutchinson: 'It's more thorough, more realistic, more working class, and carrying more news than ever.'[13] He said that *IT* stuck to its original convictions:

> The function of the underground press is to shake people's assumptions. *IT* is totally anarchic, it has no structures and no respect for anything. I think very highly of organizations like IS [International Socialists], for without them there would not be any point in *IT*. But we don't want to be like a high school lecture; we want to entertain people. You never teach anyone anything. They teach themselves.[14]

Police pressure on *IT* and *Oz* was the main cause of their eventual demise. The number of police visits became so great that both papers stopped counting. Felix Dennis from *Oz* said:

> Prosecutions are economically damaging not only in costs and fines and so on. They also damage your potential for advertising. However much people want to sell their product, they're still not willing to sully their name in court. One of the main causes of our folding was that advertising dropped significantly, even though the circulation went up.[15]

It was also very difficult for the underground papers to get printed. *Oz* went through twenty-nine printers in its forty-seven issues. Felix:

> Another reason for our bankruptcy was artificially high printing costs. We were forced to use out-of-date machinery – sheet fed instead of web-offset rollers. With the exception of our last two printers I've never met a more gutless and lily-livered bunch of people.[16]

Though *IT* never relied as much on commercial distributors as the other papers, they did use Moore-Harness to reach towns out of London. Even so, 65 per cent of Britain was beyond the reach of the underground press because W. H. Smith's and Menzies refused to carry or wholesale them, even though they were happy enough to carry all the top-shelf porn magazines. By the early seventies Moore-Harness was responsible for 55 per cent of all underground press sales and were doing very well out of them; the underground certainly helped pay for the Moore-Harness Rolls-Royces. But by 1973 their enthusiasm had waned because there was so much more money to made out of the soft-core porn market. By then much of the raison d'être for the underground press had gone: *Time Out* was carrying the listings and much of the political news, *Spare Rib*, started in June 1972, dealt with feminist news and *Gay News*, also from June 1972, catered to gay readers, and from 1977 Richard Boston's *Vole* covered ecology. Also, many of the underground journalists had moved on into music newspapers or to Fleet Street proper, working, in a mild and largely ineffective way, from within. Specialist papers had taken over and *IT*, Europe's first underground paper, closed in 1973 after 164 issues. John Lennon, wondering where his subscription copies had gone, had someone call to find out what was happening. When he found out the paper had closed he sent a cheque for £1,000, which enabled a second volume of three issues to be published in 1974. Then the staff packed it in. They left the title and logo copyright free and in subsequent years seven or more other groups of people have brought it out, sometimes for just a few issues, other times for a long run; the last copy I saw was from the late 1980s.

Of the specialist magazines, the most underground was probably *Gay News*, started by Denis Lemon and Andrew Lumsden, which ran for eleven years; but not without problems. It was charged with obscenity in 1974 after they featured a cover shot of two men kissing but won that round. Then, in July 1977, the vindictive Mary Whitehouse almost managed to close it down by bringing a private prosecution for blasphemy against James Kirkup's poem 'The Love That Dares to Speak Its Name', which described the sexual arousal of a Roman centurion as he imagined having sex with Jesus on the cross. The editor, Denis Lemon, was fined £500 and given a nine-month suspended sentence at the Old Bailey for blasphemous libel on a majority verdict of ten votes to two, the first successful blasphemy case in fifty-five years. This proved once more that there is no such thing as guaranteed freedom of speech in Britain, and though the poem has been widely reprinted, it is still technically banned in that anyone can bring the same charge against it. It was generally thought that Lemon was found guilty largely because he was gay. He told the

press: 'I feel slightly shattered and empty.' His persecutor, Mary Whitehouse, was delighted. 'I am rejoicing,' she said afterwards, having caused months of anxiety and stress for scores of people. It was a Pyrrhic victory, however, because her prosecution of *Gay News* saw the paper's circulation rise from 8,000 to 40,000 because of all the publicity.

Each year, Britain's newspaper and television news reporting is dumbed down further and further, so that it is now little more than bite-size gobbets about celebrities, sporting figures and royalty, interspersed with ads for products no-one needs or, in the case of the BBC, ads for their own programmes. The brain-numbed viewers seem happy enough, and still talk about the latest pathetic offerings as they enter the office each morning. Where is the modern equivalent of the underground press; for example, where was Britain when the Danish newspaper *Jyllands-Posten* published a dozen editorial cartoons of the prophet Muhammad on 30 September 2005 causing world-wide protests? The cartoons were a front-page news story in every paper, but though they were reprinted in more than fifty other countries, not one British newspaper or TV channel had the guts to publish them. The Cardiff university student paper, *Gair Rhydd*, printed them but the newspaper was pulped by the university before it could be distributed, the editor, Tom Wellingham, and two journalists were temporarily suspended, and forced to apologize in the next issue. Ironically, *Gair Rhydd* means 'free speech' in Welsh. So much for free speech in Britain. I like to think that *International Times, Oz* or *Frendz* would have printed the cartoons, even if it meant having to barricade the offices against fanatics (the Fleet Street press is already protected by security personnel and locked doors). But with the advent of the internet the underground press is no longer necessary in printed form as there are many sites that specialize in such information: the cartoons, for instance, are readily available online.

Part Three

25 Other New Worlds

If you want to live in the world this is the place. It's the only place where you have a total grasp of the whole world. Whatever is happening in every country you can feel in London. Every single building, every single person, every scratch on a tree, is global because it is one of the most modern places in the world.

GILBERT AND GEORGE, 1981[1]

Though Camden Town and Notting Hill were the traditional art student areas, many students found that housing to the east of the City of London was even cheaper, and in the sixties that was where many chose to live. Small enclaves of underground London life began to sprout, but it was a big area and they were scattered from docklands to Hackney. The poet Lee Harwood, for instance, wrote movingly of Cable Street, while many art students were attracted to the Georgian housing in Spitalfields. 12 Fournier Street, a run-down terraced house built by William Taylor in 1726 but refronted in the nineteenth century, was lived in by a succession of St Martin's School of Art students, including the pop artist Gerald Laing. Gilbert and George first met as sculpture students at St Martin's in 1967 and took over the ground floor apartment when one of their fellow St Martin's students moved out. They stayed. Though much has been made of their decision to live in the East End, they were simply following their classmates in search of inexpensive housing. By the late sixties they had expanded their living space to include the basement, which they had to fumigate for fleas, and also an upper floor. In 1973 they bought the building and they now own two more houses on Fournier Street, which is also home to Tracey Emin, bringing a new generation of artists into the street.

George Passmore was born in Plymouth, Devon, and grew up in Totnes. After a spell at Dartington Hall College of Art and the Oxford School of Art, he arrived in London in 1965, starting at St Martin's School of Art in 1966. He had grown up in poverty. His mother had gone into service at the age of twelve and it had been a struggle for her to bring up her two boys alone.

Gilbert Proesch came from San Martin, in the Italian Dolomites north of Venice, where his mother was a cook and his father a cobbler. He studied at the Wolkenstein School of Art and Hallein School of Art in Austria and the Akademie der Kunst in Munich, before arriving in London in 1967 to attend St Martin's. Gilbert and George first met on 25 September 1967 at the school and became immediate friends. Gilbert: 'It's very simple. George was the only one who accepted my pidgin English.' In a 2002 interview with the *Daily Telegraph* they claimed: 'It was love at first sight.'[2] They don't discuss their sex life, though George has described himself and Gilbert as 'two poofs'.[3] In fact, when they met, George had been married to fellow student Patricia Stevens for three months (they married on 19 June 1967 at Stepney register office). Their daughter, Sunny, was born in May 1968 and their son, Rayne, in 1972, at which time Patricia was still living with George; the names 'Sun' and 'Rain' suggest a greater acceptance of prevailing hippie philosophy than Gilbert and George would later admit. The children grew up in a semi-detached house in Hackney, not far from Fournier Street.

Together Gilbert and George explored London and in particular the East End. They investigated Hampstead and other outer suburbs by taking buses to the end of the line and walking back; their own form of psychogeographical exploration. In sculpture class they displayed their works together at the end of year show, mixing them up so that it was impossible to tell whose was whose. They even made one object together, a portrait head, but they never collaborated in quite that way again.

Gilbert, talking to Wolf Jahn: 'At the end of the year we posed with our sculptures, but we realised we didn't need them. That was when we realised that we didn't believe in objects.'[4] Their own life became the artwork. They had been moving towards this in their various experiments, but the turning point came one day when they walked out of the house on Fournier Street together and said: 'We are the art.' Gilbert told David Sylvester: 'That was before doing the Singing Sculpture. It was shortly after moving to Fournier Street that we decided we were the object and the subject. And I think that was the biggest invention we ever did. After that, that was it. We made a decision... we made ourselves the object.'[5] George:

> In our little studio in Wilkes Street in Spitalfields, we played that old record 'Underneath the Arches'. We did some moving to it, and we thought it would be a very good sculpture to present. That, in a way, was the first real G&G piece. Because it wasn't a collaboration. We were on the table as a sculpture, a two-man sculpture.

They worked on it and for their graduation show the next year, 1969, Gilbert and George presented themselves as a 'singing sculpture' and performed a six-minute version of Flanagan and Allen's old vaudeville song 'Underneath the Arches' (1932), which they sang while standing on a small office table with their faces painted gold. They moved with puppet-like jerks, one carrying a walking cane and the other a folded glove, the classic accoutrements of vaudeville. The performance was accompanied by a written dedication describing themselves as 'the most intelligent, fascinating serious and beautiful art piece you have ever seen.' They set out their own rules, described as 'The Laws of Sculptors':

1. Always be smartly dressed, well groomed relaxed friendly polite and in complete control.
2. Make the world to believe in you and to pay heavily for this privilege.
3. Never worry assess discuss or criticise but remain quiet respectful and calm.
4. The lord chisels still, so don't leave your bench for long.

Their intention was to dissolve the boundaries between art and life, to make every waking moment a 'sculpture' and to render themselves an inseparable unit, rather as John Lennon and Yoko Ono were doing at that same time. At the time of long hair and hippie attire, they chose the most conservative and conventional outfits, dressing in suits and ties, hair neatly trimmed and wearing polished brown shoes. They made sure that there was no discernible separation between their art and their everyday life, and their activities were accompanied by a series of poems and statements printed on their official headed paper bearing their motto: 'Art for All'.

The piece addressed many overlapping themes and shows the multi-faceted aspect of their work: the theme of the song is one of poverty, homelessness and the resilience of the underclass; not a topic usually addressed by art students. The song was always repeated, sometimes for eight hours at a stretch, no matter whether anyone was present in the gallery or not. This mindless repetition of action refers directly to the experience of factory workers, sorting or making the same component on an assembly line, all day, every day. The metallic paint on their faces suggested bronze, confirming the idea that they were indeed sculptures and referencing bronze statues from classical times onwards. They were both country boys and this is a song about London, their new home and ultimately their muse. It was an astonishing début.

One early examination of the difference between art and life was their

performance called *The Meal* of 14 May 1969 for which 1,000 people received invitations saying:

Isabella Beeton and Doreen Mariott will cook a meal for the two sculptors, Gilbert and George, and their guest, Mr. David Hockney, the painter. Mr. Richard West will be their waiter. They will dine in Hellicars beautiful music room at 'Ripley', Sunridge Avenue, Bromley, Kent. One hundred numbered and signed iridescent souvenir tickets are now available at three guineas each. We do hope you are able to be present at this important art occasion.

Richard West was Lord Snowdon's butler, so he knew the business. Isabella Beeton was apparently a distant relative of the great Mrs Beeton, and Mrs Beeton's original cookbook was used in the preparation of the meal for thirty guests. The meal lasted for one hour and twenty minutes and was a great success. Hockney described Gilbert and George as 'marvellous surrealists' and said: 'I think what they are doing is an extension of the idea that anyone can be an artist, that what they say or do can be art. Conceptual art is ahead of its time, widening horizons.'[6]

Seeking to reach ordinary people, at Christmas, just after they left St Martin's, they approached the Tate Gallery and offered to present a crib at the entrance, as the Tate did not have one. The RSPCA had already agreed to provide some sheep and a donkey and Gilbert and George intended to stand as two living figures in the middle of the display, like Mary and Joseph. George told David Sylvester that it would be 'a fantastic living piece, with the straw on the ground and everything; we could arrange a little star of Bethlehem. They wouldn't do it.'[7] *Drinking Sculpture* took them, and their audience, on a tour of East End pubs, and other works included picnics on the river bank and an elaborate ninety-minute piece from 1975 called *The Red Sculpture*, in which the two artists, their faces and hands painted a brilliant red, moved slowly from one statuesque pose to another in response to pre-taped commands issuing from a tape recorder.

Gilbert and George express one shared vision. They told Waldemar Januszczak: 'Our joint image is the only thing we're interested in. It's an amazing power. It becomes like a fortress, much bigger than one person.'[8] Gilbert told David Sylvester that they needed each other because they were not total. George added: 'We don't think we're two artists. We think we are an artist.'[9] To this end they invented a technical form incorporating photographs and, later, areas of colour, so that it became impossible to distinguish between them; there were no brush strokes, no individual personal statements. In the early days, when they were making charcoal drawings, it was

clear that Gilbert was far better at drawing but whether this had any effect on their decision to merge their work is not known.

From early on they became chroniclers of London: in their huge pictures they flew over the city – in one case, *Here and There* (1989), riding on a manhole cover like a flying saucer or the Mekon – pointing out, often literally, the grand landscapes of enormous office blocks in the financial centre, familiar landmarks: Westminster Abbey, St Paul's, Eros in Piccadilly Circus, as well as the tower-block-studded horizons of the inner suburbs and the throng of nameless workers filling the streets. Always present in their pictures as observers they record the sexual and racist graffiti, the chewing gum, spit, the refuse, the down-and-outs, the alcoholics, the mentally disturbed, street boys, the grey London streetscape. They made a whole series of paintings from four-letter words found chalked on walls and pavements: the *Dirty Words* pictures of 1977. Theirs is not a romantic Canaletto view of London; their view is unromantic in the extreme:

> We look at the raw material of life. We prefer to come out of the front door, its been raining, there's a puddle there, there's a bit of vomit from a Chinese takeaway, there's a pigeon eating it, there's a cigarette end, and that's all there is. And then you know what it is.[10]

In a 1987 interview George told Duncan Fallowell: 'London is the only up-to-date place in the world. London is raw, it's animal.' Gilbert added: 'When we visit Europe, or New York, those places seem so provincial.'[11]

Sadly London was up to date in every respect, including the AIDS disaster. As usual their response was direct; they produced an enormous amount of work, concerned with bodily excretions, semen, blood, sweat, piss, shit, but not in the celebratory manner of Mark Boyle's *Son et Lumière for Bodily Fluids and Functions*; Gilbert and George dealt directly with life and death, the essential systems of the body could also act as transmission channels for a killer disease. As many of their friends died of AIDS, they became, in their words, 'involved in all the blood of all our friends. All our friends were dying and so we saw all this end of life in front of us, every single day, and I think that had a big effect on us.'[12]

From very early on, they evolved a daily routine which, though seen by many as part of their life-as-art activity, was also designed to make life as unencumbered by time-wasting tasks as possible. They rose at 6.30am and went around the corner to a café for breakfast; they had no kitchen of their own. They worked until 11 a.m., then returned to the café for an early lunch. They worked all afternoon then had dinner at a local restaurant. Ideally there

would be no variation in their eating pattern, unless dining with friends or on business, but usually in restaurants and cafés close by. In 2007 they were eating dinner at a Turkish restaurant in Hackney, where they would have the same dish every night for three months then change. By eating out they saved time by not having to shop for food or spend time cooking. Shopping time was further reduced by making an annual trip to a supermarket for hundreds of rolls of toilet paper, cleaning materials and other household goods. They always wore the same conventional suits, which avoided time spent worrying about fashion or clothes shopping. Gilbert: 'You don't change it, so you don't have to think.' George: 'In the outside world it's so practical. You always get a table at restaurants. You're never searched at airports. You're accepted.'[13]

Their work, however, has not been accepted. Enormous paintings of turds, piss, sperm and other human excreta, lovingly presented almost as stained-glass church windows, meant that even in 2007, when the Tate could no longer put off giving them a retrospective, they were unable to find a corporate sponsor. For some reason companies like British Telecom did not want to associate their names with paintings called *Spunk Blood Piss Shit Piss*, *Our Spunk*, *Bloody Mooning* or *Shitty Naked Human World*, the last featuring giant turds arranged in the shape of a cross. Talking about these paintings in the Tate catalogue they said: 'Fundamentally, there's something religious about the fact we're made of shit. We consist of the stuff. It's our nourishment, it belongs to us, we're part of it, and we show this in a positive light.'[14] Many people thought the pictures were just made to shock; it was a subject matter that even now is off limits. The same pictures also show the artists themselves naked, and in *Cities Fairies* bending over to show their arses to the viewer. They show their human vulnerability, stripped of all artifice and pretence, truly naked. As David Sylvester commented, many artists have depicted the human body as 'nude' but only Gilbert and George have succeeded in portraying it as 'naked'. It is this explicit candour that makes their art so important. It is not as if they are making them for money. Gilbert told John Tusa: 'Everybody likes them but no collectors actually want them on the walls, it's quite difficult to live with one of those pictures. But we don't do them for that, we always want enough money to do what we want, and nothing else.'[15] Nonetheless, it was twenty-five years before the Serpentine Gallery could bring itself to show the *Dirty Words* series of paintings, and the more scatological series are even now challenging to some museums.

It is always problematic when an artist works in a variety of media: Derek Jarman is a case in point. He is best known as a film-maker and screenwriter

but he was also an important painter, he wrote numerous books and volumes of journals, he was a celebrated set designer and gardener. Because few, if any, critics have expertise in all these areas, his contribution to post-war British art has been largely overlooked. It must also be said that although he worked inside the gallery system to sell his paintings, he was regarded as a thorn in the side of the film and television industries. He was aware of what he was doing, even though it meant that his films, when they received funding at all, were almost always made on a shoestring. Derek Jarman: 'Why do I feel so alienated? I made my own space outside the institutions. Am I glad I did it? Yes. What I found in those institutions were dead-beat heterosexual toadies and a whole lot of queens who gave their tacit approval.'[16] Throughout his career he was an outspoken gay activist, which also did not help in attracting institutional funding.

Derek Jarman was filled with energy, ideas and enthusiasm and was central to the London scene in the seventies and eighties, a force for creativity, honesty and intelligence in the world of Thatcherism and greed. He had a profound effect on society by being out gay and living his art, but the art establishment didn't like it. Caroline Coon identifies him as at the centre of a movement: 'One of the great art movements which the establishment can't abide is what I call "heroic pop". It's the group of artists around Andrew Logan, Duggie Fields, Zandra Rhodes, Derek Jarman.'[17]

After graduating from King's College, London, in 1963, Jarman took up a place offered to him at the Slade School of Art. He spent his first summer vacation in the States and on his return he began to move in exciting new circles. He became friends with Patrick Procktor, Ossie Clarke and David Hockney. David Hockney danced with him at the 1964 Slade Christmas dance. Jarman: 'It is difficult now to imagine the effect this had, it was like diving for the first time from a very great height. David was a "star", not just a good painter, but – like Warhol – at the cutting edge of a new lifestyle which was the most enduring legacy of the 60s.'[18] Hockney was the first English painter to openly declare his homosexuality. It was a brave move at a time when it was still illegal and could have adversely affected his career, but he believed in honesty and openness, and also in having fun. He died his hair yellow because, as he said, 'Blondes have more fun!' When homosexuality was made legal for those over twenty-one, in 1967, Hockney, Jarman and their friends were ready.

Jarman's first career was as a painter; in 1967, during his last term, his fellow Slade student Nicholas Logsdail decided to open a gallery in his house in Bell Street. Jarman and several other friends threw themselves into the

project, filling holes with Polyfilla and painting the three gallery floors white. When the Lisson Gallery opened in mid-April, Jarman was included in the opening show.

It is hard to live by selling art so almost immediately Jarman had to turn to set design, a subject he had studied at the Slade. Astonishingly he started at the top; as he said: 'The beginning of my career was to resemble the end of anyone else's.' He was asked by Frederick Ashton, the director of the Royal Ballet, at ridiculously short notice, to design sets and costumes for Richard Rodney Bennett's jazz setting of the nursery rhyme 'Monday's child is fair of face...' for the Royal Opera House; it was to star, among others, Rudolph Nureyev and premiere with Princess Margaret in the audience. His sketch designs won him the job on 21 November and the ballet opened on 9 January 1968, giving him just forty-nine days to make the costumes and sets. It was a triumph: when the curtain went up to a stage dominated by two huge red circles, between which stood fair-faced Monday in a glittering skull cap and a leotard that faded from pink to white and wearing one white glove, the audience erupted into spontaneous applause. All seven scenes were as stark and abstract, simple and intensely colourful. The audience loved them and, though the critics grumbled a bit about the music, most reviewers gave the ballet high praise. The audience demanded seventeen curtain calls and on the closing night there was even an encore, almost unknown in ballet. It was a great triumph and Jarman even got to see Nureyev naked in his dressing room, though he was too flustered to do anything like proposition him.

After a spell in a nearby river-fronting property, Derek moved in August 1969 to 51 Upper Ground, a warehouse next to Horseshoe Yard at the end of Blackfriars Bridge and virtually on top of the site of Shakespeare's Globe. Jarman's friend, the sculptor Peter Logan, took the top-floor studio, which he painted yellow to enhance the brilliant sunlight, and Jarman had the large, airy, high-ceilinged, L-shaped room below. It was filled with light reflected off the river. In the mornings he was woken by the tugboat *Elegance* towing barges downriver, seagulls swirling overhead, some of which would land on his balcony demanding to be fed. In the winter it was bitterly cold, his anthracite-burning pither stove doing nothing except keep the water in the lavatory from freezing, but for the first year Jarman lived most of the time at his old flat in Liverpool Road, using Upper Ground just as a studio and only occasionally staying over. When he did move in it was not for long; in 1970, property speculators swept away Horseshoe Yard and the warehouse was demolished leaving only the old doorstep.

The use of these warehouses by artists set in motion an inevitable train

of events. The popularity of warehouses as living spaces was pioneered in New York in the late forties and early fifties by the abstract expressionists, who needed large spaces because they were working on enormous canvases. In Britain, the cost of heating, and the lack of suitable empty warehouse space, meant that the idea was late in catching on. The idea of loft living became associated with an artistic, rather bohemian lifestyle, so when artists did colonize an area, property speculators followed, often demolishing and building new 'loft-style' apartments. The demand was such that they began to introduce polished wooden floors and other appurtenances of loft-living into ordinary flat conversions. The popularity of lofts was to price most artists out of their spaces except in the newly developing East End, where they were often in unattractive areas. But, for a decade, artists were able to live by the river before rent increases and a suspiciously large number of accidental fires cleared the way for the developers.

Money was tight but fortunately, through an accidental meeting on a train with a friend of Ken Russell in January 1970, Jarman was offered a job designing the sets for Russell's film *The Devils*, and though some of his more ambitious plans were scaled back, he did get to construct an enormous life-size set for the city of Loudun in the back lot at Pinewood studios (Jarman had studied architecture under Pevsner at King's before going to the Slade). It was valuable experience for his own future career as a film director.

Jarman was part of a heavy-partying, club-going set that characterized the early seventies. Most of the excesses in sex and drugs and rock 'n' roll that are attributed to the sixties in fact happened in the seventies: a decade of seriously long hair, of cocaine and speed, of orgies and appalling fashions. The chief party-giver was Andrew Logan, but Derek came close. He described his period in the warehouses as 'one long party; there were always two or three people living there.' They all liked to frequent gay clubs such as El Sombrero, which was an important setting for both the early seventies glam rock scene, and later as a haven for the early punk rockers.

El Sombrero, in the basement below the Sombrero restaurant, distinguished by its Mexican hat neon sign, at 142 Kensington High Street, was a popular hangout in the late seventies. For a time Derek Jarman, Ossie Clarke, Angie and David Bowie, Mick Jagger and Bianca, Long John Baldry and Dusty Springfield could be found there every week, and even Francis Bacon sometimes peeped in. It was the first disco in London to have coloured underfloor neon lighting beneath its flashing, star-shaped, glass dance floor.[19] There was a raised section overlooking the dance floor which could be reserved by ordering champagne. To comply with the licensing laws, everyone was

given a paper plate with a thin slice of pork pie and a smear of coleslaw. That way you could dance until 2 a.m. for a couple of shillings. The patron was Amadeo, known to all as Armadillo, who sat at the bottom of the steep staircase, counting the pound notes. The waiters José and Manuel balanced glasses on trays held high above their heads as they weaved their perilous way through the crowds. It was mostly a gay club and later changed its name to Yours or Mine?

Jarman's next move was to a huge old corset factory at 13 Bankside, near the end of Blackfriars Bridge opposite St Paul's. In November 1970, Derek, Peter Logan and their friend Michael Ginsborg took studios there, though Derek was the only one to actually live there. His was on the top floor, a seventy-foot room with high, uninsulated ceilings with a large, three-pane skylight filling the room with light. Next to the three large arched windows overlooking the river he built a platform which ran the whole length of the room. He piled it high with cushions made from old Dutch carpets that he found in the flea markets of Amsterdam so that guests could lounge there watching the tugs pull the long low Thames barges up and down the river and the colour of the dome of St Paul's change with the sky. The wooden loading bay let down to enable goods to be hoisted up from the boats below and was a perfect place to sit out in the summer. In the centre of the room was Derek's bed, installed inside a garden greenhouse to keep in the warmth in the winter. One wall was dominated by two enormous capes, like Bishop's copes, made by Jarman in the sixties and displayed in great semi-circles on the white painted walls, surrounded by paintings and collages. The wooden floor was covered with old oriental carpets and yet more cushions. A large white hammock was slung between two columns. By the rear window he planted a garden of blue morning glories and ornamental gourds that gave big yellow flowers. On the landing at the top of the stairs that led to all three studios he installed a bath, visible to one and all.

The summer evenings drifted by with Ravel's *Daphnis and Chloë* on the hi-fi and Derek and his friends sprawled on the cushions high on acid. Derek wrote: 'the light from the river reflected in sinuous patterns on the beams, the phosphorescent stars on the glasshouse glimmered... At moments like this the room transformed and glowed upon the waters.' They could hear the incoming tide, the movement of boats on the river, gulls and distant traffic. After an all-night session they would watch the sky above the City of London change through the colours of the rainbow, then, as the first trains of the day crawled across the Cannon Street railway bridge, see the city come slowly to life. It was, he wrote, the 'most beautiful room in London'.[20]

Most of the units were empty, and the semi-derelict building had an air of foreboding. Jarman took enormous pleasure in taking an unsuspecting boy back late at night, unlocking the padlocks on the old wooden doors and walking up the endless stone stairs, dimly lit by low-wattage lightbulbs, through the enormous empty abandoned warehouse spaces. He enjoyed watching their fear and apprehension dissolve when he opened the door to his top-floor space to reveal 'The Studio'. It was here that Jarman began shooting Super 8 films of his friends, who included the artists Andrew Logan, Kevin Whitney and Duggie Fields. They were shown at Derek's regular film nights when sometimes more than a hundred people would gather to sit on cushions and watch *The Wizard of Oz* or some other main feature, accompanied by his Super 8s. Jarman: 'Of course no-one watched the films, it was just a party.' These Super 8s were later used, after considerable manipulation, as the basis of *Shadow of the Sun*, which featured a soundtrack by Genesis P-Orridge and Throbbing Gristle. The Studio was the venue for fabulous parties, with guests who included such luminaries as Katharine Hepburn and Richard Chamberlain, and for sumptuous dinner parties. One party before Christmas 1970, cooked by Peter Logan, was for forty people seated at a specially built long table banked high with scented white narcissus from the Floral Hall at Covent Garden Market. At the end of the meal, joints wrapped in American flags were served with the coffee. Jarman: 'Then we played charades behind a beautiful collaged curtain, a Rousseau Garden of Eden that Andrew Logan had made on transparent polythene.'[21] Derek and Fred Ashton went first as Edward VIII and Wallis Simpson, but he didn't record who was which.

In May 1973, Jarman and the others were forced out once more by developers and he moved to a third-floor studio in Warehouse A1, Butler's Wharf, in the enormous nineteenth-century warehouse complex that extends along the riverfront just downriver from Tower Bridge. Jarman's new studio was much larger than Bankside, but apart from a row of cast-iron columns which divided the space, it was otherwise charmless in comparison. Jarman rebuilt his bed greenhouse and set about making the space into his home. The shared toilet was on the ground floor and there was no bath. He installed both in the open room for all to see. As before, Peter Logan joined him in the new building, taking the two top floors, and it was here that he perfected his mechanical ballet. This was staged by Madeleine Bessborough at her Sloane Street gallery as a live art event using his sculptures and naked dancers from the Royal Ballet, choreographed by Jarman.[22] Later in the year Peter's brother Andrew took the top floor of Warehouse B and a number of other artists and architects moved in, making a thriving creative community. Jarman's

studio was at the east end of the building, overlooking the river to the north and a large expanse of waste ground to the east. In *Smiling in Slow Motion* he remembered it fondly: 'the forecourt where we made all the Super 8s – stark naked boys having it off all along the river wall'.[23] Among the Super 8 films were *Death Dance*, *Sulphur*, *The Art of Mirrors*, *Arabia*, and dozens more. Though they began as Super-8 home movies, edited on the camera, he soon moved on and in a film like *In the Shadow of the Sun* he used superimpositions and coloured gels to achieve a saturated colour effect. There was no narrative, they were visual poems.

At the first Alternative Miss World (AMW) competition, held in Andrew Logan's cramped studio in an old jigsaw puzzle factory in Downham Road, Hackney, in March 1972, David Hockney and Robert Medley were the judges. The event forms one of the central tableaux of Jack Hazan's *A Bigger Splash*, the documentary film of David Hockney's life at the time, and contains footage of the ceremony in which kisses are bestowed upon the lucky winner. Here Andrew met his life-long partner Michael Davis. Derek and Patrik Steede bought couture dresses at second-hand shops to wear; classic Balenciaga and Dior could still be found for five pounds. They first wore their drag at a performance of Peter Maxwell Davies's *Eight Songs for a Mad King*, where they disrupted the audience at the Queen Elizabeth Hall. The composer was not overly pleased but said nothing as the season had been launched with a reception at Jarman's studio. Patrik won the Alternative Miss World by wearing the dresses that the other contestants had cast off, a simple spur-of-the-moment expedient that, as Jarman said, 'was much funnier than anything anyone else had dreamt up for the occasion as he had not even entered officially'.[24] But Derek's ego was bruised and he determined that one day he would wear the crown.[25]

Before the move to Butler's Wharf, on 13 October 1973 Andrew Logan held the second AMW competition at his studio. Karl Bowen had borrowed a mink coat from Lindy Guinness for the occasion but the catwalk, made from orange boxes, was very narrow and there was not really room for two people to pass, and he was brushed against by Miss Germain Depraved, a Left Bank artist whose costume involved wet paint. Jarman tersely remarked: 'This was a catastrophe for the mink.'[26] The judges were David Hockney, Ossie Clarke and Zandra Rhodes. Eric Roberts as Miss Holland Park Walk won and was crowned seated on the 'Morning Glory Throne' by Miss Yorkshire, Patrik Steede, the previous year's winner, wearing a python. Logan wore his now traditional half 'n' half outfit, one side a male evening suit from a jumble sale, the other half of a glamorous evening dress designed specially by Bill

Gibb. Logan had modelled the event not so much on the tacky Miss World competition, but on Cruft's dog show, with prizes for poise and personality, and an added category, 'glamour', because the outfits had to be glamorous, though it was later changed and he adopted the three Miss World categories of 'Daywear' 'Eveningwear' and 'Swimwear'. Nonetheless, the straight 'Miss World' sued. Logan: 'We were taken to court by the Morleys, who ran the 'other' Miss World, and were defended by a young barrister called Tony Blair. The first judge was outraged by our infringement of the name, but eventually we won and the show went on.'[27]

It was not until the third Alternative Miss World, in March 1975, that the highly competitive Jarman finally won the event as Miss Crêpe Suzette. His costumes included a Jeanne d'Arc suit of armour with a built-in sound system, and a silver diamanté dress accessorized with snorkelling flippers and 'a headdress made from a green rubber frog, with pearls and lashings of ruby and diamanté drops'.[28] He was desperate to win and he did. This year the female hostess side of Logan's outfit was designed by Zandra Rhodes. This was a boisterous Miss World held at Logan's new studio in Butler's Wharf: Miss Statue of Liberty almost burnt the building down when she spilled burning oil from her flaming torch and Molly Parkin was thrown in Logan's miniature swimming pool by Miss Holland Park Walk after an unfortunately phrased remark complimenting her on doing so well considering she was not 'of our colour'. It was not ill-intentioned and Molly Parkin joined Divine and Andrew Logan as a co-host for the 1978 celebrations (they were not held every year).

The 1978 AMW was held on 20 October in the blue circus tent on Clapham Common, where Andrew had staged his 'Egypt Revisited' – a spectacular show which had finished three days earlier. It was won by Miss Carriage, Miss Linda Carriage, Stevie Hughes, who was crowned seated on a donkey. Unfortunately, shortly afterwards, in all the excitement she and the donkey tumbled off the catwalk but neither was hurt. Little Nell sang and Jenny Runacre appeared as Miss Slightly Misanthropic. Some of the most elaborate costumes were worn by the art dealer James Birch, who came as Miss Consumer Products: a cheeseburger made from two tractor inner tubes and foam rubber. For his beachwear costume, he appeared as a tube of Ambre Solaire, which spurted suggestive white gobs of liquid into the audience, and for evening wear he came as a box of After Eight Mints. He came fourth but many feel he should have won.

Jarman had been considering the idea of a film based on the life of St Sebastian for some time, and his friend Patrik Steede had even completed a screenplay for it. Then at a lunch party he met a wealthy young film student

called James Whaley who wanted to become a producer. An almost casual mention of the St Sebastian project resulted in Whaley presenting Jarman with a synopsis of the proposed film and the suggestion that he should produce it. Though Jarman acknowledged Steede's early involvement, there was always a whiff of betrayal in his treatment of Steede.

There had not been a homoerotic film made in Britain, and certainly not one where the dialogue was in Latin with subtitles. The Latin script was a clever solution to the problem of achieving some sort of historical verisimilitude given that the film was made on a tiny amount of money. The Roman soldiers were also to be naked much of the time, obviating the need for expensive costumes. Sebastian was a captain of the palace guard at the time of the Emperor Diocletian's persecution of the Christians and, because of his Christian sympathies, was condemned to be killed, but in at least one version of the story the soldiers were so taken by his beauty that he was only shot in the arms and legs and, though left for dead, was rescued by the widow of another Christian martyr. Jarman was quietly confident that *Sebastiane* would become a cult film with gay audiences and make its money back because 'it was homoerotic in its very structure'. As this was Jarman's first film, he and Whaley decided that they needed some professionals on board and managed to hire Paul Humfress, a BBC editor with years of experience.

In Rome they met the film designer Ferdinando Scarfiotti, who generously suggested that they use a strip of coastal property owned by his family at Cala Domestica in southern Sardinia, an idyllic setting on the west coast of the island with sandy beaches, rock coves and a few ruined fishermen's cottages. They were delighted to find that the nearest village was called Buggerru. They stayed in a hotel in Iglesias and Luciana Martinez rose every morning at 5 a.m. to buy that day's supplies from the market. The crew was up by six and, after a long bumpy ride along the dirt track to the coast, they usually managed to begin filming by about 10.30. With a short lunch break, they filmed until six and by the time they returned to their hotel for dinner they were all exhausted. The film was made on £30,000, by raising money from friends; Whaley had such faith in it that he borrowed money against his house. Though they paid the crew union rate, found money for the actors and even some to sustain Jarman, such a small budget meant that they could not afford daily rushes, or to edit in colour, and it was only when they reached Humfress's editing suite that they could see what they had filmed. It was immediately obvious that there was not enough footage for a feature so they added a party at Emperor Diocletian's palace, the only way of

doing 'ancient Rome cheaply' as Jarman put it as he rounded up all his most decadent friends.

Andrew Logan offered his loft in Butler's Wharf. Costumes were made. At the last minute, after the walls were hung with gold, Andrew painted the floor to look like pink marble. Johnny Rozsa painted himself gold and entered carrying a lyre, and a half-naked Lindsay Kemp arrived in whiteface with his dance troupe from *Flowers* carrying enormous phalluses, which, to Jarman's delight, eventually squirted 'a condensed milk orgasm'[29] all over Kemp. Rain on the roof meant that little more than the party could be filmed, but Jarman now had enough and so for the next eight months, beginning in September 1975, he and Humfress spent two or three days a week hunched over a Steenbeck editing suite. Naturally they were unable to find a distributor, but David and Barbara Stone, owners of the Gate Cinema in Notting Hill, visited the cutting rooms and liked what they saw, and the film opened at the Gate in late October. After sixteen sell-out weeks, it transferred to Scene 2 in Leicester Square; Jarman was playing the West End. It also opened on the Screen on the Green in Islington and in provincial art houses all over Britain. It was an underground success; the first gay film to be exhibited in high street cinemas to show full-frontal nudity and a hard-on. Strangely the film bombed in America, where it was expected to have a large cult following. The reason given was that they couldn't understand the Latin, as if the language mattered, but the Americans already had a thriving sex film industry, complete with on-screen sex, so Jarman's film did seem a little esoteric.

There's nowhere else like London. Nothing at all, anywhere. Paris is much more beautiful to look at. The French have got taste. If there's a monument, it's placed properly and really considered. London is really sprawling and if they've got a lovely monument they put it around a corner where you can't find it. It's all higgledy-piggledy.
VIVIENNE WESTWOOD[1]

The seventies was an important decade for London street fashion and style: first came glam rock – David Bowie in a dress, David Bowie without a dress – followed by punk. Punk varied from bondage trousers costing more than a week's wage to personalized jumble sale tat. By the end of the decade punk had developed into the New Romantics and the most extreme fashion statements of the century. The first inkling came in 1972 when Bruce McLean started Nice Style, a pose group consisting of himself, Paul Richards and Ron Carra. They described themselves as the World's first pose band, having eliminated all other extraneous elements of a rock band. To them, the key to style was the perfect pose. They perfected 999 styles, of which number 383 was 'He Who Laughs Last Makes the Best Sculpture'. After a year of preparation and preview performances they launched their career at the Royal College of Art's art gallery in 1973 with a lecture on 'Contemporary Pose'. The lecture was delivered by a speaker with a very pronounced stammer, while the group, dressed in a silver space suit inflated with a hair dryer, a double-breasted overcoat (homage to their hero, Victor Mature) and other stylish garb, adopted the poses described. The poses were adopted with the aid of 'stance moulds' which McLean had specially made from clothing with built-in poses or 'physical modifiers', which also incorporated huge measuring instruments to demonstrate the exact angles for arms and legs and tilt of the head required. In 1973, *Crease Crisis* was released, a filmed performance in honour of Victor Mature's famous overcoat. That same year, *The Pose That Took Us to the Top, Deep Freeze* was performed in the banqueting suite of the Hanover Grand Hotel off Regent Street. Their researches into pose continued

through 1974 when they concentrated more on entrance and exit poses. Having exhausted their subject, and its humour, they disbanded in 1975.

Club culture has always been of extreme importance to London's creative scene: the fashion industry thrives on it, the music industry cherry-picks it, and it has always provided shelter for the disenfranchised, be they blacks, gays, hippies, punks, afternoon drinkers, midnight gamblers or cross-dressers. In the seventies there were hundreds of clubs, some having a greater role in the culture than others, all of them sucking in talented young people from the far-flung suburbs. The Masquerade off Earls Court Road is a good example. It began as a rival to the Sombrero and usually managed to stay open until 3 a.m.. There was a glassed-in restaurant overlooking the dance floor and for a while it was the place to be seen and was very popular with the music business crowd. It was mostly a gay scene and there were some outrageous costumes. Pamela Rooke, known to her friends as Jordan, who became the manager of Malcolm McLaren and Vivienne Westwood's SEX clothes shop on the King's Road, was a regular on the dance floor. She told Jon Savage: 'I went to the Masquerade... I liked good dance music... the only places you could get that were those gay clubs.'[2] A particular favourite was 'Masterpiece' by the Temptations, a fourteen-minute track from their 1973 album of the same name. There was a crossover between the glam rock scene centred around these gay clubs and the punk scene which developed in the mid-seventies. Johnny Rotten, for instance, became a hero at El Sombrero when a disgruntled punter pulled a knife on the doorman but was prevented from stabbing him by Johnny kicking him in the balls.

There was one key club that helped spawn the punk movement. Before the Roxy and the Vortex, there was Louise's, a lesbian club at 61 Poland Street, Soho. The red-painted door had a brass nameplate and a small spyhole where guests were scrutinized before being admitted. Louise ran the door herself; a very chic, older French woman in a black dress and jewellery with grey waved hair and heavy eyeliner who sometimes wore a grey fur coat to escape the cold wind whistling under the ill-fitting door. Not everyone was allowed in. 'Are you members?' she would lisp, and if she liked the look of you, 'Ah, you must become members.' Admission was £3. Siouxsie Sioux was the first punk to go there; her sister was a go-go dancer and through her she knew a lot of the gay clubs in London. You entered through a small foyer where Louise sat at her low desk protected by Michael, the American doorman. The foyer led to the dimly lit bar traditionally decorated in red and black with long mirrors, a long black leatherette banquette, black chairs, red carpet and small

drinks tables with red tablecloths. It was classic Soho, designed for posing and preening. The bartender's name was Tony and the head waiter was John. Berlin, one of the Bromley Contingent of punks, described how they called him '"Ballerina John", an Irish queen with really awful acne and long red hair that he kept flicking over one eye'. Britain's peculiar licensing laws at the time meant that food had to be served if alcohol was consumed, so the drinks came with days-old recycled spam sandwiches served with shrivelled gherkins on disposable paper plates.

A spiral staircase led to the basement; a small dance floor surrounded by more low tables with red cloths and mirrors. and controlled from a smoked-glass DJ booth. Here Caroline, in her dyed cropped hair and proto-punk drainpipe pants and high heels, played the latest Motown and soul as well as Doris Day and old favourites like 'Love Hangover' by Diana Ross. The customers were middle-aged, middle-class lesbians: manly women in three-piece men's suits, role playing fluffy Marilyn Monroes or gangster's molls, the whole gamut of personality games. One regular was Butch Joe, a black woman with a shaved polished head and no front teeth who wore a beige-coloured man's suit from Burtons. Her two favourite phrases were: 'Strap a dick to me, dear' and 'I want my tits off'. Though catering mostly to lesbians, Louise was happy to allow the inchoate-punks to use the club. Peter York described it as 'a very nice little club, a little red box, where a floating popula-tion of freaks who aren't gay but would get beaten up for looking like that, the oddities, the contingent without a name, were really starting to collect in a big way in 1975/6'.[3] Jordan, Sid Vicious, Viv Albertine, who joined the Slits in 1977, and the proto-punks from Bromley who became known as the Bromley Contingent, including Siouxsie Sioux and Berlin, who was then only sixteen. There were young boys and girls in their extreme makeup, their see-through tops, fishnets, high heels and brightly coloured hair, and they danced until the 3 a.m. closing time, pausing from time to time to pose and pout in the mirrors and marvel at how fabulous they all looked. The dim lighting helped.

They were all still teenagers. Something of the flavour of the place is given in Boy George's description of meeting Siouxsie Sioux in the ladies' room at Louise's in his introduction to Bertie Marshall's *Berlin Bromley*: 'She stood preening herself in the mirror wearing a swastika armband and very little else. She glared at me with contempt, and almost knocked me flying as she stomped out...'[4] The Bromley Contingent were soon joined by Malcolm McLaren and Vivienne Westwood, who usually stayed upstairs in the bar, plotting with their friends. They brought in Johnny Rotten, the other Sex

Pistols and members of the Clash; so many punks in fact that the original lesbian clientele understandably began to complain. They were right. Jordan, Siouxsie and the other originals took to only going on weekdays because the weekends became so crowded. Louise's closed soon after punk got fully underway, unable to handle the influx of hardcore punks and no longer attractive to its original membership.[5]

Linda Ashby, one of the regulars, whose girlfriend was Caroline the DJ, befriended the punks and one night she took them back to her place for drinks. She had a large two-bedroom flat at the back of the St James's Residential Hotel on Park Place. The entrance was through the hotel foyer, then across a courtyard and up three flights of stairs. She had decorated it in the latest seventies style: a thick shag-pile carpet, smoked glass coffee table, thick damask curtains to keep out the light and two large Heal's settees where Linda and her friends sprawled to listen to *Judy Live at Carnegie Hall* on the state-of-the-art hi-fi and where many of the suburban punks would sleep rather than make the long journey home.

Linda, who was a prostitute, already knew Vivienne Westwood because a lot of the whores used to buy their bondage clothes at SEX: they had rubber masks and leather skirts and tops with strategically placed zips that were unavailable elsewhere. Linda and another prostitute worked at a dungeon in Earl's Court. She would earn around £300 for a twelve-hour shift, enough to provide for a luxurious lifestyle for herself and her girlfriend Caroline. She provided certain services to people, many of them well known: the comedian Benny Hill liked to wear a rubber mask and be locked in a cupboard, others paid to be whipped. Gradually Linda's flat became the centre of activity for the early punks: Jordan moved in, Sid Vicious and Nancy Spungen lived there for several months, Simon Barker became a paying lodger after Linda's dungeon was busted and she couldn't work for a while. Johnny Rotten, Malcolm and Vivienne were there all the time. Linda's was the punk equivalent of Mabel Dodge Luhan's Greenwich Village salon and in a matter of months her elegant walls were scrawled with punk graffiti as she took the whole lifestyle on board.

Number 430 King's Road, after the bend in the King's Road, is an inconsequential-looking building, hardly the sort of place you'd expect to find described as the 'motor of UK teen experience' (by Jon Savage). And yet for forty years, and through numerous name changes and owners, it was the centre of ever-changing London street fashion. Before that it had been a greengrocer's, and for more than thirty years it was a pawnbroker's. In the fifties it was Ida

Docker's café, then it became a yacht agency and a motor scooter dealership catering to the local mods. It was given its new direction in 1966 by Bill Fuller and Carol Derry, who ran it as an unnamed clothes shop. In 1967 it became Hung on You, Michael Rainey's swinging London clothes boutique which moved there from Chelsea Green, much closer to the centre of action. Here you could buy boots made from carpets, fabulous velvet jackets and shirts with huge droopy lapels. Inspired by the Chinese Cultural Revolution, Rainey launched a collection of high-collared drab green Chinese-style jackets and covered the wall of his shop with a huge enlargement of a photograph of Mao Tse-tung's famous 16 July 1966 swim in the Yangtze. But in 1967 Michael and Jane Ormsby-Gore left London, heading west along a ley line in a gypsy caravan to Wales with a group of Holy Grail-seeking friends, a journey which took them four years and inevitably meant that Michael was not often in the shop, to the detriment of sales.

In 1969 number 430 was taken over by Tommy Roberts and Trevor Myles, who took it resolutely downmarket. They called it Mister Freedom, after William Klein's 1968 film, and ushered in seventies bad taste with giant star-spangled kipper ties, leopard-skin prints and garish colour combinations. Just inside the door stood a huge stuffed gorilla, its fur dyed bright blue. It was not subtle but it suited the times.

A year later Tommy moved on, leaving Trevor to rename the shop Paradise Garage and build a green-painted corrugated iron South Sea island façade complete with a rusting fifties petrol pump and the shop's name spelled out in bamboo. Sometimes he parked his sixties Ford Mustang painted in tiger-striped livery outside. He filled the bamboo-lined shop with $5,000 worth of used jeans, Osh Kosh dungarees, embroidered bowling shirts, hand-painted Hawaiian shirts, baseball jackets and other Americana bought cheaply in New York. After a year he got bored, sprayed the walls black and installed a jukebox and a dance floor. One day, Malcolm McLaren was parading down the King's Road in a lamé suit copied from an Elvis Presley album sleeve, in his words 'a shining beacon in silver and blue', when Trevor Myles accosted him and asked what he was doing. 'I've got *stuff*! Stuff to sell,' he told him. Myles gestured towards the shop across the street and McLaren rushed in: 'There in the middle of the room was a gleaming jukebox and a mirror ball, a skirt and pair of old jeans tacked up on the wall. It reminded me of old dance halls with flickers of light all over the room.' The jukebox was playing fifties rock 'n' roll.

Malcolm McLaren and Vivienne Westwood rented the back room to sell fifties records and memorabilia and did it up like a Teddy boy's bedroom

with patterned wallpaper, posters for the films *Rock Around the Clock* and *The Damned*, jars of Brylcreem, framed photographs of Billy Fury and Screamin' Lord Sutch, a Dancette record player, copies of *Photoplay*, *16 Magazine*, *Spic* and *Mad*; an idealized fifties that they barely knew. They called it In the Back of the Paradise Garage. Vivienne began making Teddy boy clothes and in 1971 they took over the whole shop, changing the name to Let It Rock and began selling drainpipe trousers, bootlace ties, blue suede shoes and fluorescent day-glo socks. Malcolm had relatives in the rag trade and had box jackets made up in blue-and-white flecked material like those worn by Elvis in the fifties. Teddy boys flocked to the shop. At first the black walls and jukebox remained but then pictures of James Dean and early Elvis began to appear on the walls. McLaren dressed in full fig retro-Teddy boy splendour: drape jacket, velvet cuffs, skinny tie and waistcoat. It was a look he liked because it allowed him to 'be a peacock, standing out in the crowd' and yet it identified him as a 'part of the dispossessed'.[6]

Vivienne quickly made the style her own: they found a way to attach glitter to T-shirts to spell out the names of Eddie, Chuck Berry and Elvis. She attached strategically placed zips across the breasts and carefully sewed fifties pin-up photographs into small panels. They boiled chicken bones and Vivienne used them to carefully spell out the word 'ROCK', attaching them to the cloth with small chains. Cigarette holes were burned in T-shirts, then turned back and sewn. Each piece was a work of art.

Malcolm and Vivienne's interest moved in the direction of rockers so in 1973 the shop front was transformed yet again, this time into Too Fast to Live Too Young to Die with a shop sign designed like the colours on the back of a Hell's Angel's jacket with a skull and crossbones in the middle. They now specialized in Hells Angels and biker fashions with an even greater emphasis on studs, zips and leathers. They made the costumes for Ken Russell's *Mahler*, including the famous short leather skirt with a swastika made from brass studs covering the arse.

In 1974 they decided to concentrate entirely on the zips and leathers and turned the shop over to fetish and bondage wear. 'Rubberwear for the office', as Malcolm called it. McLaren's interest in bondage gear continued throughout the period and he wears an inflatable rubber mask in the opening sequences of the 1980 film *The Great Rock 'n' roll Swindle*. They spelled out the shop's name, SEX, across the shop front in huge human-size soft pink latex letters like a Claes Oldenburg alphabet. The window was blacked out; a certain insouciance was required to enter. Once inside, the shopper was confronted by the shop's manager, Jordan, who sat at the far end dressed in

fishnet stockings, impossibly high black stilettos and a black PVC leotard. Her blonde hair was piled high in a beehive and she had thick black eye makeup. Berlin Bromley described her as looking like 'a cross between a shark and a pickaxe'.[7] Sometimes wearing only tights and a rubber vest, it took tremendous courage for Jordan to dress that way, taking a commuter train in the morning. She did not go unnoticed. Sid Vicious also worked there in the early days, goofy-looking with his overbite, helpful and unassuming, dressed in Hawaiian shirts and fifties peg trousers; two shops behind in his attire but a welcome contrast to Jordan's full-on aggressive attitude.

Vivienne was the designer and Malcolm had the family connections to get the stuff run off; his stepfather owned the large clothing factory Eve Edwards Limited. Malcolm was the Londoner; he grew up in Hendon and was sent to the private Avigdor Hirsch Torah Temimah Primary School in Stoke Newington (his family were Sephardic Jews on his mother's side). From there he went to Orange Hill grammar school in Burnt Oak, where he showed enough ability in art to be enrolled, much against his parents' wishes, in St Martin's School of Art on Charing Cross Road; the first of many art schools he was to attend over the next six years. Malcolm's father left home when he was only eighteen months old and he and his elder brother were largely brought up by their grandmother while their mother spent her time in the South of France and Paris with friends such as the millionaire Charles Clore. Perhaps not surprisingly neither of the boys did well at school.

Malcolm and Vivienne were an unusual couple. Vivienne was born Vivienne Swire and came from the village of Tintwistle near Glossop, Derbyshire. She moved with her parents to Harrow when she was seventeen and there attended Harrow School of Art. She married Derek Westwood in 1962, and they had a son, Ben. After college she made and sold her jewellery on Portobello Road, saving enough money to train as a teacher. She taught at a primary school in North London and also at a Sunday school; she was a regular churchgoer. When her marriage failed, she and Ben separated from Westwood and in 1965 she moved into her brother's flat, where Malcolm McLaren was also living. After three weeks, they began sleeping together. McLaren was twenty-one years old and she was the first woman he ever made love to. He told Jon Savage: 'I'd come from a closeted environment, so completely cut off from the world, I had never grown up.' His powerful matriarchal Jewish grandmother had made sure that he never had a girlfriend. Caroline Coon believes that his repressed attitude towards sex had quite a profound effect on the punk scene, where mentors were few and far between. Vivienne was six years older than him and considerably

more mature. McLaren: 'From then on, I kept going back to live with my grandmother, and going back to live with Vivienne, backwards and forwards for three or four years, until I lived with Vivienne and left art school, and started in fashion.'[8] She got pregnant, and in 1967 they had a son, Joseph. They were together for fifteen years. She stopped teaching when Let It Rock opened in 1971.

Vivienne, when she made an appearance in the shop, was stunning. Gene Krell, who ran Granny Takes a Trip a few doors further west, described her: 'Vivienne was walking down the street in leather mini skirts wound round with chains and padlocks, T-shirts with holes, ripped fishnets and stilettos, or rubber negligees and rubber stockings: nobody had seen anything like it – she stopped the traffic.'[9] She was the punk fashion prototype; everything stemmed from her designs and fashion sense. Punk was really what happened when you combined Vivienne Westwood with a series of pub bands descended from the Who, Small Faces, Bowie, Mott the Hoople, Iggy Pop and the Stooges. Several commentators have suggested that punk was just skiffle with electric instruments: Wreckless Eric told Max Décharné: 'It was really skiffle – part two.'[10] There is some truth in the idea. It has also been said they were hippies with short hair and there's even more truth in that; Joe Strummer even cast the I-Ching to decide whether or not he should join the Clash.

The walls of SEX were spray-painted with lines from Valerie Solanas's anti-male SCUM Manifesto, and thick blobs of latex hung down like an amateurish fairground ghost train; in fact the shop's ambience reminded me of Jeff Nuttall's 1965 sTigma installation at Better Books. There was a noticeboard with photographs of Tom Verlaine and Richard Hell with his torn T-shirt and safety pins, and a picture of Wayne County on the toilet. (Much of the King's Road punk imagery was appropriated from the downtown New York scene, particularly from Richard Hell.) The clothes were very expensive: a wet-look T-shirt cost £7, a see-through T-shirt £5, a ripped T-shirt £30, an unravelling mohair jumper £60. As Boy George commented: 'Anarchy in the UK? More like Avarice in the UK. Still, I would have bought them if I had the money.'[11] Only fifteen at the time, he had his mum run up copies. Only middle-class punks like the Bromley Contingent could afford the clothes from SEX. That was not how Vivienne saw it; to her SEX was a revolutionary statement: she told the sex magazine *Forum*: 'We were not here to sell toys and fashion clothing but to convert, educate and liberate. We are totally committed to what we are doing and our message is simple. We want you to live out your wildest fantasies to the hilt.'[12] The Teds and rockers were outraged

at losing their source of winkle-pickers and studded jackets and made their displeasure known, but the rag trade always moves on to the next big thing, and Malcolm and Vivienne were on a roll.

In keeping with their name, they made sex the theme. There had been an American T-shirt that had been sold in underground newspapers since the early seventies that featured a life-size pair of breasts printed in their correct position, which caused a double-take when worn by a woman, and confusion when worn by a man. Malcolm and Vivienne ripped it off and had a batch made up. They took paragraphs from Alexander Trocchi's Olympia Press lesbian pornography that McLaren stole from Trocchi's bookshelf and printed them on T-shirts. Growing more bold they did shirts with a naked black footballer sporting a huge cock and, late in July 1975, they found a gay porn drawing in the style of Tom of Finland of two cowboys, naked from the waist down except for their cowboy boots; one of them adjusting the other's cravat, their large flaccid cocks almost touching, mirrored by the suggestive shape of the gun that one carries in a holster. They printed it up on T-shirts, brown on pink and red on green. Vivienne Westwood: 'We were writing on the walls of the Establishment, and if there's one thing that frightens the Establishment, it's sex. Religion you can knock, but sex gives them the horrors.'[13]

Far more offensive was a young boy T-shirt that McLaren came up with, and his design for a shirt featuring the hood worn by the rapist then terrorizing young women in Cambridge. The shop manager withdrew the Cambridge Rapist shirt when McLaren went to New York, not for reasons of taste but worried that the shop would be busted. McLaren was outraged and on his return he reprinted it with the words 'Hard Day's Night' and a salacious piece of music business gossip about Epstein's death. McLaren:

It just intrigued me from a fashion point of view, so I went forward and exploited other things, like printing voyeuristic writing on T-shirts. I also turned the Cambridge Rapist into a pop star. I thought that was good. I thought, when they catch this guy, they'll put it on the front pages and proclaim him a terror to our society and make him a scapegoat. So I thought great, why don't I associate him with Brian Epstein and the Beatles.[14]

He found an image of the type of mask that the rapist wore and put it on a T-shirt with the words 'Cambridge Rapist' above it in pop star letters and below he put a small picture of Brian Epstein and the words: 'Brian Epstein – found dead Aug 27th 1967 after taking part in sado-masochistic practices / S&M made him feel at home.' McLaren told Claude Bessy:

Suddenly Cambridge Rapist T-shirts were being bought by all these 15 year old kids saying "This is a smart T-shirt". I thought it was fucking great... they saw them as slightly shocking and that's all that was important, to annoy a few people, because they felt so lethargic... I think all those kids are artists.[15]

He claimed to be trying to shock people out of their apathy, but given his own sexually repressed youth, it probably told us more about his own confused sexuality than he realized.

Vivienne's statement about the British and sex was of course true. Alan Jones, who used to work at SEX, bought one of the naked cowboy T-shirts the day they put them on sale, and also bought a Cambridge Rapist shirt. He changed into the cowboy shirt in the shop and walked down the King's Road to the West End. At Piccadilly Circus two plain-clothes policemen assumed he was a male prostitute and asked him to accompany them to Vine Street police station, where he was charged under the nineteenth-century offence of 'exposing to public view an indecent exhibition'. McLaren promised to get him the best lawyer possible and get him off. But it was an empty promise and Jones found himself in court with no lawyer and, not knowing what to do, pleaded guilty. He was let off with a fine. The police, meanwhile, paid a visit to SEX, seized a selection of clothing, including the complete stock of the cowboy T-shirts, and charged them with the same crime. McLaren and Westwood were found guilty and also fined.

In another attempt to shock the public, McLaren and Westwood used swastikas on their 'Karl Marx Anarchy' and 'Destroy' T-shirts. Jordan wore a swastika armband as part of her general plan to outrage. It did get her banned from the local pub but only when she was wearing it; they knew she was a nice girl really. Her friend Siouxsie Sioux appeared to wear one all the time. Wearing swastikas and dressing up as Nazis is very popular in Britain. Back in the sixties the staff of *International Times*, led by Bill Levy, once hired German uniforms and posed as Nazis for a staff photo. Various forms of Nazi garb have always been popular items in the middle-class dressing-up box. In January 2007, two weeks before the sixtieth anniversary of the liberation of Auschwitz, Prince Harry, third in line to the throne, appeared at a party while dressed as a member of Rommel's Afrika Korps, complete with a swastika armband.

SEX had a group of regulars which included all of the Bromley Contingent – not yet given that sobriquet – people from Louise's, El Sombrero and other similar clubs as well as the King's Road itinerants. One very stylish customer was Steve Jones, who, together with his school friend Paul Cook, had a rock 'n'

roll group. Jones, Cook and Wally Nightingale, all from the Christopher Wren school in White City, Hammersmith, first formed a band in 1973 named 'The Strand' after the Roxy Music song. Jones was the local thief, the product of a broken home who already had fourteen criminal convictions and had spent a year in a remand home, which he found more enjoyable than living with his mother and stepfather. He later said that the Sex Pistols saved him from a life of crime. Next to join was Glen Matlock, a friend of Wally Nightingale's who had been working as a Saturday afternoon shop assistant in Too Fast to Live Too Young to Die.

In the spring of 1975, Steve Jones, Paul Cook, Glen Matlock and Wally Nightingale played at a party held in the rooms above Tom Salter's café at 205 King's Road. Their repertoire included 'Twisting the Night Away' and two other numbers with Steve Jones on vocals. Steve had been pestering Malcolm to manage the band for some time to no avail; he said he might be interested in managing them, but only if they sacked Wally. But when McLaren returned from a long stay in New York in the spring of 1975, after unsuccessfully trying to manage the New York Dolls, he took up the offer, enthused by the downtown Manhattan punk scene and determined to put his ideas about management into practice in London. Malcolm had always wanted to be an old-fashioned Denmark Street-style Jewish manager in the tradition of Larry Parnes. The first casualty was Wally Nightingale, whom Malcolm fired. He wanted someone who better expressed the transgressive style he was promoting at SEX. Malcolm was also not happy with Steve's vocals, so he gave him a Gibson Les Paul custom guitar brought back from New York and previously owned by Sylvain Sylvain of the New York Dolls, and told him to learn to play it. Steve:

> I guess I learnt properly about three months before we did our first gig... I still didn't know what I was doing in those three months really. I just used to take a lot of speed and just play along to a couple of records over and over again, 'Raw Power' and the New York Dolls' first album.[16]

Mick Ronson, then with Bowie's group, and Brian May were both an influence. Now they needed a new vocalist.

John Lydon was an old friend of Sid Vicious, who worked part-time at SEX – they shared a flat in Hampstead near the station and once had a job working together in the kitchen at Cranks restaurant above Heal's in Tottenham Court Road. Sid's name was not, as many people thought, one of McLaren's Larry Parnes rename attempts: 'Sid' was the name of John's particularly stupid hamster, and 'Vicious' came either from the Lou Reed song, or possibly the

time that the hamster bit Sid so badly it drew blood. Lydon took to hanging out in the shop, visiting with Sid, but though he wore punk-looking clothing, it was of his own invention. He had originally been thrown out of the parental home for chopping his long hair off and dying it green 'like a cabbage'. At SEX he wore chains and safety pins, torn clothing and badges: it was a mixture of Richard Hell, Ian Dury and Lydon's own inventiveness. Vivienne took many of her ideas from him, such as the torn shirts and the unravelling sweaters. He later wrote: 'There was a lot of Viv selling stuff that she took from everything and everyone, particularly me. I was angry about that. I would put things together, and she'd have it in the fucking shop a couple of weeks later – mass produced.'[17]

One day he was in the shop wearing a Pink Floyd T-shirt that he had annotated in ballpoint pen to read 'I hate Pink Floyd'. He had his green hair and the T-shirt was ripped and held together with safety pins. Bernie Rhodes, one of Malcolm's assistants, was particularly struck by this, which, to him, was the right attitude, so he suggested he stop by the Roebuck pub on the King's Road that evening and meet McLaren, Steve Jones and Paul Cook to audition for their new band.[18] Lydon hesitated, but went along. After a few drinks they went back to the shop and Johnny mimed in front of the jukebox, thrashing around and acting like a spastic, miming to Alice Cooper. This did the trick and he was invited to join the band.

Jones and Cook had been playing together for years before punk. The Strand was very much in the glam rock tradition, fast and furious with lots of flash and style; however, they remained very restricted in their musical aspirations, which turned out to be perfect for punk. As Johnny Rotten said in 1994: 'It couldn't have worked without Steve being as structurally limited as he was. I found it absolutely thrilling to be next to him on a stage, the power that would come out of that poxy little amp with usually three strings, because that's all he could remember to hit at one point...'[19] Steve and his mates posed as road crew at a David Bowie concert and walked away with amplifiers, microphones and other expensive stage equipment. Now the band was complete and fully equipped.

McLaren clearly saw the group as his own Monkees-style creation: 'If I could be a sculptor, I necessarily needed clay. I suddenly thought I could use people, it's people that I used, like an artist, I manipulated. So something called the Sex Pistols was my painting, my sculpture. My little artful dodgers.'[20] Lydon, however, had his own agenda and challenged McLaren from the very beginning; he had no intention of playing Trilby to McLaren's Svengali. McLaren:

He didn't even want to be called the Sex Pistols, he wanted just to be called Sex... I wasn't having it, I was in control and I wasn't going to waste my time with a bunch of herberts going out with a name like Sex, I wasn't going to allow it. I was out to sell lots of trousers.[21]

As far as Lydon could see, Jones and Cook were 'two Cockney spivs who jumped at the chance of Small Faces-style fame'.[22] That was fine. Lydon had nothing else going on, so he joined the band. And McLaren sold a lot of trousers.

We were very anti-establishment anything – music and art. We wanted to destroy anything that had ground rules, that kept everything suffocating and safe. We were out to break all the rules any way we could.

COSEY FANNI TUTTI

Meanwhile Genesis P-Orridge,[1] then still legally known as Neil Andrew Megson, had quit the Exploding Galaxy in October 1969 and returned to Hull, where he started a commune, the Ho-Ho-Funhouse, and put together a performance art unit called COUM Transmissions, a name open to many interpretations which Genesis has always claimed came to him in a vision. The most obvious suggestion, given the Exploding Galaxy's interest in new spellings and language, is another word for 'come' – semen. He was still absolutely committed to the reconstruction of behaviour, identity and imagination; this, however, eventually gave rise to problems with the fellow Funhouse members who were more committed to having a good party than changing society.

By this time he was living with Christine Newby, who in 1973 was to become Cosey Fanni Tutti. They first met at an Acid Test party in 1969. She was dressed in archetypal hippie gear of velvets, silks and heavy eye makeup, and Genesis stopped to look at her closely because he thought she looked so much like a 'pretty cartoon'. As he gazed at her, Cosey's knicker elastic snapped, which, as she was high on acid, seemed highly significant to her. COUM Transmissions began as a free-form improvisational group; in other words they couldn't play their instruments. Genesis scraped the bow randomly over the violin strings. Most live reports use words like 'dreadful!' Genesis has described it as being a bit like the Third Ear Band only with theatre. From 1969 until December 1971 they concentrated on musical events, but with Cosey's participation they moved in the direction of performance art, eventually leaving the music behind. The culmination of this

was the infamous *Prostitution* exhibition held at the ICA in 1976. By then they had formed a new band, Throbbing Gristle, which played at the exhibition launch party.

In Hull they acquired a three-ton Austin truck that they named Doris. In the back they built a four-poster bed complete with curtains and bolted down an old rocking chair by the back doors. They painted the interior pink and silver and made it really pretty, 'faggotized' it as Genesis put it. They began to put on COUM Transmissions performances all over the country and soon they knew a number of artists living in London. Robin Klassnik and Jules Baker in particular encouraged them to move to town. Genesis: 'They said we were wasted in Hull. It was better for us to come to London with what we were doing.' In 1973, with only four weeks left on their lease, they had to either find another place in Hull or make the move. Robin and Jules both had studio space at 10 Martello Street, E8, in Hackney, a large factory premises containing forty artists' studios leased out through the SPACE scheme, across the street from London Fields. In 1970 the SPACE scheme had been allocated 200 short-term studio spaces by the GLC but 10 Martello Street proved to an exception and remained in the hands of artists. The rents were very cheap, but the artists had to clear the space and build their own walls. They weren't supposed to live in them but many artists did. Genesis rang and explained their predicament and Robin told him there was one space available in the basement but that it was in terrible condition. Genesis said: 'We'll take it.'

The basement was the one derelict room that no-one wanted: it was damp, it had no floor, no electricity and no water supply. They drove Doris down, complete with their dog, Tremble, and three cats, and parked outside while they did the place up. The floor was so rotten that it had to be replaced. Genesis drove around Hackney until he found a site where several houses were being demolished. He explained to the workmen that he was working for a children's charity that was renovating a building and they needed timber for new floors. The men gave him as much timber as he could take. They inserted a series of beams and built a suspended floor above the original one. This was where Throbbing Gristle later played and rehearsed. Because no-one was allowed to live in the studio spaces, Genesis and Cosey built a giant box in one corner of the derelict room made to look like a pile of timber when in actual fact it was hollow. Inside was a single mattress and a tiny light running off a battery. It was a snug little nest and at night Cosy and Genesis would sneak inside. There was one sink. They fixed the water and an eccentric Arab neighbour who liked to visit the artists' studios turned out to be an electrician and provided them with sufficient electricity to work and

make cups of tea, though not enough to cook. So 10 Martello Street became the new COUM headquarters and later, when they started Throbbing Gristle, it was renamed the Death Factory (London Fields across the road had been a plague pit, and it was already a factory).

They did not have to live in a box for long. They met the girlfriend of a member of the band Rinky Dink and the Crystal Set who were squatting a terraced house at 50 Beck Road, just around the corner. The band had just received a contract from the EMI Harvest label and were about to move out. Beck Road was scheduled for demolition by Hackney Council, which was intending to build an extension to Hackney College, but as they moved their tenants out, more and more of the houses were squatted by artists, among them Helen Chadwick and Mikey Cuddihy. In the end, after a successful campaign to save Beck Road, the council made the squats legal and gave their management to the Acme Housing Association, an artists' housing charity set up in 1972. By the time Genesis and Cosey got involved, Acme was managing thirty-one properties in the East End of London. Between them, Acme and SPACE are largely responsible for the East End becoming known as an artists' area.

Genesis and Cosey quickly got to know others at 50 Martello Street, including Gary Wragg, Ian McKeever, Roger Bates, John Fassolas, Noel Forster and Mike Porter, who all had studios there. The building operated much like an art collective. Rather than each having a traditional painting studio, many of the artists had left their studios open-plan so they could share with each other, and there was an emphasis on inflatables, film-making, the manufacture of multiples, and theatrical and performance events rather than easel painting. The caretaker, who also had a studio there, was Bruce Lacey, one of the first performance artists in Britain, whose robots had performed at the 1965 Albert Hall reading. He had continued to investigate this area and in the early seventies he and his family put on a week-long event called *The Laceys at Home*. They built a three-walled room on the lawn outside the Serpentine Gallery in Hyde Park and proceeded to live in it as normally as possible, cooking meals, watching television, while completely ignoring the onlookers. One evening David Bowie managed to attract their attention and told them he was a fan of their work. They returned the compliment. It was at Martello Street that they made the film *The Lacey Rituals*, which documented the way they made toast, boiled an egg or put on makeup throughout the whole of a day. Their son John was studying fine art at Goldsmiths and soon became involved with Genesis and Cosey. He began to perform with COUM using the name John Gunni Busck. Inevitably COUM's own actions were

influenced by those of the Lacey family, but mostly they performed within a relatively well-defined form which began more than a decade earlier with the happenings artists Yves Klein, Joseph Beuys, Claes Oldenburg, Allan Kaprow and Jim Dine and which continued into the late sixties and beyond. Within this genre, COUM's approach seems closest to the confrontational style of the Viennese Action school of Hermann Nitsch, Otto Mühl, Günter Brus and company.

Their own bleak, harrowing vision was from a distopian future. They were concerned with getting their audience to confront the darkest areas of their being: the most unacceptable and most forbidden. They were not operating on the outer limits – except possibly of the law – because they saw no limits. Their performances took them into areas that were traumatic both to their audiences and to themselves. Continuing the ideas Genesis had absorbed during his three months with Transmedia Explorations, he set out to shock their audiences into a clear recognition of present time, devoid of prudery, hypocrisy or any preconceived notions of behaviour. Like William Burroughs's *Naked Lunch*, he wanted them to see what was on the end of the fork. COUM appeared naked, they slashed their bodies with knives, they sloshed around in stage blood and real blood, they performed and simulated sex, they drank urine and vomited, and the audience vomited too: even the famously theoretical performance artist Chris Burden – notorious for having himself crucified on the bonnet of a Volkswagen – and conceptualist John Baldessari had to run from the room during one performance after fifteen minutes. They said afterwards: 'It's sickening and disgusting and it's not art!'

The general direction of COUM at this point was one of exploring preconceived notions of sexual differences and attitudes. In Hull and when they first moved to London they had made a number of collages, usually in the form of mail art to send to other artists, often using girlie pin-ups and other sexual images. Now they concentrated on more commonplace elements of everyday female experience which were normally never mentioned, such as menstruation and the use of tampons. The problem that many members of the audiences had with this was that rather than celebrate the female experience or make it inclusive, the actions were often so disgusting that preconceived notions were reinforced rather than demolished as Genesis chewed on used Tampax, poured milk over his naked body and drank menstrual blood. One such action was described by Cosey in an interview as involving 'anal and vaginal sex at the same time using a beautiful object we had made from a length of wood with 6 inch metal spikes all around it and dildos on each end.

It was very tribal and ritualistic, an initiation ceremony. It wasn't sexually arousing at all.' The unplanned, intuitive approach to their actions often led them in directions that possibly contradicted their original intentions. In this particular instance there was an opportunity to analyse the event as it was held at the Arts Meeting Place (AMP), an artists' co-operative at 48 Earlham Street, in Covent Garden, which held a Sunday afternoon open house where artists could meet to discuss their work. AMP had everything from traditional painting exhibitions to performance art and music. There was music on Friday nights and open meetings on Thursdays.

In 1974, Cosey's exploration of attitudes to female sexuality led her to give up her job as a secretary and begin full-time modelling for an agency specializing in pornography. Many people have questioned whether this was simply a way of making money but Cosey told *Kinokaze* magazine that it was part of her ongoing exploration of the female body. She told André Stitt: 'We'd used a lot of girlie magazines for the collages etc., and I wanted to be able to use myself.' In her *Time to Tell* booklet she wrote:

My photographic and Striptease projects were you might say like any other investigation but with a real purpose... Through working in a wide variety of photographs/films and venues and with an equally wide variety of men and women, all involving sex in its many guises, I have lost the element within me which suggests as a woman I must always appear sexually presentable. Sex is beautiful and ugly, tender and brutal both physically and mentally.[2]

Her employers naturally didn't know her ulterior motive and when the fact emerged some time later many of the magazines refused to use her again. For several years, however, she appeared regularly on the pages of *Curious*, *Alpha*, *Oui*, *Pleasure*, *Obey*, *Fiesta*, *Park Lane*, *Gallery* and *Men Only*, as well as in a number of sex films and working as a stripper.

Meanwhile, Bruce Lacey's son John had introduced Cosey and Genesis to Chris Carter, a sound engineer who had worked with a number of television stations, including Granada, Thames and LWT. They became friends and he became a regular visitor to Martello Street. Most weekends were spent experimenting with bits of second-hand electronic equipment, exploring the various possible sounds. COUM didn't want to work just within the elitist avant-garde art world and thought that they would have a better chance of reaching a wider audience of young people by performing as a group. On 3 September 1975 they formed Throbbing Gristle, featuring Chris Carter on keyboards, Genesis on vocals, bass guitar and amplified violin, Cosey on lead guitar and special effects – she was taught piano as a child and passed

her exams so naturally she was given a different instrument – and Peter Christopherson on tapes and trumpet. Christopherson, known as 'Sleazy' for his interest in sex, had joined COUM early in 1975. In their first perform-ance he read aloud a text describing the sadistic castration of a teenage boy, pushing COUM into an ever more extreme form of performance art. He was a member of the Casualties Union, volunteers who play the part of casualties in Civil Defence and emergency services exercises, and was trained in the application of stage makeup to create horrific wounds and mutilations, a talent that COUM immediately utilized. He told Simon Ford: 'As a consequence of my joining COUM they became more visceral in their interests.' It also meant they had a brilliant designer on board as Sleazy was a member of the Hipgnosis design team, responsible for, among other things, the design of the Pink Floyd album sleeves. For a while, COUM and Throbbing Gristle's activities overlapped with TG, as they came to be known, giving their first public performance at the opening of a week-long COUM programme held at the ICA on the Mall on 19–26 October 1976.

The opening-night party involved strippers, a blue comedian, Throbbing Gristle, and the punk band Chelsea, renamed LSD for the night as a way of countering the anti-hippie rhetoric that people like McLaren had been spreading. They brought along Mick Jones and the Bromley Contingent. It was through this connection that Bernie Rhodes was able to get the Clash booked in later that same week as part of COUM's programme. COUM had been marginally involved in the Sex Pistols when McLaren had asked Sleazy to take some photographs of them. The results made them look like 'psycho rent boys' according to Jon Savage and were altogether too strong for McLaren, who did not use them. The exhibition space was devoted to Cosey Fanni Tutti's *Prostitution* show and consisted of the props used in COUMs past performances: an unsettling collection of anal syringes, meat cleavers, jars of Vaseline, used tampons, chains and so on. There was a display of framed photographs of COUM in action and of photocopies of press cuttings about COUM. But it was the fourth element of the show, available for viewing only on request, that drew the attention of the tabloids. These was a series of framed tearsheets from the various men's magazines that she had posed for as art works. Although none showed actual sexual intercourse, many of them were explicit. The exhibition was accompanied by a leaflet, written by Genesis, in which he explained:

> Cosey has appeared in 40 magazines now as a deliberate policy. All of these framed form the core of the exhibition. Different ways of seeing and using

Cosey with her consent, produced by people unaware of her reasons, as a woman and as an artist, for participating. In that sense, pure views.'[3]

The Tory MP Nicholas Fairbairn saw the show and fulminated in the *Daily Mail* that it was 'a sickening outrage. Obscene. Evil. Public money is being wasted here to destroy the morality of our society. These people are the wreckers of civilization! They want to advance decadence.'[4] The *Daily Telegraph* felt that 'every social evil is celebrated'[5], whereas the *Sun*, home of the topless page three girl, thought that the show attacked traditional British values: 'It has nothing to do with the Britain we are proud to promote. Mr. Orridge is prostituting Britain – and sending us the bill.'[6] These wonderful new cuttings were framed and added to the exhibition. But COUM had touched on a raw nerve. None of the papers wanted to discuss the issues raised by the exhibition, or by the radical and unorthodox way that Cosey had chosen in order to investigate and critique pornographic imagery. They just saw it as obscene. Questions were asked in the House and the Home Secretary was asked if he had any plans to amend the legislation on the law of obscenity. Genesis and Cosey explained their intentions on television but the furore dragged on and on until everyone was thoroughly fed up with it, including the other residents of Martello Street, who had to put up with Fleet Street hacks trying to get to Genesis and Cosey. Pressure was put on the ICA and they were forced to close their controversial theatre. Their grant was suspended until they submitted plans for further cost-cutting and the director, Ted Little, and Robert Loder, chairman of the ICA council, resigned two months later.

Genesis was now a targeted man. Earlier in the year the police had already successfully prosecuted him for his mail-art. In a case reminiscent of the prosecution of the playwright Joe Orton, who was jailed for sticking collage elements on the dustwrappers of library books, Genesis was prosecuted for sending five mail-art postcards to other artists which the post office deemed obscene. These included one in which a naked bottom had been stuck on a postcard of Buckingham Palace and another of René Magritte's *Time Transfixed* of a train (penis) emerging from a fireplace (vagina), to which had been added an actual copulating couple. The magistrates dismissed the defence of 'artistic merit' as irrelevant and fined him £100 plus costs. He had twenty days to raise the money or go to jail. Genesis borrowed it. His lawyers cost a further £150. Afterwards the police approached him and showed him an envelope containing a further twenty intercepted postcards. They told him: 'We can get you on each of these, any time we want. And you get twelve months inside then. So watch your step!'

As TG was an attempt to reach a wider audience, they now made themselves more recognizable as a group. Genesis cut his long hippie hair and they began wearing black T-shirts, leather trousers or jeans. Cosey would sometimes take off her jacket and show her breasts, covered with fake scars and Chris Carter would slash his arms with a razor, but this was just in the early phase. They soon settled on a vaguely unsettling military look of camouflaged army fatigues. They already had a reputation thanks to the scandal surrounding the *Prostitution* show but had no means of capitalizing on it as they had no record label and no record out. A number of record companies were sniffing around, and Virgin said they would release an album if Cosey was naked on the sleeve but TG wanted complete control and the only way to get that was to start their own label. They called it Industrial Records and launched it with the witty slogan, 'Industrial Records for Industrial People'.

In the early days, they were criticized for an unhealthy interest in and glamorization of Nazi Germany and the iconography of fascism: they took as their corporate logo a photograph of Auschwitz death camp and Throbbing Gristle adopted a lightning flash which, though used as the universal symbol for electricity, also bore a resemblance to the lightning flash of Oswald Mosley's British Union of Fascists. Genesis defended their use of an image of Auschwitz, saying:

> We chose Auschwitz as our logo because it seemed appropriate for our music. And it's also one of the ultimate symbols of human stupidity. And I like to remind myself how stupid people are and how dangerous they are because they're so stupid... Humanity as a whole is stupid to allow anything like that to begin to occur.[7]

There was no doubt though that the whole band had a fascination not just with Nazi atrocities, but with Charles Manson, mass murderers and aberrant behaviour in general. Their first vinyl release, as opposed to a small run of cassettes which they gave away, was in May 1977, with TG's *Second Annual Report*. It was the beginning of the genre which later came to be known as industrial music. Throughout the later seventies, TG and the punks ran on parallel tracks, sometimes overlapping and often sharing the same sensibilities. It is only in retrospect that we can see how courageous Genesis and TG were in taking on the police and the establishment to break new ground artistically, musically and politically.

28 Punk

My personal view on Punk rock is that it's disgusting, degrading, ghastly, sleazy, prurient, voyeuristic and nauseating. I think most of these groups would be vastly improved by sudden death.

BERNARD BROOKE PARTRIDGE, Conservative member of the Greater London Council, 1976[1]

Larry Debay, a Frenchman, had a record shop in Paddington called Bizarre which specialized in Iggy Pop, Zappa, the Modern Lovers, the Flaming Groovies, garage bands; all the coolest material available. He also had a big sideline in bootlegs: Roxy Music, Iggy Pop, Zappa, the Velvet Underground, Pink Floyd, Hendrix and, of course, Dylan, the Rolling Stones and the Beatles. As a record distributor he was in partnership with Marc Zermati's Skydog Records in Paris so Bizarre was the best place to find Dutch and French releases by Hendrix, Flamin' Groovies, the Velvet Underground, Kim Fowley, and Iggy and the Stooges. Larry was a striking-looking individual, even for the record industry, with high riding boots, jodhpurs, long, ginger, hennaed hair and a full beard, dyed bright green. It was quite a sight to see him walking his huge dogs along Maida Avenue, next to the canal, where he lived. Larry, and the other record dealers operating from market barrows in Notting Hill, Camden and Soho, made available the best in proto-punk and had an enormous influence on the British bands.

The two key albums that influenced British punk bands were Patti Smith's *Horses* (November 1975) and the Ramones' eponymous first album (April 1976). Patti believed that the guitar had an iconic value onstage and that it was not necessary to be able to play it. I was personally always irritated by the way she strummed furiously at an open-tuned guitar, as anyone can learn the three basic chords required by rock 'n' roll in a few hours. The Ramones' impact came from the brevity of the songs, the simplicity of the lyrics, and the speed of execution: they were very fast. There were no guitar solos, and certainly no drum solos, with the Ramones.

'I'm Stranded' by the Australian band the Saints was released in Brisbane in September 1976 on their own Fatal Records label, predating all the British punk bands. It was pure punk, fast and fabulous, with no middle eight, just furious energy. All the punks bought it. Bernie Rhodes, the manager of the Clash, had a box of them and gave me one just two weeks after release. Then came 'New Rose' by the Damned, released on 22 October 1976 on the independent British label Stiff; the first home-grown punk record. It sold 4,000 copies in the first week. The Damned had funny punk stage names – Captain Sensible and Rat Scabies – and a goth singer, the ex-gravedigger Dave Vanian, who knew how to put on a good stage act. Like 'I'm Stranded', 'New Rose' was very fast and when the Pistols finally got their first record out, the Damned turned up their noses: 'It's a bit slow, ain't it?' asked Captain Sensible.[2] Several members of the Damned – the guitarist Brian James, bass player Captain Sensible and drummer Rat Scabies – were previously with the London SS, a proto-punk band whose members also included Mick Jones and Terry Chimes, who both went on to become founder members of the Clash, and Tony James, who was first in Chelsea, then Generation X. When Chrissie Hynde joined, they changed their name, at her suggestion, to Mike Hunt's Honourable Discharge. McLaren put them in a studio for two days to see if he was interested in managing them. Captain Sensible: 'They sat there watching us, laughing, and told us to fuck off. No commercial possibilities.' Captain Sensible used to share a squat with Sid Vicious and Sue Catwoman. Most of the early London punk bands, like the Damned, the Adverts and the Clash, who all emerged at more or less the same time as the Sex Pistols, knew each other, had the same musical influences, and had played together in various incarnations, often in pub bands such as Joe Strummer's 101ers.

There was no clear break between the pub bands and the punk bands. Johnny Rotten's deranged Richard III stage pose, the hunched stance, look-ing up at the audience while clutching the microphone, was taken directly from Ian Dury, one of the best pub rock acts and someone that the Pistols admired and who they often saw perform. The razor blade earring was also Ian Dury's. The biggest difference was in speed of delivery; if you played fast, the inadequacies in your playing were less apparent. The speed was also in the performers; the whole punk rock scene was fuelled by amphetamine: fast, hard and aggressive. Siouxsie Sioux told Jon Savage:

> The Pistols were very much part of rock 'n' roll, they weren't breaking down any aural barriers at all, it was rehashing what had gone before, and it was what they put into that that made it theirs. Without Rotten, they would probably have

just been a pub band, in all honesty. Talking about breaking down walls and actually doing it are different things.[3]

There were other punk bands, a different crowd of musicians who had been around for years but who sensed that change was needed in the moribund music scene. Ten years older than most of the punks, the guitarist Andy Summers cut his hair, dyed it blond, mumbled when asked his age, and joined a Newcastle schoolteacher called Sting who played in his local jazz band, Last Exit, and a drummer, Stewart Copeland, to form the Police. Summers had previously been in Zoot Money's Big Roll Band. He had gone psychedelic when Zoot changed the name of that band to Dantalion's Chariot for the hippie market; now he was quite prepared to become a punk. One of Britain's best guitarists, Summers reduced his playing to short jerky chords in a watered-down reggae format with no solos or displays of technical proficiency. It was a winning formula.

There was a third type of punk band, perhaps the only true punks. These were all the kids who saw the Pistols play and went out and started their own band: most of them never managed even the slightest degree of technical proficiency and had faded away again by the end of the seventies. Some, however, made their mark, such as the Slits, John Peel's favourite punk group. Peel: 'Their inability to play coupled with their determination to play – the conflict between these two things was magnificent.'[4]

There was a lot of conflict at gigs as well; punk was characterized by violence. Peter York wrote that punk was almost all style and very little substance: the violent images that first set the tone for the movement were Joe Stevens and Kate Simon's photographs of McLaren attacking a hippie in the front row of the Nashville at a Pistols concert on 23 April 1976.[5] It was a high-profile gig, the audience was filled with friends and members of future rock groups, photographers and rock journalists like Jonh [sic] Ingham. In the middle of 'Pretty Vacant', Vivienne Westwood suddenly turned on the girl next to her, a complete stranger, and began slapping her face. The girl's boyfriend, who was standing about six feet away, immediately reacted, grabbed Vivienne and began to hit her. McLaren may or may not have seen Vivienne's original attack, but he now leapt across the front of the stage to leap on the long-haired boyfriend and thump him. Johnny Rotten, a huge smile on his face, dived off the stage to join in the fray, throwing punches wildly before Steve and Glen intervened to try and pull everyone apart. Vivienne later told Caroline Coon that she had been bored, the Sex Pistols were boring, and had decided to liven things up a bit so she slapped the girl for no reason.[6]

Some of the dimmer members of the community, such as Sid Vicious, took this behaviour as a role model and his violence marred the famous 100 Club Punk Festival. This was held over two days: 21 September 1976 featured the Sex Pistols, the Clash, Subway Sect and Siouxsie and the Banshees; the next night Stinky Toys, Chris Spedding and the Vibrators, the Damned and the Buzzcocks played. The festival appears to have had some of the experimental qualities of the old UFO Club. The organizer, Ron Watts, said it was 'just people getting up and trying to do something'. It was the first-ever gig for Subway Sect and also for Siouxsie and the Banshees – various members of the Bromley Contingent – who formed specially for the event and had never played together before; their act was entirely improvisational with Siouxsie reciting the Lord's Prayer and a few other bits of text she could remember while Sid Vicious on drums thumped away behind her; never varying his beat; none of them knew any actual songs. They had been going to use the Clash's equipment, but their manager, Bernie Rhodes, objected to Siouxsie's swastika armband, and the swastikas drawn in ballpoint pen on Sid's grubby T-shirt, and refused. The Sex Pistols lent them theirs instead. Sid was in a belligerent mood and at one point threw a beer glass which shattered against an iron pillar, cutting several people and blinding a girl in the audience in one eye. The police were called and Sid was arrested, and when Caroline Coon from Release went to find out why, the police helpfully arrested her too (she was later given an absolute discharge). As an event, the Punk Festival can be seen as the genesis of the punk rock scene; in the audience were Gaye Advert and TV Smith who went on to form the Adverts, Shane MacGowan, who later formed the Nipple Erectors and the Pogues, Viv Albertine of the Slits and Chrissie Hynde, who later formed the Pretenders. Caroline Coon, reporting on the festival, wrote: 'If the punk rock scene has anything to offer, it's the opportunity for anyone to get up and experience the reality of their wildest stage-struck dreams.'

Another characteristic example of punk violence occurred at a Clash gig I attended at the ICA in October 1976 when Mad Jane Crockford, later Jane Modette of the Modettes, appeared to bite off the earlobe of her boyfriend, Shane MacGowan. There was blood everywhere and that was what he told me had happened; which I duly reported in the *NME*, helping to associate punk with violence. Joe Strummer saw what was happening from the stage and, unlike Johnny Rotten, who would have presumably joined in, shouted at them: 'All of you who think violence is tough, why don't you go home and collect stamps? That's much tougher.' It was not a bad spontaneous response. MacGowan later told *Zigzag* magazine:

I was up the front at this Clash gig in the ICA, and me and this girl were having a laugh, which involved biting each other's arms 'til they were completely covered in blood and then smashing up a couple of bottles and cutting each other up a bit. Anyway, in the end she went a bit over the top and bottled me in the side of the head. Gallons of blood came out and someone took a photograph. I never got it bitten off – although we had bitten each other to bits – it was just a heavy cut.[7]

I interviewed the Clash for *NME* a week later and asked Joe Strummer about the violence at punk gigs. His attitude was clearly ambivalent. He had initially told me: 'We're anti-fascist, we're anti-violence, we're anti-Racist and we're pro-creative. We're against ignorance', but throughout the interview he was playing with a flick knife which, at one point, he held right in front of my face to make a point. Strummer:

Suppose I smash your face in and slit your nostrils with this, right?... Well, if you don't learn anything from it, then it's not worth it, right? But suppose some guy comes up to me and tries to put one over on me, right? And I smash his face up and he learns something from it. Well, that's in a sense creative violence.[8]

A side of Strummer remained fascinated by thuggery, part of his attempt to transform himself into a working-class lad when in reality he was a middle-class public schoolboy, son of a diplomat, who had made a conscious effort to adopt a working-class accent. He carefully adapted his vocabulary, use of language and mannerisms, slurring his words to disguise his plummy voice. Few things were authentic in punk and the pretence that they were all working class was the most absurd. As the culture critic Peter York wrote: 'The most fantastical part of punk, the most irritating part of it, was the altogether lurid ideas it put about about what it was to be working class in the mid-seventies.'[9]

Looking back on the punk movement in 1998 Johnny Rotten commented: 'I know there was a Pistols, then you got that very nice middle-class copy called The Clash which was really a band all about sloganeering. Oi Oi for the upwardly mobile! And then you get all this other stuff.'[10] Rotten never liked the Clash, though he liked the musicians in the band. The Clash rapidly transformed themselves from a punk band into a world-class rock 'n' roll band, reaching a vastly larger audience and still managing to get across something of a political message. Of all the bands, they were the most successful at using punk as a vehicle for political change and songs such

as 'Career Opportunities', 'I'm So Bored with the USA', 'London's Burning', 'The Guns of Brixton', 'Julie's been Working for the Drugs Squad' and '(White Man) In Hammersmith Palais' give an idea of the scope and range of their message.

Dick Hebdige saw the punks as responding directly to their social situation: unemployment was at its highest since the war, lack of opportunity, a lack of facilities for young people, sink schools and sink estates. London was the target of IRA bombs on shops, restaurants and tube stations, so nowhere felt safe. Football matches were also unsafe, disrupted by waves of football hooliganism with multiple stabbings, dart throwing and invasions of the pitch. Most punk bands were in their late teens or early twenties, but the foot soldiers were younger, many of them still at school and most of them living at home. They felt disengaged, a lost generation, but by living at home they absorbed the casual racism and reactionary ideology fed their parents through the television and the right-wing tabloids. Very few punks went to college or read books.

Punk was their reaction to all this: the utopian ideology of the hippies had obviously failed, a point made over and over by the tabloids and willingly absorbed by the punks. The much-vaunted left-wing anti-racist stance of the punks is largely fiction; a revisionist assessment by sociologists and the punks themselves rewriting their own history to make it more acceptable. They were inarticulate, barely educated, unable to give form to their feelings, and struggling to create their own language to deal with the situation: the ripped and torn clothing, the safety pins through the cheeks and lips, the swearing and heavy macho stance, the self-harm, the antagonism towards hippies, the claim to be working class even though a large number of them were middle-class suburbanites. Hebdige wrote: 'The punks appropriated the rhetoric of crisis which had filled the airwaves and the editorials throughout the period and translated it into tangible (and visible) terms.'[11] Though some of it was phoney – Billy Idol and Chelsea singing about the 'right to work' had many people in stitches – much of it was a relevant and honest attempt to articulate their lives. Johnny Rotten:

> my whole attitude towards the Pistols was 'This is going to be an *honest* band'... It started out as a laugh, right? Being asked to sing in a band!?! I just thought 'Whoopee! Ha Ha! What fun! A bumpkin like me who can hardly be bothered to talk.' And then I took myself a little serious. And I found I wasn't scared shitless of yelling in a microphone and it was really good fun. And 'cos they couldn't write words I did all that – all the literature. It suited me fine.

All the things I've wanted to moan about all my measly life I got into songs. Whoopeeee![12]

Vivienne Westwood and Johnny Rotten got on very well initially because they both went to church, though he was a Catholic and she was C of E. John attended mass and took confession every Sunday with his mother until after they recorded 'Anarchy in the UK'. McLaren later claimed: 'I never could feel comfortable in his presence because I felt this dreadful Catholic guilt.' This was one of the big differences between the punks and the hippies; whereas the hippies celebrated love and sex, almost to the point of obsession, the punks were repressed and almost asexual. Johnny Rotten's famous comment to Caroline Coon, 'Love is 2 minutes and 52 seconds of squelching noises', summed it all up.

Though he initially appeared to celebrate the violent side of punk, Rotten soon changed his mind. He saw punk as empowering, a way of energizing his generation into doing things for themselves. He told Jennifer Byrne:

We were there for that sense of rebellion – 'we've had enough of this, thank you'. Nothing to do with violence... it's about making our world a better place... I opened a few doors. It's a shame a lot of trash and mosquitoes came in with the goods.[13]

He said it was best done through humour: 'I've always said, I thought the Sex Pistols was more Music Hall than anything else – because I think that really, more truths are said in humour than any other form.'[14]

This is a side of punk rarely mentioned: many of the bands *were* funny. The Damned were almost a comedy act, with Captain Sensible in his frilly white tutu in contrast to David Vanian's dramatic gothic posturing in his cape and white makeup. The *Snuff Rock* EP released on Stiff by the street theatre group/ punk novelty act Alberto y Lost Trios Paranoias was such an accurate parody of punk rock themes that some punks took it seriously.

Punk was not a religion or political party, there was no manifesto or agreed platform. Some people, like McLaren, associated it with anarchy but he was torn by his desire to cause complete chaos and his desire to make lots of money. Sometimes he consciously enacted the stereotype of the rapacious Jewish manager, talking in the thick middle-European accent he used in the opening scene of *The Great Rock 'n' roll Swindle*, and on other occasions he appeared to be acting against his own interests, as when he sacked Glen Matlock – their principal songwriter and a reasonable bass player – from the Sex Pistols and replaced him with Sid Vicious, who wrote nothing and could

not play a note. Glen Matlock had to play Sid's part on recordings and Sid's amp was turned off when they were onstage. Which of the two Malcolms was involved in making the clothes for SEX is hard to say: they were so expensive that only middle-class kids could buy them, but on the other hand, he encouraged kids to copy them. He told Claude Bessy:

> The greatest thing, the most amazing inspiration that I was conscious of and certainly party to, and certainly helped to create, was this do-it-yourself thing. See, the greatest thing about my clothes were the fact that anybody could imitate them; it was the ideas that counted, not the manufacturing of them.[15]

It was this encouragement to do it yourself that, in McLaren's view, spawned the do-it-yourself punk Xerox magazines, the cartoons, the ripped and torn clothes made from bin-liners and clothes pegs, and gave them the confidence to get up onstage and perform, even though they could barely play a note. McLaren: 'I don't think they considered they could do any of that before. They always felt inferior... I think the whole punk thing was extremely artistic, probably the most artistic thing that's come about for years, really.' Peter York agreed that they were artistic: 'Punk clothing and terminology were *so* Post-Modern it hurt. The clothes were literal cut-ups which pulled together bit of previous youth cultures and Art references in a way that suggested history was a trash-can.'[16]

It was not the Pistols who encouraged their audiences to make their own clothes but the Clash, whose manager, Bernie Rhodes, had helped compose one of McLaren's most innovative garments, the 'You're gonna wake up one morning and *know* what side of the bed you've been lying on!' T-shirt. This listed Rhodes and McLaren's loves and hates, like a fashion magazine charting what's 'in' and what's not, or, to give it greater gravitas, a 'punk manifesto'. 'Loves' included Eddie Cochrane, Christine Keeler, Pat Arrowsmith, Mal Dean, zoot suits and dreadlocks, Gene Vincent, Alex Trocchi and the strangely conflated 'John Lacey and his boiled book v St Martin's Art School' – presumably meaning John Latham's chewed book and Bruce Lacey. 'Hates' went on much longer and included the Divine Light Mission, Elton John, Bryan Ferry, Tramps, Mars bars, and McLaren's rag trade rivals, including Ossie Clark, Nigel Waymouth (Granny Takes a Trip), Biba and Antiquarius 'and all it stands for'.

Rhodes, who worked with the early format Sex Pistols when McLaren was away in the States before Johnny Rotten joined, seemed to mirror almost everything that McLaren did, a few weeks later. Seeing the success of the

Pistols under McLaren's management, he found himself a group, the Clash, hoping to make them the Rolling Stones to McLaren's Beatles. Rhodes had his office in a warehouse near the Roundhouse in Camden where he stored second-hand jukeboxes – one of his many sidelines – which he now named Rehearsal Rehearsals and fixed up for the band to practise in. Bernie had his own line in torn, silk-screened T-shirts that he sold from a stall in Antiquarius, so just as the Pistols dressed in ripped, torn clothing with silk-screened messages, so the Clash were encouraged to personalize their own clothes. First they went through a Jackson Pollock phase and were covered in splattered paint; then came zips and stencils of words and phrases. (This may be one of the ideas that supposedly came from the International Situationist group; their predecessors, the Lettrists, had political slogans written on their trouser legs; there is a well-known photograph by Ed van der Elsken of Jean-Michel Mension with several texts between his knees and trouser cuffs. Strummer told Jon Savage: 'Bernie Rhodes was guiding and packaging... He probably suggested that we write words on our clothing. I never knew much about that Situationist stuff, still don't today, but that's where it came from.')[17] Their fans were urged to do it yourself, and they did.

After the 'Anarchy' tour, where the Clash played support to the Pistols, McLaren and Rhodes decided that their bands were becoming a little too independent and needed a firmer hand. Rhodes called a meeting of the Clash at the Ship, on Wardour Street near the Marquee, and told the band that he wanted 'complete control'. Strummer: 'I came running out of the pub with Paul collapsing on the pavement in hysterics at those words "complete control".'[18] Joe and Mick Jones quickly wrote a song, using 'Complete Control' as the title, that was released as a single in September 1977.

But first the bands had to find record labels. The Damned had remained true to the do-it-yourself punk ethic and signed up with Stiff, a small independent label, but McLaren, despite his anti-capitalist rhetoric, signed the Pistols to Britain's biggest record label, EMI. Rhodes, who spouted even more anarchic, anti-capitalist ideas than McLaren, followed suit and signed the Clash to the American giant CBS for the then huge sum of £100,000.

Of course, the high prices charged in SEX and his previous shops made it hard for McLaren to claim he was a true anarchist. He told Simon Napier-Bell on a talk show:

Only as a fantasy. I was never really committed to it. I just liked causing trouble – like getting £50,000 from EMI for a group they were afraid to sign but equally afraid to miss out on – then causing so much trouble that they had to drop

them, then getting the money all over again from another company. That's the sort of anarchy I loved.

But even if the Pistols individually were not politically committed, they delivered a political message with their behaviour – stage-managed as it often was – and by their lyrics, and many other groups and fans were very influenced by them. They did change many people's lives, as did the whole punk movement. Malcolm McLaren:

I didn't ever consider I was managing a rock 'n' roll band. I considered myself more a person ultimately concerned in driving as many people wild as possible with the hope of creating some kind of different social outlook on kids' lives. To give them potential for them to realise that they are important and give them a critique in which they can then direct their energies.[19]

And so, all over Britain, kids wrote 'anarchy' on their T-shirts with biro and modified their old school blazers. Bands like the Adverts prided themselves on taking charity shop clothing and remaking it to create punk classics. McLaren kept an eye open for any new street fashions that he could copy and market.

Punk put the record companies into something of a quandary; even though the bands were pulling in big crowds, the A&R men only had to listen to a few seconds of playing to know that the energy level could not be reproduced in the studio, and without that most bands were nothing – none of them could play and in studio conditions their inadequacies would sound even worse. And as for their energy, it did not take much to recognize that it was largely chemically induced: far from being the energy of youth, it was the typical behaviour of people who had ingested large amounts of amphetamine sulphate. Speed was the drug of choice for punks, and lots of it. These were the reasons why the record companies were reluctant to sign up the bands; there was no way that most of them would ever get played on mainstream BBC radio. Who should they select and market and who not? In this respect punk certainly challenged capitalism: in a do-it-yourself movement, there are no commodities. The anarchic side of McLaren celebrated this fact – but he had one of the few bands who were musically gifted and at times Johnny Rotten was in danger of displaying a rich Irish tenor. McLaren told Paul Taylor:

Punk rock couldn't be sold... it was too much to do with do-it-yourself. As soon as you get a do-it-yourself force out there, you spawn 5,000 other groups. The record industry never wanted 5,000 groups. They only want one

group. One group is more manageable. It's one dictator telling you what the culture is about rather than 5,000. They don't like the socialist idea that everyone can do it.[20]

The punk attitude also went against commodification. 'We're not into music, we're into chaos,' Paul Cook told Neil Spencer of the *NME*, an attitude that made people in organizations like the BBC hesitant to get involved. John Peel, later famous for promoting obscure punk bands, never recorded Peel sessions with the Sex Pistols or with the Clash. As far as the Pistols went, he thought the band had turned down his offer whereas in fact his producer, John Walters, had felt that he could not impose such an unruly band on delicate BBC engineers. With the Clash, it was a simply a case of their lack of professionalism. Peel noted in his dairy:

> They actually got as far as recording backing tracks, but then they were so out of their heads they couldn't finish it, and decided the BBC's equipment wasn't good enough. It was one of those things where you thought: How do you argue with stupidity on this level? Not a very punk attitude, I thought.[21]

Given the circumstances, punk was quite a challenge to the marketing men but they responded with their usual brilliance: coloured vinyl, strangely shaped records, picture sleeves, limited edition singles, 12" remixes; whatever small market there was for each group was sold the same product in as many forms as the marketing departments could come up with. The other way to sell records was to attract as much publicity to your group as possible. This McLaren attempted, but it was not his staged attempts at outrage such as signing a recording contract outside Buckingham Palace that provoked a feeding frenzy among the more simple-minded tabloids; it was a relatively minor incident on Thames Television's *Today* programme, broadcast live on 1 December 1976. Arranged at the last minute as a replacement for Queen, who had cancelled, the Sex Pistols and members of their entourage were invited on to the show to be interviewed by old school TV presenter Bill Grundy, who clearly felt it was beneath his dignity to talk to such an unruly bunch of yobs.

At the studio they were given unlimited alcohol in the green room, which they enthusiastically drank. Then, with Johnny Rotten, Steve Jones, Glen Matlock and Paul Cook seated, with the Bromley Contingent, Siouxsie Sioux, Steve Severin, Simon Barker and Simone, standing behind, Grundy introduced the band by saying: 'You see, they're as drunk as I am.' Grundy apparently didn't notice the first four-letter word, spoken by Steve Jones when Grundy asked

him where the advance money from EMI had gone: 'We've fuckin' spent it, ain't we?'

This line was leading nowhere so Grundy changed tack to try and patronize them with comparisons to Beethoven, Mozart, Bach and Brahms, but Johnny Rotten immediately claimed: 'They're all wonderful people... they really turn us on.'

Steve Jones: 'But they're dead!'

Bill Grundy: 'Well, suppose they turn other people on?'

Johnny Rotten, muttering under his breath: 'That's just their tough shit.'

At last Grundy had something to work with: 'It's what?'

Johnny Rotten realized what Grundy was doing and tried not to be led: 'Nothing. A rude word. Next question.'

Bill Grundy: 'No, no, what was the rude word?'

Johnny Rotten: 'Shit.'

Bill Grundy: 'Was it *really*? Good heavens, you frighten me to death.'

Grundy then paid attention to the Bromley Contingent and addressed Siouxsie Sioux. She told him that she'd always wanted to meet him.

Bill Grundy: 'We'll meet afterwards, shall we?'

Siouxsie played along by pouting.

Steve Jones realized that Grundy had to be dealt with the way you would humour a drunk in the pub: 'You dirty sod. You dirty old man!'

Bill Grundy: 'Well keep going, chief, keep going. Go on, you've got another five seconds. Say something outrageous.'

Steve Jones: 'You dirty bastard!'

Bill Grundy: 'Go on, again.'

Steve Jones: 'You dirty fucker!'

By this time the group were cracking up with laughter and Grundy goaded Jones into more and more obscenities.

Bill Grundy: 'What a clever boy!'

Steve Jones ended with an inspired choice of words: 'What a fucking rotter.'

Bill Grundy: 'Well, that's it for tonight... I'll be seeing you soon, I hope I'm not seeing you [gesturing to the band] again. From me, though, goodnight.'

As the signature tune began and the band began dancing, Grundy muttered an off-mic 'Oh shit!' to himself, as if he had only just realized what he had done. His career was over, and the Sex Pistols' had just begun.

'Fuck' had only been said twice before on British television: first by Kenneth Tynan in 1965, who took some time to stutter it out, and again by

Sir Peregrine Worsthorne in 1973. The *Today* show in 1976 had three. The autocue operator had thrown up her hands in horror at Jones's first expletive, sending her handbag flying through the air, showering makeup across the sound stage. By the end of the show, the studio switchboard was lit up with complaint calls; a Liverpudlian lorry driver, James Holmes, had been so outraged that he had kicked in the screen of his new £380 television set. Siouxsie and members of the band grabbed the phones and told the callers to 'Fuck off!' Their EMI driver, experienced in the ways of rock bands, quickly ushered them into the limo and drove them away just as the first police car arrived.

Although the programme was only shown in the London area, the national tabloids picked up on the story and made it front-page headline news: 'The Filth and the Fury,' screamed the *Daily Mirror*, a line that Julien Temple later used as the title of his Sex Pistols film, and the *Daily Mail*, the *Daily Telegraph*, the *Daily Express* and the *Sun* all fulminated with self-righteous indignation with front-page headlines. The *Mirror* particularly loved the group and between 1 and 3 December ran huge headlines proclaiming: 'TV Fury at Rock Cult Filth' and 'Siouxsie's a Punk Shocker'. The *Evening Standard* ran a huge front-page headline: 'The Foul Mouthed Yobs'. The next day there were press reporters waiting outside the Pistols' homes, and they were followed to their meeting at EMI. Workers at the pressing plant were refusing to sleeve 'Anarchy in the UK'. Bill Grundy had been suspended from the *Tonight* show for two weeks and the press were camped outside EMI headquarters in Manchester Square. Paul Cook: 'I've never seen Malcolm panic so much.' When a badly hungover Paul Cook threw up at London airport, it became front-page news. For the press it sold papers, but the self-appointed custodians of British morality took it all seriously.

The result was that it became almost impossible for the band to play anywhere without the local council, police or community groups cancelling the booking. The Pistols, the Clash and the Damned with Johnny Thunders' Heartbreakers as special guests were booked to play an EMI-supported tour of Britain. By the time they set out to play their first date, at the University of East Anglia, six of the dates had been cancelled. The UEA date was cancelled on the day by the vice-chancellor, prompting a sit-in by the enraged students. By the time they reached Sheffield, thirteen out of the nineteen dates had been cancelled. The BBC refused to play 'Anarchy' (except John Peel, who managed to get it on twice) and in Caerphilly, Wales, they had to contend with local Christians holding a prayer meeting outside the gig. McLaren exacerbated the situation by telling the *Daily Mirror*:

'It will be very likely there will be violence at some of the gigs because it is violent music.'[22]

Then, on 5 January 1977, the EMI board, in the face of opposition from the record division, sacked the band, paying them the remainder of their advance to leave. That same month, Johnny Rotten insisted, with Malcolm McLaren's connivance, that Glen Matlock be fired and replaced by his old friend Sid Vicious; he didn't get on with Matlock, who was too musical for his taste, and Cook and Jones were old school friends and kept their own company. They never really accepted him. Now the band had a bass player who couldn't even play three notes and who was also a junkie, thanks to his new girlfriend, Nancy Spungen. Glen Matlock had to be hired as a session musician to play bass on the records. It was the beginning of the end of the band.

Central to the Sex Pistols' work was a reworking of the themes of nationality and the images of the state, particularly the flag. This was a time when the dole queues were getting longer, particularly for the 16- to 24-year-olds, and the fantasies of empire had not yet left the British establishment; perfectly described by Rotten as 'England's dreaming'. The Union flag was incorporated into Pistols poster art and T-shirts and Rotten's 'God Save the Queen' not only had powerful lyrics, but almost accidentally exposed how the record charts were fixed to show what the record companies wanted them to show. Johnny Rotten: '"God Save the Queen" is a very valiant record. But you're under the powers that be; you're supposed to just roll over and salute the very forms that make you cannon fodder.'[23] Its message was genuinely shocking. It was a message from the streets, from a younger generation who saw nothing for them in the future except the dole or a dead-end job, literally 'no future', the original title of the song.

The designer Jamie Reid, who had been at art college with McLaren, defaced Cecil Beaton's formal portrait of the Queen for the record sleeve by adding a safety pin through her cheek, a pastiche of the May 1968 Situationist International poster *Une jeunesse que l'avenir inquiète trop souvent* of a bandaged head with a safety pin across the mouth. The blackmail style of lettering, with each letter cut from a newspaper, was first used for Pistols graphics by Helen Wallington Lloyd, a friend of Malcolm's from Goldsmiths school of art, and was continued by Reid as the Pistols' 'brand'. It became symbolic of punk in general.

Though at the time Johnny Rotten claimed he was not consciously aware of the upcoming royal jubilee, this was precisely the time when the record began to rise in the charts. The acquiescent population, bribed by a two-day

bank holiday, duly hung out tawdry bunting, flew the Union Jack (made in China) and sat down to street banquets and parties, more than 4,000 in London alone. 'God Save the Queen' rose in the charts, selling twice as many copies as its nearest chart rival. W. H. Smith, Woolworth's and Boots the Chemist had all refused to stock the record. Radio and TV stations refused to transmit an advertisement for it. Despite the establishment's best efforts, by the end of Jubilee week, 'God Save the Queen' had sold 200,000 copies. Clearly they could not allow the number one record in the week of Queen's jubilee to proclaim her kingdom as 'a fascist regime' so they quite simply fixed the charts. CBS Records, who distributed Virgin, confirmed to Malcolm McLaren that the Sex Pistols were outselling Rod Stewart, whom they also distributed, by two to one, but inexplicably the Pistols stalled at number two while Rod went to number one.

The reasons were various: the primary one was that, for that week only, the BPI (the recorded music industry's trade body) had issued a secret directive to the British Market Research Bureau, the people who actually compile the charts from weekly shop returns, that all chart-return shops with financial connection to record companies should be dropped from the weekly consensus of record sales. The Virgin Megastore chain, which had been publicizing the Pistols heavily and was consequently selling more of their records than anywhere else, was not allowed to add their sales to the census. The next week the directive was rescinded. Even at number two, some shops, such as W. H. Smith, simply left that line blank in their in-store chart listings. John Fruin, the head of WEA Records (Warner, Elektra, Atlantic), was the head of BPI at the time. In 1981 he lost his job after irregularities were detected in the chart positions of several of WEA's artists.[24]

The establishment reaction to the punks was far more extreme than it had been to the hippies: right-wing papers like the *Sunday Mirror* ran headlines like 'Punish the Punks!' and their dim-witted readers did just that. Johnny Rotten was attacked by thugs chanting 'We love our Queen' as they slashed his hands, severing two tendons so that he could never play guitar again. He also suffered a bad slash down his thigh from a machete. In a separate incident Paul Cook was hit on the head with a metal bar. Anyone dressed in punk attire became the automatic target for Teddy boys or drunken yobs.

The contradictions between the original punk attitude and the bands signing to major record labels was extreme, insurmountable. 'Punk' itself became a marketable commodity and the message was lost in advances from EMI, CBS and the other big labels and their marketing men and women. Johnny Rotten has a slightly revisionist take on this but saw what was happening:

'We never considered ourselves punk. It was a moniker put on us. The Sex Pistols were directly related to our culture in England – the message of "Yeah, you can do it yourself"... [the] street sense of 'This is all fucked up, let's change it.'[25]

Punk, a sobriquet bestowed on the movement by Caroline Coon, was a label he was never happy with. As early as 1978 he told *NME*:

> I refute that term. It was ridiculous. I hate that name. I think it's loathsome. And I particularly hated the people who took upon themselves to go around calling themselves punks. They didn't have the mentality to suss out that that was pure media walking all over them. People always get it wrong.[26]

Rotten described how, on the Pistols' Swedish tour, he and the photographer Dennis Morris had incurred managerial wrath for staying in his hotel room listening to reggae when 'Malcolm thought we should be down smashing things up and living up to our image.' Similarly, after John had chosen, amongst others, the likes of Captain Beefheart, Dr Alimantado and Tim Buckley to play on the hour-long Capital Radio show he put together in the summer of 1977 with DJ Tommy Vance, McLaren was equally furious. Rotten: 'It seemed to mean that if I liked records that I couldn't be half as ignorant, moronic, violent, destructive, etcetera, etcetera as they wanted to promote me as.'[27] It was no surprise that Rotten eventually left the group in disgust: 'The Sex Pistols just became a publicity fiasco rather than something with actual content and purpose. All that was thrown by the wayside and we ended up as some sorry rock 'n' roll sad, sad thing that I didn't want to be a part of.'[28]

In 1978, Johnny Rotten used £1,200 of his Sex Pistols money as the down payment on a house on Gunter Grove, SW10, which was used as the gathering place for his new group PIL. Rotten:

> We lived near to the Chelsea nick. That's apparently where they train the drug squads. So, you know, they needed places to practice. I suited their purpose. They even sent me the bomb squad once: 'Uh, we have reason to believe there are bombs on the premises.' 'Why?' I said. 'Because an Irish flag was raised through your window!'[29]

It was the Italian flag and it was being used as a curtain. Unfortunately the house became well known to fans and attracted a large number of hangers-on and parasites. On 13 December 1980, the door was broken down in the middle of the night. Rotten grabbed a ceremonial sword to defend himself before he realized it was the police making their usual entrance. As there

was no other thing they could charge him for, they got him on possession of a spray can of Mace, bought legally in the USA. They released him from the police station in his pyjamas and dressing gown and he had to walk home in the middle of the night down the Fulham Road in his bare feet. The police continued a programme of harassment against him and in the end they got what they wanted. Early in 1981 he moved to the United States, where he could live in peace.

**I think the so-called punk movement is indeed a media creation.
I have, however, sent a letter of support to the Sex Pistols in
England because I've always said that the country doesn't stand
a chance until you have 20,000 people saying 'Bugger the Queen!'
And I support the Sex Pistols because this is a constructive,
necessary criticism of a country which is bankrupt.**

WILLIAM BURROUGHS to Victor Bockris

A few days after the Bill Grundy incident, McLaren and Westwood changed the
name of their shop yet again. It became Seditionaires. Punk had become too
popular. Now the shop looked completely anonymous, more like a sex shop,
with frosted-glass windows making it impossible to see inside or out, and a
small brass plaque, which Peter York likened to that of a provincial doctor,
reading: 'Clothes for Heroes. Open Monday to Saturday, 11am to 6pm'. It was
very intimidating and kept out most of the sightseers looking for punks. It
was not long before they had to install metal grilles over the windows
because Teddy boys broke them so often. There was grey industrial carpet and
the walls were painted grey, featuring huge blow-up photographs of the fire-
bombing of Dresden. Behind the counter was a floor-to-ceiling photograph
of Piccadilly Circus, mounted upside down. To continue the wartime theme,
McLaren knocked a large hole in the ceiling to simulate bomb damage. There
was a small table with a built-in cage containing a live rat. The room was
furnished with sixties Adeptus chairs with fluorescent orange nylon covers
giving it a slight retro look. Now that they were making money Vivienne had
completely taken over the clothes line and was making coordinated outfits
aimed at the high fashion market. The shop's new label read: 'For soldiers
prostitutes dykes and punks' beneath the anarchy symbol. The clothes were
now very expensive – a week's wages for a pair of bondage trousers with the
legs constrained by a strap – and were being bought by collectors. No real
punks could possibly afford them.[1] This was the inspiration for Poly Styrene's
famous song 'Oh Bondage Up Yours!' She saw a pair of bondage trousers in
Seditionaires and it sparked a flow of images: of Suffragettes chained to the

railings of Buckingham Palace, and of David Bowie's 'Suffragette City'; scenes from the film *Moses*; pictures of African slaves, chained and shackled; the arguments in Wilhelm Reich's *Sexual Revolution* – all combined to create her punk anthem. Poly Styrene: 'I had an innate desire to be free. To be free from unwanted desires, seemed desirable.'[2]

X-Ray Spex were one of the best of the second wave of punk bands. Like the Pistols, the band had its origins in the King's Road, where Poly Styrene had a boutique stall in the Beaufort Market. She put a band together that was a model of today's multi-cultural London: Poly's father was a dispossessed Somaliland aristocrat; the guitarist, Jak Airport, was brought up by his Anglo-German mother; the bass player, Paul Dean, had a Polish father who escaped to Britain from the Nazis; Lora Logic, the sax player, had a German Jewish father and a Finnish mother, and when her mother insisted she finish school – she was only fifteen – she was replaced by Rudi Thompson, who was Australian. Only the parents of the drummer, B. P. Hurding, were described by Poly as 'true Brits'. X-Ray Spex got their start by playing a residency at the Man in the Moon pub on the King's Road every Wednesday night. 'Oh Bondage Up Yours!' was their first single.

One of the best things to come out of punk was the proliferation of punk fanzines, a late-seventies version of the sixties underground press. The first one was started by Mark Perry, a bank clerk from Deptford. Called *Sniffin' Glue*, it was named after the Ramones song 'Now I Wanna Sniff Some Glue' on their first album and it was the Ramones that inspired the magazine. Perry read Nick Kent's review of their first album in *NME* and rushed out to buy it. After listening to it he felt the need to write about it, even though he had never written before. 'I thought the Ramones were the most basic rock band ever. I decided that they should be written about on that level, a basic street level, not intellectual.' He took each track as it came and said how great they were, then set about getting his views into print. He said that he had seen fanzines about country music and R&B and that another influence was a Scottish magazine called *Bam Balam*, about sixties pop, but it's hard to imagine that he had not seen John Holmstrom and Legs McNeil's *Punk* magazine, which began publication in New York in December 1975 and was widely available in London by the time punk took off. At one point *Punk* sold more copies in London than in New York (the final print run was 10,000 copies).[3]

Perry: 'I could see that it was possible to do a magazine without having loads of resources.'[4] The first issue, which came out in July 1976, was put together entirely with the materials available in his bedroom: a children's

typewriter and a felt-tip pen. He just thought of it as a one-off. The headlines were scribbled in a loose freehand, the text hand-typed on to single-sided pages stapled at the top left. His girlfriend ran off twenty copies on the photocopier at her office and he took them into Rock On, the Soho music shop. 'How many have you got?' they asked, desperate for anything to do with punk. They bought them all and advanced him money to get more copies printed. In addition to the Ramones, the first issue of *Sniffin' Glue + Other Rock 'n' roll Habits For Punks,* to give it its full title, featured stories on the Blue Oyster Cult and 'Punk reviews'.

It quickly became the house organ of the punk scene. Perry told the *NME*: 'I was a massive rock fan, and went to loads of gigs during that period', but it was punk, and the newly formed Sex Pistols, that transformed his life: 'It seemed to be about the actual life you were living in 1976, it really was a lifestyle choice. If you got into the Pistols, you changed your life. That's how dramatic it was.' In the third issue, he branched out and used an illustration. The photographer Michael Beal offered him the use of his pictures free of charge and he ran a front-page picture of Brian James from the Damned in what has become a classic *Glue* cover. The magazine filled a demand and sold well. Perry moved the office from his bedroom in Deptford to a spare room in Rough Trade Records. He retained the rough-and-ready, amateur look because it encouraged other people to have a go. In issue 5, November 1976, he wrote: 'All you kids out there who read Sniffin' Glue, don't be satisfied with what we write. Go out and start your own fanzines... Let's really get on their nerves, flood the market with Punk writing.' And, just as punk bands proliferated, within months there were dozens of punk fanzines, including *48 Thrills, Ripped and Torn, London's Burning, Anarchy in the UK, Tomorrow the World, Bondage,* and my favourite, *Apathy in Ilford,* mostly produced clandestinely on office Xerox machines. Sarah Shosubi of *More On* fanzine told Virginia Boston: 'We felt something special, part of a new thing, which was very radical – underground.'[5] When punk became commercialized in 1977, Mark Perry folded *Sniffin' Glue,* not wanting it to lose its edge. He was not in it for the money and it had served its purpose. The punk fanzines knew no rules, and so constantly broke them, not just in the manner of layout and production, which was always amateur at best, but in subject matter: they libelled the bands, they challenged the authority of the police, the army, the church and the government and they usually did it with a big humorous 'Fuck off!' They were a breath of fresh air.

The problem of not having anywhere to play was a serious one and was partially solved by Andy Czezowski, who opened a dedicated punk venue,

the Roxy Club. When Malcolm McLaren was away in New York, attempting to manage the New York Dolls, Andy Czezowski had stepped in to manage the books at the shop. After this, he joined his partner Sue Carrington on the team at Acme Attractions. Acme Attractions was owned by John Krevine, and began, like Malcolm and Vivienne's shop, by selling retro clothing. He had a stall at the Antiquarius Antiques Market on the King's Road, but the other stallholders objected so much to their jukebox that they were forced to move down into the basement. Here they could do what they liked; as you descended the stairs you were hit by the body-thump of heavy-duty dub, straight in the gut, enough to stop people in mid-step. Don Letts, one of the few black punks on the scene, was the shop manager and DJ. The clothes may not have been as innovative at those at SEX, but they were much cheaper and the music was far far better. Acme was often the only place you could hear some of the records Don Letts played. Letts: 'It was the best club in town... It reflected the multi-cultural way that London was heading. All tribes were represented and I was the Don.'[6]

Among the regulars were Boy George and the members of the Damned. Often overlooked by punk historians, the Damned were the third pole in the punk triumvirate along with the Pistols and the Clash. They were among the most articulate of the punks and never fell for the press image of punk. Captain Sensible told Jon Savage: 'I don't think there was such a thing as punk, it was an attitude that existed before punk, and it still exists now. It was a way of me existing without the state infringing on me, as little as possible, anyway.'[7] The Damned were friends with John Krevine and used his storage space in Deptford for rehearsals, and it was through Acme Attractions that they met Andy Czezowski, who offered to manage them. All of this activity irritated Malcolm McLaren, who soon saw Acme Attractions as his arch rival. McLaren felt very proprietorial about the punk scene and when Czezowski opened the Roxy, he refused to let the Pistols play there because he had no part in its ownership or organization. It was all to do with selling more trousers.

The Roxy Club, at 41 Neal Street in Covent Garden, was the premier punk club. It had previously been a gay club called Chaguaramas, and members of Spandau Ballet had been among its customers as early as spring 1976. Named after Chaguaramas Bay in Trinidad, it had been one of the many gay clubs frequented by Siouxsie Sioux and the Bromley Contingent, Sue Catwoman and Gene October, the lead singer with the newly formed band Chelsea. It was Gene October who introduced Andy Czezowski to the owner, a one-armed Swiss barrister called René Albert. He charged Czezowski £300 to rent

the club on Tuesday and Wednesday nights which, as the club was normally closed those nights, was a risk-free deal for Albert. Czezowski brought in Barry Jones as a partner to help raise the money.

Inexplicably, before the club opened its doors, the owner changed the name to the Roxy, presumably for mysterious legal reasons connected to the fact he had been given ninety days to vacate. The first gig was on 21 December 1976, when Generation X did a preview gig, but the official opening was by the Clash on 1 January 1977. It was a dark, cavernous basement with round metal pillars supporting a low ceiling. This meant that the stage also had to be low, less than a foot high, which didn't stop some bands from smashing the polystyrene tiles when they swung the mic stand or leapt in the air with a guitar, puncturing the ceiling with the machine head. Pogoing punks often smashed the polystyrene tiles above them to show how high they could jump. Repairs had to be paid for the next day. One of the main reasons people pogoed was because unless you were in the front row, you couldn't see the band. Andy let the audience do whatever they wanted: they smashed the plastic glasses by jumping on them, sprayed graffiti on the walls, took drugs and gave blowjobs in the toilets. The floor was always sodden with spilt beer, spit, blood and vomit. It was a wild club and people were free to do their thing.

The stairs and the room were painted matt black, which made it very difficult to find your way around. There were floor-length mirrors everywhere for the punks to look at themselves, which also gave the illusion that the room was bigger than it really was. As with all clubs, the action was mostly in the ladies' toilets. The Roxy in its original incarnation ran from December 1976 until April 1977. Don Letts was the DJ, but as few punk records had yet been released, he mostly played the reggae and ska that he played at Acme Attractions. There were short gaps between records because only one of the turntables worked but that was all right. Letts: 'In that gap you could feel the vibe of the room by the ambient noise you heard.' He also recruited his brother Desmond and some of the Rasta brethren to work at the club. Letts told Paul Marco: 'They saw the potential for an untapped herb market and the women.'[8] The punks didn't know how to roll proper joints so they sold them pre-rolled.

There were two bars: a small lounge bar upstairs with a maroon carpet where the Bromley Contingent and the occasional Sex Pistol would pose and members of the music press would drink, and a proper bar downstairs where the real action was. It was run by Tony Gothard, the house hippie who had hair down to his shoulders. Lubricated by a pre-gig drink at the White Lion on

the corner of James Street and Floral Street, the punks lined up outside the Roxy in orderly fashion, always dressed for maximum effect. It was nothing like the scrum outside CBGBs in New York; in London even the bartender queued up to gain entry. The look was *Rocky Horror Show* meets SEX with fishnets and black satin, white face paint and heavy black eye makeup. Many girls wore ripped men's shirts with the name of bands scrawled on them, the holes and tears held together with safety pins. According to Peter York, the safety pins and razor blades came from Warhol transvestite superstar Jackie Curtis and were picked up on by the Sex Pistols from Malcolm McLaren, but the razor blades were from Ian Dury and the safety pin from the May 1968 poster.[9] Czezowski had to replace the lavatory chains virtually every day as these were much favoured as necklaces. There were people dressed as Nazis, dressed in black bin-liners, see-through plastic macs, bondage trousers and muslin tops, there were punks with noughts and crosses in dayglow paint all over their faces, in torn unravelling jumpers and fishnets with no skirt. One Japanese girl wandered around naked all evening. Very little of the clothing came from the King's Road; it was all hand-made. Faces were painted in bizarre shapes and colours, hair was sculpted and shaved, coloured and spiked. It was all tremendously creative and inventive, but even more remarkable was how they had managed to get into the West End from the suburbs dressed that way. The punks were much more extreme than the hippies ever were because they were purposely looking to shock.

The Roxy provided a venue for all the new bands: the Adverts did their second ever gig there; Eater, Johnny Moped, Chelsea, the Cortinas, Slaughter and the Dogs, the Damned, the Outsiders, the Stranglers, the Lurkers, the Jam, the Vibrators, the Boys, the Zips, Squeeze, the Rejects, the Only Ones – virtually every punk band going mounted the low stage and thrashed away at their instruments. Most of them didn't bother with a sound check, most of them could barely play at all. Those that did attempt to balance their sound were wasting their time because Armand Thompson, who worked the PA, only used three microphones: an overhead, a guitar and lead vocals. He claimed that when he was pissed he was incapable of mixing more than that and, anyway, the club was so small there was no need to mic the drums. He would pretend to change things if a band wanted to try and set proper mic levels if that made them happy.

Czezowski had a season of American bands – Cherry Vanilla, the Heartbreakers, and Wayne County and the Electric Chairs – which helped the club's finances. They were not strictly punk but they had the right levels of energy and were more professional than the British punks, who learned

quite a bit from them. Unfortunately the Heartbreakers, and their camp follower Nancy Spungen, also introduced them to heroin.

Czezowski did not have a proper agreement with René Albert, the club's owner, and often made a loss. At the end of March, the owner brought in a new manager, called Reiner, and turned over the booking of the bands to an agency. It was the beginning of the end. On 23 April 1977, Andy Czezowski was physically ejected from the club for non-payment of rent, which by that time was running at £25,000 a year. Siouxsie Sioux was playing that night and opened her set by announcing that as Andy was no longer running the club, this was the Roxy's last night. Before performing her encore she announced from the stage:

> 'I'd like to make an announcement that Andy's been kicked out of this club, that the people who actually own the lease here are taking advantage of the fact that he made the place famous. I want every single one of you in the audience tonight to promise that you're never going to show up here again. This place is closing.'[10]

Meanwhile the new manager, Reiner, was jumping up and down on a banquette at the back shrieking: 'No it's not. It's staying open! It's not closing!' It dragged on until 24 April 1978, but from the moment Czezowski left, it became just another venue. Punk had worked too well and there were hundreds of bands out there, all desperate for somewhere to play, so the owners never had a problem booking acts. As punk became more mainstream, plenty of kids from the suburbs trekked in to fill the place. But the atmosphere was gone. The real Roxy had closed.

Czezowski started a new place, the Vortex at the Crackers discotheque at 203 Wardour Street, but he got swindled out of it almost immediately, and the Vortex never had the atmosphere of the old Roxy. He and Sue Carrington finished up by buying a building in Brixton, from which they could not be evicted, and successfully ran the Fridge Club there for twenty years.

The massive publicity given to punk by the tabloids was taken up by the music press as a way to boost their flagging circulations. *NME*, *Melody Maker* and *Sounds* covered every punk gig, interviewed the most inarticulate punk bands ('People who can't write interviewing people who can't talk for people who can't read' – Frank Zappa), encouraged the public to buy extremely bad records ('If you really be honest about it most Punk records were fuckin' awful, and just another con' – Johnny Rotten[11]), and wrote yards of overwrought prose about punk being the music of the streets that was empowering working-class youth. In reality most of the key members of the

scene – Malcolm McLaren, Vivienne Westwood, Jamie Reid, Glen Matlock, Joe Strummer, Mick Jones, Paul Simonon, TV Smith and Gaye Advert, Viv Albertine – had been to art school, which had far greater impact on punk sensibility than any tower blocks overlooking the Westway. More directly, the T-shirts, the record sleeves and the posters all showed a profound sense of the history of contemporary art, making references to Dada, Surrealism, Lettrism, the Situationist International and other twentieth-century art movements. In the future, punk was to become more celebrated for its graphics and clothes than for its musical contribution, though in 2007 Rupert Murdoch's *Sunday Times* did give away a free CD of tracks by the Sex Pistols, the Damned and the Buzzcocks called *Anarchy in the UK*, packaged with Jamie Reid-style graphics, to commemorate the thirtieth anniversary of a movement it vilified at the time.

The commodification of punk didn't take long; as a social movement it was over by April 1977, the time Andy Czezowski was thrown out of his own club. It had taken about nine months from start to finish; after that it was just a question of record companies trying to wring records out of the bands; of King's Road shops and market stalls flogging unravelling sweaters and plaid bondage trousers, and the entrepreneurial spirit shown by those punks prepared to pose for tourist photographs for money. Some of the original Roxy crowd turned to prostitution, others dealt in speed.

It is axiomatic that the true character of a culture, the state of its national consciousness, can be glimpsed through a nation's popular music, television shows and tabloid newspapers. In the post-war period there was never such a division as the one between the punks and the cultural establishment in the late seventies. The punks exposed the barely restrained violence beneath the British stiff upper lip; the repressed rage of the 'flog 'em, bring back hanging' old ladies delicately sipping their tea in Bexhill-on-Sea and Windsor; the roiling frustrations and daily disappointments of the robot-like millions commuting into the City of London each day to make millions for foreign bosses and anonymous shareholders; the blatant hypocrisy of the Fleet Street newspapers, suppressing and distorting facts to suit the political objectives of their millionaire owners; the cynical manipulation of children and the poor by the pony-tailed advertising men of Charlotte Street – one punk band had a song about the champagne party held to celebrate the launch of individual fish-finger packs for pensioners – the steady diet of murder, murder, murder in films and television drama, and, in the seventies, still the puritan admonitions against sex. The contradiction here was at its most obvious and schizophrenic: sex was legal, in fact, and yet it was a crime to

depict it graphically on film or in print; murder was illegal, in fact, and yet it was celebrated and depicted dozens of times a night on television. One was healthy, pro-life, natural; the other its exact converse, but the anti-life brigade were in power, spreading a grey fog of sexual guilt and fear, headed by Mary Whitehouse, the Billy Graham Crusade, and the right-wing Festival of Light.

Punk was opposed to all this. Punk put a crack in the carapace of power and control and exposed the Wizard of Oz hiding within. It said 'Fuck this!' instead of 'Mustn't grumble'. It was overwhelmingly negative, but that was what was needed. As the country waved flags and celebrated Queen Elizabeth's Silver Jubilee as if Britain still ruled the waves the punks showed the true state of the country. Punk believed in absolute honesty and personal empowerment; do it yourself, don't wait for some boss or bureaucrat to condescendingly help you. The way things were going, with a shrinking manufacturing base and ever-growing dole queues, there was no future for young people. Punk encouraged them to develop what skills they had and take a pride in personal achievement; it was pretty basic but it was better approach to life than they received in sink schools. Nor were the kids from the council estates the only ones who were disillusioned; the ex-public school managers of the Members told me how they felt adrift; they had been brought up to rule an empire, to be leaders in society, but that society no longer existed and it had not yet been replaced.

Whereas the hippies had a pantheon of gurus and mentors – William Burroughs, Allen Ginsberg, R. Buckminster Fuller, Marshall McLuhan, R. D. Laing, Wilhelm Reich, Herbert Marcuse, Bob Dylan and the like – the punks did not read and their ideas remained garbled and ill-formed. People like Johnny Rotten, Joe Strummer and Malcolm McLaren took on that inspirational role in the movement. Malcolm McLaren, despite his contradictions and financial hypocrisy, clearly felt that punk could be the agent for social change. Unfortunately his eye for the main chance distracted him. Johnny Rotten told Chris Salewicz: 'I think he did things to the best of his abilities. He didn't start out for the wrong reasons. It's just that money interfered. He gets things wrong and tries to manipulate people's lives like it's a game of chess.'[12] With no-one to offer any direction, punk rapidly ran out of steam. It did not, however, run out of speed, which continued to be the drug of choice for the next movement, the New Romantics.

Perhaps the most significant role played by the punks in the late seventies was in the formation of Rock Against Racism (RAR), one of the most important anti-fascist organizations of the period, which was supported

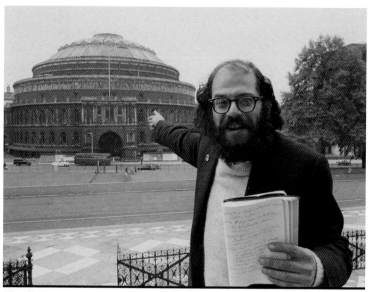

Allen Ginsberg outside the Royal Albert Hall at the press conference called to announce the *Poets of the World* reading in July 1965. Ginsberg was the main inspiration behind the formation of the British counter-cultural scene of the sixties.

Adrian Mitchell was the surprise hit at the 1965 Albert Hall poetry reading with his anti-war poem 'To Whom It May Concern (Tell Me Lies about Vietnam)'.

Gustav Metzger at Gallery One, 16 North Audley Street, helping to install Victor Musgrave's *Festival of Misfits* show of Fluxus artists in October 1962. The photograph is by Ida Kar.

Constructing Indica at 6 Mason's Yard in September 1965. From left to right: Barry Miles, John Dunbar, Marianne Faithfull, Peter Asher and Paul McCartney. McCartney also designed the wrapping paper for the shop.

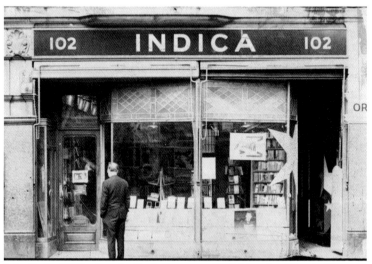

Indica Books at 102 Southampton Row in the summer of 1967. *International Times* had its offices in the basement. The stars painted on the window (right) are by Michael English.

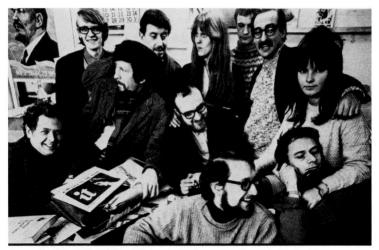

The staff of *International Times* (*IT*) pose in their basement office at Indica Books, 102 Southampton Row. Back row, from left to right: V. I. Lenin, Barry Miles, Peter Stansill, Sue Miles, Roger Whelan and David Z. Mairowitz; middle row: Jeff Nuttall, Jim Haynes, Tom McGrath and Christine Uren; front row: Jack Henry Moore and John Hopkins.

Inspired by Malcolm X in America, Michael de Freitas changed his name to Michael X and started his own Black Power group. Seen here in 1967 with two of the brothers: left, Winston Branch and right, his brother Frankie Dymon.

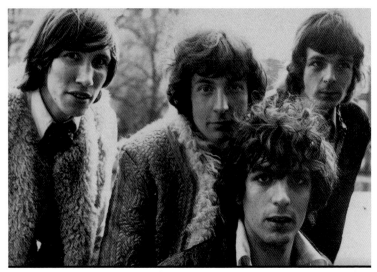

The original Pink Floyd line-up. From left to right: Roger Waters (bass), Nick Mason (drums), Syd Barrett (guitar and vocals) and Rick Wright (keyboards). The group was named after Barrett's cat, which was in turn named after two American bluesmen.

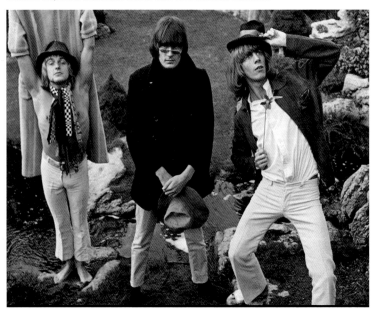

The Soft Machine were the other house band at the UFO Club. From left to right: Robert Wyatt (drums), Mike Ratledge (keyboards) and Kevin Ayers (vocals). The name was taken from the William Burroughs novel, with his permission.

Yoko Ono's first gallery show, *Unfinished Paintings and Objects*, opened at Indica Gallery in Mason's Yard on 9 November 1966. John Lennon had arrived two days before while the show was being hung and met Yoko there for the first time.

Caroline Coon photographed by Loomis Dean at the offices of Release – a 24-hour helpline to provide bail services for people arrested for drugs offences – at 50 Princedale Road, Holland Park, June 1969.

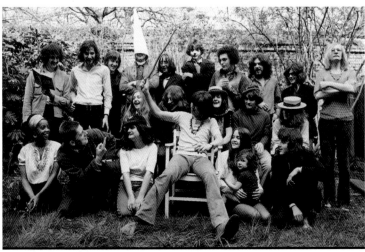

The 'schoolkids' who actually edited the Schoolkids issue of *Oz*. Richard Neville is in front, waving a cane, a bearded Felix Dennis is on the back row, third from the right, and Jim Anderson is on the far right.

Vivienne Westwood, right, in Seditionaires, getting street fashions back on the street in 1977. Her daughter Tracy O'Keefe, left, wears one of Westwood's famous unraveling sweaters.

Mary Quant, on the floor with her classic Vidal Sassoon haircut, photographed at a fashion show in 1966 while making sure that the miniskirts are short enough.

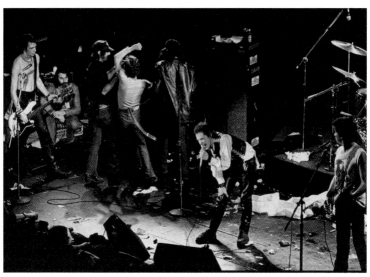

The Sex Pistols' last ever gig, held at the Winterland Ballroom in San Francisco, California on 14 January 1978. From left to right: Sid Vicious (bass) – watching security remove a fan from the stage – Johnny Rotten (vocals) and Steve Jones (guitar).

Derek Jarman, modern Renaissance man: film-maker, screen-writer, painter, author, essayist, set-designer, gardener, gay-rights and **AIDS** activist.

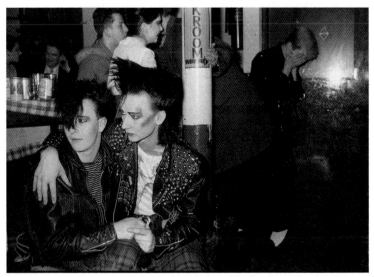

Boy George, young, innocent and in love in the early days of the New Romantics. Ever since World War Two, London street style has inspired couturiers around the globe and in the early eighties it was at its most extreme.

Damian Hirst, main organizer of Freeze, the 1988 art show responsible for launching the group of London art students who became known as the YBAs (Young British Artists).

The Colony Room in the new century, photographed by Carla Borel. On the right, artist Sarah Lucas talks to a glum-looking Neal Fox. Part of her self-portrait made from cigarettes is at the far left of the bar.

– albeit sometimes reluctantly – by most of the punk bands. RAR was formed in response to a racist outburst from a quite unlikely source. At a concert in Birmingham on 5 August 1976, Eric Clapton, who had based his entire career on playing the music of black American blues musicians, launched into a drunken racist diatribe in which he supported the anti-immigrant 1968 'rivers of blood' speech of the right-wing politician Enoch Powell. The man who at various times had said: 'All I did was copy B. B. King' and 'If it ain't Mississippi black music it ain't worth a damn', now drunkenly told the audience:

Vote for Enoch Powell! Enoch's our man. I think Enoch's right, I think we should send them all back. Stop Britain from becoming a black colony! Get the foreigners out. Get the wogs out! Get the coons out! Keep Britain white. I used to be into dope, now I'm into racism. It's much heavier, man. Fucking wogs, man. Fucking Saudis taking over London. Bastard wogs. Vote for Enoch, he's our man, he's on our side, he'll look after us. I want all of you here to vote for Enoch, support him, he's on our side. Enoch for Prime Minister! Throw the wogs out! Keep Britain white![13]

The response was immediate. A left-wing activist, Red Saunders, his friend Roger Huddle and others wrote a joint letter to the music press which read:

Come on Eric... you've been taking too much of that Daily Express stuff and you know you can't handle it. Own up. Half your music is black. You're rock music's biggest colonist. You're a good musician but where would you be without the blues and R&B? You've got to fight the racist poison otherwise you degenerate into the sewer with the rats and all the money men who ripped off rock culture with their cheque books and plastic crap. We want to organize a rank and file movement against the racist poison in music. We urge support for Rock Against Racism. PS: Who shot the Sheriff, Eric? It sure as hell wasn't you!

The next month Saunders and his friends organized RAR and began publishing *Temporary Hoarding*, a cross between a sixties underground paper and a punk fanzine. They also began preparations for a huge rally. This saw 80,000 people march all the way from Trafalgar Square to Victoria Park in London's East End on 30 April 1978 for an open-air concert featuring, among others, the Clash, X-Ray Spex, Steel Pulse and the Tom Robinson Band. The contrast between the reactionary old hippy millionaire going on about 'bastard wogs' while ripping off their licks, and the energetic young punks onstage, spreading a message of tolerance and goodwill, could not have been

greater. There had been a lot of unthinking racism and anti-semitism in punk, and RAR helped to focus people on real issues and stop the movement from being taken over by the National Front, who saw disaffected youth as their natural recruiting ground. Clapton never recognized he had done anything wrong; he continued to support Powell's position and refused to apologize. Years later, when he played with Dire Straits at a Nelson Mandela concert, the organizer, the anti-Apartheid activist Jerry Dammers from the Specials, approached him and said: 'You know this is your chance formally to apologize for what you said.' Clapton told *Uncut* magazine: 'I thought "You must be fucking joking." And I wouldn't do it. I was so insulted.'[14]

Though it is now considered to be the best film about British punk, Derek Jarman's *Jubilee* was never intended to be a documentary film about the period but, better than any of the dedicated punk films, it captured the punk sensibility of the time, albeit in a highly romanticized, art film format. Derek Jarman told Jon Savage:

> Jubilee was originally a Super 8 film with Jordan, it wasn't anything to do with punk in that sense. It was to do with Jordan and whatever she wanted to make, but it grew in the course of early '77, while we were writing it, and it was Jordan who brought in the punk element, because we wanted musicians involved.[15]

Derek Jarman had known Jordan since 1974, ever since he first saw her stepping off the Brighton Belle at Victoria station dressed in white patent leather boots, a transparent plastic mini-skirt 'revealing a hazy pudenda', a Venus T-shirt, smudged black eye shadow and a 'flaming blonde beehive'. He rushed up and introduced himself, saying he would like to get to know her.[16] He used her in the party scene of *Sebastiane* and also on Valentine's Day, 1976, when he filmed her at a party at Andrew Logan's loft where the newly formed Sex Pistols were playing. When the evening seemed to be flagging, McLaren persuaded Jordan to get up onstage and strip, which she did with Johnny Rotten's half-hearted collusion. It still didn't get them any press.

Jarman spent months making the rounds of the punk concerts and clubs, looking for likely actors for the film. Nell Campbell, known as Little Nell, from the *Rocky Horror Show* played Crabs, described by Jarman as 'sexy, nymphomaniac, plastic schmaltz, nubile'. The nineteen-year-old actress Toyah Willcox, recently arrived from Birmingham and not yet a punk rock star, played Mad, 'the flame–haired embodiment of craziness'. Toyah: 'When I got to his flat, Derek's lover, a beautiful French boy called Yves, was wandering

around naked. Derek was completely sexually liberated. He asked me if I wanted tea… I asked, "What part do you want me to play?" He said: "You'll be Mad, the pyromaniac."' Wayne County was hired to play Lounge Lizard, 'the world's biggest star', having sold 50 million copies of his hit 'Paranoia Paradise' in Russia alone. The Slits became a street gang, a role they took to with great enthusiasm. Gene October, from Chelsea, played Happy Days, and Hermine Demoriane, who had walked a tightrope to present Derek with his Alternative Miss World crown, played Chaos, a mute, tightrope-walking, motorcycle mechanic au pair.[17] (She later released a 12" EP called *The World on My Plates*.)

The young Adam Ant played Kid. He described the meeting in his auto-biography. Earlier that afternoon Adam had lain face down on the floor of Jordan's bedroom while she slashed a hole in back of his black T-shirt, pulled the fabric apart and carved the word 'FUCK' into his back with a razorblade. He jumped up afterwards, but had to sit down again, feeling faint. Adam Ant: 'Jordan washed the blood away and put an old T-shirt on to my first bit of body decoration to soak up the blood. Then she put the kettle on.'[18] After a nice cup of tea, he slung his leather jacket over his shoulder and went for a walk down the King's Road, hoping to impress the punks. He had only gone a few hundred yards when someone ran up to him. Adam: 'He said he was a director and would I like to be in his film entitled Jubilee, all the while beam-ing a cheeky smile at me.' Jarman was delighted to hear that he knew Jordan and was in a band but had not realized that the 'Fuck' on Adam's back was written in blood until Jordan told him later; he thought it was eye liner.[19]

Though punk intruded on *Jubilee*, the film dealt with the decline of Britain in more universal terms. The framing device has Dr John Dee, Queen Elizabeth I's court astrologer, showing his queen a vision of her kingdom 400 years in the future; a parallel jubilee to that of Queen Elizabeth II. The old queen is horrified: the country is bordering on fascism, gangs of feral youths fight it out with neo-Nazi police, murderous gangs of girl punks cause mayhem, the streets are desolate, boarded up, the rich live behind barbed wire cordons. One of the high points comes when Jordan, dressed as a half-naked Britannia, carrying her trident and wearing her helmet, goose-steps across the stage to a performance of 'Rule Britannia' by Suzy Pinns. It's as if the statue on top of Tate Britain had come to life. Jarman described his dystopia in *Dancing Ledge*: 'In Jubilee all the positives are negated, turned on their heads. Its dream imagery drifts uncomfortably on the edge of reality, balanced like Hermine on the tightrope. Its amazons make men uncomfort-able, ridicule their male pursuits. Its men are all victims.'[20] The derelict

warehouses and wharfs around Jarman's studio in Butler's Wharf and Shad Thames were perfect locations for this desperate, depressing view of Britain in decline. The film was shot entirely on location and in Jarman's studio over a six-week period. Sometimes there would be a delay in shooting while the producers, Howard Malin and James Whaley, ran around London looking for more money but they scraped by. The film cost £200,000 in all, a tiny sum.

Jarman took his mother to the premiere, where the audience response was tumultuous. At the end, as the credits rolled, people were shouting, arguing and fainting as he wheeled his mother up the aisle in her wheelchair. She looked around and told him: 'This is a very accurate film.'[21] Much of Fleet Street liked the film and *Variety* described it as 'one of the most original, bold and exciting films to come out of Britain this decade'. Predictably, the 'punk experts' on the weekly music papers damned it. They did not know Jarman's work and were unfamiliar with his type of individual artistic expression. They were expecting something like a documentary or a punk musical; there is music, but it is only a small part of it. Vivienne Westwood called it as 'the most boring and therefore disgusting film'[22] she had ever seen and produced a souvenir T-shirt, silk-screened with her long rant against the film, which she ended by saying: 'I ain't insecure enough nor enough of a voyeur to get off watching a gay boy jerk off through the titillation of his masochistic tremblings. You pointed your nose in the right direction then you wanked.' Malcolm and Vivienne saw the film as being in competition with their own, ill-conceived, *The Great Rock 'n' roll Swindle* (which has not stood the test of time). All the other punk films faded away with time, but *Jubilee* remains remarkably prescient.

As far as Derek was concerned, everyone was corruptible, particularly the punks. As he said in his memoirs: 'Afterwards, the film turned prophetic. Dr. Dee's vision came true – the streets burned in Brixton and Toxteth, Adam [Ant] was on *Top of the Pops* and signed up with Margaret Thatcher to sing at the Falklands Ball. They all sign up one way or another.'[23] Though it, unsurprisingly, contained echoes of Ken Russell and Pier Paolo Pasolini, *Jubilee* was a perfect auteur film: the cast and crew were all Jarman's friends and many of the roles were written specially for them; the locations were the streets and warehouses where he had lived for the previous decade. The film changed and grew from day to day, with an infinitely flexible script determined by the previous day's shooting and sometimes by money. He wrote: 'With Jubilee the progressive merging of film and my reality was complete.'[24]

Jubilee is remarkable as a visual record of the face of London in 1977, and also as a fashion document. Punk was above all a fashion statement. 'You

are what you wear.' It was about to enter its mannerist phase complete with pirates, pierrots and pashas. King's Road shops no longer sold clothes; they sold costumes. Never had the dressing-up box been so thoroughly raided. The young generation of punks like Boy George and Steve Strange now took punk fashion to an extreme.

The new generation was totally, unquestionably, more open and optimistic... Club life had never existed like this before: more kinds of drugs were consumed in London than ever before; more people gathered on a Saturday, *outside* mainstream pop culture, than ever before.

MALCOLM MCLAREN

It was a huge movement. By the autumn of 1978 punk had worn itself out and the London club scene had become stagnant. Flatmates Steve Strange and Rusty Egan decided to remedy this by opening a new club of their own. They even had the location lined up. Steve Strange, who had been a regular at Louise's, and was briefly involved in the Moors Murderers punk band, had become the doorman at Billy's, a gay club at 69 Dean Street. When Louise's closed, the club's DJ Caroline had also moved to Billy's. They noticed that the club was virtually empty on Tuesday nights and two weeks later, after some enthusiastic discussions, Steve and Rusty approached the owner and told him they could fill the club on Tuesdays with their friends. They would take the entrance money and he would get an enormously increased bar take. He had nothing to lose. Billy's was the latest incarnation of David Tennant's old Gargoyle club, and was still entered by the rickety lift on Meard Street just around the corner. Calling it Billy's – a Club for Heroes, they printed up flyers which read: 'Fame Fame Jump Aboard the Night / Fame, Fame, Fame. What's Your Name?' and quickly packed the place. Tuesday nights quickly became known as Bowie Night, and the crowd it attracted were those punks who had started off as Bowie fans and still retained that love of reinventing themselves with their costumes. News of the club spread by word of mouth as the music press was not interested – there were no live bands; despite this, the line soon stretched around the block and people had to be turned away.

Many of these people had been very young when punk first began and now came into their own. Boy George was only fifteen when the Sex Pistols formed and could not afford Vivienne Westwood's clothes; now he had developed

his own unique look, making his spectacular entrance in a kimono, face paint and one of his extraordinary headdresses. Black bin-liners, safety pins and zips now gave way to some of the most innovative clothing ever seen on the streets of London, creative combinations of Bowie's various personae combined with what Peter York has called the 'Ruritanian toy soldier' look,[1] with little peaked caps and sashes, the huge baggy Turkish pants, pill-box hats with veil, lots and lots of makeup: Stephen Linard wore a tartan battle-dress suitable for Culloden, Boy George's boyfriend Marilyn arrived dressed as Rita Hayworth, and David Claridge and Daniel James arrived one night as characters from *Thunderbirds*. Every Tuesday night Theresa Thurmer, a secretary at the *Daily Express* by day, transformed herself into Pinkie Tessa and arrived in a pink Little Bo Peep outfit complete with golden tresses. The fashion department of St Martin's School of Art used it as their R&D department. Steve Strange described the scene in *Blitzed!*:

> People stood in the Soho rain in gold braid and pill box hats, waiting to get in. Cossacks and queens mingled happily and narcissism ran riot... All these people were dressed like royalty, while in reality they were just ex-punks running up the clothes on their mum's sewing machines at home in the suburbs or living in the nearby squats in Warren Street.[2]

The club ran from 10 p.m. until 3.30am with Rusty Egan at the turntables. He did not play much in the way of punk records; the Bowie Night audience was fed up with punk and looking for something new. As well as the many ages of Bowie, he played 'Warm Leatherette' by the Normal (Daniel Miller, founder of Mute Records), whose lyrics referenced J. G. Ballard's *Crash*; Human League's 'Being Boiled'; the theme from *Stingray*; Barry McGuire's 1965 'Eve of Destruction'; 'In the Year 2525' by Zager & Evans from 1969; and minimalist electronic German rock albums, particularly Kraftwerk's *Autobahn* (1974), *Radio-Activity* (1975) and *Trans-Europe Express* (1977). These were combined with Berlin cabaret from Marlene Dietrich, which gave a decadent thirties feel to the club. Steve Strange, dressed in a German army greatcoat and leather jodhpurs, maintained a strict door policy while making sure that people who did get in would be comfortable in each other's company. Robert Elms wrote: 'Billy's wasn't a place for those who dressed up for the occasion but for those who dressed up as a way of life. A small incestuous group numbering no more than a couple of hundred kids in search of a life of style.' After three months the club had outgrown the premises and it was time to move. The owner did not want to lose this winning formula and became so threatening that Rusty Egan went into hiding. They moved anyway, and on

Tuesday, 6 February 1979, Bowie Night opened at the Blitz wine bar in Covent Garden.[3]

Blitz was at 12 Great Queen Street, across the road from the Freemasons' London HQ and surrounded by suppliers of Masonic regalia. Though they sometimes looked askance at these fancy-dressed clubbers gazing enviously at the Masonic aprons and chains displayed in the local shop windows, given their own penchant for fancy dress the Masons could hardly complain. At Blitz the walls were decorated with large murals of the London blitz: bombers illuminated by searchlights in a smoke-filled sky and St Paul's Cathedral standing defiant surrounded by flames. Each Tuesday 350 people crammed into the club, paying £2 to become a member and £1 to enter; there was no guest list and no free entry; everyone had to pass Steve Strange's critical gaze to get through the door. He could be merciless, and most Tuesdays he was threatened or spat at but he knew how to handle himself. Even with his foot-high jet-black hair, eyeliner and whiteface, the South Wales bruiser sometimes showed through. He was also carrying a silver-topped cane. There was a regular 'Come as your favourite blonde' night which emphasized the camp side of the club.

Boy George in kabuki whiteface and kimono manned the cloakroom and Rusty Egan played the records. Soon the lines were down the block and people like Andrew Logan, Duggie Fields, the designer Zandra Rhodes and Nicky Haslam began stopping by to check what was happening. There was a famous occasion when Mick Jagger and his entourage were turned away, but this was because Steve Strange had just been warned that any more overcrowding would result in the club losing its licence. Nonetheless Jagger was not pleased and retired hurt to the Zanzibar Club a few doors down the street. Then one night in July, Bowie himself showed up unannounced to see Bowie Night for himself. As most of the people there began as Bowie fans, dressing like him, collecting his records, posting his picture on their bedroom wall, his arrival caused tremendous excitement. He was ushered in the back way and given the best position upstairs to watch the scene. Extra security was hastily found to stop him being mobbed. Before he left, he asked Steve Strange to appear in the video for his next single, 'Ashes to Ashes', and to choose three other extras and a makeup artist. The bus left for the shoot location at 6 a.m. the next morning but even though the club did not close until 3 a.m., they were all there, with their outfits. In the video Bowie walked along a beach dressed as Pierrot, followed by Steve Strange and his gang, who were in turn followed by a large bulldozer. It was a striking image even if no-one knew what it meant.[4]

Soon, Blitz began to produce its own groups. First came the dance troupe Hot Gossip, who performed a toned-down version of their Blitz dance routines on the *Kenny Everett TV Show*, but then came Spandau Ballet. It was a Blitz regular, the journalist Robert Elms, who gave them their name, which he saw written on a wall in Germany, and the Blitz-kids, as the tabloids were now calling them, who gave them their style. The band, school friends from Islington, had been around for several years in various incarnations, first as the Cut, then as the Makers, moving from soul, through punk, to the smooth techno-electronic sound that characterized their first hit: 'To Cut a Long Story Short'. As Gary Kemp said: 'Spandau Ballet started out in an environment which was extremely fashion-conscious with regard to the club scene, and overall attitude.'[5] Spandau Ballet played their first gig outside their Islington rehearsal studio at Blitz. Chris Blackwell from Island Records was in the audience and offered to sign them after the third number, but their manager, Steve Dagger, held out for a better offer.

Their next gig there, in January 1980, had members of Japan, Thin Lizzy, the Skids, Magazine, Generation X, the Banshees and Ultravox in the audience. Record labels clamoured to sign them, but they held out for the right deal and it was not until October 1980 that they finally drew up a contract with Chrysalis which gave them complete control of everything connected to the band, the music, their image, their stylists and their graphic representation.

The next month, Steve Strange and Rusty Egan, working as a studio band called Visage, signed with Polydor and released their first single, 'Fade to Grey', which went to number two in the UK charts and number one in nine foreign countries. They had previously released a single, 'Tar', on the producer Martin Rushent's small independent label the previous September, but the distribution company had failed, making it impossible to obtain. Polydor released their *Visage* album the same day as the single. Their keyboard player, Billy Currie, then started his own group, called Ultravox, and had an even bigger hit with 'Vienna'. The excitement surrounding Blitz and the New Romantic bands quickly spread out beyond London and groups like Duran Duran from Birmingham and Depeche Mode from Basildon in Essex visited Blitz to see what was happening. Similar clubs began opening around the country. Boy George was to be the most spectacular of the Blitz-kids when his band Culture Club finally released 'Do You Really Want to Hurt Me?', which became a world-wide hit. Blitz went down in history as an energy centre similar to the Cavern in Liverpool, the UFO Club and Soho's 2i's.

After the negative, self-harming nihilism of the punk era, many young

people saw the New Romantics as a breath of fresh air. Most of them had been punks, but saw it as a dead-end movement with little constructive to say except 'do it yourself' and this is what they were doing. In this sense the lasting legacy of punk has not been the music, which was for the most part terrible, but the clothes, which were innovative and creative. It was this aspect that the neo-romantics took up. Away went the piercings and self-mutilations, in came face paint and eyeliner. Unfortunately for many of the bands, away went the amphetamine and in came cocaine and heroin, but mostly the New Romantics were a positive flipside to punk, stressing the self-empowerment and do-it-yourself creativity of the movement.

At the end of 1980 the artist and gallery director David Dawson took over a huge, 16,000-square-foot floor of a tea warehouse in Wapping Wall, a continuous wall of warehouses separating the street from the river. Warehouse B of Metropolitan Wharf was built in 1864, an enormous solid structure standing on cast iron doric columns. The warehouses were built right on the Thames so that goods could be unloaded straight into the storage areas by huge forged iron wall-cranes. They must have left by the same route as nothing large could be carried up or down the two long flights of narrow stone steps that led to B2. The space was divided into two by a corridor and was absolutely stunning. Both rooms overlooked the Thames and were filled with shimmering river light. Tugs and barges passed the windows and a game of swans lived on the river directly below. David had reserved part of the gallery as his living space and his chaise longues and armchairs and his large library and photographic collection contrasted strongly with the bright, freshly painted white walls of the gallery and performance space. His assistant and collaborator, the performance artist Roger Ely, curtained off a section of the second space as his living quarters. B2 was not just a gallery and performance space; it was more of an arts and ideas workshop in the tradition of the Arts Lab.[6]

The Wapping tube station stood in an almost deserted neighbourhood and closed early. Buses were a long walk away through streets of boarded-up warehouses. This meant that the audience for events were often stranded and returned to the gallery looking for somewhere to sleep. After one event more than a hundred people spent the night. There was plenty of room, though not enough bedding. As Roger Ely wrote: 'This almost live-in-home-club-like quality combined with the diversity of the presentations made B2 special.'[7] This was true. The exhibitions covered a wide range of subjects from photography to performance art, poetry to painting. B2 began with shows by Diane

Arbus and Robert Mapplethorpe, and more contemporary work by young British photographers. Dawson showed artworks by Vivienne Westwood, John Maybury, Duggie Fields, Andrew Logan and Derek Jarman – Jarman also presented regular Sunday Super 8 and 16mm film evenings. Adrian Henri, Bob Cobbing, Benjamin Zephaniah and Attila the Stockbroker all gave poetry readings; Evan Parker played saxophone; Anne Bean and Paul Burwell performed; Roger Ely combined performance with cooking an Indian banquet for the audience; the New York dominatrix Terence Sellers gave a talk about her dungeon; Victor Bockris's biography of Blondie was launched by Debbie Harry and Chris Stein, who arrived by boat. During the Final Academy conference William Burroughs used the gallery as his headquarters and Brion Gysin stayed there. But, to many people, the most memorable event of all was the week-long live-in by the Neo-Naturists.[8]

One of the most interesting cabaret entertainments at the Blitz club was by the Neo-Naturists, whose 'Easter Communion' must have made many of the clubbers feel overdressed when confronted by the Neo-Naturists' nudity. The Neo-Naturists were Christine and Jennifer Binnie, Wilma Johnson and Jennifer's boyfriend, Grayson Perry. Christine studied pottery at Eastbourne College of Art in the seventies, Wilma was at St Martin's, and Jennifer and Grayson were at Portsmouth College of Art. Grayson Perry and Jennifer arrived at Christine's Fitzrovia squat to spend the summer of 1980. She was living in Carburton Street, on the corner of Great Titchfield Street, in a five-floor eighteenth-century building which has since been demolished. Other occupants included the music hall double act Robert Durrant and Robert Laws and their friend 'Loud Mouth Tracy'. Boy George and Marilyn lived on the ground floor and George was the squat 'boss'. The building was in bad shape, with an outside toilet that had no roof, and a flooded basement.

The empty shop next door had been a Lewis Leathers shop, the favourite leather jacket of the Teddy boys. Christine, Jennifer and Grayson broke into the building, which Christine had decided she wanted to open as a café. There were no leather jackets left, but Grayson, who was a biker, was delighted to find some dome-top fifties crash helmets, one of which he kept for years. They also found plaster models of christening fonts, which they used as ashtrays. Jennifer painted a large mural of a horse on the wall, they installed a record deck and some Abba records, and then they opened for business. There was an old typewriter which the guests like Boy George, Marilyn, Philip Sallon, and Cerith Wyn Evans used to write poems, often in the form of concrete poetry; visual shapes on the page. Christine called it the Coffee Spoon, after

the line in the T. S. Eliot poem, *The Love Song of J. Alfred Prufrock*. The water had been disconnected so she organized a water patrol, with a group of friends filling empty cider bottles and carrying them round. Cider, at 10p a cup, was a popular drink. She named all the dishes on the menu after poets: there was toast Robert Burns and tea T. S. Eliot, and coffee was a Cavafy. The Coffee Spoon was quickly adopted by all the New Romantic squatters in the area of Warren Street, Carburton Street and Great Titchfield Street, as well as by all the people they'd met in nightclubs or had arranged to meet. It was a better place to hang out than most of the squatted rooms.

Christine was the star of the show. Boy George wrote: 'Miss Binnie, as she was known, truly had her lid off and everyone loved her. She held poetry readings where her film student friends John Maybury and Cerith Wyn Evans would project their latest works over her naked body.'[9] One evening John Maybury screened two films, one of his boyfriend dancing, shot in a cracked mirror in Andrew Logan's studio, and the other of Christine running towards the camera. Just as she reached it, Christine herself burst through the paper screen, dressed in the same clothes. It was at one of these prototype Neo-Naturist cabarets that Grayson Perry first appeared in public dressed in women's clothes. Watching him get ready one of the girls remarked: 'Oh, you've done *that* before!' as he skillfully pulled on his tights. Before the show, Jennifer had been crying and Marilyn came up to her and asked solicitously: 'Is it because your boyfriend's a trannie, Jen?' causing her to burst out laughing. Grayson and Jennifer appeared as the television cooks Fanny and Johnny Cradock. Grayson played Fanny, the bossy one, and Jennifer wore biker gear posing as her cowed husband Johnny. They made a dramatic entrance. There was a storm that night, and just as the lightning cracked, the door of the café was flung open and they roared in on Grayson's Suzuki 125. The crowd exclaimed appreciatively as they skidded to a halt in the middle of the café, revving furiously. They dismounted and made their way to a Baby Belling, where they cooked a banana flambé. Grayson: 'I passed the flambé round for the audience to taste. The whole time I was achingly embarrassed.'[10] Fanny and Johnny Cradock remained an influence on the Neo-Naturists' repertoire, and cookery demonstrations were often included in their cabarets. This was the result of Christine's interest in tribal rituals. Christine:

> Any props we had to bring onstage we would bring on in carrier bags because they are like the modern hunter-gatherer's gathering bag, really. When people said how do you want the lighting on stage? They thought we wanted be moody and things. I'd always say like a kitchen with fluorescent light, please.[11]

Grayson's next outing as Fanny occurred that Christmas, when Christine had managed to hire Notre Dame Hall, off Leicester Square, for an evening performance of Hans Christian Andersen's *The Snow Queen*, a Neo-Naturist Christmas pantomime. Christine's mother had been a Girl Guide leader and when Jennifer and Christine were in the Guides they had to do *The Snow Queen* as a panto. Christine: 'I had to be the back end of the reindeer, and I never quite got over it. So we redid it. I was Kai [the little boy] and Jen was Gerda.'[12] It played to a packed house of Blitz-kids and their friends and was a triumph.

Many of the Carburton Street people moved to a squat around the corner at 65 Warren Street; they included John Maybury, David Hollar, Geoffrey Hinton and Christine Binnie, who shared a room with Cerith Wyn-Evans; they drew a line down the middle of the room. It was a large building on the north side of the street and it was possible to walk right through to another squat in a separate building on the Euston Road. Though there was a lot of interaction the Euston Road squat was more into drugs, whereas the Warren Street people were basically Blitz-kids, into fashion and art. When Christine Binnie brought back some LSD from a festival at Stonehenge, John Maybury and David Hollar were very disapproving. Christine: 'They went berserk, and they were really horrible to me because I'd brought drugs back.'

Although Grayson Perry performed with the Neo-Naturists on numerous occasions, the founding core of the group remained the two Binnie sisters and their friend Wilma Johnson. Wilma first met Christine when she became Wilma's 'personal life model' at St Martin's College of Art. Christine was not like the usual agency models – bored housewives earning a bit extra – she had a peroxide blonde beehive hairdo, with a turquoise streak through the middle, and holly berry red lipstick and was wearing a pale blue negligee. Wilma thought she looked fantastic. She did drawings of her throughout the morning, but by lunchtime they were bored so they went to Soho Square for a picnic and discussed performance art. Wilma: 'By the afternoon, I had swapped my flesh tint oil paint for some blue and gold body paint and transformed her into a voluptuous version of Tutankhamen's sarcophagus with the help of a feather boa I happened to be wearing. That was the beginning of the Neo-Naturists for me.'

The most ambitious Neo-Naturist event was in July 1982 and involved fifteen people living in the nude at David Dawson's B2 Gallery at Wapping Wall for a week, sleeping in a large roped-off bed in the middle of the gallery. Each day had a different theme, the first of which was Art Day. Christine invited all the artists she knew to come and use the Neo-Naturists as their canvas.

Andrew Logan, Duggie Fields, Derek Jarman, all the people who showed at B2 came to the gallery during the day to paint them. Christine finished up looking like a Jackson Pollock, with paint flicked and dribbled all over her body. That evening there was a private view in which they all posed, motionless, as the art. Unfortunately there was only enough hot water for one bath and as there were fifteen Neo-Naturists, they rarely were able to get all the body paint off each evening.

The Prospect of Whitby was just down the street, and at lunchtime they would all go there for a drink. Wilma had stitched huge floor-length overcoats for them all, made from fun fur, which looked comical but kept them warm as they were still naked underneath. Wilma's coat kept falling open, endearing her to the men who worked behind the bar, who began bringing them the unsold sandwiches from lunchtime as an excuse to see her naked in the gallery. Day three, Friday, was Macbeth Day, a very uncomfortable day for Grayson Perry. They did two performances, a matinee at 3 p.m. and an evening performance at 7.30 of a somewhat truncated version of the play. It lasted for only ten minutes and included seven witches, as that was everyone's favourite part. Christine played Mrs Macbeth. She spent most of the play draped in tartan, frying up Scottish pancakes, neeps and tatties, haggis and porridge on an industrial cooker. Grayson single-handedly played the entire Birnam Wood, holding above his head great bunches of buddleia that he had gathered from a local bombsite. He was covered in body paint mixed with Scottish oats to give his body the texture of tree bark. Unfortunately the porridge set hard, trapping all his body hair. At the end of the play, they were supposed to run screaming from the gallery. Grayson could barely walk as the slightest move tugged at his body hair. He wrote: 'The crusty oatmeal was *all* over me. It was very, very painful to move in, let alone wash off.'[13]

On Fashion Day they modelled body-painted clothes and on Black Rapport Day they were only permitted to use black body paint. This resulted in some striking designs being produced: stripes and tribal markings, spirals and blobs, everyone different, including at least one painted child. When they were painted they went for a naked black picnic on Wapping beach by the side of the Thames, where they were only allowed black food: black pudding, black olives, black bread, washed down with Guinness. According to Grayson Perry they looked like a 'strange, apocalyptic tribal gathering'.[14] A police boat stopped to observe them, but did not intervene. Some of the best photographs of the week-long event are from this day.

The biggest audience was for Punk Day, for which someone brought

along a huge tub of Evo-Stik glue – a punk reference to the Ramones' song and *Sniffin' Glue* magazine. By now word had got around and the gallery was packed for the official closing party. David Dawson made professional videos of each day but all this valuable documentation was lost when someone stole the video recorder and all the tapes. Grayson and a few others had made their own records but nothing so extensive. The installation remains a legend, like the banquet held for Le Douanier Rousseau by Picasso at the Bateau-Lavoir in 1908, much discussed and fondly remembered.

Jennifer and Grayson next moved to the basement of the building that Marilyn, Boy George's friend, had squatted at 26 Crowndale Road. There were several junkies in the building, the woman on the top floor was a prostitute and there was a guitarist called Firewolf, with spiderweb tattoos all across his face, who moved into the squat next door. The basement was in terrible condition, having had both a fire and a flood, but they were desperate and made the best of it. They furnished it from skips and filled the walls with paintings and posters, curtains and pieces of jewellery. Grayson constructed a throne for himself out of scaffolding planks and made small sculptures at a work table in front of the window. Jennifer used the largest wall in the living room for her paintings, tacking huge canvases on to it, then taking them and hanging them out to dry in another part of the basement while she tacked up a new one. Her paintings expanded from the canvas and soon she was painting furniture found in the street and in skips, old chairs, tables, a television set. The place had a distinct, gothic feel.

The junkies and the prostitute moved on: Christine Binnie took over the top floor, Wilf Rogers and his girlfriend the upstairs rooms, Cerith Wyn Evans and Angus took the ground floor, and Grayson and Jennifer remained in the basement. They were there for several years. Grayson had originally studied sculpture while he was at Portsmouth but in September 1983, a year or so after he moved to London, Christine Binnie persuaded him to join her in the evening pottery classes held at the Central Institute. He enjoyed it so much that he began going three days a week. Pottery quickly became his main interest. It also allowed him to use anything as subject matter as he knew the police were never going to raid a pottery exhibition, no matter how obscene the subject matter used in the decoration of the plates and pots. He told Joe La Placa: 'When I started making plates, it was about how I could wind people up... I'm attracted to things that make me feel uncomfortable, that make me think, "Oh my god I've stepped over the mark here". So I started using sexual and fascist imagery.'[15] Pots have titles like 'We've Found the Body of Your Child' or 'Saint Claire 37 Wanks' and take as their subject matter run-down

housing estates, abused children, dysfunctional families, high-rise blocks of flats, often juxtaposed with details from classical oriental pottery, all to unsettling affect.

Meanwhile, Jennifer was having some success with her paintings. The art dealer James Birch had a gallery on the King's Road, James Birch Fine Art, specializing in British Surrealism but he was interested in exhibiting contemporary work. He saw a Neo-Naturists performance for the launch of Derek Jarman's *Dancing Ledge* in which they blew up an inflatable paddling pool, fried up some fish fingers, then attempted to fill the pool by pissing into it from a balcony before 'launching' Derek's book by throwing it into the pool. Derek was delighted; so was James. He got to know them and liked Jennifer's work so much that in June 1984 he put on her first show. At the opening Jennifer and Christine gave a performance, making dresses for themselves from see-through Sellotape then painting themselves in body paint. The audience was very appreciative and the paintings sold well. Then Jennifer said: 'Why don't you show my boyfriend, Grayson Perry?' so James gave him his first show. Perry was mostly making plates at the time, priced around £30–£60 and the show sold out. The second show a couple of years later contained more pots and had greater critical acclaim, but did not sell so well.

In 1985, James gave Jennifer a second show and asked her what her dream would be for a perfect opening. She said: 'To ride naked down the King's Road on a white horse.' James: 'She didn't have long hair, she had a skin-head haircut so it was even better. Of course it was raining at the time.' That same year James showed Wilma Johnson's paintings and instead of wine they served cider to commemorate the old Coffee Spoon café that Christine had run. James remembered: 'We didn't have wine, we had scrumpy and everyone got absolutely pissed and then, after the private view had closed down, we played spin the bottle.'[16]

The Neo-Naturists were the last great hippie manifestation: they combined English village fête practicality with Girl Guide common sense, hippie idealism, the spirit of love, a child-like innocence and amateurism, all in a post-punk context. The Binnie sisters were brought up in a strong C of E environment, tempered by their father's interest in Rudolf Steiner. Participating in church services, carrying flags and such, gave them a taste for ritual. Like COUM before them, Christine insisted that there be no rehearsals as she didn't want to put on a show or provide anything resembling entertainment. Rituals do not require rehearsals and these were ritual performances, exploring everyday actions such as cooking or cleaning, celebrating nudity, the Mother Goddess, and the different shapes of women's bodies. Christine

had been inspired by the punks she met when she lived for a time in Berlin in the late seventies:

> They didn't wear all black clothes and sit in tiny weenie little rooms all the time going 'Uugggghhh!' like English punks. They walked around their flat in the nude with stilettos on looking happy. Mohican hairdos. I thought they were fantastic, and in the summer there we went off to the lakes for nude sunbathing. I loved it.[17]

It was a great contrast with the negativity of the English punk scene.

Nudity appealed to her, it is a performance art classic: one of the most basic actions and one which had been thoroughly worked over in the sixties. Consequently she was surprised when people were shocked at the Neo-Naturists. She had expected people to be bored at yet more nudity and body paint, but the British audience reacted as if it was still the fifties. Their nakedness was not designed to titillate; nor was it confrontational like Genesis P-Orridge. They were naked but not 'sexually packaged', as Christine put it, and their performances incorporated many of the ideas that had emerged from the women's movement in the early seventies. One of their films showed them baking bread in the shape of the Venus of Willendorf incorporating their own menstrual blood and James Birch remembered a performance at Heaven nightclub when they appeared on the same bill as Genesis P-Orridge and Psychic TV. James: 'They put flour in their pussies and they pulled it out and they mixed it in a pot and they went round and they put this flour and pussy juice into everybody's mouths.'[18] Grayson wrote: 'The girls were fearless but I was always nervously aware that the dangling presence of a male member painted blue with a bell tied to it lent the performance an extra edge to which some of the crowd could take exception.'[19] It was not always as a naturist that Grayson appeared; sometimes it was as his alter-ego Claire, wearing some variation of Tenniel's Alice in Wonderland dress. In fact, he was more vulnerable, and placed himself at much greater risk, by appearing in public as a transvestite than by being naked. Nudity is commonplace but anything that challenges the traditional gender roles causes tremendous anxiety in the public and is liable to cause considerable antagonism.

Their gallerist, James Birch, is perhaps best known as the organizer of a number of groundbreaking exhibitions in Communist countries. A believer in the political power of art, he was the first to exhibit Francis Bacon in Moscow, following that by showing Gilbert and George first in Moscow, then

in Peking.[20] Francis Bacon was a friend of James Birch's parents so he had known him ever since he was a child. Bacon trusted him, which is why he immediately agreed when James asked if he would like to do a show in Moscow. It took two years and five visits to Russia for James to organize it, but in the summer of 1988 forty-four paintings worth between £10m and £15m were taken by truck under armed guard to Moscow. Bacon himself pulled out of attending the opening at the last minute, even though he had been taking Russian lessons and had his bag packed ready to go. He withdrew because the British Council tried to hijack the show and wanted to include formal meals with the ambassador and the British Council staff, speeches by Francis and a press conference. James: 'He just didn't like the pomp and circumstance.' The show opened at the New Tretyakov Gallery on 22 September 1988 and caused a sensation. 150,000 Muscovites crowded through it in six weeks and the 5,000 catalogues they had printed sold out almost immediately. The show coincided with the first of the reforms brought in by Mikhail Gorbachev and would not have been possible even two years before. James Birch: 'I'm not saying art changed it, but it started the crack in the dam, and that's what I think is important. Art is something that actually has a longer impact than sport or anything.'

James first met Gilbert and George at the Blitz Club, where they were regulars, and when they heard he was taking a Bacon show to Moscow they asked if he could do the same for them. James: 'So the day after the Francis Bacon show opened I proposed a Gilbert and George show and said "They're very good artists" and they said "Yes, of course they are."'[21] The British Council was horrified and one of its representatives asked the Russians: 'Why are you interested in showing the work of two homosexual fascists?' But the Russians trusted James, and certainly didn't trust the British Council, which had only recently been allowed back into Moscow after being banned for many years for spying, and so preparations for the show went ahead. It took two years of Russian red tape but in April 1990 the enormous show opened, sponsored by Gilbert and George themselves and their gallery, Anthony d'Offay. Though none of the works were for sale, the exhibition helped establish their international reputation. For the Russians, it was a revelation and a great triumph. James made sure that the show had lasting impact by insisting on lots of souvenirs. James: 'I was saying to Gilbert and George, "We've got to give these people badges, we got to give them T-shirts, posters, we've got to give them out." Three years later I go to a rave party in the Sputnik Terminal Pavilion of Economic Achievements and there are people wearing these Gilbert and George T-shirts.'[22]

'Where would you like to show now?' James asked Gilbert and George when they returned from Russia. 'China!' they said. And so, in September 1993, a large Gilbert and George exhibition opened in Peking, then travelled on to Shanghai that October. James wrote in the catalogue: 'The new pictures suitably have the warmth and vigour to break down barriers speaking as they do the universal language of truth and beauty, they hold out the hand of friendship to viewers of all nations.'[23]

Leigh didn't have the same size prejudices as the rest of us.
He celebrated his fleshy proportions and turned them into
a gorgeous fashion statement. I think that's what I loved
about him most; he pushed it in your face. Like the night he
swanned into Daisy Chain in a puff-ball face mask, sequined
boots with a matching push-up bra. Except for those garish
trimmings, he was butt naked.

BOY GEORGE[1]

The area of performance art worked in by Throbbing Gristle and the Neo-Naturists had a third, even more extravagantly transgressive act. Born into the sleepy backwater of Sunshine, in the western suburbs of Melbourne, Australia, Leigh Bowery studied fashion design for a year at the Royal Melbourne Institute of Technology, where he saw copies of the London street fashion magazine *i-D*. It was a classic case of 'London calling'. Leigh: 'England seemed the only place to go. I considered New York but that just seemed full of cheap copies of London.'[2] In October 1980, aged nineteen, he left for London armed with his portable sewing machine, determined to see for himself the New Romantics, the punks, the clothes shops and the clubs.

He went to ChaCha's, the 'alternative' club run by a nineteen-year-old girl called Scarlet and held every Tuesday night in the back room of Richard Branson's Heaven. It had its own entrance from Hungerford Lane and for a time in the early eighties it was the in-club, filled with celebrities: I walked in one day to see the footballer George Best snorting lines of coke from his table, making no effort to hide what he was doing, while the rest of his party waited anxiously for their turn. But mostly ChaCha's was a gay club and it was there, in November 1981, that Leigh met Guy Barnes, later known as Trojan. He and Trojan became lovers and together with a mutual friend, David Walls, they took a flat together, first in Ladbroke Grove, then in the East End. Leigh designed costumes for them all, and in the West End clubs they became known as the Three Kings. Inspired by the fabrics and jewellery on sale in Brick Lane, Leigh came up with his 'Pakis from Outer Space' look. With chains looping from their nostrils to their ears, blue faces and rings on every

finger, they combined Hindu iconography, Ruritanian court dress and even high modernism: Leigh painted a nose on Trojan's cheek and used lipstick to give him an off centre mouth, like Picasso's cubist portraits. Leigh Bowery: 'Wearing platforms, red and green faces and these high hats we looked so frightening, and the same time too theatrical to be taken seriously. But we did get some abuse from the boys on the estate.' 'Pakis from Outer Space' was presented at the Camden Palace for London Fashion Week, 1982–3, as his second collection (the first being 'Hobo' shown as part of New York Fashion Week, 1982). In 1984 he did his 'Pakis' act with the Neo-Naturists at one of their shows in Great Portland Street, which involved Leigh drinking Trojan's piss and also using it to put out a fire they started onstage. The audience liked them, they fitted right in.

In 1983, Leigh met Michael Clark, who had just left the Ballet Rambert to start his own troop. They became good friends and for a decade Leigh designed stunning costumes for him, some of which incorporated dildos and open crotches. (His later costumes, which revealed the dancers' bare bottoms, inspired the designer Alexander McQueen's 'bare bum' look.) Clark even asked Leigh to dance with them. Leigh: 'Michael liked the idea of how some movements and shapes looked on an untrained body, I didn't have a classical dance background, and I was very open and eager. I began doing more performance rather than just the look of things.'[3] Just as Michael sometimes danced in Doc Martens, Leigh, who was a trained pianist, would play a Chopin Nocturne wearing gardening gloves and high platforms. One of their favoured hangouts those days was the Pink Panther, a rent boy bar in an upper floor on Wardour Street that stayed open until 7 a.m.; none of them ever wanted to go home. Clubs were Leigh's life and it was inevitable that he would want to start one of his own. On 31 January 1985, Leigh Bowery, his business partner Tony Gordon and a girl known as Angela Frankie, because she had danced with Frankie Goes to Hollywood, opened Taboo, held every Thursday night at the Circus Maximus disco on Leicester Square. Leigh was the club's public face. It was opened on a shoestring. They did not even have enough money to print flyers so Leigh clipped photographs of naked men from his large collection of pornographic magazines and stuck them on bits of cardboard. Then he stencilled the name Taboo over them in gold paint and, using a John Bull printing set, rubber stamped the address and time on the back. He handed them out to friends and likely looking people while doing his usual round of clubs.

Circus Maximus had seen better days. It was an old-fashioned West End nightclub with red velour banquettes and the walls lined with mirrors.

A mirror ball threw moving spots of light around the room. A long flight of stairs led from the entrance lobby down to the cloakroom and toilets, where most of the sex and drugs action took place. The doorman was Mark Vaultier, tall and thin, dressed in Leigh Bowery clothes and known for his alarming wigs. It was hard to get in. Leigh announced the door policy as: 'Dress as though your life depends on it or don't bother. We'll only let in fabulous, over-the-top dressers and stars. We can sniff out phoneys and weekend trendies a mile away.' Mark had a mirror at the door and was prone to holding it in front of a frustrated clubber's face and asking: 'Would you let yourself in?' Taboo quickly became a financial success. The deal with Circus Maximus was that they paid them £315 a night and after that the rest of the takings were theirs. Most of the staff received £50, which was very good for a night's wages. Angela left early on, leaving Leigh and Tony as sole owners.

Each week, Leigh wore a different, more outrageous ensemble: short skirts, polka dots on his face, frilly knickers, denim, glitter, face paint and jewellery, but usually wearing his cheap plastic tourist policeman's helmet, and always on outrageous platforms that were so high that he was able to kick out the lights above the cocktail bar if he was feeling particularly exuberant. The club opened around 10 p.m. but regulars like David Holah from Bodymap and the film-maker John Maybury arrived between midnight and 2 a.m.. The club soon attracted the stars: Boy George and Marilyn, George Michael, Bryan Ferry and Paul Young. John Galliano would circulate, handing out flyers for his latest fashion show, before hitting the dance floor. Many of the designers who have since achieved world-wide success with London's street fashions owed something to Leigh and his utterly fearless creations, including Vivienne Westwood, who kept a close eye on the New Romantics and the Taboo scene. She once said that Bowery and Yves Saint-Laurent were the two most important designers she knew.

It didn't take long for the old glamour crowd to discover Taboo and Andrew Logan, Derek Jarman, Duggie Fields, Luciana Martinez and all their friends soon became regulars. As is usual, the more famous the club became, the more it lost its initial exclusivity. Depeche Mode, Marc Almond, Sade, New Order and the stars of the day made regular appearances. Leigh and Tony knew they were still on the right track, however, when Paul Weller stamped out after only fifteen minutes. Even Mick Jagger buried the hatchet and visited. He and Leigh had had a previous contretemps:

Jagger: 'Freak!'
Bowery: 'Fossil!'

For eighteen months Taboo was the coolest club in London, but even though he was making a lot of money, Bowery grew bored with it. When his friend Peter-Paul Hartnett, known to the Taboo crowd as Powder-Puff Hairnet, suggested to Leigh that it might be time to get the club closed down, Leigh, according to his friend and biographer Sue Tilley, 'lifted a white begloved finger to his lips as if to say "Don't tell anyone" and Peter-Paul took this as a sign to put his plan into action.'[4] It was easy; all he had to do was invite reporters from the *Mail on Sunday* to visit the club. He showed them round and the next Sunday there was an article condemning Taboo and everything it stood for. The Circus Maximus management contacted Leigh the next day, telling him the club was closed. By ending on a high point, the club went into history alongside UFO, Blitz and all the other innovative venues in London's club history. It had been open for eighteen months.

In the course of Taboo, Leigh had established himself as one of the most innovative dressers on the London club scene, blurring the lines between male and female, incorporating unusual materials, making sculptural exaggerations that distorted recognized body lines and shapes, particularly that of his own overweight self. He was described by Boy George as 'modern art on legs'.[5] He reinvented his look every few weeks, creating some of his most memorable looks such as the paint running down his bald head as if someone had broken an egg on top. He particularly enjoyed the fact that the paint would pull off in one go at the end of an evening. He found that some of his most beautiful garments, made from satin and velvet and specially printed fabrics, were being ruined by the greasy marks from his face paint, which was very hard to clean. His solution was to create crewel work cloaks with an attached head mask, with small holes for the eyes and mouth, made from the same material. This had the same effect as the face paint, and he still made up his eyes and mouth, but at the worst it only ruined the head mask, not the whole garment. He began to experiment with embroidery and beaded headdresses, semi-precious stones and lace, taking his costumes into a whole new area.

If the New Romantics were the mannerist phase of punk, then Leigh Bowery was single-handedly its baroque phase. He had never been slim, but as he put on more weight, he made his body a canvas for every form of cultural reference from circus clown to the wildest excess of Hieronymus Bosch, all mixed together. Mark Simpson, writing in the *Independent*, described how he used to glimpse 'in teenage terror – his enormous, corseted frame gliding and fluttering past like a hand-sewn battleship, Copydex-spattered head glowing under the UV light, lime-green nylon ruffs bouncing, black-lipsticked

mouth pouting'. Leigh exaggerated his weight, frequently added more pad-
ding in unlikely places and adopted a difficult, confrontational style which
many people found overpowering and offputting. This was largely defensive;
most of the men he felt attracted to were put off by his bizarre looks and he
defended himself by responding with a sharp tongue. Leigh was one of the
few people who didn't have a lot of sex at Taboo. He and Trojan had broken
up and he met most of his sex partners in public lavatories or Hampstead
Heath: he adored cottaging and would travel right across London if told
about a particularly promising place. His friend Sue Tilley wrote: 'Any toilet,
however grotty, was a temple for him.' He claimed to have had 'unsafe sex
with 1,000 men'.

Though gay, he had close, often tempestuous, friendships with women,
mostly of a 'master–slave' type. He had a series of subservient 'slaves' who
would wash, clean and cook for him, and whom he treated badly, bullied
and ordered to do outrageous things; one was made to sit outside the
Rijksmuseum in Amsterdam, topless, with a sign around her neck saying
'Give me money'. Oddly, in most instances, the relationship gave the women
in question confidence and they went on to careers of their own; one became
a TV presenter. Nicola Bateman, whom he met at Taboo, eventually mar-
ried him. Nicola: 'I was the mum – I mothered him. We did have a sexual
liaison at the start. He said, "Let's get the sex out of the way so we can be
friends."'[6]

Bowery had a difficult time after the closure of Taboo, coping first with
the death of Trojan, who overdosed on heroin in August 1986, then the death
four months later from a methadone overdose of his friend Mark Vaultier
(Mark Golding), the doorman at Taboo and a model in some of Leigh's fashion
shows. But he survived a deep depression by throwing himself into his design
work and his performance art, which became even more extreme. Leigh: 'I try
to have as much sex, violence and gore as possible in the shows – pee drink-
ing, vomiting, enemas and fake blood. It's a formula which always seems
to please.'[7]

Like Malcolm McLaren before him and Damien Hirst after him, he had
always wanted to be 'The Andy Warhol of London'. None of them succeeded,
of course, but Bowery's attempt was the most spectacular. A receding hair-
line had made him shave his head so that no-one would know, and he copied
Warhol by wearing obvious wigs, often askew, as part of his fabulous cos-
tumes. In the mid-eighties the New York downtown underground art world
nightclub Area changed its art display each month. The central corridor
leading to the dance floor had large display cases on either side, like Fifth

Avenue shop windows, and in one of them Andy Warhol presented himself as an artwork: sitting absolutely still, staring out at the passing clubbers, with a little smile on his face. Many people thought it was a waxwork until he moved slightly. Leigh loved the idea; he had been making an art object of himself for years with his costumes but had never taken it to its logical conclusion.

Just such an opportunity was provided by Anthony d'Offay, the owner of one of London's top contemporary galleries, who, after seeing him perform, offered him a week at his Dering Street premises in the West End. The show opened in October 1988 and every day, between 4 and 6 p.m., Leigh performed behind a two-way mirror that enabled the audience to see him, but he could not see them.

Most of the time Leigh lolled about on a chaise-longue, modelling a different outfit each day. He had recorded a tape of random traffic sounds which played for the duration and each day he scented the gallery with a different smell: one day marshmallow, the next banana. He would get up and prowl around and sometimes do some high kicks. On the first day he wore a green suit with tangerine coloured spots with makeup in the same colours and pattern. The next day he wore a black wig, green face makeup, a fur coat, scarlet pants and enormous jewellery. This was followed by a disco ball crash helmet worn with a light blue frock, then a bright green bodice and feather tutu complemented by a paint-dripped head. His final costume consisted of a fur cape and head mask with the usual small openings for mouth and eyes. People returned every day and some stayed for the whole two hours, mesmerized. The show was a great success. Every performance was filmed by Cerith Wyn Evans and one day he brought along his friend Lucian Freud. Leigh was first introduced to Freud by Angus Cook, who had taken Freud to visit Taboo. Now Freud wondered whether he could paint this fabulous creature. It took him a year to decide that he would like to.

Freud invited him to lunch at Harry's Bar and Bowery tactfully dressed in colours from Freud's palette, grey brown trousers and jumper worn with a mouse coloured wig. He was hoping that Freud would ask him to sit for a picture and wanted to please him. They were both nervous, Bowery all the more so because he had arrived without a jacket and the restaurant refused to let him in. They finally compromised by lending him a waiter's jacket two sizes too small. He told *Modern Painters* magazine: 'We talked about a show I'd done that week in Amsterdam which climaxed in me squirting an enema at the audience. I described my costume and dance. Lucian finally

brought up the idea of painting me. I told him I loved the idea.' According to his friend Sue Tilley, Bowery's life made a radical change from the moment he began working with Freud. He learned about the art world and began to meet Freud's artistocratic and high-flying friends. Freud told him stories about Picasso, Cecil Beaton, Greta Garbo and Judy Garland; all Leigh's idols. He changed his voice and began speaking very 'proper'. His lifestyle had to change as Freud painted him in the mornings and he was expected to arrive at 7 a.m. sharp. Sometimes Freud would take him in his Bentley to lunch at the River Café or some other expensive restaurant. Each portrait took scores of sittings, sometimes as many as five a week, and Leigh became Freud's best-known model. 'I find him perfectly beautiful,' Freud said. A number of large pictures of Leigh were included in Freud's Whitechapel show in October 1993, but when the show travelled to New York, the prudish Americans left out one called *Parts of Leigh Bowery*, a close-up of Leigh's cock and balls cut down from a larger painting that Freud had given up on. Freud also painted Leigh and Nicola together naked.

Freud and Leigh became friends and Leigh introduced him to Sue Tilley, affectionately known as Big Sue as she weighed twenty stone. She, in turn, posed for him for four years though she never gave up her job as a benefits supervisor in a West End Job Centre. His painting *Benefits Supervisor Sleeping* sold for $33.64m at Christie's New York in 2008, the highest price paid in auction for a work of art by a living artist.[8] Freud liked her as a model because he was 'very aware of all kinds of spectacular things to do with her size, like amazing craters and things one's never seen before'.[9]

In the late eighties the best gay club in London was the Daisy Chain, organized every Tuesday night by Jimmy Trindy at the Fridge in Brixton, the club owned by Susan Carrington and Andrew Czezowski. Leigh never missed it. The designer Rifat Ozbek wrote: 'Every week I thought he couldn't possibly surpass himself but he always did.'[10] Ozbek hired Leigh to work with him as an adviser. Leigh was businesslike during the day and was polite and conservatively dressed, he would open doors for women and display old-fashioned Australian manners. He worked on two collections for Ozbek, which took them on numerous fabric-buying trips to Italy during which Leigh behaved impeccably, charming all the Italians. Ozbek: 'I wanted someone from the outside who had a different sense of proportion, of body distortion.'[11]

In 1993, Leigh, Nicola, the guitarist Richard Torry and a group of friends formed the band Minty, designed to push performance art rock to its the ultimate limits. Their first gig was in 1994, at Smashing Live's Monsters of

Drag night, during which, after singing their first single, 'Useless Man', they launched into a pornographic version of the Pepsi-Cola 'Lip-smacking, thirst-quenching' TV advertisement while Leigh simultaneously appeared to be going into labour. He was now so large, and his clothing so oddly shaped, that he was able to strap Nicola upside down to his stomach, with her feet up by his shoulders in a specially made cloth harness without anyone knowing she was there. Amid a frenzy of grinding guitars and a heavy rock 'n' roll beat, Leigh began screaming and yelling at the top of his voice. He threw himself back on a trestle table, arms and legs flailing, and proceeded to give birth to Nicola, who emerged naked between his legs, smeared in fake blood and petroleum jelly, trailing strings of sausages, while the audience stood, mouths agape in disbelief. Leigh then pissed in a glass and gave it to 'the child' to drink as Minty blasted out the Beatles' 'All You Need is Love'. Nicola: 'I was inside his costume in a harness and nobody knew I was there. Then he suddenly got up on the table and I popped. We did it loads of times.'[12]

Perhaps the ultimate Minty performance was in April 1994 at the Fort Asperen art festival in Holland. Minty were to play and Leigh intended to hurl himself through a plate glass window as the climax of his act but the sheet of theatrical sugar glass was too large to go through the door. Instead, the organizers rigged up a sheet of real glass, electronically wired in such a way that it would shatter the moment he touched it, giving the illusion that he had broken it. Inspired by images of Fakir, a well-known American masochist exhibitionist, Leigh had attached clothes pegs to his nipples and all down the length of his penis. He then had himself suspended upside down wearing just black stockings and enormously high platforms as Richard Torry, also naked, played guitar, and Nicola, wearing an exquisite tutu, sprayed air freshener over the milling crowds of children and onlookers in the afternoon sunlight. Leigh sang his lyrics, upside down, then, when the moment came, threw himself with all his force at the window. The electronics shattered it but he was showered with shards of glass, cutting him all over. He ran to the dressing room, leaving a trail of blood as the audience stood speechless. Afterwards he commented: 'That's the cheapest publicity gimmick I've ever done.'[13] Leigh's last show with Minty was in November 1994, when they opened a two-week residency at the Freedom Café on Wardour Street. Westminster City Council had been forewarned and to Leigh's delight closed the show down after only one night, citing nudity and indecency. Leigh was not well; he had been diagnosed HIV-positive some years before, but that November he suddenly fell ill and was taken to Middlesex Hospital.

He did not want his friends to know where he was, telling Sue Tilley to say he had gone pig farming in Bolivia. Sue and his wife Nicola were his only visitors for the first four weeks, then Lucian Freud was told and Leigh's family. He died of AIDs-related meningitis on New Year's Eve. 'He was my soulmate,' said Nicola. 'We just had a very unique relationship.'[14]

Afterword

**SAME THING DAY AFTER DAY – TUBE – WORK –
DINNER – WORK – TUBE – ARMCHAIR T.V. – SLEEP –
TUBE – WORK – HOW MUCH MORE CAN YOU TAKE.
ONE IN TEN GO MAD – ONE IN FIVE CRACKS UP**

Graffiti on the tube between Ladbroke Grove and Westbourne Park stations

In the eighties the underground began to fall apart. As Thatcherism kicked in during the early part of the decade, many of the underground artists and writers fled the country. Of the editors of *International Times*, for instance, Jack Henry Moore left for Amsterdam, as did Bill Levy; David Mairowitz moved to Berkeley; Peter Stansill settled in Portland, Oregon; Mick Farren spent years in New York before moving to Los Angeles; and Don Atyeo travelled around the Far East. I spent the next two decades dividing my time between London and New York, Only Tom McGrath and Roger Hutchinson remained in Britain, and they both moved to Scotland. At *Oz* Richard Neville returned to Sydney and Jim Anderson moved to Bolinas, California, leaving Felix Dennis to build up his magazine-publishing empire. For some people a few years, or perhaps a decade, in London is enough.

It was not all gloom. In 1983, Channel Four opened for business, dedicated to bringing art and culture to the masses. In the early days it was fearless, standing up to complaints made in the House by Tory MPs and attacks from the tabloids. It took eighteen months to bridle them. Then the tabloid *Daily Star* attended a viewing at the Bijou Theatre of Jarman's *Sebastiane* and devoted the whole of its New Year's Eve front page to 'The Films Which Should Never be Shown to Your Kids'. Channel 4 immediately wrote to the *Daily Telegraph*, of all newspapers, to explain that they had no intention of showing *Sebastiane* and it had been bought as part of a package. Jarman was the last independent British film-maker to have his work shown on Channel 4, and that was when in 1985 David Robinson, film critic of the *Times*, was asked to programme a season of films and he included *The Tempest*,

Jubilee and finally the shocking *Sebastiane*, which was shown late at night with a grim warning to the delicate audience. The screening of the films was met with a roar of disapproval. During the early months of 1986 the debate surrounding the proposed video nasties bill revolved around Jarman's films. Jeremy Isaacs, then the head of Channel Four, defended them on two *Right to Reply* programmes, and when Michael Winner told the audience at BAFTA that Jarman was making pornography, Isaacs gave a wry smile and replied that Jarman was a genius.

Derek did get his recognition in the end: in a ceremony held on Sunday, 22 September 1991, at his famous garden in Dungeness, Kent, he was canonized as a saint by the Sisters of Perpetual Indulgence, a worldwide order of gay nuns whose mission is to expiate homosexual guilt from all and to replace it with universal joy, for all his work for the lesbian and gay community, and because 'he has a very sexy nose.'[1] The ritual included a procession, the hymns 'Amazing Pride' and 'All Nuns Bright and Beautiful', a laying on of hands and a mass communion. Jarman was crowned with a saint's halo, appropriately woven from movie film, and was given the title 'Saint Derek of Dungeness of the Order of Celluloid Knights'.

Musically, 1988 brought a second Summer of Love as the New Romantics were followed by hip hop and house music. The official airwaves broadcast very little of it so fans started their own pirate radio stations. Not motivated by commerce they no longer needed to moor a ship outside British territorial waters; they simply erected a cheap transmitter on the roof of a high-rise council block and blasted out the good music until the police arrived. The next day they were on the air again from a new location.

House music first took over in 1985 and all-night raves and late-night 'raver' clubs spread throughout London (as well as other cities across the country). Sixties psychedelia was updated as young people danced the night away, not on LSD but on ecstasy. The first club was Danny Rampling's Shoom held in the Fitness Centre on Southwark Street, but it quickly outgrew the premises and moved to the YMCA on Tottenham Court Road, where it gained a reputation as being the easiest place in London to buy ecstasy. The Limelight on Charing Cross Road was another popular venue and the biggest of them all was Richard Branson's Heaven, situated under the arches of Charing Cross railway station. Originally London's biggest gay club, on Monday nights Heaven became 'Spectrum: Theatre of Madness', where 3,000 young people on ecstasy danced the night away to the solid four-on-four beat while spaceships and lasers filled the air. Unlike sixties psychedelic clubs, these dance clubs proliferated immediately. Some were central, like

the Dial 9 Bar on Argyll Street or Delirium held at the Astoria on Charing Cross Road. Most were one-night-a-week affairs, like Emergency on Rosebery Avenue or DMJB on Anhalt Road (both 1986). Some were held in warehouses, like Skat on Theed Street off Stamford Street. Many were advertised with no venue and a telephone call to Clubline was needed. Raves were held in empty warehouses, film studios and, in the case of Wetworld, at the Fulham Pools on Lillie Road – bring a swimsuit (1986–7). During the summer months many of the raves were held in fields, abandoned factories and disused airstrips outside London where no-one could complain about the noise.

E changed London's nightlife totally. So many young people were taking ecstasy that beer sales in Britain declined by 11 per cent. The huge e-raves grew in momentum. The police, of course, wanted to close them down and even set up a special squad under Ken Tappenden, divisional commander of Kent police, whose entire job was to search out and close down raves, but they met with little success; the advent of mobile phones proved too much for them. Party organizers set up equipment that could relay messages to a thousand mobile phones, giving the location of the venue, and at 1 a.m. the motorways would suddenly be packed with kids. By the time police arrived the rave was usually too big for them to stop without a riot ensuing. Killjoy Tappenden claimed victory because, as he said: 'We won because we stopped it all in 18 months and we drove it underground... we drove it into warehouses.'[2]

Now raves were in the safe hands of proper businessmen the police were happy. The Ministry of Sound, London's premier rave club, was in a disused London Transport bus garage beneath the railway arches at Elephant and Castle, with an intimidating fortress-like façade, made secure so that no-one could get in without paying, and with the roof fixed to stop leaks. It was owned and run by an old Etonian, James Palumbo, who had made his money in the City selling stock options. His father, Lord Palumbo, had been the head of the Arts Council of Great Britain during the Thatcher regime. Palumbo had a very simple business model: he only opened from midnight until seven in the morning on Fridays and Saturdays, ensuring that people could get home, just like the UFO Club. He dressed conservatively, in pinstripes and cufflinks, and had no trouble in getting what he wanted from the local council. As everyone was on ecstasy there was no need for a drinks licence; all he needed was a dance licence, and it was very easy to convince the council that it was much better to let the kids stay until the first tubes and buses began running rather than turf them out into the streets in the middle of the night, where they might cause a nuisance. Jeff Kruger had used the same arguments with

the police back in the fifties for his Flamingo Club. The club may have been a tip but Palumbo did spend money on constructing the best sound system in Britain, operated it at maximum volume and flew in the world's best DJs. It was so successful that he started his own record label of compilation CDs of music played there.

Even the Notting Hill Carnival succumbed to Thatcherite economics. When in 1988 the carnival lost £133,000, the committee found themselves ousted and replaced by people who had always felt threatened by the way that Carnival celebrated morals and values that the police, in particular, didn't like. They immediately implemented the recommendations of accountants Coopers and Lybrand to make the subsidized event into a profitable concern. Though it is still fun, at first glance it seems little more than streets and streets of overpriced ethnic food stalls. And so market values finally overtook one of the last children of the London Free School.

In addition to clandestine radio stations, there was underground television. For six months, throughout the months of April to September 1986, the pirate NeTWork21 broadcast on channel 21 on the UHF band, just below ITV, using a low-power transmitter that covered an eight-mile radius across London. The programme lasted thirty minutes and went out on Friday night at midnight. The station was estimated to have about 50,000 viewers after most of the newspapers ran stories on it. The Department of Trade's principal concern was over the channel's complete lack of censorship of the programme's contents, which appeared to be dangerously close to freedom of the press, something unknown in Britain. The collective who made the programmes said: 'We want to challenge people's perceptions of what broadcasting really is. The images we display speak for themselves.' Programmes centred mostly on the underground arts scene, with an interview with Derek Jarman, footage of the Sex Pistols' television appearance with Bill Grundy, a programme on tattoos, live concerts by Diamanda Galás and Test Department, and many films by video artists of admittedly varying quality.

London had changed. In the sixties there were no tables on the streets outside restaurants, by the eighties London had begun to look like Paris. In the sixties you had to drive out to London airport to get a meal after midnight: an outing that was so popular that the terminal restaurant began to insist that at least one member of the party held a boarding card. By the eighties, Soho had gone through a period of revitalization caused by a combination of the pink pound, which had made Old Compton Street as crowded at midnight as it was at midday, and the opening of the Groucho Club just around the

corner on Dean Street. Not only did Old Compton Street have gay pubs, bars and cabarets, but it had gay cab companies ensuring a safe journey home, as well as sex shops and specialized clothing stores, making it 'the gay high street of Europe'[3] according to one Dutch magazine.

The Groucho Club,[4] which opened in May 1985, was the idea of a group of publishers and literary agents who wanted somewhere to meet other than a restaurant or pub. None of the traditional, conservative, old gentlemen's clubs were suitable, as places like the Garrick, Boodle's and White's all then refused to accept women as members. The publishers Liz Calder, from Bloomsbury, and Carmen Callil, from Virago, came up with the idea at the Frankfurt Book Fair when they and a group of other British publishers and literary agents, including Louis Baum, Matthew Evans, Michael Sissons and Ed Victor, sat around discussing the news that the Garrick had once more voted against allowing women members. Fed up with the fact that there was nowhere for them all to meet in London they decided to start their own club. Louis Baum produced a document setting out their aims: they wanted a 24-hour, seven-day-a-week bookshop, a sauna and jacuzzi, coffee shop, meeting rooms and of course a bar and restaurant. They approached Tony Mackintosh to be managing director as he had already had great success with Dingwalls Dance Hall in Camden, the 192 restaurant in Notting Hill and the Zanzibar Club just down from Blitz in Covent Garden. On all three ventures he had worked with the same friends: the wine merchant John Armit and architect Tchaik Chassay. A dozen of the group met with Tony at Tchaik's Notting Hill flat and set out their proposals. Seeing the large group of partners already involved, Mackintosh initially proposed that they pay him to conduct a four- to six-month feasibility study. As they wanted somewhere in Fitzrovia, Bloomsbury or Soho he immediately recognized that premises large enough to house all their wants would be prohibitively expensive and asked them which elements were sacred, that he couldn't cut out. After a long silence Louis Baum said: 'The name.'[5]

Several years before, with an eye to starting a Soho restaurant, Tony had looked at Gennaro's, at 45 Dean Street, which had been closed for several years, but there were so many rooms on so many floors that it was impractical. However, the premises were well suited for a club so he returned. The price was £450,000 with about the same again to do it up. With an amusing prospectus designed by Richard Adams with drawings by Quentin Blake they found more than 400 people to put up the minimum subscription of £500 or more. The required amount did not come in until the morning the offer legally had to close; any later and the cheques would have had to be returned.

Tony was appointed CEO and chairman, a position he held for the club's first eighteen years. In another inspired move, Liam Carson was made general manager.

Liam had started out at Blitz, where he rose from being the washer-up to managing the club in a matter of a few weeks. He moved from there to Langan's Brasserie at the time when Peter Langan was at the height of his powers: drinking eight bottles of champagne a day, pouring wine over the customers, throwing out any who dared to criticize the food and administering cunnilingus under the tables to any female diner who would allow it. Langan showed Liam how things should be done and he learned fast. After a few other culinary adventures he finished up at the Groucho possessed of a love for late nights, drugs and parties. He was beautifully described by Jonathan Meades as looking like an 'unusually dissipated cherub' who 'carried with him a faint but distinct whiff of danger – and the inchoate prescience of future self-destruction'.[6]

As Thatcherism brought mass unemployment, and her deregulation of the Stock Exchange opened the way for decades of greed and the amassing of paper fortunes, an atmosphere was created in London of hedonism and total self-indulgence among those who were benefiting that only ended with the terrible crash of 2008. At the Groucho Club, cocaine was the king. Celebrities stumbled among the tables, their nostrils coated with the stuff. The tops of the cisterns and the sinks in the bathrooms all bore traces of hastily snorted lines. Several pushers worked out of the club itself and at one time you could ask at the bar for matches and the bartender would reply: 'Certainly, sir, that will be £40', handing over a wrap hidden inside the club's free bookmatches. For a decade the Groucho Club was one long party, a modern-day equivalent to the old Gargoyle Club across the street.

Liam encouraged everyone to treat the club as their living room, and they did. His interests extended from sport to music and, on one memorable occasion, he had the captains of the English cricket team, football team and rugby team all lined up at the bar. I remember walking in one day to see Neil Kinnock, leader of the Labour Party, deep in conversation with the former armed robber John McVicar, or John McCriminal as people called him behind his back. After an anxious startup financially, Tony Mackintosh knew the club was finally going to survive when he walked in one afternoon and found only two people in the bar, sitting at each end of the room, reading the newspaper and having a cup of tea: one was Eric Clapton and the other Harold Pinter. There were so many rock stars that the membership committee had a person specifically designated to deal with their applications; musicians

of course had a reputation to live up to and they caused the most damage. Liam Gallagher from Oasis went on a coked-up rampage in the snooker room in November 1996, laying into the lighting, a wide-screen television and the snooker table itself with a snooker cue. The table had been donated by Janet Street Porter in memory of her late husband, Frank Cvitanovich. It cost £5,000 to repair and Gallagher was banned for life.

But it was not just rock stars who suffered bans. The Groucho was quickly added to the rounds of the old time Sohoites Dan Farson, Francis Bacon and Jeffrey Bernard. Farson got himself banned when a rent boy he had spent the night with in one of the club's nineteen bedrooms not only robbed him, but ransacked the rooms of all the other guests as well. When he was readmitted, he celebrated by getting so drunk that he pissed against the bar. Despite Liam's arguments that Farson would have probably injured himself if he had attempted to negotiate the notoriously tricky narrow staircase leading to the men's toilet he was banned again by the unsympathetic management.

There were two Groucho Clubs. The daytime club, which began with power breakfasts and led on to business lunches: people doing deals, agents discussing projects with writers or screenwriters, lawyers advising their clients. After lunch things became slightly less respectable. There was a period when Jeffrey Bernard spent each afternoon sleeping off his liquid lunch in the armchair just inside the bar by the window. Later, when he was wheelchair-bound, they moved the furniture so that he was accommodated in his usual place. When he was awake, he would trade loud insults with Dan Farson across the room though much of it was put on for the benefit of other afternoon drinkers. The other Groucho Club began around six o'clock when the bar quickly filled with people from the Wardour Street film industry and others who worked nearby. The club really got into its stride around ten, when people stopped by after dinner. It was going flat out by the official closing time of 1 a.m.. Of course there were lock-ins and sometimes the party carried on all night. Liam Carson was so impressed by the prodigious drinking marathon held by Robert Elms and Spike Denton in 1987 that he framed the final bill on his wall at home. The total was seventy-six bottles of Becks, two bottles of champagne and one club sandwich, all consumed over fifteen hours.

Cocaine use was so blatant, and went on for so many years, that it was often commented upon how strange it was that the drugs squad never made an appearance, despite numerous reports of drug-taking in the tabloid press. One reason may have been that they were never sure who they might find there. When Prince Edward was working nearby for Andrew Lloyd Webber's

The Really Useful Company, he became a regular lunchtime guest; there was no telling if he might return in the evening and the police certainly didn't want to bust the place when he was there. There were also a number of politicians who used the club, again making it more or less immune. This feeling of safety led to greater hedonism and feats of excess.

Damien Hirst was the most outrageous of the artists at the Groucho, better known for his penchant for exposing his penis to everyone, and for his excessive cocaine use, than for his art. In *On My Way to Work* he said: 'I had the best two years of my life on drugs. We used to celebrate. I used to walk into the Groucho Club with my arm in the air: going "Chop 'em out!" And I used to love it.'[7] Hirst stories abound: there was the night he, the actor Keith Allen and Alex James from Blur hid under the pool table when the club closed and remained locked in until 10 a.m. opening, fortified by bottles of wine and an ample supply of cocaine. To extend the evening into the new day they removed their trousers and stood behind the bar naked from the waist down telling the long-suffering staff that it was 'no trousers day'. Stephen Fry walked in for a business breakfast and ordered sausages. Hirst walked out from behind the bar with his cock on a plate which he plonked down in front of Fry: 'You ordered sausage, sir.' Fry didn't blink: 'I said a sausage, not a chipolata.' A more dangerous prank occurred when Hirst set fire to the publicist Mark Borkowski's chest hair, burning him so badly that he ended up in casualty. Hirst spent thousands of pounds in the club so they did not complain, except by letter, asking him to please refrain from pissing in the sink. After a decade of service, Liam Carson was so exhausted that his wife persuaded him to quit and they moved to France, near Nice, where he attempted to write a sitcom. The club was never the same without him.

In 2001 the Groucho was bought by Joel Cadbury, Matthew Freud and Rupert Hambro for £11.8m and was sold on in 2006 to the private equity company Graphite Capital for £20m. The drugs are gone and the atmosphere is much straighter now – even the old busted settee is gone; but nothing can stand still and it remains one of the best of the late-night London clubs. The success of the Groucho quickly spawned imitators. The first was Auberon Waugh's Academy Club, next door to the offices of his magazine *Literary Review*, which opened in 1986. This was not really in competition as it is more like the Colony in scale, a single upstairs room, and encourages a small membership who all know each other. Black's, situated directly across the street from the Groucho, attracted a younger crowd. As residents still live on the top floors the entrance is through the basement. In order to prevent

members from continually attempting to get in through the front door a sign was affixed to it which read: 'No admittance to Blacks', the unfortunate wording of which quickly attracted the attention of the police.

The most serious competition comes from Soho House, which not only stays open until 3 a.m. but has an outdoor smoking terrace on the roof, giving it a considerable advantage over the Groucho, which has nowhere for its smokers to go except out on to Dean Street, where they are at the mercy of paparazzi and beggars. Recently Soho House has opened an even more opulent branch in the East End. Shoreditch House is in the Tea Building on Bethnal Green Road and has its own gym, sauna and steam rooms, private dining rooms, a two-lane bowling alley and, adjoining a large rooftop bar and restaurant, a sixteen-metre heated outdoor pool incongruously surrounded by groups of smokers. The Colony Room closed in December 2008 amid a chorus of opprobrium and lawsuits, leaving its shell-shocked members to roam Dean Street, searching for a friendly home. Soho is ever-adaptable and ever the same and they were quickly absorbed into nearby drinking clubs.

The eighties are seen by many people as the beginning of the end for non-commercial art in London. Under Thatcher, artists, galleries and museums were encouraged to get private sponsorship rather than rely upon government grants, even though the country made enormous amounts of money from the art business through auction houses and Cork Street, and through museums and galleries as tourist destinations. This had the predictable effect of restricting the type of exhibition held by the public institutions to those approved of by big corporations and led to the 'blockbuster' shows where people shuffle past 'great art' on timed admission tickets. It led to a greater commodification of art, and the creation of work that pandered to the public taste. This is exacerbated by the disastrous move of amalgamating the art colleges into universities and colleges so that instead of having the freedom to experiment and explore dead-ends, to make mistakes and chop and change, students are now subject to regular assessment and evaluation as if they were studying maths. The aim is now to produce workers for the 'arts industries', a ghastly new hybrid created by arts consultants who know nothing about the actual creation of art.

From 1970, Saatchi and Saatchi had grown to become the biggest advertising agency in the world, with a staff of 16,000 people in fifty-eight countries, allowing the art collector Charles Saatchi to spend around a million pounds a year on his hobby of buying and selling paintings. This huge sum of money

inevitably had an impact on the market; he was the only big collector in Britain. Everyone wanted to sell to him, and to do so they made the kind of things he might like to buy. In 1985 he opened an enormous gallery space in Boundary Road, St John's Wood, to exhibit his collection. At the same time, a new generation of artists were emerging from the art schools. Brought up in the Thatcher era when greed and commercialism were celebrated, they treated art as a business, feeling that if they did their apprentice years in art school they were somehow entitled to a career in art. Many of them, including Sarah Lucas, Gary Hume, Gillian Wearing, Marcus Harvey, Anya Gallaccio, Michael Landy, Fiona Rae, Simon Patterson, Mark Wallinger, Abigail Lane, Angus Fairhurst and Damien Hirst had attended Goldsmiths College, where they were encouraged and guided by their senior tutor, the conceptualist artist Michael Craig-Martin. He was most famous for his work *Oak Tree*, consisting of a glass of water on a shelf and a semiotic text. (It was banned from entering the USA by customs officials who believed it to be a plant. Craig-Martin had to explain that it was just a glass of water. This was no doubt an amusing encounter.) Conceptual art usually only works in a gallery context – otherwise it just looks like the load of rubbish it often is – so he taught his students how to present their work professionally.

In 1988 the second-year student Damien Hirst, Angus Fairhurst and a group of fellow students decided to mount an exhibition of their work. Fairhurst had previously organized a show of student work that July but it was Hirst who took over as the main organizer of this show, which they called *Freeze*, named after Matt Collishaw's *Bullet Hole*, an enlarged photograph, taken from a pathology textbook, of a bullet wound to a human head and described in the exhibition catalogue as 'dedicated to a moment of impact, a preserved now, a freeze-frame'. *Freeze* opened in July 1988 in an empty administration building in the Surrey Docks and was jointly sponsored by the London Docklands Development Corporation, who gave Hirst £4,000, and the property developers Olympia and York, responsible for building Canary Wharf, who paid £10,000 for a professional catalogue. Craig-Martin used his contacts to persuade Charles Saatchi, Norman Rosenthal, director of exhibitions at the Royal Academy, and Nicholas Serota, newly appointed director of the Tate, to visit the exhibition, sending cabs to pick them up. Charles Saatchi bought Collishaw's *Bullet Hole* directly from the exhibition. Many of the sixteen exhibitors in the show went on to become known collectively as the Young British Artists, or yBas, who were to dominate the British art scene for more than a decade, producing what the critic Julian Stallabrass has cleverly dubbed 'High Art Lite'. Hirst quickly became the best-known of

them, and was soon able to put into practice his widely quoted statement from 1990: 'I can't wait to get in to a position to make really bad art and get away with it. At the moment, if I did certain things people would look at it, consider it and then say "Fuck off". But after a while you can get away with things.' Damien Hirst's £50m jewel-encrusted skull, or his 2008 £111m Sotheby's show filled with works featuring gold, butterflies and diamonds, all designed to appeal to his wealthy collectors and to look nice on the wall of a boardroom, are good examples of this in practice.

The imbalance caused by having only one modern art collector determined the artistic direction of scores, if not hundreds, of artists desperate to sell their work. Saatchi was an advertising man, and he liked his art to have an immediate impact, and if possible also to have a pun attached – rather like an ad. The Turner Prize winner Chris Ofili wrote: 'A lot of artists are producing what is known as Saatchi art... You know it's Saatchi art because it's one-off shockers. Something designed to attract his attention. And these artists are getting cynical. Some of them with works already in his collection produce half-hearted crap knowing he'll take it off their hands. And he does.'[8]

But there are still plenty of artists who are able to see beyond this, and the arts are still a breeding ground for genuine free spirits who cannot be contained. Whereas someone like Gustav Metzger reacted to the big-money gallery system of turning art into product by refusing to have anything to do with it, some artists today are more proactive. When Damien Hirst curated a show called *Some Went Mad, Some Ran Away* at the Serpentine Gallery in May 1994, he included his own *Away from the Flock*, a sheep in a tank of formaldehyde. Mark Bridger, an artist from Oxford, poured a bottle of black ink into the tank and retitled it *Black Sheep*. Hirst was not amused and allowed the police to prosecute him. Bridger told the magistrate that he was surprised at Hirst's reaction as he thought they were on the 'same creative wavelength'. He said: 'To live is to do things, I was providing an interesting addendum to his work. In terms of conceptual art, the sheep had already made its statement. Art is there for creation of awareness and I added to whatever it was meant to say.'[9] He was found guilty of criminal damage and given a two-year conditional discharge.

It was left to Genesis P-Orridge to cause the biggest art fuss with a spectacular police bust which occurred on 15 February 1992, while he was away in Kathmandu, Nepal. A Scotland Yard SWAT team raided his house in Brighton with dozens of police and with helicopter support. They seized more than two tons of archives: tapes, videos, manuscripts, film and posters, including rare books and photographs by other writers and artists. When he returned

to London he was not charged with anything. It seems that the reason for the raid was his contravening the law on body piercing and tattoos, both of which were apparently illegal, though use of a helicopter and armed police seems something of an over-reaction. This was the same month as the appeal by fifteen gay men who were found guilty of assaulting each other while engaging in private and mutually consenting sado-masochistic acts. Lord Lane set a legal precedent by declaring that any form of injury or piercing to the body was illegal if it was done in the course of, or for the furtherance of, sexual pleasure because it constituted 'unnatural sex'.

The police told Genesis: 'We know you didn't do anything', but they also refused to return his archives. They had 'lost' them. Genesis: 'They never charged me, nor did they return my archives. Responsibility for that has gone round and round to this day. The stuff's either hidden in a warehouse or destroyed. Very Kafkaesque. I was symbolic of everything they didn't like.'[10] Social Services then informed him that if he remained in Britain, his children would be taken into care. He sensibly went into self-imposed exile in the USA. At the time of writing, sixteen years later, his archives have still not been returned.

The commodification of art has not gone unchallenged. Among the more amusing protests was an action taken against Tracey Emin's unmade bed. On 25 October 1999, at the Turner Prize show at the Tate, two Chinese performance artists, Yuan Chai and Jian Jun Xi, jumped on Emin's *My Bed* stripped to the waist and intent on 'improving' the work, which they thought had not gone far enough. They called their performance *Two Naked Men Jump into Tracey's Bed*. They had a pillow fight and attempted to drink from the empty vodka bottles Tracey had lying about before being removed by security guards. Other visitors to the exhibition had responded by applauding, thinking it was part of the show and at first the security people were also confused and did not immediately intervene. Police and security men were booed by the public when they arrested Chai and Xi and took them away. It had been their intention to perform some 'critical sex' as they felt 'a sexual act was necessary to fully respond to Tracey's piece', but unfortunately they had no time. Chai said that, although Emin's work was strong, it was nevertheless institutionalized and said: 'We want to push the idea further. Our action will make the public think about what is good art or bad art. We didn't have time to do a proper performance. I thought I should touch the bed and smell the bed.'[11] The artists were taken to the cells of Belgravia police station, where they explained their intervention to the police. 'We usually get a different type of artist down here,' said one officer. No charges were

brought as neither Tracey nor the gallery wished to take the matter further. Further interventions by the duo included scattering £1,200 around a room at Goldsmiths college to draw attention to the greed and commercialism of the art market, causing the audience to scramble on the floor for the money. They also made an, apparently, unsuccessful attempt in the spring of 2000 to piss in Marcel Duchamp's *Fountain*, a urinal lying on its back and signed 'R. Mutt', at the Tate.

Members of 'The Chaps' had better luck with an action on 27 April 2006 when three young men, one with a monocle and old school tie, all dressed like Bertie Wooster in tweeds, made a successful ascent of the south face of 'Whiteread', a 67-foot-high mountain that was one of the dominant features of *Embankment*, an installation made up of 14,000 resin casts of cardboard boxes assembled by Rachel Whiteread in the Turbine Hall of Tate Modern. According to the Chaps: 'Gustav Temple, Michael Attree and Torquil Arbuthnot gasped audibly upon first witnessing Whiteread, for it appeared to them to be the most unassailable monolith they had ever seen.'[12] At only ten feet from the peak, they were halted by the sound of a megaphone calling up to them but a swift scramble took them to the summit where they planted the Union flag, drank a chilled martini and passed around a celebratory briar before agreeing to descend. They were rather rudely ejected from the building. The Chaps had previously demonstrated against Rachel Whiteread's work in May 2004 when twenty-seven of them handcuffed themselves around her *Untitled (Room 101)* in the plaster cast room of the V&A to protest against the intrusion of modern works into the celebrated nineteenth-century collection of the world's greatest architecture. When the sleepy guards took no notice, they climbed to the top of it and dispatched the contents of several hip flasks of good quality whisky before being ejected.

Despite all the media attention, the YBAS did not completely control the art scene. In 2003, when the Chapman Brothers were confidently expecting to win the Turner Prize, the jury chose instead to award the prize to Grayson Perry. It was as Claire, dressed in a specially made £2,500 lilac and blue frock, frilly white socks and red patent leather shoes, that Grayson Perry ascended the podium at the Tate Gallery on 7 December 2003, and declared: 'It's about time a transvestite potter won the Turner Prize.'[13] After twenty years of working in an unpopular medium, with little or no critical support, he finally won the highest prize in the contemporary art world, the £20,000 Turner Prize. In the years to follow, no TV arts chat show was complete without Grayson in his dress holding forth.

In many ways, Grayson's winning the Turner Prize showed there was no

longer an underground, as such. This proved that there was no longer one society with everyone agreeing how to live, and a shadowy alternative world, but many possible overlapping lifestyles and choices. The underground had officially come above ground, and consequently no longer existed. That which was once private was now public. Just after the war, to be avant-garde or underground meant to be below the radar. The general public knew little of your activities and would have been deeply shocked if they did: abstract painting, four-letter words, nudity, living in sin, homosexuality, drugs. It was so far away from the lives of most people it was almost incomprehensible. In the fifties the tabloids fulminated against rock 'n' roll and Teddy boys, establishing Elvis Presley as a teen icon and ensuring that even the smallest town had a few Teddy boys. Gradually, the arts and popular culture came to be seen as a free source of ideas by business rather than as a threat to society. By the end of the sixties, even the most radical and avant-garde ideas were raided by big business for their advertising, fashion and graphic design. Now, as Danny Eccleston from *Mojo* told me: 'the consumer society keeps just reaching in and taking what it likes from the popular culture side and the rift never seems to heal.' One good example was Marcus Harvey's infamous picture based on the equally infamous thirty-year-old police mug shot of Myra Hindley. His large painting was made using a stamp made from a child's handprint to represent the dots or pixels of the image. The picture caused controversy when it was exhibited at the Royal Academy's *Sensation* show, mostly being condemned by the same newspapers that had made the image famous in the first place. Shortly afterwards Adidas launched a series of advertisements, making portraits of sportsmen from trainer prints, just as Harvey's picture was made from handprints.

Some artists have been able to use the media to their own advancement. Tracey Emin and Damien Hirst used the press to help turn their art into a celebrity brand and make them multi-millionaires, only this time round it is a collaborative effort with the tabloids. They are now both playing the same game; a measure of notoriety is an essential part of the brand for the artists and for the tabloids it means sales.

And now art has become global. London pulls in more people than ever: in 2001 a quarter of the population of London was foreign-born and the city continues to attract students from all over Britain to its colleges and universities as well as people moving to the metropolitan centre to improve their careers or find better jobs. The most amazing development has been in the East End, where it has been estimated that more than 10,000 artists have established

studios, catered for by almost 200 galleries as well as the usual trendy bars, restaurants and private drinking clubs such as Shoreditch House.

There is still plenty of transgression, protest, experimentation and excess in London; much of it in the East End. But it is just not underground any more. Since the mid-eighties, art and music have gone mainstream and the newspapers and glossies compete to report on the latest thing. A rock band has only to play a handful of well-regarded gigs to get reviewed in the music press, and thanks to the publicity-seeking YBAS art became a popular subject for the weekend newspaper colour magazines because it was inherently colourful and visual. Drug-taking became so prevalent in the Thatcher era among City traders, bankers, advertising executives and media people and at middle-class dinner parties that it could hardly be counted as a subversive activity any more.

Public attitudes towards homosexuality have probably undergone the greatest change: from demonization to more or less general acceptance. Now, even members of the Cabinet can be open about their homosexuality without much in the way of protest from the tabloids; a few smutty head-lines usually suffices. The London Gay Pride march in 2008 was enormous. I watched for more than an hour as the usual gladiators, brides, bunnies and butterflies marched and danced down Oxford Street. But it was the floats that demonstrated how far London has progressed since 1967 because they represented such a wide cross-section of the British public. It was moving to see a gay British Airways group of about a hundred people, men and women, in full flight deck uniform marching under the airline's banner, followed by gay groups from the Crown Prosecution service, the gay National Archives, by football teams and local government officers. There was a large float from the Battersea cats and dogs home, the 'reel gay Gordons' in kilts and a large float from the Gay Muslim support group. There were buses and trucks representing gay African women, London Transport, even several high street banks with what appeared to be official bank banners. London's Conservative mayor, Boris Johnson, attended, walking the full length of the march from Baker Street to Trafalgar Square. They were ordinary people. As some of the banners read: 'Some people are gay, get used to it.'

London is like a palimpsest, with pockets of different counter-cultural groups scattered across the city: old hippies near the Westway in Notting Hill in the few surviving head shops and hippie stalls in the market; Goths and technofreaks in Camden market, living a cyberpunk life; there are even a few mohawked punks still parading down the King's Road, posing for tourists for money. The latest sub-set is in the East End, where edgy-looking muscular

arts types with their close-cropped hair and turned-up, paint-splashed jeans hang about outside the Old Truman Brewery on Brick Lane.

Since the war we have seen the growth of mimeographed poetry magazines, underground newspapers, Xerox-copied punk fanzines and brilliantly designed flyers for raves. With the coming of the internet, underground publication has effectively disappeared. There can be no avant-garde unless there is a time delay before the general public knows what you are doing. Now, events are broadcast live on the net or images are bounced straight from people's telephones to the other side of the world in nano-seconds. The underground newspapers and Xeroxed punkzines have been replaced by blogs, YouTube and Facebook, giving immediate publication and instant access to the general public to even the most avant-garde of activity. Information can arrive from anywhere and it is often impossible to know if a message or image has come from around the corner or from 10,000 miles away. Whereas artists in the sixties could work for years with no media coverage, the hardest thing now is to *not* have thousands of hits on Google or an entry on Wikipedia. Nonetheless, a walk around Shoreditch or down Dean Street, late at night, shows that in London there are still plenty of people determined to achieve a complete 'derangement of senses' and in that way the underground lives on. There will always be cutting-edge activity but bohemia has been globalized. Now, more than a location, the underground is a state of mind.

Notes

Introduction

1 Deyan Sudjic, 'Cities on the Edge of Chaos', in the *Observer*, 9 March 2008.
2 Foreword by Derek Taylor in Mark Lewisohn, Piet Schreuders and Adam Smith, *The Beatles' London*.
3 Stanley Jackson, *An Indiscreet Guide to Soho*, p. 25.
4 Dan Farson, *Soho in the Fifties*, intro, p. xiii.

Part One

Chapter 1. A Very British Bohemia

1 Tambimuttu, 'Fitzrovia'.
2 The best source of information on Tambimutti is Jane Williams (ed), *Tambimutti*.
3 ibid., p. 86.
4 Helen Irwin, 'Tambi', in *Tambimuttu*, p. 90.
5 Tambimuttu, 'Fitzrovia'.
6 See Denise Hooker, *Nina Hamnett*.
7 Janey Ironside, *Janey*, p. 56.
8 Quoted by David Rhys, in 'Nina Hamnett, Bohemian' in *Wales Magazine*, September 1959.
9 See Paul Willetts, *Fear & Loathing in Fitzrovia*. Willetts is responsible for restoring interest in the life and work of Maclaren-Ross with this biography and his introductions to Maclaren-Ross's collected writings.
10 Dan Davin, *Closing Times*, p. 5.
11 Wrey Gardiner, *The Dark Thorn*, p. 96.
12 Robert Hewison, *In Anger*, p. 34.
13 Humphrey Seale, *Quadrille with a Raven*, at www.musicweb-international.com/searle/500.htm, accessed September 2008.
14 Joan Bakewell, *The Centre of the Bed*, p. 120.

15 Dan Davin, *Closing Times*, p. 131.
16 ibid., p. 145.

Chapter 2. The Long Forties: Soho

1 Michael Luke, *David Tennant and the Gargoyle Years*, p. 49.
2 Andrew Sinclair, *The Life and Violent Times of Francis Bacon*, p. 115, quoting Michael Luke, *David Tennant and the Gargoyle Years*.
3 Henrietta Moraes, *Henrietta*, p. 28.
4 ibid., p. 30.
5 The best account of John Minton is Frances Spalding, *Dance Till the Stars Come Down*.
6 Ruthven Todd, *Fitzrovia & the Road to the York Minster*.
7 John Lehmann, *I am My Brother*, p. 113.
8 Henrietta Moraes, *Henrietta*, p. 35.
9 Frances Spalding, *Dance Till the Stars Come Down*, p. 206.
10 ibid., p. 201.
11 Michael Wishart, *High Diver*, p. 113.
12 Michael Luke, *David Tennant and the Gargoyle Years*, pp. 182–3.
13 Judith Summers, *Soho*, p. 226.
14 Dan Farson, *Soho in the Fifties*, p. 53.
15 Dan Farson, *The Gilded Gutter Life of Francis Bacon*, p. 71.
16 Dan Farson, *Soho in the Fifties*, p. 17.
17 Dan Farson, *Out of Step*, p. 56.
18 Anthony Cronin, *Dead as Doornails*, p. 140.
19 ibid., p. 133.
20 Dom Moraes, *My Son's Father*, p. 132.
21 Dan Farson, *Soho in the Fifties*, p. 59.
22 George Melly, *Owning Up*, p. 72.
23 Dan Farson, *Soho in the Fifties*, p. 88.
24 Andrew Barrow, *Quentin & Philip*, p. 196.

Chapter 3. Sohoitis

1 Blogspot.com, accessed 18 February 2006.
2 'An Interview with George Melly, Jazz Singer, Surrealist, Zoot Suit Enthusiast', at www.alternativestovalium.blogspot.com/2006/02/interview-with-george-melly-jazz.html,18 February 2006, accessed February 2007.
3 Colin MacInnes, 'See You at Mabel's', in *Encounter*, March 1957, collected in *England, Half English*.
4 Oliver Bennett, 'Licor-ish Allsorts'.
5 Frank Norman and Jeffrey Bernard, *Soho Night & Day*, p. 138.
6 Michael Wojas in conversation with the author.
7 Interview by Sian Pattenden in the *Independent*, 11 May 2005.
8 Oliver Bennet, 'Licor-ish Allsorts'.
9 Dan Farson, *The Gilded Gutter Life of Francis Bacon*, p. 56.
10 From 'The Hopkin Syndicate' (unpublished), quoted in Frances Spalding, *Dance Till the Stars Come Down*, p. 171.
11 Paul Potts, *Dante Called You Beatrice* (Readers Union edn), p. 24.
12 Dan Farson, *Soho in the Fifties*, p. 43.
13 Dom Moraes, *My Son's Father*, p. 169.

14 Michael Wishart, *High Diver*, pp. 61–4.

15 Dan Farson, *The Gilded Gutter Life of Francis Bacon*, p. 41.

16 ibid., pp. 16–17.

17 ibid., p. 106.

18 John Russell, *Francis Bacon*, p. 21.

19 John Banville, 'False Friend', in the *Sunday Telegraph* magazine, 27 February 2005.

20 John Russell, *Francis Bacon*, p. 71.

21 George Melly, *Rum, Bum and Concertina*, p. 74.

22 George Melly, *Don't Tell Sybil*, p. 12.

23 George Melly, *Rum, Bum and Concertina*, p. 113.

24 ibid., p. 113, and *Don't Tell Sybil*, p. 52.

25 Philip Oakes, *At the Jazz Band Ball*, p. 137.

26 Dan Farson, *The Gilded Gutter Life of Francis Bacon*, p. 53.

27 ibid., p. 54.

28 Stanley Jackson, *An Indiscreet Guide to Soho*, p. 44.

Chapter 4. The Stage and the Sets

1 Andrew Barrow, *Quentin & Philip*, p. 188.

2 Crisp, *The Naked Civil Servant*, p. 160.

3 Publicity handout for *An Evening With Quentin Crisp*, 1976.

4 Alex Witchel, 'Quentin Crisp'.

5 www.televisionheaven.co.uk/harrysecombe.htm, accessed December 2008. I am grateful to Colin Fallows for drawing my attention to Secombe's early work.

6 Stanley Jackson, *An Indiscreet Guide to Soho*, p. 107.

7 George Melly, *Rum, Bum and Concertina*, p. 86.

8 Jane Williams (ed.), *Tambimutti*, p. 228.

9 ibid., p. 98.

10 Frank Norman and Jeffrey Bernard, *Soho Night & Day*, p. 143.

11 Dan Farson, *The Gilded Gutter Life of Francis Bacon*, p. 73.

12 Raymond Thorp, *Viper*.

13 ibid.

14 ibid., pp. 29–33.

15 Ronnie Scott, *Some of My Best Friends are Blues*, p. 40.

16 George Melly, *Owning Up*, p. 39.

17 Humphrey Lyttelton, *I Play As I Please*, p. 112.

18 George Melly, *Owning Up*, p. 98.

Chapter 5. This is Tomorrow

1 Ralph Rumney, *The Consul*, p. 37.

2 Peter Everett, *You'll Never be 16 Again*, p. 18.

3 *The Times*, 25 March 1954.

4 *Daily Mail*, 27 April 1954.

5 George Melly, *Revolt into Style*, p. 38.

6 Kenneth Coutts-Smith, *The Dream of Icarus*, p. 40.

7 Richard Hamilton, *Collected Words*, p. 148.

8 ibid., pp. 10–11.

9 Martin Harrison, *Transition*, p. 12.

10 Ralph Rumney, *The Consul*, p. 18.

11 ibid., p. 30.

12 ibid., p. 18.

13 ibid., p. 30.

14 ibid., p. 37.

15 ibid., p. 31.

16 ibid., p. 74.

17 Martin Harrison, *Transition*, p. 92.

18 ibid., p. 92.

19 ibid., p. 92.

20 ibid., p. 105.

21 *Tate* 4 (magazine).

22 David Robbins and Jacquelyn Baas, *The Independent Group: Postwar Britain and the Aesthetics of Plenty*, MIT Press, 1990, p. 190.

23 Richard Hamilton, 'Pop Daddy', in *Tate Magazine*, 4 March 2003.

24 *Motif*, winter 1962.

25 Richard Hamilton, *Collected Words*, p. 28.

Chapter 6. Bookshops and Galleries

1 Christopher Logue, *Prince Charming*, p. 185.

2 Dom Moraes, *My Son's Father*, p. 171.

3 *Guardian*, 4 June 2004.

4 Robert Fraser, *The Chameleon Poet*, p. 239.

5 ibid., p. 236.

6 Dom Moraes, *My Son's Father*, p. 173.

7 Dan Farson, *Out of Step*, p. 72.

8 Quoted from unpublished MS in Robin Muir, *A Maverick Eye*, p. 11.

9 Dan Farson, *Never a Normal Man*, p. 114; Dan Farson, *Out of Step*, pp. 69–70.

10 Henrietta Moraes, *Henrietta*, p. 72.

11 ibid., p. 71.

12 ibid., p. 72.

13 Dan Farson, *Out of Step*, p. 243.

14 Dan Farson, *The Gilded Gutter Life of Francis Bacon*, p. 190.

15 Dan Farson, *Out of Step*, p. 244.

16 Unpublished; quoted in Tony Gould, *Inside Outsider*, p. 111.

17 Val Williams, *Ida Kar*, p. 22.

18 ibid.

19 ibid., p. 26.

20 ibid., p. 28.

21 ibid., p. 64.

22 Steven Henry Madoff, 'Bridget Riley – First Break', in *Art Forum*, November 2002.

23 Dan Farson, *Out of Step*, p. 138.

24 Dan Farson, *Never a Normal Man*, p. 248.

Chapter 7. Angry Young Men

1 Humphrey Carpenter, *The Angry Young Men*, p. 158.

2 *New Statesman*, January 1954 (online).

3 Kenneth Allsop, *The Angry Decade*, p. 83.

4 ibid., p. 83.

5 John Osborne, *A Better Class of Person*, p. 275.

6 *The Times*, 26 May 1956.

7 'The *Observer*', in *Tynan on Theatre*, p. 42.

8 Irving Wardle, *The Theatres of George Devine*.

9 ibid., p. 185.

10 John Osborne, 'Conversation with Richard Findlater', in Findlater (ed.), *At the Royal Court*, p. 19.

11 Kenneth Allsop, *The Angry Decade*, p. 96.

12 *Daily Mail*, 29 April 2006.

13 Colin Wilson, *The Outsider*, Victor Gollancz, London, 1956, p. 1.

14 Colin Wilson, *Autobiographical Reflections*, Pauper's Press, Nottingham, 1988, p. 20.

15 Kenneth Allsop, *The Angry Decade*, p. 158.

16 Colin Wilson, *Autobiographical Reflections*, pp. 111–12.

17 ibid., p. 122.

18 ibid., pp. 122–3.

19 Kenneth Allsop, *The Angry Decade*, p. 153.

20 Dan Farson, *Out of Step*, p. 129.

21 ibid., p. 130.

22 Kenneth Allsop, *The Angry Decade*, p. 161.

23 Doris Lessing, *Walking in the Shade*, pp. 208–9.

24 Tom Maschier (ed.), *Declaration*, p. 58.

25 *Daily Herald*, 15 October 1958.

26 Doris Lessing, *Walking in the Shade*, p. 214.

Chapter 8. Pop Goes the Ease

1 Colin McInnes, *Absolute Beginners*.

2 Dan Farson, *The Gilded Gutter Life of Francis Bacon*, p. 45.

3 Tony Gould, *Inside Outsider*, p. 81.

4 ibid., p. 94.

5 ibid., p. 118.

6 In conversation with the author.

7 Colin MacInnes, 'Nicked', in *New Society*, 16 September 1965.

8 ibid.

9 Tony Gould, *Inside Outsider*, p. 104.

10 ibid., p. 113

11 ibid., p. 114

12 ibid., p. 137

13 ibid., p. 199

14 Frank Norman, 'Colin MacInnes, 1914–1976', in the *New Statesman*, 30 April 1976.

15 Colin MacInnes, *Absolute Beginners*, p. 61.

16 Quoted at 'School of Francis Bacon', at www.alexalienart.com/school_of_bacon.htm, accessed September 2006.

17 Dan Farson, *Never a Normal Man*, p. 256.

18 John Richardson, *Sacred Monsters*, p. 327.

19 ibid., p. 325.

20 *Tatler*, November 2006.

21 John Russell, *Francis Bacon*, pp. 87–8.

22 *Art Review*, June 2002.

23 British Council Collection, entry for Lucien Freud:
http://collection.britishcouncil.org/exhibition/past/12/15249.
24 Richard Cork, *The Times*, 3 May 2006.
25 John Tusa interviews, BBC website.
26 Chili Hawes (ed.), *Gerald Wilde 1905–1986*, p. 15.
27 ibid., pp. 4 and 50.
28 Gavin Stamp, 'Anti-Ugly Action', in *Blueprint*, January 2007.
29 Adam Smith, *Now You See Her – Pauline Boty – First Lady of British Pop*, at www.writing-room.com.
30 Christopher Logue, *Prince Charming*, p. 257.
31 www.writing-room.com, accessed 2006.
32 http://burning-brightly.tripod.com/mrlacey.html, accessed September 2008.

Chapter 9. The Big Beat

1 George Melly, *Revolt into Style*, p. 147.
2 Chas McDevitt, *Skiffle*, p. xvi.
3 Mary Quant, *Quant by Quant*, p. 34–5.
4 Chas McDevitt, *Skiffle*, pp. 61–3.
5 ibid., p. xv.
6 ibid., p. 147.
7 Michael Moorcock interviewed by Patrick Hudson for *The Zone*, online science fiction magazine: www.zone-sf.com, accessed June 2009.
8 Chas McDevitt, *Skiffle*, p. 147.
9 Alan Woods, *Ralph Rumney*, p. 38.
10 Chas McDevitt, *Skiffle*, p. 115.
11 Judith Summers, *Soho*, p. 197.
12 Simon Napier-Bell, *You Don't Have to Say You Love Me*, p. 43.
13 ibid., p. 42.
14 Chas McDevitt, *Skiffle*, p. 8, quoting from Adam Faith, *Acts of Faith*, Bantam Books, London, 1996.
15 ibid., p. 51.
16 Max Décharné, *King's Road*, p. 63.
17 Dick Heckstall-Smith and Pete Grant, *Blowing the Blues*, pp. 19–20.
18 The story of the design of the Nuclear Disarmament badge is covered in detail in Barry Miles, *Peace*. The CND was a major factor in the development of the youth counterculture in Britain. There are a number of useful histories, including Richard Taylor and Nigel Young (eds.), *Campaigns for Peace. British Peace Movements in the Twentieth Century*, Manchester University Press, 1987; Joan Ruddock, *CND Scrapbook*, Macdonald Optima, London, 1987; Peggy Duff, *Left, Left, Left*, Allison and Busby, London, 1971, for an early, personal account; and the standard work, Kate Hudson, *CND, Now More Than Ever. The Story of a Peace Movement*, Vision, London, 2005.
19 *Spectator*, 12 April 1960.
20 Kenneth Allsop, *The Angry Decade*, p. 208.

Part Two

Chapter 10. The Club Scene

1 Colin MacInnes, 'Out of the Way', in *New Society*, 8 November 1962.
2 Sara Maitland, 'Introduction', in *Very Heaven*, p. 5.
3 Andrew Loog Oldham, *Stoned*, p. 78.
4 ibid., p. 78.
5 ibid., p. 79.
6 Earl Kirmser, 'Things Happen in Soho's Folk Club', in *Rolling Stone* 102, 17 February 1972.
7 George Melly, *Revolt into Style*, pp. 97–8.
8 Keith Richards, interviewed by *Playboy*, October 1989.
9 Simon Napier-Bell, *You Don't Have to Say You Love Me*, p. 37.
10 Charles Marowitz, *Burnt Bridges*.
11 ibid., pp. 21–2.
12 ibid., pp. 55–6.
13 Peter Everett, *You'll Never be 16 Again*, p. 62.
14 Mike Kemble, 'Radio Caroline History', at www.mikekemble.com/ caroline/caroline4. html, accessed March 2006.

Chapter 11. The Beat Connection

1 Allen Ginsberg in conversation with the author.
2 Quoted in Nicholas Zurbrugg, *Critical Vices*, at www.scribd.com/doc/14709295/critical-vices-the-myths-of-postmodern-theory, accessed November 2007.
3 Tony Rayns, 'An Interview with Anthony Balch', in *Cinema Rising* 1, April 1972.
4 ibid.
5 ibid.
6 ibid.
7 ibid.
8 ibid.
9 ibid.
10 Allan Campbell and Tim Niel, *A Life in Pieces*, p. 139.
11 ibid, p. 128.
12 Greil Marcus, *Lipstick Traces*, p. 385. Trocchi interviewed in 1985.
13 Original promotional leaflet advertising Stigma.
14 Allan Campbell and Tim Niel, *A Life in Pieces*, p. 162.
15 ibid, p. 163. Burroughs intervewed in September 1995.
16 Interviewed by Leonard Maguire for *Scope* on BBC Radio Scotland. Collected in *A Life in Pieces*, p. 147.
17 Christopher Logue, *Prince Charming*, p. 291.
18 Allan Campbell and Tim Niel, *A Life in Pieces*, p. 140.
19 Jeff Nuttall, *Bomb Culture*, p. 151.
20 Bryan Forbes interviewed by Dee Shipman and Paul Jacobs. 'Write Up There with the Best', website, accessed July 2005.
21 Jeff Nuttall, *Bomb Culture*, p. 237.

Chapter 12. The Albert Hall Reading

1 James Morrison, 'The International Poetry Incarnation: The Beat Goes On', in the *Independent*, 22 September 2005.

2 ibid.

3 Will Hodgkinson, 'Snap: Allen Ginsberg', in the *Guardian*, 21 October 2005.

4 From the printed 'press release' for the Albert Hall poetry reading.

5 Jeff Nuttall, *Performance Art. Volume 1: Memoirs*, p. 20.

6 ibid.

7 Paul A. Green, 'Young Adam', at www.culturecourt.com/Br.Paul/film/YoungAdam.htm, accessed January 2009.

8 Allen Ginsberg, in the *Times Literary Supplement*, 19 June 1965 (unpublished).

9 Catalogue to the Ideageneration show of John Hopkins' photographs, 19 June 2009.

10 See Sabine Breitwieser (ed), *Gustav Metzger*, and Gustav Metzger, *Damaged Nature, Auto-Destructive Art*.

11 Kenneth Coutts-Smith, *The Dream of Icarus*, p. 60. And quoted by Eddie Wolfram in 'In the Beginning', in *Art and Artists*, August 1966.

12 Gustav Metzger, in *Art and Artists*, August 1966, 'Auto-Destructive Art Issue', p. 22.

13 Interview with the author, February 1967.

14 'John Latham in focus 12 September 2005–26 February 2006', Tate Britain website, accessed April 2008.

15 ibid.

16 *Frieze* 90, April 2005.

17 'John Latham, Awkward Artistic Visionary', obituary in the *Independent*, 5 January 2006.

Chapter 13. Indica Books and Gallery

1 Jan Wenner, 'Lennon Remembers, John Lennon interviewed by Jan S. Wenner', in *Rolling Stone*, 7 January and 4 February 1971.

2 Robert Sheppard, 'Bob Cobbing, concrete poet who inspired and pioneered, across half a century, new ways of hearing and seeing', in the *Guardian*, 7 October 2002; and the *Times* obituary, 7 November 2002.

3 Hugo Ball, *Flight Out of Time. A Dada Diary* (1916), University of California Press, Berkeley, 1996.

4 'Lennon Remembers, John Lennon interviewed by Jan S. Wenner', 7 January and 4 February 1971, *Rolling Stone* website, accessed October 2009.

5 Mark Boyle and Joan Hills, 'Mark Boyle and Joan Hills's Magical Projections', in *Tate Etc* 4, summer 2005.

6 Christopher Logue, *Prince Charming*, p. 304.

7 Gerald Woods, Philip Thompson and John Williams, *Art Without Boundaries*, p. 54.

8 Alph Moorcroft, 'Lights'.

9 See *Journey to the Surface of the Earth, Mark Boyle's Atlas and Manual*.

10 Gerald Woods, Philip Thompson and John Williams, *Art Without Boundaries*, p. 54.

11 'Boyle Family: Biographical Information', at www.boylefamily.co.uk/boyle/about/index.html, accessed January 2009.

Chapter 14. Up from Underground

1 Michael Hollingshead, *The Man Who Turned On the World*, p.146.

2 Simon Napier-Bell, *You Don't Have to Say You Love Me*, p. 86.

3 See Eric Burdon's autobiography, *I Used to be an Animal But I'm All Right Now*, for details of his Bateille-esque interest in eggs.

4 Mark Edmonds, 'With a Little Help From Their Friend', in *Sunday Times* magazine, 20 March 2005.

5 Derek Jarman, *At Your Own Risk*, p. 53.

6 Derek Jarman, *Last of England*, p. 50.

7 Derek Jarman, *At Your Own Risk*, p. 57.

8 Jay Landesman, *Jaywalking*, p. 33 (also reported in John Clellon Holmes's *Displaced Person*).

9 Dan Farson, *The Gilded Gutter Life of Francis Bacon*, p. 23.

10 Freddie Foreman and Tony Lambrianou, *Getting It Straight*.

11 Tim Leary in conversation with the author, Millbrook, New York, July 1967.

12 Michael Hollingshead, *The Man Who Turned On the World*, p. 160.

13 Nik Cohn, *Awopbopalloobop Alopbamboom*.

14 Jonathon Green, *Days in the Life: Voices from the English Underground 1961-1971*, p. 144.

Chapter 15. Spontaneous Underground

1 In conversation with the author.

2 'Party Organiser', in the *Sunday Times*, 30 January 1966.

3 Michael Vestey, 'Raving London'.

4 Michael Vestey, 'Raving London'.

5 Edwin Prévost, *No Sound is Innocent*, p. 19.

6 ibid., p. 17.

7 ibid., p. 14.

8 ibid., p.15.

9 ibid., p.17.

10 ibid.

11 ibid., p.18.

12 ibid., p. 19.

13 John Williams's biography of Michael X is the best source but see also Derek Humphry and David Tindall, *False Messiah*, and his autobiography, *From Michael de Freitas to Michael X*. I have also drawn upon *The Souvenir Programme for the Official Lynching of Michael Abduk Malik*, Cokaygne Press, London, 1973, and V. S. Naipaul, 'The Life and Trials of Michael X'.

14 Michael Abdul Malik, *From Michael de Freitas to Michael X*, p. 170.

15 ibid.

16 Heather Hodson, 'We Have Lift Off', in the *Daily Telegraph*, 9 March 2002.

17 Michael Abdul Malik, *From Michael de Freitas to Michael X*, p. 170.

18 Richard Gilbert, 'London's Other Underground', in *Town*, March 1967.

19 Elizabeth Wilson, *Mirror Writing*, p. 115.

Chapter 16. *International Times*

1 *International Times*, 16 February 1968.

2 Tom McGrath, *The Riverside Interviews 6: Tom McGrath*, p. 54.

3 Maureen Green, 'Who's Who in the Underground'.

4 Daniel Spicer, 'Psychedelia: Paying Homage to it's Origins', in the *Independent*, 11 October 2006.

5 Daniel Spicer, 'All Tomorrow's Parties'.

6 Kenneth Rexroth, in the *San Francisco Examiner*, October 1966.

7 Hunter Davies, in the *Sunday Times*, 16 October 1966.

8 *IT* 2, 31 October 1966.

9 Tom McGrath, *The Riverside Interviews 6: Tom McGrath*.

10 Richard Gilbert, 'London's Other Underground', in *Town*, March 1967.

11 Derek Taylor, *It was Twenty Years Ago Today*, p. 199.

12 ibid., p. 199.

13 *IT* 10, 19 March 1967.

14 Peter Fryer, 'A Map of the Underground'.

15 Diana Athill, *Stet*, p. 88.

Chapter 17. UFO

1 'Syd Barrett Interview (1970)', in *Terrapin* 17, 1975.

2 Alph Moorcroft, 'Lights', in *Unit*, summer 1967.

3 David Allen, *Gong Dreaming*, p. 48.

4 John Hopkins, 'Memoirs of a Ufologist'.

5 From an unidentified press interview in 1967.

6 John Hopkins, 'Memoirs of a Ufologist'.

7 Mick Farren, *Give the Anarchist a Cigarette*, p. 134.

8 'Interview with Twink' (1985), at www.angelfire.com/wr/breastmilky/twink/html, accessed November 2008.

9 Barry Miles, *Pink Floyd. A Visual Documentary*, entry for 22 December 1966.

10 ibid.

11 John Hopkins, 'Memoirs of a Ufologist'.

12 Derek Taylor, *It Was Twenty Years Ago Today*, p. 192.

13 From an unidentified interview in Q magazine.

14 King, *Wrong Movements*, entry for 5 May 1967.

15 Nick Mason interviewed in March 1973, possibly for a French Pink Floyd fanzine, www.pinkfloyd-co.com/band/interviews, accessed 2007.

16 Rick Wright interviewed by K. Whitlock for *Record Collector* magazine, at www.pinkfloyd-co.com/band/interviews, accessed 2007.

17 John Peel talking on *Capital Radio Pink Floyd Story*, Capital Radio, London, 17 December 1976.

18 David Tomlin, *Tales from the Embassy. Volume II*, p. 51.

19 'Legolas', 'The Third Ear Band'.

20 ibid.

21 Mick Farren, *Give the Anarchist a Cigarette*, p. 111

22 Unidentified clip, in the *Daily Telegraph*, 1967.

23 George Melly, 'Poster Power', in the *Observer*, 3 December 1967.

24 ibid.

Chapter 18. The 14 Hour Technicolor Dream

1 Daevid Allen, *Gong Dreaming*, p. 45.

2 Ivor Trueman, 'Twink Interview', in *Opel* 11, 5 December 1985.

3 Julian Palacios, *Lost in the Woods*, at www.furious.com/perfect/sydbarrett.html, accessed December 2008.

4 Michael King, *Wrong Movements*, entry for 29 April 1967.

5 Pete Jenner and Roger Waters in *Dancing In the Street*, BBC Radio, 1996.

6 Barry Miles, *Pink Floyd. A Visual Documentary*, entry for 29 April 1967.

7 John Gordon, *Sunday Express*, 2 July 1967.

8 Richard Hamilton, *Collected Words*, p. 104.

9 Horace Judson, 'The Right London Number for Youngsters in Trouble'.

10 ibid.

11 *IT* 27, 8 March 1968.

12 Alan Travis, 'It's porn if the ink comes off on your hands', in the *Guardian*, 14 September 2002. For greater detail on Jenkins, Goodman, Driberg and the raids see Alan Travis, *Bound and Gagged*, Profile, London, 2000.

13 ibid.

14 ibid.

15 ibid.

16 Martin Short, 'A Firm in a Firm'.

17 Peter Stansill, 'The Life and Times of *IT*'. There is a large literature dealing with police corruption in London. A very good introduction can be found in Barry Cox, John Shirley and Martin Short, *The Fall of Scotland Yard*, and James Morton, *Bent Coppers*.

18 ibid.

19 ibid.

20 ibid.

Chapter 19. The Arts Lab

1 Francis Wheen, *The Sixties*, 1982.

2 Jeff Nuttall, *Performance Art. Volume 1*, pp. 22–3.

3 ibid., p. 31.

4 ibid., p. 33.

5 Peter Fryer, 'Inside the Underground'.

6 Jeff Nuttall, *Performance Art. Volume 1*, p. 71.

7 ibid, p. 72

8 Jonathan Green, *Days in the Life. Voices from the English Underground 1961–1971*, p. 159

9 Mick Farren, *Give the Anarchist a Cigarette*, p. 60

10 Unidentified press interview.

11 Anon., 'What's All This Damn "Arts Lab" Nonsense?'.

12 ibid.

13 ibid.

14 Alan Rickman, 'A Fortress and a Haven for Adult Games', in *Arc* 45, winter 1969.

15 Derek Taylor, *It was Twenty Years Ago Today*, p. 166.

16 Alan Rickman, 'A Fortress and a Haven for Adult Games'.

Chapter 20. The Summer of Love

1 In conversation with the author.

2 Neil Spencer, 'The Underground Press'.

3 Charles Nicholl, 'IT, Oz and All the Others'.

4 Michael Thomas, 'Lord Buckley is Dead', in *Penthouse*, vol. 2, no. 11, October 1967.

5 Maureen Green, 'Who's Who in the Underground'.

6 'Where Did Patti Get That Gear?' in the *Daily Mirror*, quoted in Derek Taylor, *It was Twenty Years Ago Today*, p. 157.

7 Maureen Green, 'The Fool's Paradise'.

8 ibid.

9 ibid.
10 In conversation with the author for Barry Miles, *Many Years From Now*.
11 ibid.
12 ibid.
13 ibid.
14 Geraldine Bedell, 'Turned In', Turned Out, Still Fort Out', in the *Observer*, 3 December 1967.
15 Chris Stephens, 'Still Swinging After All These Years?', in *Tate Etc* 1, summer 2004.
16 Derek Taylor, *It was Twenty Years Ago Today*, p. 24.
17 David Widgery, 'Against Grown Up Power', in *Preserving Disorder*, p. 6.
18 ibid., p. 194.
19 Quoted in *Time Out* 947, 12–19 October 1988.
20 Hermine Demoriane, 'From Kathakali to Biokinetic Theatre, interview with David Medalla', in *IT* 42, 13 December 1968.
21 Paul Keeler, *Planted*, unpaginated.
22 ibid.
23 ibid.
24 ibid.
25 Robert Harris, 'Exploding Galaxy'.
26 Jack Henry Moore, *IT* 17, 28 July 1967.
27 Unidentified news clipping.
28 Quoted in 'Down in the dirt' by Patrick Wright, in *London: from Punk to Blair*.
29 Gavin Jantjes in conversation with David Medalla, London, 29 May 1997, in *A Fruitful Incoherence: Dialogues with Artists on Internationalism*, Institute of International Visual Arts, London, 1998, pp. 94–109.
30 Unpublished document quoted in Guy Brett, *Exploding Galaxies*.
31 *IT* 25, 2 February 1968.
32 The Islomaniac, entry for 13 February 2007. www.the-islomaniac.com/2007/02/oilean-john-lennon, accessed January 2008.
33 Jonathon Green, *Days in the Life*, p. 425.
34 *Time Out* 947, 12–19 October 1988.
35 Sara Maitland, Introduction to *Very Heaven*. p. 13.

Chapter 21. Dialectics

1 Elizabeth Young, 'The Best Bookshop in Britain', in Render (ed.), *The First 25 Years of Compendium Bookshop*. This is the best source of information on the history of the shop.
2 David Widgery, *Preserving Discontent*, p. 111.
3 Joan Bakewell, *The Centre of the Bed*, p. 160.
4 Mick Farren, *Give the Anarchist a Cigarette*, p. 103.
5 Emmett Grogan, *Ringolevio*, pp. 433–4.
6 ibid.
7 ibid., pp. 434.
8 Cornelius Cardew in the Anti-University brochure.
9 Alexander Trocchi in the Anti-University brochure.
10 *Cogito* 44–45 (2006), accessed on the net, July 2008.
11 'Granny Takes a Trip', at www.vintagefashionguild.org/content/view/237/121/, accessed July 2008.

12 ibid.

13 www.vintagefashionguild.org, accessed 2006.

14 *IT* 35 12 July 1968.

15 *IT* 47.

16 *IT* 17, 28 July 1967 – reprint edition with new front page.

17 John Peel and Sheila Ravenscroft, *Margrave of the Marshes*, p. 274.

18 ibid., p. 192.

19 *IT* 44, 15 November 1968.

Chapter 22. *Performance*

1 Marianne Faithfull, *Faithfull*. p. 164.

2 Carey Schofield, *Jagger*, pp. 153–4.

3 Stanley Booth, *Keith. Standing in the Shadows*, p. 94

4 Marianne Faithfull, *Faithfull*, p. 159.

5 Carey Schofield, *Jagger*, p. 157.

6 Christopher Andersen, *Jagger Unauthorized*.

7 Tony Sanchez, *Up and Down with the Rolling Stones*, p. 116.

8 Christopher Andersen, *Jagger Unauthorized*, p. 189.

9 ibid., p. 190.

10 Marianne Faithfull, *Faithfull*, p. 160.

11 Tony Sanchez, *Up and Down with the Rolling Stones*.

12 Anthony Scaduto, *Mick Jagger*, p. 211.

13 Marianne Faithfull, *Faithfull*, pp. 160–1.

14 George Melly, *Owning Up*, p. 132.

15 ibid., p. 178.

16 ibid., pp. 177–8.

17 Mim Scala, *Diary of a Teddy Boy*, p. 67.

18 ibid., pp. 68–9.

19 Angela Bowie, *Backstage Passes*, p. 196.

20 Wensley Clarkson, *Bindon*, p. 123.

21 ibid., p. 123.

22 ibid., p. 127.

23 ibid., p. 66.

24 ibid., p. 64.

25 Carey Schofield, *Jagger*, p. 155.

26 Jagger talking to Jonathan Cott and Sue Cox, *Rolling Stone*, 12 October 1968.

27 ibid.

28 Jagger talking to Tony Elliott, *Time Out 'Performance' Special*.

29 Victor Bockris, *Keith Richards*, p. 114.

30 ibid., p. 114.

31 Christopher Andersen, *Jagger Unauthorized*.

32 Barbara Charone, *Keith Richards*, p. 113.

33 Christopher Sandford, *Jagger*.

Chapter 23. The Seventies: The Sixties Continued

1 Introduction to J. G. Ballard, *Crash*, French edition, Paris 1974.

2 Colin Greenland, *The Entropy Exhibition*, p. 15.

3 Doris Lessing, *Walking in the Shade*, p. 31.

4 Colin Greenland, *The Entropy Exhibition*, p. 140.

5 *NME*, 2 July 1977.

6 *IT* 58, 13 June 1969.

7 J. G. Ballard to Charles Platt in Charles Platt (ed.), *Dream Makers*, p. 89.

8 J. G. Ballard interviewed by V. Vale and Andrea Juno, 29 October 1982, in *RE/Search* 8–9.

9 Charles Platt (ed.), *Dream Makers*, p. 94.

10 Quoted in V. Vale and Andrea Juno (eds.), *RE/Search* 8–9.

11 ibid.

12 From *Ambit* 32, 1967.

13 March 1970. See Alan Burns and Charles Sugnet (eds.), *The Imagination on Trial: British and American Writers Discuss Their Working Methods*, Allison, London, 1981.

14 Texts in *Ambit* 50, 1972. Bax interview in *RE/Search* no. 8–9, conducted in San Francisco, winter 1983.

15 J. G. Ballard, interviewed by Graeme Revell.

16 J. G. Ballard, Introduction to *Crash*, French edition, Paris 1974.

17 Simon Ford, 'A Psychopathic Hymn'.

18 David Curtis interviewed by Michael Mazière for the BFI Study Group.

19 John Hopkins, 'Arts Lab London 17 March 1970 John Hopkins Reporting'.

20 Simon Ford, 'A Psychopathic Hymn'.

21 J. G. Ballard, 'In Conversation with Eduardo Paolozzi and Frank Whitford'.

22 Iain Sinclair, *Crash*, p. 98.

23 Eduardo Paolozzi, J. G. Ballard and Frank Whitford, 'Speculative Illustrations', in *Studio International*, vol. 182, 1971, pp. 136–143.

24 J. G. Ballard, 'In Conversation with Eduardo Paolozzi and Frank Whitford'.

25 Jo Stanley, 'Ballard Crashes'.

26 Simon Ford, 'A Psychopathic Hymn'.

27 Iain Sinclair, *Crash*, p. 99.

28 Hansard, 12 March 1970.

29 David Mairowitz, *Burnt Bridges*, pp. 140–5.

30 In conversation with the author.

31 David Mairowitz, *Flash Gordon and the Angels*.

32 Barry Miles, *William Burroughs*, p. 181.

33 'Nixon to be portrayed on the London Stage', in Londoner's Diary, *Evening Standard*, 7 December 1970. 'Down to Earth', in *Jewish Chronicle*, 19 February 1971. B. A. Young, 'Flash Gordon and the Angels'. And conversations with D. Z. Mairowitz by the author.

34 Barry Miles, *William Burroughs*, p. 181.

35 ibid., p. 181.

36 William Burroughs, *The Job*, p. 18.

37 Barry Miles, *William Burroughs*, pp. 156–7

38 William Burroughs to Ted Morgan, tape in University of Arizona at Tempe (unpublished).

39 Dan Farson, *The Gilded Gutter Life of Francis Bacon*, p. 181.

40 ibid.

41 David Sylvester, *Interviews with Francis Bacon*, p. 90.

42 Perry Ogden and John Edwards, *7 Reece Mews*, p. 13.

Chapter 24. The Trial of *Oz*

1 Much of this information is taken from Tony Palmer, *The Trials of Oz*. See also Jonathon Green, *Days in the Life*.
2 Carol Sarler, 'A Moral Issue'.
3 *IT* 95, 31 December 1970. 'British Cops and Angels Vamp on Underground', in *Rolling Stone* 75, 4 February 1971.
4 Quoted in Tony Gould, *Inside Outsider*, p. 214.
5 George Negus interview with Richard Neville, *New Dimensions*, Australian Broadcasting Corporation, broadcast 15 July 2002.
6 Charles Nicholl, '*IT*, *Oz* and All the Others', in the *Daily Telegraph* magazine, 465, 28 September 1973.
7 Free Oz Campaign press release.
8 'The Oz Boys Win Their Appeal' in *Rolling Stone* 97, 9 December 1971.
9 *Guardian*, early February 1996.
10 'Father Fuck Fights On', in *Frendz* 13, 28 October 1971.
11 ibid.
12 'Father Fuck Fights On', in *Frendz* 13, 28 October 1971.
13 Charles Nicholl, '*IT*, *Oz* and All the Others'.
14 ibid.
15 ibid.
16 ibid.

Part Three

Chapter 25. Other New Worlds

1 Robert Rosenblum, *Introducing Gilbert & George*, p. 119.
2 *Daily Telegraph*, 28 May 2002.
3 BBC TV *Arena* documentary, *Imagine*, aired on 8 May 2007.
4 Wolf John, 'Naked Human Artists', in *Tate Etc* 9, spring 2007.
5 David Sylvester, *Interviews with Francis Bacon*, pp. 161–2.
6 RoseLee Goldberg, *Performance*, pp. 198–9.
7 David Sylvester, *Interviews with Francis Bacon*, p. 147.
8 Waldemar Januszczak, 'Making Snap Judgements', in the *Hackney Gazette*, 10 July 1981.
9 David Sylvester, *London Recordings*, p. 149.
10 Gilbert & George, *The World of Gilbert & George*, documentary film 1981, Tate Media DVD, 2007.
11 Duncan Fallowell, 'Gilbert & George, Talked To/ Written On', in *Parkett* 4.
12 Tate Modern press release, Gilbert & George Major Exhibition, 15 February–7 May 2007.
13 Rachel Cooke, 'Just the Two of Us', in the *Observer*, 28 January 2007.
14 Tate Modern press release, Gilbert & George Major Exhibition, 15 February–7 May 2007.
15 John Tusa, BBC Radio 3 interview (BBC online).
16 Derek Jarman, *Smiling in Slow Motion*, p. 230.
17 Caroline Coon in conversation with the author.
18 Derek Jarman, *Dancing Ledge*, pp. 71–2.
19 Derek Jarman, *Last of England*, p. 60.
20 ibid., pp. 55–7.
21 Derek Jarman, *Dancing Ledge*, p. 204.

22 *Independent*, 3 March 2001.
23 Derek Jarman, *Smiling in Slow Motion*, p. 10.
24 ibid., p. 94.
25 ibid., p. 94.
26 Derek Jarman, *Dancing Ledge*, p. 133.
27 Vinny Lee, *The Times*, 16 December 2006.
28 Derek Jarman, *Dancing Ledge*, p. 138.
29 ibid., p. 155.

Chapter 26. Fashion, Fashion, Fashion

1 Maggie Davies, *Time Out*, 18 September 2008.
2 Original transcripts of John Savage interviews for *England's Dreaming*.
3 Peter York, *Style Wars*, p. 242.
4 Bertie Marshall, *Berlin Bromley*, p. 11.
5 Alan Jones and Jussi Kantonen, *Saturday Night Forever. The Story of Disco*, p. 265.
6 Julien Temple, *The Filth and the Fury*, DVD.
7 Bertie Marshall, *Berlin Bromley*, p. 33.
8 Original transcripts of John Savage interviews for *England's Dreaming*.
9 Gene Krell, *Vivienne Westwood*, p. 11.
10 Max Décharné, *Kings Road*, p. 300.
11 Boy George, *Take It Like a Man*, p. 67.
12 *Forum*, June 1976.
13 *Fashion Guide*, 1976.
14 Malcolm McLaren interviewed by Claude Bessy.
15 ibid.
16 Steve Jones interviewed by Phil Singleton, 7 May 2002. Accessed on the net, summer 2008.
17 John Lydon, *No Irish, No Blacks, No Dogs*, p. 124.
18 Max Décharné, *King's Road*, p. 300.
19 John Lydon interviewed by Tom Hibbert.
20 Julien Temple, *The Filth and the Fury*, DVD.
21 ibid.
22 John Lydon interviewed by Tom Hibbert.

Chapter 27. COUM Transmissions

1 Much of the information in this chapter comes from the author's interview with Genesis P-Orridge and later conversations with him. Another important source is Simon Ford, *Wreckers of Civilisation*. Many of the other details come from the enormous amount of material on Genesis P-Orridge and Cosey Fanni Tutti on the web, including their own official sites.
2 Cosey Fanni Tutti, 'Time to Tell', at http://throbbing-gristle.com/COSEYFANNITUTTI/content/text_ttt.html.
3 Programme for DOUM at the ICA, 19–26 October 1976.
4 *Daily Mail*, 19 October 1976.
5 *Daily Telegraph*, 19 October 1976.
6 *Sun*, 21 October 1976.
7 Genesis P-Orridge, *NME*, 22 July 1978.

Chapter 28. Punk

1 *Daily Mail*, 19 October 1976.
2 BBC TV documentary on Stiff Records, 2006, Part 2.
3 Original transcripts of John Savage interviews for *England's Dreaming*.
4 *Peel Night*, Channel 4, 2000.
5 Peter York, *Style Wars*, p. 14.
6 Jon Savage, *England's Dreaming*, pp. 166–7.
7 'Interview with Shane MacGowan', in *Zigzag* 99, 1980.
8 Author interview with Joe Strummer, October 1976.
9 Peter York, *Style Wars*, p. 206.
10 John Lydon interviewed by Michael Holen, *Loaded*, April 1998.
11 Dick Hebdige, *Subculture*, p. 87.
12 John Lydon interviewed in the *NME*, 23 December 1978.
13 John Lydon interviewed by Jennifer Byrne, Australian Broadcasting Corporation, 27 June 2000.
14 ibid.
15 Malcolm McLaren interviewed by Claude Bessy.
16 Peter York, *Style Wars*, p. 206.
17 Jon Savage, *England's Dreaming*, p. 230.
18 From the booklet in the *Clash on Broadway* CD box set.
19 Malcolm McLaren interviewed by Claude Bessy, *New Music News*, 10 May 1980.
20 Malcolm McLaren talking to Paul Taylor, 1985, quoted in Iwona Blazwick (ed.), *An Endless Adventure...*
21 John Peel and Sheila Ravenscroft, *Margrave of the Marshes*, p. 307.
22 'Who are these punks?', in the *Daily Mirror*, 2 December 1976.
23 John Lydon to Jack Rabid, *Spin*, 20 September 2007.
24 Simon Napier-Bell, *Black Vinyl, White Powder*, pp. 192–3.
25 John Lydon, to Jack Rabid, *Spin*, 20 September 2007.
26 John Lydon interviewed in the *NME* 23 December 1978.
27 ibid.
28 John Lydon interviewed by Tom Hibbert.
29 John Lydon interviewed by Patrick Zerbib in *The Face*, December 1983.

Chapter 29. *Jubilee*

1 Peter York, *Style Wars*, p. 129.
2 Poly Styrene, 'Diary of the Seventies', at www.x-rayspex.com, accessed May 2008.
3 Roger Sabin (ed.), *Punk Rock. So What?* p. 104.
4 Tony Parsons, 'Glue Scribe Speaks Out', in the *NME*, 12 February 1977.
5 My account draws heavily upon Paul Marco, *The Roxy London wc2*, which is an exhaustive reconstruction of the club's complete history.
6 Quoted from 'Pop Matters' by Charlotte Robinson, in Paul Marco, *The Roxy London wc2*, p. 26.
7 Original transcripts of John Savage interviews for *England's Dreaming*.
8 Paul Marco, *The Roxy London wc2*, p. 56.
9 Peter York, *Style Wars*, p. 138.
10 Paul Marco, *The Roxy London wc2*, p. 236.
11 CarlingLive.com, 24 June 2002, accessed July 2008.

12 John Lydon to Chris Salewicz, in *DOA the Official Film Book*.

13 http://en.wikiquote.org/wiki/Eric_Clapton, accessed October 2009, and many other sources on the net.

14 Quoted at www.ilxor.com, accessed September 2008.

15 Jon Savage, *England's Dreaming*, p. 376, but complete quote in Tony Peake, *Derek Jarman*, p. 547, note 27.

16 From Derek Jarman's papers, quoted in Tony Peake, *Derek Jarman*, pp. 241–2.

17 See Hermine Demoriane, *The Tightrope Walker*.

18 Adam Ant, *Stand and Deliver*, p. 88.

19 Adam Ant, *Stand and Deliver*, p. 87.

20 Derek Jarman, *Dancing Ledge*, p. 170.

21 Derek Jarman interviewed by Jeremy Isaacs.

22 Tony Peake, *Derek Jarman*, p. 251.

23 Derek Jarman, *Dancing Ledge*, p. 172.

24 ibid., p. 176.

Chapter 30. New Romantics and Neo-Naturists

1 Peter York, *Modern Times*, p. 74.

2 Steve Strange, *Blitzed!*, p. 44.

3 Comprehensive documentation of the Blitz scene is available at www.geocities.com/theblitzkids.

4 Steve Strange, *Blitzed!*, pp. 51–3.

5 'Spandau Ballet', at http://kelendria.proboards.com, accessed September 2009.

6 See the B2 section of *Fast and Loose (My Dead Gallery)* organised in 2006 by The Centre of Attention, www.thecentreofattention.org/dead.html, for a chronology and a very good summary of the gallery's activities by Roger Ely.

7 ibid.

8 My information about the Neo-Naturists comes from four main sources: a taped conversation with Christine Binnie, a taped conversation with James Birch, Jane England, *The Neo Naturists*, and Grayson Perry, *Portrait of the Artist as a Young Girl*.

9 Boy George, *Take It Like a Man*, p. 134.

10 Grayson Perry, *Portrait of the Artist as a Young Girl*, p. 142.

11 Interview with the author.

12 ibid.

13 Grayson Perry, *Portrait of the Artist as a Young Girl*, p. 171.

14 ibid., p. 172.

15 Joe La Place, 'London Calling', at www.artnet.com/Magazine/reviews/laplaca/laplaca1-16-04.asp, accessed January 2009.

16 Christine Binnie in conversation with the author.

17 James Birch in conversation with the author.

18 ibid.

19 Grayson Perry, 'Letting It All Hang Out: My Life as a Naked Artist', in *The Times*, 20 June 2007.

20 James Birch in conversation with the author.

21 A full account of Gilbert and George in Moscow appears in Daniel Farson, *Gilbert & George. A Portrait*, and *With Gilbert and George in Moscow*.

22 James Birch in conversation with the author.

23 Preface to *Gilbert & George China Exhibition 1993*.

Chapter 31. Leigh Bowery and Minty

1 www.alissongothz.com.br/leighbowery/xtravaganza/, accessed December 2008.

2 The best source of information on Leigh Bowery is Sue Tilley, *Leigh Bowery*. See also Fergus Greer, *Leigh Bowery Looks*, and Charles Darwent, 'Britart's Lost Queen?'.

3 Karl Peter Gottschalk, 'Leigh Bowery: Goodbye to the Boy from Sunshine', at http://easyweb.easynet.co.uk/karlpeter/zeugma/inters_bowery.htm, accessed February 2009.

4 Sue Tilley, *Leigh Bowery*, p. 65.

5 ibid., cover quote.

6 Fiachra Gibbons, 'Theater: The Alien Emperor of 80s London', in the *New York Times*, 2 November 2003.

7 Unidentified newspaper clipping.

8 See Elizabeth Hopkirk, 'Freud's JobCentre Muse', in the *Evening Standard*, 11 April 2008; '"It's lovely," says benefits supervisor whose portrait is set to sell for £17m', in the *Guardian*, 12 April 2008.

9 Dalya Alberge, 'Freud's Naked Civil Servant to smash auction record for work by living artist', in *The Times*, 12 April 2008.

10 Rifat Ozbek, 'Leigh Bowery', in *Leigh Bowery*.

11 ibid.

12 Quoted in Lenny Ann Low, 'Designs from Artist Who Broke Every Taboo', in the *Sydney Morning Herald*, 17 December 2003.

13 Sue Tilley, *Leigh Bowery*, p. 232.

14 Quoted in Lenny Ann Low, 'Designs from Artist Who Broke Every Taboo'.

Afterword

1 Tony Peake, *Derek Jarman*, p. 484.

2 For more on the notorious Criminal Justice and Public Order Act 1994, section 63 (1) (b), which outlawed outdoor parties, see Tim Guest, 'Fight for the Right to Party', in the *Observer Music Magazine*, July 2009. See also Jimi Fritz, *Rave Culture*; Tara McCall, *This is Not a Rave. In the Shadow of a Subculture*; Sheryl Garratt, *Adventures in Wonderland*; Jane Bussmann, *Once in a Lifetime*; and Bill Brewster and Frank Broughton, *Last Night a DJ Saved My Life*.

3 Quoted in the window of a clothing store in Old Compton Street, since removed.

4 Anthony Mackintosh, 'The Origins of the Groucho Club, London', in Barry Delaney (ed.), *A Celebration of 20 Years of the Groucho Club*.

5 ibid., p. 144.

6 Jonathan Meades, *A Celebration of 20 Years of the Groucho Club*, p. 151.

7 Damien Hirst and Gordon Burn, *On My Way to Work*, p. 224.

8 Alexander Cockburn and Jeffery St. (eds), 'Shit Happens!', in *Counterpunch*, 11 October 1999, at www.counterpunch.org/nyart.html, accessed January 2009.

9 'Painting Modernism Black', in the *Guardian*, 19 August 1994.

10 Genesis P-Orridge in conversation with the author.

11 Fiachra Gibbons, 'Satirists Jump into Tracey's Bed', in the *Guardian*, 25 October 1999.

12 'The Tate Protest', at www.thechap.net/content/section_manifesto/tateprotest.html, accessed November 2008.

13 'Transvestite Potter Wins Turner', BBC News Channel, 7 December 2003, also at http://news.bbc.co.uk/1/hi/entertainment/3298707.stm.

Bibliography

Although this book is not divided into conventional decades, a very large number of the books sourced for it are categorized in this way so, for the reader's convenience, I have therefore organized the bibliography in this manner.

London

Ackroyd, Peter, *London, the Biography*, Chatto & Windus, London, 2000

Bacon, Tony, *London Live*, Balafon, London, 1999

Breward, Christopher, Edwina Ehrman and Caroline Evans, *The London Look. Fashion from Street to Catwalk*, Yale University Press/ Museum of London, London, 2004

Butler, Tim with Garry Robson, *London Calling. The Middle Classes and the Re-making of Inner London*, Berg, Oxford, 2003

Campbell, Duncan, '"Outsider" appalled at 1970s Met corruption', in the *Guardian*, 22 January 1996

—, 'Soho pornographer pardoned after betraying police partners in crime', in the *Guardian*, 22 January 1996

Clayton, Antony, *Decadent London*, Historical Publications, London, 2005

Clarkson, Wensley, *Hit 'em Hard. Jack Spot, King of the Underworld*, HarperCollins, London, 2002

Cox, Barry, John Shirley and Martin Short, *The Fall of Scotland Yard*, Penguin Books, Harmondsworth, 1977

Davies, Sydney, *Walking the London Scene*, Grimsay, Glasgow, 2006

Décharné, Max, *King's Road. The Rise and Fall of the Hippest Street in the World*, Weidenfeld & Nicolson, London, 2005

Deighton, Len, *Len Deighton's London Dossier*, Penguin, Harmondsworth, 1967

Everett, Peter, *You'll Never be 16 Again. An Illustrated History of the British Teenager*, BBC, London, 1985

Fido, Martin, *The Krays. Unfinished Business*, Carlton, London, 1999

Findlater, Richard (ed.), *At the Royal Court. 25 Years of the English Stage Company*, Amber Lane, Ambergate, 1981

Fryer, Peter, *Private Case – Public Scandal. Secrets of the British Museum Revealed*, Secker & Warburg, London, 1966

Gorman, Paul, *The Look. Adventures in Pop and Rock Fashion*, Sanctuary, London, 2001

Gray, Marcus, *London's Rock Landmarks*, Omnibus, London, 1985

Grigg, Mary, *The Challenor Case*, Penguin Books, Harmondsworth, 1965

Kerr, Joe and Andrew Gibson (eds.), *London from Punk to Blair*, Reaktion, London, 2003

Lewisohn, Mark, Piet Schreuders and Adam Smith, *The Beatles' London*, Hamlyn, London, 1994

McMillan, James, *The Way It Changed 1951–1975*, William Kimber, London, 1987

Morton, James, *Bent Coppers*, Little, Brown, London, 1993

Morton, James and Gerry Parker, *Gangland Bosses. The Lives of Jack Spot and Billy Hill*, Time Warner Books, London, 2004

Napier-Bell, Simon, *Black Vinyl, White Powder*, Ebury, London, 2001

Pearson, John, *The Profession of Violence. The Rise and Fall of the Kray Twins*, Weidenfeld & Nicolson, London, 1972

Platt, John, *London's Rock Routes*, Fourth Estate, London 1985

Quennell, Peter (ed.), *London's Underworld. Being Selections from 'Those That Will Not Work', the Fourth Volume of 'London Labour and the London Poor' by Henry Mayhew*, William Kimber, London, 1950

Savage, Jon, *Teenage. The Creation of Youth 1875–1945*, Chatto & Windus, London, 2007

Sinclair, Iain, *Lights Out for the Territory*, Granta, London, 1997

— (ed.), *London. City of Disappearances*, Penguin Books, London, 2007

Southall, Brian, *Abbey Road*, Patrick Stephens, Cambridge, 1982

Stewart, Tony, *Cool Cats. 25 Years of Rock 'n' Roll Style*, Eel Pie, London, 1981

Sylvester, David, *London Recordings*, Chatto & Windus, London, 2003

Thompson, Jessica Cargill, *London Calling. High Art and Low Life in the Capital since 1968*, Time Out, London, 2008

Vague, Tom, 'Counter Culture Portobello. Psychogeographical History', http://www.portobellofilmfestival.com/talkpics/talk-vague01.html

Weinreb, Ben and Christopher Hibbert (eds.), *The London Encyclopedia*, Macmillan, London, 1983 (revised 1993)

White, Jerry, *London in the Twentieth Century*, Viking, London, 2001

Wooldridge, Max, *Rock 'n' roll London*, New Holland, London, 2002

Fitzrovia

Bailey, Nick, *Fitzrovia*, Historical Publications, New Barnet, 1981

Bakewell, Michael, *Fitzrovia. London's Bohemia*, National Portrait Gallery, 1999

Camden History Society, *Streets of Bloomsbury and Fitzrovia*, London, 1997

David, Hugh, *The Fitzrovians. Portrait of Bohemian Society 1900–55*, Michael Joseph, London, 1988

Fiber, Sally, *The Fitzroy. The Autobiography of a London Tavern*, Temple House, Lewes, 1995

Hobson, Polly, *Brought Up in Bloomsbury*, Constable, London, 1959 (fiction)

Hooker, Denise, *Nina Hamnett. Queen of Bohemia*, Constable, London, 1986

Pentelow, Mike and Marsha Rowe, *Characters of Fitzrovia*, Chatto & Windus, London, 2001

Sturgis, Matthew, 'Fitzrovia's Return', in the *Evening Standard Magazine*, 18 February 1994

Survey of London, vol. xxi, *Tottenham Court Road and Neighbourhood*, LCC, London, 1949
Tambimuttu, 'Fitzrovia', in *Harpers & Queen*, February 1975
Todd, Ruthven, *Fitzrovia & The Road to the York Minster, or, Down Dean Street*, Michael Parkin Fine Art, London, 1973

Soho

Baker, W. Howard, *Expresso Jungle*, Sexton Blake Library No. 435, London, September 1959
Bernard, Jeffrey, *Low Life*, Gerald Duckworth, London, 1986
—, *More Low Life*, Pan, London, 1989
Connor, Michael, *The Soho Don. Gangland's Greatest Untold Story*, Mainstream, Edinburgh, 2002
Farson, Dan, *Out of Step*, Michael Joseph, London, 1974
—, *Soho in the Fifties*, Michael Joseph, London, 1987
—, *Never a Normal Man. An Autobiography*, HarperCollins, London, 1997
Foreman, Freddie and Tony Lambrianou, *Getting It Straight. Villains Talking*, Sidgwick & Jackson, London, 2001
Fothergill, Stephen, *The Last Lamplighter. A Soho Education*, London Magazine Editions, London, 2000
Fryer, Jonathan, *Soho in the Fifties and Sixties*, National Portrait Gallery, London, 1998
Goldstein, Murray, *Naked Jungle. Soho Stripped Bare*, Silverback, London, 2005
Jackson, Stanley, *An Indiscreet Guide to Soho*, Muse Arts, London, n.d. [1946]
Katz, Bernie, *Soho Society*, Quartet, London, 2008
Littlewood, Clayton, *Dirty White Boy. Tales of Soho*, Cleis, San Francisco, 2008
Lord, Graham, *The Wives and Times of Jeffrey Bernard, 1932–1997*, Sinclair-Stevenson, London, 1992
Norman, Frank and Jeffrey Bernard, *Soho Night & Day*, Corgi, London, 1966
Richardson, Nigel, *Dog Days in Soho. One Man's Adventures in 1950s Bohemia*, Victor Gollancz, London, 2000
Ruane, Medb, 'The Colony Room', in the *Daily Telegraph*, 19 October 2001
Samuels, Sammy, *Among the Soho Sinners*, Robert Hale, London, 1970
Survey of London, vols. xxxi and xxxii, *The Parish of St. James Westminster*, Athlone Press, University of London, 1963
—, vols. xxxiii and xxxiv, *The Parish of St. Anne, Soho*, Athlone Press, University of London, 1966
Summers, Judith, *Soho. A History of London's Most Colourful Neighbourhood*, Bloomsbury, London, 1989
Tomkinson, Martin, *The Pornbrokers. The Rise of the Soho Sex Barons*, Virgin, London, 1982

Film/TV
Spaight, Philip (producer), *The Street. Dennis Rose's Films of Archer Street*, BBC TV, 1985

General

Brake, Mike, *The Sociology of Youth Culture and Youth Subcultures*, Routledge & Kegan Paul, London, 1980
Carr, Roy, Brian Case and Fred Deller, *The Hip. Hipsters, Jazz and the Beat Generation*, Faber & Faber, London, 1986

Cook, Richard and Brian Morton, *The Penguin Guide to Jazz on CD, LP & Cassette* (1st edn), Penguin Books, London, 1992

Coutts-Smith, Kenneth, *The Dream of Icarus. Art and Society in the Twentieth Century*, George Braziller, New York, 1970

Coverley, Merlin, *Psychogeography*, Pocket Essentials, London, 2006

Curtis, David, *A History of Artists' Film and Video in Britain*, BFI, London, 2007

Fryer, Peter, *Mrs Grundy. Studies in English Prudery*, Dobson, London, 1963

Godfrey, Tony, *Conceptual Art*, Phaidon, London, 1998

Goldberg, RoseLee, *Performance. Live Art 1909 to the Present*, Thames & Hudson, London, 1979

Hall, Stuart and Tony Jefferson (eds.), *Resistance Through Rituals. Youth Subcultures in Post-War Britain*, Hutchinson, London, 1975

Harris, Sheldon, *Blues Who's Who*, Arlington House, New Rochelle, NY, 1979

Hebdige, Dick, *Subculture. The Meaning of Style*, Methuen, London, 1979

Laing, Dave, *The Sound of Our Time*, Sheen & Ward, London, 1969

Lessing, Doris, *Walking in the Shade*, HarperCollins, London, 1997

McKay, George, *Senseless Acts of Beauty. Cultures of Resistance since the Sixties*, Verso, London, 1996

Plant, Sadie, *The Most Radical Gesture. The Situationist International in a Postmodern Age*, Routledge, Abingdon, 1992

Polhemus, Ted, *Street Style. From Sidewalk to Catwalk*, Thames & Hudson, London, 1994

Sams, Gregory, *Uncommon Sense on Chaos, Disorder, Society and the State*, Chaos Works, London, 1996

Van Tijen, Tjebbe, *Art Action Academia 1960–2006*, Imaginary Museum Projects, Amsterdam, 2006

Walker, John A., *Cross-Overs. Art into Pop, Pop into Art*, Comedia, London, 1987

Whitcomb, Ian, *After the Ball*, Allen Lane The Penguin Press, London, 1972

Widgery, David, *Preserving Disorder*, Pluto, London, 1989

Williams, Mark, *Running Out of Road*, Bunch Books, London, 1982

Wilson, Elizabeth, *Bohemians. The Glamorous Outcasts*, I. B. Taurus, London, 2000

Woods, Alan, *Ralph Rumney. The Map is Not the Territory*, Manchester University Press, Manchester, 2000

York, Peter, *Modern Times*, Futura, London, 1984

Zec, Donald, *Put the Knife in Gently*, Robson, London, 2003

Forties

Agar, Eileen, *A Look at My Life*, Methuen, London, 1988

Davin, Dan, *Closing Times*, Oxford University Press, Auckland, 1975

Ferris, Paul, *Dylan Thomas. A Biography*, Dial, New York, 1977

Fitzgibbon, Constantine, *The Life of Dylan Thomas*, J. M. Dent, London, 1965

Gardiner, Wrey, *The Dark Thorn*, Grey Walls, London, 1946

Hamilton, Patrick, *Twenty Thousand Streets under the Sky*, Vintage, London, 1998 (1935; fiction)

Hawes, Chili (ed.), *Gerald Wilde 1905–1986*, October Gallery, London, 1988

Heppenstall, Rayner, *Four Absentees. Dylan Thomas, George Orwell, Eric Gill, J. Middleton Murry*, Barrie & Rockliff, London, 1960

Hewison, Robert, *Under Siege. Literary Life in London 1939–1945*, Quartet, London, 1979

Horwitz, Julius, *Can I Get There by Candlelight*, André Deutsch, London, 1964 (fiction)

Ironside, Janey, *Janey*, Michael Joseph, London, 1973

Lehmann, John, *I am My Brother*, Longmans, London, 1960

—, *In the Purely Pagan Sense*, Blond & Briggs, London, 1976 (fiction)

Luke, Michael, *David Tennant and the Gargoyle Years*, Weidenfeld & Nicolson, London, 1991

Lyttelton, Humphrey, *I Play As I Please*, MacGibbon & Kee, London, 1954

Shelden, Michael, *Friends of Promise. Cyril Connolly and the World of Horizon*, Hamish Hamilton, London, 1989

Thomas, Caitlin with George Tremlett, *Caitlin. Life with Dylan Thomas*, Secker & Warburg, London, 1986

Maclaren-Ross, Julian, *Memoirs of the Forties*, Alan Ross, London, 1965

—, *Collected Memoirs*, Black Spring, London, 2004

—, *Bitten by the Tarantula*, Black Spring, London, 2005

Melly, George, *Don't Tell Sybil. An Intimate Memoir of E. L. T. Mesens*, Heinemann, London, 1997

—, *Rum, Bum and Concertina*, Weidenfeld & Nicolson, London, 1977

O'Connor, Philip, *Memoirs of a Public Baby*, Faber & Faber, London, 1958

—, *The Lower View*, Faber & Faber, London, 1960

Scott, Ronnie, *Some of My Best Friends are Blues*, Northway, London, 2002

Skelton, Barbara, *Tears Before Bedtime*, Hamish Hamilton, London, 1987

Spurling, Hilary, *The Girl from the Fiction Department. A Portrait of Sonia Orwell*, Penguin Books, London, 2002

Sutherland, John, *Offensive Literature. Decensorship in Britain 1960–1982*, Junction, London, 1982

Waller, Maureen, *London 1945*, John Murray, London, 2004

Willetts, Paul, *Fear & Loathing in Fitzrovia. The Bizarre Life of Writer, Actor, Soho Dandy Julian Maclaren-Ross*, Dewi Lewis, Stockport, 2003

Williams, Val, *Ida Kar, Photographer*, Virago, London, 1989

Film/TV

Wall, Antony (director); Nigel Williams (author and presenter), *Arena. Dylan Thomas. Grave to Cradle*, BBC TV, 2003

Fifties

Allsop, Kenneth, *The Angry Decade. A Survey of the Cultural Revolt of the Nineteen Fifties*, Peter Owen, London, 1958

Amaya, Mario, *Pop as Art*, Studio Vista, London, 1965

Amis, Kingsley, *Socialism and the Intellectuals*, The Fabian Society, London, 1957

Bakewell, Joan, *The Centre of the Bed. An Autobiography*, Hodder & Stoughton, London, 2003

Barrow, Andrew, *Quentin & Philip. A Double Portrait*, Macmillan, London, 2002

Bosanquet, Reginald, *Let's Get through Wednesday. My 25 Years with ITN*, Michael Joseph, London, 1980

Bennett, Oliver, 'Licor-ish Allsorts', in the *Guardian*, 16 January 1999

Calder, John, *Pursuit. The Uncensored Memoirs of John Calder*, John Calder, London, 2001

Caron, Sandra, *Alma Cogan. A Memoir*, Bloomsbury, London, 1991

Carson, Anthony, *Carson was Here*, Methuen, London, 1962

Carpenter, Humphrey, *The Angry Young Men. A Literary Comedy of the 1950s*, Penguin Books, London, 2002

Crisp, Quentin, *The Naked Civil Servant*, Jonathan Cape, London, 1968

Cronin, Anthony, *Dead as Doornails*, Calder & Boyars, London, 1976

Daily Express, 'Of All Things She is Secretary of the Anti Uglies!', 16 March 1959

Davies, Hugh, *Francis Bacon. The Papal Portraits of 1953*, Museum of Contemporary Art, San Diego, Calif., 2002

Doncaster, Pat (ed.), *Top of the Pops*, Daily Mirror Newspapers, London, 1961

Driberg, Tom, *Ruling Passions*, Stein & Day, Briarcliff Manor, NY, 1977

Duff, Peggy, *Left, Left, Left. A Personal Account of Six Protest Campaigns 1945–65*, Allison & Busby, London 1971

Dundy, Elaine, *Life Itself*, Virago, London, 2001

Elsom, John, *Erotic Theatre*, Secker & Warburg, London, 1973

Farson, Dan, *The Gilded Gutter Life of Francis Bacon*, Century, London, 1993

Feldman, Gene and Max Gartenberg, *Protest. The Beat Generation and the Angry Young Men*, Souvenir, London, 1959

Fraser, Robert, *The Chameleon Poet. A Life of George Barker*, Jonathan Cape, London, 2001

Gale, Iain, 'The Fine Art of Drinking at Muriel's Bar', in The *Independent*, 22 July 1995

Gould, Tony, *Inside Outsider. The Life and Times of Colin MacInnes*, Chatto & Windus, London, 1983

Gowing, Lawrence and Sam Hunter, *Francis Bacon*, Thames & Hudson, London, 1990

Greer, Herb, *Mud Pie. The CND Story*, Max Parrish, London 1964

Hamilton, Richard, *Collected Words*, Thames & Hudson, London, 1982

Harrison, Martin, *Transition. The London Art Scene in the Fifties*, Merrell/Barbican Art, London, 2002

Heckstall-Smith, Dick and Pete Grant, *Blowing the Blues. Fifty Years Playing the British Blues*, Clear Books, Bath, 2004

Heilpern, John, 'So was John Osborne Gay?', in the *Daily Mail*, 29 April 2006

Hewison, Robert, *In Anger. British Culture in the Cold War 1945–60*, Weidenfeld & Nicolson, London, 1981

Hudson, Kate, *CND. Now More Than Ever*, Vision, London, 2005

Knabb, Ken, *Guy Debord. Complete Cinematic Works*, AK, Oakland, Calif., 2003

Kops, Bernard, *Shalom Bomb. Scenes from My Life*, Oberon, London, 2000

Lancaster, Marie-Jaqueline, *Brian Howard. Portrait of a Failure*, Timewell, London, 2005

Leiris, Michel, *Francis Bacon*, Poligrafa, Barcelona, 1983

Leslie, Peter, *Fab. The Anatomy of a Phenomenon*, MacGibbon & Kee, London, 1965

Logue, Christopher, *Prince Charming. A Memoir*, Faber & Faber, London, 1999

Lucie-Smith, Edward, 'Pop Art', in Tony Richardson and Nikos Stangos (eds.), *Concepts of Modern Art*, Penguin Books, Harmondsworth, 1974

McDevitt, Chas, *Skiffle. The Definitive Inside Story*, Robson, London, 1997

MacInnes, Colin, *England, Half English*, MacGibbon & Kee, London, 1961

—, *The Colin MacInnes Omnibus: City of Spades; Absolute Beginners; Mr Love and Justice*, Allison & Busby, London, 1985

Maschler, Tom (ed.), *Declaration*, MacGibbon & Kee, London, 1958

Melly, George, *Owning Up*, Weidenfeld & Nicolson, London, 1965

Mesens, E. L. T., *Collages*, Palais des Beaux-Arts, Bruxelles, 1959 (exhibition catalogue)

Miles, Barry, *Peace. 50 Years of Protest 1958–2008*, Collins & Brown, London, 2008

Moraes, Dom, *My Son's Father*, Secker & Warburg, London, 1968

Moraes, Henrietta, *Henrietta*, Hamish Hamilton, London, 1994

Moynihan, John, *Restless Lives. The Bohemian World of Rodrigo and Elinor Moynihan*, Sansom, Bristol, 2002

Muir, Robin, *A Maverick Eye. The Street Photography of John Deakin*, Thames & Hudson, London, 2002

Oakes, Philip, *At the Jazz Band Ball. A Memory of the 1950s*, André Deutsch, London, 1983

Ogden, Perry and John Edwards, *7 Reece Mews. Francis Bacon's Studio*, Thames & Hudson, London, 2001

Osborne, John, *A Better Class of Person. An Autobiography 1929–1956*, Faber & Faber, London, 1981

Peppiatt, Michael, *Francis Bacon. Anatomy of an Enigma*, Weidenfeld & Nicolson, London, 1996

Potts, Paul, *Dante Called You Beatrice*, Eyre & Spottiswoode, London, 1960

Procktor, Patrick, *Self-Portrait*, Weidenfeld & Nicolson, London, 1991

Quant, Mary, *Quant by Quant*, Cassell, London, 1966

Repsch, John, *The Legendary Joe Meek. The Telstar Man*, Cherry Red, London, 1989

Richards, Rick (2i's), unpublished MS

Richardson, John, *Sacred Monsters, Sacred Masters*, Random House, New York, 2001

Ruddock, Joan, *CND Scrapbook*, Optima, London, 1987

Rudolph, Anthony and Colin Wiggins, *Kitaj in the Aura of Cezanne and Other Masters*, National Gallery, London, 2002

Rumney, Ralph, *The Consul*, Verso, London, 2002

Russell, John and Suzi Gablik, *Pop Art Redefined*, Praeger, New York, 1969

Russell, John, *Francis Bacon*, Thames & Hudson, London, 1971

Sherry, Norman, *The Life of Graham Greene. Volume Three: 1955–1991*, Jonathan Cape, London, 2004

Sinclair, Andrew, *The Life and Violent Times of Francis Bacon*, Sinclair-Stevenson, London, 1993

Spalding, Frances, *Stevie Smith. A Biography*, W. W. Norton, New York, 1989

—, *Dance Till the Stars Come Down. A Biography of John Minton*, Hodder & Stoughton, London, 1991

Stamp, Gavin, 'Anti Ugly Action', in *Blueprint*, January 2007

Steele-Perkins, Chris and Richard Smith, *The Teds*, Travelling Light/Exit, London, 1979

Sylvester, David, *Interviews with Francis Bacon* (3rd enlarged edn), Thames & Hudson, London, 2004

Tennant, Emma, *Girlitude. A Portrait of the 50s and 60s*, Jonathan Cape, London, 1999

Thorp, Raymond, *Viper. The Confessions of a Drug Addict*, Robert Hale, London, 1956 (fiction)

Travis, Dave, 'As good as it gets', liner notes to *Skiffle* (double CD), Castle Communications , London, 2000

Tynan, Kenneth, *Tynan on Theatre*, Penguin Books, Harmondsworth, 1964

Wardle, Irving, *The Theatres of George Devine*, Jonathan Cape, London, 1978

Watling, Sue and David Alan Mellor, *Pauline Boty. The Only Blonde in the World*, Whitford Fine Art/The Mayor Gallery, AM Publications, London, 1998

Wheen, Francis, *The Soul of Indiscretion. Tom Driberg*, Chatto & Windus, London, 1990

Williams, Jane (ed.), *Tambimuttu. Bridge between Two Worlds*, Peter Owen, London, 1989

Williams, Val, *Ida Kar. Photographer 1908–1974*, Virago, London, 1989

Witchel, Alex, 'Quentin Crisp, Writer and Actor on Gay Themes, Dies at 90', in the *New York Times*, 22 November 1999

Wise, Damon, *Come by Sunday. The Fabulous, Ruined Life of Diana Dors*, Sidgwick & Jackson, London, 1998

Wishart, Michael, *High Diver*, Blond & Briggs, London, 1977

Sixties

Adams, Tim, 'The Lady's Not a Tramp', in the *Observer Review*, 18 February 2001 (Christine Keeler)

Aitken, Jonthan, *The Young Meteors*, Secker & Warburg, London, 1967

Allen, Daevid, *Gong Dreaming. Soft Machine 66–69*, n.p., n.d.

Ali, Tariq, *1968 and After. Inside the Revolution*, Blond & Briggs, London, 1978

Andersen, Christopher, *Jagger Unauthorized*, Simon & Schuster, London, 1993

Anon., 'What's All This Damn "Arts Lab" Nonsense?', in *Unit* 9, December 1967, Keele University

Athill, Diana, *Stet. An Editor's Life*, Granta, London, 2000

Balfour, Victoria, *Rock Wives*, Beech Tree, New York, 1986

Ballard, J. G., *The Atrocity Exhibition*, Jonathan Cape, London, 1970 (fiction)

Beatles, *The Beatles Anthology*, Chronicle Books, San Francisco, 2000

Bernard, Barbara, *Fashion in the 60s*, Academy Editions, London, 1978

Berne, Martina and Barry Miles (eds.), *Book 'im. 70 Years on the Game: A Tribute for Bernard Stone from His Many Friends*, Friends of Bernard Stone, London, 1994

Berton, Pierre, *Voices from the Sixties*, Doubleday, Garden City, NY, 1967

Biggs, Bryan (ed.), *Mal Dean 1941–74. Cartoons, Illustrations, Drawings & Paintings*, Bluecoat Gallery, Liverpool, 1993

Bockris, Victor, *Keith Richards*, Poseidon, New York, 1992

Booker, Christopher, *The Neophiliacs. The Revolution in English Life in the Fifties and Sixties*, Pimlico, London, 1992

Booth, Stanley, *Keith. Standing in the Shadows*, St Martin's Press, New York, 1995

Bowie, Angela, *Free Spirit*, Mushroom, London, 1981

—, *Backstage Passes. Life on the Wild Side with David Bowie*, Orion, London, 1993

Boxer, Mark, 'Times Ahead', in the *Observer Magazine*, 8 September 1985 (colour supplement)

Boyd, Joe, *White Bicycles. Making Music in the 1960s*, Serpent's Tail, London, 2006

[Boyle, Mark], *Journey to the Surface of the Earth. Mark Boyle's Atlas and Manual*, exhibition catalogue from the Haags Gemeentemuseum, 16 May–12 July 1970, Edition Hansjorg Mayer, Cologne, 1970

Breitwieser, Sabine (ed.), *Gustav Metzger. History History*, Generali Foundation, Hatje Cantz, Vienna, 2005

Brett, Guy, *Exploding Galaxies. The Art of David Medalla*, Kala, London, 1995

Breward, Christopher, David Gilbert and Jenny Lister (eds.), *Swinging Sixties. Fashion in London and Beyond 1955–1970*, V&A, London, 2006

Brown, Mick, *Performance*, Bloomsbury, London, 1999

Burdon, Eric, *I Used to be an Animal, But I'm All Right Now*, Faber & Faber, London, 1986

Burgess, Anthony, *You've Had Your Time*, Heinemann, London, 1990

Campbell, Allan and Tim Niel, *A Life in Pieces. Reflections on Alexander Trocchi*, Rebel, Edinburgh, 1997

Charone, Barbara, *Keith Richards*, Futura, London, 1979

Clarkson, Wensley, *Bindon*, John Blake, London, 2005

Cohn, Nik, *Awopbopaloobop Alopbamboom. Pop from the Beginning*, Weidenfeld & Nicolson, London, 1969

—, *Ball the Wall*, Picador, London, 1989

Connolly, Ray, *Stardust Memories*, Pavilion, London, 1983

Cooke, Rachel, 'Just the Two of Us', in the *Observer Magazine*, 28 January 2007 (Gilbert and George)

Coon, Caroline, *Jim Anderson, Richard Neville and Felix Dennis. The Oz 3, Free! A History Painting by Caroline Coon*, n.p., London, 1996

Coon, Caroline and Rufus Harris, *The Release Report on Drug Offenders and the Law*, Sphere, London, 1969

Cowie, Peter, *Revolution! The Explosion of World Cinema in the 60s*, Faber, London, 2004

Crosby, John, 'Return of the Dandy', in the *Observer*, 1 May 1966

Dallas, Karl and Barry Fantoni, *Swinging London*, Stanmore, London, 1967

Davies, Ray, *X-Ray*, Viking, London, 1994 (autobiography/fiction)

Deakin, Rich, *Keep It Together. Cosmic Boogie with the Deviants and the Pink Fairies*, Headpress, London, 2007

de Villeneuve, Justin, *An Affectionate Punch*, Sidgwick & Jackson, London, 1986

English, Michael, *3D Eye*, Paper Tiger, Limpsfield, 1979

Etchingham, Cathy, *Through Gypsy Eyes. My Life, the Sixties and Jimi Hendrix*, Victor Gollancz, London, 1998

Fabian, Jenny, 'All Change', in *Queen*, 5 February 1969

—, *A Chemical Romance*, Talmy Franklin, London, 1971

Fabian, Jenny and Johnny Byrne, *Groupie*, New English Library, London, 1969

Faithfull, Marianne, *Faithfull*, Michael Joseph, London, 1994

—, *Memories, Dreams & Reflections*, Fourth Estate, London, 2007

Farren, Mick, *Get On Down. A Decade of Rock and Roll Posters*, Futura/Dempsey & Squires, London, 1976

—, *Give the Anarchist a Cigarette*, Jonathan Cape, London, 2001

Farren, Mick and Edward Barker, *Watch Out Kids*, Open Gate, London, 1972

Fountain, Nigel, *Underground. The London Alternative Press 1966–74*, Comedia/Routledge, London, 1988

Freeman, Gillian, *The Undergrowth of Literature*, Thomas Nelson, London, 1967

Fryer, Peter, 'A Map of the Underground. The Flower Power Structure & London Scene', in *Encounter*, October 1967

—, 'Inside the Underground', in the *Observer*, 3 December 1967

Gilbert, Richard, 'London's Other Underground', in *Town*, March 1967

Grant, Linda, *Sexing the Millennium*, HarperCollins, London, 1993

Green, Jonathon, *Days in the Life. Voices from the English Underground 1961–1971*, Heinemann, London, 1988

—, *All Dressed Up. The Sixties and the Counter Culture*, Jonathan Cape, London, 1998

Green, Maureen, 'Who's Who in the Underground', in the *Observer*, 3 December 1967

—, 'The Fool's Paradise', in the *Observer*, 3 December 1967

Greenland, Colin, *The Entropy Exhibition. Michael Moorcock and the British New Wave in Science Fiction*, Routledge & Kegan Paul, London, 1983

Grogan, Emmett, *Ringolevio. A Life Played for Keeps*, Heinemann, London, 1972

Harris, Bob, 'Exploding Galaxy', in *Unit* 9, December 1967, Keele University

Haynes, Jim, *Thanks for Coming!*, Faber & Faber, London, 1984

Hamblett, Charles and Jane Deverson, *Generation X*, Tandem, London, 1964

Henri, Adrian, *Autobiography*, Jonathan Cape, London, 1971

Hewison, Robert, *Too Much. Art and Society in the Sixties 1960–75*, Methuen, London, 1986

Hopkins, John 'Hoppy', *From the Hip. Photographs 1960–1966*, Damiani, Bologna, 2008

Horovitz, Michael (ed.), *Children of Albion. Poetry of the 'Underground'; in Britain*, Penguin Books, Harmondsworth, 1969

—, 'Obituaries. Author of 1968's Bomb Culture, Jeff Nuttall', in the *Guardian*, 12 January 2004

Humphry, Derek and David Tindall, *False Messiah. The Story of Michael X*, Hart-David, MacGibbon, London, 1977

Hunt, Marsha, *Real Life*, Chatto & Windus, London, 1986

Hutchinson, Roger, *High Sixties. The Summers of Riot & Love*, Mainstream, Edinburgh, 1992

Ironside, Virginia, *Chelsea Bird*, Secker & Warburg, London, 1964 (fiction)

Jagger, Mick, 'Jagger on Performance', in David Dalton (ed.), *The Rolling Stones*, W. H. Allen, London, 1975

Jarman, Derek, *Dancing Ledge*, Quartet, London, 1984

—, *The Last of England*, Constable, London, 1987

—, *At Your Own Risk. A Saint's Testament*, Hutchinson, London, 1992

Johnson, B. S., *Aren't You Rather Young to be Writing Your Memoirs?*, Hutchinson, London, 1973

Judson, Horace, 'The Right London Number for Youngsters in Trouble', in *Life* magazine, UK edn, 15 September 1969 (Release)

Keeler, Christine, *Nothing But... Christine Keeler*, New English Library, London, 1983

—, *Scandal!* Xanadu, London, 1989

—, *The Truth at Last. My Story*, Sidgwick & Jackson, London, 2001

King, Michael, *Wrong Movements. A Robert Wyatt History*, SAF, London, 1994

Kurlansky, Mark, *1968. The Year That Rocked the World*, Jonathan Cape, London, 2004

Kurtz, Irma, *Dear London. Notes from the Big City*, Fourth Estate, London, 1997

Lahr, John, *Prick Up Your Ears. The Biography of Joe Orton*, Alfred Knopf, New York, 1978

— (ed.), *The Orton Diaries*, Methuen, London, 1986

Landesman, Jay, *Jaywalking*, Weidenfeld & Nicolson, London, 1992

'Legolas', 'The Third Ear Band', in *Gandalf's Garden, Mystical Scene Magazine* 4, 1969

Leigh, David, *High Time. The Life and Times of Howard Marks*, Heinemann, London, 1984

Lennon, Peter, *Foreign Correspondent. Paris in the Sixties*, Picador, London, 1994

Levy, Shawn, *Ready, Steady, Go! Swinging London and the Invention of Cool*, Fourth Estate, London, 2002

Levy, William, *Natural Jewboy*, Ins & Outs, Amsterdam, 1981

Lichtenstein, Rachel and Iain Sinclair, *Rodinsky's Room*, Granta, London, 1999 (David Litvinoff)

Lobenthal, Joel, *Radical Rags. Fashions in the Sixties*, Abbeville, New York, 1990

Lulu, *Lulu. Her Autobiography*, Granada, London, 1985

MacCabe, Colin, *Performance*, BFI, London, 1998

McGough, Roger, *Said and Done. The Autobiography*, Century, London, 2005

McGrath, Tom, *The Riverside Interviews 6: Tom McGrath*, Binnacle, London, 1983

Maitland, Sara (ed.), *Very Heaven. Looking Back on the Sixties*, Virago, London, 1988

Malik, Michael Abdul, *From Michael de Freitas to Michael X*, André Deutsch, London, 1968

Mandelkau, Jamie, *Buttons. The Making of a President*, Sphere, London, 1971

Marks, Howard, *Mr. Nice*, Martin Secker & Warburg, London, 1996

Marowitz, Charles, *Burnt Bridges. A Souvenir of the Swinging Sixties and Beyond*, Hodder & Stoughton, London, 1990

Marshall, Austin John, 'The Jimi Hendrix Experience', in the *Observer*, 3 December 1967

Mason, Felicity (as Anne Cumming), *The Love Habit. The Sexual Confessions of an Older Woman*, Penguin Books, New York, 1980

—, *The Love Quest*, Peter Owen, London, 1991

Masters, Brian, *The Swinging Sixties*, Constable, London, 1985

Mehta, Gita, 'Gita Mehta on Jim Haynes', in *Tatler*, February 1984

Melly, Diana, *Take a Girl Like Me*, Chatto & Windus, London, 2005

Melly, George, *Revolt into Style. The Pop Arts in Britain*, Allen Lane The Penguin Press, Harmondsworth, 1970

Metzger, Gustav, *Damaged Nature, Auto-Destructive Art*, coracle@workfortheeyetodo, London, 1996

Michell, John, *Eccentric Lives and Peculiar Notions*, Black Dog & Leventhall, New York, 1999

Miles, [Barry], *Mick Jagger in His Own Words*, Omnibus, London, 1982

Miles, Barry, *Paul McCartney. Many Years from Now*, Secker & Warburg, London, 1997

—, *The Beat Hotel*, Grove, New York, 2000

—, *In the Sixties*, Jonathan Cape, London, 2002

—, *Pink Floyd. The Early Years*, Omnibus, London, 2006

Moller, Karen, *Technicolor Dreamin'. The 1960s Rainbow and Beyond*, Trafford, Victoria, BC, 2006

Moorcroft, Alph, 'Lights', in *Unit* 9, December 1967, Keele University

Murray, Charles Shaar, *Crosstown Traffic. Jimi Hendrix and Post-War Pop*, Faber & Faber, London, 1989

Naipaul, V. S., 'The Life and Trials of Michael X', in the *Sunday Times Magazine*, 12 and 19 May 1974

Napier-Bell, Simon, *You Don't Have to Say You Love Me*, New English Library, London, 1982

Nelson, Elizabeth, *The British Counter-Culture 1966–73. A Study of the Underground Press*, Macmillan, London, 1989

Neville, Richard, *PlayPower*, Jonathan Cape, London, 1970

—, *Playing Around*, Hutchinson, London, 1991

—, *Hippie Hippie Shake*, Bloomsbury, London, 1995

—, *Out of My Mind*, Bloomsbury, London, 1996

Nicholl, Charles, 'IT, Oz and All the Others', in the *Daily Telegraph Magazine* 465, 28 September 1973

Norman, Philip, *Elton*, Hutchinson, London, 1991

Novotny, Mariella, *King's Road*, Leslie Frewin, London 1971 (fiction)

Nuttall, Jeff, *Bomb Culture*, MacGibbon & Kee, London, 1968

—, *Performance Art. Volume 1: Memoirs*, John Calder, London, 1979

—, *Performance Art. Volume 2: Scripts*, John Calder, London, 1979

O'Dell, Denis, *At the Apple's Core. The Beatles from the Inside*, Peter Owen, London, 2002

Oldham, Andrew Loog, *Stoned*, Secker & Warburg, London, 2000

—, *2Stoned*, Secker & Warburg, London, 2002

Orton, Joe, *Up Against It. The Screenplay for the Beatles*, Eyre Methuen, London, 1979

Palacios, Julian, *Lost in the Woods*, Boxtree, London, 1998

Peel, John and Sheila Ravenscroft, *Margrave of the Marshes*, Bantam, London, 2005

Phillips, Mike with Charlie Phillips, *Notting Hill in the Sixties*, Lawrence & Wishart, London, 1991

Platt, Charles (ed.), *Dream Makers. Science Fiction and Fantasy Writers at Work*, Xanadu, London, 1987

Povey, Glenn, *Echoes. The Complete History of the Pink Floyd*, Mind Head, Chesham, 2007

Pritchard, Martyn and Ed Laxton, *Busted! The Sensational Life-Story of an Undercover Hippie Cop*, Mirror Books, London, 1978

Prévost, Edwin, *No Sound is Innocent*, Copula, London, 1995

Raymond, Derek, *The Hidden Files. An Autobiography*, Little, Brown, London, 1992

Rayns, Tony, 'An Interview with Antony Balch', in *Cinema Rising* 1, April 1972

Redding, Noel and Carol Appleby, *Are You Experienced? The Inside Story of the Jimi Hendrix Experience*, Fourth Estate, London, 1990

Rees, A. L., 'Warhol Waves. The Influence of Andy Warhol on the British Avant-Garde Film', in *Andy Warhol Film Factory*, ed. Michael O'Prey, BFI, London, 1989

Robins, David and Liz Béar, 'Underground Voices: Jim Haynes, David Medella, Jack H. Moore', in *Circuit* 5, Winter 1968

Robson, Jeremy, *Poems for Jazz*, Leslie Weston, Leicester, 1963

Roby, Steven, *Black Gold. The Lost Archives of Jimi Hendrix*, Billboard, New York, 2002

Sanchez, Tony, *Up and Down with the Rolling Stones*, William Morrow, New York, 1979

Sandford, Christopher, *Jagger. Primitive Cool*, Victor Gollancz, London, 1993

Sargeant, Jack, *Naked Lens. Beat Cinema*, Creation, London, 1997

Scaduto, Anthony, *Mick Jagger*, W. H. Allen, London, 1974

Scala, Mim, *Diary of a Teddy Boy. A Memoir of the Long Sixties*, Sitric, Dublin, 2000

Schofield, Carey, *Jagger*, Beaufort, New York, 1985

Scott, Andrew Murray, *Alexander Trocchi. The Making of the Monster*, Polygon, Edinburgh, 1991

—(ed.), *Invisible Insurrection of a Million Minds. A Trocchi Reader*, Polygon, Edinburgh, 1991

Shawn, Wallace and André Gregory, *My Dinner with Gregory*, Grove, New York, 1981

Sheff, David, *Last Interview, John Lennon and Yoko Ono*, Sidgwick & Jackson, London, 2000

Short, Martin, 'A Firm in a Firm. Freemasonry and Police Corruption', http://freemasonrywatch. org/true_blue.html, accessed July 2009

Shrimpton, Jean, *My Own Story*, Bantam, New York, 1965

—, *An Autobiography*, Ebury, London, 1990

Smith, Ken, *Inside Time*, Harrap, London, 1989

Spencer, Neil, 'The Underground Press', in *Arrows* 95, Sheffield University,1968

Spicer, Daniel, 'All Tomorrow's Parties', in the *Independent*, 11 October 2006

Stansill, Peter, 'The Life and Times of IT' (unpublished MS)

Stansill, Peter and David Zane Mairowitz (eds.) *BAMN. By Any Means Necessary: Outlaw Manifestos and Ephemera 1965–1970*, Penguin Books, Hamondsworth, 1971

Steele Waller, Georgiana, *My Life So Far...* privately published, Los Angeles, 2007

Tate Gallery, *Peter Blake*, exhibition catalogue, 1983

Taylor, Derek, *As Time Goes By. Living in the Sixties*, Straight Arrow, San Francisco, 1973

—, *It was Twenty Years Ago Today*, Bantam, London, 1987

Trevena, Philip, *Landesmania. A Biography*, Tiger of the Stripe, London, 2004 (Jay Landesman)

Twiggy, *Twiggy. An Autobiography*, Hart-Davis, MacGibbon, London, 1975

Umland, Rebecca and Sam, *Donald Cammell. A Life on the Wild Side*, FAB, Godalming, 2006

Vaizey, Marina, *Peter Blake*, Weidenfeld & Nicolson, London, 1986

Vale, V. and Andrea Juno (eds.), *J. G. Ballard*, RE/Search 8–9, San Francisco, 1984

Vestey, Michael, 'Raving London', in *London Look*, 11 February 1967

Waterlow, Nick, *Larrikins in London. An Australian Presence in 1960s London*, University of New South Wales College of Fine Arts, n.d. [2005]

Watt, Judith, *Ossie Clark 1965/74*, V&A, London, 2003

Wheen, Francis, *The Sixties*, Century/Channel 4, London, 1982

Whitechapel Gallery, *The New Generation, 1968. Interim*, Whitechapel Gallery, London, 1968

Whitcomb, Ian, *Rock Odyssey. A Chronicle of the Sixties*, Limelight Editions, New York, 1994

Whitehead, Peter (ed.), *Wholly Communion*, Lorrimer, London, 1965

Whiteside, Thomas, *Twiggy & Justin*, Farrar, Straus & Giroux, New York, 1968

Williams, John, *Michael X. A Life in Black and White*, Century, London, 2008

Wilson, Andrew, 'Moving Times – New Words – Dead Clocks. Sigma, London Counter-Culture', in David Alan Mellor and Laurent Gervereau (eds.) *The Sixties. Britain and France 1960–1973: The Utopian Years*, Philip Wilson, London, 1997

—, 'Everything. A View on a Developing Counterculture in the mid-1960s London' in Henry Meyric Hughes and Gijs van Tuyl (eds.), *Blast to Freeze. British Art in the 20th Century*, Kunstmuseum Wolfsburg, Hatje Cantz exhibition catalogue, 2002

Wilson, Elizabeth, *Mirror Writing. An Autobiography*, Virago, London, 1982

Wollen, Roger (ed.), *Derek Jarman. A Portrait*, Thames & Hudson, London, 1992

Woods, Gerald, Philip Thompson and John Williams, *Art Without Boundaries 1950–70*, Thames & Hudson, London, 1972

Yoko Ono, *Yes*, Japan Society/Harry Abrams, New York, 2000

Film/TV

Klinker, Robert and Iain Sinclair (directors), *Ah! Sunflower* (1967) PicturePress, DVD, 2007

Pearce, John (director), *Moviemaker* (1968), privately issued DVD, London, n.d. [2006]

Wadhawan, Jamie (director), *Cain's Film* (with William Burroughs, Alexander Trocchi, Ronald Laing et al.), London, 1969

Wilcocks, Desmond (ed.), 'What's Happening?', *Man Alive*, BBC TV documentary on '14 Hour Technicolor Dream', 17 May 1967, and *Late Night Lineup*, panel discussion on the *Man Alive* programme, 17 May 1967

Seventies

Ant, Adam, *Stand and Deliver. The Autobiography*, Sidgwick & Jackson, London, 2006

Ballard, J. G., 'In Conversation with Eduardo Paolozzi and Frank Whitford', in *Studio International* 183, October 1971

Bessy, Claude, interview with Malcolm McLaren in *New Music News*, 10 May 1980

Blazwick, Iwona (ed.), *Endless Adventure… an Endless Passion… an Endless Banquet. A Situationist Scrapbook*, ICA/Verso, London, 1989

Boy George, *Take It Like a Man*, Sidgwick & Jackson, London, 1995

—, *Straight*, Century, London, 2005

Boycott, Rosie, *A Nice Girl Like Me. A Story of the Seventies*, Chatto & Windus, London, 1984

Bradley, Lloyd, *Bass Culture. When Reggae was King*, Viking, London, 2000

Burchill, Julie, *I Knew I was Right*, Heinemann, London, 1998

Burchill, Julie and Tony Parsons, *The Boy Looked at Johnny. The Obituary of Rock and Roll*, Pluto, London, 1978

Cardew, Cornelius, *Stockhausen Serves Imperialism*, Latimer, London, 1974

Cardew, Cornelius (ed.), *Scratch Music*, MIT, Cambridge, Mass., 1974

Cork, Richard, *Everything Seemed Possible. Art in the Seventies*, Yale, New Haven, Conn., 2003

Crisp, Quentin, *How to Become a Virgin*, Fontana, London, 1981

Demoriane, Hermine, *The Tightrope Walker*, Secker & Warburg, London, 1989

Fashion Guide, London, 1976

Ford, Simon: *Wreckers of Civilisation. The Story of COUM Transmissions and Throbbing Gristle*, Black Dog, London, 1999

—, 'A Psychopathic Hymn. J. G. Ballard's "Crashed Cars" Exhibition of 1970', in *Seconds* 001, http://www.slashseconds.org/issues/001/001/articles/13_sford/index.php, accessed August 2008

Gilmour, Sarah, *Twentieth Century Fashions. The 70s: Punks, Glam Rockers & New Romantics*, Heinemann, Oxford, 1999

Gimarc, George, *Punk Diary 1970–1979*, Vintage, London, 1994

Gray, Marcus, *Last Gang In Town. The Story and Myth of the Clash*, Fourth Estate, London, 1995

Green, Johnny, *A Riot of Our Own*, Indigo, London, 1997

Greer, Germaine, 'Germaine Greer – Female Emancipator', in *The Unexpurgated Penthouse*, New English Library, London, 1973 (interview)

Greenfield, Robert, 'The Oz Obscenity Trial. Guilty', in *Rolling Stone* 90, 2 September 1971

Guthrie, Hammond, *AsEverWas*, SAF, London, 2002

Haslam, Dave, *Not Abba. The True Story of the 1970s*, Fourth Estate, London 2005

Hewitt, Paolo, *The Soul Stylists. Six Decades of Modernism – from Mods to Casuals*, Mainstream, Edinburgh, 2000

Heylin, Clinton, *Babylon's Burning. From Punk to Grunge*, Viking, London, 2007

Hopkins, John, 'Arts Lab London 17 March 1970 John Hopkins Reporting', in *Friends* 5, 14 April 1970

Home, Stewart, *Cranked Up Really High. Genre Theory and Punk Rock*, Codex, Hove, 1995 (new edn 1996)

—, *Neoism, Plagiarism & Praxis*, AK, Edinburgh, 1995

Jarman, Derek, *Smiling in Slow Motion*, Century, London, 2000

Jones, Alan and Jussi Kantonen *Saturday Night Forever. The Story of Disco*, Mainstream, London, 2005.

Jones, Martin, *Psychedelic Decadence. Sex, Drugs, Low-Art in Sixties & Seventies Britain*, Headpress, Manchester, 2001

Julien, Isaac (curator), *Derek Jarman. Brutal Beauty*, Serpentine Gallery, London, 2008

Krell, Gene, *Vivienne Westwood. Fashion Memoir*, Thames & Hudson, London, 1997

Letts, Don, *Culture Clash. Dread Meets Punk Rockers*, SAF, London, 2007

Levy, William, *Natural Jewboy*, Ins & Outs, Amsterdam, 1981

Lydon, John, *No Irish, No Blacks, No Dogs. The Autobiography of Johnny Rotten*, Hodder & Stoughton, London, 1994

Lydon, John, interviewed by Tom Hibbert in Q, June 1994

Marco, Paul, *The Roxy London WC2. A Punk History*, Punk77, London, 2007

Marcus, Greil, *Lipstick Traces. A Secret History of the Twentieth Century*, Secker & Warburg, London, 1989

—, *In the Fascist Bathroom. Writings on Punk 1977–1992*, Viking, London, 1993

Marshall, Bertie, *Berlin Bromley*, SAF, London, 2006

Melly, George, *Mellymobile 1970–1981*, Robson, London, 1982

Mension, Jean-Michel, *The Tribe*, Verso, London, 2002

Miles, Barry, *William Burroughs. El Hombre Invisible* Virgin, London, 1992

Moorcock, Michael, *The Great Rock 'n' roll Swindle*, Virgin, London, 1981

Palmer, Tony, *The Trials of Oz*, Blond & Briggs, London, 1971

Peake, Tony, *Derek Jarman*, Little Brown, London, 1999

Perry, Roger, *The Writing on the Wall*, Elm Tree, London, 1976

Q magazine, *The Q Book of Punk Legends*, Q, London, 1996

Ratcliff, Carter and Robert Rosenblum, *Gilbert and George. The Singing Sculpture*, Thames & Hudson, London, 1993

Reid, Jamie with Jon Savage, *Up They Rise. The Incomplete Works of Jamie Reid*, Faber & Faber, London, 1987

Render, Chris (ed.), *The First 25 Years of Compendium Bookshop*, Compendium, London, 1993

Rosenblum, Robert, *Introducing Gilbert & George*, Thames & Hudson, London, 2004

Sabin, Roger (ed.), *Punk Rock. So What? The Cultural Legacy of Punk*, Routledge, London, 1999

Salewicz, Chris, *Redemption Song. The Definitive Biography of Joe Strummer*, HarperCollins, London, 2006

Sarler, Carol, 'A Moral Issue', in the *Sunday Times* magazine, 9 June 1991 (*Oz* magazine trial)

Savage, Jon, *England's Dreaming. Sex Pistols and Punk Rock*, Faber & Faber, London, 1991

—, *Time Travel*, Chatto & Windus, London, 1996

Sounes, Howard, *Seventies. The Sights, Sounds and Ideas of a Brilliant Decade*, Simon & Schuster, London, 2006

Sinclair, Iain, *Crash*, BFI, London, 1999

Stanley, Jo, 'Ballard Crashes', in *Friends* 7, 29 May 1970

Strongman, Phil, *Pretty Vacant. A History of Punk*, Orion, London, 2007

Tennant, Emma, *Burnt Diaries*, Canongate, Edinburgh, 1999

Tomlin, David, *Tales from the Embassy*, 3 vols., Iconoclast, London, 2002, 2006, 2007

Tynan, Kenneth, *The Diaries of Kenneth Tynan*, Bloomsbury, London, 2001

Vermorel, Fred, *Vivienne Westwood. Fashion, Perversity and the Sixties Laid Bare*, Overlook, Woodstock, NY, 1996

Waldrep, Shelton, *The Seventies. The Age of Glitter in Popular Culture*, Routledge, London, 2000

Walker, John A., *Left Shift. Radical Art in 1970s Britain*, I. B. Tauris, London, 2002

Wates, Nick and Christian Wolmar (eds.), *Squatting. The Real Story*, Bay Leaf, London, 1980

Widgery, David, *Beating Time. Riot 'n' Race 'n' Rock 'n' roll*, Chatto & Windus, London, 1986

Wilcox, Claire, *Vivienne Westwood*, V&A Publications, London, 2004

Wilson, Andrew, *No Future. Sex, Seditionaries and the Sex Pistols*, The Hospital, London, 2004

Wollen, Roger (ed), *Derek Jarman. A Portrait*, Thames & Hudson, London, 1996

York, Peter, *Style Wars*, Sidgwick & Jackson, London, 1980

Young, B. A., 'Flash Gordon and the Angels', in the *Financial Times*, 17 February 1970

Film/T V

Hazan, Jack and David Mingay (directors), *A Bigger Splash. David Hockney*, Salvation, DVD, London, 1974

—, *The Clash. Rude Boy: The Movie*, Prism, DVD, London, 1980

Logan, Andrew (producer), *I Wanna be a Beauty Queen*, Active Video, Beverly Hills, Calif., 1984

Shand, Terry and Geoff Kempin (producers), *Sex Pistols. Never Mind the Bollocks*, Classic Album Series DVD, Isis Productions, London, 2002

Temple, Julien, *The Filth and the Fury*, MGM, 1999, London; Channel 4 DVD, 2007

Wadhawan, Jamie (director), *Marihuana, Marihuana* (with Alexander Trocchi, Simon Vinkenoog), Amsterdam, 1972

Eighties

Almond, Marc, *In Search of the Pleasure Palace*, Sidgwick & Jackson, London, 2004

Barr, Ann and Peter York, *The Official Sloane Ranger Handbook*, Ebury, London, 1982

—, *The Official Sloane Ranger Directory*, Ebury, London, 1984

Birch, Ian, *The Book with No Name*, Omnibus, London, 1981

Boy George, *Take It Like a Man*, Sidgwick & Jackson, London, 1995

—, *Straight*, Century, London, 2005

Button, Virginia, *The Turner Prize*, Tate Gallery, London, 1997

Calhoun, Dave, 'Bohemian Rhapsody', in *Time Out* 1955, 6 February 2008 (Derek Jarman)

Darwent, Charles, 'Britart's Lost Queen?', in the *Independent on Sunday*, 18 March 2007

Delaney, Barry (ed.), *A Celebration of 20 Years of the Groucho Club*, Groucho Club, London, 2005

England, Jane (ed.), *The Neo Naturists*, England & Co, London, 2007 (exhibition catalogue)

Fallowell, Duncan, 'Gilbert & George, Talked To/Written On', in *Parkett* 14, Zurich, 1987

Fisher, Susie and Susan Holder, *Too Much Too Young? Today's Generation Speak Out on being Young in the Eighties*, Pan, London, 1981

Foege, Alec, *Confusion is Next. The Sonic Youth Story*, St Martin's Press, New York, 1994

Garratt, Sheryl, *Adventures in Wonderland. A Decade of Club Culture*, Headline, London, 1998

Greer, Fergus, *Leigh Bowery Looks*, Thames & Hudson, London, 2002

Hewison, Robert, *Future Tense. A New Art for the Nineties*, Methuen, London, 1990

Jarman, Derek, *Modern Nature. The Journals of Derek Jarman*, Century, London, 1991

—, *Up in the Air. Collected Film Scripts*, Vintage, London, 1996

Julien, Isaac (curator), *Derek Jarman. Brutal Beauty*, Serpentine Gallery, London, 2008

Knight, Nick, *Skinhead*, Omnibus, London, 1982

McLaren, Malcolm and Louise Neri, 'Malcolm McLaren, Cannibal of "Looks and Sounds"', in Maria Luisa Frisa and Stefano Tonchi, *Excess. Fashion and the Underground in the 80s*, Stazione Leopolda, Florence, 2004 (exhibition catalogue)

Ozbek, Rifat, 'Leigh Bowery', in *Leigh Bowery*, Violette, London, 1998

Perry, Grayson, *Portrait of the Artist as a Young Girl*, Chatto & Windus, London, 2006

Rambali, Paul, 'The Trojan Story', in *The Face*, January 1987

Rimmer, Dave, *Like Punk Never Happened*, Faber & Faber, London, 1985

Savage, Jon, et al., *Highflyers clubravepartyart*, Booth-Clibborn Editions, London, 1995

Sinclair, Iain, *White Chappell Scarlet Tracings*, Goldmark, Uppingham, 1987 (fiction)

—, *Lights Out for the Territory*, Granta, London, 1997

—, *Downriver*, Paladin, London, 1991 (fiction)

Sladen, Mark (ed.), *Helen Chadwick. A Retrospective*, Barbican Arts Centre, London, 2004

Tilley, Sue, *Leigh Bowery. The Life and Times of an Icon*, Hodder & Stoughton, London, 1999

Verguren, Enamel, *This is a Modern Life. The 1980s London Mod Scene*, Helter Skelter, London, 2004

Weiner, Bernard, 'The Romans in Britain Controversy', in *The Drama Review*, Sex and Performance Issue, vol. 25, no. 1, March 1981

Wright, Patrick, *A Journey through Ruins. The Last Days of London*, Paladin, London, 1992

Film/TV

Scarlett-Davis, John (producer-director), interview with Derek Jarman, *South of Watford*, LWT TV, 1984

Nineties

Allen, Keith, *Grow Up. An Autobiography*, Ebury, London, 2007

Birch, James, 'Preface', in *China Exhibition 1993. National Art Gallery, Peking, and the Art Museum, Shanghai*, Gilbert & George China Project, London, 1993

Brewster, Bill and Frank Broughton, *Last Night a DJ Saved My Life. The History of the Disc Jockey*, Grove, New York, 1999

Bussmann, Jane, *Once in a Lifetime. The Crazy Days of Acid House and Afterwards*, Paradise/Virgin, London, 1998

Collings, Matthew, *Blimey! From Bohemia to Britpop: The London Artworld from Francis Bacon to Damien Hirst*, 21 Publishing, London, 1997

Eno, Brian, *A Year with Swollen Appendices. Brian Eno's Diary*, Faber & Faber, London, 1996

Farson, Daniel, *With Gilbert and George in Moscow*, Bloomsbury, London, 1991

—, *Gilbert & George. A Portrait*, HarperCollins, London, 1999

Fritz, Jimi, *Rave Culture. An Insider's Overview*, Smallfry Press, Victoria, BC, 2000

Garratt, Sheryl, *Adventures in Wonderland. A Decade of Club Culture*, Headline, London, 1998

Gilbert & George, *China Exhibition 1993. National Art Gallery, Peking, and the Art Museum, Shanghai*, Gilbert & George China Project, London, 1993

Hirst, Damian and Gordon Burns, *On My Way To Work*, Faber & Faber, London, 2001.

Hoare, Phillip, 'Obituaries. Leigh Bowery', in the *Independent*, 5 January 1996

Home, Stewart, *Slow Death*, High Risk/Serpent's Tail, London, 1996 (fiction)

—, *Blow Job*, Serpent's Tail, London, 1997 (fiction)

— (ed.), *Mind Invaders*, Serpent's Tail, London, 1997

— (ed.), *Suspect Device. Hard Edged Fiction*, Serpent's Tail, London, 1998

Horsley, Sebastian, *Dandy in the Underworld*, Sceptre, London, 2007

James, Alex, *Bit of a Blur. The Autobiography*, Little, Brown, London, 2007

Jarman, Derek, *Chroma*, Century, London, 1994

McCall, Tara, *This is Not a Rave. In the Shadow of a Subculture*, Insomniac, Toronto, 2001

Redhead, Steve, *Repetitive Beat Generation*, Rebel Ink, Edinburgh, 2000

Stallabrass, Julian, *Highartlite*, London, 1999

—, *Art Incorporated. The Story of Contemporary Art*, Oxford University Press, Oxford, 2004

Vermorel, Fred, *Addicted to Love. Kate Moss*, Omnibus, London, 2006

Film/TV

Isaacs, Jeremy, interview with Derek Jarman, *Face to Face*, BBC TV, 1994

New Century

Collings, Matthew, *Art Crazy Nation. The Post-Blimey! Art World*, 21 Publishing, London, 2001

—, *Sarah Lucas*, Tate Gallery, London, 2002

Delaney, Barry (ed.), *A Celebration of 20 Years of the Groucho Club*, Groucho Club, London, 2005

Emin, Tracey, *Strangeland*, Hodder & Stoughton, London, 2005

Glancey, Jonathan, *London, Bread and Circuses*, Verso, London, 2001

Gregory, Steven, *Skullduggery*, Cass Sculpture Foundation, Goodwood, 2005 (interview by Damien Hirst)

Hirst, Damien, *The Cancer Chronicles*, Other Criteria, London, 2003

Home, Stewart, *69 Things to Do with a Dead Princess*, Canongate, Edinburgh, 2002 (fiction)

—, *Down & Out in Shoreditch and Hoxton*, Do-Not Press, London, 2004 (fiction)

—, *Tainted Love*, Virgin, London, 2005 (fiction)

Lucas, Sarah, *Exhibition Catalogue and Catalogue Raisonné*, Kunsthalle Zürich, Hatje Cantz, Zurich, 2005

Merck, Mandy and Chris Townsend (eds.), *The Art of Tracey Emin*, Thames & Hudson, London, 2002

Taylor, Brandon, *Art Today*, Laurence King, London, 2005

Townsend, Chris, *New Art from London*, Thames & Hudson, London, 2006

Index